A Garland Series

OUTSTANDING
THESES FROM THE

Courtauld
Institute
of Art

Women Artists in Nineteenth-Century France and England

Their Art Education, Exhibition Opportunities
and Membership of Exhibiting Societies
and Academies, with an Assessment of
the Subject Matter of their Work
and Summary Biographies

In two volumes

Volume I

Charlotte Yeldham

Garland Publishing, Inc., New York & London

1984

All volumes in this series are printed
on acid-free, 250-year-life paper.

Library of Congress Cataloging in Publication Data

Yeldham, Charlotte, 1951–
Women artists in nineteenth-century France and England.

(Outstanding theses from the Courtauld Institute of Art)
Bibliography: p.
1. Women artists—France—Biography. 2. Art, Modern—
19th century—France. 3. Women artists—England—
Biography. 4. Art, Modern—19th century—England.
I. Title. II. Series.
N6847.Y4 1984 704′.042′0942 [B] 83-48689
ISBN 0-8240-5989-1

Printed in the United States of America

WOMEN ARTISTS IN NINETEENTH CENTURY FRANCE AND ENGLAND:

THEIR ART EDUCATION, EXHIBITION OPPORTUNITIES AND

MEMBERSHIP OF EXHIBITING SOCIETIES AND ACADEMIES, WITH

AN ASSESSMENT OF THE SUBJECT-MATTER OF THEIR WORK AND

SUMMARY BIOGRAPHIES

CHARLOTTE ELIZABETH YELDHAM

PH.D.THESIS

COURTAULD INSTITUTE

ABSTRACT

Equal opportunities for women in art education were not
achieved in England or France until the beginning of the twentieth
century. Before then, there were four main types of art education
available to women. Firstly, there was the elementary instruction
to accomplishment level provided at school and at home; secondly
the education offered by the Schools of Design which was intended
for women who were compelled to earn their living and for commercial
application; thirdly the art education given at private art schools
and ateliers which in France was of an extremely high standard;
finally, academic instruction: after long efforts women were
admitted to the Royal Academy Schools in 1860 and to the Ecole des
Beaux-Arts in 1897, but they were not allowed to study from the nude
figure at these institutions until 1903 and 1900 respectively.
Throughout the century women who wished to study from the life encoun-
tered difficulties, particularly in England, whether because of the
lack of facilities or social taboo. Women's art was generally
stigmatized as accomplishment art. Many of the most successful
women artists came from artistic families and received their education
at home.

The inferior art education available to women explains many
aspects of their position and performance in the fine arts: why
works by women at mixed exhibitions never constituted more than a
small proportion of the total; why women were more prolific in water-
colour and miniature painting than in oil and classical compositions;
why only a few women achieved membership of exhibiting societies and
academies, although the exclusion of these few from equal rights and
responsibilities until the end of the century can only be ascribed to
prejudice against women in positions of authority, and why separate
exhibiting societies for women only were established at which a lower
standard was required than at mixed exhibitions. With the improve-
ment of art education towards the end of the century more works by
women were admitted to mixed exhibitions and there was a more equal
balance between artistic media in their exhibits.

The subject-matter favoured by women also reflects their
education. Portraits, landscapes and still-lives were popular
throughout the century. In figurative compositions female subjects
were most common, whether in the smaller categories of classical and
literary works or in scenes from everyday life, and the latter division
includes portrayals of women as wage-earners and artists. The

emphasis on women and on particular themes such as loneliness and suffering suggests that in many cases the approach of female artists to their work was highly personal.

Biographies of some of the most eminent and prolific women artists illustrate these general themes and also show the extent to which exceptional circumstances were necessary for full development: several were born into artistic families and several were obliged to earn a living by their art.

CONTENTS

Volume 1

ABBREVIATIONS

AAW	– Associated Artists in Water-colour
BI	– British Institution
DG	– Dudley Gallery (water-colour exhibitions)
DG(oil)	– Dudley Gallery (oil painting exhibitions)
DG(b&w)	– Dudley Gallery (black and white exhibitions)
EU	– Exposition Universelle
EX	– Exhibited
FAS	– Fine Art Society
GG	– Grosvenor Gallery
HPG	– Hyde Park Gallery (Free Exhibition of Modern Art)
IPO	– Institute of Painters in Oils
MI	– Commissioned by the Ministery of the King's Household (France)
NEAC	– New English Art Club
NG	– New Gallery
NSPW	– New Society of Painters in Water-colour (Royal Institute)
OWS	– Old Water-colour Society (Royal Water-colour Society)
PG	– Portland Gallery (National Institution of Fine Arts)
PP	– Parliamentary Papers
RA	– Royal Academy
SBA	– Society of British Artists
SFA	– Society of Female Artists (in reference to England)
SFA	– Société des Femmes Artistes (in reference to France)
SI	– Salon des Indépendants
SLA	– Society of Lady Artists
SM	– Society of Miniaturists
SN	– Société Nationale des Beaux-Arts
SPP	– Society of Portrait Painters
SR	– Salon des Refusés
SWA	– Society of Women Artists
UFPS	– Union des Femmes Peintres et Sculpteurs

Note : Unless otherwise indicated (i.e. by the letters EU, SFA, SI, SN, SR , SFA or UFPS) works in France were exhibited at the Paris Salon.

INTRODUCTION

The basic handicap facing anyone who attempts to study female activity in the arts is that no similar unilateral study has been made of male artistic activity. While general histories and studies are mostly concerned with men and read as male history, women have never been excluded as a matter of principle. In the absence of an examination of men's art seen as a manifestation of the male sex, a study of women's art lacks focus; it lacks the comparative element which both draws attention to the social and as a result artistic differences between men and women and at the same time makes clear that not only women were moulded and therefore restricted by society.

The handicap presented by the absence of a study of nineteenth century art by men is particularly noticeable in the field of subject-matter. Enough is known about art education facilities available to men for a review of those available to women to stand out in contrast. A statistical survey of percentages of works by women at nineteenth century exhibitions carries an inherent contrast. Subject-matter, however, is different. Even an attempt to generalize on the subject-matter of all exhibited works of art by men would be a colossal undertaking, far beyond the scope of the present work, and yet at the very least this is necessary for the themes which emerge from women's art to be seen in their proper light. A knowledge of the subject-matter of works of art by the most famous and well documented male artists is no solution, for women's art, which lacks big names and good documentation, can only be studied in its entirety. Thus a study of themes in men's art in its entirety will be the only effective counterbalance. This, then, is an apology for the incomplete nature of Chapters Three and Four. Despite this deficiency the present study is, it is hoped, justified by the fact that some of the themes favoured by women artists become more significant when seen as the choice of women.

CHAPTER ONE - ART EDUCATION

This chapter is intended to explain both the dearth of women artists in the nineteenth century - that is, professional and publicly acknowledged artists as opposed to lady amateurs and practitioners of accomplishment art (1) - and also certain aspects of their work: in particular technical limitations and choice of subject-matter.

England

Available information on women's art education in the last century in England falls into three sections: firstly, the sort of education which was largely enforced on middle and upper-middle class women throughout the century but chiefly in the first four decades, as a result of social pressures; secondly, the kind of art education which was officially provided for women who wanted to study art; finally, the art education which women won for themselves by the end of the century, through persistence and gradual infiltration of a predominantly male system.

In roughly the first four decades of the century art instruction for women was understood to serve two main purposes. The first and lesser of these, gradually superseded, applied mainly to middle class women and was purely functional. An elementary knowledge of composition and colour was considered necessary for domestic uses such as embroidery and to a certain extent the drawing taught in schools and at home by drawing-masters and governesses was practically motivated. It was a means to an end. The idea that women were especially gifted in design was a vital factor behind the Female School of Design which opened with Government support in 1843 and it soon became accepted that those women who had to earn their living, from the middle and lower classes, could be taught art for commercial application also. A modicum of art education was essential for women hoping to become governesses (2).

Most women from the upper classes and increasingly from the middle classes, however, were taught art as an accomplishment, to make them fit for society and attractive to prospective husbands and this fashion, which eclipsed art training for practical purposes, was frequently deplored. In "Strictures on the Modern System of Female Education" and "Coelebs", published in 1799 and 1809 respectively, Hannah More exposed the evils of this trend and regretted the disappearance of former, more functional priorities in female education. The same criticisms were voiced by many other writers on female education during this period, such as the Edgeworths in 1798, the

Reverends Shepherd, Carpenter and Joyce in 1815 and numerous contributors to journals in the 1830 s (3). Hannah More described the new fashion most succintly. Her whole criticism centres round the following passage: "This frenzy of accomplishments, unhappily, is no longer restricted within the usual limits of rank and fortune; the middle orders have caught the contagion, and it rages downward with increasing and destructive violence, from the elegantly dressed but slenderly portioned curate's daughter, to the equally fashionable daughter of the little tradesman, and of the opulent but not more judicious farmer". She went on: "And is it not obvious, that as far as this epidemical mania has spread, this very valuable part of society is declining in usefulness, as it rises in its ill-founded pretensions to elegance". She referred to "swarms of youthful females, issuing from our boarding schools, as well as emerging from the more private scenes of domestic education, who are introduced into the world, under the broad and universal title of 'accomplished young ladies'", who in reality were accomplished in nothing. "The study of the fine arts", she wrote, "is forced on young persons, with or without genius, fashion having swallowed up that distinction, to such excess as to vex, fatigue, and disgust those who have no talents, and to determine them, as soon as they become free agents, to abandon all such tormenting acquirements". The natural result of this imposition of accomplishments was the association of women with mediocre art. "Men of learning", wrote Hannah More, "who are naturally disposed to estimate works in proportion as they appear to be the result of art, study, and institution, are inclined to consider even the happier performances of the other sex as the spontaneous productions of a fruitful but shallow soil, and to give them the same kind of praise which we bestow on certain salads, which often draw from us a sort of wondering commendation, not indeed, as being worth much in themselves, but because, by the lightness of the earth, and a happy knack of the gardener, these indifferent cresses spring up in a night, and therefore, we are ready to wonder they are no worse" (4).

According to a relation of the water-colour painter, Francis Nicholson, the opening exhibition of the Old Water-colour Society in 1805 stimulated this trend still further. He wrote: "For some time after, the doorsteps of artists were beset by applicants for lessons. It became an absolute craze among ladies of fashion to profess landscape painting. To such a degree was this mania carried that every hour of the day was devoted to this easy employment and the more difficulty there was found in obtaining admission the greater of course became the

anxiety to gain it. No time was too early, no hour too late for
receiving what was called a lesson" (5).

At this stage some attempt should be made to define accomplishment
art. The most important point to establish is that it rigorously exclu-
ded study from the nude. In 1815, the English author of "A Trip to
Paris in August and September" mentioned "the phenomenon of a female
French artist being seen sitting before and making a drawing from a
totally naked large male statue" and she was seen too by hundreds of
others who visited the Louvre, none of whom appeared shocked or ashamed.
The writer thought that this indicated an unaccountable want of a sense
of propriety, quite foreign to English standards; even nude casts were
taboo for young ladies in England at that time (6). Copying, of course,
formed an important part of their curriculum; the Bronte sisters and
Charlotte in particular, who is said to have spent hours reproducing en-
gravings line by line, are the most obvious examples of this (7). Jane
Austen's Emma drew and painted flowers, landscapes and above all portraits,
for "taking a likeness" was an important part of accomplishment art (8).
Lady Fitzpatrick, in Catherine Sinclair's "Modern Accomplishments" of
1836, insists that her daughter "must paint flowers, landscapes, and
miniatures, like an artist" (9). The most detailed account is given by
Miss Rattle in "Coelebs" by Hannah More. Miss Rattle is a fashionable
young lady who is taken to London every winter to be accomplished; her
drawing master teaches her "to paint flowers and shells, and to draw
ruins and buildings, and to take views" as well as varnishing, guilding,
japanning, modelling, etching and engraving in mezzotinto and aquatinta.
Very rarely, she admits, does she finish her pictures herself; like Lady
Fitzpatrick's daughter, Eleanor, Miss Rattle relied on the help of her
drawing master (10). Agnes Grey in Anne Bronte's book, complained that
she had to teach Miss Murray "such drawing as might produce the greatest
show with the smallest labour, and the principal parts of which were gen-
erally done by me" (11).

Such instruction was easy to find. Drawing was an important part of
education at most girls' schools (12) and a knowledge of drawing was
necessary in governesses, who in most cases were employed to prepare the
daughters of upper and middle class families for society (13). Further-
more every English town of any size had its drawing master and in some
fashionable centres such as Bath they were numerous (14). David Cox is
an example. From 1814 to 1819 he held a post at Hereford as drawing
master in Miss Groucher's Academy for Young Ladies and was paid £100 a
year for teaching figure drawing and still-life twice a week. For

private tuition he charged 7s.6d. a lesson (15). A little later John
Sell Cotman advertised his terms in the Norwich Mercury: "In schools and
families 1½ to 2 guineas the quarter. Private tuition for finishing more
advanced pupils, 24 lessons 12 guineas" (16). Many women no doubt made
use of the numerous drawing and painting books which were published at
this time: works such as Rudolph Ackermann's "Six Progressive Lessons
for Flower Painting" of which a second edition was printed in 1802,
William Orme's "Studies from Nature, arranged as Progressive Lessons for
Instruction in the Art of Drawing Landscape" of 1810 and Patrick Syme's
"Practical Directions for learning Flower-Drawing" of 1813 (17).

By the 1840 s it would seem that art as an accomplishment for women
had gone out of fashion among the upper classes: with the latter,
remarked Mrs. Ellis, "it appears to be sinking into disrepute in compari-
son with music" (18). The middle classes lagged behind this change of
fashion in superior spheres and the highly influential Mrs. Ellis, whose
books on the character and education of women went through many editions
in the nineteenth century, confirmed them in their ways. Her broad claim
was that "The Female Character, though invested with high intellectual
endowments, must ever fail to charm without at least a taste in music,
Fig.1 painting or poetry" (19). In her encouragement of painting and drawing
she expressed awareness of the fact that an artist's life was beset with
difficulties; these, however, did not apply to women for it was not "an
object of desirable attainment that they should study the art of painting
to this extent. Amply sufficient for their purposes, is the habit of
drawing from natural objects with correctness and facility" (20). It was
especially useful for women, she thought, to be able to record the places
they had visited and the features of those dear to them (21). Mrs. Loudan,
in her popular handbook "The Lady's Country Companion, or, How to enjoy a
country life rationally", published in 1845, held the same views. Sketch-
ing in the open air from nature comes second in her list of five country
amusements "in which a lady can properly indulge" (22). Women were thus
encouraged to study art but the range of their studies was severely cir-
cumscribed. Although facilities for women's art education progressed from
the 1840 s as will presently be seen, in the middle classes generally art
for women continued to be seen as an accomplishment. Throughout the nine-
teenth century articles appeared denouncing the present system of female
education in which accomplishments played so large a part (23).

To complete the picture of conditions during the first four decades
of the century, mention should be made of the opportunities for art educa-
tion among working class women. Art was part of a very general curricu-
lum at the Mechanic's Institutes, founded in 1823; women were admitted to

these from 1830 (24). Likewise at the Lyceums, founded in 1838, women were taught drawing as well as reading, writing, arithmetic, sewing and singing (25). Needless to say the level of instruction was elementary.

In none of these cases was the idea even entertained of women becoming serious or professional artists. Generally speaking, the only women to emerge as artists despite this stigmatization of art in relation to women as craft or accomplishment - and this applies to the greater part of the nineteenth century - either came from artists' families thus escaping the taboo on women as serious art students, or, coming from the middle and upper classes, were sufficiently gifted and persistent to carry their studies beyond the level of design and artistic accomplishment. With the former instruction was often received at home; with the latter any instruction after the ladies' finishing school stage was usually given by successful artists of the day, who were often friends of the aspiring artist's family or otherwise only too willing to oblige for a certain fee. Many worked independently, copying in museums and galleries. A very few gained admission to Sass's Academy in the 1830 s, at that time the only good pre-Royal Academy Art School. Women were not, until 1860, admitted to the Royal Academy Schools.

Opportunities increased for women art students in the 1840 s. The first of these was based on the idea that women were naturally gifted in design, and was initially directed towards women of the lower and lower-middle classes. The opening of the Female School as one of the Government Schools of Design was part of the official scheme to improve the standard of design in England; the need for remunerative employment for women was a secondary consideration. The motivation behind the school was thus entirely practical and it was certainly not intended to produce female artists. The Head School of Design for men operated on the same principle. There were differences, however, in the instruction provided for men and for women. Furthermore, while it was fully acknowledged that men might become artists outside the Head School, where women were concerned the Female School of Art was thought to provide all the art education suitable for, and needed by, women; thus the existence of the Female School was used as an excuse for not admitting women to the Royal Academy Schools during the next seventeen years and subsequently for limiting female admissions. Since the history of the Female School reveals the class and number of women who responded to facilities for art instruction and also the prevalent idea of a proper art education for women, I will briefly describe its development before going on to a more general, chronological survey of opportunities for women seeking art instruction in the nineteenth century.

The opening of the Head Government School of Design in 1837 was instigated by disquiet at continental and especially French competition in many markets where ornamental design was of commercial importance; there were 80 Schools of Design in France and 33 in Bavaria. This had eventually led to the appointment of the 1835 Select Committee of the House of Commons which was required to "consider the Best Means of extending a Knowledge of the Arts and of the Principles of Design among the People", in particular the manufacturing population of the country (26). William Dyce, who had worked in a School of Design in Scotland, was consulted and appointed director. By 1841 it was realised that women offered a broader field of recruitment: "the fitness of such an occupation for females; the various branches of ornamental manufacture for which their taste and judgement are adapted; the desirableness of enlarging the field of employment for well-educated women; and the successful precedent of a similar institution on the Continent appeared to the Council to furnish strong grounds for adopting this measure" (27). In October 1843, the Female School opened in Somerset House, in a room in which sculpture submitted for the Academy Exhibition had previously been housed. The Superintendent was Mrs. Fanny McIan. The Report of the Female School for 1843/44 included the "Rules for Attendance, Conduct and Studies" and the first of these ten rules succinctly describes the aims of the School: "The School of Design having been established strictly with a view to the benefit of those who desire to study commercial Art with reference to its use in some industrial occupation, no-one who wishes to study drawing merely as an accomplishment can be admitted" (28). The equivalent rule for male students at the Schools of Design provides an interesting contrast with this: the male students were forbidden to enter the Schools with the intention of becoming artists, practitioners of Fine Art (29). The differing vocabulary in these two rules, for female and male students respectively, illustrates well the prevailing distinction between art for women and for men: for the former it meant accomplishment, for the latter, Fine Art. The Female School was not intended to meet the needs of the fashion for artistic accomplishment; it was to be a school of commercial art.

Applications exceeded by about 30 the number which it was possible to accommodate. There were 54 pupils on the books and the daily attendance was 44 (30). The fees were extremely low: two shillings a month for elementary and advanced pupils. The subsidiary provincial schools of design had separate classes for women almost immediately. Birmingham

was one of the first and the Report for 1844/5 included Newcastle and Glasgow. By 1850 all the provincial schools took women students. For the first two decades the curriculum at the Female School was devoted to drawing from lithographs, examples of ornament, and from casts, to the copying of geometrical figures, and to ornamental drawings for wood engraving which was considered especially suited to women (31). The painting of flowers was also a priority and the designing of patterns for lace and embroidery. Instruction in porcelain painting was offered to students after Mrs. McIan had visited Sèvres in 1843 and become personally acquainted with current techniques (32). The most important difference from the curriculum at the Head School was in the Figure Class. At the Female School this involved drawing from casts only, until 1864. At the Head School on the other hand, the living model was intermittently conceded as being necessary for students of certain trades, and from 1846 to 1848 was even compulsory.

The students in the early years did in fact support the aims of the School. The Report of 1844/5 gave their various occupations: there were nineteen pattern designers for various purposes, twelve designers for wood-engraving, ten porcelain painters, six designing for lithography, three learning drawing and design generally and one hoping to design for children's books; there were also five students who were learning for teaching purposes. The total was 56 and applications still greatly exceeded capacity. They were frequently complimented on their work and won so many of the prizes available to students of the Schools of Design that a second list of prizes had to be introduced to prevent the women from acquiring them all (33). Women proved particularly adept at drawing and engraving on wood and it was in connection with their skill in this department that the first organized opposition to the school arose. In 1844 several male wood-engravers "twice memorialized the council and obtained a hearing by deputation, the deputation insisting that the formation of a school for the education of ladies in the art would materially interfere with the profession of wood-engraving, reducing the income of its followers by the increase of qualified persons" (34). Although largely a record of success, the Report of 1844/5 stated a serious problem which had not been foreseen. While many female students had by then progressed to advanced studies, and "while the progress of the pupils and the talent which they display for ornamental art, are highly satisfactory, the difficulty which is experienced by females in obtaining employment, even in those branches of ornamental design which they could most advantageously undertake, and for which they are peculiarly fitted, is a source of regret" (35). The problem was that jobs

for women were hard to find as many manufacturers were biassed against
the employment of women. The result was that the Female School and
the women's classes at the provincial schools were gradually infiltrated
by middle class women. A large number of these, especially at the
Female School, intended to earn their living as governesses, the one
acceptable profession for women; many also, however, were listed as
having no occupation, present or intended, thus coming under the pro-
scribed "accomplishment" heading. This latter development was par-
ticularly noticeable in the provincial schools where, unlike at the
Female School, classes for women were often divided into ladies' classes,
governesses' classes and female or working women's classes; the ladies'
classes tended to be much larger and more over-subscribed. As early as
1845, T.M. Richardson complained of this at the School in Newcastle-upon-
Tyne (36). At the York School in 1849 it was reported that "there are at
least seven ladies in the books of the school who certainly ought not to
be there. The wife of the highest resident church dignitary in York,
three daughters of another high and well beneficed dignitary, and three
daughters of the principal physician of the place, are of a class whose
claims to the benefit of the Government School could hardly be sustained
on any pretence" (37). A teacher in the same school complained of the
difficulty of keeping the girls to elementary study; their ambition, he
said, was to draw the figure, although few proceeded beyond the heads;
not many pupils attended to ornament (38). The same problem arose in
Manchester in 1850, in Birmingham in 1851 and in Glasgow and Nottingham (39).
As a result of this influx of accomplishment students, local drawing
masters were put out of business for they could not compete with the low
fees at the provincial schools (40).

Criticisms were soon voiced on the basis of the women students at
the provincial schools. It was claimed that the women were not serious
students, that they distracted the male students and soon married. But
the main stricture was that they did not come from the classes for which
the schools were intended and saw art as an accomplishment rather than
as a means of earning their livelihood (41). In 1849 Mrs. McIan hotly
defended the Female School of Art against these criticisms. Certainly,
she replied, her pupils were respectable, but this did not mean that
they did not intend to earn their living; as in Glasgow that year most
of them hoped to qualify as governesses. She asserted: "There had never
been a pupil in the School during the time we were located in Somerset
House whose object in coming to the School was not to get her livelihood"(42).
Mrs McIan's opposition to the way the Female School was officially run

emerges strongly from this examination of 1849. Not only was she at
odds with the Committee over the social class of her students: she did
not think that this mattered so long as they intended and preferably
needed to earn their living; she also differed on the nature of the
instruction provided. In her view even ornamental art required a
knowledge of the human figure and this was not available.

In 1848 the Female School had moved to the opposite side of the
Strand due to the decision of the Committee which had succeeded Dyce (43).
Here conditions were crowded and in 1851, by which time the number of
students on the books had risen to 70, it moved again to 37 Gower Street
where it became known as the Metropolitan School of Ornament for Females (44).
The Report of 1852/3 described the scope of the School in its new location.
On the resignation of Mr. McIan who had assisted the Superintendent, Mrs.
McIan, for several years, two ladies holding scholarships, Miss Louisa
Gann and Miss West, were appointed assistants. The School was far more
organized. An entrance fee had been established and the fee for advanced
instruction raised above that for elementary tuition. The fees were
still, however, remarkably low: two shillings a month for students in
the elementary class and four shillings for those in the advanced class (45).
The special classes for wood-engraving had been extended and moved to
Marlborough House under Mr. John Thompson (46). The Report recorded huge
progress: whereas for the six months ending December 1851 the monthly
average of pupils was 52 and the total fees £26 8s., for the corresponding
period in 1852, the figures were 118 and £74 14s. (47). The total number
of students on the books was 133 and the number of women attending the
provincial schools was equally high (48). This was probably due to the
fact that in 1852 Henry Cole lifted the ban on accomplishment students,
having realized that the intrusion of the gentry could be made a source
of income. Henceforth they were admitted at a special higher rate (49).
In 1853 anatomy was added to the curriculum, a compulsory course in geo-
metry and perspective held under Mr. Bowler and an evening class estab-
lished for those busy in the day (50). The Reports of 1853 and 1854 also
recorded progress in the matter of jobs for women in commercial art (51).
With such proof of success Mrs. McIan reported in 1854: "I have there-
fore only to state my conviction of the importance of this establishment
and the confidence I feel, in its affording the means of respectable sub-
sistence to a most interesting portion of society, the educated women of
the middle classes" (52). Again the provincial schools were not so
successful: the outstanding majority were "accomplishment" students or
governesses (53). In all the schools women from the middle classes now

preponderated. It should be emphasized that the Female School was still not intended for women hoping to become artists although some certainly attended with such motivation. One of these was Eliza Turck who was a pupil around 1852. E.C. Clayton, describing her experience there, wrote that she spent her time "vainly trying to satisfy a wholesome appetite for study, with dry bones" and commented that in those days "no advantages whatever were offered in the Government Schools to those female students who desired to attain proficiency in any branch of art except decorative art. No models were then allowed, no draperies or other accessories. The 'Figure Class' as it was pompously, if ironically designated, was 'instructed' in one small room, containing a few casts from the antique, the instruction being imparted during one daily visit from the lady superintendent" (54). In conclusion it may be said that there was a discrepancy between the aims of the School, the facilities afforded and the class and motivation of the women attending.

In 1857 the Head School of Design moved from Marlborough House to South Kensington and became known as the National Art Training School. Following a decision to promote women as art teachers, women were admitted to this establishment from the beginning; as in the provincial schools they were instructed in separate classes. In 1857 also, Mrs. McIan resigned and until 1859 the Female School was supervised by Mr. Burchett who was also Headmaster at South Kensington. In October 1859 Mr. Burchett's superintendence at Gower Street ceased and Louisa Gann was appointed to succeed him. Then in December, 1859, the Government grant to the Female School was withdrawn for the following reason: "as the State bears no part of the local expenses in the district schools of the metropolis, the school in Gower Street is to that extent an unfair competitor with them. For all the requirements of female students, whose means are limited, the various district schools do, or may, afford ample and cheap opportunities for study" (55). The second sentence bore the weightier reason: the State was not prepared to finance an institution which offered instruction to well-to-do students of accomplishment art; nor was the State willing to assist women whose aim was to become professional artists as opposed to artisans. Steps were immediately taken to prevent dissolution: the new superintendent, Miss Gann, together with the teachers and students, subscribed a sum and petitioned the Queen for her special patronage; this was promised on condition that sufficient funds should be raised to enable the School to be self-supporting. In February, 1860, a group of men met to consider the desirability of saving the School; they formed themselves into a Committee and circulated a paper

appealing to the public for subscriptions, the first two of which were
made by David Roberts R.A. and John Ruskin, father of the art critic.
Money was also raised by a "conversazione" at the South Kensington
Museum, a successful appeal to the City Companies and a Bazaar, also at
South Kensington. Thus in the same year, 1860, the School was solvent
and firmly established in Queen's Square, Bloomsbury, under the manage-
ment of a Committee supervised by Miss Gann; it was an independent
institution connected with the Science and Art Department of the Commi-
ttee of the Council on Education (56). In 1862 the Queen granted her
patronage and it became known as the Royal Female School of Art (57).

The new premises in Queen's Square consisted of five rooms and
could only accommodate 80 to 100 students (58). Attendance figures
dropped. 233 were on the books in 1859, the highest number in the history
of the School, whereas there were only 128 in 1863. The School was still
crowded, nonetheless, with a long waiting list (59).

From 1863 the School held annual meetings, the substance of which
was published as statements "of the Proceedings at the Annual Meeting
and Distribution of Medals and Prizes to the Students of the Female School
of Art". The first of these are very interesting with regard to the
theoretical bases of the institution in its new independent condition. In
1863 Professor Westmacott, a member of the School's Committee, made a
speech at the annual meeting in which he outlined the purpose of the
School. This was to enable women without means to earn their living by
the special pursuits taught there. An excellent intention and one which
had existed since 1843 although originally the emphasis had been placed
more heavily on improving the general standard of design. However, that
this was not exactly a liberating measure is made clear by subsequent
remarks. He said: "It is not the habit of the English to desire to see
women over-demonstrative; the quieter qualities are what are admired, and
instead of having them declaiming on the rights of women, we prefer
believing that they can influence society most beneficially by their
gentler virtues and accomplishments. The arts are eminently calculated
to assist in doing this" (60). In 1867 he was forced into a more extreme
position by the dynamic speech of a visitor, Sir Francis Grant. The
latter, having said that he "took the most lively interest in the remark-
able progress which female art is making in this country", went on to
express an attitude which was quite at odds with the views of the School's
spokesman: not only was he a "warm advocate of the admission of lady
students to the Royal Academy" where he hoped that "they would always
enjoy the same privileges as the male students", he also thought that
Louisa Starr's recent acquisition of the gold medal was "a very serious

consideration for us men who call ourselves the lords of creation. We
may well tremble in our shoes, when we see this great storm wave of
female talent and enterprise rolling rapidly forward and threatening to
overwhelm us; but while I shall ever be the advocate of an open field,
fair play, and no favour, I trust the result will be better art, and a
friendly, peaceable, and even affectionate rivalry" (61). These stim-
ulating words instantly provoked a restatement of the prescribed position
from Westmacott. The real object of the School, he said, was not to
"raise Michael Angelos and Raffaelles"; female artists "might indulge
in a higher ambition" but it was important to explain that "the real aim
of these institutions (Schools of Design) was to advance education in a
less pretentious direction", in other words, "to afford good elementary
instruction in the principles and practice of art to ladies who desire
to accomplish themselves in its study; and secondly, to qualify those
who required it to gain an honorable livelihood by the exercise of an
elegant and refined occupation" (62). The words "accomplish" and "ele-
gant and refined occupation" effectively define his standpoint. Although
now independent, the School still clung to the old idea of a proper art
education for women; this included instruction in design, and instruc-
tion for accomplishment purposes. The only marked differences between
Westmacott's statements and the conditions stipulated at the opening of
the School in 1843, are the present encouragement of accomplishment
students and the admission that women might now actually want to become
artists.

The Report of 1864 stated several alterations of which the most strik-
Fig.2 ing was the existence of a life class, for study from the costume living
model rather than the nude, which assembled on two mornings a week. The
general bias was still towards design. Since 1860 yearly exhibitions
were held of the students' work. Fees had increased by that date although
they were still low: elementary and advanced pupils were charged £2 2s.
for five months of half-day study; admission to the life and wood-
engraving classes cost considerably more. As a crown to this Report Miss
Gann listed the prizes won by pupils since the origin of the School; they
were numerous indeed but of average quality (63). In 1866 an evening
class was started for the study of the draped living figure "offering an
opportunity not only to pupils wishing to complete their education, but
to ladies not connected with the school who may be desirous of improving
themselves in drawing" (64) and in 1868 anatomical lectures were offered
to students (65). In subsequent years the number of students increased,
the maximum figure being 244 in 1874/5 (66). An article in the "Art

Journal" of 1889 recorded the progress of the School by that time (67).
The course was extensive, including geometrical drawing and perspective;
free-hand drawing from the flat and the round; drawing from solid
models; figure drawing from the flat, from the antique and from the
life; anatomical studies and study of drapery; modelling in clay and
wax from ornament; figure painting in water-colour, tempera and oil;
exercises in composition and original design for decoration and manufac-
ture. There were also new studios and class and lecture rooms. It was
estimated that 2,227 students had received their education at the School
since 1860, a large number of whom had already become teachers or were
earning their living in various industrial trades. Following the
admission of women to the Royal Academy Schools in 1860 some students
had been admitted to this institution from the Royal Female School the
best known of these being Laura Herford, Helen Paterson (Mrs. Allingham),
Alice Elfrida Manly, Elinor Manly, Margaret Isabel Dicksee and
Henrietta Rae (Mrs. Ernest Normand) (68). The record of the School was
indeed good and the list of honours gained by students there was not small.
By the 1880's however, there were excellent facilities for women art
students elsewhere and from that decade fewer pupils attended. The need
for a school for women only was gradually erased and in 1910 the Royal
Female School of Art was incorporated into the Central School of Arts and
Crafts, Southampton Row.

The development of this School reveals three main facts: firstly the
crowded conditions and long waiting lists show the strong need for a
proper art education, at a reasonable price, for women in the nineteenth
century; secondly it was predominantly middle class women who demanded
this education; finally the slow progress, after 1850, of facilities in
this School, the official training ground for women artists, gives a clear
picture of what was considered a proper art education for women in the
nineteenth century: the original bias towards design, always considered
a fitting occupation for women, remained after 1860 as did the equally
acceptable idea of training women in art for teaching purposes; the more
general instruction introduced after 1864, although an advance on what
had preceded, still did not match the level of that provided in the art
schools attended by male students: it was a specific art education for
women in which the idea of artistic accomplishment still played a large
part.

Although the Royal Female School or Art was the only art school of
any size for women in England in the nineteenth century, surprisingly
few women who subsequently emerged in the public eye as artists attended

it. In her book "English Female Artists" published in 1876, E.C. Clayton
mentioned only four artists who went to the school and in her "Women in
the Fine Arts" of 1904, C.E. Clement referred to one more (69). Several
reasons may be advanced but the most probable seems to be that the School,
after its independence, retained the image of a school of design and re-
inforced the idea of art as an accomplishment. Three factors contrib-
uted to this: firstly the vocal part of the School's management, predom-
inantly male, fostered this approach; secondly, the teaching staff, at
least until 1885, consisted entirely of women (70) most of whom were
former pupils of the School - this suggested an amateur level of instruc-
tion; finally, there were no classes for proper "life" study from the
nude figure. These facts, and particularly the last, would certainly
have deterred the serious artist. The development of art education for
women in the nineteenth century is chiefly a question of increasing oppor-
tunities for them to work from "life". Initiative and persistence grad-
ually achieved these opportunities.

The decade which saw the origin of the Female School of Art also wit-
nessed the emergence of other openings for women.

In the 1830 s and 1840 s a number of women attended Henry Sass's
School of Art in Bloomsbury, which from 1842 was conducted by Francis
Stephen Cary. Sass's was the first good pre-Royal Academy Art School,
although it quickly found imitators, and is said to have been run on the
model of the School of the Caracci in Bologna (71). There is scant docu-
mentation on the School. Lady Eastlake, who attended in 1832, wrote
that Mr Sass held classes for ladies (72); none of these, however, is
traceable. In the late 1830 s Mrs. Margaret Backhouse, then Miss Holden,
studied there for nine or ten months; Clayton wrote: "he forwarded (her)
studies as much as possible, watching her steady progress with paternal
interest. He even yielded to her (then daring) desire of passing through
more severe studies, only accorded as a rule to male students, and he gave
her sound advice and friendly suggestions, encouraging her in her enthus-
iastic labours" (73). Five other women are known to have studied there
in the 1840's. Margaret Tekusch received her entire artistic training
at the School in the early years of the decade (74); Eliza Fox attended
for three years from 1844 to 1847 at which time the visitor was Richard
Redgrave (75); Eliza Turck "made good progress" at the classes in 1848 (76);
Adelaide Claxton was a pupil at the School "where she sketched from models
and busts" (77) and at the very end of the decade Henrietta Ward pur-
sued "a course of anatomical study" there (78). It is impossible to
establish for certain whether women were allowed to study from the nude.

The year after she left Sass's, Eliza Fox arranged a ladies' evening
class for practice in drawing from the nude, "female students having
experienced in its full bitterness the difficulty of thoroughly study-
ing the human figure concealed by its habiliments"; no instruction was
given and model expenses were shared. The classes continued until
1859 (79). This implies that previously she had been unable to pursue
such studies when she was at Sass's. In a story called "The Sisters in
Art" published in 1852, on the other hand, the heroine attends a Mr. C's
Academy - almost certainly Cary's - where "we draw the undraped figure"
and where "our attention is chiefly directed to the living figure and
anatomical drawing" (80). Whatever the truth, the Academy run by Sass
and then by Cary had one distinct disadvantage; high fees detracted all
but the more well-to-do students (81).

Those who could not afford Sass's tended to go to Dickinson's Academy
which from 1848 was conducted by James Matthew Leigh. The charge there
was half a guinea monthly (in 1848) and for many years this was the only
school in London where students could enter and study from the nude with-
out any formality beyond the payment of fees (82). It originated in 1845
when several rebel pupils were expelled from the Government School of
Design over a dispute concerning study from the life; for this the School
did not provide. They formed a separate group and on January 18th the
"Spectator" published the following report: "The want of a school of
figure-drawing, for amateurs as well as artists, in the Metropolis, is
now supplied by the re-opening of the Drawing-Gallery in Maddox Street,
with separate classes for students in different stages of progress. For
the more advanced there is a select class for painting from living models
dressed in picturesque costumes; which, as well as one for drawing from
the antique, is directed by Mr. Mogford, a person of considerable ability.
There is also an elementary class in the evening, for model-drawing, under
the direction of Mrs. Deacon. The morning classes are attended chiefly
by amateurs; among whom, we were pleased to hear, there are many ladies
of rank" (83). Emily Mary Osborn was a pupil of Mr. Mogford and of his
successor, James Matthew Leigh (84). Under the latter's direction, from
1848, the School became known as James Matthew Leigh's General Practical
School of Art and the establishment moved to Newman Street (85). It was
open all the year round from six in the morning to ten at night and the
nude model sat four times a week (86). The School was in all respects
unusual. Leigh was "in full sympathy with the continental methods of
art study" and attached great importance to individual development: he
deplored copying (87). Most important in the present context, it was

"the first school to admit lady students on equal terms with men" (88).
Ladies' classes for anatomy were held, as well as early morning study from
life for female students (89). From the early 1850 s a large number of
women attended. Clayton, in her select list, mentioned nine women artists
who studied there before 1876 (90) and remarked that in 1858, when Frances
Fripp Rossiter was a pupil, she "met many ladies who have since attained
reputation as artists" (91). Laura Herford and Anna Blunden are per-
haps the most famous of the nine women in her record, but others, better
known that the latter, also studied at Leigh's - Thomas Heatherley's
from 1860 -during this period: Kate Greenaway (92), Louisa Starr (93)
and Louise Jopling (94) all attended the School in the 1860's and doubtless
many others could be added to the list had the records been preserved.
The tradition was continued both by Heatherley from 1860 and by his nephew,
John Crompton, from 1887 (95). During the latter's tenancy, "women were
in the majority at the day classes" (96). Baroness Orczy, a pupil at this
time, wrote: "The students were for the most part simple boys and girls,
most of them from the City of London or St. Paul's School". The fees in
those years were still low, only two guineas a month and the student
"was at liberty to work either from the nude or the costume model every
day from nine in the morning till dusk". He or she could also draw from
plaster casts, paint still-lives, work in oil, water-colour or pastel and
attend portrait classes; "there was no real teaching" (97). This School,
which from the earliest years of its existence, admitted students of either
sex and of any standard while still affording excellent opportunities for
the gifted, is one of the most important factors in the history of art edu-
cation for women in the nineteenth century. Four of the first women
to be admitted to the Royal Academy Schools in the 1860 s were previously
trained there - Laura Herford, Louisa Starr, Frances Fripp Rossiter and
Elizabeth Campbell-Collingridge - and 24 more were accepted before 1880 (98).
In offering the same facilities to male and female students, the School
gave the latter a chance to prove that with a proper education they could
produce work of a high standard.

In October, 1847, the Society of British Artists opened an art school
at their gallery in Suffolk Street where the course included "study of
antique sculpture, human anatomy, comparative anatomy, living figure, per-
spective, and chromatics, by means of lectures" (99). One of two new
features, highly commended in the "Spectator", was "a school of design from
the life for ladies, in which the figure will be 'classically draped';
and thus lady artists will no longer be debarred from an important branch

of study, or forced to seek it in modes at once costly and unpleasant" (100).
This class was held three times a week (101). During the first season the
Society charged students two guineas; thereafter the courses were free (102).

The late 1840 s saw the founding of the first two colleges for the
secondary education of women: Queen's College and Bedford College. In
both, and particularly in the latter, art was an important part of the cur-
riculum. Frederick Denison Maurice, the founder of Queen's, wrote: "Gifts
which are intended for both sexes, but are oftener exhibited by women than
by men may, I believe, be more successfully cultivated by the study of
drawing, if it is honestly and faithfully pursued, than by any book instruc-
tion whatever" (103). The study of drawing, he said,"cultivates a power
of looking beneath the surface of things for the meaning which they
express (104). Thus drawing, as well as music, were not to be taught as
accomplishments, but "in the spirit of the general guiding principle, hand-
maids of religion", like the other subjects (105). After the opening of
the College in May, 1848, Paul Mulready took the drawing classes (106).
Subsequent teachers were William Cave Thomas, Albert Warren, Henry Warren
and Frank Dicksee (107). Despite the eminence of the instructors, the
teaching does not seem to have been either profound or profitable (108).
No woman artist has come to light who received her training there.

From 1849 the newly founded Ladies' College in Bedford Square, origi-
nated and financed by Mrs. Elizabeth J. Reid, with a strong orientation
towards arts subjects, offered art instruction to women (109). Francis
S. Cary, who conducted Sass's School in the 1840 s, was appointed the
first Professor of Drawing and he held the post for twenty years. In the
initial years of the College, "the studio was open to the pupils for prac-
tice at all times during the College hours except when the classes were
being held" (110). Then in 1854 a life class was opened: "The studio was
the first in England in which women could work from the life and was con-
sequently welcomed by those among them who were anxious to take their
drawing and painting seriously, not as mere accomplishments" (111). This
was untrue, as we have seen (112). There can be no doubt, however, that
the Art Department was especially successful at that time (113). Barbara
Leigh Smith Bodichon and Laura Herford both studied there in the 1850 s (114).

After the retirement of Cary, the drawing school had a chequered
career. It was known successively as "The Art School for Ladies" (1884),
"The Art School for Women" (1892) and "The Art School and Bodichon Studio"
(1895) (115) because a part of the legacy of £1,000 received on the death
of Barbara Bodichon in 1891 was used to improve the equipment of the studio
(116). Attendance dropped in the early 1870 s. Then from 1873 to 1884,
during which time Gertrude Martineau and Ellen Connolly directed the

studio and when a series of distinguished artists acted as examiners,
the School again became popular. Poynter reported in 1876: "The School
may be congratulated on possessing an admirable studio where the pupils
can draw from the living model as well as from casts of the figure" (117).
Gertrude Martineau was succeeded by two male principals in the mid-1880 s
and figures dropped. Then, under the excellent tuition of Frederick
Smallfield from 1887 to 1893 attendance again improved. In 1894 the
School offered instruction in freehand drawing, drawing from casts, paint-
ing from the draped living model, miniature painting and landscape, flower,
animal and still-life painting. Fees at that time were eight guineas
for a term of six day weeks and five guineas for a term of three day weeks
(118). Frederick Smallfield was succeeded by two short-term professors
and in 1899 George Thompson took over until the closure of the Art School
in 1914. His success caused him to be appointed Director of the Art
School and Bodichon Studio, but despite this the number of entries still
remained low, never greatly exceeding the minimum of fifteen in 1895/6.
The School closed in 1914 when the College moved to Regent's Park owing to
the difficulty of housing it adequately (119). Surprisingly the School
sponsored only three successful applicants for the Royal Academy Schools (120)

A summary of opportunities for women to study from the living model in
the 1850 s must include James Matthew Leigh's Academy, the School run by
the Society of British Artists (121) and the Ladies College in Bedford
Square (122). As women and men were offered equal instruction at Leigh's
it must be assumed that they could also study from the nude figure at his
Academy and there were independent classes, such as that run by Eliza Fox,
for the same purpose. The existence of these facilities cannot have been
broadly known, for the "Art Journal", in a review of the annual exhibition
of the Society of Female Artists in 1858, expressed admiration for the work
exhibited in view of the fact that "we have no school for the instruction
of ladies in painting from the living model" (123). Clearly these oppor-
tunities were exceptional and in a general sense the "Art Journal" was
correct. Sympathy for the cause of women art students was frequently
voiced in this periodical; the previous year it had been written: "even
in private schools females have not the advantages of unlimited study that
students of the other sex enjoy and which can alone capacitate them for
the undertaking of the highest departments of art" (124). The progress-
ive influence of statements like these should not be underestimated.

The 1860 s saw important developments in the facilities for women
art students. In 1857, on the subject of the "Employment of Female
Teachers who have obtained a certificate of Competency", the Government
had pronounced that "The Lords of the Committee of the Privy Council for

Education being desirous of promoting art education by means of female
teachers are prepared to recommend ladies who have taken certificates
of Competency in the Department of Art" (125). Thus women were ad-
mitted to the National Art Training School at South Kensington (the
Government School of Design) from its inception in 1857. Separate
classes were held for women (126). Clayton mentions nineteen female
artists who attended in the 1860 s alone and Clement adds five more who
received instruction there before 1904 (127). A further thirteen worthy
of the attention of these two writers studied at the provincial schools
of Design and seven of these were also pupils in the 1860 s (128). In
that decade the Schools were still principally intended to produce
designers and teachers and several students who attended at that time
expressed dissatisfaction with a system which enforced an extensive ele-
mentary course before more ambitious work from the antique and from life
were permitted. Lady Dilke, who entered the South Kensington School in
1858, shocked her contemporaries by her insistence on drawing from the
nude, a privilege which she finally obtained in her last year (129).
Elizabeth Thompson (Lady Butler) who hated copying and longed to study
from the life, was so demoralized by the elementary course that she left
in order to advance her studies elsewhere; on returning to the South
Kensington School in 1866 she was admitted at a higher level (130). In
1863 Harriette Seymour "did not find the method of instruction very use-
ful to her as it is adapted chiefly to designing for decoration purposes
and she sought rather for aid in composition and the management of light
and shade" (131). In the 1880 s the Baroness Orczy expressed the same
discontent at the West London School of Art, a branch of South Kensington,
for, she remarked, the object of the School was "decorative art rather
than pictorial"; she went on: "The tuition which I was receiving at the
time was on the dull and uninspired side, for it only meant drawing from
plaster casts in charcoal and in chalk and I hated drawing. I wanted to
paint" (132). Laura Knight had similar complaints about the Nottingham
Art School which she entered in 1890: "No nude model was then pro-
vided for any female student at the Art School. This entailed my having
to make endless studies from life-size plaster casts of antique statuary
instead.. This copying of such stillness I discovered later in life to
have been extremely harmful, bringing a woodenness,a dead look,to all my
studies" (133). She also complained of the separation of the male and
female students. This meant that she had to work with girls for whom
"art was no more than one accomplishment among other forms of higher
schooling - before taking place in society as a lady" (134). Where

the South Kensington School is concerned, although several students were impatient with the course, many progressed from this institution to the Royal Academy Schools (135). Among star pupils, Helen Arundel Miles and Catherine Adeline Sparkes should be mentioned; they studied there for three and four years respectively and in the course of this time won a considerable number of local and national medals (136). Alice Elfrida Manly and Susannah Soden were also highly successful at the School (137).

By the 1860 s there were several more opportunities for working class women to study art. The Sheffield People's College, to which women were admitted from its origin in 1846, like the Mechanics' Institutes included drawing in its curriculum (138). Then from 1856 there were classes, one of these a drawing class, for women at the Working Men's College (139). In 1860 an interesting controversy arose in the "Working Men's College Magazine" on the subject of whether or not drawing was a suitable subject for working class women. In January, 1860, "A Student's Wife", under the heading "Will College Night Classes be of use to Women?", wrote: "The Drawing and Music classes would, I think, be the only ones we should attend with much profit. The general lectures undoubtedly we should attend with both pleasure and profit , but the general classes of the College I do not think would be of much use to us if we were to attend them. The drawing and singing, I am sure, would be of immense use to us, and I am sure we should have a very great pleasure in attending them: but whether we could, with much advantage, attend classes for Latin, Greek, Algebra, Geometry, Logic or Political Economy (whatever that is) is, I think, very doubtful". She went on: "The connection between the beauty of a drawing and the neatness of a home, between the harmony of a part song and the harmony of kind words and loving looks, is far more real than imaginary" (140). This provoked a reply in the same magazine from "a Working Woman": the "Student's Wife", she claimed, had a flowery, select view of women: "'Music and Drawing', why, crowns and coronets seem scarcely more beyond our reach than these ladylike accomplishments. All honour to the generous men who are willing to teach us even Algebra and Trigonometry, not that we may become thereby more fit Priestesses of the Temple, but in order that we may be better qualified to do our duty in that state of life in which it may please God to place us" - whether as spinsters or widows (141). There was, nonetheless, a response to the classes. At the Working Women's College founded in 1864 by Elizabeth Malleson (142), drawing was included in the curriculum. It was taught in connection with botany "as means of increasing the perception and love of beauty in Nature" (143). The instruction was essentially

elementary as the promoters of the College did "not so much desire to
assist Women to gain special attainments (though this of course, is
desirable), as to help them to gain that kind of knowledge which brings
interest into the simplest daily labour, and which helps to make life
dutiful and noble" (144). Octavia Hill taught drawing at the College
for several years (145).

Before coming to the admission of women to the Royal Academy Schools
brief mention should be made of two other art schools which became pop-
ular with female students in the 1860 s. Around 1859 the Crystal Palace
School of Art was established. It was for ladies only and offered
classes in history, languages, drawing, music, singing and various other
subjects. It was run by a board of directors aided by a committee of
ladies resident in the neighbourhood; the secretary and superintendent
was Mr. Henry Lee (146). In 1865 it was reported that nearly 200 ladies
had joined the classes of the School during the last term. In 1872 the
water-colour class was conducted by Edward Goodall and the clay modell-
ing class by William Shenton. By 1879 the Faculty of Fine Arts
offered instruction in drawing from the antique, the figure and life
(given by Oswald von Glehn); sculpting in marble, modelling in clay and
terra-cotta from the figure, ornament and also portraiture (Constant
Vinoelst); water-colour painting, sketching, landscape painting and
architectural drawing (Edward Goodall); painting from the figure and
the costumed living model (Frederick Smallfield); painting in oils from
the life (George Harris); pottery (Miss E. Cowper) and artistic wood-
engraving (G.A. Rogers) (147). Visitors over the next three decades
included Edward Poynter R.A., Edwin Long R.A. and John Burgess A.R.A.
By 1900 men were also admitted, in separate classes (148). The School's
most famous female pupil was Eleanor Fortescue-Brickdale who studied
there under Herbert Bone in 1889.

The Lambeth School of Art was also extremely popular with female
students in the 1860 s. It was founded in 1853 by Doctor Gregory as an
evening class in his School and was intended for artisans: "engineers,
potters, joiners and other mechanics" (149). With the aid of the
Department of Science and Art the School moved in 1860 to larger prem-
ises in Vauxhall Gardens; entries increased and the scope of instruc-
tion was extended: "The School provides systematic instruction in draw-
ing, painting, modelling and designing, adapted to the requirements of
professional artists, designers, craftsmen, teachers and those who
study Art as a branch of general education" (150). Day and evening
classes were held, casts were provided "and as figure drawing forms a

prominent feature in the various courses of study, life classes are
held both day and evening". It was claimed that every student on leav-
ing was qualified to adopt a profession (151). It may safely be said
that no other Art School catered for so many tastes at that time.

After 1860 numerous female students frequented the Lambeth School.
Clayton mentions six of the most successful who attended in the 1860's
and 1870's and Clement adds one more name (152). It had several attrac-
tions: "Life classes are held, men and women working in separate rooms";
"the fees are remarkably low"; exhibitions were held three or four
times a year; finally the School prepared students for various scholar-
ships and for entry to the Royal Academy Schools to which many were
admitted on the recommendation of John Sparkes, Headmaster of the Lambeth
School from 1864 to 1905 (153). Catherine Adeline Sparkes, who attended
from 1861 to 1866, obtained probationership at the Academy Schools in
1863 and full studentship the following Spring (154). Many female
students became designers on Doulton faience under the aegis of the
School. In the "Free Press" of 1913 it was remarked: "The School is
a large one and no less than 200 students, of whom two-thirds are women,
pass through it in the course of a year" (155). In 1916 it was closed
and the pupils and headmaster transferred to the LCC Clapham School of
Art (156).

The most impressive advance of the 1860's was the admission of
women to the Royal Academy Schools (157). They had never been specif-
ically prohibited but they did not initially apply and custom soon became
law. Only one woman is known to have worked in the Schools before 1860;
this was Miss Patrickson, a pupil of John Young, the engraver, of Charles
Hayter and finally, in 1805, of Henry Fuseli. The latter allowed her to
work in the Council Room of the Academy which adjoined his own apartments
and also, through the influence of his wife who had introduced her to
the Keeper, permitted her to draw from the casts in the Antique School
during the vacations; there Fuseli paid her "two or three visits every
day" to inspect her progress (158). This was an exceptional case. The
idea of her being allowed to work with the men, in the Antique School
or the Life Class, was not even entertained.

The only real step towards the admission of women, prior to 1860,
was recorded in the "Art Journal" of 1857. Here it was written:
"Although not prescriptively excluded from the lectures of the Royal
Academy, few ladies were bold enough to attend them. For a long time, no
female was seen in the lecture room, until Miss Fanny Corbaux, we believe,
rallied some other ladies around her, broke through the rules established

by custom only and, with her friends, made her appearance before the
academical professors" (159). Whether Miss Fanny Corbaux was the actual
pioneer is uncertain. Henrietta Ward also claims to have been the first
woman at the Royal Academy lectures in the early 1850 s. According to the
latter, her presence caused George Jones R.A., who was Keeper of the Royal
Academy Schools, to convene a special meeting to exclude women. "He was
unsuccessful, however, and the next lecture I attended had five women
present, and the following one had thirty of the fair sex" (160). The
question of entry to the Schools themselves first arose in the late 1840's.
At that time Eliza Fox, having just started her ladies'classes for study
from the nude, obtained promises from various Academicians who sympa-
thised with her efforts that women would soon be admitted (161). Nothing
happened, however, until 1859 when Sir Charles Eastlake was President. In
that year, in a speech at the annual dinner, Lord Lyndhurst remarked on
the benefits conferred on all Her Majesty's subjects by the Academy Schools.
Miss Laura Herford, a former pupil of Leigh's Academy and of Eliza Fox's
class, then wrote to him pointing out that half Her Majesty's subjects -
women - were excluded (162). Communications and interviews with Eastlake
ensued and 38 women, all professional artists, signed a memorial which was
forwarded to every member of the Academy (Appendix I). Still admission
was refused on the grounds that a separate Life School would have to be pro-
vided and for this there was no room. The next step was suggested by
Eastlake himself: Laura Herford sent in qualifying drawings and signed
herself L. Herford. The reply stating acceptance was addressed to L.
Herford, Esq., but with this proof of eligibility the Academy was persuaded
to admit women to the Schools. Laura Herford became a probationer and,
amidst wide consternation, entered the Antique School in December, 1860
(163). Four more female students entered in 1861, six in 1862 and three
in 1863 (164).

Having admitted women the Academy faced the problem of facilities; to
what level and under what conditions should they be allowed to study?
In December, 1861, the following resolution was passed: "On the question
of admitting Female Students to the School of the Living Draped Model, it
was resolved that the qualification which is deemed sufficient to admit a
Student to draw from the Life, shall be deemed sufficient to admit a Female
Student to draw from the Living Draped Model" (165). This took effect and on
January 25th, it was reported: "Miss Herford having submitted drawings
according to the resolution passed on December 18th, 1861, and the draw-
ings being approved by the Council, she was admitted to the Painting
School to draw from the Living Draped Model" (166). In December 1863
Catherine Babb and Gertrude Martineau progressed to the Painting School and

were followed, in 1864, by Louisa Starr, Edith Martineau and Kate
Aldham (167). Nonetheless women did not receive the same instruction
or the same treatment as the men: they were not admitted to classes for
study from the nude model; in the School of Painting "they had a separate class for study from the draped model and modelling from the head";
furthermore, it was resolved "that young women students be placed in
communication with the Housekeeper and be especially recommended to her"
and "that the strictest propriety be observed in the Antique School with
reference to such students" (168). W.S. Spanton, a witness of the
Academy Schools in this first decade, wrote of the female students: "they
were all good workers and most discreet". Louisa Starr, he recalled, was
accompanied by her mother to the lectures (169).

In 1863 a limit was imposed on female admissions. There were to be
no more "at present" (170). This provoked immediate objections (171).
A Memorial, apparently of June 1863, was drawn up by the "Undersigned
Female Students at the South Kensington and Other Art Schools" (Appendix II).
The leaflet stated that two female students of the South Kensington School
having submitted drawings for entry to the Schools, they were told that no
more female students would be admitted. They sought reversal; in other
words "fair field and no favour". No women, however, were accepted from
1864 to 1867. In this latter year the previous exclusion was accounted
for. "Numerous applications for admission"had followed Laura Herford's
entry in 1860 "but it was found impossible, with the restricted space, to
accommodate the number that applied, and consequently the Council limited
the number to thirteen". The Report went on: "As those admitted have,
with one exception, passed through the course of study in the Antique
School, and qualified themselves for the School of Painting, the female
students were desirous that the vacancies then created in the Antique School
should be filled up, and with this intent a Memorial was presented to the
President and Council, praying that the rule excluding, 'for the present'
any addition to the number of female students might be so far relaxed as
to allow of others entering as vacancies occurred in the thirteen. This
request was acceded to, and anticipating the period at which the term of
seven years studentship should lapse, and the vacancies actually occur,
three probationerships were opened to female candidates at the competition
in July" (172). Thus, on April 2nd, 1867, entry was reopened to women.
In 1868 four female students entered and in the following year, six (173).
From 1869 the limit was relaxed due to the extension of the Schools in
Burlington House (174).

Despite these concessions women were still not admitted to the Life School and it was on this problem that they henceforth focussed their complaints. In January 1872, a Memorial, signed by 22 female students of the Academy, requested the Council to "establish a separate school under given restrictions where female artists should have the advantage of studying from the nude model, as is afforded to the male students in the Life School" (175). The request was declared "inexpedient and unanimously declined" (176). In the following year they were allowed to attend lectures on Anatomy "subject to the condition that two of the six lectures shall be reserved for Male Students only" (177). Again in 1881 it was sternly resolved that "the Male and Female Students work in different Painting Schools" (178). The women continually complained about their exclusion from life studies and in the course of the next decade gained some support in their demand for a nude male model (179). A concession was finally made in 1893 when the following resolution took effect: "It shall be optional for Visitors in the Painting School to set the male model undraped, except about the loins, to the class of Female students. The drapery to be worn by the model to consist of ordinary bathing drawers, and a cloth of light material nine feet long by three feet wide which shall be wound round the loins over the drawers, passed between the legs and tucked in over the waist-band; and finally a thick leather strap shall be fastened round the loins in order to insure that the cloth keeps its place" (180). Louise Jopling, for one, did not overestimate this concession. Writing on "Art as a Profession for Women" just after the turn of the century, she recommended that female students at the Academy Schools should seize every opportunity of studying from the nude outside; she wrote: "There are clubs formed amongst the more ambitious of the students where, at a private studio, a model can be posed, and the expense divided" (181). In 1903 the coveted regulation was made; it was decided to establish a life class for females and to allow all other classes to be mixed (182).

The number of female students increased considerably over the years, the highest number of entries for one year over the period 1860 to 1914 being 21, in 1883, 1884 and 1888. William Powell Frith remarked in 1888 that whereas a few years ago women were inadmissible to the Schools "now they are almost equal in number to the male students" (183). From 1860 to 1881 782 male students attended the Schools and 163 women; from 1891 to 1914 the figures were 637 and 229 (184). The preparatory art schools which contributed most female students to the Royal Academy Schools were Heatherley's, the National Art Training School at South Kensington, the St. John's Wood Art School and the Painting Schools run by John Watson Nicol in Pelham Street (185).

The women quickly proved their worth. Catherine Adeline Sparkes, who obtained full studentship at the Academy in 1863, won the £10 premium for the best figure from the antique in 1865 (186). Louisa Starr won a silver medal in 1865 and in 1867 was awarded the gold medal for painting (187). In the 1880 s Emmeline Halse won two silver medals and a £30 prize and Gertrude Demain Hammond, after various prizes in 1886 and 1887, in 1889 received the prize for decorative design (188). Frith observed in this decade that the female students "constantly carry off prizes" from the men and in his view this was deserved: "My position as visitor, or teacher, in the higher schools has brought me into contact with numbers of lady students, whose admirable studies from the life have often surprised and delighted me, and in the Antique School I have seen drawings by mere girls that could not be surpassed. Here, then, we have students armed with the means of producing good, and even great, pictures; and I think I may safely assert that if the great pictures are yet to come, our Annual Exhibitions show good ones by several female artists" (189). The record was equally good in the 1890 s (190). The "Art Journal" of 1907 described the 136th annual prize-giving at Burlington House as "remarkable for the success of the Women Students. Of 30 awards, seven were carried by women" (191). There was a similar exclamation in 1909. Miss Mabel Dicker won the Creswick Prize, Miss Amy Fry the First Armitage Prize, "and all along the line women were to the fore" (192).

There was one other opening in art education for women in the 1860 s. In 1863 the Society of Female Artists organised a class in which female students could study from the living model in costume (193).

In October, 1871, the Slade School opened at University College and, due to the principles of the first Director, Edward Poynter, who was convinced of the superiority of the French system of art instruction, the curriculum took a form which, by English standards, was most unusual (194). The College Calendar for 1871 stated that "in the Slade Schools, the study of the living model will be considered of the first and paramount importance, the study of the Antique being put in second place, and used as a means of improving the style of the students from time to time" (195). So, instead of a separate course for the antique, there was a general course, "in which the Students will be entirely under the direction of the Professor", including drawing from "the Antique, the Nude Model and the Draped Model", at a fixed fee, seven guineas, as well as evening study in drawing and modelling from the antique and from living models. There were also special provisions, at a reduced fee, for those students, ladies in particular, who could only attend three times a week (196). Women were admitted to the Schools from the beginning.

This general curriculum concealed one basic difference between the
male and female students. Women were not allowed to study from the nude
and for the first year at least, separate classes were held for women
to work from the draped living model (197). In 1871 it was reported:
"The buildings and their approaches have. been carefully designed in
such a way as to make due provision for the admission of ladies as
students of the Fine Art School. The structural arrangements will
render it easy to keep the Ladies' Classes quite distinct from the others,
if it should be thought desirable to maintain such separation, and in any
case, there will be entrances and other accommodation reserved for the
exclusive use of the Ladies, for whom a female attendant will be provided"
(198). The classes began in October 1871, "and were soon attended by
considerable numbers of male and female students" (199). In 1872 there
was greater integration. It was written: "The male and female students
work together in the Antique School and from the Draped Model, except
on the mornings of Tuesdays, Thursdays, and Saturdays, when the Draped
Model will sit for Ladies only, in order to suit those Ladies who may not
wish to work in the mixed class" (200). Women could also work in a
special class for study from the Draped Model in the evenings. In the
daytime they were admitted to lectures on anatomy, archeology and per-
spective like the men and furthermore they were eligible for the Slade
Scholarships (201). At the Annual General Meeting in 1873 the follow-
ing statement was made: "As apprehensions have sometimes been expressed
respecting the practical working of the plan of having mixed classes for
the study of art - a plan -, however, which has been successfully adopted
by the Royal Academy several years before the opening of the Slade School
- it may be desirable to state what has so far been the result of that plan
in the College. Professor Poynter and his Assistants report that not the
slightest inconvenience has arisen from having classes composed of ladies
and gentlemen, and the officers of the College are not aware that objec-
tions have ever been made by any of the students to this combined
Fig.3 instruction" (202). This situation continued with slight modifications
for several years. The first statement of the existence of classes for
women to study from the nude was in 1898: "In the life classes for men
and women a figure model poses every day and a draped model three times
a week"; "The men and women students work together in the Antique
School only" (203).

As in the Royal Academy Schools women scored early successes. The
first two Slade Scholarships to be awarded (1872) went to women - Miss
Ellen M. Wild and Miss Blanche Arthur R. Spencer (204). In 1873 Miss
Margaret L. Hooper was one of the two winners (205) and in 1874 Miss

Evelyn Pickering won one of the Scholarships (206). Many notable
women artists were taught at the School. Clement's list includes eight
women who attended the Slade classes in the first two decades of its
existence; of these Kate Greenaway and Evelyn de Morgan (Miss Pickering)
are probably the best known (207). In addition Ethel Walker, who was
a pupil in the 1890 s, Anna Airy, Margaret Fisher Prout and Gwen John,
who spent three years there as a pupil from 1895, should be mentioned (208).
Augustus John remarked that his sister was by no means alone as a female
student at the Slade, for it abounded in talented women students, amongst
whom were Gwen Salmond, Edna Waugh, Ursula Tyrwhitt and Ida Nettleship (209).

From what has preceded it might appear that by the 1880 s women art
students had considerable opportunities for study and indeed this was
broadly true. Although the Royal Academy Schools and the Slade did not
at that time offer women life classes for study from the nude, facilities
for such study were available at Heatherley's (run by John Crompton from
1887) and also, apparently, at the Crystal Palace School and the Lambeth
School (210). Social prejudice, however, deterred many women from taking
advantage of these openings. The close association of women with
accomplishment art which has already been considered in the first four
decades of the nineteenth century, was equally prevalent in the 1880 s.
Bessie Rayner Parkes, in 1865, deplored the low level of atainment in
women's art and put it down both to the general lack of discipline in
women's education and to the absence of facilities for life study: "the
life-class is a difficulty", she wrote; "yet without it they had far
better resign all idea of painting the figure" (211). In 1880 Phillis
Browne published a work similar to the handbooks of Mrs. Ellis and Mrs.
Loudan, called "What girls can do. A book for Mothers and Daughters".
In her view sketching from nature enabled a young girl "not only to pro-
duce something worth keeping, but it gives her the power of recalling to
her remembrance and that of her friends, pleasurable scenes and lovely
landscapes enjoyed long ago". She was anxious that girls should not
confuse women's art with professional art; they were quite separate
categories (212). Many women artists objected to this double standard.
Gertrude Massey, an art student in the 1880 s, wrote: "A careful and
thorough study of the nude is a practical and very necessary method
towards rapid and genuine progress in art. In our days, however, girls
were expected to paint portraits, still-life groups, landscapes, and all
that sort of thing, but we were certainly not expected to study from the
nude. In fact, it was almost a crime to mention the word nude; and
although acquainted with our personal anatomies, we were supposed to

accept the conventional point of view that women had no legs. They had
heads, arms and feet, apparently linked together by clothes" (213).
While Victorian morality prevailed, stipulating that "however beautiful
the body might be, it was to be hidden as a thing of shame" (214),
women were prevented from taking advantage of the new opportunities open
to them and thereby progressing in their work. One of the most entertain-
ing instances of middle class reactions to the nude in art may be seen in
the correspondence columns of "The Times", 1885. The controversy was
instigated by a letter from "A British Matron" and her argument against
the nude in art was endorsed by many other female correspondents, most of
whom insisted on the immoral effect of such pictures and of the study of
the nude, on the rising female generation. One woman, who signed her-
self "Another British Matron", wrote that the increase in nude studies
was a sign of "stealthy, steadfast advances of the cloven foot" (215).

Despite these limitations art education of a kind had become extremely
fashionable for women at this time. The "Pall Mall Gazette" was cynical
about this and commented: "In these happy times every young lady learns
to dabble in paint" (216). In the same year, 1888, under the heading
"A Ladies Picture Competition", it reported: "The frequent pertinent
question 'What shall we do with our daughters?' draws from Mr A. Ludovici,
the reply, 'Make artists of them'; or if not artists, at least painters.
If he cannot teach them the royal road to art, he certainly has the
extraordinary power of imparting the royal road to producing pictures -
and large ones too - upon canvas with the most 'taking' effects of the
Whistler School" (217). Ludovici ran a crowded studio for women on the
atelier system and taught figure and landscape painting. The Gazette
went on: "Sentiment and effect are the qualities most eagerly sought and
certainly most easily gained, thanks to a clever dodging of the real
difficulties of art and to a seeking after facility" (218). Fashionable
studios of this sort, often claiming to follow foreign and particularly
Parisian methods of instruction, abounded at this time. The Grosvenor
School of Art, in North Audley Street, was established by a Miss Digby
Williams in the 1870 s and offered "every requirement, from the most
simple geometrical figure to the most approved casts of the antique, and
the life model" (219). In 1878 the "Art Journal" commented: "Situated
as it is in the aristocratic quarter of London, its clientèle consists
principally of amateurs in that class of society" (220). By 1882 the
School was "for Ladies only, instruction being given in Drawing, and
Painting, from the Life, Figure and Model" (221). In 1879 Henrietta Mary
Ada Ward opened a School "for the Art education of Ladies" at 6 William
Street, Lowndes Square (222). Instruction was offered in oil painting,

water-colour painting, drawing, tile and china painting and the studio
was visited monthly by Royal Academicians (223). Louise Jopling
opened an extremely popular class for female students in 1886 in which
the Paris atelier system was said to be employed (224) and by 1891 a
studio for ladies run by Sir James Linton was operating in Cromwell Place,
South Kensington and offering daily study from the costume model (225).
In 1876 Charlotte Yonge had remarked that "the old-fashioned girls' -
school drawing-master is happily nearly extinct" (226). Drawing was
still taught in schools as a necessary accomplishment but by the late
1870's many of those seeking art training at an accomplishment level
attended fashionable schools such as those mentioned above.

Around 1890 opportunities for women to study from the life increased.
Concessions at the Royal Academy Schools and the Slade School in the 1890's
have already been mentioned (227). At least three schools specialised in
training students for entry to the Royal Academy Schools. The Leigh Studio
which opened at 38 Great Ormond Street on January 12th, 1890 was speci-
fically "for the preparing of Ladies for admittance into the Schools of
the Royal Academy" (228). It was run by Percy Short and visited by
William Frederick Yeames R.A. and John Seymour Lucas A.R.A. For a six-
day week the charge was six guineas a term (229). The St. John's Wood
Art School was for men and women. It opened in 1880 and in the course of
the next 34 years had 116 female students accepted at the Royal Academy
Schools (230). Women were admitted to all classes, including the life
class, by 1890. Under A.A. Calderon and B.E. Ward, the School offered
not only life classes but also summer sketching trips and special instruc-
tion in drawing in black and white with a view to press reproduction and
fashion drawing (231). In 1876 Charlotte Yonge had observed that young
ladies who wanted to earn money nearly always resorted to illustration and
this last item was probably calculated to appeal to women with such
intentions (232). The Pelham Street Studios, founded in the 1890 s and
run by John Watson Nicol and Arthur Stockdale Cope A.R.A., also admitted
women to life classes and were successful in training students for the
Royal Academy Schools (233). Many schools, apart from the Leigh Studio,
were for women only. The Grosvenor School of Art or the Grosvenor Life
School (234) was founded in 1893 and became extremely popular with female
students due to the progressive approach to instruction adopted by its
principal, Walter J. Donne. Donne wrote: "I consider that a knowledge
of drawing based upon a thorough study of the living model is of the
first importance. Therefore, as soon as ever a student can draw still-
life objects with accuracy, she is set to work upon full-length charcoal
studies of the human figure". Study from the antique came later. Donne

was "anxious to correct the popular impression that women produce only
weak work" (235). The School also offered sketching trips and drawing
in black and white with a view to illustration (236). Other art
schools for women only in the 1890 s included Sophia Beale's Art School
for Ladies and Children, A. Davis Cooper's Art Classes for Ladies, Clare
Atwood's Women's Evening Practice Life Class, the Wimbledon Art College
(A Residential Art School for Ladies), the St. James's Life School for
Ladies run by Edwin Norbury, the women's art departemnt of King's College
London and Alyn Williams' Practical Demonstration and School of Miniature
Painting (237). Women could also study from the life at Mrs Jopling's
school from the late 1880 s (238), and at the Chelsea Life School and the
Bury Art Schools in the 1890 s (239). There were also many schools
specialising in landscape painting - particularly in Cornwall -, animal
painting, the applied arts and flower painting to which women were
admitted (240).

By the end of the nineteenth century women were frequently given infor-
mation, in books and the press, about conditions for women art students
at home and abroad. Clayton gave details of the situation in Rome (241)
and in 1886 a very informative article appleared in the "Art Journal"
called "Lady Students in Munich" (242). Neither of these places offered
a better education than England. In 1904, however, a similar article
was written in the "Studio" entitled "A Lady Art Student's Life in Paris"
and in this England certainly lost by the comparison (243). Clive Holland
began with the remark that "English schools of painting (with a few
exceptions) do not appear to encourage individuality and more particularly
the individuality of the woman artist, however good the technical instruc-
tion may be". Lady art students, he wrote, were going to Paris in
increasing numbers for there they could lead an independent and serious
working existence without outraging public opinion, and numerous ateliers,
such as the Académie Julian and the Académie Colarossi offered excellent
instruction to female students, particularly in study from the life. But
although Paris itself did not stigmatize female art students, going to
Paris from England was another matter. Lady Kathleen Kennet, who pro-
gressed from the Slade to Colarossi's studio in Paris at the turn of the
century, wrote: "In the first years of the twentieth century to say that
a lass, perhaps not out of her teens, had gone prancing off to Paris to
study art was to say that she had gone irretrievably to hell" (244).

Louise Jopling, in her chapter on "Art as a Profession for Women" of
1903, gave an effective summary of the opportunities open to women at the
end of the period under discussion (245). Having expressed full awareness
of the difficulties besetting women who wished to study for a profession,

"handicapped by tradition, by their mothers and by health", she gave
first priority to entrance to the Royal Academy Schools after attendance
at one of the many preparatory schools of art. For those preferring
purely technical studies, she recommended the Royal College of Art at
South Kensington (246). At the Slade, women could study from the
antique at once, from the nude in a special studio and attend lectures.
She mentioned Frank Calderon's School of animal painting, Professor
Herkomer's School at Bushey, the Spenlove School in Beckenham, Kent where
instruction was given in landscape as well as in figure drawing, the
School of Mr. and Mrs. Stanhope Forbes in Cornwall and the School at
Crystal Palace for women. Numerous artists' studios could also be
attended in Cornwall and London. Finally, and quite in keeping with the
general drift of women art students at that time, she suggested the studios
in Paris, where the model, she wrote, posed for four hours in the morning
and in the afternoon, and where an optional evening class was held for
study of the nude figure. Contrary to the situation in the 1850's,
women by the end of the century were well aware of the facilities avail-
able to them. They no longer remained uneducated through ignorance of
opportunity.

Lest it should be thought that everything was easy for women art
students at this time, one last instance should be given of the lingering
prejudice against women artists. Hubert Herkomer, who ran an art school
in Bushey, Hertfordshire from 1884, wrote in 1905: "When I started the
Herkomer School, I made a point of giving the female students the same
chance as the male students"(247). This assertion does not appear to have
been strictly true. In the 1890's Gertrude Massey applied for admission,
but Herkomer "would not listen to the idea. Indeed he would not have
married women as pupils at any price. I went to see him in his studio, but
he refused point blank even to glance at my work and told me bluntly to go
home and make puddings" (248). Nonetheless women were admitted and some,
such as Lucy Kemp-Welch, excelled. Herkomer commented that "the curious
result" of his allowing women to enter was that "after twenty-one years,
a woman has to be proclaimed the most successful artist" (249). From 1905
to 1926 the School was run by Lucy Kemp-Welch and like many women artists
before her, she placed chief priority on life studies (250).

Two points should finally be made. The first has already been
suggested, but stress is important. Although England, in comparison with
many other countries, was indeed progressive in the matter of concessions
to women art students, the new opportunities were not necessarily within
the reach of all women who wanted to study art. The vast majority of

documented women who attended the schools came from artists' families,
or at least from families who were sufficiently appreciative of the arts
not to mind their daughters adopting an artistic profession. A few
examples should suffice from amongst those female students who made most
frequent use of the art schools open to women. Elizabeth Campbell
Collingridge was brought up in London and Paris by her father's mother
and sister, both amateur artists who "took great interest in her early
attempts at sketching portraits from recollection" (251). Her art educa-
tion occurred in the 1860's: she received a few lessons from a landscape
painter in Paris, then attended a session at South Kensington, spent
several years at Heatherley's and in 1869 entered the Royal Academy
Schools. The father of Catherine Adeline Sparkes was a pianoforte manu-
facturer in Lambeth and "both father and mother had great love for paint-
ing and music" (252). Her first drawing lessons were under Mrs.John
O'Connor. She studied at the South Kensington School from 1858 to 1862,
at the Lambeth School of Art from 1861 to 1866 and in 1863 obtained full
studentship at the Royal Academy where she remained until 1868. The
father of Kate Greenaway was "a well-known wood-engraver" (253). She
worked at South Kensington and Heatherley's in the 1860's and then went on
to the Slade. Alice Elfrida Manly was the eldest daughter of H. Manly,
principal writing master at the City of London School. After preliminary
instruction from her father, she entered the Female School of Art in 1862
and subsequently worked at South Kensington; in 1869 she entered the
Royal Academy Schools (254). Mary Gow belonged to a family of artists:
her uncle and brother both followed the profession. A year at the Female
School of Art was followed by study at Heatherley's untill 1874 (255).
Examples could equally well be taken from the early and late years of
the century at both of which times women tended to remain at one school,
in the first case because there were not many alternatives, and in the
second because most schools by that time provided all the facilities
that were needed and it was unnecessary to move from school to school.
A number of women, such as Mary Ellen Edwards, Anna Blunden and Evelyn
Pickering attended art school despite the disapproval of their parents
(256). Art school leading to the status of artist was generally taboo
for young women. On the other hand, to make limited use of the new
opportunities for accomplishment or commercial purposes was a different
matter and socially acceptable; doubtless many women, of whom under-
standably there is no record, attended on these bases.

My second point is a natural sequel to the first. It should be
emphasized that many women artists in the nineteenth century did not attend
art schools at all. A large number, especially from wealthy families,

received private instruction and advice from successful artists of the
day who were often friends or acquaintances of their parents. Ford
Madox Brown, Ruskin, Frederick Cruikshank, William Collingwood Smith,
Thomas Landseer, William Callow and many others all gave instruction
to female pupils (257). Several,coming from artists' families, were
instructed either at home or by relatives (258). Many, too, taught
themselves (259).

Many women studied art in the last century, at home, privately, or at
art school where gradually they were allowed the same facilities as men.
But while Victorian codes of conduct prevailed, prohibiting serious study
and more particularly the study of the nude, the result, broadly speaking,
was a huge wash of accomplishment artists thinly scattered with those born
in artistic purple. In 1893 George Moore wrote: "England produces
countless thousands of lady artists; twenty Englishwomen paint for one
Frenchwoman, but we have not yet succeeded in producing two that compare
with Mme. Lebrun and Mme.Berthe Morisot" (260). The quantity is largely
explained by the extraordinary popularity of accomplishment art in England;
the poor standard of the majority is primarily due to the limited inter-
pretation of art in relation to women as manifest in the facilities pro-
vided for their art education.

France

During the greater part of the nineteenth century, current opinion on
the nature of art in relation to women was just as restrictive in France
as in England. The most positive view was that women had a definite con-
tribution to make in the context of fashion, home decoration and industrial
art; they were the arbiters of taste. Several influential theorists on
the education of women may serve to illustrate this attitude. Fénelon,
for example, in his treatise "De l'Education des Filles", considered paint-
ing and drawing necessary occupations for young girls of social standing,
but he carefully defined the scope of this instruction: "cet art doit
avoir un but utile, en l'appliquant à la broderie, à la dentelle et à
l'ornementation des étoffes. De tels ouvrages ne peuvent avoir aucune vraie
beauté si la connaissance des règles du dessin ne les conduit" (261).
Rousseau held similar views. His ideal education for girls, propounded
in "Emile", included drawing, "car cet art n'est pas indifférent à celui
de se mettre avec goût: mais je ne voudrais point qu'on les appliquât
au paysage, encore moins à la figure. Des feuillages,des fruits, des
fleurs, des draperies, tout ce qui peut servir à donner un contour élégant
aux ajustements, et à faire soi-même un patron de broderie quand on n'en
trouve pas à son gré, cela leur suffit" (262). In the latter half of the

nineteenth century the emphasis shifted to the role of women in the
industrial arts. In May, 1896, for instance, in the Section Féminine
of the Union Centrale des Arts Décoratifs, a ladies' committee was
created, the mission of which was "de grouper les femmes, pour arriver,
par un effort commun, à élever le niveau de la production des travaux
d'art" (263). Such was the belief in their innate talent for design
that in 1892 their proficiency in this field was used as an argument in
refusing women admission to the Ecole des Beaux-Arts (264).

The negative corollary of this approach was the view that the higher
regions of art were out of woman's sphere. In 1838 Madame Necker de
Saussure expressed views which recall those of Mrs. Ellis in England (265).
She began by stating that there was "une alliance naturelle entre les
facultés des femmes et les beaux-arts": Les mêmes dons de l'âme qui
donnent tant de charme et de pouvoir à un sexe faible, font aussi fleurir
les talens, la sensibilité, un certain souffle d'inspiration, le goût de
la nature, la vivacité des impressions, le désir d'embellir le monde
matériel pour en retirer l'essence d'une vie divine et pure" (266). But
is it right, she goes on, to cultivate emotions which are only too pre-
valent in women already? (267) Her own view is that a certain amount of
art instruction can do girls no harm and she gives three reasons for this.
Firstly, parents do not want more for their daughters: "L'art pour eux
n'est pas du tout l'essentiel, c'est un accessoire agréable, un ornement
ajouté qui perd son prix s'il n'est pas subordonné à l'ensemble et s'il en
altère la solidité" (268). Secondly, women are not likely to be highly
gifted and "ce qui arrive à peine une fois en cent ans ne mérite pas
qu'on s'y arrête" (269). Finally, women are not permitted to excel: "La
société, toute frivole qu'elle est, sent si bien la nécessité de l'équilibre
moral chez une femme, que celle qui s'y distingue par un don trop spécial
est mal placée" (270). She thinks that there is a middle road for women
between "la médiocrité la plus insipide" and "un succès auquel sa destinée
ne se prête pas" (271): the advantage of drawing for women was that "il
fait aimer, il fait admirer la nature; il apprend à la voir en artiste, il
en retrace les scènes où l'âme s'est surtout livrée au charme pur de la
contemplation. C'est un privilège heureux du paysagiste que de faire
renaître de doux sentiments en retraçant les lieux où l'âme en a été
pénétrée. Encourageons ainsi les modestes essais de nos jeunes filles et
ne méprisons pas leurs petits albums". On the other hand, do not let her
spend too much time on art: "Pensez que les arts ne sont, après tout, que
le luxe de la vie" (272). Also, successful study might breed vanity (273).

Such views correspond with the actual situation for women art students in the first three quarters of the nineteenth century. Beyond the school level the government was only prepared to encourage women in design. Good instruction in fine art for women had to be obtained privately, often at considerable expense.

The Ecole gratuite de Dessin pour les Jeunes Filles was the model for the English Female School of Design in the 1840 s (274). As the one art institution to which women had free access throughout the nineteenth century, a brief indication of its origins and scope may help to give an idea of the extent to which women could study art within the official system. Afterwards, the development of opportunities for women to pursue more advanced studies will be considered.

In 1803 the Ecole gratuite de Dessin pour les Jeunes Filles was opened in the 11th arrondissement in Paris through the efforts of two women: Madame Frère-Montizon and Madame Fanny Beauharnais (275). It was to be the female counterpart of the Ecole gratuite de Dessin founded in 1766 by "le respectable Doyen de l'ancienne Académie de Peinture, le citoyen Bachelier" (276). In her opening speech, Madame Frère-Montizon described the origin of her idea, worth recounting in full on account of the marked contrast it presents with the inaugurative words surrounding the Female School of Design in England. As men monopolized "les places et les emplois publics, et que les travaux qui requièrent de la force leur sont pareillement attribués", no other occupation, she said, is left to women "que dans le maniement de l'aiguille et dans les métiers qui ont rapport à ce qui le concerne". Thus she was inspired to discover whether "dans les arts et métiers, il n'en étoit pas quelques-uns qui, n'exigeant ni force de corps, ni qu'on se répandit au-dehors, leur fussent convenables" (277). The examples of Madame Vigée Le Brun and Madame Labille-Guyard suggested to her that art was suitable, and that "le dessin, qui forme le base de cet art, étoit applicable à nombre d'objets d'occupation lucrative, tels que: les étoffes; les papiers peints; la dentelle; les fleurs artificielles; l'éventail; l'enluminure; la peinture en tabatières; les camaïeux; les vignettes, etc." Such occupations would save women from indigence and idleness (278). It should be said that this idea was not new. Adélaide Labille-Guyard had formed a similar project towards the end of the eighteenth century and presented a written exposé of her ideas to Monsieur de Talleyrand. As Joachim Lebreton wrote in an obituary: "Toujours elle avait été tourmentée du défaut absolu où nous sommes d'institutions qui pussent offrir des ressources honnêtes, aux jeunes filles privées de fortune" (279). Madame Frère-Montizon was aware that for the realisation of this

scheme education, and indeed cheap education, was necessary. This was available to men at the Ecole gratuite de Dessin and the solution was clearly to create a similar institution for women (280). Subscriptions were necessary and it was then that she approached Fanny Beauharnais who not only subscribed but also secured the aid of others. The Mayor of the 11th arrondissement was appointed receiver of subscriptions. The provisions of the School were as follows: teaching was to take place from nine to three o'clock every other day "jusqu'au moment où le montant des souscripteurs permettra qu'il aît lieu tous les jours". Monsieur Tarre, former inspector of the Ecole de Dessin au Panthéon was to teach landscape and flower drawing and Madame Frère-Montizon was to instruct pupils in "la figure et l'ornement" (281). On the same occasion, the Mayor, Monsieur Boulard, gave his own, more dramatic account of the purpose of the School: "C'est rendre un grand service à la société; c'est, j'ose le dire, bien mériter de l'humanité, que de s'occuper de donner aux jeunes personnes du sexe des talens qui leur servent de ressources dans le malheur, et qui les préservent des dangers du désoeuvrement dans la prospérité" (282). Drawing was especially suited to the tranquil life of women and indeed many had already excelled in art (283). He then developed a theme which, as will presently be seen, is of particular interest in the context of this thesis. Speculating on the possibility of an especially feminine art which this institution would make possible, he said: "La peinture acquerra peut-être sous leurs mains un caractère encore plus touchant et plus moral. Les femmes maniant le crayon et le pinceau nous représenteront plus souvent les scènes domestiques qui reposent l'âme fatiguée du choc des passions; elles nous peindront les soins qu'elles prodiguent sur-tout à l'enfance et à la vieillesse; les belles actions, qu'elles se plairont à nous retracer, nous rappelleront les souvenirs les plus chers, et exciteront parmi nous une noble émulation", for "la sensibilité est plus vive chez les Dames" and it is in them that charity is most evident. He hoped that the pupils would immortalize in portraits the charitable women of France (284).

The Female School of Design in England arose because of the need for a national improvement in design; the interests of the women themselves were secondary. In France things were different, partly, no doubt, because although the school was officially recognized in 1810, it was founded by individuals. Here there was a thorough understanding of the needs of women, readiness to accept them as artists and a serious attempt to comprehend their nature. Women were to be given the means of earning their living and new opportunities for development.

Women were also admitted to the provincial schools of design in
France. In these, however, it would seem that students, both men and
women, were given more specialized instruction, directed towards their
employment in trade, than in Paris. From William Dyce's description of
the Lyon School, cited as a model for the projected School of Design in
England, one deduces that general art instruction was followed by con-
centration on the manufacture to be pursued which in turn led to instruc-
tion in the day to day practice of designing for industry (285). Every-
thing was geared towards the production of craftsmen or women and their
ultimate employment. They were not schools of fine art. During the
course of the century, however, it would seem that the schools were
attended by more middle class pupils intending to be artists but reject-
ing the academic instruction in Paris (286).

In the capital, as Dyce reported, things were different. Here, on
the whole, there was no career direction in the Schools of Design and
most of these were intended for the instruction of the poorer classes in
drawing and modelling. Until the mid-nineteenth century, for example,
the head Ecole de Dessin was limited to a "low level academic system of
copying from drawings, ornaments and decorative motifs" despite the fact
that it was meant to provide for workers in trades (287). It seems pro-
bable that the Ecole de Dessin pour les Jeunes Filles provided a similar
curriculum - it was after all administered by the same body as the Ecole
de Dessin (288) - although, as will soon be shown, the field of recruit-
ment was certainly not limited to the poorer classes.

In 1848 Raymond Bonheur was appointed Director of the School, then
in the rue de Touraine-Saint-Germain. He died less than a year later
and was replaced by his daughter Rosa, who ran the School until 1859 with
the assistance of her younger sister Juliette (289). The establishment
was particularly successful under the direction of Rosa Bonheur and
Arsène Houssaye gave effusive speeches at the annual prize givings in 1859
and 1860 (290). With Rosa Bonheur as an example to follow it may readily
be supposed that fine art tended to eclipse decorative art during this
period. An English art student, Joanna Samworth, attended classes there
in 1850 and reported that Rosa Bonheur came twice a week for an hour or
two; her sister undertook the rest of the instruction. The latter "was
principally in chalk or charcoal, from the flat or round" (291). Miss
Samworth was greatly impressed by the high standard of the work there in
comparison with that produced by women artists in England. Madame
Marie-Elisabeth Cavé reinforces the view that at this time it was not
really a school of design. Writing of her projected Notre-Dame des Arts,

a school for poor female children of "progressive" impoverished families,
she claimed: "Toutes les carrières sont ouvertes aux hommes, tandis que
les femmes n'ont aucune ressource pour gagner leur vie. Pensons donc
seulement aux femmes, et demandons au gouvernement des institutions de
dessin industriel pour les jeunes filles de la société" (292). This was
in 1854.

By the 1870 s the Ecole de Dessin pour les Jeunes Filles had achieved
some success in the matter of training women for employment. In 1860
Mlle. Nelly Marandon de Montyel succeeded Rosa Bonheur and before 1874 the
School moved to the Rue de Seine. A review of the annual exhibition of
the students' work in the latter year suggests the scope of instruction at
that time. Prizes were awarded for drawing from the nude, human head,
flowers and for fan painting, ceramic and enamel painting and decorative
work; copies also played an important part in the course (293). In the
review of 1875, engraving and drawing from plaster casts were added to the
list of subjects and the exact nature of the decorative work was specified:
this was for book bindings, wallpaper and tapestries. The author
offered a tribute to Madame Marandon de Montyel: she deserved congratula-
tion "pour le sens pratique qu'elle imprime aux études". Taste had to be
inculcated and "il est donc urgent d'assurer à toute une école le profit
des études en ouvrant une carrière accessible à toutes les élèves: celle
des arts industriels qui convient si bien aux femmes". The Directrice
might consider herself successful (294). In 1878 Princesse Jeanne
Bonaparte, in reduced circumstances, was a pupil, having taken "la sage
résolution d'être maîtresse de sa destinée, grâce au travail, et de de-
venir femme artiste... et s'appliqua surtout à la gravure sur bois" (295).
In 1881 the School was reorganized (296). Thenceforth the following
courses were available to students: "1. le dessin linéaire et géométrique,
la perspective et les éléments d'architecture; 2. le dessin, le modelage
et l'anatomie comparée; 3. un cours de composition d'ornement; 4. un
cours d'histoire de l'art; 5. la peinture; 6. des cours spéciaux pour
différentes applications des arts du dessin à l'industrie; céramique,
émail, gravure à l'eau-forte, gravure sur bois, sur cuivre, etc." In
principle the School was for French girls only, although foreigners could
be admitted if specially authorized (297). By the 1880 s design was
the most important consideration.

In the 1860 s subsidiary schools of design for women began to appear,
both in provincial towns and in Paris. Virginie Hautier directed one
in Paris from 1860 (298). In 1862 an Ecole Municipale de Dessin pour les
Jeunes Filles was founded in the 10th arrondissement under the direction
of Mlle. Durand; the following was written of the School in 1865: "Les

cours dirigés par Mlle. Durand, et qui ont lieu trois fois par semaine, de une heure à quatre, me paraissent conduits dans une voie sérieuse et excellente; j'ai vu à cette exposition des dessins remarquables, faits par des jeunes filles dont la moyenne âge est de seize ans environ" (299). In 1868 the "Chronique des Arts" announced the foundation of "une école de dessin et de gravure sur bois pour les jeunes personnes et les femmes" in the 1st arrondissement (300) and by the same year a similar institution existed in the 20th arrondissement (Belleville) under the management of Madame Delphine de Cool (301). By 1869 there were seven Schools of Design for men in Paris and as many as twenty for women (302). These local and provincial schools appear to have exhibited annually in conjunction with the head Ecole de Dessin pour les Jeunes Filles. A review of this exhibition in 1874 mentioned several of the local schools, many if not all of which were run by women. That in the 9th arrondissement was directed by Madame MacNab, the one in the 19th by Mlle. Léonide Poisson, the 16th by Mlle. Augusta Le Baron, the 14th by Mlle. Solon, another by Madame Levasseur and the school in the 7th was run by Mlle. Delphine Keller who had been one of Rosa Bonheur's favourite and most brilliant pupils (303). Finally, and most important, the School in the 1st arrondissement was conducted by Delphine de Cool, "attachée à la manufacture de Sèvres" and "reconnue par le grand nombre de ses élèves"; her School was described as "une école libre, très-suivie des étrangers, et qui compte parmi ses habituées les plus distinguées, Mlles. Djina Gomez et Julia Granier" (304). Indeed the Salon catalogues reveal that many female exhibitors were her pupils (305). She retained this post until 1895. The same review of 1874 also mentioned the provincial schools of Montluçon and Nice (306). In 1884 the Société d'enseignement moderne was founded with State patronage. The Society offered courses to young women who needed to earn their living in and outside Paris and arts subjects included ceramics and ornamental design (307).

Despite the undoubtedly good reputation of these Schools of Design - and their fame extended beyond France (308) - they were not without their critics. Edouard Lepage, biographer of the sculptor Madame Léon Bertaux, wrote in 1912: "Sans doute les femmes et les jeunes filles ont des cours de dessin assez libéralement répartis dans les divers arrondissements de Paris; mais si l'on en juge par le nombre des élèves qui en sortent véritablement artistes, assez habiles pour trouver dans la peinture ou le dessin une profession et une ressource, il faut bien reconnaître qu'elles y ont cherché une distraction agréable et saine à l'esprit plutôt qu'un enseignement profitable" (309). Madame Bertaux herself, the prime mover in the admission of women to the Ecole des

Beaux-Arts, wrote in similarly disparaging terms, although her anger was directed towards the government rather than the pupils. Her view was that "on encourage même les jeunes filles à apprendre le dessin, en le leur enseignant dans les écoles primaires, mais dès qu'elles veulent pousser plus loin leur instruction artistique, mille difficultés se dressent devant elles et la porte où elles pourraient frapper (the Ecole des Beaux-Arts) leur demeure obstinément close. C'est à peu près comme si l'administration des Beaux-Arts disait: 'Nous voulons bien des femmes artistes, mais nous voulons les enfermer dans la plus humble médiocrité; il leur sera permis de faire de l'art industriel, des éventails, des écrans, des petits pots de fleurs et des museaux de chat, mais nous leur barrons la route qui mène aux honneurs et à la gloire que nous nous réservons pour nous seuls'" (310). This was partially true. In 1892 the Ecole de Dessin pour les Jeunes Filles was cited in an attempt to prove the invalidity of admitting women to the Ecole des Beaux-Arts (311). Until the mid 1890 s the French Government was only prepared to encourage women in design.

As in England, however, the idea of women as drawing teachers was acceptable and almost simultaneously in the two countries it was decided to promote women as such (312). The "Kunstchronik"of 1867 reported that Paris, especially attentive about drawing instruction for young girls "hat deshalb eine Aufforderung an geübte Zeichnerinnen erlassen" (313). For qualification as a drawing mistress an exam was to be held which would include an ornamental drawing from a solid model, a whole figure drawing after the antique, an ornamental compositionand an oral exam (314). By 1869 drawing was subsidized in 241 "écoles communales laïques et congré-ganistes" fifteen of which were for girls (315) and female teachers were most probably employed in these. Women subsequently played an important role not only as art teachers but also in the organisation of drawing instruction, particularly in Paris. The most successful women in this field were Mlle. Virginie Hautier, Mme. Jules Héreau, Mlle. Camille Aderer, Mme.de Callias, Louisa Chatrousse and Delphine de Cool (316).

Women in the first half of the nineteenth century who desired to pursue their studies beyond basic instruction in drawing and design and who hoped to become artists, did not have the same opportunities as men. The normal course for the latter was registration at a private or independent atelier in Paris. No reference is made by Albert Boime to the attendance of women at these ateliers and indeed it seems most unlikely that they would have been admitted as the main purpose of the ateliers, particularly the private ones, was to qualify students for admission to the Ecole des Beaux-Arts, the ultimate goal being the Prix de Rome (317);

women were excluded from the Ecole des Beaux-Arts and the Prix de Rome competitions. However, there were a few separate ateliers for women and the majority of these were run by successful female artists of the day. Adélaide Labille-Guyard was one of the first to take female pupils, during the last two decades of the eighteenth century. She was not allowed a studio in the Louvre because of the possible scandals which might arise as a result of the presence of her female students. These included Gabrielle Capet and Mlle. Carreaux de Rosamond (318). Around 1804 Marie Guillemine Benoist established a studio for women (319) and about the same time Mme. Regnault ran an "atelier de jeunes demoiselles" the most famous of whom were Henriette Lorimier, Pauline Auzou and Adèle Romany (320). Around 1810 Mme. Davin-Mirvault opened a painting studio for women artists (321). The next was Pauline Auzou who maintained an atelier for female students for at least twenty years (322). In 1836 Mme. Camille de Chantereine started a course for flower painting (323) and in the same year Mme. Elise Boulanger directed an "atelier de dessin, de peinture et d'aquarelles" in connection with a girls' finishing school run by Mme. Chevreau Lemercier (324).

Eminent male artists also instructed female pupils during this period. Louis David taught ten women, the most famous of whom were Mme. Davin-Mirvault, Angélique Mongez and Mme. Benoist; Jean Baptiste Regnault taught Sophie Guillemard, Angélique Mongez, Pauline Auzou, Claire Robineau and Adèle Romany and Jean Baptiste Greuze's pupils included Constance Mayer, Jeanne Philiberte Ledoux and Mme. Elie (325). François Rude, Eugène Delacroix and many others also gave help and advice to women artists in the first half of the century (326). In the 1820 s organized classes for female pupils under the direction of male artists began to appear. Fig.4 By 1822 Abel Pujol had established a studio for women artists which was still in existence in 1855 (327). By 1831 Pierre Joseph Redouté ran a class for flower painting in the Salle de Buffon in the Jardin des Plantes (328) and by 1834 Léon Cogniet conducted a studio for women which continued until the 1860 s (329); his pupils included Emilie Leleux and Laure de Châtillon. Two other classes are worthy of mention, both of which were operating in the 1850 s. In this decade Joanna Samworth attended Henri Scheffer's studio and during her six months there she was taught with six or seven other girls, Spanish, French and Italian. The main instruction involved painting in oil from plaster casts; but instead of using just brown or black as in England, the whole range of colours was employed and he insisted on exact recording of local colour. There were

some portrait painters there and all were under twenty years of age.
"He took great pains with his lady pupils" she wrote (330). Thomas
Couture also ran a class for women in this decade (331).

There is scant documentation on the nature of the instruction
provided at these classes but judging from the preponderance of portraits
and flower and fruit compositions at the Salon over this period it did not
- as a rule - include study from the life.

Women from the upper classes and aristocracy often received art
education at home and for them the level of study was equally limited. Ary
Scheffer, art teacher to the Princesse Marie de Wurtemburg in the 1830 s,
described the limits imposed on the progress of such girls (332). His
pupil hated copying and so attempted historical compositions in water-colour.
She executed about 50 of these in two years "avec une originalité et un
bonheur très remarquables; mais tous très incorrects de dessin et bien
médiocrement colorés". He attributed these faults to "les idées étroites
de Madame Malet (her governess), les craintes de la Reine, et mon respect
à moi, pour la pudeur de jeune fille, (qui) empêchèrent les progrès de
dessin et d'exécution. Ne pouvant copier que des figures drapées, (et
très drapées) elle a toujours ignoré la structure du corps humain" (333).
A little later, "ennuyée de toujours bien composer, et de toujours mal
dessiner, elle prit le dessin en dégoût, et me demanda un jour si je ne
pouvais pas lui donner quelque chose à faire de moins monotone". She
resorted to sculpture (334). Although her father did not consider her
art as a mere accomplishment (he later commissioned his daughter to exe-
cute a statue of Joan of Arc for Versailles), morality prevented her from
realising her full potential; it was not proper for women to study from
the life. Antony Valabrègue gave an extensive list of such women in his
book "Les Princesses Artistes" and also made some interesting generalisa-
tions. He pointed out that women from the aristocracy were in a position
to receive advice and often lessons from prominent artists of the day
whenever they chose, but in spite of this and even when the lady concerned
had talent, they only attained "une certaine habileté d'expression" (335).
Valabrègue himself did not offer reasons for this but one, at least, may
be deduced from his own evidence: he himself wrote that the substance of
such a lady's instruction was "à retracer avec goût une image et à rendre
agréablement les impressions qu'elle recevait de la nature" (336). This
is art as accomplishment, the art prescribed by Madame Necker de Saussure
(337) and its practice was far more pernicious than no practice at all as
it associated women with a low level of attainment. It should be said
that as in England drawing books were available and many women undoubtedly
instructed themselves (338).

During the Second Empire facilities for women improved rapidly.
Marius Vachon wrote that from 1850 artistic taste made huge strides
amongst the female population: "La peinture à l'huile et à l'aquarelle
fait partie du programme de toute éducation supérieure dans la haute
bourgeoisie et dans l'aristocratie". As a result of this "révolution
hardie accomplie dans l'enseignement féminin", what Vachon called "les arts
d'agrément", in other words accomplishments, became even more fashionable
in Society "et les Salons furent envahis par les femmes peintres, sculpt-
eurs et graveurs" (339).

One of the most important manifestations of these new, higher stan-
dards of secondary education was the School founded by Elisa Lemonnier
in 1862, shortly followed by many others; they were called Les Ecoles
Professionnelles d'Elisa Lemonnier (340). Art was an important part of
the curriculum (341) and in view of the fact that the Schools qualified
several women for Salon entry, it must have been taught to a high stan-
dard. Marie Rouget, Mlle. Eugénie Kieffer, Mlle Marie Larsonneur and Mlle
Juliette Manbret all received training there (342). In 1869 and 1870
art was taught by Monsieur Trichon and Monsieur Midderigh at the head
School (343). The Ecoles Professionelles were discussed in a publica-
tion of 1891 by Alexis Lemaistre. By that time many were in existence,
several of which were founded by the Ville de Paris on the model of Elisa
Lemonnier's original school (344). The method in these establishments
was to devote the mornings to general education and the afternoons to prac-
tice in the professions selected by the students; these included sewing,
the making of artificial flowers, embroidery, braiding, dress-making,
laundering, ironing and finally painting and drawing. Painting was
taught for its own sake and also on porcelain, earthenware, glass, enamel
and fans (345). Those who specialized in the fine arts spent their first
year drawing, chiefly from casts and then in the second year they pro-
gressed to painting (346). Occasionally it was possible to work from the
living model (347). Lemaistre payed the following tribute to this system:
"Ce qui cause dans tous ces différents genres les rapides progrès que l'on
constate, c'est l'importance donnée continuellement à l'étude du dessin,
ce sont les leçons d'anatomie, de géométrie, de perspective faites aux
élèves dès la première année, ce sont les cours de composition décora-
tive et d'histoire de l'art qu'elles suivent en deuxième, en troisième
et en quatrième année, leçons et cours professés avec autant de méthode et
de savoir que de talent et d'originalité par des professeurs choisis avec
le plus grand soin ou munis de diplômes spéciaux" (348). Although
similar in their orientation to the Ecole de Dessin pour les Jeunes Filles

these Schools appear to have produced far more Salon exhibitors and one may thus assume that there was more scope for the study of fine art.

Madame Cavé and her idea for the Notre-Dame des Arts should be placed in this context. Although the latter was never realized, she was, as Boime writes, "a successful painter and art instructor during the July Monarchy and Second Empire" (349). As well as inculcating the principle of the sketch from memory, she attached great importance to preparing girls for remunerative employment (350). During the 1860's and 1870's drawing became a vital feature of both primary and secondary education for girls (351).

There was also an increasing number of "ateliers féminins" from the 1850 s on and it was in these that the first real progress in the art education of women was achieved. One example is Madame O'Connell who received lady students at her studio in Montmartre from 1859 and taught drawing "d'après la bosse ou le modèle vivant" (352). But the most famous and popular resorts for female art students were the studio of Charles Chaplin which was attended by a large number of women artists in the 1860's and 1870's, and the women's section of the Académie Julian. Both were visited by many foreign women, especially from Germany and America for whom Paris was not only the artistic capital but also the place which offered the greatest opportunities and freedom from social disapproval (353).

Louise Jopling was a student at Chaplin's studio in the 1860's. She wrote that "he had a large following for his was the only atelier at that time where all the students were women, so that careful mothers could send their daughters there without any fear of complications arising between the sexes" (354). Here women could paint from the nude figure: Miss Besley, an ex-pupil of Chaplin, held a class for such study at seven in the morning. Chaplin allowed his best pupils to see his own work in the studio above (355). A letter from Chaplin to Louise Jopling sheds light on his priorities; they present a strong contrast with those in England. He told her not to worry about titles: "En Paris cela est inutile, quand la peinture est bonne. Laissez les titres, et la description aux Anglais qui ne comprennent absolument rien à l'art. La peinture doit vivre par elle-même sans le secours ridicule d'aucune anecdote ou histoire quelconque" (356). Even for women in France, art meant fine art and not photography or sentiment or story-telling as it did in England according to the rules of accomplishment art. J.K. Huysmans, in 1879, remarked that Chaplin's studio was the training ground for most women artists of the day, and indeed this was so (357). Later, in 1891, the "Journal des Femmes Artistes" made a similar observation : "Rappelons.. que bien de nos sociétaires de l'Union des Femmes Peintres et Sculpteurs

ont reçu de Chaplin l'éducation artistique qui les distingue" (358).
Amongst his most famous pupils were Eva Gonzalès, Louise Abbéma,
Madeleine Lemaire, Henriette Browne and Mary Cassatt (359).

The Académie Julian was another mecca for women art students.
Founded in 1868 by Rodolphe Julian in the Passage des Panoramas, it soon
admitted women in a special class on the first floor (360). Four of the
School's most famous female pupils in the 1870 s were Amélie Beaury-
Saurel, later to become the wife of Julian, Louise Breslau, Emma Herland
and Marie Bashkirtseff (361). By 1877 the women were allowed to study
from the nude figure during certain hours of the day and in 1880 they
Fig.5 could work from the life all day long, as the men did (362). Marie
Bashkirtseff had two criticisms of the School however. Firstly she con-
sidered it unfair that the male students should have three instructors
whereas the women had only one - Tony Robert-Fleury (363). Her other
complaint, also voiced in 1877, was that "ces Messieurs nous méprisent
et ce n'est que quand ils trouvent une facture forte et même brutale qu'ils
sont contents, car ce vice-là est absolument rare chez les femmes"(364).
Tony Robert-Fleury, Jules Lefebvre, Benjamin Constant, Gabriel Ferrier and
William Bougureau all taught there. Such was the influx of women and
foreigners, especially Americans, that Julian was soon forced to divide
his establishment into separate schools. One of these was a school for
women at 51 rue Vivienne where 22 students were immediately installed, in
1880, and this was shortly followed by another in the rue de Berri (365).
Robert-Fleury and Lefebvre were the chief instructors in the rue Vivienne.
Ludwig Hevesi wrote that it was through this, "die erste Kunstschule für
Damen, mit lebendem Modell", that Julian achieve fame; the result of
allowing women to study from the nude figure was, as Hevesi wrote, "ein
sogenannte Skandal. Die Zeitungen schrien: Erröte Paris die Hauptstadt
der Tugend!" (366). Many successful female pupils may be cited. Anna
Bilinska, Maximilienne Guyon, Cecilia Beaux, Hélène Dufau, Madeleine
Carpentier, Marie Antoinette Marcotte, Elisabeth Sonrel, Angèle Delasalle
and many others were students in the 1880 s and 1890 s (367). In 1890
new premises were opened in the rue du Dragon. Evening classes were
started in the Passage des Panorams in 1902 and in the rue du Dragon in
1904 and in 1906 a course for young girls between ten and fifteen years of
age was established in the rue du Cherche-Midi (368). An article in
"Fémina" giving the main facilities for female art students in 1903 des-
Fig.6 cribed the women's class in the Passage des Panoramas (369). The most
remarkable thing about the studio, wrote Gabrielle Réval, was "l'oubli
complet des inégalités sociales: car, à côté d'une princesse, d'une fille
d'ambassadeur, travaille une petite, dont la mère est institutrice". The

fees were 100 francs a month, 700 francs a year. The model posed from
eight in the morning and the evenings were devoted to the designing of
posters and illustration. "Le plan d'étude est simple: l'étude
d'après le plâtre, puis d'après nature, enfin la composition. Le maître
toutes les semaines donne un sujet d'étude qu'il viendra corriger;
l'élève reste absolument libre dans son travail". Jean-Paul Laurens
instructed the female students at this time. There were five or six
competitions each year in which women competed with the men: "C'est en
soumettant l'esprit féminin à cette forte discipline, à cette étude
directe de la nature, que l'Académie Julian a su former de véritables
artistes" (370). In 1905 there were about 1000 students on the School's
books, of whom between 300 and 400 were women and the latter occupied three -
out of the five working studios of which the Académie was then composed.
Women paid a maximum of 700 francs a year, men only 400 (371). By this
time Amélie Beaury-Saurel, or as she then was, Madame Julian, conducted
the studios for women and on the death of Julian in 1907 she took over
the management of the School, delegating to her nephew, Jacques Dupuis,
responsibility for the studio in the rue du Dragon while she continued to
superintend the female pupils (372).

One other important art school for women originated in the 1870 s.
In 1873 Madam Léon Bertaux opened "des cours de modelage et de sculpture"
for women at 233 rue du Faubourg -Saint-Honoré (373). Her aim was not
only to give women an opportunity for art education but also to enable
them to earn their living and thereby benefit industrial art. All tastes
were catered for but the stress was on craft. After three months, the
numerous pupils, almost all "femmes du monde", were doing good work and
at least nine had had work accepted at the Salon (374). In 1879 she built
a special house in the avenue de Villiers for this new school of sculpture
for women and at the ceremony which marked the laying of the foundation
stone, she said: "Vous êtes les fondatrices d'une école qui n'emprunte sa
forme d'aucun précédent. A ce titre, je dis que vos noms auront tous
droit à la reconnaissance de vos successeurs; car, maintenant que le
premier exemple est donné, d'autres vous suivront et L'Ecole de Sculpture
pour les Femmes sera désormais, grâce à vous, un besoin dans notre pays" (375).
This School was the first of many important achievements gained by Madame
Bertaux in the cause of art education for women. It was shortly followed
by a resolute campaign for the admission of women to the Ecole des
Beaux-Arts.

Before examining in detail the history of this event it is worth
reproducing Madame Bertaux's summary of the opportunities for women art
students at that time and also suggesting the extent of dissatisfaction with
these conditions.

"En 1873", wrote Edouard Lepage, "il n'existe encore pour la
femme aucun centre d'études, pas plus d'atelier que de maître" (376).
In Madame Bertaux's view this was all the more regrettable as women
were allowed to exhibit in the Salon: in other words inferior training
was meant to qualify women for the same competitions as men (377). She
then described the places where this training was to be obtained. Firstly
women could be taught in a number of artists' studios. These were of
two sorts. Some were run by fashionable painters who wanted to make
money; they were expensive and "le rendez-vous des mondaines et des
demi-mondaines élégantes qui s'y retrouvent par 'snobisme'". The second
kind of studio for women was equally undesirable as it catered for
"jeunes filles de la bourgeoisie, qui apprennent la peinture comme elles
apprennent le piano parce que ça marque bien, parce que c'est très comme
il faut et tout à fait bon ton" (378). Her opinion of the Ecoles de
Dessin for women, the only official concession made to female art students,
has already been indicated (379). Finally there were the Académies such
as Julian's and it was only in these that women could receive anything
approaching a serious education: "Les élèves y trouvent un enseignement
très complet, la peinture, la sculpture, la taille-douce, et elles dessi-
nent ou sculptent d'après le modèle vivant". The high fees, however,
were beyond the means of many (380). Her appeal was to the State, to
recognize "cette poussée, qui, dès maintenant semble irrésistible" (381).
"Ne vaut-il pas mieux qu'une femme, si elle a du talent, devienne peintre
ou sculpteur, au lieu d'accumuler cinq ou six diplômes d'institutrice trop
souvent inutiles? En France, a-t-on souvent répété, l'art surtout se
paye. Donnons donc à la femme le moyen d'y parvenir; alors, du moins
elle pourra lutter" (382). If men refused women admission to the Ecole
des Beaux-Arts much longer they would show that they dreaded female com-
petition and were motivated by "une vanité ridicule et un égoisme eff-
réné" (383). Dissatisfaction of this kind found frequent expression in
the 1870 s. The "Gauloises", for instance, in 1874, wrote that one of
the most serious disadvantages faced by women art students was their
inability to go out or travel alone: "Les femmes sont donc réduites aux
livres, aux monographies, aux copies. Ah! si elles pouvaient voyager
librement, on ne leur ferait plus ce reproche irréfléchi de rester dans
les natures mortes ou les scènes banales, de faire du petit" (384).
They had neither the education nor the experience to produce strong
work. Virginie Demont-Breton's efforts to achieve a better art education
for women also date from this decade.

Although, as in England, there was no law proscribing the entrance
of women to the Ecole des Beaux-Arts, exclusion had become "une question
de principe absolu" (385). Madame Bertaux and Virginie Demont-Breton
were the main instigators of change. The first move was in 1878 when
Madame Bertaux asked the Director of the Ecole des Beaux-Arts for a
special studio for women and received the reply that the establishment
"ne disposait d'aucun crédit applicable aux dépenses qu'entraînerait une
telle création". They could simply register her demand (386). Then in
1884, Virginie Demont-Breton spoke to Jules Ferry not only of the admission
of women to the School but also of their participation in the Prix de Rome
competitions (387). He was agreeable but did nothing. In July, 1889,
Madame Bertaux took up the question in earnest on the occasion of the
Congrès International des Oeuvres et des Institutions Féminines held at
the Mairie St. Sulpice under the presidency of Jules Simon. As President
of the Union des Femmes Peintres et Sculpteurs (388) she put the follow-
ing proposition to the vote: "qu'il soit créé, à l'Ecole des Beaux-Arts,
une classe spéciale, séparée des hommes, où la femme pourra, sans blesser
les convenances, recevoir le même enseignement que l'homme,avec faculté,
dans les conditions qui règlent cette école, d'être admise à tous les con-
cours d'esquisses ayant pour conséquence l'obtention du prix de Rome". The
project was unanimously approved (389). In December of the same year,
at the annual meeting of the Union, 250 female members decided that this
proposal should be submitted to the Director of the Ecole des Beaux-Arts
(390). This was done and the Conseil Supérieur des Beaux-Arts subse-
quently nominated a Commission consisting of Paul Dubois (Director), Charles
Garnier, Jules Pierre Cavelier, Antoine Bailly, Jean Gérôme and Jean-
Baptiste Guillaume, who in May 1890 gave audience to Madame Bertaux and
Virginie Demont-Breton, representing women sculptors and painters respec-
tively (391). Two objections were made by the Commission. The first
was general and voiced by Charles Garnier: "Il s'écria avec véhémence
que ce n'était pas possible, que mettre les jeunes hommes et les jeunes
filles sous le même toit, ce serait mettre le feu près de la foudre et que
cela produirait une explosion dans laquelle sombrerait l'Art tout entier"
(392). The second objection was to the idea of creating new studios as
this would entail an impossible financial outlay (393). In October Mme.
Bertaux simplified her demand and asked for immediate small scale
admission; separate instruction need not entail new studios. It was on
this occasion that she brought up a subject that was to prove more influ-
ential than any of her former arguments: she hoped that the minister
"voudra faire pour les Femmes Françaises ce que la Suède, la Hollande,

l'Angleterre,le Danemark, l'Allemagne, la Russie elle-même, font déjà
pour les leurs" (394). Despite France's renown in the arts, it was
one of the last countries to provide facilities for its women artists.

December, 1890, saw the creation of a new magazine, "Le Journal des
Femmes Artistes". It was the organ of the Union des Femmes Peintres et
Sculpteurs and espoused all causes which were in the interest of women
artists. The need for a better art education for women was a main
theme. In the first article the hope was expressed that the standard
of the Union's exhibitions would rise continually and so gain the atten-
tion of the press, who, "en éclairant et rassurant le public par des
raisonnements de haute portée sur la nécessité de donner à la femme qui se
destine à l'art le même enseignement qu'aux hommes, avec les précautions
que dicte la bienséance, en lui ouvrant les portes de l'Ecole des Beaux-
Arts", would prove highly influential in their cause (395).

In July, 1891, Léon Bourgeois convened the Conseil Supérieur des
Beaux-Arts in order to hear the Report of the Commission. Monsieur
Tréteau was eloquent in the cause of the women. He repeated the compara-
tive argument of Madame Bertaux, in particular citing the example of com-
mual art education in the South Kensington School; this, he said, had
occurred quite simply, "sans que la pudique Angleterre so soit émue d'une
promiscuité qu'on prétend redoutable et dont rien n'est encore venu
révéler le danger". The final statement was as follows: "Le Conseil
Supérieur des Beaux-Arts est d'avis, avec le Conseil Supérieur de l'Ecole,
que les jeunes filles puissent, avec le concours de l'Etat, trouver pour
leur éducation artistique, les mêmes facilités que les jeunes gens. Mais
il estime qu'il est de toute impossibilité de donner cet enseignement aux
femmes à l'Ecole des Beaux-Arts, dans l'état actuel de cette Ecole. Il
appartient à l'Administration seule de concilier les intérêts" (396).
Nothing, therefore, was done. Apparent willingness to help concealed con-
siderable hostility to the idea of change.

The "Journal des Femmes Artistes" then accelerated the campaign. The
original tactic had been simply to demand the innovation on the basis of
the situation in other countries. From now on considerable space was
devoted to the nature and consequences of the injustice. In February,
1892, it was written: "Pour un temps encore la femme ne pourra, faute
d'études assez fortes, se livrer aux grandes compositions ni aux concours
qui lui permettraient d'obtenir sa part dans les commandes officielles;
il n'est pas besoin d'insister pour prouver que dans l'état actuel des
choses la femme artiste est laissée volontairement dans une infériorité si
grande au point de vue des études qu'il est monstrueux d'insinuer que la
nature lui a refusé le génie" (397). Each number of the Journal contained

similar reflections and in particular speculations on the nature of the
new, particular woman's art which would arise as a result of better
education. These will be examined in detail later (898).

In June, 1892, Madame Bertaux wrote a petition on behalf of women
artists. In this she begged the Députés "de renverser le semblant d'
impossibilités qui ont été accumulées comme à plaisir, par des concurrents
de l'autre sexe, pour entraver un droit qu'on n'ose plus leur nier ouver-
tement, mais dont on veut reculer la mise en pratique par tous les moyens
possibles". There was, she went on, no just reason for refusing their
demand. From a social point of view the practice of art was in no way out
of keeping with the performance of family duties. From an artistic point
of view, was woman incapable, given the same education, of doing the same
work as men, in other words producing "les grandes compositions"? Finally,
was it just that women should be excluded from the moral and financial
advantages offered to the students of the Ecole des Beaux-Arts? Many of
the prizes awarded by the School, had, after all, been founded by women.
She concluded: "Si vous trouvez, Messieurs, ces revendications légitimes,
vous déciderez comme le Conseil Supérieur des Beaux-Arts, dont l'avis est
resté, jusqu'à ce jour dépourvu de sanction, que les femmes ont droit à un
enseignement artistique égal à celui que les hommes recoivent gratuitement
de l'Etat" (399). After this petition the Conseil Supérieur convened once
more and a final attempt was made to prevent the execution of the scheme.
Puvis de Chavannes, Jean Louis Meissonnier, Gustave Moreau, Paul Dubois
and many others were all in favour but, as we have seen, the
Minister for Arts wanted to restrict women to decorative work and for this
the Ecoles de Dessin pour les Jeunes Filles already provided (400).

Final success in 1896 was due to the efforts of Maurice Faure, a
Deputy Senator (401). In March of that year, Emile Combes, Minister of
Public Instruction and Arts, received Virginie Demont-Breton, then President
of the Union des Femmes Peintres et Sculpteurs, and announced to her that
the matter had been agreed on in principle; money was the only problem.
Hopefully women would be admitted to the Ecole des Beaux-Arts from Easter,
1897 (402).

In April, 1897, the "Chronique des Arts" published the following state-
ment: "La loi des finances pour 1897 contient un supplément de crédit de
13000 francs pour les dépenses auxquelles doit donner lieu l'admission des
femmes à l'Ecole des Beaux-Arts. En conséquence le directeur des Beaux-
Arts vient de faire signer par le ministre un arrêté conforme au vote du
Parlement. D'après cette décision, les jeunes filles et les femmes âgées
de plus de 15 ans et de moins de 30 ans, qui, à l'appui d'une demande
d'inscription présentée au secrétariat de l'Ecole, produirant, avec une

pièce établissant leur identité, un certificat délivré par un artiste
connu constatant qu'elles peuvent subir, avec des chances de succès les
épreuves d'admission, seront autorisées à travailler dans les galeries
et à la bibliothèque; elles pourront, en outre, suivre les cours oraux
et fréquenter, au moins provisoirement, le cours de dessin et celui de
modelage qui vont être institués." (403). The first entry exam occurred
in the Section of Drawing and Painting in June 1897, when, out of 42
candidates who presented themselves, ten were admitted as students (404).
This was over 30 years after women had been admitted to the Royal Academy
Schools in England and the same caution was observed with regard to facil-
ities for study. Initially they were excluded not only from life studies
but also from painting. From July, however, three girls, one of whom,
Mlle. Jamin, was a member of the Union des Femmes Peintres et Sculpteurs,
were admitted to the School of Painting (405). An advertisement in the
"Journal des Femmes Artistes" of November, 1897, shows that for painting,
sculpture, drawing and anatomy, women were taught separately; lectures
were communal (406). By December, 1897, 40 female pupils were attending
the drawing course and a total of 160 were on the books for the oral
courses. A "cours de figure dessinée d'après l'antique" was started at
that time (407). As in England the exclusion of women from life studies
was deplored. "La Fronde", for example, exposed "la situation déplorable
faite aux femmes admises comme élèves à l'Ecole des Beaux-Arts; les vexa-
tions et les désillusions qui les attendent, le mauvais vouloir, pour ne
pas dire plus, de Monsieur Roujon à leur égard, l'injustice profonde avec
laquelle elles sont traitées, puisque, malgré leur admission après con-
cours, on leur prive de l'instruction intégrale donnée à leurs camarades
hommes, en ne leur permettant pas l'accès des ateliers, l'administration
supérieure prétextant l'immoralité possible des ateliers mixtes" (408).
However, on January 19th, 1900, an amendment was presented by Monsieur
Viviani and voted by the Chamber, as a result of which women were
admitted to the ateliers (409). The number of women listed in the Inscrip-
tions pour les épreuves d'admission in fact decreased between 1897 and 1900,
as a result, no doubt, of the failure of the School to provide full facil-
ities (410). In April 1901, after the ateliers concession, the number
went up from 26 - in April of the previous year - to 55. The victory of
1897 was nominal. Equal opportunities for study were not achieved until
Fig.7 the early 1900 s. By 1903 women received exactly the same instruction at
the School but they were still taught in separate studios. In October
1902 there were eighteen women among the 80 candidates who were accepted (411)

The necessary sequel to this was the admission of women to the Prix
de Rome competitions. Although the Prix de Rome was always mentioned in

Madame Bertaux's demands for admission to the Ecole des Beaux-Arts, the
latter was the point of focus and the former ignored by the authorities.
Her first separate demand that women should be eligible for the prizes
was in 1893. In January of that year the "Journal des Femmes Artistes"
reproduced an extract of Jean Gérôme's speech delivered at the annual
public meeting of the Académie des Beaux-Arts on the occasion of the dis-
tribution of the Prix de Rome and other prizes. His speech, which
evoked the great benefit and pleasure to be gained from studying in Italy,
had inspired envy in women artists. Better education and fair incentive,
wrote Mme. Bertaux to the author, would enable women to transcend the kind
of art they produced at present, which she described as "facile, mièvre
et gracieux". "Etant donné le critérium de l'art féminin, dois-je dire
l'Art? toutes les femmes peuvent se croire artistes; il n'en sera plus
de même quand il faudra montrer du savoir" (412). In July, 1901, Madame
Bertaux used another approach. She offered an annual prize to the Ecole
des Beaux-Arts for those female pupils who took part in the Prix de Rome
competitions. It was refused, of course, as women were not eligible (413).
Success came in 1903. In February of that year the "Chronique des Arts"
reported that women would be able to participate for the various Prix de
Rome: sculpture, painting, music, engraving and architecture, from the
following June (414). The competition was open to unmarried French
women between the ages of fifteen and thirty (415). As the "Kunstchronik"
euphemistically wrote, this caused several objections "weil die Folge
solcher Verleihungen der Einzug von Damen in das römische Akademiehaus
wäre und zu besorgen stände, dass die heiligen Hallen der Villa Medici die
Brutstätte kleiner Romane im Stile Marcel Prévost's werden könnten " (416).
The first woman to receive the Prix de Rome for painting was Mlle. Odette
Pauvert in 1925 (417).

One of the most interesting facts revealed by the "Journal des
Femmes Artistes" is the existence of a large number of art schools in
Paris, run by women, for women, by the 1890's. These covered an extreme-
ly extensive range of art instruction, including work in pencil, charcoal,
water-colour, pastel and oil and pupils could paint or draw landscape,
flowers, still-lives, casts and both the nude and costume living model. In
1880 Mme. Pauline Ruffin directed the women's studio founded by Edouard-
Alexandre Sain in the rue Taibout (418). In November 1895 there were
three advertisements of Schools conducted respectively by Madame
Delacroix-Garnier, Madame Fichel and Mlle. Bonnefoi (419). By November
1897, there were fifteen (420). The words "Modèle Vivant" and "Académie"
were almost always in large type in these advertisements suggesting that
female pupils were most attracted by the possibility of working from the
life.

Clive Holland, in 1904, gave a detailed account of the opportunities for women art students in Paris, excluding of course the Ecole des Beaux-Arts which was only accessible to French women (421). Female students in Paris, he wrote, were mostly attached to the classes of the Académie Julian, the Académie Colarossi (formerly the Académie Suisse) or to some other atelier. Occasionally they worked under an artist who took pupils "instead of learning their craft in the more cosmopolitan environment of the Académies" (422). The "bolder girls" in the latter, attended a mixed class "and there they will work shoulder to shoulder with their brother art student, drawing from the costume or the living model in a common spirit of studenthood and camaraderie" (423); the more modest could be accompanied by ladies who were allowed to be present during the classes (424). At most Académies, he went on, there were several competitions a year. Five were held at the Académie Julian and these consisted of a portrait study, a full length figure of a woman, a full length figure of a man, a torso of a woman and a torso of a man; "although there are separate classes for women who do not care to work side by side with men, the concours are for both men and women competing together" (425). There were also monthly exhibitions at which the girls' work was shown alongside the men's. Broadly, the course of instruction was the same as in England: pupils would progress from elementary drawing to drawing from the antique and finally to studies from the living model; "but for the study of anatomy and drawing from the living model the opportunities provided are far greater than in the average English Art Schools. Moreover the individual talent and bent of each pupil is more carefully studied and fostered than with us". At most studios a model posed for eight hours daily and good models were far easier to obtain in Paris than in England. Very soon the pupil was allowed to paint pictures and if these were good they were sent to the Salon (426). The fees ranged from 60 francs for one month of half-day study to 700 francs for one year of whole-day study, plus an entry fee of ten francs at Julian's, and fees at other schools were similar (427). Two or more women often clubbed together on a cooperative system in which case they could have a larger studio, engage one model for all of them and live more cheaply; very few women went to artists for private tuition because of the expense (428). Holland estimated that the total annual cost for a woman art student in Paris would be about £94 a year (429).

Many of the best known women artists of the last quarter of the century were foreigners who lived and studied or just studied in Paris. Susan D. Durant, Isobel Lilian Gloag, Annie Swynnerton, Katherine Cameron and Gwen John from Britain, Julie Wolfthorn, Jeanna Bauck, Marie von

Eickhof-Reitzenstein, Dora Hitz, Sabina Lepsius, Clara Rilke-Westhoff,
Eugénie Hauptmann and Paula Modersohn-Becker from Germany, Harriet
Backer from Norway, Anna Bilinska from Poland, Louise Breslau and
Ottilie von Roederstein from Switzerland, Mary Cassatt, Cecilia Beaux
and Elizabeth Gardner from America, Marie Collart and Marie Antoinette
Marcotte from Belgium, Irene Deschly from Roumaina, Hanna Pauli from
Sweden, Juana Romani from Italy, Helene Schjerfbeck from Finland,
Therese Schwartz from Holland, Marie Bashkirtseff and Sonia Delaunay from
Russia - all these received art instruction in Paris and they are but a
selection (430). They were attracted not only by the progressive state
of the arts in France, but also by the régime of the Académies and the
centralized student life.

Despite the exceptional opportunities in the ateliers, academic France,
as has been shown, was extremely slow and reluctant to accord higher facil-
ities to women and it was on this matter that most French women artists
focused their attention, as witness articles in the "Gauloises", "Gazette
des Femmes" and "Journal des Femmes Artistes". The need for better art
education cannot have been the only reason for this, for the ateliers or
Académies afforded excellent instruction. To a certain extent, to be sure,
it was a question of national pride: it was only just that what had
already been accorded in other countries should be granted in France; in
some degree, too, it was a question of money: the Académies were expensive.
But two other, perhaps less obvious reasons, should be mentioned. Firstly,
the admission of women to the Ecole des Beaux-Arts would weaken the taboo
on women progressing beyond a certain point in their art studies, the
point when Berthe and Edma Morisot's art teacher asked their mother whether
she was prepared to allow her talented daughters to continue, for if she
was they would certainly become artists (431). She, being liberal and
appreciative of the arts, said yes, but the very existence of the incident
suggests that many would not. Madame Necker de Saussure's generalisation
on parents was still broadly true (432). As in England the most success-
ful women artists came from artists' families and thus did not encounter
such obstacles: Jeanne Mathilde Herbelin, Rosa Bonheur, Madame Léon
Bertaux, Georges Achille-Fould, Emilie Leleux, Delphine de Cool, Marie
Petiet, Virginie Demont-Breton and Jacqueline Marval, all had artistic
parents. If official sanction were given to women artists by their
admission to the Ecole des Beaux-Arts, social disapproval would gradually
disappear. Secondly, their admission would help to destroy the associa-
tion of women with second-rate, accomplishment art, for while their educa-
tion was different, so, it was thought, was their art. It was this idea,
and above all the idea of "un art facile, mièvre et gracieux" (433), which

Madame Bertaux, Virginie Demont-Breton and Louise Abbéma wanted to over-
come (434). They all held the view that women's art was of a particular
nature that should be fostered, but to have it recognized as such rather
than as inferior art, it was necessary that women should have the same
opportunities. Then a differentiation would be made rather than a first-
second evaluation.

In view of the early progress in art education facilities for women in
England it might seem odd that so few foreigners came to England for the
purpose of studying art. This may doubtless be explained by the fact that
in the Victorian era in England, art in relation to women was seen pre-
dominantly as an accomplishment. Thus, although the facilities existed
and were exploited by some women, for most it was socially offensive to
carry their studies beyond a certain limited level. Throughout the nine-
teenth century Paris was mecca for the aspiring woman art student and large
numbers from England and other countries went there, especially from the
1860 s when Chaplin's School, the Académie Julian and other Académies
offered what was, in comparison with systems elsewhere, a stimulating
course of instruction. The idea of women's art as an accomplishment did
exist in France, but on the whole there was greater opportunity to mingle
in artistic life - due to centralisation and the informal atelier system
- and therefore less segregation and less danger of being submitted to
a separate, lower standard.

CHAPTER TWO - EXHIBITION

Part 1. Mixed Exhibitions (showing works by men and women)

The tables on which this chapter is based have several flaws which should be borne in mind throughout the following discussion. Firstly, exhibition catalogues vary from edition to edition and final editions were not always available; thus the catalogues used are not necessarily an accurate representation of the exhibitions themselves (1). Secondly, from the fact that some women artists are known to have used pseudonyms, one may deduce that others did too, whose identity has not yet been established (2). The division of works into those by men and those by women may not, therefore, be absolutely correct.

In explanation of my method, I should say that I have chosen to base my analysis on individual works rather than artists because increases and decreases in the categories of oil and water-colour painting, sculpture and graphics are more informative than fluctuations in the number of exhibitors. These increases and decreases are made more evident by the method adopted than through the division of exhibitors into painters, sculptors and graphic artists; many artists experimented with various media, to varying degrees, and to call a painter who exhibited one sculpture or one print in addition to several paintings, a sculptor or a graphic artist to the same extent as a painter, would be false. Also, from a purely numerical point of view, tables showing changes in the numbers of male and female exhibitors would not give a true picture of the varying amount of female artistic activity because many exhibitors, women in particular, exhibited only one or two works in their entire lives.

I am concerned here with the corpus of work by women rather than the individual female exhibitor and my basic unit, the individual work, has been examined according to the category - whether oil, water-colour, sculpture or graphics - to which it belongs.

The final total columns of Tables 1 to 5 reveal that the first real increase in female contributions to English exhibitions occurred in the late 1870 s. During the first three-quarters of the century (judging from the selected dates only) percentages of works by women ranged from 5.5 to 10.5 at the Royal Academy, 3.1 to 11.4 at the British Insitution, 5.9 to 14. at the Society of British Artists and 5.6 to 10.5 at the Portland Gallery or National Institution. During the last three decades of the century there was a rapid increase to 20 and 21 per cent: the variation at the Royal Academy was between 10.1 and 20.6, at the Grosvenor Gallery between 9.9 and 20.9 and at the Society of British Artists between

12.7 and 21.9 per cent. During both periods women maintained a higher
percentage at the Society of British Artists, which, originating as it
did with the purpose of providing more accessible exhibitions and member-
ship than the Royal Academy and lacking the awesome tradition and bureau-
cracy of the latter, doubtless attracted many lady amateurs.

The low percentage of exhibited works by women during the first
three-quarters of the century reflects above all the quality of women's
art rather than the number of women artists. It is certainly true to say
that more women than men were taught art as part of their education and
many of these must have sent their works to exhibitions without success.
Miss Florence Claxton's "Scenes from the Life of a Female Artist" of
1858 portray a girl painting a picture "of the ascent to the Temple of
Fame" for exhibition; "the picture is rejected, and the disconsolate
young painter is seen sitting in comical despair, gazing at an enormous
R, chalked on the back" (3). This was surely a generalisation. The
art education available to women, although gradually broader and more
serious, did not equip them for open competition with men until the end
of the century. Another reason for the low representation of women at
exhibitions during the first three-quarters of the century was the fact
that certain media such as water-colour and pastel and certain types of
subject-matter such as portraits, genre, landscape and flower painting
were estimated lower than oil paintings of historical and classical sub-
jects; as a result they were accorded limited wall space, particularly
at exhibitions of the Royal Academy and British Institution (4). Women
were more prolific in these subsidiary media and classes of subject-
matter.

The rapid increase of works exhibited by women in the 1870 s was
mainly due to greater facilities in art education (5). Another factor
was the increasing popularity of art not only as a pastime but also as a
profession for women (6). Finally, as has already been indicated, there
was a gradual equalisation of genres and media in the last three decades
of the century, a corollary of which was the equalisation of male and
female art. As the sections devoted to water-colour, pastel and minia-
ture grew, so did the overall percentage of works by women.

There was a marked difference in the pattern of the Paris Salon
(Table 7). In France during the first four decades of the nineteenth
century, women's work constituted a relatively high proportion of the
total, ranging from 11. to 13.3 per cent. Reviewers often commented on
this proliferation. Thus in 1802: "Plusieurs dames artistes, d'un
talent distingué, contribuent, depuis quelques années, à la gloire

de notre Ecole; mais elles ne s'étaient point encore présentées en aussi grand nombre, ni avec autant d'avantage qu'à cette exposition.." (7). In 1808 a reason was advanced: "Comme elles viennent d'être admises à partager avec les hommes les récompenses destinées aux talens, il est vraisemblable que la liste des concurrentes s'accroîtra à chaque exposition publique" (8). It is also significant that these years saw the emergence of women artists trained before the Revolution when attitudes to women were freer and more encouraging than under the Code Napoléon. During the Second Empire, between 1850 and 1865, women's contributions to exhibitions reached a low ebb, the percentage ranging from 4.9 to 8.9. In 1847 a Salon reviewer in the "Magasin des Demoiselles" described the fate of the typical woman artist in terms which recall Florence Claxton's "Scenes from the Life of a Female Artist" of 1858. "Quelques femmes ... quittant la province trop étroite pour leur ardeur, viennent à Paris tenter la fortune et confier leur avenir aux chances de l'exposition; c'est le but de leurs efforts, c'est le rêve enchanté de leurs espérances. Quelques-unes frappent inutilement à la porte du Musée, et alors brisées elles se désolent et regrettent la vie studieuse et restreinte de leur petite ville, où elles sont trop heureuses de retourner. D'autres voient leurs toiles suspendues dans quelque angle obscur; celles-là, et ce sont souvent les plus malheureuses, s'obstinent, se fixent à Paris, où elles croient trouver la fortune et la gloire. Pour se soutenir, elles épuisent toutes leurs ressources et celles de leur famille. Elles végètent dans l'oubli; le chagrin les énerve, et presque toutes se préparent une douloureuse vieillesse" (9). Success for a woman artist was almost impossible at that time; their training did not equip them for it. The Salon des Refusés of 1863 gives a good idea of the number of unsuccessful women artists. Out of 2925 works exhibited at the official Salon, 220 or 7.5 per cent were by women. At the subsequent Salon des Refusés 98 were by women out of 781 - 12.5 per cent of the total (10). Thus the Salon rejected a larger proportion of works by women than by men.

As in England there was a sensible increase from 1870; the percentage varies between 12.2 and 21.2, the latter occurring in 1900. An examination of percentages at the Société Nationale, the Salon des Indépendants and the Salon d'Automne reveals a maximum figure of 22.5 at the Salon des Independants in 1889 (Tables 8, 9 and 10). The 1870 s saw a spate of articles devoted to women's growing contribution to the Salon (11). In 1873 E. Muntz observed that 161 out of 1,150 exhibitors at the Salon of 1872 were women. He went on: "Cette proportion parait assez respectable. Elle est infiniment plus élevée que chez la plupart de nos voisins du

continent" (12). In 1880 one critic expressed no surprise at the number
"eu égard à l'énorme et utile multiplication des écoles de dessin, tant
à Paris qu'en province, aux efforts de l'Union Centrale pour leur offrir
des programmes pratiques, au goût sérieux de la peinture qui si développe
dans les classes riches et succède aux puériles distractions mondaines" (13).
Art education once again is the key, France offering the greatest opportun-
ities to female art students. I would advance one other tentative explan-
ation for the rapid increase. In reviewing an exhibition of women's art
in 1910, J-F. Schnerb wrote: "La proportion de l'élément féminin dans la
corporation des peintres augmente sensiblement. Et le niveau de sa pro-
ducation n'est pas notoirement inférieur à celui de l'élément masculin.
C'est que, d'une part, elles se haussent, et que de l'autre, ils dévalent.
Il ne faut pas s'étonner de voir les femmes réussir dans un art efféminé,
mais plutôt déplorer que des hommes se complaisent à des petits travaux
d'arrangements, de transcription superficielle, où leurs facultés supér-
ieures n'ont pas d'emploi. N'est-ce pas une leçon de voir la manière
crâne du Salon d'Automne si bien imitée par les faibles mains des grâces?
Mmes. Agutte, L. Cousturier, Galtier-Boissière, Mutermilch savent aussi
bien que leurs confrères barbus exécuter de petites toiles d'une sage
excentricité" (14). This idea that women artists achieved a higher standard,
or seemed to, when the precepts governing a good picture altered, becoming
more lax, is interesting and should be borne in mind when considering the
increase of exhibited works by women.

Oil Painting

 As the Royal Academy did not divide oil and water-colour paintings
in the early years of the century conclusions are best based on the British
Ins titution, which excluded water-colour. Here it is evident that at the
beginning of this period women maintained quite a high proportion in the
oil painting sector - a maximum of 11.4 per cent was achieved in 1812 -
decline setting in around 1814 (Table 2). Thereafter the percentage
remained very low (15). Between 1824 and 1880 at the Society of British
Artists the percentage of oil paintings by women varied from 2.7 to 10. per
cent, the lowest figures occurring between 1835 and 1845 (Table 3). At the
National Institution from 1850 to 1861 the variation was between 1.9 and
6.4 (Table 4). The highest percentage of oil paintings by women before
1880 was at the Dudley Gallery where 14.4 was attained in 1873 (Table 6).

After 1880 there was a sudden change. The variations were as
follows::

Royal Academy (1885 - 1900) 12.8 - 15.3 (Table 1)

Society of British Artists (1885 - 1900) 19.4 - 22.0 (Table 3)

Dudley Gallery (Winter Exhibitions
of Cabinet Pictures in Oil)
(1883 - 1889) 18.6 - 22.9 (Table 6)

At the Paris Salon oil painting was not given an exclusive section
until the early 1860 s. Between 1865 and 1900 the percentage of oil
paintings by women varied from 6.4 to 16.3 per cent (Table 7). In 1889
when their contributions constituted 12.5 of the total, a critic wrote
in "L'Art": "Jusqu'à présent l'effort pratique des jeunes filles
s'arrêtait à la céramique ou à l'aquarelle. Les voici à la grande
peinture! La peinture de chevalet leur parait inférieure" (16).

Oil painting was not, on the whole, a part of accomplishment art.
Several reasons may ue advanced for this. Oil painting was hardly suit-
able as a drawing-room activity; it involved more materials and mess than
water-colour. Also it was associated with highly finished pictures and
most women lacked the serious training necessary for working up pictures
to finish. Finally it implied larger pictures than women were thought
capable of composing.

Sculpture

During the greater part of the nineteenth century sculpture was con-
sidered unsuitable for women for the same reasons. At the Royal Academy
until 1870, sculptures by women represented a maximum of 5.6 per cent of
the total, or 11 works out of 194 (in 1870). Between 1880 and 1900 the
percentage varied from 9.5 per cent (in 1880) to 22 per cent (in 1900)
(Table 1). At the Grosvenor Gallery sculptures by women reached 28.5 per
cent of the total (12 out of 42) in 1886 (Table 5). In 1880 when women
contributed 8 out of 31 sculptures, the "Art Journal" remarked: "In
sculpture the ladies occupy a very prominent place" (17).

In England sculpture constituted a very much smaller section of
exhibitions than in France. At the Salon before 1875 women sent a max-
imum of 47 sculptures (out of 728) in 1870 - 6.4 per cent of the total.
After 1875 the highest figure was 148 (out of 1,145) or 12.9 per cent in
1889 (Table 7).

During the first half to three-quarters of the century, a woman
wishing to learn sculpture had to take private lessons; there were no
public facilities. As was stated in "Le Pausanias Francais" of 1806:

"La Sculpture convient moins aux dames que la Peinture; tous les
travaux en sont rudes, et doivent répugner à leur délicatesse" (18).
Félicie de Fauveau, whose work will be considered in detail in Chapter
Five, and Marcello, whose real name was la duchesse Colonna di
Castiglione, were the first to make a mark as sculptors and their emer-
gence provoked astonishment. In 1865 a critic wrote in reference to
Marcello: "Qui aurait pensé que la main d'une femme, - une main fine,
élégante, souple, délicate, aristocratique, une main qui semblait unique-
ment faite pour froisser la dentelle et la soie, - pût aussi tailler la
marbre, manier l'ébauchoir et tenir le lourd marteau des sculpteurs" (19).
And again in 1870: "Il a paru curieux aux nouvellistes de voir une femme,
une patricienne, manier si furieusement l'ébauchoir et se hasarder aux
plus téméraires aventures. Les juges prudents ont demandé la permission
de se taire" (20). In the 1870 s a considerable number of women trained
as sculptors in the newly founded studio of Mme. Léon Bertaux; in 1879
a critic observed: "L'atelier de Mme Bertaux joue au rez-de-chaussée le
rôle de l'atelier Chaplin dans les salles de la peinture. Les élèves sont
fort brillantes, et on remarque ... Mlle de Lanchâtres, Mlle. d'Anetal,
Mlles . Dombrowska, de Saint-Gervais, Mme. Halévy, la comtesse de
Beaumont-Castries, Mlle. Sarah Bernhardt"(21). In the view of Charles
Timbal, writing in the "Gazette des Beaux-Arts" in 1877, more sculpture
was produced generally at that time: "Il n'est pas facile de nier que
la sculpture ne prenne décidément le pas sur la peinture. C'est un fait
que plusieurs expositions ont demontré déjà ... Les femmes elles-mêmes,
démentant leurs habitudes de coquetterie et bravant leur faibless, pétris-
ssent la glaise sans craindre que l'humidité altère l'épiderme de leurs
jolis doigts; les mieux douées brandissent le maillet" (22).

Water-colour, etc.

In oil painting and sculpture women only began to make a mark towards
the end of the nineteenth century. In water-colour, pastel and minaiture
painting, painting on porcelain and enamel, and drawings, however, they
maintained a much higher proportion throughout the century and by the last
decade approximately 50 per cent (23). Once again it is not easy to pro-
duce figures for the early years of the century as the Royal Academy did
not, at that time, divide painting into separate categories. For a brief
period miniature paintings were listed in a separate section: in 1800, 30
out of 138, or 21.7 per cent, were by women (Table 1). Where water-colour
is concerned my statistics begin in 1830 after which date the minimum
water-colour percentage at the Society of British Artists was 12.8 (in

1835) and the maximum 35.7 (in 1855) (Table 3). At the Royal Academy
drawings and miniatures were listed separately in 1840, 1850 and 1855,
the maximum percentage of works by women in these years being 27.7 in
1840. Then from 1870 when water-colours, miniatures, drawings and
from 1879 paintings on porcelain, were given a separate section, per-
centages ranged from 19.2 (in 1870) to 43.3 (in 1900) (Table 1). At
the Portland Gallery (National Institution) minimum and maximum percent-
ages were 14.8 (in 1851) and 41.6 (in 1854), at the Grosvenor Gallery
17.9 (in 1878) and 37.8 (in 1883) and at the Dudley Gallery 11.6 (in 1865)
and 40.1 (in 1890) (Tables 4, 5 and 6). As will be seen in the follow-
ing section, there were women members of the various water-colour soci-
eties throughout the century. The Dudley Gallery, which held the only
exhibitions devoted purely to water-colour and open to everyone, was
especially popular with women artists. In 1866 a critic wrote: "The
rights of women are fully recognized within these walls. No other gallery,
with the single exception of that occupied by the Society of Female Artists
contains so formidable an array of lady exhibitors" (24). And again in
1873: "One of the most commendable features of the exhibition is that
of the contribution of more than 70 ladies, many of whose works are of
signal excellence" (25).

In France again, it is difficult to produce figures for the early
years of the century owing to the absence of separate categories in the
Paris Salon. Statistics are only possible from 1865 after which date
water-colours, pastels, drawings, miniatures and paintings on enamel and
porcelain by women constituted from 23.7 to 51.6 per cent of the total
(Table 7). Reviews of exhibitions are the main source for information
on their earlier performance. Thus in 1827 A.Jal remarked on the large
number of women exhibiting paintings on porcelian (26) and in 1841 a critic
mentioned the suitability of water-colour and pastel, as "genres légers
et faciles, sortes de transitions toutes naturelles entre le dessin et
la véritable peinture" for women artists, a large number of whom contri-
buted such works to the Salon (27). In 1859 attention was drawn to the
numerous lady miniature painters (28). In 1861 a critic referred to
"quelques genres moins importants qui sont comme les manifestations
familières de l'art de peindre; la miniature, la porcelaine, les émaux,
etc." He went on: "Sur ce terrain peu fréquenté, à l'ombre des mouve-
ments du grand art, les talents féminins se donnent rendez-vous: la main
délicate de la femme semble, en effet, prédestinée à tenir le pinceau
éffilé du miniaturiste. La peinture sur porcelaine appelle presque la
faiblesse, tant, la force ye devient un danger. Aussi les femmes ont-
elles de tout temps réussi dans ces deux genres. Aujourd'hui encore, des

femmes ou jeunes filles y tiennent le premier rang" (29). And in 1864:
"Les dames occupaient une place d'honneur dans la galerie des dessins
à l'aquarelle" (30). Finally, in 1873, E. Muntz emphasized that "les
femmes, fidèles à leurs instincts, s'attachent de préférence aux genres
faciles, exigeant de l'élégance plutôt que de l'énergie et de l'invention:
l'aquarelle, la miniature, la peinture sur porcelaine etc." (31). This
proliferation continued. The size of the water-colour section in the
Paris Salon and the early admission of paintings on china (these were not
admitted to the Royal Academy until 1879) suggest that the Salon had a
more lenient attitude to the "less important" genres than the Royal
Academy. This may have been one cause of the higher percentages at the
Salon throughout the century.

Prints

An accurate estimation of women's performance in the print or black
and white department at the Royal Academy before 1870 is impossible
owing to the absence of an exclusive section but it may safely be des-
cribed as negligible. In 1870 they contributed 3 out of 42 and figures
remained low until the 1890 s; in 1895 they exhibited 29 out of 137 or
21.1 per cent and in 1900, 27 out of 153 or 17.6 per cent (Table 1). At
the Dudley Gallery's black and white exhibitions the percentage ranged
from 6.1 (32 out of 522) in 1872, to 12.7 (82 out of 642) in 1880 (Table
6) (32).

At the Paris Salon there was a separate print section throughout
the nineteenth century so women's contribution may be gauged exactly.
Until 1865 they barely registered at all, sending a maximum of 7 works to
any one exhibition. The tide appears to have turned in 1868: in en-
graving, woodcuts and lithography "les demoiselles avaient fait invasion".
Names included Mlle. Hélène Boetzel, Mlle. Elise Flameng, Mme.V. Brux,
Mlle. Thomas, Mme. Trichon, Mlles. L. Basset, Aline Lemaire and Jeanne
Schiff (33). In 1870, 19 out of 359 exhibits were by women and there-
after the number grew, reaching 89 (out of 568) or 15.6 per cent in
1895 (Table 7).

Part 2 - Membership

England

Although the two female founder members of the Royal Academy,
Angelica Kauffman and Mary Moser, were full Academicians, they were not
required to attend meetings and indeed it was not considered suitable
that they should. They voted in absence (34). After the death in
1807 of Angelica Kauffman and towards the end of her own life, Mary
Moser did however, on occasions, attend (35). She died in 1819.
Thereafter women were totally excluded until 1922 when Annie Swynnerton
became an Associate. Laura Knight was similarly elected in 1927 and in
1936 she became the first female Royal Academician with full rights.
Women did, nonetheless, continue to constitute a large proportion of the
Honorary Members after 1819 until this section faded out in 1867; there
were over 185 Honorary Lady Members between 1800 and 1867 (Table 11) (36).

There would seem to have been no lack of women artists eligible for
Academical status. Throughout the nineteenth century, press reviews of
exhibitions claimed the right of certain women to such honour, often
roundly criticizing the Royal Academy for unfair exclusion. Margaret
Sarah Carpenter, the portrait painter, was most frequently the artist at
issue. Thus in 1833 the "Athenaeum" wrote that her portrait of the
Countess of Denbigh at the Royal Academy might be "compared, without fear
with the female heads of most of the Academicians, from some of whom she
would surely win the honours of the Academy, were a lady allowed, as of
old, to become a competitor" (37). In a discussion of Mary Francis'
"The Orphan Flower Girl" at the Royal Academy in 1839, the "Art Union"
remarked: "Now that women are maintaining their intellectual rank, and
affording daily proofs that the 'soul is of no sex', the Academy might
give a fine example to the nation and to the world - by distinguishing
such a painter as Mrs. Carpenter and such a sculptor as Mary Francis from
among the thousand competitors for fame" (38). A critic in the same mag-
azine, wrote of her picture "First Love" at the British Ins titution in
1842: "How very few of our British Painters are there who can surpass
this work in any one of its qualities; indeed, in the whole range of
modern Art we could scarcely name one who, in this style, could go
beyond it"; in his view she should be a member of the Royal Academy (39).
In 1843 the question was frankly posed by the "Athenaeum": "Why should
not Mrs Robertson and Mrs Carpenter be Members of the Royal Academy as
well as Angelica Kauffman or Mrs. Moser, the flower painter?" (40). And
again in the "Art Union" of 1846: "Mrs. Carpenter is entitled to

consideration, even from the Royal Academy, on account of the high
qualification by which she is distinguished and which so few of her
male competitors possess in the same degree" (41).

From the late 1850 s the expression of such views reflected the
growth of the Women's Movement. Mrs Carpenter's portrait of her
husband, William Carpenter, in the Royal Academy Exhibition of 1859, was
described in the "Art Journal" as "a picture that, with others by the
same hand, will go farther than a volume of argument to compel the Royal
Academy to acknowledge 'the rights of women', which they have been
always disposed to ignore" (42). And in her obituary of 1873: "Had
the Royal Academy abrogated the law which denies a female admission to
its ranks, Mrs Carpenter would assuredly have gained, as she merited, a
place in them; but we despair of ever living to see the 'rights of
women' indicated in this respect. The doors of the Institution are
yet too narrow for such" (43).

From 1866 Henrietta Ward came into the limelight. Her picture
"Palissy the Potter" exhibited at the Royal Academy in 1866 provoked the
following response in "Blackwood's Magazine": the picture "places her
in the foremost rank among ladies who in Europe have used the brush. In
the pending reconstitution of the Royal Academy, it is worthy of consid-
eration whether means can be devised by which female talent shall receive
fair recognition" (44). In 1870 she was again singled out for her
picture "The First Interview of the divorced Empress Josephine with the
King of Rome" at the Royal Academy: "whether the Academy ever intends
to admit ladies into its ranks may be a question; but there can be no
question as to the fact that Mrs. E.M. Ward ought to be there" (45). In
1871 it was Louisa Starr: "Why should not ladies be eligible for election
into the corporate body of the institution?" Such a measure might be
unwise with 40 Members and only 20 Associates, "but with a wider and in
the best interests of Art - a more liberal and comprehensive scheme of dis-
tributing academical degrees, such concessions would be both graceful and
politic" (46). In 1876 E.C. Clayton took up the battle: "It cannot be
denied that since the days of Angelica Kauffman and Mary Moser and the
female honorary members of the same period, the Academy has studiously
ignored the existence of women artists, leaving them to work in the cold
shade of utter neglect" (47).

The only substantial defence of the Academy's position prior to
1879 was in William Sandby's "The History of the Royal Academy of Arts"
of 1862. He was quite aware of the existence of a "grievance" among
women and also admitted that "no law forbids such a selection"; "but",
his defence runs, "one or two ladies if elected as members, would

scarcely be expected to take part in the government or in the work of the
Society; and as the practice even of giving votes by proxy has long since
been abolished the effect of their election as Royal Academicians would
be, virtually, to reduce the number of those who manage the affairs of
the institution and the Schools, in proportion as ladies were admitted
to that rank: as long as the number of Associates is limited, a diffi-
culty would arise in the fact that the higher rank has to be recruited
from that body. Whether a number of honorary appointments could be made,
to recognize talent in such cases, but conferring none of the other rights
or privileges of membership, is a matter which the Council of the Academy
are best able to determine; and there is no doubt from their desire, as
far as is wise and reasonable, to meet any just demands, that the claims
of all artists of ability, whether male or female will meet with due
consideration" (48). Their exclusion, then, was due to the fact that
it was not thought seemly for women to hold responsibility, nor were they
considered capable of authority. Sandby omitted to mention that
towards the end of her life Mary Moser voted at the Royal Academy meetings
in person (49).

In 1874 the Misses A.F. Mutrie and M.D. Mutrie and Mrs. E.M. Ward
were nominated by certain Royal Academicians for the degree of Associate-
ship and Mrs. Ward carried off a considerable number of votes (50). In
1879 still further headway was made by Elizabeth Butler whose exhibits in
the 1870 s had been widely acclaimed (51). In the A.R.A. elections of
that year her name appeared on the slate and in the first ballot she had
the highest score: 12 votes out of a possible 52; Hubert Herkomer came
second with 10. In the second ballot Herkomer had 18, Lady Butler 16
and Mr Dicksee 8, and in the final vote Mr. Herkomer won by 2 votes with
27 against Lady Butler's 25 (52). A contemporary witness, George Dunlop
Leslie R.A. wrote later that this event "gave rise to a series of animated
debates in the General Assemblies. The ladies had already obtained a
strong foothold in the Schools, and now the 'Patres conscripti' of the
Society were much alarmed at the idea of a possible invasion into the
very hearts of their own ranks. There was no law against the election of
women; .. Members considered the difficulty of the treatment of women
after they had been elected; for instance, they might choose to come to
the banquet; possibly one solitary lady would come!" Then there would be
the problem of escorting. "Would ladies be eligible to serve on the
Council? - or to serve as Visitors? Might we not some day even have a
female President? And if not, why not?" (53).

As a result of this shock, "on August 8th (1879) the General
Assembly referred to the Council to consider the subject of admission
of women to the membership of the Royal Academy, and to report (1)
whether the existing laws provide for the election of women as Members
of the Royal Academy; (2) whether the privileges and duties of
Academicians as now established differ from those exercized by the
ladies who, by the nomination of King George 3rd, were created Acade-
micians at the foundation of the Royal Academy - if so, in what manner
and to what extent. The Council were further requested to draw up and
submit to the General Assembly Resolutions defining the offices and
duties that can appropriately be connected with the membership of the
Royal Academy when such membership shall be held by women. The Council
considered the subject on November 11th and 18th, and on December 5th
they reported to the General Assembly that in answer to the first point
they were of opinion that the letter of the law, as given in Article 1
of the 'Instrument' does not provide for the election of women as members
of the Royal Academy". It is worth mentioning the terms used in speci-
fying eligibility for membership in Article 1. In the view of the
Council the phrase "men of fair moral characters" was crucial and was
bound to be interpreted as not including women. One cannot help wonder-
ing if it was the word "men" or the qualification "of fair moral charac-
ters" that led to such an interpretation; if it was the latter, then women
would have been excluded on account of a supposed lack of status and moral
qualities (54). To continue the report of the Council to the General
Assembly: "In Answer to the second point they found, after an examina-
tion of the Minutes of the General Assembly and of the Council, (1) that
female Members have never served on the Council; (2) that in the year
1800 a list was drawn up of Members eligible to sit on the Council, and
which was sanctioned by the King, and that on this list the names of the
female Members were omitted; (3) that of the female Members, only one
(Mary Moser) exercised the privilege of attending General Assemblies, her
first appearance being at a meeting 11 years, and her second at a meeting
21 years after the foundation of the Academy, subsequent to which her
attendances were frequent; (4) that the female Members previously exer-
cised the privilege then enjoyed by Members of the Royal Academy of voting
by proxy at elections: (5) that there is no instance on record of a
female Member having attended the Banquet; (6) nor of having served as
Visitor in the Schools; (7) nor of having drawn a pension; (8) nor of
having held any office in the Royal Academy. The Council further
presented a series of Resolutions defining as requested, the offices and

duties that could be appropriately connected with membership of the
Royal Academy when such membership shall be held by women. The dis-
cussion on the Report and the Resolutions was postponed until the
first meeting in 1881" (55).

The Resolutions ran as follows:-

"1. That women be eligible for Membership of the Royal Academy, with
the following privileges:-

1, That they be admitted to vote at General Assemblies for the
Election of Members.

2, That they be eligible for the Professorships of Painting,
Sculpture and Architecture.

3, That they be eligible for Retiring Pensions under the same
conditions as other Members.

4, That they have access to all such Schools, and be admitted to
all such lectures as are open to and attended by Female students.

5, That they be admitted to the Library as other Members.

6, That their Signature be accepted on Applications of Relief

7, That they have the same privileges as other Members with regard
to the Admission and Exhibition of their works, including that
of attending on varnishing days.

8, That they have, in common with other Members, free access to
the Exhibition and also for their husbands and children.

9, That tickets for the Private Views and Soirée be sent to them
as to other Members" (56).

Although this sounds generous, there were two privileges which were not
extended to women Members. Firstly, they could vote for the election of
Members but they could not serve on the Council; in 1936, on the election
of Laura Knight, a special law was passed to make this possible. Secondly,
they were not allowed to attend the banquet; as we have seen this point
loomed large in the minds of many Academicians.

Despite this legislation women were not elected in any capacity until
the 1920 s. Lucy Kemp-Welch was nominated several times around and after
the turn of the century and frequently seconded by Hubert Herkomer who had
so narrowly ousted Lady Butler in 1879 - but without success. Apparently,
when William Powell Frith R.A. stopped to admire one of her paintings at a
private view of the Royal Academy, he was asked why she had not been elected.
He remarked that he had had a narrow squeak with Lady Butler a few years
before and they would not risk such a thing again (57).

At the Manchester Academy of Fine Arts women were treated far more generously (Table 12). From 1879 to 1884 they were listed in a separate category of Lady Exhibitors. Then in 1884 (January 11th) the "British Architect" reported "that a proposal will shortly be brought before the Manchester Academy.. by which the somewhat anomalous title of 'Lady Exhibitor' will be allowed to die out, and ladies will then be eligible for election as associates or members" (58). Thus from 1885 women were elected as Members and Associates. Their number was higher in the latter category. In 1893 the first female Member of Council was elected and in 1895 the second and third (59).

The Royal Scottish Academy was as slow to recognize women as the Royal Academy. They were admitted as Honorary Members in the nineteenth century but the first female Academician was not elected until 1944 (60).

The Society of British Artists admitted women as Honorary Members from its foundation in 1824 and in this capacity women constantly outnumbered men (Table 13). The Society was considered generous in this respect, especially as they allowed them to exhibit with no financial obligations (61). In 1824 there were 5 female Honorary Members, 1 male Honorary Member and 26 male Members. By 1840 there were 9 female Honorary Members, 2 male Honorary Members and 28 male Members. Subsequently, the Honorary Members section was reduced by the loss of the Misses. Corbaux, Miss M.A. Sharpe and Miss Sharples, 4 of its most accredited Members. It was owing perhaps to this that in the following year the category of Honorary Members was abolished; this, of course, meant the abolition of women. In 1860 the Honorary section was reintroduced without women. This situation continued until 1902 when women were granted full membership; Mrs. Mabel Hankey, Mrs. Louise Jopling, Miss Lucy Kemp-Welch and Mrs. Anna Lea Merritt were the first 4 (there were 186 male Members and 9 Honorary male Members at the time) and by 1914 there were 9 (171 male Members and 13 male Honorary Members).

Although the Old Water-colour Society (Table 14) admitted women as Associates and then Members, it did not confer on them any more authority than was given to Honorary Members by the Royal Academy and the Society of British Artists. Miss Byrne was not only the first female to be admitted, she was also the first flower painter, owing to a law excluding such artists, rescinded in 1809 (62). The terms of her election were quoted in the "Microcosm of London" in 1808: "Lady associate exhibitors... as they can never share actively in the management of the Scoiety's affairs, are not eligible as members; but from the moment of their election they become entitled to partake of the 'profits' of the exhibition in the same proportion as the members, while they are exempt from the trouble of

official duties and from any responsibility whatever on account of any
losses incurred by the Society" (63). They were not allowed to vote.
Miss Byrne was made a Member in 1809 but her position did not alter.

From 1813 to 1820 the Society became known as the Society of
Painters in Oil and Water-colour and the exhibitions were open to every-
one. There were several female exhibitors throughout this period, but
the only female Member was Miss Gouldsmith, Miss Byrne having resigned
over the issue of change in 1813. In 1821 the Society reverted to its
original form. The number of Members remained limited to 20, as in the
interval, 1813-20, but a body of Associate Exhibitors was again estab-
lished, with a maximum of 12. Lady artists were to "be called Members,
and have the rights of Associate Exhibitors, being subject to no
expenses nor trouble of business in the Society"; on the other hand they
were not "to have any interest in the receipts" (64). Miss Byrne re-
appeared as a Member in 1821 and was accompanied by Mrs. Fielding who
first emerged the year before as an exhibitor. Between 1821 and 1849
women were constantly present although their maximum representation over
these years at any one time was only 6 in 1829 when there were 23 male
Members and 15 male Associates. The position of lady Members remained
restricted throughout this time. Thus in 1827, when a law was passed
providing for the devolution to the representatives of a deceased Member,
of his share in the property of the Society in cash or in public funds, it
was afterwards explained that this did not apply to ladies or Associates,
"who had neither claims on, nor responsibilities in relation to, the
Society" (65). After 1836 when there were 4 female Members, their
number declined. In 1837, a critic reporting the election to fill vacan-
cies, wrote that out of 9 candidates 3 were chosen and Miss Corbaux was one
of the unlucky six. His comment was critical: "How it happens that a
young lady of such surpassing talent should be rejected we are puzzled to
think. This smacks of the Academic spirit" (66).

Women Members clearly caused anxiety. In 1850 they were all placed
in a special Honorary Members section devoted entirely to women. The
"Athenaeum" commented: "There is a new addition (Nancy Rayner) to the list
of what we perceive the Society now denominate "honorary" members - mean-
ing thereby lady members. This title is calculated to mislead the public
into the idea that these are amateurs" (67). In 1851 the Society aban-
doned Honorary Members and instead listed all the women under the title
"Ladies Section". For the next ten years they averaged 4 in number.
From 1861 women were once again placed in the mixed Associate section and
from 1878 they also appeared as Honorary Members. At this time women
were not admitted in any membership capacity either to the Royal Academy

or to the Society of British Artists; earlier, more generous days were
forgotten and the Old Water-colour Society was considered very liberal in
acknowledging women at all. In 1878 the "Art Journal" wrote: "The
Society of Painters in Water-colours has always been chivalric to the
ladies, and the works of such elegant artists as Mrs. H. Criddle,
Margaret Gillies and Maria Harrison, have long been a delight to the fre-
quenters of the gallery. Of late years, however, two ladies have been
added to the Associate list who combine power with refinement, and about
whose works there is nothing feminine but keen insight and consummate
taste. It would be hard to say whether Mrs Allingham or Clara Montalba
is the more powerful painter of the two" (68). These two artists were
later to be the first women admitted as full members. This occurred in
1890 and 1892 respectively, after a new rule of 1889 authorizing the
admission of ladies to full rank in the Society (69). Miss Rose Barton
was the next in 1911. From 1889 all categories were mixed and women
appeared on the lists as Members, Associates and Honorary Members. In
1904, on the Society's centenary, they could refer to "the recognition
which female talent has always enjoyed at the hands of the Society" (70).

In the centenary report the author also paid tribute to the gener-
osity of the Society of Associated Artists in Water-colour in this res-
pect (71). This Society existed for only five years, from 1808 to 1812
but during this span women were admitted as full Members and were allowed
to vote on all occasions (72) (Tabld 15).

The later New Society of Painters in Water-colours resembled the Old
Society in refusing its lady members responsibility (Table 16). Until
1860 women were nevertheless called Members and their number grew from 3
in 1835 to 10 in 1855. In 1852 a critic wrote in the "Athenaeum":
"There is no exhibition room in which female talent and genius figure to
such good effect as this" (73). In 1860 the New Society of Painters in
Water-colours imitated the Old Society in creating a special Ladies'
Section presumably to underline the difference in the rights and duties
of men and women. An Associate section was introduced in the same year
to which women were not admitted. They were, however, listed as
Honorary Members, with men, when this distinction first appeared in 1870.
In 1875 there were 14 Lady Members, 2 lady Honorary Members, 45 male
Members, 22 male Associates and 6 male Honorary Members. By 1900 these
numbers had increased to 5 female Honorary Members, 14 Lady Members (the
same), 82 male Members and 11 male Honorary Members.

At the Dudley Gallery Water-colour Society the number of lady Members
was very high (Table 17). From 12 out of 92 in 1883, the total grew to
24 out of 98 in 1891 and then to 34 out of 93 in 1900. Women also

appeared as Members in the catalogues for the Dudley Gallery's oil
painting exhibitions; there were, however, no female members of the
Institute of Painters in Oil Colours in the nineteenth century (74).
At the New English Art Club women were admitted as Honorary Members
in 1887 and 1888 and from 1889 as full Members; in the latter year the
membership list included 74 men and 4 women (Table 18).

The most startling manifestation of female responsibility was to be
seen in the Society of Miniaturists which in 1899 possessed 101 Members,
84 of whom were women. There were also 7 female Honorary Members includ-
ing Mrs. E.M. Ward and Miss E. Robertson, out of a total of 26. In 1905
their number was even more formidable: 102 of the 112 Members were
women (75).

It is worth drawing attention to the fact that towards the middle of
the century women's membership rights diminished. At the Society of
British Artists women were excluded totally from 1846 to 1902 having pre-
viously been classified with men as Honorary Members. At the Old Society
of Painters in Water-colours women were categorized separately form 1850,
first as Honorary Members, then as Ladies; from 1860 they were allowed
back into the mixed Associate section. At the New Society of Painters
in Water-colours they were banished from the Membership section in 1860
from which date they were classified as Ladies. At the Royal Academy they
lost all status in 1867 when Honorary Members were abolished. Finally,
it is worth noting that in 1872 the Society of Female Artists (which will
be considered in the following section) became known as the Society of
Lady Artists.

In explanation of these alterations of title and in particular of
the emphasis on "Ladies", I would refer to an article called "Women
Versus Ladies" in the "Athenaeum" of 1847. The author wrote: "The
women and the females are all gone - and the feminine terminations are
following them very fast. To supply their places we have ladies, -
always ladies. There are no authoresses - only lady authors; and there
are lady friends, lady cousins, lady readers, etc. Do the women know that
lady is derived from laide? ... Let women notice that with the term lady
in our language, as used to supplant woman, arose the school of men which
sneered at females of cultivated mind under the name of bluestockings.
Search antiquity through time and space, from age to age and from country
to country, and it will be found that respect for knowledge in females is
always coexistant with their designation under homely names. The word
lady, generically used, ought to be as odious as the product of a time
in which women were taken to be necessarily frivolous" (76).

The vogue for Ladies' Sections and Lady Members was almost cer-
tainly due to a decrease in regard for women as artists. One reason
for this may be that the body of exhibiting women artists was different
to what it was at the beginning of the century. At that time there
were a few well-trained professional women artists and there were also
amateurs; the two were quite distinct. Accomplishment art was favoured
mainly by the aristocracy and both they and the public recognized it as
such. By the 1840 s, as we have seen in the previous chapter (77), the
middle classes had adopted the fashion and many women from this back-
ground tried to create a profession out of one of the few occupations in
which they were permitted to indulge. To do this, exhibition was neces-
sary, and thus the overall standard of women's exhibited work went down,
for art education facilities for women were neither broad enough nor
sufficiently widespread to produce many professional artists. It was on
account of this plethora of ambitious amateurs, perhaps, that the ten-
dency arose to group women members separately as if to underline the
different standard. Other possible explanations for the popularity of
the term "lady" are the effect of the industrial revolution which made
many lower-middle and middle class women aspire to lady-hood and secondly
the accession of Queen Victoria: her example encouraged emphasis on
femininity.

The title given to women members of exhibiting societies was, in
effect, immaterial, for, apart from the short spell of equality at the
Society of Associated Artists in Water-colour, women were not allowed
any say in management until 1890 when Mrs. Allingham became the first
full Member of the Old Water-colour Society.

France

Between 1663 and 1783, 15 women were admitted as Members of the
Académie Royale de Peinture et de Sculpture in France (78). In 1770 the
number of women members was restricted to 4 owing to the large number of
female applicants (79). Despite this measure Mme. Vigée Le Brun gained
entry in 1783 and the details of this event are worth giving in full on
account of the light shed on the Académie's attitude to women artists.
In 1783 Joseph Vernet proposed Mme. Le Brun for admission but M. Pierre,
"alors premier peintre du roi, s'y opposait fortement, ne voulant pas,
disait-ill, que l'on reçut des femmes" (80). Mme. Le Brun's own version
then runs as follows: "Son opposition aurait pu me devenir fatale si,
dans ce temps-là, tous les vrais amateurs n'avaient pas été associés à
l'Académie. Ils formèrent une cabale pour moi, contre celle de M. Pierre;

je fus reçue. Il fit alors courir le bruit que c'était par ordre de
la cour, qu'on me recevait. Je pense bien, en effet, que le roi et la
reine étaient assez bons pour désirer me voir entrer à l'Académie, mais
voilà tout" (81). Other evidence suggests that Royal intervention was
no rumour. After M. Pierre's opposition to Mme. Le Brun's admission,
the Queen, who had long since honoured the latter "d'une protection
particulière", communicated to M. Le Comte d'Angivillier her desire that
Mme. Le Brun should be received. The reason then given for her
exclusion was her husband's career in picture dealing; no-one involved
"soit directement, soit indirectement" in such a profession could be
granted membership of the Académie. The Queen then asked M. Le Comte
d'Angivillier to obtain a special dispensation from the King. The
Memoir he wrote was dated May 14th, 1783 and is a most interesting docu-
ment. He began by reminding the King of the Statutes "données par
Louis XIV à l'Académie de Peinture" in which membership was denied to
those associated with picture dealing. For this reason Mme. Le Brun
should not be admitted; "On dit, et je le crois, qu'elle ne se mêle pas
de commerce, mais en France une femme n'a pas d'autre état que celui de
son mari". He then changed his tone and encouraged the King to make an
exception in the present case, at the same time begging him "de vouloir
bien borner à quatre le nombre des femmes qui pourront à l'avenir être
admises à l'Académie. Ce nombre est suffisant pour honorer le talent,
les femmes ne pouvant jamais être utiles au progrès des Arts, la décence
de leur sexe les empêchant de pouvoir étudier d'après nature et dans
l'Ecole publique établie et fondée par Votre Majesté" (82). The reason
given here may have been shortsighted but at least it was rational which
is more than may be said for the defensive arguments of the Royal Academy
in England. The King agreed to both proposals and Mme. Le Brun was duly
instated. Before proceeding, the differences in the rank of Academician
for women and for men should be pointed out. As women could not attend
the Académie's classes, they were not eligible as "agréés" or apprentice
Academicians; they could only be elected to the full title. For women,
however, this did not mean full privileges and responsibilities and they
were not able either to teach or to hold office.

 In 1790 Adélaide Labille-Guiard proposed two successful motions at
the Académie Royale: firstly, abolition of the restriction to four
female Academicians; secondly, she suggested that as female Academicians
were without responsibilities, women should be admitted as "conseilleurs"
only and as such have the sole privilege of exhibition (83). Thus the
Salons were opened to women exhibitors. The following letter from the

Secretary of the Académie, Renou, to a deputy of the Legislative
Assembly probably refers to these proceedings. It was written on the
subject of the Fine Art exhibition of 1791 and shortly before the
dissolution of the Académie; "L'un veut détruire l'Académie pour régner
seul, et il fait appuyer ses projets par un député qui a essayé d'être
artiste et qui publiquement s'est déclaré notre ennemi. D'autres veu-
lent la conserver, mais dans l'espoir de la dominer. A l'abri de ces
derniers est une Jeanne d'Arc. Il ne tiendra pas à elle que l'Académie
ne tombe en quenouille. Elle a semé parmi nous la plus dangereuse divi-
sion. Deux coqs vivaient en paix: une poule survint, et voilà la
guerre allumée. Cette poule, par molle complaisance et sans l'autorisation
de la loi, siège au milieu des coqs. C'est de ces abus que nous solli-
citons la suppression devant les législateurs, dont les prédécèsseurs ont
exclu les femmes de la régence. On dit que les talents n'ont pas de
sexe; mais ceux qui les possèdent en ont un, et quand il est féminin, il
faut l'éloigner du masculin, à cause de son influence inévitable. Enfin,
Monsieur, vous aimez le bien, vous cherchez la vérité; méfiez-vous de
cette Armide qui a fait apostasier tant de chevaliers chrétiens" (84).
"Cette Armide" would seem to have been Labille-Guiard.

In the same year the Académie Royale was dissolved and briefly
succeeded by the Commune Générale des Arts de Peinture, Sculpture, Archi-
tecture et Gravure, the academic and closed character of which was soon
criticized. In 1793 the latter was suppressed by the Convention and
replaced by the Société Populaire et Républicaine, with Bienaimé as
President and Allais as Vice-President (85).

One of the first discussions held by this Society was devoted to the
question of women's admission. A member of the organisation Committee
read a Report on this subject "duquel il résulte que les femmes, differ-
entes des hommes sous tous les rapports physiques et moraux, ne doivent
pas être admises". Several members then spoke, one saying that as the
Society existed for the cultivation of the arts and not of politics, and
furthermore, as the law forbade women to assemble and discuss any subject,
to admit them would be illegal. "Un membre cite la Société des Jacobins
où il y a une citoyenne admise; mais un autre membre, sans avoir égard à
cette exception, dit que chez des républicains les femmes doivent absolu-
ment renoncer aux travaux destinés aux hommes. Il convient cependant que
pour sa propre satisfaction, il auroit beaucoup de plaisir à vivre avec une
femme qui auroit des talents dans les arts, mais que ce seroit agir contre
les loix de la nature. Chez les peuples sauvages, dit-il, qui par consé-
quent se rapprochent le plus de la nature, voit-on des femmes faire
l'ouvrage des hommes? Il pense que c'est par ce qu'une femme célèbre, la

citoyenne Le Brun, a montré des grands talens dans la peinture, qu'une foule d'autres ont voulu s'occuper de la peinture tandis qu'elles ne devroient s'occuper qu'à broder des ceinturons et des bonnets de polices". One final reason was given: "Plusieurs membres, ainsi qu'un député de la société populaire de la section des Arcis, prétendent que cette admission ne pourroit que déplaire aux Sociétés populaires, et que cela feroit perdre leur affiliation à la société". This united all in favour of exclusion. The description of the proceedings concluded as follows: "Au même instant un membre qui avoit demandé l'admission pour sa fille retire sa demande, et d'après l'observation faite par un autre membre, que la loi ayant déjà prononcé, le Comité n'auroit pas dû même faire un rapport sur cet objet, l'assemblée sans avoir égard au rapport de son Comité, arrête purement et simplement que les citoyennes ne pourront être admises dans la Société" (86). In 1795 Napoléon reconstituted the Académie as the fourth class of the Institut. The Revolution brought no improvement in the condition of women and in the arts their position may even be said to have deteriorated.

As in England, the French press carried frequent reminders of the injustice done to women by excluding them from Academic honours. Many articles were published on the female Academicians of pre-Revolutionary days. In 1853 Edouard Houssaye asked: "On n'a pas décoré Mlle. Rosa Bonheur, ni Mme. Herbelin. Est-ce parce-qu'il faudrait décorer George Sand et Mme. Emile de Girardin? On décore les soeurs de charité qui font voeu d' humilité, pourquoi ne donnerait-on pas la croix à ces quatre femmes, qui ont fait voeu d'esprit et de talent" (87). Indeed the first nineteenth century tribute to female genius in the arts followed soon after in 1865 when Rosa Bonheur was made Chevalier de la Légion d'Honneur.

In 1872 the "English Woman's Review" published a report which I cannot find substantiated in France. It said that the Academy of Fine Arts in France was about to take into consideration the admission of female members. "Should the decision be favourable, it is believed that Rosa Bonheur, and Mlle. Jacquemart, who has distinguished herself as a painter of portraits, will be brought forward as candidates" (88).

The first concession to women concerned the representation of women on the Salon Jury. At the Assemblée Générale of the Union des Femmes Peintres et Sculpteurs on December 14th, 1890 Mme. Aron-Caen proposed this and the vote was unanimously in favour (89). In 1891 Rosa Bonheur and Mme. Demont-Breton were voted to the Jury of the Salon (90). Mme. Marcotte was the next in 1901.

In 1891 also, Mme. Léon Bertaux applied for membership of the Académie des Beaux-Arts but was unsuccessful because she got the formalities wrong.

She was told that in principle her application was acceptable (91). In
July of 1892 she applied again sending a list of her works and activities
for the benefit of women artists. Her letter ran as follows:-

"J'ai l'honneur de poser ma candidature de membre de l'Institut
(section de sculpture) au fauteuil laissé vacant par le décès de M.
Bonnassieux.

"Je vous adresse cette lettre Messieurs non seulement dans l'espoir
d'obtenir cette haute récompense, d'une vie exclusivement consacrée à
l'art, mais encore, mais surtout pour vous donner l'occasion d'interpréter
votre règlement, sur un point qui n'a jamais été élucidé:

"Vos suffrages peuvent-ils se porter sur une femme?

"Rien ne s'y oppose, votre règlement est muet etc."

"Postscriptum: Un usage, m'a-t-on dit, veut que le candidat aspirant
à la dignité de Membre de l'Institut sollicite par une visite la bien-
veillance des hommes éminents qui composent votre illustre Compagnie; cette
démarche semblerait peut-être déplacée de la part d'une femme, le cas étant
sans précédent ; c'est pourquoi messieurs, je me permets de suppléer en
mettant sous vos yeux (comme à des juges) ma demande et les titres sur les-
quels je l'appuie" (92). She was not accepted. In 1895 she was elected
to the Jury of the sculpture section of the Paris Salon.

In 1894 Rosa Bonheur and Virginie Demont-Breton were both made
Officiers de la Légion d'Honneur and in 1901 Louise Breslau Chevalier de la
Légion d'Honneur.

In 1902 the magazine "Fémina" published an interesting competition
entitled "Une Académie Féminine idéale". The introduction read: "Les
hommes s'étant arrogé le privilège de l'immortalité et fermant jalousement
les portes de l'Académie française au sexe faible, voulez-vous, chères lec-
trices, que nous réparions dans la mesure de nos moyens leur injustice?"
It was proposed to create "Une Académie de quarante femmes" elected by the
readers of the magazine. The choice was to be made between women writers,
poets, novelists, philosophers, painters, sculptors, musicians, actresses
and singers; also society women remarkable for their charity. To facili-
tate selection a list of possible candidates was then given. Each reader
was to send a card listing 40 in order of preference. The following
painters and sculptors were proposed: Mmes. Louise Breslau, Nancy Adam,
Malvina Brach, Bourillon-Tournay , Boyer-Breton, Louise Abbéma, Madeleine
Carpentier, Lisbeth Carrière, Coutan-Montorgueil, Debillemont-Chardon,
Delacroix-Garnier, Demont-Breton, Dufau, Maximilienne Guyon, Kaub, Baronne
Lardenois, Madeleine Lemaire, Moreau de Tours, Juana Romani, Duchesse
d'Uzès, Vallet-Bisson, Vallgren and de Wentworth (93). In the results

only 5 women artists qualified: Madeleine Lemaire (no.2), Louise
Abbéma (no.3), Mme. la Duchesse d'Uzès (no.6), Virginie Demont-Breton
(no.23) and Mme. Achille Fould (no.27)(94).

In October of the same year the magazine asked the question: "Une
Académie Féminine - Peut-elle passer du Rêve à la Réalité?" They asked
the elected 40 for their opinion "sur le rôle que celle-ci pourrait
jouer, sur le but utile qu'elle pourrait remplir, sur l'action qu'elle
pourrait exercer en matière d'éducation, d'instruction, d'assistance
muette, de protection de la femme etc." Of the women artists, Louise
Abbéma and Madeleine Lemaire both disapproved of the idea believing that
a lower standard would be attributed to a separate female organization.
Virginie Demont-Breton alone approved: "Je crois qu'une académie de
femmes s'occupant de questions sérieuses, pourrait comme celles des hommes
contribuer au Progrès. J'ai toujours été partisante zélée de tout ce qui
peut favoriser le développement intellectuel de la femme et je le con-
sidère comme complétant très heureusement son rôle dans la vie .. En art
nous sommes arrivées déjà à obtenir l'entrée des jeunes filles à l'Ecole
des Beaux-Arts. Il reste encore bien des rêves à réaliser pour amél-
iorer le sort de la femme qui travaille et qui pense" (95).

Neither the Académie Française nor the Académie des Beaux-Arts
admitted women as Members until the twentieth century. Five more women
painters were made Chevalier de la Légion d'Honneur between 1904 and 1909
(96) and in 1914 Virginie Demont-Breton was awarded the rosette.

The Société Nationale des Beaux-Arts was founded in 1862. It was
administered by artists and held exhibitions based on the jury-free prin-
ciple. The membership system was complicated. The Statutes reproduced
in the catalogue for the Society's exhibition in 1864 decreed that the
Director of the Society (Louis Martinet) would preside over a committee
composed of a President (Théophile Gautier), a Vice President (Aimé Millet)
and fourteen members. In 1864 these were all men (97). Women were,
however, admitted as Sociétaires, or as they were sometimes called in the
first few years of the Society's existence, Membres Fondateurs. For
such status artists had to have one of their works approved by the commi-
ttee and to pay an annual subscription fee. The Sociétaires met at
annual general meetings to discuss the affairs of the Society and to
elect the members of the committee; they were obliged to exhibit at
least one work at the Society's annual exhibitions (98). In 1862 there
were 90 men and 4 women among the 94 Artistes Sociétaires Fondateurs:
the former included Ingres, Delacroix, Flandrin, Gustave Doré and
Théodore Rousseau; the women were Henriette Browne, Mme. Becq de
Fouquières, Mme. Cavé and Mme. Lefèvre-Deumier (99). In May 1864 there

were 187 men and five women among the Membres Fondateurs (100). No
appreciable increase occurred until the 1890 s. In 1890 there were 2
women - Louise Breslau and Madeleine Lemaire - among the 124 Sociétaires
and in a second category - of Associés - 8 out of 54 were women.
By 1899 there were 8 women among the 226 Sociétaires and 30 among
the 258 Associés. There were still no women on the Délégation de la
Société (101).

Since artists only participated in the Impressionist exhibitions on
invitation, they were in effect a membership group. A total of four
women - Berthe Morisot, Jacques-François, Marie Bracquemond and Mary
Cassatt - exhibited with the group in the course of their eight exhibi-
tions between 1874 and 1886 (102). The last exhibition was organised
almost entirely by Berthe Morisot who may be said to be the only woman
artist to have approached presidency of a mixed exhibiting society (103).
At the Salon des Artistes Indépendants which held exhibitions from 1884
and which, like the Société Nationale des Beaux-Arts, eliminated jury
selection, women held no membership at all until 1895 when one of the 14
members was Mme. Philibert. There were no women on the committee or
the Commission de Placement. In 1899 there were 2 women among the 15
members: Mlle. Philibert and Mme. Poilay (dit Jean de Chaville).

At the Société d'Aquarellistes Français, the only French counterpart
to the numerous English water-colour societies, women were poorly repre-
sented as members. In the catalogue for the second exhibition in 1880,
12 Honorary Members were listed and 18 Titular Members; the latter group
included 2 women - Madeleine Lemaire and the Baronne Nathaniel de
Rothschild. In 1886 the list excluded Madeleine Lemaire and the Baronne
remained the only female member until 1895 when Mlle. Maximilienne Guyon
was elected. The Société des Peintres-Graveurs, which held its first
exhibition in 1889, included only one woman among 43 Sociétaires, Marie
Bracquemond; even she was absent from 1891. The only exhibiting society
to explicitly exclude women as members and exhibitors was the Society of
the Rose-Croix whose rules contained the clause: "Following Magical Law,
no work by a woman will ever be exhibited or executed by the Order" (104).

After 1900 women were more readily admitted to exhibiting societies.
In 1901 the Société Artistique des Amateurs was composed of 30 Sociétaires
11 of whom were women (105). At the Société du Salon d'Automne women were
represented as follows in 1904 and 1910. In 1904 the founders included
90 men and 2 women (Mm. Gonyn de Lurieux and Mme. Van-Bever) and the
Sociétaires consisted of 147 men and 17 women. Finally there was one

woman (Mlle. Dufau) and 47 men on the Committee (106). In 1910 there were 48 male and 4 female founder members; the Sociétaires comprised 302 men and 44 women. There were 3 women among the 119 Membres d'Honneur and women were also represented on the Jury (107).

Part 3 - Societies of Women Artists

England

The Society of Female Artists was founded in 1857 as a result of
the "exertions and liberality" of Mrs. Grote. "She engaged the interest
of many friends, both in the form of contributions and patronage. But
Mrs. Grote her self, with the late Mrs. Stanley - not to omit Mr. Grote,
who became guarantee for the rent of the exhibition room - were the main
and indefatigable workers of an Institution, which, however modest in its
pretensions, remains active and useful to this day" (108).

Before an account of the history of this Society, attention should
be given to some possible reasons for its foundation. In the absence of
documentation conjecture must suffice. The status of water-colour at
that time was probably an important factor. During the first half of
the century there was a definite bias against this medium at the Royal
Academy and above all at the British Institution. The water-colour
societies which arose as a result of this bias were closed and inaccess-
ible to all but a few privileged women members. Added to this there
was continual reference to water-colour and miniature as lesser genres,
which doubtless offended women, who favoured these as opposed to the
"higher arts" of oil painting and sculpture. It is probable that these
women wished to create an exhibition room where there was no hierarchy of
genres. Another negative or "alternative" reason may have been the pre-
dominantly comparative and condescending criticism apportioned to women
in reviews of mixed exhibitions. In a review of the Society's second
exhibition in 1858, a critic in the "English Woman's Journal" wrote: "we
feel some regret at the tone of comparison adopted by certain contempor-
aries; a comparison which the Society does not invite, and which is
wholly irrelevant so long as the domestic and academical facilities
afforded to the female artist are so very far below those of a male stu-
dent" (109). It is worth mentioning too, that many women found their
works badly hung and, according to reviewers, often without any justifica-
tion (110). Also women were allowed no power or voice in the management
of the main exhibiting societies; there was surely an element of fighting
exclusion with exclusion in establishing a separate group. There is one
important positive motive behind the Society. In 1856 Mrs. Grote wrote
to Mrs. Stanley on the subject of unmarried women: "Having no regularly
defined circle of duties and occupations for practical employment of facul-
ties, the poor mind and imagination must pay the Scot, and so become over-
wrought - one knows all the rest. Many a time have I reflected upon the
usefulness of Protestant sisterhoods, whose lives at least could wear away

without perpetual conflict with worldly temptations" (111). She was
very concerned that women should have resources of their own to fall back
on. Her main motive was thus probably the desire to give opportunities
and encouragement to those girls and women whose works were not of a
sufficiently high standard to gain admission to the larger mixed exhibi-
tions. In the "English Woman's Journal" the main reason for sympathy
with the Society was that it would "foster and train up much female
talent, which under present disadvantages of instruction could with
difficulty aspire to the walls of the Royal Academy" (112), and an "Art
Journal" reviewer conceded that "other opportunities of exhibiting their
productions than those afforded in galleries already existing were
required; and therefore that these ladies had sufficient cause to justify
the step taken" (113). As stated by an informed critic these exhibitions
were for "professional and amateur" ladies by which he or she presumably
meant those whose work was of a high standard and those whose work was
not, as well as those who did and those who did not, earn or try to earn
a living by their art (114).

The first exhibition, in 1857, was held in the Gallery at 315 Oxford
Street and at the end of the year an appeal for public subscriptions
appeared in the daily papers (115). In 1858 they moved to the Egyptian
Hall, Piccadilly where sales were high but the Society still remained
insolvent (116). After the third exhibition at no. 7, the Haymarket, in
1859, the debt was finally cancelled by Jenny Lind (then Mme. Goldschmidt)
who was one of the Committee; "She and her husband held a concert in
the exhibition room to raise money" (117). In 1859 a list appeared in
the catalogue of the Committee Members and Honorary Members which included
all the original exhibitors in 1857 with 12 more. The Committee was com-
posed of Mrs. Edward Romilly, Mrs. Grote, Mrs. Stephenson, Lady Trelawny,
Mrs. Edward Stanley, Mme. Lind-Goldschmidt, Miss Sotheby and Mrs. Murray
(118). From 1860 to 1862 exhibitions were held in what was formerly the
room of the New Society of Painters in Water-colours.

Between 1861 and 1863 there were several signs of establishment and
expansion. In 1861 a number of works by French women appeared in the
Exhibition implying some foreign publicity. In 1862 the Committee took
on the lease of a gallery in Pall Mall (no.48) (119) and they opened there
the following year. In the same year, 1862, there were plans for a
school: "In connection with this Society, it is contemplated to establish
a school for the study of costumed figures, on the plan of public schools
in Paris and London, where the model is set by the students in turn, and
each may practice her own particular kind of Art, be it painting in oil,
water-colour, or drawing in chalk" (120). The next year the School

opened in their new gallery with excellent attendance during the first term (121). In the same year, 1863, between 200 and 300 pictures sent in for exhibition were returned through want of room and foreigners of other nationalities began to participate (122).

In 1865 the Society was reorganized. The "Art Journal" recorded: "By the retirement of the ladies who have hitherto undertaken the direction of the affairs of the Society, the entire management devolves upon the artists themselves, by whom a committee has been formed" (123). The new patrons of the Society were HRH the Duchess of Cambridge and 17 other titled ladies including the Marchioness of Waterford, the Countess of Westmoreland and Lady Eastlake. In addition there were 17 Members and 12 Honorary Members. In 1866 Miss Mary Atkinson became the Honorary Secretary, "a lady who devotes her life to the interests of Lady Artists in general, and rising young aspirants in particular" (124) and a fund was started for members in case of illness. In the following year a list of life subscribers to this fund appeared in the catalogue; it included many men.

In 1867 the exhibition took place in the gallery of the Architectural Institute, Conduit Street. Here again "an Academy for the study of the living model in costume" was opened twice a week in the gallery; it was conducted by Mrs. Eliza Lee Bridell (formerly Miss Fox) and visited by Cave Thomas (125). In 1868 the Academy was under the superintendance of William Henry Fisk with George Dunlop Leslie A.R.A. officiating as visitor (126).

In 1872 the Society was renamed the Society of Lady Artists and from the same year only professional artists were eligible as Members. In 1874 they moved again to no. 48, Great Marlborough Street. In 1878 Associate Membership was introduced as "a proving ground for Full Membership" (127). In 1880 "The Year's Art" carried the following information: "Pictures and drawings by non-members are hung at the Annual Exhibition, which opens in March, subject to the approval of the Hanging Committee. Should, however, exhibitors be non-professional, a fee of 10s 6d or 21s is charged according to the number of pictures hung" (128). In this year the Society consisted of 2) professional Members, 3 Associates and 13 Honorary Members. The exhibition had grown considerably by this time and in 1880, 835 works were hung and 500 rejected through lack of space (129).

In 1885, after the death of Miss May Atkinson, the Society was again reorganised under the same patronage with Mrs. Marrable as President. The Society expanded as a result and its art forms widened to include metal and needlework, fan-painting and tooled leather, besides painting and sculpture. Miss Ellen Partridge was made Vice-President. In 1896 another

move took place, this time to the Gallery of the Society of British
Artists, Suffolk Street. Through these years it was kept going by
numerous donations, the generosity of its Patronesses and a growing
list of Life Subscribers. The craft section developed greatly towards
the turn of the century. In 1899 the name was changed once again to
the Society of Women Artists. In 1904 the chief aim was reaffirmed:
"To help and encourage the Art of women in all its phases" (130).

An examination of the table showing the number of works exhibited
at each exhibition reveals that these fluctuated considerably (Table 19).
In the second year of its existence the number rose from 358 in the pre-
ceding year to 582, a result, no doubt, of all the favourable publicity
the Society had received. From 1859 to 1865, the year of reorganisation
the figures remained low; thereafter, they rose into the 400s and after
1872, from which date only professional artists were admitted as Members,
contributions increased rapidly, reaching a record of 835 in 1879. The
election of Mrs. Marrable as President in 1885 marked a turning point;
from that date numbers declined, reaching a low of 383 in 1895. The
increase of craft exhibits around 1900 swelled the exhibitions once again;
in 1903 there were 845 numbers. From 1908 to 1914 there was a decline.

Reviews are the main source of information as regards the standard
of the exhibitions. Several established names appeared in the first
exhibition; Mrs. Fanny McIan, Head of the Female School of Art, Mrs. E.M.
Ward and Mrs. Thornycorft. According to the "English Woman's Journal"
"few of the pictures exhibited in 1857 were painted for the express pur-
pose of appearing under the auspices of the new institution. The commi-
tte did not organize their plans until the winter of 1856-7 and could only
avail themselves of such works as happened to be in the studios" (131).
This, then, was an improvised exhibition. There were, nonetheless, rea-
sonable sections of oil painting and sculpture as well as water-colour.
In the following year both the "English Woman's Journal" and the "Art
Journal" carefully outlined their critical attitude to the Society. In
the former the reviewer resolved "to take this exhibition on its own
ground, and to examine its double object, that of opening a new field for
the emulation of the female student, and also a wider channel of industrial
occupation, thereby relieving part of the strain now bearing heavily on
the few other profitable avocations open to educated women" (132); there
was to be no comparison with male efforts. In the "Art Journal"
allowances were also made,"labouring under such disadvantages as the female
student does (133).

In 1858 works were shown by "many of the best female artists, who
had conquered a place in the Royal Academy" - Susan Durant, the sculptor,
Miss Howitt and Barbara Leigh Smith Bodichon for example; other names
included were Anna Blunden, Mrs. E.M. Ward, Miss Fox, Mrs Carpenter and
Mrs. Thornycroft (134). Some good figure drawing surprised the "Art
Journal" reviewer (135). Despite this the general conclusion was that
"The proportion of flower and fruit compositions was excessive in com-
parison with that of figure works" (136). Reviewers differed somewhat
in their reception of the third exhibition. The "Art Journal" was
encouraging, as before: "The works in subject matter are more ambitious,
and in execution more careful and accurate than those that have preceded
them... There are among these pictures productions of a quality so rare,
as at once to achieve a reputation for their authors, yet which, but for
the establishment of a society of lady artists had never been seen " (137).
There were still too many flowers and still-lives, although the standard
achieved was higher this year. The "English Woman's Journal", going
against its original intentions, complained, on the other hand, of the
general amateurishness, of a "pell mell of colours", "an extraordinary
preponderance of children and flowers", "a total want of finish" and a
lack of "intellectual brightness". Finally the question was posed:
"How is it that so many of the best names are absent, that they have not
been secured by treaty, or induced to heartily volunteer?" Many of the
best works exhibited in the previous two years were by women whose names
were absent in 1859: Mrs Thornycroft, Miss Susan Durant, Miss Fox, Mrs.
Robinson, Miss Howitt, Jane Benham Hay, Miss Anna Blunden were all missing
and Miss Margaret Gillies, "the best known representative of the female
artists of England" sent only one work. Still the Misses Mutrie, so
widely celebrated for their flower pictures, refused to participate (138).

In 1860 the complaint was too many copies of which there were more
than 50 among the 319 works (139). In 1861 there were fewer copies and
both magazines gave favourable reviews. "We must offer our congratulations
to this Society on the superiority of the present exhibition to those of
the preceding years, a superiority to be attributed in part to the ab-
sence of the unsightly copies which have hitherto disfigured and over-
whelmed the walls, and still more to a real advance in the quality of the
pictures themselves". "The wild and confused glare of colour" had gone,
there were fewer "frantic pre-Raphaelite attempts". Now there were
"soberer efforts". "The subjects too, are more varied, and, if we may be
allowed the expression, more healthy and vigorous; landscapes and still-
life replacing the somewhat sentimental subjects of former years" (140).
The main reason for the higher standard of 1861 was that several pro-

fessional women artists sent work: Emma Walter, the Misses Harrison,
Louise Rayner, Mrs. Elizabeth Murray, Mrs. Lee Bridell (formerly Miss
Eliza Fox), Margaret Gillies and the two French women, Rosa Bonheur and
her sister, Juliette Peyrol-Bonheur. In the following year many
successful women artists again abstained: Margaret Gillies, Elizabeth
Murray, Barbara Leigh Smith Bodichon, Jane Benham Hay, Emily Osborn.,
Eliza Lee Bridell and Rebecca Solomon were all absent. Rosa Bonheur
still sent work and a large number of other French artists. Despite so
many omissions the exhibition was considered a good one: "There are more
figures and skilfully painted landscapes, and the still-life and flower
subjects are less numerous than heretofore" (141). Perhaps as a result
of the recent opening of the School for figure study, the exhibition of
1863 was "especially strong in figure composition" (142); this was all
the more remarkable as there was no French contingent this year. In
1864 the exhibition reverted once again to amateurishness. As so often
before Margaret Gillies was the only well-known artist and the only one
to receive real praise. No progress was marked this year in "correct
drawing and conscientious study from the life" (143) despite the exhibi-
tion of studies made in the School (144). In the "English Woman's
Journal" a serious piece of advice was offered to the Committee of the
Exhibition which may have had something to do with the reorganization of
the following year. The reviewer claimed that in a separate exhibi-
tion for women "ultimate success can hardly be hoped for, unless the sex
be represented by those who are foremost in its ranks, and to this end
every effort should be made to induce women of the highest talent to
combine with their more moderately gifted sisters in what is set forth
to the world as an exposition of feminine ability... The Committee of the
Society of Female Artists would do well to consider whether their scheme
is not susceptible of revision; whether at present they really offer
anything likely to induce the highest class of female artists to become
members of their Society .. " (145). This criticism, voiced so often
before, may have caused the withdrawal of the Committee and their replace-
ment by a Committee of artists. Be this as it may, the change did not
solve the problem. Year after year, from 1865 to 1872 reviews regretted
the absence of professional women artists and complained: "Lady artists
are not sufficiently ambitious of excelling in figure composition.
Flowers and 'still-life' form a proportion, too marked, of this collection"
(146). The most successful works over these years were contributed by
Florence Claxton, Amelia Lindegren, Henriette Browne, Rosa Bonheur, Mrs.
E.M. Ward, Marie Spartali, Kate Swift, Jane Benham Hay and Margaret
Backhouse.

From 1872, when it was decided that only professional artists
should be eligible as Members, presumably in a second attempt to reduce
the number of amateurs and encourage established artists, there was a
marked improvement. In 1874, Elizabeth Thompson sent work, as did
Louise Jopling, Rebecca Solomon and Mary Ellen Edwards and well-known
names continued to appear during the following years. In 1878 a
reviewer wrote: "The Society of Lady Artists has reached such a degree
of healthy vitality and success as will in future command recognition
from the general Art public" (147). It was over these years that the
number of works exhibited increased so rapidly from 469 in 1873 to 835
in 1879, maintaining a high average over the next 6 years. Between
1885 and 1895 the exhibitions grew gradually smaller again, due, perhaps
to the increasing success of women artists in the larger, mixed exhibi-
tions. Over this period the names of the more successful women artists
gradually faded out. With the introduction of craft in 1896 and the
rapid expansion of this section, the final blow was given to the fine
art aspect of this Society. Craft took over and most of the more pro-
fessional women ceased to participate. In 1900 a critic wrote that the
exhibits were "for the most lamentably poor. Yet again one asks why a
group of undistinguished women should dissociate themselves to form an
exhibition of this kind" (148).

In considering the success of the Society it should be emphasized
that throughout its history the institution was based on two incompatible
motives. The first of these was the philanthropic desire to provide a
service for those women who could not get their works admitted else-
where, but who nonetheless deserved opportunities on account of the low
standard of art education for women; philanthropic too was the idea of
encouraging women who hoped to make a living out of art, either as art
teachers or as industrial designers; finally it was hoped that the
Society would give young women something to work for. These were the
reasons which justified the establishment of a separate Society for women
alone. The second motive behind the Society took the form of a constant
attempt to achieve professional artistic status; this may be seen in
the devolution of management to the artists themselves in 1865, the
exclusion of amateurs from membership in 1872 and the subsequent demand
for a fee from amateur exhibitors. This was an obvious contradiction;
success in either one of these directions could only be achieved at the
expense of the other.

On the whole the philanthropic motive succeeded best. The Society
surely saved many women from idleness by giving them something to work
for; it also exhibited the first works of at least one woman who later

achieved repute- Lady Butler - and may therefore be said to have ful-
filled one of its major aims (149); also, by founding a School for the
study of the costumed model, it gave women a chance to improve in figure
composition. Artistically, despite the gracious participation of
successful artists such as Rosa Bonheur, the Society never achieved a
high standard. The amateurs, for whom the Society was originated, made
this impossible. As the "Art Journal" put it: "Nothing has done so
much to lower the credit of this praiseworthy enterprise as the amiable
admission of works which could not find a hanging on other walls" (150).

In 1879 another large exhibiting art society was started for women
- the Manchester Society of Women Painters. The "British Architect"
printed the following: "This welcome addition to the educational art-
institutions of Manchester has just been inaugurated. The object of the
newly-formed society is stated to be 'to provide facilities for the members
working together and studying from the life, and to disseminate the prin-
ciples of true art among art students generally, who are desirous of more
thorough training, wider experience, and a higher culture'. Art classes
are to be held in connection with the Society, and an exhibition of the
works of lady artists is also in the programme. Miss S. Isabel Dacre has
been elected President, Miss A.L. Robinson acting as secretary and Miss
Emily Robinson as treasurer. Miss E. Gertrude Thompson, of whose charm-
ing work we have given examples in the 'British Architect', Miss E.S. Wood
Miss J. Atkinson, and Miss J. Pollitt are amongst the pioneers of the
society, which deserves the generous support and recognition of the art
supporting patrons of Manchester" (151). In the obituary of Miss Susan
Isabel Dacre, it is said that she and Miss Robinson founded the Society (152).
I have traced catalogues only of the first three exhibitions of the
Society. The first was held from November 30th to December 3rd, 1880, at
Barton House, Deansgate, Manchester. The Members are listed above. In
addition to these there were 5 Associates. This first exhibition con-
sisted of 88 items. At the second, in January of 1882, there were 97
numbers and the "British Architect" carried the following review: "The
second annual exhibition of the Manchester Society of Women Painters
serves quite sufficiently to justify the existence of such a society.
The small but meritorious collection exhibited in the Old Town Hall of
that city during the past few days brings into clear light the fact that
Manchester, or we suppose its near neighbourhood, possesses a considerable
strength of talent among women painters, for much of the work shown is
really painter's work. The force, it is pretty evident, lies in portrai-

ture and still-life, we presume largely due to the influence of School
of Art teaching, whence most of these ladies have, we believe, derived
their training. There is practically no landscape shown, and, as the
poor Irish say, what there is is bad" (153). An excellent feature was
the grouping together of each artist's productions. Out of 74 works on
sale, 31 were already sold, the total value of sales amounting to £478 17s.
(154). By the time of the third exhibition, held in 1883, there were
10 members and 4 Associates. The exhibition took place at 10 South King
Street and there were 120 numbers in the catalogue. One review began:
"With the title of the Manchester Society of Women Painters, we are
inclined to associate the hope that women are beginning to find a means
of livelihood from the regular pursuit of painting". But, "we found little
to encourage the hope; out of a hundred and twenty frames we found only
3 or 4 on the promise of which we should like to found our security
against the tax collector" (155). It would seem that the Manchester
Society of Women Painters later became known as the Attic Club and that
Mrs. Rutherston succeeded Isabel Dacre as President, presumably after the
death of the latter in 1933 (156).

The third main society was the Women's International Art Club.
It opened in Paris on June 1st, 1898 and was first known as the Paris Club
of International Women Artists. According to the "Art Journal" it was
brought into existence on account of the difficulty of getting a fair
start if one had been trained in Paris , as almost all women were. The
objects of the Club were as follows: "to unite together women artists
for mutual help in exhibiting in different countries, and, by means of
centres, to lessen the cost of sending pictures; secondly, to create
club-rooms for the use of members; and lastly, to help forward the cause
of international women artists in every way". Two qualifications only
were necessary for membership: "first, that each member must have
studied in Paris, and second, that they must do strong work". Finally:
"The Club was not to be representative of any one school of painting or
work, but to exhibit fairly all schools, just as all schools are repre-
sented in Paris. Nor was membership to be confined to painters alone.
Sculptors and handicraft workers were to be admitted wherever they were
able to fulfil the two conditions of membership" (157). Among the
Founder Members were: Lucy Kemp-Welch, Rose Barton, Lucy Galton and
Mrs. Jopling (England); Kate Carl (America); Mrs Dignams (Canada);
Cecilia Beaux (France); Mrs. Mendag (Holland); Anna Nordgren (Sweden).
In 1899 a short notice was sent out in print: "An international club for

women artists who have worked in Paris is being started, with an annual subscription of a guinea, and a guinea entrance fee. Members are required to have exhibited twice in the three years anterior to joining, in the Salon or the principal exhibition of the country to which they belong. Two yearly exhibitions will be held, one being in London in the Grafton Gallery. If you wish to become a member, please write to the London Secretary, Miss Gertrude Badnall, 26 Kensington Court Gardens, before August 1st, stating that you can fulfil the requirements, and enclosing your subscription and entrance fee. The first London exhibition will be in the Grafton Gallery during the first fortnight of March, 1900, but there will probably be a small one in Paris this Autumn" (158).

By 1900 there were more than a hundred members, representing 17 different countries. French, English and American artists predominated at that time but there were also members from Canada, Australia, Norway, Russia, Germany and other countries. Centres had been formed in London, Paris, Philadelphia and Melbourne and one was shortly to be opened in Toronto. The "Art Journal" reported: "The exact way in which the work of these centres will be carried on has not been permanently decided, but at a meeting held on June 1st, which the club will always keep as Founder's Day, the whole working of each centre was gone into and put on a solid foundation. The London centre will remain the head, a kind of parent nucleus round which the other centres will gather. But each one is to be independent and self-governing in its character" (159). In the same year the first exhibition was held in London at the Grafton Galleries. There were 235 exhibits and the largest contributions were made by Anna Nordgren, Miss Beatrice How, Mrs. Jopling and Mlle. C.H. Dufau (160). The "Art Journal" called it an unusual exhibition "much more influenced by the Champs de Mars Salon, than by that everlasting backbone of British art, the Academy". Each artist's work was hung together and there was "a harmony of tone, a breadth of handling, and an individuality of treatment which prevented the weariness that so often follows a visit to the usual run of picture galleries" (161). The only criticism referred to the absence of sculpture and crafts. In 1901 the Club became known as the Women's International Art Club. There were 12 members of the London Committee at the time and the exhibition, which ran from March to April, consisted of 174 works. Sculpture was included. In 1903 miniatures prints and handicrafts were added to the list and the exhibition grew to 325 numbers. In 1910 the exhibition included work by women artists of the past. The largest pre-war exhibition was held in June, 1904 when there were 520 items; thereafter numbers reduced steadily (Table 19).

These three societies - the Society of Female Artists (1857), the
Manchester Society of Women Painters (1879) and the Women's International
Art Club (1898) - were founded for entirely different reasons, and they
are worth comparing on account of the light shed thereby on the changing
needs and status of women artists. Obviously, all originated with the
purpose of providing some service for women, which was not to be found
elsewhere; beyond this, however, their objectives diverged. The exis-
tence of the Society of Female Artists was based on the assumption that
women's art fell into a different category to that of men - a lower cat-
egory. It was originally intended for those women who could not get
their works accepted at the larger mixed exhibitions, in other words, for
amateurs. This was the class of women to whom the Society appealed in
the first instance (162). The origins of the Manchester Society of
Women Painters (founded in 1879) and of the almost contemporary Glasgow
Society of Lady Artists' Club were quite different (163). These origin-
ated for the benefit of the woman art student. From the start there was
equal emphasis on education (life classes) and exhibition. It was no
longer passively accepted that women produced work of a different standard;
these Societies existed for the purpose of remedying this by providing
equal educational facilities. By 1898 the development was almost com-
plete: gone was the assumption of women artists' amateurishness;
disappearing was the view that lack of art education facilities was the
main hindrance to women's development and the improvement of such facil-
ities the first priority for their success, for by that date opportunities
were considerable. The Women's International Art Club was not directed
to the lady amateur, nor to the woman art student,but to the professional
woman artist who was required to produce strong work and to have exhibited
in principal exhibitions.

 Brief mention should be made of three other women's exhibiting
groups which appear to correspond with the three already described. In
1876 the first annual exhibition of Lady Amateurs and Artists was held
at the Howell and James Gallery. For the first four years at least
these exhibitions consisted entirely of paintings on china (164). Then
from 1881 to 1883 and perhaps afterwards the exhibitions were devoted to
tapestry paintings (165). One possible reason for the existence of
this group may be deduced from the fact that in 1872 lady amateurs were
excluded from membership of the Society of Lady Artists and their partic-
ipation made more difficult. The group may have arisen for the benefit
of the excluded (166). In 1895 the Society of Women Painters was
founded and in the same year it held its first annual exhibition at the

Hanover Gallery. The only evidence for the existence of this Society
is the catalogue of this exhibition and on one of these it is written in
pencil that all but 5 of the exhibitors were "past and present pupils of
the atelier Ludovici; the result of 15 years teaching" (167). Finally,
in 1906 and 1907 exhibitions were held of 13 Women Artists at the Doré
Gallery. There were also numerous isolated exhibitions of work by two
or more women artists after 1900 (Appendix VI).

France

Having started her sculpture school for women (168), Mme. Bertaux's
next move for women artists was the creation of a Society under the aegis
of which they could exhibit their work. "Rassemblons-nous, afin de nous
compter, de nous défendre! Soyons unies pour la loyale lutte! Appelons
nous'L'Union des Femmes Peintres et Sculpteurs'" (169). In the same
speech of 1879 she made it clear that such an organisation would have a
positive aim, never, for one moment, echoed in the English societies.
"Pour réagir contre ces écarts désastreux, promoteurs de décadence, j'ai
la foi que l'élément féminin viendrait fort à propos, car la vraie femme,
celle qui vit bien, aura toujours à coeur de faire bien penser d'elle; je
me demande pourquoi, aussi savante que l'homme, si le pays lui donne les
moyens d'étude, elle n'aurait pas pour ainsi dire, son art, art d'un
domaine immense, côtoyant de très près celui de l'homme où sa note plus
douce, et, je le répète, aussi savante, traitera, avec une autorité par-
ticulière, les sujets les plus favorables à l'expression du grand art".
She described the woman artist as "gardienne de l'art élevé" (170).

The foundation was announced in kind and encouraging words by M.
Louis Enault on August 7th, 1881. Women were excluded from most artis-
tic circles, he wrote; "Je ne dis point que cela soit injuste, mais je
trouve que la position faite aux femmes est vraiment rigoureuse". He
went on: "Le but de la nouvelle Association est surtout d'organiser des
expositions, qui mettront ses membres en communication directe et régul-
ière avec le public, - n'est-ce point le public qui donne à l'artiste la
notoriété et l'aisance - parfois la gloire et la fortune?" (171). There
were to be two or three exhibitions each year: one for painting, one for
sculpture and one for the other genres. This was not realised.

The first exhibition ran from January 25th to February 14th, 1882 at
no. 49 Rue Vivienne. Mme. Léon Bertaux was President and Mlle. Berthe
Formstecher, Secretary. The circular issued to the press ran as follows:-

"On sait combien de femmes s'adonnent, depuis quelques années, à la
peinture et à la sculpture. Seulement, il faut avouer, un grand nombre
des dames, figurant au Salon annuel, s'occupent d'art pour rendre surtout
hommage à la mode.

"Un groupe de femmes véritablement artistes, de celles qui, avec courage entreprennent de lutter contre les difficultés de la carrière, ont résolu de faire oeuvre personnelle.

"A tort ou à raison, elles ont jugé qu'au Salon les artistes hommes s'arrogent la part du lion et traitent les travaux de femmes avec trop de dédain.

"Mais, au lieu de se répandre en lamentations inutiles, elles ont fièrement réclamé leur droit à la critique raisonnée, impartiale, et se sont dit:

"Nous aurons notre exposition!

"Elles vont l'avoir, en effect, et, quoiqu'il s'agisse d'un premier essai, nous pouvons compter sur autre chose que sur une exhibition banale et médiocre" (172).

36 artists sent work to this first exhibition, including, as the "Gazette des Femmes" put it, "de nos meilleurs artistes féminins" such as Mmes. Demont-Breton, Breslau, Lavillette, Muraton, Ayrton, Salles-Wagner, Daru, de l'Aubinière, Beauvais, de Châtillon and Bourges. The exhibition consisted of painting (genre, portrait and landscape), enamels, prints and a small proportion of sculpture (173). It was not an amateurs' exhibition. Much encouragement was given to the venture in the press (174).

In 1883 the second exhibition was held from February 1st to the 15th in the two rooms normally reserved for architecture in the Palais de l'Industrie (pavillon nord-est). These were conceded after formal application to the administration of the Fine Arts (175). On April 22nd a General Assembly was held at which Mme. Bertaux was made Présidente Perpétuelle (176). In 1884 improvement was noted although strangely enough, as in England, greatest praise was accorded to foreigners. "Cette Union est pleine d'avenir; dans peu d'années ce salon féminin aura son caractère et sa grande importance", wrote the "Gazette des Femmes" (177). In 1885 the exhibition was held in the same place and contributions almost reached 300. Hommage was paid to the late Marie Bashkirtseff by exhibiting her works in a separate room.

In 1886 the Union saw fit to emphasize its purpose, in view, presumably, of the criticism it had received to that date. Just before the fifth exhibition, the "Chronique des Arts" printed the following note:-

"Cette exposition, installée aux frais des sociétaires, offre gratuitement au public l'intéressant spectacle de femmes unies dans un but d'utile émulation.

"Parmi les sociétaires, sans mesquine rivalité, il se fait généreusement et affectueusement l'échange de conseils et d'encouragement, susceptibles d'aider et à démêler, à préciser (au milieu de leurs irrésolutions)

le sentiment propre que chacune apporte au début de la carrière, ce
qu'on appelle, chercher sa voie.

"En art, l'oeuvre de la femme ne doit pas chercher à entrer en
rivalité avec l'oeuvre de l'homme; sa note personnelle doit être comme
la voix douce et nécessaire à l'effet d'un choeur, son éducation, son
rôle dans la vie lui interdisant le plus souvent l'accès des études
sévères et lui commandant d'autre part de remplir dans la société le
rôle d'affectueuse et tendre protection qu'elle doit à la famille.

"La critique voudra bien rester dans cet esprit et par conséquent ne
pas refuser de mêler à ses conseils les encouragements susceptibles d'aider
dans leur marche les travailleuses de bonne volonté. Les sociétaires de
l'Union ne prétendent pas le moins du monde se poser en rivalité avec
aucune exposition similaire, encore moins avec le Salon; elles veulent
être une Société d'intérêt général" (178).

The subsequent exhibition comprised 324 paintings and 23 sculptures.
Numbers grew yearly and in 1889 there were 651 paintings and 37 sculptures
(Table 20). Progress was also evident in the standard of the exhibitions.

The year 1890 was crucial. The previous December, at the Union's
General Assembly, Mme. Bertaux had read a proposal that a special class
should be created for women at the Ecole des Beaux-Arts where they might
receive an equal education. On February 29th the text was submitted to
M. Fallières, Minister of Public Instruction (179). The same year saw
the foundation of the Union's own organ, the "Journal des Femmes Artistes".
The Journal had three main purposes. The first was to create a feeling
of solidarity among women artists by defending their interests. Their
second aim was to persuade the public of "la nécessité de donner à la
femme qui se destine à l'art le même enseignement qu'aux hommes, avec
les précautions que dicte la bienséance, en lui ouvrant les portes de
l'Ecole des Beaux-Arts". The third motive was aesthetic: the creation of
a female art. "Déjà nous pouvons pressentir que, par la mise en commun
d'un idéal encore indéfini, la femme, en possession de ses facultés
spéciales par l'étude et les hautes traditions, donnera, dans le grand
concert des Arts, sa note personnelle; elle ne sera plus la concurrente
de l'homme que son imitatrice; elle aura trouvé l'art féminin. Pourquoi
pas? Ce domaine n'est-il pas sans limites? Alors, assise sur cet
esprit d'union et de paix qui justifie son passé, notre Société aura,
par ces principes, ordonné son avenir; tel est l'esprit de la Société,
tel sera celui de son journal" (180). The third important event of 1890
was Mme. Aron Caen's proposal, at the Union's General Assembly on
December 14th, that women should be represented on the Salon Jury (181).

From 1890 each of the Union's meetings was fully reported in the Journal which became the forum for all questions relating to women artists. It was here that Mme. Bertaux and her followers developed their idea of a female art which, it was hoped, would find final expression in the Union's exhibitions. One of the first subjects raised in 1891 concerned the method of the Union Jury. The latter was composed of three elements: Sociétaires who had received prizes at the official Salon; Sociétaires who had exhibited at least five times at the Salon; 10 Sociétaires whose names were pulled out of a hat from all those who wished to take part in the Jury's duties (182). On February 1st, a short article was printed by a Sociétaire with the initials L.B. (Louise Breslau or Mme. Bertaux herself?). She expressed concern at the Jury's standard of selection which she considered too high; "no doit-on pas plutôt ménager la place à l'essai timide encore et naif, à bien des égards insuffisant, mais d'où se dégage au moins une garantie d'avenir ?" (183) The aim of the Union, surely, was to encourage incipient artists, not the professional. The author was not trying to support amateurs, but the young and inexperienced.

The same article also contained the first contribution of the year on the subject of female art. "Combattons, mes amies, il n'est que temps, cette fureur de singularités modernes. Par nous femmes, par le caractère des nos travaux, que l'Art redevienne avec force civilisatrice, qu'il redonne au monde ce qu'on lui demandait à l'origine, ce qu'il a donné: l'oubli des réalités, l'éblouissement de la pure lumière en place de la nuit profonde. L'Art, c'est l'invention. Inventons ce qui console le coeur, charme l'esprit et fait sourire le regard. Voilà, certes, une mission bien féminine. Oui, créons, femmes, nous le devons et nous le pourrons, cet art nouveau qu'on attend: l'Art féminin". The first elements of this Art were to be found in tradition, "les meilleurs modèles dans la nature" and "les plus heureuses inspirations dans notre coeur". She concluded with an appeal for cooperation: "Puisque d'heureuses circonstances leur ont permis de se grouper, c'est aux femmes artistes qu'il appartient de produire les manifestations de cet Art nouveau, que nous souhaitons si ardemment. Toutes les formes de l'Art, les plus élevées comme les plus modestes, peuvent y trouver leur place. Que les femmes auteurs, poètes, critiques, que sais-je? Que toutes celles qui pensent et travaillent fassent comme nous; qu'elles se réunissent, et, toutes ensemble, nous formerons une vaste et fière association dont le centre, naturellement, sera notre chère Société, aujourd'hui florissante et prospère".

On February 15th the Journal denied a rumour of division within the Union. The following explanation was given: "Il est vrai que Mme. Eliza Bloch nous a fait parvenir sa démission, mais c'est juste au moment où les attaques incessantes de cette ex-sociétaire, recueillies dans une petite feuille, autorisaient le Comité, dans sa séance du 10 janvier dernier, à demander la radiation de Mme. Bloch, conformément à la proposition de notre conseil judiciaire" (184). Whether there was division at that time it is difficult to establish, but it is a fact that in 1892 a new society for women artists was formed to which several exhibitors at the Union subsequently sent work (185).

The tenth exhibition was held from February 21st to March 14th, 1891; there were 797 paintings and 33 sculptures contributed by 332 "Sociétaires". Reviews were encouraging and much thought was given to the idea of a separate feminine art. Some critics described the Union's exhibitions as a female equivalent to the Salon and indeed with some justification for there were as many as 393 members at that time (186). In "Le Temps" the reviewer echoed Mme. Bertaux: "Certes les Femmes ont raison d'aborder la peinture et la sculpture, car elles y apportent des dons très particulières, une faculté d'assimilation, une adresse et une grâce originelle indéniables.

"Il ne me paraît pas impossible qu'elles arrivent à avoir un art à elles où les raffinés d'impression fine les puissent reconnaître du premier coup" (187). Jules Gerbaux wrote a letter to Mme. Bertaux on the subject of the exhibition, in which he expressed his belief in "les qualités intuitives et primesautières de la femme" and "art féminin .. dont les grandes lignes sont en train de se dessiner visiblement" (188).

On the tenth anniversary of the Union in June, Mme. Léon Bertaux repeated the appeal for cooperation and femininity voiced twelve years ago in 1879 on the occasion of the opening of her new school for sculpture. With the same opportunities for study as men, she said, "l'art de la femme se manifestera bien personnel; il sera le corollaire naturel de l'art masculin. De cette alliance naîtra quelque chose que nous ne connaissons pas encore, mais il n'est peut-être pas téméraire de supposer que l'idéal féminin rendra à l'Art ce que le monde lui demandait à son origine: l'oubli des misères terrestres, la lumière qui doit chasser les ténèbres". For this reason, she cried, "serrons les rangs". She went on, with oratory which illustrates well her commitment to the cause:

"Restons femmes, non-seulement en maintenant à notre groupement le cadre qui lui est propre, mais restons femmes dans la société, dans la famille; montrons qu'on peut être artiste, et même grande artiste, sans cesser de remplir la somme de devoirs qui est notre gloire et notre honneur.

"Restons femmes: au point de vue artistique aussi: ne calquons pas nos maîtres, créons selon notre sentiment. Même avec l'intention de les égaler, ne copions pas les chefs-d'oeuvre; donnons naissance à un art qui portera la marque du génie de notre sexe; restons femmes, restons artistes, restons unies" (189).

At the eleventh exhibition in 1892 which ran from February 21st to March 19th, M. Roujon, director of Fine Arts , bought three pictures and in June the Union received the final seal of official approval in being accorded a Décret de Reconnaissance d'Utilité Publique (190). In 1893 the Union was credited with 55,000 francs and was also the beneficiary of bequests amounting to 20,000 francs (191). By 1894 the Union was acknowledged, respected and successful and in November of that year the Journal carried a proud article on the origins of the Institution. It began: "Aujourd'hui, bien constituée, reconnue comme établissement d'utilité publique, riche, considérable, considérée, l'Union, à l'aide d'un bon fonctionnement, c'est-à-dire d'une administration sage et économe, peut entrer dans sa deuxième période avec la tranquillité des forts" (192). In this same year Mme. Bertaux resigned in the hope that Mme. Demont-Breton, a Vice-President of the Union since 1891, would be appointed her successor. The main reason for her resignation seems to have been a desire to return to work for which her duties as President left her little time; she remained a Sociétaire. Simultaneously the other Vice-President, Mme. Aron-Caen, also resigned (193).

Mme. Demont-Breton was nominated but in her printed statement of acceptance she made it plain that her Presidency would entail a fairly important change in policy. "Vous connaissez depuis longtemps ma manière de voir, qui diffère sur plusieurs points de la ligne de conduite qui s'était tracée notre ancienne présidente. Je ne vous ai jamais considérées comme ayant besoin d'être tenues en tutelle. Je vous estime comme par-faitement capables de juger par vous-mêmes de tout ce qui a rapport à l'intérêt général. La plus modeste peut avoir d'excellentes idées et nous les soumettre, et, d'ailleurs, la plus modeste d'aujourd'hui peut devenir la plus grande artiste de demain, et notre devoir est de l'y aider de toutes nos forces.

"Notre devoir est de mettre en lumière les premiers essais de celles qui travaillent sérieusement, et d'attirer à nous toutes les artistes qui par leur talent font honneur à l'art féminin. C'est à celles qu'anime une véritable amour de l'art que nous porterons surtout un sympathique et utile intérêt. C'est pourquoi je crois nécessaire, pour nous assurer le concours de ces laborieuses, seules capables de maintenir et de rehausser le niveau de notre Société, de ne plus ouvrir nos portes à la première

venue, à qui il suffisait, jusqu'à présent, de payer sa cotisation pour
avoir le titre de sociétaire. Je n'ai pas besoin d'ajouter que le
Comité, chargé d'examiner le mérite artistique des postulantes, se mon-
trera d'une grande indulgence, faute de quoi le but que nous poursuivons
serait manqué" (194). These views of Mme. Demont-Breton recall those of
the Sociétaire, L.B., in 1891. It was clearly a grievance under Mme.
Bertaux's presidency, that young talent was not given enough encouragement.
The new policy, then, was to be one of lenient selection.

By 1895 various prizes were offered to the exhibitors: Prix de
l'Union - 500 francs; Prix Pérate - 200 francs; Prix Ocampu - 300 francs;
Prix Léon Bertaux - 200 francs (195).

In 1897 the "Chronique des Arts" reported a schism in the Union and
the details of this event suggest that it was brought on by Mme. Demont-
Breton's new approach to admissions. The information was couched in a
highly critical review: "Nous ne nous trompions pas quand, l'autre jour,
à propos de l'Exposition des Femmes-Artistes à la salle Petit, nous pen-
sions avoir affaire à un schisme. Les Artistes qui ont formé ce nouveau
groupe se sont séparés de l'Union des Femmes Peintres et Sculpteurs le
jugeant trop facile dans ses admissions. Je ne saurais leur donner tort,
car vraiment les 5 ou 6 salles où l'Union vient d'inaugurer sa 16ième
exposition annuelle sont par trop encombrées d'oeuvres absolument dénuées
d'intérêt". It was unfair to encourage girls with no talent. "Rien
n'est lamentable comme les fausses vocations, et je crains que beaucoup
de ces pauvres jeunes filles que j'apercevais hier, suivant d'un oeil
anxieux les impressions de la foule devant leurs touchantes aquarelles, ne
maudissent avant longtemps ceux ou celles qui les ont encouragées dans
cette carrière de l'art, la plus ingrate de toutes pour ceux que la nature
n'y a pas destinés" (196). Details of this new society will be given
presently; for the moment it is only necessary to mention that some of
the most staunch supporters of the Union sent work to this new Society in
1897, including Mme. Bertaux and Virginie Demont-Breton, so there can not
have been much animosity involved in the split. The strength of the
Union was in no way impaired by the existence of a rival organisation and
in 1897 there were 942 numbers in the catalogue.

The article in the "Chronique des Arts" was the first in a long
succession of derogatory reviews. In 1898 a critic wrote: "Le tableau
de fleurs ou la nature morte, sans aucune finesse spéciale de coloris, le
tableau de genre, banalement conçu et plus banalement traité, sévissent
depuis la cimaise jusqu'à la corniche..." (197). The worst review was
given by Julien Leclercq in 1899. What characterized the exhibition, he

wrote, was that the canvases "sont toutes admirablement et visiblement
signées, en grandes lettres anglaises". All the talented women artists
sent their work to the larger mixed exhibitions; the Union was left with
hopeless amateurs (198). As a German critic wrote, the level was "ein
traurig niedriges" (199). The exhibitions went on expanding year after
year, rising sharply from about 1,200 in 1903 to approximately 1,500 in
1908, but still, and despite the successive presidential elections of La
Duchesse d'Uzès in 1901 and of Mme. Esther Huillard in 1904, reviews were
bad. Each exhibition received the same criticism of too much amateur-
ishness, too many studies, pastels and water-colours and excessive flower
paintings. In 1908: "La plus souple galanterie se voit réduite aux
expédients dès les premiers regards jetés dans ce Salon. Rien n'est
pénible à respirer comme l'atmosphère de mesquinerie qui règne ici sans
aucune vitalité naturelle" (200).

The fact was that the Union was facing the same problems that har-
assed the Society of Female Artists in England. Naturally, when women
artists had reached a certain standard in their work they wished to
exhibit in the mixed Salons rather than remain associated with an organis-
ation whose professed aim was to encourage the young and inexperienced.
The only women of whom this was not true were those motivated by the
altruistic desire to help their sisters and those who believed, like Mme.
Bertaux herself, in the possibility of a completely separate feminine
culture. During Mme. Bertaux's Presidency, a large number of successful
women artists sent work presumably in support of the continual agitation
and claims made by the latter on behalf of women artists and also, per-
haps, in support of her belief in an imminent feminine art. The list of
renowned participants is a long one: Louise Breslau, Mme. Salles-Wagner,
Virginie Demont-Breton, Claude Vignon, Annie Ayrton, Félicie Schneider,
Emilie Leleux, Marie Bashkirtseff, Thérèse Schwartze, Marie Petiet, Mme.
Besnard, Henriette Ronner, Mme. Beaury-Saurel, Anna Bilinska, Jeanne
Rongier, Esther Huillard, Delphine de Cool, Mme. Peyrol-Bonheur, Mme.
Delacroix-Garnier, Madeleine Carpentier and many others. Virginie Demont-
Breton, who succeeded Mme. Bertaux in 1894, did not possess her rallying
influence, nor was she as eloquent on the subject of a feminine culture.
Also her policy of encouraging the inexperienced lowered the standard of
exhibitions. Many women must have thought that the cause of women
artists was sufficiently advanced and that the Union could dispense with
reinforcements. Whatever the reason, the range of talent after 1894 was
not considerable. As Julien Leclercq wrote in 1899: "Les femmes de
talent exposent généralement dans les grands salons" (201). At no time

during its history did the Union exhibit works by Berthe Morisot, Mary Cassatt, Marie Bracquemond or Henriette Browne and even Rosa Bonheur, who had been so active in her support of the Society of Female Artists, sent only one crayon drawing in 1899.

Two other exhibitions of women's art were held in the 1880 s. In March, 1882, a group of women exhibited at the Cercle de la Rue Volney. There were almost 400 items of painting and sculpture and, according to the "Gazette des Femmes", "presque tout l'état-major des artistes féminins y a participé" (202). Apparently, however, most of the good pictures had been exhibited previously, either at the Salon or at provincial exhibitions. This exhibition was almost certainly the first of several, or at least intended to be - "L'Art", for example, referred to it as "absolument digne d'encouragement" (203) - but I have found no other references to the group. In April 1884 the Berlin Society of Women Artists organized an exhibition in the rooms of the Académie des Beaux-Arts. It comprised 300 paintings, studies, sculptures and industrial art objects by about 120 women artists from all over Germany (204).

In the 1890 s the number of exhibiting groups of women artists increased rapidly. The first was a single large-scale exhibition entitled "L'Exposition des Arts de la Femme" and organized by the Société de l'Union Centrale des Arts décoratifs. The committee included Mmes. Hippolyte Carnot, Edouard André, Léon Bertaux, Rosa Bonheur, Madeleine Lemaire, Dieulafoy, George Duruy and Veuve Spitzer and Rosa Bonheur was Honorary President of the Fine Art Section (205). The exhibition comprised a large range of domestic art such as needlework and fan painting as well as painting and sculpture. "Toutes m'ont paru charmantes", wrote Théodore de Wyzewa (206). In 1892 the Société des Femmes Artistes - previously referred to as a possible splinter group of the Union - was founded. Its premises were the Galerie Georges Petit. The third exhibition in January 1895, consisting of 107 works, was the first to receive a substantial review and remark was made on the wide range of genres: "Les 'Femmes Artistes', sans crainte des obstacles, aiment à cueillir des fleurs à toutes les branches des arts du dessin" (207). Apart from in 1897 when several Union exhibitors sent work - Mme. Bertaux, Virginie Demont-Breton, Mlle. Lavillette and Mlle. Elise Voruz for example - the Society did not boast many well-known exhibitors in the 1890 s. Mme. Duhem and Mme. Desbordes were most frequently mentioned in reviews. In 1898, when 213 works were shown, a critic concluded: "Aucune tendance particulière, aucun caractère général ne semblent commander ce groupement. L'occasion y est rare qu'une sensibilité spéciale se manifeste. Le plus

souvent, des traces de deux ou trois manières se contredisent dans le
même sujet sans présenter d'autre intérêt que celui d'un élément de repré-
sentation graphique des influences contemporaines. Des matériaux d'art
décoratif, des études, des portraits, des paysages - immotivés" (208).
From 1900 a number of female Salon exhibitors sent work to these exhi-
bitions; several were also exhibiting at the Union des Femmes Peintres
et Sculpteurs. The names of Mlle. Lisbeth Carrière, Mme. Nanny Adam,
Mme. Andrée Séailles, Mlle. Madeleine Carpentier, Mme. Florence Esté,
Mlle. Hélène Dufau, Mme. Galtier-Boissière, Mme. Debillemont-Chardon,
Mme. Marie-Antoinette Marcotte and Mme. Pauline Adour are worth mention-
ing in this respect. Criticism, however, was monotonous. There were
frequent exclamations such as "tant de portraits et tant de fleurs!" (209)
and reviewers constantly described the participants as amateurs: "les
talents aimables et nombreux qui, consentant à se divertir de lignes et
de couleurs, au lieu de consacrer tout leur temps à des occupations plus
futiles, s'efforcent de divertir les autres à leur tour" (210). If the
Society did originate as a breakaway group from the Union, it did not
gain favour with the press thereby. In size it never compared with the
Union, the maximum number of works exhibited in one year at the Society
being 265 in 1906 (Table 20).

The Association des Femmes Artistes Américaines must have been
formed in or just after 1892 as it held its fourth exhibition in 1895
and thereafter they occurred yearly (211). They were held at 4 rue de
Chevreuse. The first proper review in the "Chronique des Arts" was in
1903: "Dans un atelier sis à Montparnasse sont réunis sans faste des
paysages de Mmes. Hudson, Mac-monnies, Gréatore, et Florence Esté; un
portrait de Mlle Hariotte Taliaferro; un dessin de Mlle. Nourse; des
sculptures de Mlle. Pfeifer; d'autres travaux encore, moins heureux peut-
être, portent à une centaine le nombre des ouvrages inscrits au catalogue;
pris dans leur ensemble, ils révèlent de l'indépendance chez ces artistes
américaines, que le souci d'un bon labeur tourmente davantage que
l'appétit de la réclame" (212). It is clear from reviews that most of
the women were trained in Paris. The last notice within this period
occurred in 1910 (213).

In January of 1895 there was an exhibition of Femmes Pastellistes at
La Bodinière, 18 rue St.-Lazare, consisting of 88 works (214) and in the
same year the Union Centrale des Arts décoratifs organized a second exhi-
bition entitled "Les Arts de la Femme" in the Musée des Arts Décoratifs
(215). In 1898 the feminist paper "La Fronde" held an exhibition of 7
women artists in its offices at 14 rue Saint-Georges (216) and 1899 saw
the foundation of another society of women artists who called themselves

Les XII. The participants in these exhibitions, which took place at
La Bodinière in 1899, 1900, 1901 and probably after, were: Mmes. Nanny
Adam, Arosa, Baillon Turner, Julia Beck, Bourgonnier-Claude, Marguérite
Brémont, Mathilde Delattre, Eugénie Faux-Froidure, E. Guillaumot-Adam,
Cammile Métra, Maris Slavona, Fréd. Vallet-Bisson, Esther Huillard,
Jeanne Pinot, Madeleine Carpentier and Olga Behr (217). Twelve of these
exhibited at each exhibition.

New groups were formed almost yearly from 1900. In 1900 it was the
Association mutuelle des Femmes Artistes de Paris which exhibited for two
years at least in the salon of "La Plume", 31 rue Bonaparte (218). In
1902 the Fédération Féministe held an exhibition of women's art at the
Serres du Cours-La-Reine (Champs-Elysées) from June to October. It
embraced all aspects of women's life including women in history, at home,
at work, in the theatre, science, literature and, of course, art (219).
In December "Le Gaulois" organized a "Concours des Arts de la Femme" which
was an assembly of all work that women produced with their hands (220).
The Committee included La Duchesse d'Uzès and Madeleine Lemaire. In 1903
the "Kunstchronik" announced the foundation of a society of women artists
in Lausanne where "haben sich kürzlich die Malerinnen und Bildhauerinnen
zur gemeinsamen Vertretung ihrer Interessen und zur Veranstaltung von
Austellungen zu einer Societeromande des femmes peintres et sculpteurs
vereinigt, die ihrer Sitz in Lausanne hat und in allen Hauptplatzen der
französischen Schweiz Zweigvereine grunden will" (221). In January of the
same year Mme. Faux-Froidure, the water-colourist, held an exhibition of
the work of her female pupils which consisted of 60 items (222). In
March 1905 a group of women exhibited at the Palais de la Femme (Grand
Palais des Champs-Elysées) (223) and in 1906 an "Exposition internationale
des Arts de la Femme" was held at the Palais de Glace (224).

1907 saw the foundation of two more large societies. The origins
of both are slightly mysterious since in 1907, an exhibition from
February 15th to 28th at 97 boulevard Raspail was referred to as the work
both of the Union Internationale de Femmes Artistes and of Quelques, where-
as in the following year these were definitely two organisations holding
exhibitions in the same place, 19 rue de Caumartin, but at different
times of the year. The review associating the two in 1907 appeared in
the "Chronique des Arts" and was written by Paul Jamot. He wrote:
"L'Union Internationale de Femmes Artistes - pour la plupart françaises
- qui s'intitule 'Quelques' donne sa première exposition dans une belle
et confortable bâtisse neuve du naissant boulevard Raspail. Elle groupe
des exposantes choisies parmi les meilleures: Mme. Chauchet-Guilleré

et Mlle. Delasalle, Mlle. Jeanne Duranton et Mme. Galtier-Boissière,
Mme. Geneviève Granger et Mme. Desbordes, Mme. Séailles et Mme. Delvolvé-
Carrière, Mme. Marie Bermond and Mme. Marie Cazin. A ces noms il convient
d'ajouter celui, moins inconnu, de Mlle. Dorothée George. Trois aquarelles
de Mme. Jeanne Simon apportent ici le valable appoint d'un talent délicat
et sincère dont on serait heureux de recevoir plus souvent les confidences.
Il n'y a donc aucune raison de ne pas souhaiter la bienvenue aux fonda-
trices de cette Société" (225). In 1908 the Union Internationale de
Femmes Artistes was referred to as the International Art Union; it held an
exhibition at 19 rue de Caumartin in May whereas Quelques exhibited work
in January at the same place (226). In 1909 the International Art Union
received a bad review from Jean-Louis Vaudoyer in which he wrote: "Les
peintres, en général, et, en particulier, les femmes-peintres n'hésitent
pas à encadrer et à exposer le moindre de leurs croquis" (227). Mmes.
Raeburn, Shawn, Felsom, Cockroft, Goldthwaite and Mlles. Poupelet and de
Boznanska were briefly mentioned. In 1910 the exhibition was held in
April and J-F. Schnerb wrote another disparaging review (228). In 1911
works were exhibited in the Galerie Barbazanges by 88 women including Mme.
Y. Serruys, Mlle. Poupelet, Mme. Galtier-Boissière, Mlle. Desmor, Mlle.
Jozon, Mme. Hodgkins, Mlle. de Boznanska and Mlle. Louise von Sprekelsen
(229). In 1912 the Union moved to the Galerie Roger Levesque, 109 rue du
faubourg Saint-Honoré and exhibited in November. On this occasion the
name of the President was given - Mlle. de Félice. There were over 150
pictures and sculptures and amongst those singled out were Paule Adour and
Mela Muter (230). A good exhibition was finally achieved in 1913. René
Jean wrote: "Une excellente exposition féminine, où Mmes. Paule Adour,
Beveridge, Elisabeth Boyd, Marguérite Carpentier, Jeanne Duranton, Galtier-
Boissière, Dannenberg, Mutter, Florence Esté, Erna Hope, rappellent aux
admirateurs de leur talent l'apport fécond qu'elles ont fait à l'art de
notre temps" (231).

 Quelques held its second exhibition in January of 1908 and received
a favourable review, the critic beginning: "Ce qui nous attire partic-
ulièrement dans l'art féminin, c'est le laisser-allez, la grâce alerte,
la spontanéité du goût" (232). Mention was made of Mlle. Jeanne Duran-
ton, Mme. Metchnikoff, Mme. Galtier-Boissière, Mlle. Dufau, Mlle. Druon,
Mlle. Crespel, Mlle. Marie Cazin, Mme. Adour, Mme. Carpentier, Mlle. Esté,
Mme. Chauchet-Guilleré, Mlle. Bermond, Mlle. de Boznanska, Mme. Delvolvé-
Carrière, Mme. Desbordes-Jouas, Mme. Hoppe, Mme. Weise, Mlle. Dannenberg
and Mlle. Stettler. It will have been noticed that several of these
also exhibited at the International Art Union. In 1909, Jean-Louis

Vaudoyer, who reviewed the latter so scathingly in the same year, became
quite lyrical in his description of Quelques (still in the rue Caumartin).
He began: "Impressions fugitives, notes légères, divertissements grac-
ieux, voilà ce que les 'Quelques' nous montrent". These, and not serious
paintings, were what suited women's talents. He mentioned Mlle. de
Boznanska, Mme. Amiard, Mme. Marie Duhem, Mme. Blum-Lazarus, Mme. Galtier-
Boissière, Mme. Delvolvé-Carrière, Mme. Duranton, Mlle. Florence Esté,
Mme. Beatrice How and Mme. Besnard (233). In the following three years
the same artists participated and in addition Marie Cazin, Mlle. Jeanne
Poupelet, Mlle. Mutermilch, Paule Séailles and others. The standard,
according to reviews, remained high (234). In 1913, René Jean wrote:
"Dans l'aridité des Expositions féminines ouvertes un peu partout, cet
ensemble apparait comme un oasis de fraîcheur et de sincérité" (235).

By 1907 the number of exhibitions devoted to women artists was so
considerable - we have omitted to mention an exhibition of decorative work
by women at the galerie Shirleys, 9 boulevard Malesherbes (236) - that one
worried critic wrote: "Le temps approahe, semble-t-il, où les femmes
artistes ne le cèderont en rien à l'autre sexe pour le nombre des groupe-
ments et des sociétés" (237). Many more were yet to come before 1914 (238).
In December, 1908, an exhibition of 6 women artists was held in the
galerie E. Blot, 11 rue Richepanse (239). Also in 1908, the Lyceum Club,
a feminist organisation, began to hold exhibitions. The first, held on
the Club's premises, was called an "Exposition rétrospective d'Artistes
Femmes". It was arranged by Mme. Albert Besnard and included work by
Judith Leyster, Rosalba Carriera, Mme. Vigée-Lebrun, Mme. Vallayer-Coster,
Mme. Labille-Guiard, Mlle. Gabrielle Capet, Mme. Benoit, Mlle. Bouillard,
Adèle Romany, Marguérite Gérard, Constance Mayer, Rosa Bonheur, Marie
Bashkirtseff, Eva Gonzalès, Berthe Morisot and Mme. Delance (240). This
was the first real attempt in France to assemble past and present female
talent. The exhibition was open from February 25th to March 15th. At
the end of April, a "Salon des Indépendantes" was held in the same rooms
(241). From 1909 to 1912, 6 exhibitions were arranged, each devoted to
the work of 2 or 3 contemporary women artists. These included Mlle. M.
Delorme, Beatrice Howe, Mlle. Kate Tizard, Mme. Albert Besnard, Mlle.
Angèle Delasalle, Mme. Suzanne de Callias, Rose Dujardin-Beaumetz,
Mme. Berthe Cazin, Mlle. H. Tirman and Mlle. Pauline Adour (242).

In 1909 an exhibition by a group called Mademoiselle took place at
255 rue Saint-Honoré (243) and in the same year there was an exhibition
of "Art appliqué à la femme" at the Hôtel des Modes, 15 rue de la Ville-
l'Evêque (244) and an exhibition of Artistes Femmes Peintres et Sculpteurs
at 416 rue Saint-Honoré (245). 1909 was also the foundation year of

the Syndicat des Artistes Femmes Peintres et Sculpteurs whose second
exhibition was held in 1910 at the Petit Musée Beaudouin, 253 rue
Saint-Honoré; this was shortly before an exhibition of the work of yet
another group of women artists held at the Galerie Devambez, 43 boulevard
Malesherbes (246). Even René Jean, so generous with his praise else-
where, found this too much. He wrote the following in a review of the
third annual exhibition of the Syndicat des Artistes Femmes Peintres et
Sculpteurs in 1911: "Le jour où il sera démontré qu'un Salon ou une
petite Société d'artistes aura fermé ses portes à une femme de talent,
parce que femme, ce jour-là on pourra sans doute comprendre l'utilité de
syndicats de ce genre, et on devra les soutenir et les encourager. Mais,
que cinquante peintres, sculpteurs ou décorateurs féminins convient à
examiner leurs oeuvres pour que, parmi elles, on puisse à peine indiquer
les études de Mlle. Philastre et de Mlle. Jozon, les émaux de la Marquise
de Courtavel, qui n'apportent aucune idée neuve, mais montrent seulement
une certaine habileté technique, n'est-il pas permis de trouver cela
excessif?" (247) The exhibitions of this Syndicat were held successively
at the Galerie Allard, the Galerie Marcel Bernheim and the Galerie La
Boëtie (248). They were still going on in 1914. Another society which
survived was Unes Internationales, founded in 1910, and so called, pre-
sumably, as a sympathetic response to the earlier Quelques (249). It
received scant notice in the press although René Jean did use the word
"indigente" in 1911 (250). There was also an exhibition of work by
women artists at the Cercle "La Française" in March of 1911 (251) and in
December of the same year a group began exhibiting at 4 rue des Réservoirs
(252). 1912 saw the first exhibition of "Arts de la Femme" organised by
L'Oeuvre de l'Etoile (253) and 1913 was notable for three exhibitions of
decorative art by women (254).

 The same names crop up in all these exhibitions; very few remained
faithful to one Society or exhibiting group. Both Virginie Demont-Breton
and Mme. Bertaux - the former present, the latter previous President of
the Union des Femmes Peintres et Sculpteurs - exhibited with the Société
des Femmes Artistes in 1897, the year in which a schism was reported in the
Union. In view of their faith in the latter it can hardly be supposed
that their contributions to the Society were motivated by anything but
the desire to assist a fellow group. Many women, including Olga de
Boznanska, Mme. Fréd. Vallet-Bisson, Madeleine Carpentier, Mlle. Arosa,
Nanny Adam, Esther Huillard, Mme. Galtier-Boissière, Mlle. Florence Esté,
Mlle. Duhem, Paule Séailles, Mlle. Lavillette, Mlle. Desbordes, Mlle.
Elise Voruz and Mme. Debillemont-Chardon sent their work around to

different groups, often simultaneously (255). Some names, and perhaps
the best known, are conspicuously absent from all these women's exhibi-
tions: Berthe Morisot, Louise Abbéma, Mary Cassatt, Nélie Jacquemart,
Angèle Dubos, Emma Herland, Suzanne Valadon, Maximilienne Guyon,
Louise Chatrousse, Louise Hervieu, Marie Collart, Anna Boch and Juana
Romani for example. All these were successful Salon exhibitors.

There are several possible explanations for the proliferation of
female exhibiting groups. It was often supposed that women exhibited
separately because of the difficulty of getting their work accepted at
the Salons. In 1873 E. Muntz wrote: "N!était la crainte de déplaire
à la partie la plus aimable du public, je chercherais si dans ces divers
exemples le chiffre des 'female artists' n'est pas en raison de
l'indulgence des jurys" (256). Might one not just as well attempt to
establish the degree of bias or severity? Such a survey being impossible
in retrospect, one must make do with the kind of evidence presented by the
Salon des Refusés of 1879. The large number of women exhibiting in the
refused section leads one to suppose that many were unsuccessful. As we
have seen women artists were commonly associated with failure (257).
Exhibitions were needed in which works of a lower or different standard
might find admittance. This may well have been one reason for Mme.
Bertaux's foundation of the Union des Femmes Peintres et Sculpteurs as
well as for the numerous later groups. Equally important though, in the
case of this first society, were certain ambitions of its founder. To
enable Mme. Bertaux to address the establishment on behalf of women
artists and make authoritative her claims for improved art education,
eligibility for the Prix de Rome and election to Academic status, it was
necessary for her to represent a corporate body of women. As President
of an exhibiting society of women artists and as editor of a journal re-
presenting their interests she could do this. Doubtless many women
associated themselves with the Union in support of her cause. Another
ambition of Mme. Bertaux, as we have seen, was the realisation of a
separate female culture and this naturally implied separate exhibitions
where women could exhibit without having to undergo comparison with men.
Her repeated call that women should save art from degeneracy by producing
pleasurable and positive images could have provoked two cooperative
responses: firstly the satisfying thought that possibly the Salon did
not contain the highest contemporary manifestation of art, thus making
the rejection of many women's entries appear as a compliment rather than
just deserts; secondly a feeling of missionary solidarity with other
women. Both responses could have led to involvement with the Union.

The rise and popularity of the Union des Femmes Peintres et Sculpteurs is understandable chiefly on account of all the documentation surrounding its activities. There is one undocumented factor, however, which is important for the Union and for all the other societies and exhibiting groups as well. This factor relates to the nature of Paris as a mecca for art students of both sexes not only from provincial France but from all over the world. Of all cities, Paris abounded most in homeless, uprooted art students living alone in rented rooms. Owing to propriety, women in this situation found it far harder to make friends and contacts than men. The only friends that it was possible for such women to make were fellow students - those with whom they worked - and again due to propriety these would usually have been other women. In this way female cliques were formed often consisting of foreigners and provincial French and frequently too developing into active groups and societies such as the Association des Femmes Artistes Américaines, the International Art Union, Unes Internationales and Quelques. Once established these societies would have presented an ideal opportunity to outsiders for meeting new people. There were other societies which operated as ladies' clubs: the Union des Femmes Peintres et Sculpteurs with its regular meetings and banquets is one of these and also the Lyceum Club and Fédération Féministe. Finally, of course, these numerous exhibitions gave women the chance of selling their work and this must have been important especially for provincials and foreigners who had to pay for their keep.

The main difference between women's exhibitions in England and in France is above all a question of quantity . There were far fewer in England than in France. One reason for this is simply that England lacked the huge influx of foreigners who gravitated to Paris as the centre of modern art and art education. Secondly, there were many more mixed exhibiting societies in England where women could send their work: the most important of these were the Royal Academy, the British Insititution, the Society of British Artists, the various water-colour, oil, black and white and miniature societies, the Portland Gallery, the Grosvenor Gallery and the New Gallery. There were also, as will presently be seen, many more small galleries in England where group or one-man exhibitions could be held. In France there was no such choice; for the greater part of the nineteenth century the main option was between provincial exhibitions and the Paris Salon and even though the Salon held much larger exhibitions than the Royal Academy, there must still have been a huge superfluity of artists - given the nature of Paris as a focus for the arts - who could not get their works accepted. Thus the growth of small societies.

The second difference is that the English exhibitions totally
lacked the ideological aura of the French. I have been unable to find
any exhibitions of women's art in England which were based on a belief in
a separate feminine culture. In England women's exhibitions appear to
have existed for practical reasons alone: to provide an outlet for the
excess of amateur artists; to help art students; to give women artists
a chance to exhibit their works at minimum expense. The ideological
basis of the Union des Femmes Peintres et Sculpteurs is most easily
explained by the climate in which it was founded. Impressionism had
made Paris the focus of modern art and provoked much theorizing on art.
Reaction against "cette fureur de singularités modernes" was widespread.
Like many others Mme. Bertaux insisted that art should not be a question
merely of technique, nor the mindless portrayal of reality for the sake
of it. She also - and this was more unusual - insisted that art should
give positive pleasure.

The most striking similarity between the women's groups in both
countries is the reception they received in the press. All reviews
of these exhibitions were pervaded with the same attitude of condescension
whether in praise or criticism. This stance was surely created by the
exhibitions themselves. The result of grouping women together was bound
to be a generalized attitude to women as artists, and since most of these
societies existed for some remedial reason - chiefly to help women artists
lacking privileges and adequate art education - the standard was bound to
be fairly low, and so too the standard adopted by critics. Attitudes to
women as artists and criticism of their work will be considered in
chapters 3 and 4. At this stage it is sufficient to point out the role
played by these societies and exhibiting groups in fostering a definite
view - generally pejorative - of women artists which provided one more
obstacle to their success.

Part 4 - One-woman exhibitions

There was a steady increase in the number of one-woman exhibitions
in London during the second half of the nineteenth century (Appendix VIII).
I have found references to 3 in the 1850 s, 4 in the 1860 s, 6 in the
1870 s, 16 in the 1880 s and 34 in the 1890 s. After 1900 the number
grew rapidly. 61 were held between 1900 and 1905, 185 between 1906 and
1910 and 161 between 1911 and 1914. The sum of such exhibitions held
in a single year rose from 2 in 1877, to 9 in 1900, 38 in 1906, 44 in
1910 and 56 in 1913. Several of these were devoted to the work of
foreign artists such as Henriette Ronner, Madeleine Lemaire, Henriette
Browne and above all Rosa Bonheur who received much publicity in England.
All the best-known English female artists were naturally represented:
Lady Butler (the first artist to have work exhibited at the Fine Art
Society), Mrs Allingham, Kate Greenaway, Eliza Turck, Helen Thornycroft,
Eleanor Fortescue-Brickdale, Evelyn de Morgan and Mrs. Stanhope-Forbes
for example. The vast majority of these exhibitions, however, com-
prised the work of relatively obscure women artists. In examining the
titles of these exhibitions one is first of all struck by their explicit-
ness; it is as if the public were sooner attracted by subject-matter than
by technique or the name of the artist. Secondly, one observes the
large number of exhibitions devoted to flower-paintings, landscapes and
above all, travel sketches of which there was an extraordinary preponder-
ance. The last of these emphases requires explanation. For the upper
classes travel was not only an essential part of education but also a
panacea for illness. One of the results of the fashionableness of
travel was autobiographical travel books which were numerous in the last
century; another was pictorial records which, until photography became
widespread, took the form of sketches. The titles of some of these
exhibitions, such as "A Variety of Sketches of Scenery in Africa and
America", "From Rye to the Riviera" and "Pastel Studies of the Glories
of Sky and Sea in the Far East" are remarkably similar to the titles of
contemporary travel books: for example, "Through the Tyrol to Venice"
by Mrs. Newman Hall and "Sunshine and Storm in the East" by Mrs Brassey.
Such titles left the public in no doubt as to what the book or exhibi-
tion would contain and were guaranteed to attract people on account of
the subject - travel. With subject-matter as the most important
aspect of an exhibition, as opposed to the quality of the work or the
medium employed, it is hardly surprising that there were so many one-
woman exhibitions in England.

In Paris there were far fewer one-woman exhibitions (Appendix IX). They amount to 5 in the 1880s, 28 in the 1890s, 39 between 1900 and 1905, 46 between 1906 and 1910 and 62 between 1911 and 1914. Taken in single years, there were 4 in 1896, 7 in 1899, 9 in 1900, 10 in 1905, 19 in 1910 and 18 in 1912. A comparison of the titles of these exhibitions with those in England illustrates well the different attitudes to art in these two countries. In the list of one-woman exhibitions in Paris there are hardly any subject titles; in most cases only the medium is indicated. This may help to explain the fact of fewer exhibitions in Paris. With quality of technique as the standard rather than subject-matter, there were bound to be fewer women artists worthy of isolated focus.

CHAPTER THREE - SUBJECT MATTER IN ENGLAND

There are obvious difficulties involved in an attempt to analyse the subject-matter of works shown at the principal exhibitions in the nineteenth century. As it is impossible to locate all exhibited works even at selected exhibitions, reliance must be placed chiefly on titles and reviews. Until approximately 1870, this method may justifiably be adopted since before that date titles tended to be explicit and reviews frequently described works as well as criticising them. Afterwards, with the proliferation of non-descriptive titles and the increasingly critical rather than descriptive nature of reviews, it is not possible to analyse subject-matter with any degree of accuracy. At the very end of the century this situation was slightly improved by the appearance of illustrated catalogues.

A. Classical Subjects (1)

Classical subjects by women never constituted more than a small pro-portion of the total of women's entries to exhibitions. It is broadly true to say that they were slightly more numerous at the beginning and the end of the century and this pattern also holds for men's contributions in the classical style although these were always greater in number than those of women. Before examining the nature of women's contributions in classical art, some attempt must be made to explain why there were so few.

Generalisation on women's education in the last century is not easy, since many girls - and among these the most highly educated - were taught privately at home by their parents and by governesses and masters (2). The nature of such an education varied widely and it is not unusual to read of girls learning Latin, Greek, Mathematics, as well as History and Literature at home (3). An excellent education was available to girls fortunate enough to have parents who were well educated and open-minded on the subject of a woman's training. The usual home governess education on the other hand and that provided by the boarding schools and dame schools - in other words the education given to the vast majority of upper and middle-class girls - was of an extremely low standard. In the Taunton Report (1867-8) the following was written about girls' education: "We have had much evidence, showing the general indifference of parents to girls' education, both in itself and compared to that of boys. It leads to a less immediate and tang-ible pecuniary result; there is a long-established and inveterate prejudice, though it may not often be distinctly expressed, that girls are less capable of mental cultivation, and less in need of it, than boys; that accomplish-

ments, and what is showy and superficially attractive, are what is really essential for them; and in particular, that as regards their relations to the other sex and the probabilities of marriage, more solid attainments are actually disadvantageous rather than the reverse" (4). Parents' wishes were naturally mirrored both in home and school education (5). If it was essential for ladies not to know too much, it was equally important that they should know a little. In 1877 Charlotte Yonge outlined the minimum: "I suppose the lowest standard for a lady must include, besides reading aloud, tolerable composition of a letter, and arithmetic enough for accounts, respectably grammatical language, and correct pronunciation, command of the limbs and figure, facility in understanding French, history enough not to confound Romans with Greeks, and some fuller knowledge of that of England, with so much geography as to avoid preposterous blunders, dexterity to needle-work, and general information and literature sufficient to know what people are talking about. This is indeed a minimum. Some knowledge of music is almost always added, and less invariably the power of using a pencil; .. The most frivolous mother knows that the most frivolous girl must learn thus much, and be up to a kind of Mangnall's Questions perception of things in general" (6).

Mrs Richmal Mangnall's "Historical and Miscellaneous Questions" first appeared in 1800 and went through at least 25 editions before 1869. It covered Greek, English and Roman history and although intended to be a mere aid to knowledge it was probably the most widely used text book in girls' education. It is a sequence of unrelated facts, the answer often having no bearing whatsoever on the question. Other similar text books for what we have termed "classical" subjects were "Little Arthur's History", Mrs. Trimmer's "Bible Lessons", Mrs Markham's Histories of England and France, the "Child's Guide to Knowledge", Blair's Catechism , Pinnock's Catechisms, Eve's "Examiner", Maunder's Treasuries and Bowdler's version of Gibbon's "History of the Decline and Fall of the Roman Empire". Among more substantial works Oliver Goldsmith's "History of England" in four volumes, was probably the most popular. David Hume and Thomas Macaulay were read less frequently (7). Catechisms and Conversations were the most usual source of information however. Two commissioners at least among those who furnished evidence for the Taunton Report remarked on the widespread use of catechisms "of grammar, of history, of geography, of music, learnt by heart, question by question and answer by answer..., the pupil being merely required to remember a certain number of detached facts, whose mutual bearing she can have no notion of" (8).

If emphasis was placed on any serious subjects in a girl's educa-
tion, it was probably on history and religious knowledge. History was the
most important subject at Queen's College which opened in the 1850 s and
in 1868 the commissioners reported that girls were most proficient in this
subject: "English history is taught everywhere; Greek and Roman history
in some of the cheaper, and in all of the more ambitious schools" (9). But
the widespread practice of rote learning precluded any real appreciation of
correlated events or cause and effect; for girls, history meant bare facts
and anecdotes. Home education was often superior and even in some schools
a higher level of instruction was given, but generally speaking it was not
until the 1870 s, with the spread of Public Day Schools or High Schools for
Girls, that real improvement set in.

Where the creation of works of art with classical subject-matter
is concerned, the absence of a good classical education was perhaps less
important being less irremediable than the lack of the type of art education
available to men - in other words study of the human figure and nude (10).
In 1782 a patron wrote to Catherine Read's brother: "Was it not for the
restrictions her sex obliges her to be under, I dare safely say she would
shine wonderfully in history painting, too, but as it is impossible for her
to attend public ac ademies or even design or draw from nature, she is
determined to confine herself to portraits" (11). Angelica Kauffman , the
most celebrated female painter of classical subjects in England, provoked
the following comments from Anthony Pasquin: "I have not seen the works of
any female, who could draw the human figure correctly: their situation in
society and compulsive delicacy, prevents them from studying nudities, and
comparing those studies with muscular motion, though without such aid, they
cannot do more than this lady has effected, which is to design pretty faces
and graceful attitudes, without any authority from Nature to warrant the
transaction" (12). We have already seen how the same conditions appertained
in the nineteenth century although gradual improvement was effected by small
academies (13).

Finally it should be mentioned that public opinion did not consider
women capable of grand conceptions; nor were grand subjects thought suit-
able for them. It was suitable, on the other hand, for women to paint
flowers and paint or sculpt portraits and this many of them did. Public
opinion surely influenced performance. Reviews provide the clearest illus-
tration of what was expected of women and the most noteworthy of these will
be examined in the course of the following survey of women's contributions
in the classical style.

Maria Cosway and Mary Lloyd RA sent their last works to the Royal
Academy in the early years of the nineteenth century. After three years'
absence from the Academy - due it is thought, to the death of her daughter
- in 1801 Mrs Cosway exhibited four works, three of which were on religious
themes: "The Guardian Angel" (no. 36), "The Call of Samuel" (no.114) and
"The Exultation of the Virgin Mary, or the salvation of mankind, purchased
by the death of Jesus Christ" (no.232). Mary Lloyd's last exhibits on
classical themes were "The Priest of Bacchus stabs himself at the altar
(Pausanias vol.2, p.266)" (RA 1800 no.180) and "Queen Eleanor's Confession
to King Henry II" (RA 1802 no.873). Of the 20 works on mythological
themes exhibited by women between 1801 and 1809 (A), most were unambitious
works portraying figures such as Venus, Cupid and Ariadne. There is one
exception. In 1802 Miss Emma Smith, before the age of 21, exhibited "The
Parting of Hector and Andromache" which E.C. Clayton described as a "most
ambitious subject" for a young lady (14) although the quotation included
in the title suggests that the real content was parental joy in a promising
child. Between 1800 and 1809, twelve exhibited works depicted religious
or Biblical themes (B). Apart from Mrs Cosway, Maria Spilsbury was the
most important artist in these. Her four main exhibits over these years
were all ambitious compositions depicting numerous figures: "The Ascension
of the Innocents" of 1800, "Christ feeding the multitude" of 1804, "The
Return of the spies from the promised land" of 1805 and "Eli and Samuel in
the Temple" of 1807. After marrying Mr John Taylor, a poor philanthropist,
in 1809, it became necessary for her to earn a living and as a result she
abandoned classical themes, devoting herself thenceforth to portraits and
cottage scenes which were more lucrative. Her last Biblical subject was
"The Holy Family" of 1810 (BI no.31).Of the nine works on historical themes
exhibited between 1801 and 1808 (C) four deserve particular mention. One
was Mary Lloyd's "Queen Eleanor's confession"; in 1808 Miss Smith, author
of "The Parting of Hector and Andromache" exhibited "Mary Queen of Scots;
her lament on the approach of Spring"; the third and fourth were "Cleopatra
dissolving the Pearl" of 1807 and "Agrippina habited mournfully" of 1809
by Miss H.A.E. Jackson.
 Between 1810 and 1819 the classical field was almost monopolized by
Miss Jackson and Mrs Ansley, daughter of the architect Mr Gandon. Of the
fifteen works on mythological themes exhibited by women over this period (D),
five were by Miss Jackson and four by Mrs Ansley; thirteen works on
religious themes (E) included five by Miss Jackson and three by Mrs Ansley.
Historical works constituted a small minority (F). One of the latter was

an early female attempt at recent history: in 1811 Miss E.H. Trotter
exhibited "Oiselette and his son ..." who were condemned to death by
Robespierre.

The most prolific and ambitious female exhibitor of classical sub-
jects over the first twenty years of the century was Miss Jackson, an
honorary member of the Royal Academy. "Venus and Cupid" and "Poetry and
Painting" at the Royal Academy in 1803 (nos. 585 and 608) and "A nymph
bathing" in 1806 (RA no.248) were followed in 1807 by the first of her
works to focus on a particular emotive incident in the life of a famous
woman: "Cleopatra dissolving the pearl" (no. 248). She portrayed ten
other celebrated women over the next eight years: the mother of Moses,
Agrippina, Hersilia, Venus, Clymene, Clytemnestra, Naomi, Ruth, the
intrepid Judith and Rebekah and in all these she depicted emotionally
intense and usually sad moments (15). By 1820 the vast majority of classi-
cal pictures by women involved female subjects and among these the most
frequent themes were fear of or mourning over separation or death and re-
joicing at reunion. Emphasis was on the effect of such incidents on
women; their reaction to the departure or death - whether threatened or
actual - of another. As well as Miss Jackson's works examples are Miss
Smith's "Parting of Hector and Andromache" of 1802 and "Mary Queen of Scots:
her lament on the approach of Spring" of 1808; the distraught mother of
the contested child in "The Judgement of King Solomon" exhibited by Harriet
Hill in 1814 and finally Eve's despair at "The Death of Abel" exhibited
by Mrs Ansley in 1816.

Harriet Jackson's work was most frequently reviewed and criticisms
reveal the contemporary attitude to the treatment of classical themes by
women. Her picture of "Naomi and her daughters-in-law before the city of
Bethlehem-Judah" at the British Institution in 1813 gave rise to an interest-
ing discussion on the suitability of nude figures in pictures by women:
"It is grateful, in commenting upon works of art, the productions of the
fair sex, when the subject which is selected is such as displays the
talents of its author, without the liability of censure for being of a
nature that is not strictly conformable to female delicacy. It is acknow-
ledged, that a lady may have a genius for composition wherein an exhibition
of the naked figure is most congenial to her talent for painting: yet,
without wishing to encourage fastidious notions upon the subject of art,
allowing full scope to philosophical feelings as they regard study, there
are subjects of art not less dignified, where the human figure may be dis-
played, embracing whatever is fine in composition, expression, drawing and
colouring, and yet clothed. If subjects are occasionally painted wherein

the human figure is shewn entirely naked, we cannot but express our wish, that the composition should not be chosen by a lady. This picture is composed with the purest taste, is well drawn, and is conformable to the beautiful passage in sacred writ from which it is taken. It is well coloured, and has considerable pathos" (16). The author of this passage appears to have had no criticisms of Miss Jackson's technique in figure representation. The only thing he objects to is the existence of the nude in a picture by a woman. Her ability was not doubted, only her "delicacy".

In 1815 the same artist exhibited a work called "Mars subdued by Peace" at the British Institution (no.140). The following quotation was appended to the title: "He yields! He yields! The gods themselves obey;
Own her sweet thraldom; court her blissful sway.
The Loves, delighted, throng the warrior round,
And hurl the torch of discord to the ground.
The hero, conqueror of hostile fields,
To Her, and Her, alone, the triumph yields".

Again critical response is revealing: "Few subjects could have been invented more becoming the mind of a lady than this, and few ladies could be found with so many requisites to do justice to the thought, by embodying it with such truth and graceful personnification. Mars is here represented, not as the 'stern veteran', but as a man in the prime of youth. The imple- ments of war are laid aside, and the mild maiden Peace, is binding his hands with silken cords. The Loves are represented as affording their aid. There is much grace in the composition of the figures; the background, the attributes, and all the expletives, are appropriately introduced. The colouring is not only rich but eminently chaste" (17). In the same year Miss Jackson exhibited "Rebekah going down to the well" at the Royal Academy (no.14). A critic wrote: "In all the works of this fair artist we perceive the same chaste feeling throughout; the story is well recorded; Rebekah is beautiful and artless, and accords with the images raised by the sacred historians etc." (18).

Two points should be made. Firstly it is worth considering why "Mars subdued by Peace" should be thought so fitting for woman's mind. A vital factor is women's traditional opposition to war, but important also is the role of woman in the home in the nineteenth century. Broadly this resem- bled the role of Peace. For men - actively engaged in worldly affairs, frequently in warfare - women became associated with stable, moral, peace- ful values. Moral content, lack of violence and happiness of mood were often praised in works of art by women, a reflection of the role they were

expected to play in life. Secondly, attention should be drawn to the
frequency of the word "chaste". As in these previous examples, a
nineteenth century biographical account of Angelica Kauffman described
her art as faithful to "the character of her sex", continuing: "she never
painted but the most chaste imaginations" (19). While "chaste" was often
used of purity and lack of meretricious ornament in literary or artistic
style in the eighteenth and nineteenth centuries - and this definition
certainly applies to our first example of its use - the sense of "free from
indecency and offensiveness" was the most usual and is surely relevant for
the second and third. The word was a defence against the expected charge
of impropriety which might be levelled against female attempts in the
classical style and also an epitomization of what was expected of women in
art at that time (20).

In the 1820s women exhibited only six works on Biblical themes (G).
There were slightly more on historical themes (H) but these were greatly
outnumbered by mythological subjects, at least 22 of which were exhibited
by women during this decade (I). Female figures were most common and the
most important works in all three categories were by Mrs Ansley and Emma
Eleonora Kendrick. Three mythological works by the latter artist further
illustrate the themes of death and separation and their effect on women:
"Andromache mourning over the helmet of Hector" of 1820, "Agrippina bear-
ing the Ashes of Germanicus" of 1824 and "Andromache discovering Achilles
dragging the body of Hector round the walls of Troy", also of 1824. In
1825 the same artist exhibited three works portraying historical women at
the Society of British Artists. In 1821 Mrs Ansley surprised the public
with her picture, "Satan borne back to his chariot after having been
wounded by the Archangel Michael" (RA no.229) from Milton's "Paradise Lost".
A reviewer in "Ackermann's Repository" wrote: "Whatever may be our
opinion of the merit of this lady as an artist,(and it is by no means
inconsiderable), there will, we trust, be but one opinion upon her intre-
pidity, in boldly advancing to an historical subject of this description.
Our male artists had better take care lest new Angelica Kauffmann's should
arise, and successfully dispute with them the palm of academic honours. The
thing has been, and may occur again, and our best wishes must always be
with the ladies. They sometimes study philosophy, and more generally
painting, an art for which they are better adapted by nature and education
(we wish the latter gave them a fuller scope), than for exploring the
abstruse studies of speculative science. Mrs Ansley has vigour and
expression in her picture; the colouring is also forcible. Let the ladies

traverse new paths of art; our best wishes shall always attend them" (21).
The subject was considered bold for a lady presumably because of the drama
of the scene, the imagination required for its representation, the incon-
gruity of Satan as an object for woman's attention and finally perhaps on
account of the all-male cast.

In the 1830 s Miss Kendrick and Mrs E.C. Wood enlarged the gallery of
female mythological figures with Juno, Clytie, Venus, Psyche, Hero, Ceres,
Hebe and Medusa (J). From the titles it would seem that these were mostly
portraits involving little or no drama. Mythological subjects were greatly
outnumbered by religious ones at exhibitions in the 1830s (K). Miss Anne
Beaumont, the Misses Sharpe, Miss Margaret Gillies and Miss Fanny Corbaux -
all regular exhibitors in this decade - favoured the Bible as a source for
their themes. If strong emotion associated with death, separation and
reunion was the key-note of classical subjects in roughly the first twenty
years of the century, from the late 1820s the emphasis changed impercep-
tibly. The dominant theme thereafter and throughout the 1830s was less
dramatic: the importance of the family and loyalty thereunto. This theme
often involved the portrayal of maternity and maternal feelings. Numerous
Holy Family's were exhibited and the popularity of the stories of Hagar
and Ishmael, Naomi and her daughter-in-law, Moses and the raising of the
widow's son may well have been due to the illustration these afforded of
the strength of maternal and filial love.

Historical anecdotes became very popular in the 1830s. Lady Jane Grey,
Cleopatra, Mary of Burgundy, the Rose Queen of Salency and of course Mary
Queen of Scots all provided subjects as well as certain male figures such
as Richard Coeur de Lion (L). Towards the end of the decade Mrs Fanny
McIan exhibited the first of a succession of works devoted to contemporary
Scottish and Irish history. "The Escape of Alaster Macdonald, with his
Wife and Child, from the soldiers of Lieutenant-Colonel Hamilton, the
Morning after the Massacre of Glencoe, when his Father (The Chief of the
Clan) with Forty Men, Women and Children, were murdered in the Night, by
the command of the then existing Government - 1692" (SBA 1837 no.417) (22)
was followed by a work - historically more recent - called "Exiles from
Erin: They sighed for the land which they left broken-hearted" (SBA 1838,
no.591) for which high praise was given in the "Spectator". It was des-
cribed as "a scene of deeper distress and more squalid misery with much
greater force and pathos, and with equally literal truth" (than Prentis'
"The Friend in Adversity") .." The most eloquent speech of O'Connell on
behalf of his countrymen never produced a more powerful impression than

this truthful and touching delineation of human destitution, the most
unmitigated and the most inevitable"(23). In 1827 Rolinda Sharples had
exhibited the first of her grand portrayals of contemporary events in local
Bristol politics: "Suspension of Payment, County Bank" (SBA no.441). Her
second, "The Court Marshall subsequent to the Bristol Riots" was exhibited
at the Society of British Artists in 1834 (no.349). It is noteworthy that
both these artists favoured the Society of British Artists as opposed to
the Royal Academy or the British Institution for the exhibition of pictures
illustrating topical history. This may reflect the Society's more recent
establishment and less academic nature.

The most ambitious mythological work by a woman in the 1840s was Lady
Burghersh's "The Sacrifice of Alcestis" (BI 1840 no.395) taken from
Euripides' play on the subject (24) (M). The same familial subjects were
drawn from the Bible: the two Marys, Hagar and Ishmael, Ruth and Naomi,
Rachel and Leah, Moses and Jephtha's daughter were variously depicted by
Miss Margaret Gillies, Fanny Corbaux and two younger artists - the Misses
E. and M.A. Cole, amongst others (N). Historical subjects vastly out-
numbered the last two categories in the 1840s. Firstly there were many
incidents, and these often sad, in the lives of women in history (O). Death
and separation reappeared as strong themes, but in a different light to that
which prevailed in the first two decades of the century. Instead of the
effect on women of the death of someone they love and the effect on women
of sad partings in which they are left, in the 1840s the focus was on the
death of women themselves and their own positive exclusion, often through
imprisonment. Marie Antoinette, Vivia Perpetua and Portia were all por-
trayed just before their death. The first two were shown with members of
their family prior to their execution; Portia suffocated herself with
burning coals. All were victims of persecution. Elizabeth Woodville,
Queen of Edward IV, was twice represented in sanctuary at Westminster with
her son the Duke of York and Arabella Stuart was shown in prison. Mater-
nity was a recurrent theme and Lady Jane Grey the most popular figure. The
second group of historical works comprises four more pictures by Mrs McIan
on sad aspects of recent history: "A Buccaneer's Daughter Releasing a
Prisoner" (BI 1842, no.281), "The Dying Cateran" (BI 1843, no.188) (25),
"Highland Refugees from the '45 on the coast of France, looking towards
Scotland. 'We'll maybe return to Lochaber no more'" (BI 1845, no.409) and
"Soldiers' wives waiting the result of a battle" (HPG 1849 no.92) (26)

The women artists most highly praised in the 1840s for their essays in
classical art were Mrs McIan, Fanny Corbaux, Margaret Gillies and Jane
Sophia Egerton. Fanny Corbaux's "Properzia Rossi" at the New Society of

Painters in Water-colours in 1841 about "the love-lorn sculptress who
carved the image of her disconsolate self as Ariadne, to express her con-
suming passion" was described in the "Spectator" as "the nearest approxi-
mation to a fulfilment of the demands of a subject of serious interest" in
the exhibition (27) and in 1848 when she exhibited "Leah" (187) and
"Rachel" (206) at the same gallery a reviewer wrote: "The art of this
painter is expressed each succeeding year with greater confidence; and
this confidence being the result of experience, might lead her usefully to
larger essays" (28). Miss Gillies' "Ruth and Naomi" (BI 1846 no.393) was
described as "in many points successful beyond what ladies have generally
accomplished" (29). At the Royal Academy in 1847 Miss E. Cole exhibited
"Portia", the account of whose death she gleaned from Valerius Maximus.
It was called "one of the most interesting of its class in the exhibition"
(30.). Mrs McIan received high praise constantly. In 1842 the "Art Union"
referred to her as "almost the only one of her sex who essays loftier sub-
jects in Art" and "a lady who has gone far to establish the intellectual
equality of the sexes", remarking: "Her works are always of a high order,
both in conception and execution" (31). Of "The Dying Cateran" at the
British Institution in 1843, a critic wrote that "in subject as well as
execution it puts to shame the productions of many who are wont to be con-
sidered learned in the Art" (32). Again in 1845, her "Highland Refugees"
were described as "remarkable for boldness of design and good drawing" (33).
The most acclaimed single picture on a classical theme by a woman in the
1840s was Jane Sophia Egerton's "Vivia Perpetua" at the New Society of
Painters in Water-colours in 1848. According to the "Art Union" the subject
was taken from Milner's "Church History" although a more recent version of
the story did exist in the form of a dramatic poem by Sarah Flower Adams (34).
It told of "the firm faith in Christianity of a young lady of quality at
Carthage. Her father implores her to recant but she is inexorable" (35).
Both the "Art Union" and the "Athenaeum" gave full praise: "As the work
of a lady, the drawing is extraordinary in force and in those qualities dis-
coverable only in the works of the masters of the Art" (36). And in the
"Athenaeum": "Miss Egerton has exhibited courage in her selection, from
early church history, of a subject whose due illustration makes demands on
such studies as are rarely attainable in female Art-education. 'Vivia
Perpetua" (329) testifies to a true disposition for the historic proprieties
.." (37).

 A large number of religious pictuers were exhibited by women in the 1850s.
Jessie Macleod, Eliza Sharpe, Fanny Corbaux and Emily Farmer were
important contributors in this genre. Female figures were most usual and

these included the mother of the Prodigal Son, Hannah, Miriam, Mary the
sister of Lazarus, the Virgin Mary, Hagar, Ruth and Naomi, Herodias and
Salome, Esther and Jephtha's daughter (P). Historical works in the 1850s
also focused on women, and particularly, as in the 1840s, instances of their
heroism and suffering: the Martyr of Antioch (St. Margaret), Lady Jane
Grey, Beatrice Cenci and Vivia Perpetua were all shown on the eve of their
death (Q). Two other themes emerge. Scenes from the margins of Scottish
history retained their popularity and in these also sadness was the usual
mood (R). Secondly the 1850s saw the first of a long succession of sub-
jects from domestic genre by Mrs E.M. Ward. Her "Scene from the Camp at
Chobham, in the encampment of the 179th Highlanders" (RA 1854, no.582) and
"John Howard's farewell to England - Taking leave of his tenants at
Cardington" (RA 1858, no.360) were the first of these (38). Five other
works may be included in the same category: "Miss Jessie Macleod's "The
Childhood of Haydn" (BI 1852, no.46) (39), Miss Emily Macirone's "Alfred
and the Monk" (Alfred the Great, when a child, learning from a monk) PG
1852, no.366), Miss A.B. O'Grady's "A Domestic Scene in the Time of Charles
the First" (SBA 1852, no.145),"An Incident in the Life of Rubens" (BI 1853,
no.368) by Ambrosini Jerome (40), "An Incident in the Last Days of the Poet
Collins, as described by the Rev. Mr. Shenton" (SFA 1857, no.158) by Mrs
Musgrave (41) and "The meeting of Henry VIII and Anne Boleyn, in Sir
Thomas Maryon Wilson's garden, Charlton" (SFA 1858, no.80) by Lady Tulloch.

Allegory registered significantly for the first time among women's
productions in the 1850s (T). The majority of these were based on contrast,
the most elaborate instances of this being Mrs McIan's "Captivity and
Liberty" of 1850, Margaret Gillies' "The Past and the Future" of 1855 and
Anna Blunden's "Past and Present" of 1858.

Highest praise was accorded Miss Fanny Corbaux for her "Miriam" and
"Hannah" at the New Society of Painters in Water-colours in 1852 (42), Mrs
E.M. Ward for "John Howard's farewell to England.." at the Royal Academy in
1858 - a picture which was said to surpass "The production of many of her
masculine and even highly reputed contemporaries" in "vigour of execution"
(43) - and once again Mrs Fanny McIan. Her "Captivity and Liberty" of 1850
which contrasted the imprisonment of two female gypsies and their children
with the freedom of a bird who flies in through the barred window of their
cell, was described as "a beautiful and truly feminine subject" with "a
depth of feeling that makes it come home to every heart" (44) and "a work
possessing qualities which would do honour to eminent professors of the
Art" (45). Her "Departure of Highland Emigrants" of 1852 was awarded the

fullest tribute: "While we feel the appeal of the dirge played by the piper, we sympathize in every well-depicted burst of emotion. Of this picture we can only say that we have never seen one so perfectly free from license. It is all honest daylight effect and places this lady among the most powerful sentimental painters of the time" (46).

Very few works with mythological subject-matter were exhibited by women in the 1850s or 1860s (U). Biblical subjects also declined in the 1860s and the few that were exhibited differed from those that preceded in the lack of emphasis on female figures (V). The two most interesting works in this category correspond with many historical productions of this decade in their themes of female heroism and suffering. One was Mme. de Feyl's "Jephtha and his daughter", who heroically accepts the necessity of her death, of 1864; the second, by the same artist, was "Rizpah Mourning for her Sons" of 1866. Women exhibited at least nine allegorical works in this decade (W). Historical works outnumbered all these categories in the 1860s. The decade was characterized by portraits of women in history and, as in the 1850s, examples of their bravery and suffering (X). Vivia Perpetua was depicted once again - this time by Eliza Bridell. As in the last two decades, war was a strong theme, but not, as previously, in a Scottish setting (Y). There were also several pictures with subjects based on scenes from the childhood of famous people, mostly by Henrietta Ward (Z).

Henrietta Ward was paid more critical attention than any other female historical painter in the 1860s. She won approval by her choice of subjects which almost always featured women and children - she frequently drew on Miss Strickland's "Lives of the Queens" -, her lack of sentimentality and
Fig.8 her "masculine" style. Of her exhibit at the Royal Academy in 1863 it was written: "Mary Queen of Scots is a character on which writers and painters have indulged in a sentimentality that has not unfrequently grown sickly. Mrs Ward - to her praise be it spoken - has escaped this snare. The picture possesses a power which preserves it from the approach of weakness. The queen, by her simplicity, wins sympathy; by the command of her bearing, quiet yet regal, she seems to say she needs not our pity. This is thoroughly a woman's subject which a woman's heart and hand may best understand
Fig.9 and paint" (47). In 1866 her picture of "Palissy the Potter" was described as "truthful and picturesque, earnest and heartfelt" (48). Of her "Scene
Fig.10 from the Childhood of Joan of Arc" of 1867 a reviewer wrote that "it would be difficult to go beyond this charming composition whether for interest of incident or for skill in technical treatment" (49). In conclusion, when she exhibited her "Scene from the Childhood of the Old Pretender" in 1869, a reviewer remarked: "Her various and varied subjects are so many proofs

of reading and reflection: always avoiding the commonplace yet carefully eschewing the repulsive, even the uninteresting, her pictures are sources of instruction no less than of pleasure" (50). The only other woman artist to receive high praise for an historical picture in the 1860s was Miss Osborn in 1861 when she exhibited "The Escape of Lord Nithisdale from the Tower" at the Royal Academy. As in so many other cases praise was accompanied by surprise at such an achievement by a woman: "The subject of this picture is a bold one for a lady, and she has treated it with more strength and historical power than are usually ascribed to her sex. Some of the artistic lords of the creation, who succeed in treating such subjects with great feebleness, must begin to feel rather jealous, as they certainly ought to feel very much humbled, at being thus outstripped in their professional race. The incident is a difficult one to portray, from the mingled feelings requiring to be expressed; but in the embodiment of these, especially in the principal head, Miss Osborne has achieved a most triumphant success" (51)

Fig 11

Mrs Ward excelled in a type of historical picture which was considered eminently suitable for women artists. A fuller idea of what was expected of women at this time may be gleaned from a review in the "Art Journal" of Madame Jerichau's "Italy" (RA 1860). The reviewer described an attempt to guess the content of the picture from its title. "Painted by a lady, it must be a nymph with bright and flowing hair, beset with all the sunny sweets of that luscious land? No. Then a glorious landscape, the essence of Byron and Turner, - a visionary Hesperia, the golden promise of the gods? No. Mme. Jerichau is perilously political; this is a picture which can only hang with impunity in a free atmosphere. Italy is represented by a young man, on whose brow the sufferings of his prostrate country have settled the darkest cloud of despair" (52). The same assumptions prevailed in 1860 as in 1815 (53). Optimism, encouragement, beauty were expected of women, not disillusionment or harsh realism.

The picture may be completed by an examination of a review of Jane Benham Hay's "Tobias restoring the eye-sight of Tobit" (RA 1861) in which the critic described very clearly the bounds which were set to female endeavour: the work "is one of two pictures of a character peculiar to themselves, and still more peculiar when looked at as the labour of a lady artist. The subjects are imposing in character, and by no means destitute of ability in general treatment; while Mrs Hay shows a perception of harmonious colour which many more efficent and popular artists might envy. But with all the good qualities - and respectable drawing ought to be numbered in these, - there is such an absence of reality, and so much

pretentious striving after the classical and the antique, that even the
pencil of St. Luke himself, had he been a better painter than we have any
reason to suppose he was, could not have made the class of subjects popu-
lar, or even interesting, to which Mrs. Hay has, with but indifferent
success, devoted herself. Ladies, in Art as in other subjects, are more
generally endowed with the perceptive, than with the reflective faculties.
Mrs Hay has no special exemption from this general law; and, if she would
devote the artistic knowledge and patient skill displayed in these pictures
to scenes and subjects by which she must every day be surrounded, she
might successfully increase a reputation that will most surely be wrecked
against such old rocks as 'Tobias restoring the eye-sight of Tobit'. Only
the very highest qualities of genius could imbue such subjects with
sufficient life and reality to make them either pleasure-giving or profit-
able to the men and women of these generations; and it is doing this lady's
ability no injustice to say, that she does not give evidence of possessing
such indispensable requirements" (54). Implicit in the first of these
reviews, explicit in the second, is the assumption that women are incapable
of serious thought . They are considered deficient in the "reflective
faculties" and, according to the latter writer, gifted only in description.
Such views must surely have influenced women's choice of theme, either
deterring them from ambitious attempts, or inspiring a will to provide
evidence to the contrary.

The 1870s witnessed a revival of myth in the hands of a new and much
larger generation of women artists. Louisa Starr, Marie Spartali, Mrs
Thornycroft, Mrs H. Champion, Jessie Macgregor, Edith Martineau, Blanche
Macarthur and Evelyn Pickering (Evelyn de Morgan) were the most notable of
these. Some of the figures portrayed were Undine, Chloe, Brynhilde, Cassandra,
Io, Orpheus and Eurydice, Atalanta, Danae, Circe, Pomona, Medea, Oenone,
Hero and Leander, Psyche, Cadmus and Harmonia, Iduna, Antigone, Ariadne
and Venus (A1). The number of religious pictures remained low. Female
suffering figures in two of these: Miss J.K. Humphreys' "Rachel weeping for
her children" of 1871 and Miss E. Courtauld's portrayal of the sorrowful
Virgin Mary at "Daybreak on Mount Calvary, after the Entombment" of 1872.
In 1874 Miss Justina Deffell exhibited "Judith going down to the Camp of
Holophernes". Delilah, Jephtha's daughter and Ruth, amongst others, also
figured in works of art of the 1870s (B1). Historical works were again most
numerous in this decade and may be divided into four main sorts. Portraits
of famous women from history had always been popular with women artists
although they had probably never been exhibited in such large numbers:
Saint Barbara, Isolde, Rosamond, St. Monica the mother of St. Augustine,

Joan of Arc, Lesbia, St. Agnes, Heloise, Katherine of Alexandria, Beatrice,
Sappho, St. Cecilia, Charlotte Corday, St. Margaret, Mary Carmichael were
all represented (C1). The second and third types equally were not new:
scenes, often moving and emotional, from the lives of women in history (D1)
and domestic incidents in the lives of famous men (E1). The most notable
exponent of this type was Mrs E.M. Ward although other women artists such as
Miss Jessie Macleod and Catherine Adeline Sparkes also excelled in it. The
fourth type of historical work was unprecedented. From 1867 Elizabeth
Thompson exhibited military pictures and battle scenes based on recent
history (F1) (55).

Mrs Ward and Lady Butler were the most celebrated women artists of the
1870s. In 1874 it was pertinently written of Mrs Ward that "the art she
has always at command may not interpret the highest kind of pictorial
beauty, but it appeals to a larger class of spectators than a nobler achieve-
ment can always command" (56). Mrs Ward excelled in narrative painting and
in the selection from history of incidents with human and often domestic
interest. They were sympathetic and easy to understand. A few of her works
also had a moral purpose and it was one of these that achieved greatest pop-
ularity in the 1870s. Her portrayal of Elizabeth Fry visiting Newgate in
1818 (RA 1876, no.120) received royal and public favour: it was greatly
admired by the Queen and was engraved. "The picture is justly classed
among the best productions of British Art, and when exhibited, excited uni-
versal admiration, not only for its merits as a painting, but for its value
as a composition. The subject is one of the highest interest; it does
that which Art always professes to do - teaches. It was a noble theme to
select.." (57). However, Mrs Ward was gradually superceded in the public
eye by Lady Butler. Reviews insisted that the main reason for the latter's
success and her chief contribution to military painting was her excellent
characterisation of soldiers - in other words, her humanisation of war. She
was described as the only painter "who can seize accurately upon sudden
phases of individual character, and combine the various motives of a varied
group in such a way as to secure the effect of harmonious composition" (58).
Just as Mrs Ward was praised for her emotional insight into the lives of
famous people, her ability to make such people human, often by portraying
them in a domestic context and thus evoke sympathy in the spectator, so with
Lady Butler. Instead of producing the usual military pictures - in the words
of Charles Yriarte "ces grandes vues d'ensemble qui parlent à l'esprit et
à l'intelligence beaucoup plus qu'au coeur", she dwelt on expressions, on
the individual responses of soldiers to involvement in military events and
thereby engaged the public more fully in the spectacle (59). There was one

essential difference between these two artists. We have seen how Mrs
Ward's most acclaimed picture of this decade - "Newgate 1818" - was
praised for its educational value. Now this was a subsidiary element in
her work. Mrs Ward attached most importance to the humanisation and
realisation of history: "I have always considered that the art that can
conjure up past events and make them a living reality is something of an
achievement, well worth all the pains bestowed upon it" (60). Lady Butler,
on the other hand, in intention at least, was highly moral. She was em-
phatic on the necessity of "a worthy subject" and on the importance of
"touching the people's heart" (61). Both these artists were successful
historical painters. Both were scrupulous in their research and took pains
to be fully comprehensible - in Mrs Ward's case by means of long descriptive
titles. Part of their appeal rests on their successful humanisation of
great people and great events. But while Mrs Ward excelled at bringing
history to life in incidents remarkable only for their sentimentality,
Lady Butler inspired direct emotional sympathy for heroic actions: she
did not merely interest her public, she edified them.

In the 1880s a major change occurred in the type of classical work
exhibited by women. Historical subjects declined and there was a vast
increase in pictures and sculptures with mythological and allegorical sub-
ject matter. The Bible, too, came back into favour as a source of inspira-
tion. Mythological works tended to take the form of female portraits and
their main exponents were Catherine Sparkes, Ellen M. Rope, Evelyn
Pickering (Mrs De Morgan), Jessie Macgregor, Isabel de Steiger, Dorothy
Tennant, Constance Phillott, Beatrice Angle and above all Henrietta Rae (G1).
The latter exhibited "Ariadne deserted by Theseus" and "A Bacchante" at
the Royal Academy in 1885, "Eurydice sinking back to Hades" and "A Naiad"
in 1887, "Zephyrus wooing Flora" in 1888 and "The Death of Procris" in
1889. The occasional intrusion of a dramatic element in her works sets
them apart from other mythological pictures by women. Jessie Macgregor
should also be excepted in this sense on account of two pictures exhibited
in 1882 and 1883: "The Wail of the Valkyrs on the death of Baldur, the
Scandinavian Sun God. When Baldur died, Hela, ruler of the dead, promised
that he should return to life if everything animate and inanimate wept
for him..." of 1882 and "The Wanderings of Freyja (Norse Goddess of Love
and Beauty) in search of her husband, Odur the Immortal. 'Then she began
a weary, weary quest...'" of 1883. The most frequent allegorical subjects
were Past, Present, Charity, Poetry, Truth, Spring and Youth (H1).

Ruth, Hagar, Eve, Rebecca, Judith, Mary of Bethany, Deborah, Esther, Mary and Salome were the favourite Biblical figures. Theresa G. Thornycroft, Kate Gardiner Hastings, Lady Waterford, Ella Bedford and Rose Barton occasionally attempted more dramatic and ambitious subjects such as the feeding of the multitude, blind men begging by the wayside, the angels appearing to the shepherds and the massacre of the Innocents (I1). The work of Lady Butler excepted (62), historical pictures by women in the 1880 s consisted mostly of portraits of female saints (J1).

Fig.12 The most successful new talents of the 1890s were Henrietta Rae (Mrs Ernest Normand) and Anna Lea Merritt. "Love Locked Out" by the latter at the Royal Academy of 1890 was bought by the Chantrey Bequest for £250 and became extremely popular in photogravure reproductions (63). In 1894

Fig.13 Henrietta Rae exhibited "Psyche before the throne of Venus" at the Royal Academy. It was a large picture, and, being favourably hung, attracted much attention. The "Times", while criticizing the work for over-prettiness, conceded that "many an Academician might be well pleased to have painted it" (64). Lingering prejudice against the existence of the nude in works by women emerges from a review of her picture "Apollo and

Fig.14 Daphne" at the Royal Academy in 1895: "That Mrs Normand should succeed as well as she does in her studies of the nude, is brave demonstration that women's gifts are little more limited than man's. But even Mrs Normand we prefer when she is dealing with the draped figure; .. If we must have the ladies paint the nude, let them be single figures. Her touch is nice, and colour sweet; but when she comes to such a subject as "Apollo and Daphne" she very nearly breaks down" (65). Louise Jopling, Annie Swynnerton, Edith Martineau, Evelyn Pickering, Beatrice Angle, Constance Phillott, Kate Gardiner Hastings, Gertrude Demain Hammond, Marianne Stokes and Mary Raphael, amongst others, also exhibited mythological and allegorical pictures in the 1890s. The subjects were mostly female and from the titles one must conclude that the majority were portraits (K1).

There were not many Biblical subjects among exhibited works of the 1890s (L1). Historical works, also, remained infrequent and consisted of portraits of mostly female saints, scenes from the childhood of the great and a few portrayals of famous men and women generally connected with the arts (M1). Lady Butler sent military paintings to the Royal Academy (N1) and Margaret Isabel Dicksee continued the tradition created by Mrs E.M. Ward with a succession of works based chiefly on incidents in the lives of famous artists (66). One other theme emerges from an examination of historical works exhibited towards the end of the century. From the 1880s works appeared showing the effect of war, past and present, on women's lives.

Blanche Macarthur's "An Ironside's Bride" (SLA 1881 no.33) bore the
quotation:

"They left their homes and wives,
And ranged for freedom's cause around the farmer of St. Ives"

Fig 15 In "War" (RA 1883, no.560) Anna Lea Merritt portrayed a group of women on
a balcony or loggia watching troops passing in the streets below. Jessie
Macgregor exhibited several works on this subject. "For those in Peril on
the Sea" of 1884 (RA no.95) showing women with anxious faces around a
piano on which this hymn is being played, was followed, in the 1890s, by
Fig 16 three works of a more strictly historical nature: "In the Reign of Terror"
(RA 1891 no.1109) depicts a woman clinging fearfully to a cot containing
her baby: "News from Trafalgar - 'Officers killed and wounded on board
the Ajax, - none'.." (RA 1893, no.909) shows a woman seated by a spinning
Fig 17 wheel and overhearing the reading of news in the next room; in "Arrested.
'Last night Feodora Alexandrovna was surprised at midnight and arrested'
Extract from a letter from Russia" (RA 1894, no.311) the woman is shown
standing behind a desk covered with books and inkpots. Relevant also are
Edith Mendham's "The Reign of Terror" (SLA 1895 no.277) and Mrs Emily
Barnard's "A Reservist's Wife" (SWA 1900, no.84) (67).

It is broadly true to say that the key-note of classical works by
women during approximately the first three decades of the nineteenth cen-
tury was fear or anxiety and in particular, as has been seen, women's fear
of or mourning over separation or death. Generally speaking, women were
shown in a passive light, reacting to the departure, absence or death of
another. The most obvious reason for the predominance of this theme is
surely women's experience of the Napoleonic Wars: the constant possibility
and frequent incidence of male death. Classical pictures of this type
were therefore subjective - reflecting a state of mind.

The nineteenth century, especially from 1830, abounded in literary
and purely descriptive accounts of famous men and women from ancient, med-
ieval and modern history, legend, mythology and the Bible (68). This pro-
liferation was often attributed to the breakdown of old certainties about
religion, morality and the origins of man which resulted both in nostalgia
for the past when values were clearer and an attempt to edify the modern
mind by the contemplation of instances "of heroic action, or heroic
suffering" (69). In art the first clear ideal emerged in the 1830 s with
the idealisation of the family in Biblical scenes. There are two possible
explanations for the emphasis bestowed on the family over these years.

Firstly, the family became the refuge of principles and morals threatened by the new values created by the industrial revolution. Loyalty to one's family, maternal and paternal feelings, love between husband and wife, were virtues which remained unaffected by changes in the outside world. Secondly, the family may have represented a world of peace and stability at a time when class conflict and Chartist riots made revolution in England a distinct possibility.

This ideal still dominated religious pictures of the 1840s. But the main theme which arises from classical works in general from the 1840s right through to the 1860s is a more positive and heroic ideal. The sublimation of the family was in some sense defensive. Far more ambitious and energetic was the idealisation of acts of heroism and suffering in the lives of women, whether famous or obscure. The fact that such acts should be given an almost religious aura by the moral and even didactic intention behind their illustration, is partly explained by the evangelical revival which emphasized the practical application of one's beliefs: the demonstration of faith through acts. The note of optimism, above all of construction, is surely a product of the wave of prosperity which swept England from the late 1840s.

Whereas classical pictures by women in the first three decades of the century reflected a state of mind, in the middle years such works tended to prescribe a code of moral conduct.

In the 1870s another change is noticeable. Classical works ceased to convey moral ideas. Instead a large number of pictures (and sculptures) were exhibited with little more than anecdotal interest. A few, such as the pictures of Lady Butler, still upheld moral values, but most did little more than reveal "an age of general indecisiveness", what Walter Pater called the modern "relative" spirit (70). Nostalgia was the key-note. Refuge was taken in the Middle Ages and the mythological world, but without any sense of their relevance for the present.

B. Literary Subjects

Literary works of art may be divided into two main types: firstly
that which directly illustrates a scene in a novel, play or poem, with a
title referring to characters and/or a quotation from the relevant work.
Secondly that in which the literary quotation acts as a gloss, serving to
describe or give another dimension to the picture. In the first the
picture illustrates the literary source, in the second the quotation
"illustrates" the picture. Broadly speaking there were more of the former
type during the first half and more of the latter towards the end of the
nineteenth century (71).

For approximately the first twenty years of the century most literary
works of art by women illustrated poetry: that of Samuel Rogers, William
Hayley, John Milton, Oliver Goldsmith, Leigh Hunt, Ariosto, Mr Sotheby,
Robert Southey, Matthew Prior, Edward Fitzgerald, William Cowper, James
Thomson, Mrs Robinson, Robert Burns, William Collins, Sir Walter Scott, Lord
Byron and Shakespeare. Some prose sources were Richard Bloomfield's
"Rural Tales", Mrs Rowe's "Letters from the Dead to the Living" and Oliver
Goldsmith's "Man of the World". The majority of these "literary" works
share two common points: female subjects and the theme of sadness (01).
Mothers and children were the subjects of several works: an example from
our first category of literary work, in which the picture illustrates liter-
ature, is "The spirit of a child writing a letter of consolation to his dis-
consolate mother" from Mrs Rowe's "Letters from the Dead to the Living", by
Miss Maria Spilsbury of 1808; a unique instance of the second type, in
which literature is used as a gloss, is Louisa Sharpe's "A mother and dead
child" of 1818 (RA no.830) to which the following quotation was appended:
"Sweet infant! withering in thy tender hour,
Oh sleep! she criecd, and rise and fairer flower" (Darwin)
Mrs S. Jones illustrated her own poetry in two works exhibited in 1809. In
one Charity descends "to sprinkle comfort o'er the widow's breast, / And
gently wipe away the orphan's tear"; the second depicted Edwina who died
through excess of suffering, shortly after her father, Egbert. One other
work should be emphasized. In 1809 Miss Croft exhibited "Ophelia". The
suffering of Ophelia was one of the most popular literary subjects with
women artists in the nineteenth century.
In the 1820s there was a change of emphasis. Poetry was occasionally
illustrated but prose sources were more frequent, particularly the novels
of Walter Scott. As before female subjects were favoured. Recurrent names
in works of this sort are Eliza Jones, Emma Eleanor Kendrick and Ann

Beaumont (P1). In the 1830s literary works were extremely numerous.
Walter Scott maintained his popularity: Ellen Douglas from "The Lady of
the Lake", Anne from "Anne of Geierstein", Rebecca from "Ivanhoe", Jennie
and Effie Deans from "The Heart of Midlothian", Alice Lee from "Woodstock"
and the Fair Maid of Perth were all depicted by a wide range of artists
including Ann Beaumont, Mrs Mee, Fanny Corbaux, Louisa Sharpe, Lucy Adams,
Sarah Setchel, Fanny McIan and Sarah Elizabeth Thorn (Q1). Byron's heroines
- Bianca, Genevra, Gulnare, Myrrha, Medora and the Maid of Athens - were
also popular as were the female characters from "The Vicar of Wakefield" by
Oliver Goldsmith and Hinda and Nourmahal in"Lalla Rookh" by Thomas Moore (R1).
Shakespeare's heroines - Ophelia, Olivia, Juliet, Portia, Bianca, Miranda,
Cordelia and Lady Macbeth - were frequently represented, in connection
with which it is worth mentioning a two volume work published by Anna
Brownell Jameson in 1832 called "Characteristics of Women, moral, poetical,
and historical" and based entirely on heroines from Shakespeare's plays (S1).
Milton, Tasso, Pope, Cervantes and several other authors as well as contem-
porary magazines such as "Blackwood's" and the "Spectator" also provided
scenes and heroines for illustration in art (T1).

The primary importance of character portrayal in works of this sort
emerges from reviews in the press in which the word "expression" recurs
again and again. Of Miss Fanny Corbaux's "Juliet" (Shakespeare) and
"Rebecca" (Scott) of 1831, a critic wrote: "An attempt is made to convey the
expression of the characters, which is by no means unsuccessful" (72). The
following review of Mrs Seyffarth's depiction of a scene from Moore's
"Lalla Rookh" in 1835 is typical : "Her scene from 'Lalla Rookh', of the
young poet chanting one of his stories to the Princess, is quite worthy of
the subject. The lady is just enough concerned to give interest to her
lovely face, and Old Fadladeen looks as dull and perplexed as some of his
brother critics. The faces of the fair attendants are radiant with
beauty; especially one with a wreath of roses, and another whose bright
eyes are made more lustrous by a starting tear" (73). Such pictures were
mostly judged according to the degree of their conformity to the literary
source. The majority of literary works in the 1830s were of this illus-
trative type. A substantial minority, however, were of the second sort,
in which literature is used as a gloss to illustrate a general theme or
subject (U1). In all but one of these the glosses are poetical, and
female experience is a common theme: poetry is used to elevate and deepen
the experience of love, arranged marriages, idleness, motherhood, death
and widowhood. In two cases the poetry is by the artist herself: in 1836
Lucy Adams added eight lines of her own to a picture of a young girl

called "Dolce far niente" and in 1837 Harriet Tucker appended the
following lines to a picture of "La Jeune Veuve, or the Young Widow", a
subject popular with women artists:-

"Alas! thou'rt a lone one,

Reft of thy partner dear:

With prospects bright before him

Death closed his brief career"

Two works of this type portrayed women artists. The first, by Mrs Eleanor
Wood, was called "The Sketch" (1832) and showed a woman sketching her lover.
"The Young Poetess" of 1834 by Miss Lucy Adams was accompanied by five lines
from Alaric A. Watts which aptly sum up the type of subject favoured by
women artists and the type of subject also which was considered worthy of
poeticisation:-

"Some low, sweet dirge, of softest power,

To stir the bosom's inmost strings;

When friends departed, pleasures fled.

Or a sinless infant's dying bed -

Are the themes thy fancy brings!"

Mrs Harrison's practice of including quotations in the titles of her flower
paintings became extremely popular towards the end of the century.

Many literary heroines were portrayed in the 1840s: Rosalind, Celia,
Ophelia, Cleopatra, Juliet, Lady Macbeth, Beatrice, Imogen, Desdemona, Mrs
Ford, Perdita and Portia from Shakespeare; Effie and Jeanie Deans, the Lady
of the Lake, Luch Ashton, Rebecca, Amy Robsart, Margaret Ramsay from Walter
Scott; Nell and Dolly Varden from Charles Dickens; Elizabeth, Sybil and
Phoebe Dawson from George Crabbe; Una and Caelia's three daughters from
Edmund Spenser; Nourmahal from Thomas Moore; two versions of Ginevra, one
from Samuel Rogers' "Italy" and one from Schiller; Margarete and the Erl
King's daughter from Goethe; Laura from Petrarch; Properzia Rossi and Lady
Arabella Stuart from Mrs Hemans; the Widow Jones and Jane from Robert
Bloomfield; the Lady of Lyons from Sir E. Bulwer Lytton; Helen from Maria
Edgeworth; Sybil from William Harrison Ainsworth; Musidora and Lavinia and
her mother from James Thomson; Jennie from the "Ballad of Auld Robin Gray"
by Lady Anne Barnard; Katty Macane from Mrs S.C. Hall; Comala from Ossian's
Poems; Christine from James Fenimore Cooper; Beline and Toinette from
Molière's "Le Malade Imaginaire"; the Lady from Milton's "Comus"; Long-
fellow's Evangeline; Sancho's daughter from "Don Quixote"; Griselda from
Chaucer; heroines of old Scotch Songs; Bernardin de Saint-Pierre's Paul
and Virginie and others, including heroines from fairy tales and periodical
literature (V1).

The same decade witnessed the increasing popularity of works on
general emotional themes mostly connected with female experience, with
titles including poetical quotations. Four of the most recurrent themes
were maternal love, longing for home, sadness or mourning over illness or
death, and love. In four of the eight works about motherhood death is
involved: in two the death of the child, in one that of the father and
in one more that of the mother (W1). Fanny McIan's "The empty cradle" of
1843 was seen by William Macready when the artist was still working on it.
He described it as representing "an interesting woman holding a child's
shoe in her hand, and looking mournfully at a cradle on which the clothes
were tumbled about" (74). "Affection weeps, but heaven rejoices" was the
gloss which accompanied the work when exhibited at the Royal Academy.
Seven pictures - four of them by Mrs McIan - expressed sadness at being
far from home and loneliness (X1). In two of these the artist adapted
quotations to her own purpose; in both cases male subjects in the original
poems became female in the extracts. Thus Fanny Corbaux's "The Stranger's
heart is with her own" ("his" in Mrs Hemans' original) of 1840 and Mrs
McIan's "The Slave's Dream" of 1847. The latter bore the quotation "Again,
in the mist and shadow of sleep, /She saw her native land" whereas in
Longfellow's poem, "The Slave's Dream", the second line reads, "He saw his
native land". Mrs McIan's picture portrayed a female slave, chained and
asleep on the slave deck; on the left was a misty vision of herself and
her husband caressing their child (75). Death and illness were the sub-
ject of nine pictures in this decade and at least five of these depicted
the effect of death and illness on women (Y1). Love and marriage were pop-
ular themes in works of this type (Z1). In two interesting pictures
quotations were taken from "The Siller Crown" by Susanna Blamire to illus-
trate the theme of love versus wealthy arranged marriages. Mrs Seyffarth's
"Wedding" of 1842 bore the following lines:
"Oh! what's to me a silken gown,
Wi a poor broken heart?
And what's to me a siller crown,
Gin frae my love I part?"
It was described in detail in the "Athenaeum": "This is not a love-match,
in which a Damon in velvet leads out a Cynthia in satin,- both young and
smiling, such as we should have expected from Mrs Seyffarth's known prefer-
ence for what is dainty and delicate. It is another version of the old
tale of beauty sold to fashionable Age - of the broken heart covered by
the silken gown: - and very sweetly it is told, with some touches of nature
and feeling, which entitle our artist to a high place among designers of

domestic subjects. The bargain, we opine, has been made by the mother;
for she walks behind the pair, her full face swelling with quiet com-
placency, and not a wrinkle of misgiving on her brow because her son-in-
law is old and withered and lean, - a mummy in a splendid cerecloth, whose
airs and graces have a touch of the foppery of Hogarth's old rakes. The
father is less unscrupulously satisfied. He is struggling with deep
grief or misgivings, that will arise, and while he is unconsciously patting
the head of the little boy, who is wondering at the satin of the bride's
garment, he is watching his daughter and questioning himself sternly, with
an 'Ought this to be?' which amounts to the first stirrings of regret and
remorse. The bride herself is very sweet and lovely .. and the Romeo, to
whom she looks an agonized farewell, as he leans distractedly against the
window, is a 'proper youth' .. The best figure .. is that of the little
girl, whose feminine love of finery is not so strong as the feminine sym-
pathies which make her bend a tearful look on her sister to inquire what
that strange trouble on her countenance may mean" (76). The second picture,
ig.18 with a longer quotation from the same poem, was by Sarah Setchel and
depicted "an aged mother appealing to the vanity of a spirited but simple-
minded maiden" (77). In two unusual pictures of the 1840s love was assoc-
iated with poverty, misery and even death; in both cases the woman's lover
or husband was in prison. The most important of these was Sarah Setchel's
ig.19 "The Momentous Question", which, when exhibited at the New Society of
Painters in Water-colours in 1842, bore a long quotation from Crabbe's
"Tales of the Hall" (78). Poetry was also used to convey the thoughts of
the principal figure in a picture; sometimes the figure was praying or
reading the Bible (A2). In one instance childhood was idealized through
verse and in three others poetry was used to emphasize the expression or
character of the main subject (B2). Mrs Harrison included poetical quota-
tions in the titles of some of her flower paintings and so did Mrs
Hurlstone and Fanny and Louisa Corbaux in animal pictures (C2).

The most acclaimed literary productions by women of the 1840s were
the work of Mrs Fanny McIan and Miss Sarah Setchel. The former was
praised for two pictures illustrating scenes from Dickens. In connection
ig.20 with her 1841 exhibit, "The Little Sick Scholar", a critic wrote: "An
author has rarely received greater justice from an artist" (79) and in
1842, when she exhibited "Nell and the Widow", it was written: "A narrow
examination of this picture elicits testimony of powers rarely seen in the
productions of ladies; indeed, in substantial handling, it is an example
that many of our artists might follow etc." (80). But the chef-d'oeuvre
ig.19 of the 1840s was Miss Setchel's "The Momentous Question" of 1842 (81).

A reviewer in the "Athenaeum" wrote that in this work "the public has been <u>startled</u> by a display which distances beyond possible overtaking the male professors of the Jemmy Jessamy school of art. The motto is from Crabbe's "Tales of the Hall", but the scene might pass for a prison interior, where a girl visits a young man whose life is in jeopardy. We cannot call to mind anything in water-colour art of a much higher class than the figure of this Isabella of domestic life, who sits in the strong light of the one day-beam that visits the haunt of despair, angelic in her purity, but human, from the pity which has driven her upon the self-sacrifice seen struggling in her eye, and furrowing her pallid brow with anguish. Perhaps the strong effect of light to which we have averted, is pushed to the point of trickery; but at all events this treatment of the subject augurs a command over the resources of the art, which some strong men have never attained: and when we turn from certain gleaners, milkmaids, peasants, and Arcadian prettinesses dispersed over the walls of this exhibition-room, to this real daughter of humbler life, we cannot but ask, whether the days have or have not come when woman is to take possession of the club and lion's skin, and man meekly to amuse himself with distaff work" (82). The review is typical in attaching primary importance to the portrayal of emotion in literary works of art.

From the 1840s the division between the two types of literary work became slightly blurred. The illustrative type ceased to be merely descriptive and anecdotal as was generally the case with such works in previous decades and instead more frequently concentrated on the portrayal of emotion, in particular female suffering and love; there was also a reversion to poetical sources (D2). Whereas expression and narrative content were most important in illustrative works in the 1820s and 1830s, in the 1840s the main ingredient of such pictures was emotion and the same emotional themes emerge as from those works, of the same decade, in which poetry is used as a gloss, to "illustrate" or explain, the picture: maternal love (in "The Legend of an Ancestor" of 1847), mourning (in "The Boat Race" of 1844 and "The Interior of the Fisher's Cottage" of 1849), love (in "Young Bacchus round her brow hath wreathed etc." of 1841, "Scene from Bloomfield's 'Walter and Jane'" and "Comala" of 1846, "Madonna Laura" and "Sybilla" of 1848 and "The Wife of Alphonso" of 1849), marriage (in "Christine about to sign her Marriage contract" of 1842) and loneliness or separation (in "The Lady Arabella Stuart" of 1846). One other major theme emerges: woman waiting for the return of the man whom she loves (in "Comala" and "Little Nelly watching for her Grandfather" of 1846, "Sybilla" of 1848 and "The Wife of Alphonso" of 1849).

In the 1850s there was a proliferation of pictures illustrating emotional scenes from literature. As before the subjects were almost always female and the emotion often involved sadness and suffering. The usual subject was love, but as in the previous decade, marriage, death and waiting were also important themes (E2). Portrayals went beyond mere description and concentrated on moments of high tension and emotion. The emphasis on sadness and suffering in women makes these works comparable with classical works by women of the same period and in the same way suggests that women were not selecting their themes unthinkingly, but creating a highly personal and feminine art which both reflected their condition and posited their ideals of womanhood. A few of these works received praise in the press. Miss Egerton's "Marianna in the South" of 1852 was described as "a womanly and graceful piece of championship on behalf of Mr Tennyson's heroine.." and the expression of her sadness was called "potent and true" (83). The review of Miss Anna Mary Howitt's "Margaret returning from the Fountain" of 1854 is worth quoting at length: "It is like stepping out of the glare and noise of a country theatre into the soft lustre and dewy freshness of a May morning. There is head and heart work in this little poem of a picture; no inch of feeble thought stretched painfully over a dozen feet of canvas, no pin's head of metal beaten out to half an acre of colourless film. It is tenderly conceived, full of more heart than women usually show to the sorrows of their own sex, and painted by a hand with the firm delicacy of a man's execution. The moment is happily chosen when the flippant malice of her thoughtless fellows has probed Margaret to the quick, and has cast a shadow of despair over her deep grief and penitence. Her face shows that the heartbreak has begun, the hand pressed on her temple that dull aching of her very blood which she could not soothe.." (84). Miss Howitt's "The Lady - vide Shelley's 'Sensitive Plant'" (85) was described in the "Art Journal" : "The story is given in two parts: the lady is presented in life and in death. In the living picture, she is in the garden and bears on her head a basket of flowers; and in death we find her on the greensward, while all around her is tinctured with woe. The pictures are small ovals framed, surrounded by a field of dead gold, on which are painted most elaborate compositions of flowers wherein, in floral eloquence, is again recited the story of 'the lady' and her fate. It is a production most minute in execution and of exalted poetic feeling" (86). The woman artist is praised for the feeling she betrays in the expression of the emotion of her female subjects. The present survey is strictly limited to works shown at the principal annual London exhibitions but at this juncture passing reference must be made to Elizabeth Siddal who was working in the 1850s.

Female subjects associated with suffering, fear of separation and death
were recurrent in her illustrations of literature: the Lady of Shalott,
Fig.21 the woman in St. Agnes' Eve, Lady Clare and St. Cecilia (from Tennyson),
Fig.22 la Belle Dame sans Merci (from Keats), Lady Macbeth (from Shakespeare) and
heroines from ballads such as that of Sir Patrick Spens, Clerk Saunders,
the Lass of Lochroyan are all relevant in this context (87). Tension and
anguish were characteristics of Siddal's heroines as they were of many
literary heroines depicted by women in the 1850s (88).

In 1857 a critic observed that "the practice of substituting a poet-
ical quotation for a title is becoming very common. Where there is any
difficulty in finding a title this may be intelligible, but it cannot other-
wise be understood" (89). I would advance two explanations. Firstly,
poetry served to give greater emotional meaning and depth to works of art
with realistic themes (and also helped to point a moral where this was
needed). Secondly, it elevated the subject and made it more serious.
Examples of such works are numerous in the 1850s. The two main themes in
these works are separation - from home, family or lover, sometimes through
death - and secondly thought or memory. Maternity and social commentary
provide subsidiary themes (F2). Absence from or leaving home is the sub-
ject of "The Last Evening at Home" and "His soul is far away etc". of 1850,
"The Stranger" of 1851, "She sings the wild songs etc". of 1854, "Looking
Fig.23 back at the Old Home" of 1855, "Home Thoughts" and "The First Letter from
Home" of 1856 and "'Tis sweet to know etc" of 1859. In "I remember thy
voice" of 1853 and "The Sailor's Wife" of 1856 the subject is the suffer-
ing of the one who is left. Death figures in six works: in "The Minister-
ing Spirit" and "The Empty Cradle" of 1856 it is that of a child; in "Love
the mother, little one" of 1856 and "A Father and Daughter" of 1859 it is
that - possible in one case, actual in the other - of the mother. The
fifth and sixth are "The Mourner" of 1854 and "Hope in Death" of 1857.
Sadness also prevails in the majority of pictures portraying figures lost
in thought. Motherhood figures in five works in two of which the idea of
separation is involved: "The Empty Cradle" of 1856, "How can thy Mother
be more blest etc" of 1857 and "Mother and Child" and "Domestic Life" of
1858. One important new theme to emerge is that of social commentary.
Again the subject is usually female and in each case sadness is the domi-
Fig.24 nant emotion. In "The Lady's Dream" of 1852 and "The Song of the Shirt"
of 1854, it is woman as seamstress; in 1854 Rebecca Solomon portrayed
"The Governess" and in 1857 Emily Osborn illustrated the degrading exis-
Fig.25 tence of a poor woman artist in "Nameless and Friendless". One other work
of the 1850s fits into this context: it was by Joanna Boyce and called

"No Joy the blowing season gives", a line taken from Tennyson. This
picture was described and praised in an obituary of the artist in 1861:
"It depicted a widow and her child, every touch expressive of the deepest
poverty and distress, weary and waysore, drenched and blinded by the driv-
ing sleet, struggling onwards, beaten back by the force of the pitiless
storm. Their path was across a dreary moor-side road, over the endless
horizon of which the clouds lowered, the fitting emblem of the hopeless
continuance of woe" (90). In three more pictures sorrow is seen as
pivotal to human existence: "The Path of Sorrow etc" of 1854, "Infancy
sleeping at the entrance of the Valley of Tears" of 1857 and "Presentiments"
of 1859 and in one the subject is woman as comforter of suffering man:
"Oh, woman, in our hours of ease etc." of 1859 (91).

As we have noted of such works in previous decades, the dominant
emotion is sadness and the four pictures most favourably reviewed amongst
those given above were praised for the success with which sadness was
expressed. These were "The Stranger" of 1851 by Fanny Corbaux, "The
Governess" of 1854 and "'Tis better to be lowly born etc" of 1857 by
Rebecca Solomon, "A Father and Daughter" of 1859 by Margaret Gillies and
Joanna Boyce's "No joy the blowing season gives" (92). In all five pic-
tures the subject is female suffering: in the first it is a woman mourn-
ing the loss of her own mother; in the second the lonely loveless exis-
tence of a governess is contrasted with the happy flirtatious life of the
young lady of the house; in the third it is the suffering of the wife of
an unsuccessful gambler, in the fourth the mourning of a father and daughter
for their dead wife and mother and in the fifth the misery of a poor
widow and her child. And in all five again the emotion is both explained
and heightened by poetical quotations.

Among works illustrating literature exhibited in the 1860s some
resembled those of the two previous decades in their focus on emotional
scenes. The characters were generally female and the emotion usually of
a sad nature; as in the 1850s love was a recurrent subject. The works of
Shakespeare, Tennyson, Sir Walter Scott, Thomas Moore and Keats were the
most popular sources for such works (G2). Three pictures were singled out
for praise in the press. Of "Peg Woffington's visit to Triplet" by
Rebecca Solomon of 1860, it was written: "This is really a picture of great
power, and in execution so firm and masculine that it would scarcely be
pronounced the work of a lady ... The heroine visits Triplet and his family,
in the words of Triplet himself, 'coming like sunshine into poor men's
houses, and turning drooping hearts to daylight and hope'. It is gratify-
ing, encouraging, and full of hope, to find a picture so admirably painted

by a lady; it is, moreover, the offspring of thought and intelligence, as well as study and labour" (93). Another subject from Scott, "Edith and Major Bellenden watching from the Battlements of the Castle the Approach of the Life Guards" by Margaret Gillies of 1861, was described as a picture "of a very high order of merit" (94). In Florence Claxton's "'Dante Aleghieri' from 'La Vita Nuova'" of 1866, "overshadowing sorrow fitly preponderates. 'The father of the most wonderful Beatrice' is dead, the daughter becomes 'full of the very bitterness of grief', and Dante 'is so altered, he seemeth not himself'. This design testifies to thought and independence.." (95). Most illustrative literary works of the 1860s, however, lacked emotional content. A considerable number appear to have been mere portraits: Effie Deans, Rosalind and Celia, Ophelia, Adeline, Cinderella, Britomart, Miranda, Desdemona, the Lady of Shalott, the Lady of the Lake, Viola, Erminia, Maud, Nourmahal, Cordelia and Nerea Foscari were amongst those portrayed by women in this decade (H2). There were also many literary pictures of this category which can only be described as anecdotal (I2).

The second type of literary work, in which quotations are used to reinforce the theme of the work, also witnessed a change. As the illustrative sort was invaded by portraits of literary heroines which were most probably portraits from the life with "fancy" titles, so it became fashionable to append poetical quotations describing a mood or an expression to portraits and studies of heads. In many cases, however, the old use of quotations to point a moral or elevate a realistic theme still applied. The most striking example of this is Emily Osborn 's "The Governess" (RA 1860 no.405). The following lines accompanied the title:
"Fair was she and young, but alas! before her extended
Dreary, and vast, and silent, the desert of life, with its pathway
Marked by the graves of those who had sorrowed and suffered before her.
Sorrow and silence are strong, and patient endurance is godlike"
(Longfellow's "Evangeline").
The work was reviewed in the "Art Journal": "The narrative here is pointed, but it is true. Those who in their own experience may not have skimmed this page of woman's life have learnt it from the daily journals. This governess is presented according to the first terms of these lines, and her pathway seems to be as sad as that indicated in the continuation. She stands before the 'mater familias' - an impersonation wherein the artist has concentrated all the vulgarities - manifestly for a scolding. It is the triumph of the ill-bred brats, who, sanctioned by their worse-bred parent, utter with assured impunity their insulting taunts. Miss Osborn is bitter in her

dissertation, but there is no exaggeration in her bitterness. The work is one of rare power, the production of a comprehensive mind manifesting a thorough knowledge of the capabilities of Art. She has made Art to exercise its highest privilege, that of a teacher. A lesson in humanity - in consideration, that humblest yet most elevated of all the virtues - may surely be taught by this admirable work" (96). Longfellow's Evangeline was in fact no governess; the lines are lifted right out of their context in order to stress the misery of the subject and to make the point that the plight of this governess was common to many in the profession: thus life's pathway is "marked by the graves of those who had sorrowed and suffered before her". Poetry was used to similar effect in Mrs Curwen Gray's "The Sempstress" (1864 SBA, no.593):

"O! Men with Sisters dear!

O! Men! with Mothers and Wives!

It is not linen you're wearing out,

But human creatures' lives!" - T. Hood.

The lines point the moral and stress that the condition of this sempstress is typical. The work was approvingly referred to in the press as "a picture of sentiment and sympathy" and "touching pathos" (97).

Sadness in women was also the subject of a number of works by Margaret Gillies in the 1860s. "The Merry Days when we were young" (1860 OWS no.80) carried the following quotation:-

"My eyes are dim with childish tears,

My heart is idly stirred,

For the same sound is in my ears

Which in those days I heard" (Wordsworth).

The picture was described in the "Art Journal": "In this composition there are three figures, of whom two are young, the third is a matron, who expresses the feeling of Wordsworth's lines: A young lady is seated at a piano, and a youth is about to accompany her on the violoncello. The features of the young people are animated and happy, but those of the elderly lady, and her entire pose, are expressive of the sigh which may have accompanied the sentiment" (98). In the same year she exhibited ig.26 "Trust" at the Royal Academy (no. 776) with the lines:

"I'll tell thee why this merry world me seemeth

But as the vision's light of one who dreameth,

Passing like clouds, leaving no trace behind" (Fanny Kemble Butler).

In 1861 she sent "Beyond" to the Old Water-colour Society (no. 78):

"Yet Hope had never lost her youth,

She did but look through dimmer eyes" (Tennyson).

A reviewer described the work as follows: "In this drawing are repre-
sented two women: the one with her face full of cheerful hope, Christian
endurance, and affectionate care, points to the 'beyond', and encourages
her companion yet to brave the perils of the way. But the latter is over-
whelmed with despair; she looks not so much as if she were incapable,
but as if she felt herself utterly unworthy to make the attempt" (99).
Once again the lines serve to emphasize the emotional content of the work.
In 1863 Gillies exhibited a work called "Awakened Sorrows - Old Letters"
at the exhibition of the Society of Female Artists (no.70) with an explan-
atory quotation from Barry Cornwall:
"One whose tender talk can guide me
Through fears, and pains, and troubles;
Whose smile doth fall upon my dreams
Like sunshine on a stormy sea" -
This depicted "two persons, one of mature years, the other a girl, who
affectionately consoles her companion, borne down by some painful remem-
brance" (100). Then in 1864 she sent to the exhibition of the same Society,
a picture entitled "Desolation" with four lines from Wordsworth:
"The mighty sorrow hath been borne,
And she is thoroughly forlorn;
Her soul doth in itself stand fast,
Sustained by memories of the past" (no.181).
The following description was given in the "English Woman's Journal": "It
represents a single female figure in an attitude of utter listlessness, a
few drooping tufts of sere and withered grass at her feet, a leafless tree
behind, and only a dull drear expanse of cloud-reflecting ocean in the dis-
tance. The broad folds of neutral tinted drapery, and the amount of con-
centrated expression in the countenance, so touching in its deep pathos
that one forgets to mark the features, seem like an echo of the chaste and
lofty style of Ary Scheffer, and higher praise than this could hardly be
given" (101). Margaret Gillies used contrast to emphasize the misery of
the principal figure in "The Merry Days when we were young", "Beyond" and
"Awakened Sorrows - Old Letters". Contrast is also the subject of a work
she exhibited at the Old Water-colour Society in 1865: "Youth and Age"
(no.197):
"O'er a great wise book, as beseemeth age;
And I turn the page - I turn the page.
 * * *
Not verse now, only prose!"

Woman's misery was studied by Margaret Gillies in a very wide range of contexts. In each case emphasis is on the facial expression of the principal figures and the nature of the emotion is made more explicit by poetical quotations.

Sadness, and in particular sadness in women was, once again, the common theme of the vast majority of pictures with poetical titles by women in the 1860s (J2). In most cases the sadness is a result of separation, either from happier times in the past, a relation, home, or a lover.

Two subsidiary themes in such works during the 1860s are the idealisation of childhood and youth (K2) and of the home (L2). Most frequently, however, as we have said, poetical quotations were used simply to stress character, expression or looks and in many cases also, quotations served to poeticize a landscape, a scene or a still-life (M2).

This vogue for quotations in titles requires some explanation. It is worth mentioning perhaps that Mr Hammond, in his Report to the Schools Inquiry Commission, remarked that English literature "occupies a more prominent position in the education of girls than of boys. In most ladies schools admired passages from standard authors, and especially poetical extracts, are committed to memory; but the critical study of a great work in its entirety is not attempted. The object of the lessons is to exercize the memory and to cultivate the imagination of the scholars" (102). Some examples of "extract" publications are Oliver Goldsmith's "Poems for Young Ladies. In three parts. Devotional, moral and entertaining. The whole being a collection of the best pieces in our language" (first published 1767), Vicesimus Knox's "Elegant Extracts: or, useful and entertaining passages in prose" and "Elegant Extracts: or useful or entertaining pieces of poetry" (circa 1770), Dr. Enfield's "The Speaker; or, miscellaneous pieces, selected from the best English writers, etc" (1774), Mrs Lindley Murray's "The English Reader, or Pieces in Prose and Poetry selected from the best writers" (1799) and "Sequel to the English Reader; or, Elegant Selections in prose and poetry" (1800) all of which ran into several editions in the nineteenth century (103). Women's literary education in the last century did involve an extensive knowledge of quotations. That this knowledge should be applied to the visual arts may partly be explained by the fact that in the main women's general and art education did not equip them for proficiency in grand classical subjects; landscapes, portraits and domestic scenes were their usual material. It is possible then, that with such restrictions women were tempted to elevate everyday subject-matter and imbue it with greater meaning: to give the particular a general application and thereby

raise it to a higher level of significance. A more general explanation
of the phenomenon, which was certainly not restricted to women artists, is
that as the buying public altered, becoming less educated than it had
been before the industrial revolution, so did the works of art which
catered for its taste. Classical subjects became less saleable because
they presupposed a classical education. Readily comprehensible works of
art and especially those with explanatory titles would have appealed to
this new class of art buyer.

Portrayals of literary heroines by women were numerous in exhibitions
of the 1870s. Tennyson and Shakespeare remained the most popular sources.
Fig.27 Elaine, Queen Guinevere, Lady Godiva, the Lady of Shalott, Queen Vashti,
the May Queen, La Belle Fronde, Maud, Enid, the Miller's Daughter and the
Village Maid (from Tennyson); Rosalind, Celia, Silvia, Olivia, Viola,
Fig.28 Ophelia, Juliet, Cordelia, Charmian, Miranda, Mariana, Katherine, Hermione,
Baptista, Helena, Hermia, the Countess of Rousillon, Hero, Beatrice, Lady
Macbeth, Mrs Page, the two Portia's and Perdita (from Shakespeare) were all
portrayed. Other figures were Sir Walter Scott's Alice Lee, Rebecca,
Rowena, Lady of the Lake, Elizabeth Woodville, Lucy Ashton, Amy Robsart,
Evelina, Edith Bellenden, the Glee Maiden, Catherine Seyton and Meg
Merrilies; Oliver Goldsmith's Little Goody Two Shoes, Miss Hardcastle
and Sophia Primrose; George Eliot's Romola, Dorothea and Hetty; Goethe's
Marguerite; William Morris's Danae and Psyche; Charles Dickens' Marchio-
ness, Nell and Emily; Robert Browning's Constance, Duchess and Mildred;
Byron's Marina, Medora, Maid of Athens, Gulnare and Corsair's Bride;
Sheridan's Lady Teazle and Lydia Languish; Wordsworth's Lucy and many
others, including a large number of fairy tale heroines (N2). From the
titles one must conclude that the majority were portraits and anecdotal
scenes. The only theme to emerge from those works with quotations in their
titles is that of love and in particular sadness in love.

In the 1870s poetical quotations acted as titles for most mood pictures,
by which is generally meant portraits of figures expressing sadness,
thoughtfulness, anxiety, love and less frequently, joy. The emphasis in
such cases was on expression. The most recurrent moods were sadness and
regret (02). Figures dreaming and praying were popular (P2) and so was the
subject of love (Q2) a corollary of which is the theme of waiting for a
lover (R2). In a great many cases the poetry simply described the beauty
of a woman, flowers or landcape (S2).

During the last three decades of the nineteenth century emotionally
charged scenes from literature exemplifying female suffering and herosim
died out. Instead what we have called the illustrative category of literary

works came to consist of portraits of literary heroines - of which there were a very large number - and emotionless anecdotes from literature. The heroines listed in the context of the 1860s and 1870s recurred in the 1880s and 1890s with many additions. Shakespeare and the Romantic poets, Tennyson in particular, continued to predominate as sources, with love, usually set in the Middle Ages, emerging as the main theme. Poetry retained precedence over prose although the novels of Charles Dickens, George Eliot, Sir Walter Scott and Jane Austen were frequently illustrated. Fairy tales remained popular (T2).

Poetical tags were also of the same type. Of the many descriptive titles the most frequent was "Dear Lady Disdain" from Shakespeare (U2). Many too, accompanied figures thinking, dreaming, remembering, waiting and listening to music; sadness was the main mood (V2). The passing of time and death were also popular themes (W2). The positive antithesis to sadness and death was the happiness of childhood, the state of which was often idealized over these years (X2). One final theme to emerge from an examination of the use of poetical titles in the 1880s and 1890s is the sad condition of poor and working women, seamstresses in particular, a subject which will be considered in greater detail in Section IV (Y2).

The most vital period in literary art of both types occurred in the 1840s and 1850s. Where art illustrating scenes and characters from literature is concerned, until the 1840s such illustrative works tended to stress character and narrative and in the 1820s and 1830s the main sources were the novels of Sir Walter Scott. In the 1840s, poetry, which had been dominant until 1820, returned; the focus shifted from character and narrative to emotion, in particular female suffering, and love gradually superceded maternal love as the major theme. From the 1860s the largest category within this type of work was that devoted to portraits of literary figures and there were also many illustrations of anecdotal scenes, especially from drama, over this period. Narrative works were concerned almost exclusively with love.

Works of art with glosses illustrating or explaining the content of the pictures first appeared in significant numbers in the 1830s and from the start these titles served to deepen mainly female experiences such as motherhood, the death of a husband or child, separation from family, husband or lover and being alone. In the 1840s and 1850s this type of work became extremely popular. Emotion was crucial and, as in illustrative works of art of the same period, this usually involved suffering in women. In the 1850s literature was also used to good effect for the purpose of social commentary. From the 1860s, although quotations from poetry and literature

still served to generalise on the particular and to explain emotion - love and death above all - on the whole this practice degenerated. Poetical tags accompanied portraits, landscapes and still-lives with no apparent purpose in many cases beyond mere poeticisation. The two most common factors in works of this type are firstly female subjects and secondly sadness, resulting from death, thwarted love and above all loneliness: the numerous portrayals of women being left after sad partings, of women think-ing, dreaming, remembering, hoping, listening to music, praying and above all waiting, usually for the return of husband or lover, all point to the lonely, idle existence of many women in the last century.

C. Portrait, landscape and still-life

Women contributed more portraits, landscapes and still-lives to nine-
teenth century exhibitions than any other clearly defined category and this
is chiefly explained by women's art education at that time. Proficiency in
the above was not dependent on great compositional powers nor on practice
in study from the life. Since the subject-matter of such pictures is clear
from the titles and to discuss it qualitatively beyond the level of mere
portraiture, landscape and still-life painting proves extremely difficult
in the absence of more examples of such art, a survey of these categories
can do little more than list the most successful and prolific exponents.

a) Portrait

The importance of "taking a likeness" in accomplishment art has already
been demonstrated (104). It was also focal in professional art by women:
women exhibited more portraits at exhibitions of the Royal Academy than any
other class of work and portraits were also most numerous at the Society of
British Artists until the middle of the century. Almost all early nineteenth
century women artists practised as portrait painters. A large number
specialised exclusively in this genre; a number, including Eliza Bridell-
Fox, Miss M. Barret, Margaret Gillies and the Misses Sharpe began as portrait
painters and later diverged, mostly into subjects (105). Portraiture was
an acceptable field for female practice because proficiency could be
attained without extensive artistic training; because it exercised those
qualities traditionally imputed to women: intuition, insight into charac-
ter, sympathy; and perhaps, too, because it was a lucrative branch of art
and art was one of the few professions open to women in the nineteenth
century. Many women took up miniature or portrait painting to save them-
selves from poverty (106).

The most notable female portrait painters practising during the first
four decades of the nineteenth century were Miss Maria Spilsbury (Mrs John
Taylor) who exhibited from 1792 to 1813, Mrs Alexander Pope (afterwards Mrs
Francis Wheatley) Ex. 1796-1838, Margaret Sarah Geddes (Mrs William
Carpenter) Ex. 1814-1866, Rolinda Sharples Ex. 1820-1836, Miss H. Kearsley
Ex. 1824-1858, Miss Fanny Corbaux Ex. 1828-1854 and Miss Sarah Setchel
Ex. 1831-1840. Among female portrait sculptors only Anne Seymour Damer
Ex. 1784-1818 and Miss Catherine Andras Ex. 1799-1824 are worthy of note.
A much larger group of female portraitists practised as miniaturists:
Maria Cosway Ex. 1781-1801, Miss Mary Byrne (Mrs James Green) Ex.1795-1845,
Miss M. Barret Ex. 1797-1835, Miss Charlotte Jones Ex. 1801-1823, Miss Mary

Anne Knight Ex. 1803-1831, Mrs Mee Ex. 1804-1837, Miss Eliza Jones Ex.
1807-1852, Miss Maria Ross Ex. 1808-1814, Miss Emma Eleonora Kendrick Ex.
1811-1840, Miss Rose Emma Drummond Ex. 1815-1837, Miss Eliza Sharpe Ex.
1817-1869, Miss Louisa Sharpe (Mrs Woldemar Seyffarth) Ex. 1817-1842, Miss
Sarah Biffin (107), Miss Elizabeth Reynolds (Mrs William Walker) Ex.
1818-1850, Miss Maria A. Chalon (Mrs H. Moseley) Ex. 1819-1866, Miss
Magdalen Ross (Mrs Edwin Dalton) Ex. 1820-1856, Miss Anne Beaumont (Mrs
W. Pierce) Ex. 1820-1836, Mrs James Robertson Ex. 1823-1849, Miss Anne
Charlotte Fayermann (Mrs Turnbull, then Mrs Valentine Bartholomew) Ex.
1826-1862, Miss Millington (Mrs Mannin) Ex. 1829-1859 and Margaret Gillies
Ex. 1832-1861.

Some of these women received high appointments. In 1801 Catherine
Andras was nominated Modeller in Wax to Queen Charlotte and in the same
year won the great silver palette of the Society for the Encouragement of
the Arts for her portraits of Lord Nelson and Princess Charlotte of Wales.
In 1818 Emma Eleanora Kendrick was appointed Court Miniature Painter to
Princess Elizabeth, daughter of George III (Landgräfin von Hesse-Homburg).
In 1823 Miss Maria A. Chalon became Miniature Painter to the Duke of York.
Mrs Mee and Miss Sarah Biffin were also widely patronized by Royalty.
Several were members of various exhibiting societies and several, too, such
as Mrs Carpenter and Fanny Corbaux, won medals for their efforts in por-
traiture (108).

By the 1830s Mrs Carpenter was considered to be the pre-eminent female
portraitist. Her works were noticed constantly right through the 1830s
and praised for being natural, unaffected and true. Thus her portrait of
Mrs Ord (RA 1831 no. 157) was thought to have been painted "without
flattery" (109). A "Portrait of a Young Lady" (SBA 1831 no.206) was des-
cribed as "natural, easy" bearing "the appearance of being a true resemblance
both as regards features and character" and the style "simple and unaffected"
(110). Lack of flattery was again remarked upon in her "Portrait of
Fig 29 Bonington" (SBA 1833, no.68) which although distasteful in look and atti-
tude, was acknowledged to be "a faithful resemblance of him" (111). The
attitude and expression in two other portraits at the same exhibition were
praised for being "easy and natural" and precisely the same phrase was
applied to her full-length portrait of Mrs Fleetwood Shawe at the Society
of British Artists in 1834 (no.83) (112). In 1837 her "Portrait of Lady
Slade" (RA no.17) was said to possess "the unaffected grace of nature and
good breeding"; "a more charming and unaffectedly natural representation
of feminine grace and sweetness never was portrayed" (113). The review of
her portrait of Lady Mordaunt of 1839 (RA no.5) is worth quoting at length;

the work was denominated "one of the most gracefully managed and ably painted portraits in the collection. The lady is stately and beautiful, and the artist has deemed it unnecessary to associate with her fair form those extraneous 'aids' which are so frequently considered advantageous to a picture. There is nothing but the portrait and a sober background; no glaring red or gaudy green curtain has been introduced hanging from an awkward pillar, or a budding tree: there is a degree of classic simplicity in the arrangement etc." (114). Her portraits were often described as the best in the exhibition (115). Absence of flattery was also observed in the mostly female portraits of Mrs James Robertson who again received high praise (116). We have already seen how the Academy was criticized for not recognizing the worth of these two artists (117). The portraits of Fanny Corbaux and Margaret Gillies were also favourably noticed (118).

In 1838 Margaret Gillies wrote to Leigh Hunt with a request: "It is that you will permit me to paint a picture of yourself which if when finished you and Mrs Hunt should deem worthy of your acceptance will be a great gratification to me. Artists in general seize every opportunity of painting the nobility of wealth and rank: it would be far more grateful to me to be able to paint what I conceive to be the true nobility, that of genius, long, faithfully, earnestly, and not without suffering, labouring to call out what is most beautiful and refined in our nature and to establish this as the guide and standard of human action " (119). This remark is extremely relevant in the context of the development of portraiture from the 1830s. From that decade exhibited portraits ceased to consist so exclusively of portrayals of "the nobility of wealth and rank" and instead more frequently depicted men and women of talent in various professions. These included actors and actresses, male and female artists and writers and politicians (Z2).

Over the next two decades several other women were singled out for portraiture. In 1844 Ambrosini Jerome, Ex. 1840-1871, was appointed Portrait Painter to the Duchess of Kent; in 1841 Mrs James Robertson - who specialized in portrait miniatures and exhibited 269 works between 1823 and 1849 - was elected a member of the Imperial Academy of St. Petersburg as a result of some successful portraits of the aristocracy in that city. Mrs William Walker became Miniature Painter to William IV and in 1850 Mrs Edwin Dalton was appointed Miniature Painter to the Queen. In the 1840s Mrs Thomas Thornycroft (Miss Mary Francis) Ex. 1835-1888 received many commissions from the Queen for portrait sculptures of the Royal family. Annie Dixon, the miniaturist, Ex. 1844-1893, was also commissioned by the aristocracy from this decade and in the 1850s the same honour was bestowed on Mrs Charles Newton (Miss Mary Severn) Ex. 1863-66 and Susan D.Durant Ex. 1847-73 (120).

The works of Mrs Carpenter retained their popularity in the 1850s and 1860s and the portraits of Sarah Setchel and Mrs Charles Newton were also praised (121). Most striking, however, is the attention paid to the work of female sculptors. In 1853 Mrs Thornycroft's "Marble bust of the Queen from sittings of H.M. Gracious Majesty" at the Royal Academy was praised for execution and likeness (122) and in 1863 Francis Turner Palgrave in his "Essays on Art" wrote of her: "Sculpture has at no time numbered many successful followers among women. We have, however, in Mrs Thornycroft, one such artist, who, by some recent advance and by the degrees of success which she has already reached, promises fairly for the art. Some of this lady's busts have refinement and feeling" (123). In 1857 it was written of Miss Susan Durant's portrait of Mrs Harriet Beecher Stowe at the Royal Academy: "We have seldom seen a work of more entire excellence; it is a striking likeness of the famous lady - simple and unaffected in style, character - charmingly modelled, and very skilfully wrought" (124). In 1869 H.R.H. Princess Louise's bust of the Queen was described by the President of the Royal Academy as a "work full of truth and genius" (125). In 1874 Mrs Amelia Robertson Hill's sculpture of Captain Cook, exhibited at the R.S.A., was called "an interesting figure, and a perfectly faithful likeness, according to extant portraits of the great circumnavigator" (126). Finally, in 1877, J.Comyns Carr strongly objected to the Royal Academy's refusal of a bust of Mrs Montalba by one of her daughters - presumably Miss Henrietta Skerrett Montalba as she was the only sculptor among the four: although refused, "ce n'en est pas moins une oeuvre remarquable, qui promet à la jeune artiste un très-bel avenir. L'exposition n'a que peu de bustes qui témoignent d'un tel instinct de l'effet sculptural, et en mettant les lecteurs de l''Art' en mesure d'en apprécier le mérite, nous ne rendons pas seulement hommage au talent de Miss H. Montalba, nous apportons un document à l'appui de notre critique du mode de sélection qui préside aux expositions de la Royal Academy. Quand on refuse un buste de cette valeur, on n'a pas le droit d'admettre dans la galerie de sculpture une seule oeuvre médiocre, à plus forte raison une oeuvre ridicule. Or la galerie de sculpture est encombrée de médiocrités vraiment dérisoires" (127).

Of the 28 members of the Society of Portrait Painters which held its first exhibition in 1891, four were women: Mrs Louise Jopling, Miss Anna Lea Merritt, Mrs Anna Louisa Swynnerton and Mrs Mary L. Waller. Most of the works exhibited at exhibitions of the Society of Miniaturists were by women; in 1896 there were 41 female members (16 men) and by 1899 the number had increased to 84 (17 men).

b) Landscape

Landscapes by women were most plentiful at the beginning and the end
of the nineteenth century. During the first thirty years the main names
were Miss Maria Pixell Ex. 1793-1811, Miss Charlotte Reinagle Ex. 1798-1821
Miss Letitia Byrne Ex. 1799-1848, Miss Fanny Reinagle Ex. 1800-1812, Mrs
Keenan Ex. 1807-1813, Mrs Amelia Long Ex. 1807-1822, Miss Jane Steele Ex.
1810-1812, Miss Harriet Gouldsmith (Mrs Arnold) Ex. 1809-1855 and Miss
Jessica Landseer Ex. 1816-1866. Harriet Gouldsmith was by far the most pro-
lific artist with 204 exhibited works, seconded by Miss Maria Pixell and
Mrs Amelia Long equally with 34. Harriet Gouldsmith was also, judging from
reviews, the most successful artist although Fanny Reinagle and Amelia Long
were also praised in the press. In 1807 when Fanny Reinagle exhibited "A
Landscape and Cattle, Evening" (no. 193) and "A Landscape and Figures"
(no.205) at the British Institution, a critic wrote: "The composition in
these landscapes is excellent; and reminds us a little of Claude" (128).
In 1810 three works by Amelia Long at the Royal Academy - "View on the Thames"
(no.406), "Cottages" (no.407) and "View from Nature" (no.442) - were said to
reveal her "superior talent in water-colour drawing", "a talent most un-
common in an amateur and worthy of a first rate professor"; "few male
artists exhibit such firmness of hand, none more taste and judgment in the
distribution of her lights and shades, and the disposition of the component
parts" (129). In 1818 a critic wrote of Harriet Gouldsmith: "Her style of
landscape-painting has nothing in it of commonplace; it is always a simple
but tastefully selected copy from nature" (130) and in 1824, the year in
which she was elected an Honorary Member of the Society of British Artists
and when she published "Four Views of Celebrated Places, drawn from Nature,
and on Stone" it was written in "The Somerset House Gazette": "To the
superior talent of this lady as a painter of landscape, we have more than
once offered our tributary approbation. There is in all the works we have
seen of her pencil, an original feeling, which is pure from mannerism, or
affectedness of style. Indeed, the same simplicity of form, light, shadow
and colour, pervades the scenes which she has chosen as the objects of her
imitation, that are found to exist in nature, and which indeed constitute
the most pleasing combinations in art" (131).

It is perhaps worth drawing attention to the use of the word "view"
which recurs in titles of works of this type over this period, to be replaced
in the middle of the century by "landscape" or a simple description of the
subject (132). The practice of referring to "views" seems to correspond to
a time in which landscape painting was generally considered to be a lesser
art - the work of amateurs and accomplishment artists and indeed the word
itself suggests a personal rendering, a mood picture rather than a repro-

Between 1830 and 1860 the number of landscapes exhibited by women declined. Miss Letitia Byrne and Miss Harriet Gouldsmith were still prac-tising but the only new names were Charlotte Adams Ex. 1829-1843, Miss Frances Stoddart Ex. 1837-1840, Miss Fanny Steers Ex. 1846-1860, six female Nasmyth s originating variously in Manchester, Edinburgh and London the most prolific of whom was Charlotte Ex. 1837-1866, and lastly Mrs William Oliver Ex. 1842-1886. The sum total of Mrs Oliver's exhibited works was 542.

After 1860 the tide began to turn, at first at the Society of British Artists, then at the Royal Academy. Miss Helen Paterson (Mrs William Allingham) exhibited 249 works between 1870 and 1893, mostly rural scenes showing picturesque cottages; Miss Alice Squire exhibited 103 works, mostly landscapes between 1864 and 1893; Anna Blunden Martino concentrated on landscape painting from the 1860s (133); Clara Montalba exhibited 148 works, mostly landscapes, between 1866 and 1893 , Linnie Watt exhibited 75 works between 1875 and 1891, Miss Mary Forster (Mrs Lofthouse) 67 between 1873 and 1885 and Fanny Currey 71 between 1880 and 1893.

c) Still-life

In the first two decades of the nineteenth century the most important
Fig.30 female names in still-life painting were Miss Clara Maria Leigh (Mrs Francis Wheatley and Mrs Alexander Pope by her second marriage) who exhibited 74 works, most of them flower paintings, between 1796 and 1838 and who was employed for a long time by Mr Curtis, the botanical publisher (134); Miss M. Barret who portrayed birds, fish, fruit and other still-life objects and sent 44 works to exhibitions between 1797 and 1835, and finally Miss Anne
Fig.31 Frances Byrne who exhibited 77 works -water-colours of fruit and flowers - between 1796 and 1833. The latter two exhibited almost exclusively at the Old Water-colour Society and it was in favour of Miss Byrne, as we have seen, that the rule excluding flower painters from membership of the institution was rescinded in 1809 (135). In 1810 the same lady inspired an interesting letter, published in the "Examiner", from "An Admirer of Female Excellence". The author's complaints were, firstly, that the prices demanded for her works at the Old Water-colour Society were too low "to enable the artist to support a respectable existence" and secondly that not one was sold. Her works were "arranged with so much taste, and wrought up to so high a degree of perfection, - that, since the time of the celebrated Van Huysum, we have not seen any thing comparable to them". That such an artist should not find patrons was proof that "the age of chivalry is gone" (136). Recognition

did come however. In 1811, J.C. Burgess wrote: "There are few persons indeed in the present day who paint flowers, that possess so much both of the theoretical and practical knowledge of the art, as the admirable drawings of this female artist prove her to possess". He described her style as "chaste and unaffected" (137). She received high praise in the "Ackermann's Repository" in 1812 and on at least two occasions was credited with "uncommon taste" (138). In 1825 her works were described as "perfect imitations of nature" (139).

In the 1820s Mrs T.H. Fielding (Miss Mary Anne Walton) emerged as a painter of flowers, birds and insects, exhibiting 46 works between 1815 and 1834 and also Mlle Melanie du Comolera who exhibited 38 paintings between 1826 and 1854. The latter was appointed Flower Painter to H.R.H. the Duchess of Clarence in 1828 and Painter to H.M. the Queen Dowager in 1840 (140). In the same decade Miss M. Scott (Mrs Brookbank) became known for her fruit compositions; these constituted the majority of the 25 works she exhibited between 1823 and 1837 - all, save one, at the Old Water-colour Society.

In 1831 Mrs Mary P. Harrison (Miss Rossiter) took part in the formation of the New Society of Painters in Water-colours. "As at that time there were few flower painters, and she had been accustomed to paint chiefly roots of wild flowers surrounded by grasses, moss, and dead leaves, Mrs Harrison fixed upon that branch of art, which, being a novelty, was much admired. In birds' nests, and detached groups of fruit, too, she succeeded very well. Her art was simple, but delicate and refined; charming, even if slightly prim. Her subjects were remarkable for taste, feeling, and fond love of nature. Sometimes she would delineate cut sprigs of of garden flowers, or a branch of blackberry blossom lying near a bird's nest - violets, cowslips, crocuses, primroses, snowdrops, roses. Her careful hand was happy in picturing a wild bank" (141). She specialized in painting wild flowers in their natural habitat. One of her most famous and elaborate works, exhibited in 1862 and described at length by E.C. Clayton, affords a good example: "In 1862 first appeared a picture, in three compartments, called the 'History of a Primrose': the first called 'Infancy', in which the earliest young primrose appears in a field hedge. The second, 'Maturity', a splendid root full of bloom, growing by the water's edge, two or three flowers drooping towards their reflections in the stream. The third, called 'Decay', is admirable for richness of colour and subtlety in the shades of the brownish yellow leaves mixed with the faint delicate green. The dying root of primroses is in a corner of a copse, some of its flowers are falling, one still remaining sheltered by

its leaves, half in sunshine, half in shadow, conjuring up the idea of
a spirit smiling serenely out upon the world, not feeling outrivalled by
the tall hyacinths and stellarias that are blooming all around it. The
gray mistiness of the background in this compartment helps to complete the
story of 'Decay', and contrasts well with the fresh greenness and 'twiggy-
ness' of 'Infancy'" (142). According to her obituary in the "Art Journal"
(1876) and E.C. Clayton, she was compelled to cultivate her talent when her
husband lost money and then health, leaving his wife to provide for the
family (143). Her works were sought after not only in England but also in
France (144). She exhibited 371 works between 1833 and 1875, 322 of them
at the New Society of Painters in Water-colours.

In the 1840s three extremely prolific still-life painters emerged:
Miss Maria Harrison, daughter of the foregoing, exhibited 456 flower and
fruit compositions between 1845 and 1893, 439 of them at the Old Water-
colour Society of which she became a member in 1847; Anne Charlotte
Bartholomew was the wife of Valentine Bartholomew and the majority of the
79 works she exhibited between 1841 and 1862 were fruit compositions; Mrs
Mary Margetts exhibited 125 works, most of them flower pieces, between 1841
and 1877, all but one of them at the New Society of Painters in Water-
colours.

The most successful still-life painters to begin exhibiting in the
1850s were Miss Eloise Harriet Stannard who exhibited 61 works between 1852
and 1893. Miss Emma Walter who exhibited 110 works between 1855 and 1891
and the Misses Anne Feray and Martha Darley Mutrie Ex. 1851-1882 and Ex.
1853-1884 respectively. The first exhibited a total of 57, the latter 49
works and both exhibited mainly at the Royal Academy. Sarah Tytler, in her
"Modern Painters", wrote: "These ladies rank as excellent fruit and flower
painters. A fault has been found with their subjects - that they are apt
to be arranged arbitrarily and artificially - not as nature planted them.
Invidious critics, with a special fondness for foreign studies, have taken
occasion in exalting the wild stocks and the lilac of M. Fantin, to decry
the roses of the Misses Mutrie". The same author mentioned that a work
exhibited by Anne Feray Mutrie in 1851 "was bought by the late Mr Bickness
for about twenty pounds, and re-sold at the sale of his collection in 1863
for seventy guineas" (145). They were both "commended for great merit in
genre painting" by the judges at the Centennial Exhibition in Philadelphia
in 1876 (146).

Of the numerous female artists practising still-life painting in the
last four decades of the century, the most celebrated was Mrs Helen Cordelia
Angell (Miss Coleman). She exhibited 158 works between 1865 and 1882.

William Hunt, who died a year before her début at the Dudley Gallery, is said to have declared "that in her he saw his only successor" (147). In her obituary, it was written: "In many respects she may be said to have borne away the palm even from William Hunt; she certainly invented that crisp and masculine style of work which stamped out the effeminate and delicate method which until lately was in vogue in every school and drawing-room in the land" (148). She was a member of the Institute of Painters in Water-colours between 1875 and 1878, an Associate of the Old Water-colour Society from 1879 and in this same year she was appointed Flower Painter in Ordinary to her Majesty on the death of Valentine Bartholomew (149).

As has been seen in the section on literary art, it was in the 1860s that the practice of including poetical quotations in titles grew into a fashion (150). Still-lives and landscapes were no exception. In most cases the poetry was merely descriptive (151). In the case of still-lives, however, poetry was sometimes used to give the subject a deeper meaning; flowers often became symbols of the transcience of life (A3). A quotation from Robert Browning which was appended to a picture called "Something Common" by Sarah W.M. Fallon (1884 SLA no.393) provides a fitting conclusion to this section:

"For, don't you mark, we're made so that we love
First when we see them painted, things we have passed
Perhaps a hundred times nor cared to see".

D.

Having extracted classical and literary works, portraits, landscapes
and still-lives from nineteenth century exhibitions, there remains a body
of works which are not so easily categorized. Broadly speaking, these
may be described as figurative works of art based on real life. The pro-
fusion of vague non-descriptive titles after 1860 makes identification and
analysis of these extremely difficult after that date and our survey of
such works over the last forty years of the century must therefore be
limited to those of which some visual record exists, those with explicit
titles and those described in reviews.

An examination of this theme of "real life" in the nineteenth century
suggests several sub-headings. Firstly there are pictures and sculptures
based on the main constituents of mostly middle class female existence; in
other words such a woman's daily occupations and concerns and also her three
most vital experiences: romance and marriage, maternity, and death, usually
of a husband or child. Secondly there is the theme of women at work: women
as seamstresses, governesses and teachers, spinners, lace-makers and flower
girls for example. Thirdly, women and art, a category which includes por-
trayals of anonymous women painting and drawing, self-portraits and portraits
of specific women artists. Finally, a large number of these works were
devoted to rural and working class life. A number have already been inclu-
ded in the section on literary art, among those works with poetic, "illustra-
tive" titles (152).

a) Female Life

Scenes from life were not numerous during the first three decades of
the nineteenth century. The most recurrent themes were religion, or
"Devotion", reading and above all motherhood of which the most striking
example was Miss Louisa Sharpe's "A Mother and Dead Child" exhibited at the
Royal Academy in 1818 (B3). There were also several pictures on an unusual
theme peculiar to the first half of the century, showing woman as an outcast
and as magdalen or penitent (C3).

Between 1830 and 1849 there was a huge increase in works of this cate-
gory. All the daily occupations of middle class female life received illus-
tration: playing musical instruments, reading novels, companionship, going
to balls or the opera, religion, lessons, studying and correspondence (D3).
Love and marriage were important themes particularly at exhibitions held by
the two water-colour societies, the Society of British Artists and the
British Institution. Love letters, rendez-vous, the various stages of court-

ship were all frequently illustrated (E3). As has been seen in the section
on literary art the custom of arranged marriages provoked adverse comment
in at least three works of art over these years (F3). Woman as magdalen
remained a popular image (G3) and motherhood was also a frequent theme (H3);
quotations were often used to poeticize the experience of motherhood (153).
Death, and widowhood in particular, emerges as a main preoccupation in the
1830s (I3) and again reference should be made to the literary section for
the many works with poetical titles on the same theme (154). The vast maj-
ority of works of this type dating from these two decades portrayed figures
in thought. Contemplation, Reflection, Dream, Reverie, Meditation, Memories
and Thoughts were usual titles among the 34 examples I have found (J3). The
theme of waiting emerged in the late 1830s and at least two works on this
subject depicted wives waiting for their husbands (K3). This is perhaps an
appropriate point at which to remark that although the sex of the subject
was not always specified in the titles of works on these themes, experience
suggests that most if not all depicted women (155).

There was a distinct emphasis among figurative or real life subjects
of the 1850s. Although reading, sewing, lessons, sisterhood and friend-
ship, love and marriage, religion, motherhood and going out still figured
as essential constituents of female life (L3), it was the theme of separa-
tion and the two related themes of correspondence and death which dominated
the decade (M3). In the case of those works exhibited between 1854 and 1856
and possibly in others after that date, the most obvious explanation is
the incidence of the Crimean War. Two were specifically on this theme: Miss
Mary Ann Cole's "News from the Crimea" of 1855 and Miss Emily Macirone's
"The Wife's Dream of the Crimea" of 1855 (156). Pictures of figures think-
ing, dreaming and remembering were plentiful as before and several of these
were also concerned with separation (N3).

In the 1860s over 90 works exhibited by women portrayed figures think-
ing or waiting (O3). Death and illness remained recurrent themes (P3) and
several works depicting these were singled out for praise in the press.
Miss Kate Swift's "Das Trauenkleid (A Schewening widow buying her mourning)"
of 1864 was described as follows in the "English Woman's Journal": "While
the elderly mistress of the shop has come round to bring one piece of goods
for the inspection of her sorrowing customer, who has thrown herself into
a seat by the entrance, a pretty assistant with a world of tender pity in
her eyes, leans over the counter ready to hand another piece to choose from,
or to throw in a word to assist the choice; while another young woman
reaches something from the shelf above; and a third, just at the door, seems
checking a young man from too abrupt entry into the shop, by explaining to

him the mournful business that is going on within. The face of the widow
is expressive of deep suffering" (157). "War Tidings" by Mary Ellen
Edwards of 1864 was also described: "A father, mother, and children,
grouped together in a room, which is adorned with portraits and cabinets
after the olden times, and in the manner of polite society, listen with
anxiety, if not in dismay, to the reading of a gazette. 'War Tidings'
forebode danger, and bespeak a tragedy. The artist has escaped the con-
ventionalities which have long reduced this class of subjects to common-
place" (158). Widowhood and the effect on mothers of the death or illness
of their children were frequently represented.

Love and marriage, motherhood, religion, correspondence and reading
were also important themes in this decade and pictures were occasionally
exhibited of figures studying, sewing and playing musical instruments (Q3).

Death remained an important theme during the last three decades of
the century although there were fewer works on this subject in the 1890s
(R3). The same period witnessed the exhibition of a vast number of works
Fig.32 depicting figures thinking and waiting (S3). Love and romance became
increasingly popular as subjects, in connection with which attention should
be drawn to the Darby and Joan image which recurred during these years (T3)
and correspondence, reading, leaving and returning home, motherhood and
childhood were abundantly illustrated (U3). The most interesting new
theme to emerge over these years was a class of work devoted to types of
woman. Works portraying the widow, the bride, the mother and the wife had
already been exhibited as has been seen and works had also appeared show-
ing typical women in various professions and trades, a subject which will
be considered in the following section. Three earlier works of this type
are especially worthy of notice: firstly Miss Margaret Tekusch's "The
Wife" (SFA 1858 no.311) "in which a dainty young matron, habited in the
costume of the last century, sits copying law papers for her husband, while
with the left hand she amused her baby in its cradle" (159); secondly
Florence Claxton's "Scenes in the Life of an Old Maid" (SFA 1859 no.274)
and thirdly a collection of five or six sketches which were exhibited by
the same artist in 1866 and which the "Art Journal" described as "so many
sly satires, thrust at divers phases of our modern female pharisees, under
the several titles of 'The Chapel', 'The Oratory', 'The Synagogue', 'The
Friends' Meeting' and 'St. George's Hanover Square'. The idea is good,
the moral pointed, and the satire keen" (160). From the 1870s typical
women became extremely popular, titles ranging from "La Connaisseuse",
"The Poetess", "She", "Woman", "Mater Triumphalis", "Girls of the Future"
and "Womanhood" to "A Nondescript Girl doing nothing" (V3). A work

exhibited by Margaret Murray Cookesley in 1897 at the Liverpool Autumn
Fig.33 Exhibition of Pictures in the Walker Art Gallery, may be included in this
category. It is entitled "The Gambler's Wife" and shows a sad and anxious
woman standing in a room where scattered cards and an overturned glass
speak plainly of her husband's fortune.

b) Working Women

During the first half of the century women exhibited very few works
of art portraying women in any profession or trade at all. Peasant women
were often represented in various rural activities and this subject will be
considered in section Dd. Apart from these, women in trade and actresses
provide the only instances, reflecting the lack of professional opportun-
ities for middle class women during the first fifty years of the century
(W3). A few works are worthy of special note. Firstly two pictures by
Miss Maria Spilsbury showing women involved in charity work, at that time
the only form of work which was free from stigma for females from the
middle and upper classes:- "Sunday Evening: A Young lady teaching village
children to sing" (RA 1804 no.64) and "A clergyman's wife teaching village
children to read" (BI 1808, no.74). In 1829 Miss C.J. Hague exhibited a
"Seamstress" at the British Institution (no.265). Miss Louisa Sharpe's
"The Arrival of the New Governess" exhibited at the Old Water-colour
Society in 1831 (no.149) was one of the first pictures to portray woman in
what was then virtually the only wage-earning profession accessible to
middle class women. The picture was described in the "Spectator": "'The
New Governess' .. is an extremely clever and pleasing picture, and the
characters are well imagined and expressed. The governess is pretty and
interesting, and her air and manner, coupled with her black dress, bespeak
one who has needs of friends and is apprehensive of not finding them; the
two little girls in delight at the amiable looks of their future preceptress,
and their elder sisters, who regard her askance with looks of suspicion and
contempt, are excellent and the brother, who scrutinizes her through his
eye-glass with an easy indifference, is quite the beau of the last century.
The delineation of all these persons is perfect, even to the air of each;
.. This is much the best picture of its class at the exhibition". Miss
Sharpe was said to evince "both feeling and understanding" in her treatment
of the subject (161).

The 1840s witnessed the emergence of two Government Reports on the
condition and employments of women and children in manufacturing towns
and agricultural districts (162) and the founding of both the Governesses'
Benevolent Institution (1843) and Queen's College (1848) in response to the

precarious financial position of numerous governesses and the urgent need
for a higher standard of education for them. In 1846 Mrs Jameson wrote:
"After all that has been written, sung, and said of women, one has the per-
ception that neither in prose nor in verse has she ever appeared as the
labourer. All at once people are startled by being obliged to consider
her under this point of view, and no other" (163). The 1840s also saw the
delineation of teachers and governesses in novels, the publication of
Thomas Hood's "Song of the Shirt" about the poor condition of seamstresses
and the exhibition of five pictures by Richard Redgrave on the theme of
women forced to earn their living (164). The decade was unremarkable,
however, for portrayals of working women in art by women. In 1840 Miss
Mary Francis exhibited her "Statue of an Orphan Flower Girl" at the British
Institution (no.461). There were also three pictures of lace-makers by
Fig.34 Miss Mary Anne Laporte, Mrs William Carpenter and Mrs Valentine Bartholomew
and one of a water-cress girl by Miss Ellen Montague (X3).

In the 1850s things changed and women exhibited works involving direct
social commentary. "The Women of England in the Nineteenth Century" by
Mrs Hurlstone (SBA 1852 no.271) was, according to the "Art Journal", "a
satire on the charity of the time. The essay is in two chapters: an opera
box, with its habitués, and in the distance, Taglioni or Carlotta Grisi;
the other part of the story tells of the most abject misery. We see a
creature starved and in rags, drudging for bread which is served to her in
crumbs. She seems to be making a shirt. The splendour on the one hand and
the squalor on the other, are brought into inevitable contrast. They are,
indeed, not nearer to each other in the picture than in reality" (165). The
seamstress appeared in two other pictures by women artists in the 1850s.
Part of "The Lady's Dream" by Miss J. Sutherland (BI 1852, no.42) is a vision
of "those maidens young,/That wrought in that dreary room,/With figures
drooping and spectres thin /And cheeks without a bloom" (166). Then in
Fig.24 1854 Miss Anna Blunden exhibited "The Song of the Shirt" at the Society of
British Artists (no. 133) and added a quotation from Thomas Hood's poem to
the title:
"For only one short hour
To feel as I used to feel,
Before I knew the woes of want
And the walk that costs a meal!"
Such was the popularity of this work that it was engraved the same year and
reproduced in a July number of the "Illustrated London News" in connection
with a Memorial to Thomas Hood at Kensal Green (167). The main contempor-
ary parallel in literature is Mrs Gaskell's "Ruth" published in 1853 (168).

In 1846 Mrs Jameson had remarked on the excessive number of women seeking employment as governesses, a state of affairs which she explained by the fact that "the occupation of governess is sought merely through necessity, as the only means by which a woman not born in the service classes can earn the means of subsistence" (169) and in 1849 a writer in the "Quarterly Review" expressed the opinion that "There is none we are convinced which, at the present time, more deserves and demands an earnest and judicious befriending" (170). In 1852 Miss Clifford Smith exhibited "The Governess" at the Royal Academy (no.325) and in 1854 Miss Rebecca Solomon sent a work of the same title to the Royal Academy (no. 425) with a quotation from Martin Tupper's "Proverbial Philosophy":
"Ye too the friendless, yet dependent, that find nor home nor lover,
Sad imprisoned hearts, captive to the net of circumstance".
The work "tells two stories which are pointedly contrasted. A young lady and a youth are engaged in a flirtation at a piano, while a governess is plodding in weary sadness through a lesson with a very inattentive pupil" (171). Two other works of this decade, unusual in subject, are worth mentioning: "Factory Girls" by Naomi Burrell (SFA 1857 no.357, sculpture), an early treatment of this subject in art, and "The authoress" by Elizabeth Bundy (SBA 1858 no.656).

Emily Osborn 's "The Governess" (RA 1860 no.405) with a quotation from Longfellow's "Evangeline" and Mrs Curwen Gray's "The Sempstress" (SBA 1864 no.593) with a quotation from Thomas Hood have already been described (172). In both the sad condition of women in these two occupations was emphasized. In 1861 Florence Claxton exhibited what was probably the most elaborate nineteenth century portrayal of woman as wage-earner. The work was entitled "Woman's Work, a medley" and it was shown at the Portland Gallery in 1861 (no.4). The title included the following description: "The Four Ages of Man are represented: in the centre youth, middle age and old age reposing on an ottoman, infancy being in the background; all are equally the objects of devotion from surrounding females. The 'sugar plums' dropping from the bon-bon box, represent the 'airy nothings' alone supposed to be within the mental grasp of womankind. A wide breach has been made in the ancient wall of Custom and Prejudice by Progress - Emigration - who points out across the ocean. Three governesses in the foreground, ignorant apparently of the opening behind them, are quarrelling over one child. Upright female figure to the right is persuaded by Divinity and commanded by Law, to confine her attention to legitimate objects. Another female has sunk exhausted against a door, of which the medical profession holds the key; its representative is amused at her impotent attempts; he does not

see that the wood is rotten and decayed in many places. An artist (Rosa B.) has attained the top of the wall (upon which the rank weeds of Misrepresentation and prickly thorns of Ridicule flourish), others are following: the blossom of the 'forbidden fruit' appears in the distance". In 1862 a drawing called "The Daily Governess" by Florence Claxton's sister, Adelaide, was published in "London Society"; it depicted a miserable woman standing in the rain outside her employer's house (173) and in 1863 Florence Claxton herself exhibited "Scenes from the Life of a Governess" at the Society of Female Artists (no.225). Other works of the 1860s worthy of note are "The Waiting Maid" by Mrs Alexander Melville (OWS ,1861 no.526), "Do you want a servant?" by Mrs Backhouse (SFA ,1860 no.214), "The Little Laundress" by Emma Brownlow (SFA ,1861 no.65), Miss Birgette Neumann's "A Danish Farmer examining the References of a Girl whom he is about to engage as Servant" (SFA ,1864 no.211) and "La Filatrice" by Miss Emily Macirone (SBA ,1865 no.1015).

In 1870 Florence Claxton exhibited "L'institutrice" at the Dudley Gallery (no.447), in 1872 Miss Blanche Macarthur "The Spinner's daydream" at the Royal Academy (no.35) and in 1873/4 Harriet Kempe "The Spinster" at the Society of British Artists (no.878). In 1875 the governess was once again the subject of a work by a woman, this time Louisa Starr. "Hardly Earned" was shown at the Royal Academy (no.527). It was briefly described in the "Art Journal": "The poor thing has thrown herself back in her chair and fallen asleep: well is the picture named 'Hardly earned'" (174). Two relevant works were exhibited at the Society of Lady Artists in 1879: "A Factory Girl of Paisley" by F.M. Roberts (no.116) and "La Soubrette" by Mrs Backhouse (no.150). A number of works exhibited between 1850 and 1880 portrayed flower and fruit girls, lace makers and matchwomen (Y3).

In the 1880s and 1890s the most frequent subjects were seamstresses, spinsters and lace makers and several works showed the extent to which women in these professions were exploited (Z3). Thomas Hood's poem continued to provide quotations and titles for portrayals of seamstresses and in 1890 N. Cundell exhibited "Fashion's Victims", recalling Samuel Redgrave's "Fashion's Slaves" of 1847. Flora M. Reid exhibited two interesting works on these themes. "A Seamstress" (IPO 1883/4 no.686) was accompanied by the lines:
"With fingers weary and worn,
With eyelids heavy and red"
"A Flemish lacemaker" (NG 1894 no.218) was described by the line "Weary and worn and sad".

c) Women and Art

Throughout the century women artists favoured subjects related to
art itself as themes for their works. As well as portraits of artists
and pictures of anonymous people painting and drawing, there were also
numerous portrayals of artists' models, studios, corners of studios,
artists' materials, art critics, art schools and personifications of
Art. Here the artist only will be considered.

Between 1800 and 1829 women exhibited at least fourteen self-
portraits (A4) and two portraits of specific women artists (B4). Two
works portrayed anonymous women artists: Mrs Ansley's "A young lady
drawing" (BI 1821 no.124) and Miss M. Heape's "Portrait of a lady sketch-
ing" (RA 1822 no.551). In addition there were eight portrayals of
artists of unspecified sex (C4) and two portraits of named male artists
(D4).

Between 1830 and 1849 only five self-portraits were shown by women
(E4). There was an increase, on the other hand, in the number of por-
traits of specified women artists (F4) and specified male artists (G4).
Fig 35 Three works represented anonymous women artists (H4) and ten, artists of
unspecified sex (I4).

From 1850 to 1869 the number of self-portraits decreased to a total
of three (J4) and there were twelve portraits of contemporary women
artists (K4). The most interesting development over these two decades was
an increase in the number of works depicting unspecified women artists.
These amounted to seven, three of which involved direct social commentary
on the condition of the woman artist and her position in society. In 1850
Margaret Sarah Carpenter exhibited "A Lady Sketching" at the Royal Academy
(no. 568). The work was described and praised in the "Art Journal": "She
is presented in profile in an erect attitude, and resting with her back
Fig.25 against a tree" (175). Miss Emily Osborn 's "Nameless and Friendless" was
exhibited at the Royal Academy of 1857 (no.299) and included the following
quotation in the title: "The rich man's wealth is his strong city: the
destruction of the poor is their poverty" (Proverbs ch.10, v.15). The work
shows a poor woman artist - widow or orphan for she is dressed in black-
trying to sell her pictures to a dealer and exposed not only to his condes-
cension but also to the lewd gaze of two wealthy clients who are in the shop.
The work focuses on her misery and anxiety. In 1858 Miss Rose Rayner
exhibited "A sister artist" at the Royal Academy (no.1067) and "A Lady
Modelling" by Mrs F.P. Fellows was shown at the Society of Female Artists
(no. 395). Florence Claxton's "Scenes from the Life of a Female Artist"
were also exhibited at the Society of Female Artists in 1858 (no.379).

They were described in the "English Woman's Journal" as "a fit commentary
on the whole exhibition; there is the 'ladies' class', the studio, the
woodland wide-awake, all the aspirations, difficulties, disappointments,
which lead in time to successes. The little dog barks with all the
hidden meaning of a dog in a fairy tale; the plaster head on the shelf
winks with a certain dry amusement at its mistress, who is represented as
painting a picture of the ascent to the Temple of Fame: the picture is
rejected, and the disconsolate young painter is seen sitting in comical
despair, gazing at an enormous R. chalked on the back" (176). "Woman's
Work, a medley" by the same artist and exhibited at the Portland Gallery
in 1861, has already been described (177). It is noteworthy that in this
portrayal of the difficulties encountered by women attempting to earn
their living and the prejudice debarring them from certain professions, it
is only the woman artist who achieves a measure of success; even she,
however, is exposed to Misrepresentation and Ridicule. The seventh of
these pictures of women as artists is Lucy Madox Brown's "Painting"
exhibited at the Dudley Gallery in 1869 (no.239) which showed a young lady
at an easel working on a painting of an old woman with faggots (178). In
Miss Osborn's "Nameless and Friendless" and in the two works by Florence
Claxton the main subject is the difficulties facing women artists: ridicule,
prejudice and the lack of a good art education all stood in the way of
success. The 1850s also saw the publication of the first sizeable literary
account of the position and problems of the woman artist. "The Sisters in
Art" appeared in the "Illustrated Exhibitor and Magazine of Art" in 1852
and was followed by an article on "Women Artists" in the "Westminster
Review" of 1858 and Mrs E.F. Ellet's "Women Artists in all ages and
countries" in 1859, after which date the subject was considered more and
more frequently (179). Between 1850 and 1869 women exhibited eight por-
trayals of unspecified artists (L4) and three portraits of named male
artists (M4).

 Between 1870 and 1900 at least 38 self-portraits were exhibited by
women (N4) - mostly in the 1890s, reflecting the rapid increase in the number
of women adopting art as a profession - and at least 35 portraits of named
women artists (O4). In addition there were 33 representations of anonymous
artists (P4) and seven portraits of specific male artists (Q4). Five
pictures portraying anonymous women artists included "At her Easel" by
Louise Jopling (SLA 1875 no.338), "Portrait of a lady at her easel" by
Edith Martineau (DG 1877 no. 103), "Lady Artists" by Ida Lovering (SLA ,
1885 no.614), "A candidate for the Society of Lady Artists" by Anne Wardlow
(RA 1888 no.1571) and Catherine M. Wood's "The sisters: tea in a studio"
(IPO 1889/90 no.455).

d) Working class life

Throughout the nineteenth century peasants, cottagers, gleaners, fishermen, hop-pickers, faggot-gatherers, reapers, gypsies and beggars were popular subjects with women artists (R4). In the vast majority of these works it was the picturesque aspect of such figures and their rural setting which were emphasized - a result, in part, of the idealisation of the countryside which accompanied the growth of cities and industrial towns. Social commentary in art on the condition of the poor made isolated appearances from the 1850s, mainly in reference to city dwellers and became more frequent and more widespread in its application in the 1880s and 1890s.

One figure from this category who was less frequently glossed over with the picturesque was the poor child and in particular the orphan or foundling. The popularity of this subject with women artists may partly be explained by the fact that many women at that time were involved in charity work - as Bessie Rayner Parkes wrote in 1854: "Women have always been visitors among the poor; for the last half-century they have been active managers of schools and parochial societies" (180). One instance of direct involvement is that of Emma Brownlow whose father was Secretary of the Thomas Coram Hospital for Foundlings between 1849 and 1872. In 1852 she exhibited "The Foundling girl - a study" at the Royal Academy (no.590); in 1853 "The Orphan" at the British Institution (no.392); "The Scripture Reader", exhibited in 1856 (PG no.262), bore the following quotation: "Pure religion and undefiled before God and the Father is this; to visit the fatherless and widows in their affliction, and keep himself unspotted from the world" (Epistle, James ch.1, v.27); in 1858 she exhibited "The Child Fig.36 restored to its mother - an incident in the Foundling Hospital" at the Royal Academy (no.1013); in 1863 she painted "The Christening" and in 1864 "The Sick-room" also portraying events at the Hospital (181); in 1864 she exhibited "The Orphans" at the Society of Female Artists (no.204), in 1866 "The Foundlings" at the British Institution (no.128), in 1873 - as Mrs Brownlow King - "Les Orphelins" at the Society of Lady Artists (no.301) and in 1877, at the same gallery, "Christmas Day at the Foundling Hospital" (no.354). There are numerous instances of the treatment of this theme by other women artists, the first that I have found dating from 1829 (S4). The only other social theme to appear before the 1850s is one that has already been mentioned in the section on female life and which represents woman as magdalen or reformed prostitute and as outcast (182).

There are seven outstanding examples in women's art of the grim rather than picturesque aspect of working class life and poverty prior to the 1880s.

The first of these, by Miss C. Sherley, is a borderline case between literature and real life. The following description from Archdeacon Wilberforce's Sunday Stories accompanied the work which was exhibited at the Society of British Artists in 1846 (no.680):

"By one of the dirtiest of all the houses my guide stopped, and we stood within it. No-one saw us for the mantle was on me; and, oh! what a sad sight did I see! There were many in the room, for a whole family lived in it, and they were wicked people

 * * * *

Now I saw that there was in one corner of this room near to a broken window a sad-looking bed, in which lay a poor sick boy.

 * * * *

Oh! how sad was it to turn round from the happy bed of the dying child to the rest of that sinful room".

In 1850 Eliza Florence Fox exhibited a "Study of a Factory Child" (RA. no. 197) (183) and in the same year Mrs Hurlstone exhibited "The Clubhouse and the Workhouse " (SBA, no.318) with the direction, "Look on this picture and on this". Miss J. Sutherland's "The Lady's Dream" of 1852 and Emily Osborn's "Presentiments" have already been mentioned in the literary section (184). Another picture by Emily Osborn was described in the "Art Journal" of 1864: "it represents an attic-room tenanted by a shoemaker and his family; on a box, or bench, lies one of his children, dead, and covered with a small sheet; a younger child is beating lustily a small drum, quite unconscious of the sorrow which has overtaken the parents; the father is at his work, but seems fearful of using the hammer in his hand, lest he should disturb the dead, while the poor mother stands by with a sad countenance and heavy heart. Such scenes are, unhappily, too prevalent throughout the length and breadth of the land; the painter does well to show in pictures of this kind what 'half the world' in its luxuries and its enjoyments perhaps never thinks of, nor would know of, except through the aid of the pencil". The work was awarded first prize as "the best Historical or Figure subject in oil, by a British Artist" at the Crystal Palace exhibition (185). Finally, in 1877 Alice Havers exhibited "The End of her Journey" at the Royal Academy (no.1378). Villagers are seen hastening along a path to a spot where a woman has collapsed on the grass and apparentl died through exhaustion; her small child is seen huddling by her in fear. As the woman is dressed in black, she was probably a poor widow or perhaps she was a social outcast, her child having been born illegitimately.

Fig.37

The main thing to note about these works is that four of them involve contrast between what Disraeli in 1845 had called "The Two Nations" (186); in the first, by Miss Sherley, it is between the spectator, presumably of easy circumstances, and the scene; in "The Clubhouse and the Workhouse", "The Lady's Dream" and "Half the World knows not how the other half lives" it is between rich and poor. Mrs Hurlstone's "Women of England in the Nineteenth Century" of 1852 is relevant in this context (187) and it is also worth mentioning the use of contrast by Margaret Gillies in the 1860s (188). In the above examples the device serves to point the moral and emphasize poverty. Secondly attention should be drawn to the use of quotations in three of these works. On the one hand the use of literature heightens the emotional content by making the narrative clear; on the other reference to literature lessens the shocking, "social realist" nature of the subject. Finally Eliza Fox's "Study of a Factory Child" is remarkable as one of the first portrayals of this subject in art (189).

From the 1880s the titles of a large number of works in this category suggest a realistic treatment of the theme (T4). "Hard Times" and "A Son of Toil" were recurrent titles and others worthy of specific mention are Alice Havers' "The Rights of the Poor" of 1883, "One of the Unemployed" by Mrs Heitland Browne of 1886, "Riches and Poverty" by Mabel Moultrie of 1888 and Emma Boyd's "To the workhouse" of 1891. Of particular interest is Louise Jopling's "Saturday night: searching for the breadwinner" exhibited at the Royal Academy in 1883. The sub-title was "Pay-night, drink-night, crime-night". In her autobiography the artist described how she came to paint this picture: "Often whilst walking along the Chelsea Embankment, I was struck with the contrast between the pearly grey atmosphere of the river and its surroundings and the yellow brilliant glow issuing from the public-houses. There was a corner one which particularly attracted me. One evening I saw a wretched woman, with a baby in her arms, and another child clinging to her skirt, just open the door, look in, and walk dispiritedly away. The glow from the lighted room fell full upon her face, giving a fleeting radiance to it, and yet nothing could obliterate the hopelessness of her expression. Poor wretch! She was in search of a husband and the Saturday night's wages, which he was no doubt dissipating as fast as he could. Here I had a picture ready made. I spoke to the woman, and asked her if she would come and sit to me. She was only too pleased, poor dear, and so we each of us did the other a good turn.."(190).

Conclusion

Until 1830 women's art was, in the main, descriptive. Classical
works appear to have reflected a state of mind: fear of or mourning over
separation or death, caused most probably by the Napoleonic Wars. Literary
art of the period, in the attention paid to narrative and character and
to close observation of the text, was descriptive. Portraits mirrored the
commissioning public rather than revealing a positive choice of sitter on
the part of the artist.

From the 1830s there is a remarkable similarity of focus between the
various types of subject matter considered in this chapter. Of first impor-
tance is the gradual formulation of heroine worship. This may be seen in
the selection of female Biblical figures notable for their family feeling in_
the 1830s, in the emphasis on sad and heroic incidents in the lives of
mostly historical women from the 1840s to the 1860s and in the portrayal
of literary heroines remarkable for the strength of their emotion and the
degree of their suffering from the 1840s. It also appears, from the 1830s
in the growth of a new type of portraiture devoted to men and women of
talent rather than high birth; the many portraits of known women artists
exhibited from 1830 are relevant here. This heroine worship is also mani-
fest in the new type of literary art with poetic titles which first regis-
tered significantly in the 1830s and which, by generalisation and poetic-
isation, elevated ordinary female experiences such as love and maternity,
but more particularly mourning and separation. This type of work became
extremely popular in the 1850s, a decade which was also notable for the
"elevation", often through quotations from literature, of certain social
themes such as the sorry condition of governesses, seamstresses, women
artists and the urban working class. All these instances reflect a tendency
or a desire to see the heroic in modern life. In the case of classical and
literary works and portraits, the moral worth of the subjects is set up as
a guiding principle for human behaviour; in works with realistic themes
there is an attempt to impart a deeper, grander significance often with the
aid of literature. Edification was a primary aim. Art here does not
describe or reflect as was the case before 1830; it posits ideals. It does
its part towards what John Stuart Mill expressed in 1838 as "keeping present
to the mind an exalted standard of worth, by placing before it heroes and
heroines worthy of the name", by the delineation "of the human character
and form in their utmost, or heroic strength and beauty" (John Ruskin) (191).
When Margaret Gillies wrote that she would like to "paint what I conceive
to be true nobility, that of genius, long, faithfully, earnestly, and not

without suffering, labouring to call out what is most beautiful and refined in our nature and to establish this as the guide and standard of human action", she not only described what the artist should do but set up the artist himself as a model worthy of emulation (192).

The 1870s have been described as the beginning of an age of doubt (193). Certainly, from this decade, women's art began to lose high motivation. Classical and literary art came to consist mostly of portraits and anecdotes. The practice of appending poetical tags to the titles of works of art and of replacing titles with quotations became widespread often with no apparent reason, as we have said, beyond poeticisation. There were numerous portrayals of figures thinking, dreaming and waiting, with and without quotations. The main theme to emerge over these three decades was love, exemplified in myth, history, literature and the anonymous present. The themes which reflected modern developments most directly were firstly social realism which accompanied a wave of literature on the nature and condition of the working classes, and secondly works devoted to types of women many of which suggest an increasing interest in woman's position.

There are two dominant themes in figurative works of art by women, excluding portraits. The first of these is the predominance of female subjects which may be explained by a variety of reasons from the difficulties for women of obtaining male models to a highly personal approach to art. As has been suggested, the latter would appear to be the weightier explanation. The second theme is sadness, ranging from heroic instances of suffering to anonymous loneliness.

CHAPTER FOUR - SUBJECT-MATTER IN FRANCE

Section A - Classical subjects (1)

Women's education in France in the nineteenth century was just as restricted as in England. Religious knowledge and French history were taught at the govern ment sponsored primary schools and also at private educational establishments, such as the "pensions" and "institutions", but as in England "manuels" and "morceaux choisis" were in current usage both at school and at home (2). In explanation of women's absence from the creative field of the epic and dramatic poetry, a writer observed in 1836: "Il leur faudrait un ordre d'idées et de connaissances qui ne peuvent se développer ni dans leur éducation ni dans leur position dans la société"(3). Although a system of secondary education for girls based on that for boys was introduced in 1880, there was no appreciable change in the type of education provided until the early years of the twentieth century. The most remarkable point to emerge from an examination of writings on women and their education in the nineteenth century France is the emphasis placed on women's social role. Whereas in England arts subjects were generally taught as ornamental accessories for young girls about to enter society, in France greater importance was attached to what was considered to be women's essentially feminine role, as a moral and religious influence on society and men in particular (4). The "morceaux choisis" were calculated to develop in women an awareness of the religious duties of their sex. This early guidance of female attention in the fields of historical, Biblical and literary studies may have had an effect on women artists' choice of "classical" subjects. Awareness of the art education available to women is also illuminating where their efforts in the classical style are concerned. As has been seen in Chapter One, it was not until the latter half of the century that study from the nude figure became socially acceptable and accessible.

Between 1800 and 1809 classical pictures by women in France were chiefly on historical and mythological themes. At the Salon 19 of the former were exhibited and 18 of the latter. There were only four allegorical and four religious works. As in England the majority represented female figures. The most recurrent subject was love, Venus and "L'Amour" being popular figures (A) and maternity was the theme of four important works in the decade (B).

Judging from criticisms Mme Angélique Mongez was the most ambitious among female exhibitors of classical subjects, primarily on account of the size of her pictures. She was a pupil of David and Regnault and

exhibited nine works between 1802 and 1827. In 1802 she contributed
a work which was referred to as "vraiment historique" and "traité avec
toute la dignité historique": "Astyanax arraché à sa mère" (5). As the
first exhibited work of a woman it received full praise: "..Madame Mongez
qui vient d'acquérir une réputation distinguée dans un genre dont l'étude
longue et pénible parait mois favorable que tout autre à un sexe délicat,
a d'autant plus de droits aux éloges du Public, qu'aucune autre femme
n'avait encore produit une composition historique d'une aussi grande
dimension que celle-ci; que le tableau d'Andromaque est, en quelque sorte,
son premier ouvrage, et que l'aimable modestie de l'artiste releve encore
l'éclat de ses talens" (6). At the next Salon in 1804, she exhibited
another emotional work on a classical theme: "Alexandre pleurant la mort
de la femme de Darius" (7). A description of this work in a review suggests
that despite the title the picture was concerned more with the grief and
expressions of the female chara cters than with Alexander: "La reine est
étendue sur un lit. Près d'elle, Sysigambis s'évanouit dans les bras d'une
de ses petites filles; d'autres femmes se livrent à la douleur. Alexandre
entre dans l'appartement, suivi d'Ephestion, dont on n'aperçoit que la tête.
Sur le devant, le jeune fils de Darius joue avec son diadème" (8). As in
1804 when the face of Andromaque had been criticized for lack of "emporte-
ment" the facial expressions were said to be unconvincing, but again
tribute was paid to the attempt: "Il ne faut point oublier que l'auteur
de cette composition est une femme, qu'elle n'a encore fait que peu
d'ouvrages, et que la noble hardiesse avec laquelle elle s'avance dans la
carrière de la peinture historique, mérite les éloges et les encouragemens
du public" (9). For this work she was awarded a gold medal.

 In 1806 Mme Mongez was still the only woman to exhibit large histor-
ical works, but "Thésée et Pirithoüs purgeant la terre des brigands,
délivrant deux femmes des mains de ces ravisseurs" (no.386) was not greeted
with as much encouragement as her previous exhibits. "Le Pausanias Français"
was expansive on her faults: "On s'aperçoit d'abord que l'Artiste n'a pas
assez fait d'études préliminaires, ne s'est point préparé au grand art de
la composition par ces exercices nécessaires que présentent l'atelier,
l'observation du modèle et les esquisses multipliées; ce sont pourtant les
seuls moyens, pour un artiste, d'arriver à développer ses pensées sur la
toile, à disposer les groupes et les figures". There was no unity of action,
the faces were not characterized and appeared to have been painted "d'après
la bosse"; finally, she had tried to hide the sex of the figures out of
bienséance. "Abordons franchement la question: Quand on marche sur les
traces des hommes dans un art tel que la peinture, et surtout le peintre

historique, ou il faut s'élever au-dessus de toutes les petites considéra-
tions qui peuvent gêner le talent et nuire à l'ouvrage, ou bien, il faut
abandonner ces grands sujets à notre sexe, ou se contenter des sujets
gracieux et tendres, ou enfin peindre le portrait et le paysage" (10).
Firstly, then, her faults were technical: she had not prepared herself
sufficiently with preliminary sketches and she had not, apparently, worked
from the life. But most serious was the fact that, due to excessive
modesty and concern with bienséance, her figures were sexless, a reproach,
incidentally, which was also levelled at Angelica Kauffman. (11)

Fig 38 Her fourth exhibited work of the decade, "Orphée aux enfers" (1808,
no.435) was more successful. C.P. Landon described the picture: "Pluton
et Proserpine sont assis sur leur trône. Près d'eux on voit d'un côté,
Minos, la main élevée au-dessus de l'urne fatale, Caron, Eaque et
Radamanthe; de l'autre les 3 Parques, qui pour un moment ont suspendu
leurs travaux. Orphée, guidée par l'Amour, dont les doigts légers secondent
les accords de sa lyre, tâche de fléchir le souverain de ce terrible séjour.
Pluton paraît vaincu par le charme de la mélodie: Eurydice, qu'on aperçoit
au loin, accompagnée de Mercure, va être rendue à son époux". The figures,
of which there were thirteen, were at least life-size and the picture
measured fifteen feet long by twelve feet high. Landon observed faults
but on the whole he was encouraging: "Le sujet qu'il représente appelait
toutes les richesses d'une verve poétique; le sentiment du beau idéal a dû
seul y régler le choix des formes, le degré d'expression convenable, et n'y
admettre rien de faible ni de trop prononcé. Mme Mongez a rempli la plu-
part de ces conditions: il en fallait beaucoup moins pour faire remarquer
son ouvrage. On y aperçoit de l'inégalité dans l'exécution, mais on y
reconnaît un esprit orné, un style épuré; et sur-tout dans les contours du
nu, ce crayon magistral qui annonce une excellente école. La figure de
l'Amour, celles de l'une des Parques, de Pluton, et de Proserpine ne seraient
pas désavouées par un habile professeur". Furthermore, Napoléon had ordered
the acquisition of the work (12).

During this first decade of the nineteenth century Mme Mongez was an
exception. In the size of her works, the number of figures involved and in
her choice of complex, dramatic themes she stands out from the many other
female exhibitors of classical subjects. An examination of reviews suggests
that the norm among women artists was quite different. In 1806, for example
Mlle Henriette Lorimier exhibited "Jeanne de Navarre"; "elle conduit son
fils Arthur au tombeau qu'elle a fait élever à la mémoire de son époux
Jean IV, duc de Bretagne, surnommé "le conquérant", mort en 1399, et l'entre
tient des vertus et des malheurs de son père" (no. 362) (13). This sort of

subject was consdiered eminently suitable for women artists. C.P. Landon
wrote that even if this subject could not be seen strictly as "un trait
historique, il le sera du moins comme une idée ingénieuse de l'artiste.
l'histoire a fourni à Mlle Lorimier le motif d'une scène sentimentale,
où l'on voit briller à la fois l'expression de l'amour conjugal et maternel,
les prémices de la piété filiale, une douce mélancolie, une ingénuité
touchante. L'exécution de la peinture répond à la pensée. La composition
est simple, les attitudes sont gracieuses et expressives; le costume et
les accessoires bien choisis; le dessin est noble et correct; un ton
suave, joint à une harmonie piquante, achève de donner au sujet tout
l'intérêt dont il est susceptible" (14). The author of "Le Pausanias
Français" wrote approvingly that "cette artiste se complaît dans les sujets
où la grâce est unie au sentiment". She has rendered the scene "avec tout
le charme, avec toutes les grâces que son sexe, et particulièrement les
Françaises, savent mettre dans les Ouvrages où elles ne sortent point de
leur caractère" (15). He even credited Mlle Lorimier with inventing a
genre, by which he presumably meant marginally historical works with
sentimental domestic scenes as their main subject (16). Conjugal and mat-
ig.39 ernal love were also the subject of "Agnès de Méranie" by Mme Pauline
Auzou, exhibited at the Salon in 1808 (no.11). Landon gave the following
explanation: "Philippe-Auguste, roi de France, avait épousé en 1193 Engel-
burge, fille de Waldemar 1er, roi de Danemarck, princesse d'une beauté
rare et d'une vertu accomplie. Quatre mois après son mariage, il la
répudia, et épousa trois ans après Agnès, fille du duc de Méranie, dont il
eut deux enfans. Mais ayant irrité le pape par ce second mariage, il
craignit l'excommunication, et reconnut sa première femme, qu'il ne reprit
néanmoins qu'au bout de douze ans. Agnès se retira avec ses enfans au
château de Poissy, où elle mourut de douleur. / Mme Auzou a choisi pour
sujet de son tableau le moment où Agnès, sentant approcher sa fin, écrit
au roi: 'Philippe, souviens-toi de nos enfans!' et charge de cet écrit
la comtesse des Barres, la seule amie qui lui soit restée". The figures
were life-size, "le dessin de Mme Auzou est correct, son pinceau n'est ni
sec ni timide et, ce qui vaut mieux encore, son ouvrage se fait remarquer
par la douceur et la vérité de l'expression" (17). As in the former work
there were no male figures and the pictures shared not only the theme of
maternity, with mothers and children as the main visual subject, but also
the idea of conjugal separation: the thoughts of both mothers are with their
absent husbands. The effect of separation and loss on women was a dominant
theme in classical works by women artists at this time. In addition to
"Astyanax arraché à sa mère" and "Alexandre pleurant la mort de la femme

de Darius" by Mme Mongez, which have already been mentioned, examples are
Mme Auzou's "L'Amour dissipant les alarmes" (18), Mlle Pantin's "Le
tombeau de sa mère" (19), Mme Nanine Vallain's "Mme de La Vallière" (20)
and "Agar dans le désert" by Mme Servières (21).

 Finally in this context of approved subjects for women artists, it
is worth mentioning a few works by Mlle Constance Mayer who, having become
Prudhon's pupil in 1802, turned to classical and more particularly allegor-
ical subjects. During the first decade of the century she exhibited three
such works: "Le mépris des richesses, ou l'Innocence entre l'Amour et la
Fig.40 Fortune" (1804 no.319) (22), "Venus et l'Amour endormis, caressés et
réveillés par les zéphyrs" (1806 no.375) and "Le flambeau de Vénus" (23).
The most successful of these appears to have been "Vénus et l'Amour endormis"
of 1806, which gave rise to reflections on the suitability of certain
subjects for women artists: "L'idée de ce tableau est riante et gracieuse.
Des compositions de ce genre conviennent mieux au talent des femmes, que
des conceptions fortes, pathétiques, et souvent terribles, pour lesquelles
la vigueur d'un génie mâle et exercé suffit à peine; et cependant combien
de jeunes artistes se sont hasardées à en traiter de semblables. Plusieurs
à la vérité y ont fait preuve de talent, mais épuisées par de trop longs
efforts, elles ont atteint rarement la hauteur de leur sujet. Mlle Mayer
a eu la prudence de consulter ses forces, et ses essais donnent d'heureuses
espérances. Elle possède un dessin coulant, un pinceau facile. Elève de
Prud'hon, elle a mis à profit l'exemple et les conseils de ce peintre
aimable, et s'est tellement identifiée avec ses principes, que son tableau
offre une imitation exacte de la manière du maître" (24). The similarity
of her work to that of Prud'hon and his actual participation in some of her
pictures resulted in the attribution of many of her own to him. The paint-
ing discussed above, for instance, originally signed by Mlle Mayer, no
longer bore her name or the original title when it entered the collection of
Sir Richard Wallace. Conversely, several bad pastiches of Prud'hon were
attributed to her (25). As will presently be seen there was a strong incli-
nation to believe that successful works by female pupils of famous artists
were in fact the products of their masters.

 Women artists, then, were not expected to attempt "des conceptions
fortes, pathétiques, et souvent terribles" and the majority, lacking a
thorough classical education and hindered artistically by social convention,
particularly in the representation of the nude, did not transcend expecta-
tions. Classical works by women, seen as a whole, may be distinguished
from those by men in the focus on female figures and female emotion and in
the choice of "domestic" scenes from history, mythology, the Bible and
allegory.

As in the first decade of the century, classical works exhibited by
women between 1810 and 1819 were mostly historical, with mythological
subjects constituting a substantial category and only a small minority of
Biblical and allegorical themes. The historical pictures were in the main
dramatic domestic scenes involving famous women from French history, the
emphasis on national history being a result both of the official encourage-
ment given to artists to select such subjects (26) and also, perhaps, of
the more literary influence of Madame de Stael (27). As in England, inci-
dents revealing the suffering, heroism and generosity of historical women
were favoured suggesting a nice and natural sympathy in women artists for
the misfortunes, achievements and virtues of their sex. Four works show
charity and compassion in historical women (C), but the main themes are
death, threatened or actual, and its effect on women (D) and separation,
already evident in the previous decade (E). Extremely moving and pathetic
subjects were chosen by Mme Demanne, who exhibited four historical works in
this decade (28) and Mlle Hoguer. In 1819 the former exhibited "Françoise
de Foix, comtesse de Châteaubriant" with the following description: "Après
avoir quitté la cour de François 1er, où elle avait été attirée contre le
gré de son époux, Françoise de Foix fut contrainte de retourner à
Châteaubriant. Là, par les ordres de son mari, elle fut, aussitôt son
arrivée, enfermée dans une pièce où elle n'avait la liberté de recevoir que
sa fille, à une certaine heure du jour, et pendant un certain tems; mais
la mort ayant surpris cet enfant chéri, qui semblait demander grâce pour sa
mère, le comte ne garda plus aucun ménagement envers Françoise de Foix,
et la fit périr elle-même, dit-on, peu de temps après" (no.314). Mlle
Hoguer's work, exhibited in the same year, was a "Bénédiction maternelle"
with the description: "Succombant à une profonde douleur et près d'expirer,
la veuve d'un chevalier tué dans un combat, bénit sa fille, qu'elle va
bientôt laisser orpheline, et prie la Sainte Vierge de la prendre sous sa
protection" (no.601) (29).

Five works are worthy of particular mention not only because they
reveal sympathy and admiration in women for women, but because they further
illustrate the type of historical work expected of women artists. The story
of Agnès de Méranie, already illustrated by Mme Auzou (30), was revived in
1819 by Mme Sophie Lemire, who portrayed a later episode: "Isemburge,
reine de France, adoptant les enfans d'Agnès de Méranie" (31). Landon con-
sidered this subject extremely suitable for a woman's brush: "Cette noble
et touchante action de la femme de Philippe-Auguste est représentée avec la
grâce, la simplicité et la douceur qui conviennent au sujet, et qu'un
pinceau plus ferme et plus assuré n'aurait peut-être pas aussi bien rendues.

Le sentiment qui anime cette agréable composition, fait excuser aisément
de légères incorrections de dessin. Quoique le coloris n'en soit ni très-
fort ni très-varié, l'oeil s'y repose avec satisfaction; et ce joli
tableau est un de ceux dont l'expression fait le principal mérite, ce qui
ne se rencontre pas toujours dans les ouvrages des artistes même les plus
accoutumés aux éloges du public" (32). Female compassion and generosity
were also portrayed in Madame Servières' "Blanche de Castille, mère de St.
Louis et régente de France, délivrant les prisonniers enfermés dans les
cachots du chapitre de Chastenay, près Paris" of 1819 (33). Equally suit-
able for illustration by women was a subject commissioned by the ministry
of the king's household from Mlle Louise Mauduit (34): "Henriette de
France, femme de Charles 1er, roi d'Angleterre", which portrayed the refuge
of the queen, pursued across the sea as a Catholic, with some peasants in
France, her native country (35). The review of this work is remarkably
similar to that, already quoted, of Mme Sophie Lemire's exhibit of the
same year. It was approvingly remarked, in the same publication, that
"un pinceau doux, naif et gracieux, trouverait difficilement, pour
s'exercer, un sujet plus noble et plus touchant que celui d'une reine per-
sécutée, fugitive, bravant tous les périls pour chercher son salut sur le
sol qui l'a vue naître. Mlle Mauduit, plus jalouse de plaire et d'inté-
resser que d'éblouir et de frapper avec éclat, a prouvé, par le genre
d'exécution de ce tableau, comme de ceux qu'elle a précédemment exposés,
qu'elle sait proportionner sa tâche à l'étendue de ses moyens: on n'y
reconnaît ni le dessin rigoureusement correct ni la touche mâle et hardie
d'un professeur affermi par une longue expérience; mais on y trouve une
scène disposée avec autant de goût que de naturel, des groupes variés, et
cette suavité d'expression, que ne donneront jamais ni le travail ni
l'étude, ni les combinaisons académiques" (36). Both reviews not only gloss
over technical faults but even make virtues of them in the context of such
subjects, of which the operative descriptive words are "noble" and "touchant".
The word "touchant" was also used in reference to an unusual picture exhib-
ited by Mlle Louise Mauduit in 1817: "Fondation des Enfans-Trouvés" (37).
The scene was set in 1648 and portrayed S. Vincent de Paule appealing to
"les dames de la Charité" in the actual presence of the orphans, to make
more sacrifices on their behalf. Apart from the commandeur Brulard de
Sillery who devoted his entire fortune to the concern, the work also
included three famous women from history: Mme de Miramion, Mlle Legras
"supérieure et fondatrice des dames de la charité" and Mlle de La Fayette
who is represented taking off her bracelet as a donation. The charity of
Madame de La Fayette also played an important part in a work by Mme Servières

exhibited in the same year, "Louis XIII et Mlle de La Fayette" (38).

An unusual subject was chosen by Mlle Aurore de Lafond: "Clotilde de Vallon Chalys, poétesse du 15e siècle"; "Elle composa, près d'un siècle avant Marot, des poésies pleines de génie, de sentiment et de grâce. Quatre aimables et jeunes compagnes partageaient ses goûts et ses travaux. C'est au milieu d'elles qu'elle est représentée. Elle leur lit une épître adressée à Béranger de Surville, son époux, qui, la première année de leur union, l'avàit quittée pour aller servir Charles VII" (1819 no.665). While the preponderance of heroines in historical works by women points to a greater knowledge of and interest in, women in history as opposed to men, works such as the latter suggest a positive desire to champion notable women with buried reputations.

Apart from these more thematic works, there were also a large number, again mostly concerned with female characters, which depicted historical anecdotes, particularly from the 16th and 17th centuries (F).

C.P. Landon pointed out the increasing female monopoly of subjects of this sort. In reference to Mme Servières' picture of "Louis XIII et Mlle de La Fayette", he struck an interesting analogy between historical genre and novels: "Les tableaux qui, comme celui-ci, réunissent la grâce et la simplicité du sujet, et peuvent admettre la vérité des portraits, la richesse ou l'élégance du costume moderne, semblent être dans les arts d'imitation ce que sont les romans dans la littérature. Il appartient aux femmes de se distinguer dans l'un et l'autre genre de composition, et de disputer le prix aux hommes qui y ont obtenu le plus de succès; c'est même dans un roman, ouvrage d'une femme célèbre que Mme Servières a puisé le sujet de son tableau" (39). He also wrote that such subjects, "susceptibles d'un intérêt général et d'une exécution précieuse", midway between "le genre purement historique ou héroïque et les scènes familières" .. "conviennent particulièrement à ceux que leur goût ou leurs études n'ont pas portés vers le grand style, surtout aux dames, pour lesquels ils semblent spécialement réservés" (40). It is relevant in this context to consider the critical consequences of unsuccessful female ventures into "le grand style" and large dimensions. The reputation of Mlle Lescot (41) was based, as the critic in question wrote, on "les compositions du genre familier", particularly Italian genre. In 1819 she exhibited a work entitled "François 1er"; "Ce prince accorde à Diane de Poitiers la grâce de M. Saint-Vallier, son père, condamné à mort" (42) which appears to have been on a scale unprecedented in her work and reaped harsh benefits in the "Annales du Musée". Works of this grandeur and size, wrote Landon, demand "Une pratique de pinceau plus sérieuse et plus approfondie que celle dont elle a fait jusqu'ici l'objet de ses études", for her touch is

"délayée, froide et languissante". He prescribed a reversion to her
usual genre, "aux petites tableaux de chevalet, aux sujets gracieux,
mais populaires" (43).

Angélique Mongez, who continued to exhibit large-scale works, three
of them mythological, in this decade, received no such advice from critics.
Two of her pictures were highly praised by writers fully convinced of
women's natural inability to develop grand conceptions and to execute

Fig 41 large works. In 1810 she was represented at the Salon by "La Mort d'Adonis"
(44). While lack of coherence in composition, a point frequently at
issue in reviews of women's work, was the main objection, this fault was
negligible in comparison with the merits of the work when seen as the
achievement of a woman: "L'exécution d'un tableau composé de plusieurs
figures de grandes proportions, où dominent les parties les plus difficiles
de l'art, est une tâche imposante pour un homme consommé dans la pratique
de la peinture; combien ne l'est-elle pas davantage pour un artiste d'un
sexe délicat, d'un sexe à qui la nature a donné la douceur et la faiblesse
en partage, et comme refusé à dessein l'énergie et la constance
nécessaires pour entreprendre et conduire à son terme un ouvrage fortement
conçu. Cependant le tableau de 'La Mort d'Adonis' ne manque ni de nerf
dans la pensée, ni de fermeté dans la touche, ni de vigueur dans le
coloris". She has worked "en homme expérimenté" and the picture is even
described as one of the most considerable in the exhibition (45). The same

Fig 42 compliment was paid to her 1812 exhibit: "Persée et Andromède", which
represented Perseus having killed the monster and freeing the princess from
her chains (46). Despite unnatural flesh colours, the affectedness of
Andromeda's pose and a disagreeable expression on Perseus' face, very few
men, wrote R.J. Durdent, "seraient en état ... de s'élever à ce goût de
dessin idéal, à cette vigueur de coloris". The work was "un des plus
remarquables du Salon" (47). This picture was probably the same as that
exhibited in 1814 together with "Mars et Vénus" (48).

The majority of mythological works by women appear to have been mere
portraits although love emerges as a theme as in the previous decade (G).
A few artists, like Mme Mongez, essayed works with more drama and emotion.
In 1812, for example, Mlle Béfort, who had already exhibited "Une jeune

Fig 43 Thébaine pansant son père blessé" in 1810, sent "Thésée et Ariadne" to the
Salon (no.40), a work which contained "figures de grandes proportions" and
represented Theseus, about to enter the labyrinth, receiving the thread from
Ariadne. She was congratulated for her historical rendering of the Cretan
labyrinth in the open rather than under the ground (49). In 1814 she
exhibited three mythological subjects one of which was probably the same

Theseus and Ariadne exhibited in 1812 (50). The other two were also
dramatic works: "Eurydice fuyant les poursuites d'Aristée, est piquée par
un serpent" (no.43) and "Adieux d'Hector et Andromaque" (no.44) (51).
Mlle Cochet, Mlle Chardon and Mme Lemire should also be excepted as attempt-
ing more dramatic scenes. Mme Lemire portrayed "Glycère" mourning the
death of her mother in 1810 (52); Mlle Virginie Chardon exhibited "La
veuve du roi 'Ban'" escaping from her capital with Lancelot in 1814 (53)
and Mlle Cochet depicted the "Mort de Camille, Reine des Volsques" in
1817 and "Cérès" seeking Proserpine in 1819 (54).

Very few religious subjects were exhibited by women in this decade.
Apart from several representations of Mary, Jesus, and Saint John the Baptist
(H), the only instances were Mlle Nanine Vallain's "Tirza, femme d'Abel,
pleurant sur le tombeau de son époux et implorant la miséricorde divine
pour Cain son meutrier" (1810 no.794), Mlle Bertaud's "Hagar dans le
Désert" (1814 no.69) - a theme also rendered by Mme Servières in 1808
(no. 552), two pictures by Mlle Louise Revest: "La Madeleine se jette aux
pieds de Jésus-Christ, qu'elle avait d'abord pris pour un jardinier"
exhibited in 1814 (55) and "Rébecca et Eliézer" (1817 no.640) and finally
Mlle Louise Mauduit's "Le prophète Elysée ressuscitant le fils de la
veuve de Sarepta" shown in 1819 (56). It will be observed that among
narrative works by women on mythological and Biblical themes, female
emotion, usually in the context of danger or death, was a recurrent theme.

Three allegorical works are worthy of mention, all associated with
love. Mlle Sophie Guillemard's "La Fortune qui ramène l'Amour" (1810, no.
400), Mlle Delafond de Fénion's "La Fidelité" (1812 no.255) and most
important Mlle Constance Mayer's "Le rêve de bonheur" (1819 no.809) (Deux
jeunes époux dans une barque avec leur enfant, sont conduits sur le
fleuve de la vie par l'Amour et la Fortune), the idea of which originated
with her first teacher Greuze and the composition with her second,
Prud'hon (57)

Before passing on to the third decade of the century, consideration
should be given to a number of works, produced during the first two
decades, devoted to contemporary history. In 1808 the clemency and glory
of Napoléon were the respective subjects of two works: Mlle Marguerite
Gérard's "Clémence de S.M. L'Empereur à Berlin" (no.252) and Mme Miaczinska's
"Allégorie" à la gloire de S.M. l'Empereur" (no.430). Marie Louise was
portrayed in at least two works. Her marriage to Napoléon in 1810 shortly
after his divorce from Joséphine in 1809 was a delicate issue at the time
and several artists were called upon to justify the event (58). In 1810
g.44 Pauline Auzou exhibited "L'arrivée de S.M. l'Impératrice, dans la galerie
du château

de Compiègne" (no.21) (59). The picture is informal and shows her being
greeted by a group of maidens in white, bearing flowers. Landon described
it as "un des plus agréables de l'exposition". He also remarked that judg-
ing from the unity of execution it must have been all the work of her own
hand, a comment which illustrates well the readiness of critics to believe
the contrary (60). In 1812 Mme Auzou exhibited a second work on the
theme: "S.M. l'Impératrice, avant son mariage, et au moment de quitter
sa famille, distribue les diamants de sa mère aux Archiducs et Archi-
duchesses ses frères et soeurs. La scène se passe dans la chambre à
coucher de S.M. à Vienne" (no.22). Durdent described the work: "En
recevant les dons d'une soeur chérie, le plus âgé des jeunes princes, et
la princesse, qui va désormais rester l'aînée de ses soeurs, éprouvent un
sentiment de tristesse; tandis que les autres, sentant moins la perte
qu'ils vont faire, se livrent plus ouvertement à la joie que leur causent
les magnifiques présens qu'ils reçoivent". He pointed out defects such as
"un dessin peu correct, une couleur quelquefois crue, et le défaut
d'harmonie", but praised the idea of the picture, "une de ces idées déli-
cates qui semblent appartenir plus spécialement aux femmes qu'aux hommes,
soil qu'elles tiennent la plume ou le pinceau" (61). All Mme Auzou's
historical works are notable for their humanization of the famous and in
this particular work she gave additional interest to the scene by distin-
guishing between the reactions of Marie-Louise's brothers and sisters. A
third work by the artist, also featuring Marie-Louise and called "Napoléon
et Marie-Louise à Compiègne", was exhibited in 1830 (62). After the fall
of Napoléon in 1814 Louis XVIII succeeded as the theme for works devoted
to contemporary history. Two of these celebrated his arrival in Paris in
1814, without actually representing the King himself: Mme Auzou's "Une
des croisées de Paris, le jour de l'arrivée de S.M. Louis XVIII", now in the
collection of the Duchesse de Berri in Paris, was exhibited at the Salon in
1814 (no.21) and to the same exhibition Mme Jeanne Dabos sent "Les lis ou
la sortie du 'Te Deum'. (Deux jeunes personnes se partagent une branche
de lis à la sortie du Te Deum chanté à Notre Dame le jour de l'entrée de
S.M. Louis XVIII à Paris)" (no.229). Both are concerned with anonymous
events on the margins of history. Louis XVIII was directly flattered in
a third work, by Mme Deharme, exhibited in 1819: "'Tableau allégorique de
fleurs et de fruits' (L'artiste a voulu exprimer dans la composition de
cet ouvrage, la reconnaissance du peuple français pour les bienfaits et le
sage gouvernement de Sa Majesté)" (no.277). Portraits of Napoléon and his
family and of Louis XVIII and Charles X will be considered in Section C (63)

Historical works by women in the 1820s were once again remarkable
for concentration on women in history, and particularly, as in the previous
decade, women of the 16th and 17th centuries. Love was the commonest
topic. Henri IV and Fleurette, his first mistress and "peut-être la seule
qu'aît aimée le prince de Béarn comme il méritait de l'être" (64), but
soon dismissed, were the subject of three pictures. In 1822 Mlle Aurore
de Lafond illustrated her suicide in a fountain just before a meeting years
after their separation: "Fleurette à la fontaine de Garenne" (65) and in
1824 she depicted an earlier episode when the two were lovers: "Fleurette
et Henri à la fontaine de Garenne" (no.991). In the same year Mlle
Emilie Bès chose almost the same theme: "Henri et Fleurette revenant de la
fontaine" (no.136). In 1822 Mme Servières illustrated two extremely moving
instances of female devotion, one from the 14th and one from the 18th cent-
ury: "Inès de Castro et ses enfans se jettent aux pieds du roi don
Alphonse pour obtenir la grâce de don Pèdre" (66) and "Valentine de Milan"
who, after the murder of her husband the duc d'Orleans, "fit transporter
dans son oratoire, l'armure, l'écharpe et l'épée de ce prince, et
s'enferma, résolue de mourir en arrosant de ses larmes ces tristes restes de
son époux (67). Sadness rather than despair was the subject of a third
historical work, also with a female heroine, exhibited by this artist in
the same year: "Marie Stuart" (68). The love of the 14th century figure,
Clémence Isaure, "institutrice des jeux floraux à Toulouse", for Lautrec,
was the theme of a work exhibited by Mlle Henry in 1824 (69) and that of
Clovis for Clotilde that of one by Mlle Aimée Pagès in the same year (70).
A final instance is Mlle Eugénie Lebrun's "Sujet tiré des amours de
Louis XIV, par Boissy" of 1824 (71).

Although love was the most recurrent theme, many others were covered
under the general and most striking heading of women in history. The
emotion of Marie Leczinska on receiving news of Louis XV's proposal of
marriage was the subject of a work by Mlle Ribault in 1822 (72); in 1824
Mlle Alexandrine Delaval portrayed the generosity of another 18th century
figure, Madame Elisabeth de France, towards a young milkmaid and her
lover (73) and in the same year Mlle Volpelière illustrated a touching,
charitable gesture by "une jeune princesse de la Souabe"; "Se promenant
seule, elle rencontre une mendiante dont l'enfant est au moment d'expirer;
mère elle-même et nourrice, elle lui donne le sein" (74). The severity
of Christine of Sweden in ordering the assassination of her "grand écuyer"
Monaldeschi was the theme of two works, one by Mlle Grandpierre and one, a
g 45 basso relievo, by Mlle Félicie de Fauveau (75). The latter, which involved
six figures, inlcuding Christine of Sweden and Monaldeschi, was awarded a

gold medal and Charles X conferred the honour personally. The work
itself and the nature and beliefs of Mlle de Fauveau, which will be
considered in the following chapter, corroborate the interpretation of a
critic in 1842: "Elle vit là une justice souveraine et par conséquent
légale, exercée par la royauté sur un sujet, sur un domestique, dans
l'enceinte de sa jurisdiction. L'artiste se mit du parti de Christine
contre Monaldeschi" (76). In 1827 Mme Bouteiller depicted an unusual
subject from a more recent period of French history - the French Revolution:
the heroic "Madame de la Fonchais, née Désilles"; "Cette dame est la
soeur de Désilles qui, en 1790, périt à Nancy. Condamnée à mort sous le
nom et à la place de sa belle-soeur, elle se dévoue pour la sauver"
(no. 154). Finally, women were the anonymous and daring heroines of two
dramatic works exhibited in 1822 and 1827. In Mlle Louise Revest's
"Episode de l'escalade de Genève, arrivée le 12 décembre 1602" of 1822,
a Genevan woman throws an iron pot at the head of a savoyard about to kill
her husband (77) and in Mlle Sarrazin de Belmont's "Vue de Castelluccio,
dans la Calabre", the wife of Giaccomo Strazzieri - a criminal captured
and killed in 1816 - leads a band of his companions, despite a guard, to
steal his head which is on display at the site of his last crime (78).

This focus on women in the work of women artists was surely not for-
tuitous. That women were more proficient, because more practised, at
painting the female figure does not suffice as an explanation because many
of these works involve male figures as well. Also, the female characters
in these works are not just female figures. All are active, most are inde-
pendent and a number are heroic. In considering these themes as the work
of women artists one cannot help supposing a feeling of sympathy and
identification with the active independence of exceptional women in history.

Another striking theme emerges in the form of historical works por-
traying famous writers and artists of the past. Such subjects appeared
occasionally at the beginning of the century, there being seven instances
between 1800 and 1817 (I). In 1819 they became popular and artists were
the subject of six works exhibited in that year alone. One of these was
Fig.46 Julie Philipaut's "Racine lisant Athalie devant Louis XIV et Madame de
Maintenon", now in the Louvre (J). Eight more followed in the 1820s, three
of these being the work of Mlle Julie Ribault. she exhibited a scene
involving Piron in 1822, exemplifying the narcissism of artists (79),
"Racine, dans son ménage, jouant à la procession avec ses enfans" in 1824
(80) and "Mignard faisant le portrait de Mme de Maintenon née Françoise
d'Aubigny" in 1827 (81). Other figures were Poussin and Domenico
Zampiéri, Mignard, Raphael and Perugino, and Masaccio whose death was rep-
resented on porcelain by Mme Mutel in 1827 (K). In the same decade Mlle de

Fauveau began work on her famous "Monument à Dante" (82). Finally, of the two works of the decade devoted to Sappho, one deserves emphasis as being an extremely unusual rendering of the poetess. The following description accompanied Mlle Adèle Lauzier's picture exhibited in 1824 (no.1028): "Elle vient de composer sa dernière élégie. Sa mère et sa fille cherchent à la consoler" (83). The artist was a popular subject in 19th century literature, a result of the increasingly introspective nature of the creative process. Numerous biographies were written of artists, fictional and real (84). In the fine arts this interest appears in historical works such as those which have just been mentioned and also in the many self-portraits and portraits of named and anonymous artists produced over this period (85).

Once again death is a strong theme in historical works of the 1820s. The idea is involved in eleven of those referred to above (L) and is also at issue in Mme Louise Hersent's "Visite du duc de Sully à la reine, le lendemain de la mort de Henri IV" of 1822 in which the dead king is visible through a door in the background (86), the same artist's "Louis XIV bénissant son arrière petit -fils" of 1824 - a work incidentally which includes a portrait of Mme de Maintenon supporting the dying man - (87), Mme Thurot (née Hoguer)'s "Sainte Gertrude et sa mère" exhibited in the same year (88) and Mlle Henry's "Le voeu de Saint-Louis" of 1827 (89).

The number of mythological works decreased in this decade. Of a total of nine, four share a common theme which stands in marked contrast to those which emerge from historical works of the same period. Woman is not represented as an active, independent being, but as a sufferer, weak and dependent on man. Thus in Mlle Aimée Pagès' "Psyché enlevée par Zéphire" of 1822 (no.998), Mme Guimet's "Danae exposée sur les flots avec son fils Persée" of 1824 (90), Mlle Pagès's "Daphnis et Chloé" in which Daphnis comforts Chloe frightened by a cigalle, of the same year (91) and finally "Clytie" by Mlle Sambat, also of 1824, in which Clytie, "nymphe, fille de l'Océan et amante d'Apollon" who died when Apollo ceased to love her and was changed into a sunflower, is shown moving her head with the sun, Apollo, as he moves (92).

The most ambitious mythological work of the decade was Mme Mongez' "Les sept chefs devant Thèbes" of 1827 (93), a subject and composition which, in the critic A.Jal's opinion, was beyond woman's scope: "Il fallait un crayon et une couleur plus énergiques qu'il n'est donné à une femme de les avoir, pour grouper ces chefs irrités et leur donner un caractère convenable à leur situation". The figures were good, but "une pensée puissante, un feu vivifiant, une main vigoureuse ont manqué à cette production" (94). In

the same review Jal raised an interesting subject which is appropriate here
as 1827 was the last year in which Mme Mongez exhibited at the Salon. The
claim had often been made that David did her pictures. In Jal's view there
was no justification for this for he could see no similarity in their work.
Despite his remarks about "Les sept chefs devant Thèbes", he explained the
injustice with a clear-sightedness unusual at the time and with equally
rare sympathy: "Parce que Mme Mongez n'a peint ni des fleurs, ni des
paysages, ni des scènes familières; parce qu'elle a représenté des héros
et dessiné de grandes académies, on n'a pas voulu croire à elle, et on lui
a donné un collaborateur". He went on: "Les femmes sont bien à plaindre!
Si elles n'ont pas de talent on triomphe de leur insuccès; si elles en
ont, on s'arrange pour le nier ou le leur contester! Combien de temps a-
t-on affirmé que M. Lethière composait les ouvrages de Mlle Lescot?
N'a-t-on pas répandu que M. de Châteaubriand a écrit les Nouvelles de
Madame de Duras?" (95) Mme Mongez and Mlle Lescot, whose work will be con-
sidered later, were not the only two to be doubted: as we have seen
Constance Mayer's work was often attributed to Prud'hon (96) and another
artist who suffered in this respect was Mlle Ledoux (97).

Twelve Biblical subjects were exhibited over the same period. The
majority of these appear to have been portraits - of Christ, the Virgin Mary,
Eve, St. John the Baptist, Ruth and Naomi (M). Three exhibited in 1827
involved rather more drama: Mlle Alexandrine Delaval's "La Madeleine dans
le désert" (no.310), Mlle Legrand de Saint Aubin's "Le Christ descendu de
la croix" (no. 673) and most interesting of all, Mme Guimet's "Judith", a
subject which had always been popular with women artists but which was
rarely rendered in such a sympathetic human light: "Près de frapper
Holopherne, elle invoque le ciel pour lui demander la force d'exécuter
l'action hardie que son enthousiasme religieux lui a inspirée" (no. 532).

Historical subjects with female characters predominated once again in
the 1830s and the most prolific exponents of these were Mmes Félicie Frappart
Marie-Eve-Alexandrine Verdé-Delisle, Herminie Dehérain and Elise Clément
Boulanger. A popular theme was that of famous mistresses and lovers in
history: Henry IV and Fleurette, Tasso and Princess Leonora, Charles VII
and Agnès Sorel, the Czar PeterI and Catherine, Klovis and Klotilde, Louis
XIV and Mlle de La Vallière, Henri II and Rosamonde, Louis XIV and Mlle
Mancini, Louis XV and Mme Dubarry, Marion de Lorme and le chevalier de
Grammont, François 1er and la duchesse d'Etampes, Charles VI and Odette de
Champdivers, Ninon de Lenclos and Mme de Maintenon (veuve Scarron) were all
portrayed (N). Saints, particularly female saints and incidents in their

lives, provided a substantial category (O) and so did artists, including
writers, painters and sculptors. Three women figured amongst these:
Justine de Lévis, a poet of the 14th century, Clotilde de Surville,
also a poet, who had already been depicted in 1819 by Mlle Aurore de
Lafond (98) and Maria Tintorella, the painter. Two works represented
women as admirers of the arts: Christine of Sweden of the paintings of
Guerchino and Marguerite Stuart of the writings of Alain Chartier (P).

The most striking theme, however, is the association of women with
death. In many cases the subject was the death or imminent death of the
heroines themselves: Joan of Arc, Anne Boleyn and Marie Stuart were fre-
quently depicted in this context, and other figures were Marie de Clèves,
Inès de Castro, Charlotte Corday, Jane Gray, Henriette d'Angleterre, the
countess of Nottingham and Frédégonde. All but the last three were
executed (Q). The reaction of historical figures, especially women, to the
death and danger of others was also a recurrent subject (R). Suffering
was, indeed, the emotion most often represented in historical works involv-
ing female figures (S). A few works show women playing an active and
positive role in historical events, particularly as advisors and saviours
of their husbands and lovers (T). Two unusual works demonstrating the
bravery of women are worthy of note: firstly Mlle Clotilde Gérard's "La
veuve de feu messire Guy de la Rocheguyon", the mother of two sons and a
daughter and owner of a fine château, who, rather than make an oath of
allegiance to the King of England, forfeited her home and possessions. She
is described as "mue d'un noble couraige" and preferring to lose all "et
s'en aller desnuée et ses enfans, que soy mestre, ni ses enfans ès-mains
des anciens ennemis du royaume, et délaisser son souverain seigneur" (99).
The second, by Mlle Coraly de Fourmond, depicted the extraordinarily daring
act of Lucretia Greenwil who loved and was loved by the Duke of Buckingham,
killed by Cromwell himself at the battle of St. Needs. "Lorsqu'elle apprit
sa mort, ell ne songea qu'à le venger". She fired at him with a pistol
but missed and when Cromwell looked up she boldly declared herself the
assassin (100). Of the few historical men represented in female art, only
two observations need be made. The continuing popularity of Henri IV is
noteworthy; secondly, men were generally shown in a domestic context, often
with their children (U).

Among historical works by women of the 1830s special mention should be
made of a marble statue of Jeanne d'Arc by the Princesse Marie, Duchesse de
Wurtemberg (101). The views of a contemporary, M.J. Chaudes-Aignes, on this
work will be quoted at length as they constitute one of the most ecstatic
tributes paid to the work of a woman in the nineteenth century: "Le plus

bel ouvrage que l'art, de nos jours, ait produit en s'inspirant de
l'héroïne de Vaucouleurs (y compris la tragédie de M. Alexandre Soumet
et la 'Messénienne' de M. Casimir Delavigne), c'est, sans contredit, la
statue de Jeanne d'Arc actuellement au musée de Versailles. Jeanne est
représentée debout, les bras croisés sur sa pointrine, serrant contre son
coeur un glaive dont le pommeau figure la croix, et la tête inclinée vers
le glaive. Il est impossible de nier le talent d'invention dont témoigne
le choix de l'attitude que nous signalons ici. N'est-ce pas une admirable
idée que d'avoir réuni, de la sorte, en un symbole unique, la douceur et la
force, l'abnégation et le courage, la piété et l'héroisme, et d'avoir su
rendre, par un seul regard de la jeune fille, le caractère politique et le
caractère religieux qui la distinguent, c'est-à-dire la double valeur
qu'elle a aux yeux de l'histoire et de la poésie? Pour arriver à une si
éloquente simplification de son sujet, il ne faut pas seulement posséder
le sentiment de l'art à un dégré suprême; il est nécessaire encore d'être
familiarisé avec toutes les ressources de la plastique, afin de maîtriser
complètement sa pensée et de la gouverner sans hésitation. Ces deux
facultés éminentes se révèlent dans la statue que nous avons vue à
Versailles". Having bestowed equal praise on her execution, he referred to
"les éloges unanimes que nous avons entendu prodiguer à cette statue" and
concluded by describing her work as "une des productions les plus remar-
quables de la statuaire moderne" (102). Inevitably suggestions were made
that the original idea for the work was not hers and the journalist Vaudois
claimed that M. Pradier was the source of her inspiration, but Chaudes-
Aignes refuted this in a later article (103).

Events in recent history were reflected in the work of women artists
and we are considering this theme separately once again, not only to draw
attention to the interest and possible involvement of certain women in con-
temporary history, but also because works of this type became increasingly
scarce as the century progressed. In 1830 an exhibition was held "au profit
des blessés". Four portraits of military men were exhibited by women (V);
in addition Mme Auzou sent her "Napoléon et Marie-Louise à Compiegne"
(no.477) and Mme Rumilly a work called "1815, ou 'comment on restaurait les
Français'" (no.226) about which one can only speculate. Between 1831 and
1834 six works appeared, with events of the year 1830 as their theme: Mlle
Louise Marigny's "Une veuve de l'année 1830" (1831 no.1446), Mlle Revest's
"Une jeune femme soignant un blessé pendant les journées de juillet" (1831
no.1758), Mlle O. Rossignon's "Scènes historiques du 27 juillet" (1831 no.
1838) and "Une scène de la révolution de 1830" (1834 no.1682) and Mlle
Saint-Omer's "Mlle F..., artiste du théâtre de ..., effrayée d'une balle

entrée chez elle" (1831 no.2603). More propagandist was Mme Jouenne's
"Tableau allégorique" of 1831 (no.1157): "un coq, emblème des Français
posé sur une caisse et entouré de branches de lauriers./ Il est blessé
et semble dire avec fierté les mots qui sont inscrits sur le bandrier:
'Ils meurent et ne se rendent pas!' Au-dessus de lui plane une couronne
de laurier, de chêne et d'immortelles entrelacs avec le ruban et la croix
de la Légion d'Honneur". A rather more light-hearted work involving con-
temporary figures is Mme De La Ferrière's "Le yacht de la Reine" of 1333
(104). The involvement of the sculptor Félicie de Fauveau in political
events of the middle nineteenth century will be examined in greater detail
later, as will her works, but mention should be made here of a design she
made around 1830 while she was in prison. According to "L'Artiste", "elle
chercha un sujet dans les événements récents, et résolut de composer un
monument à la mémoire du jeune Bonnechose qui venait d'être tué d'une
manière déplorable par les gendarmes chargés de l'arrêter" (105). This
work, which she executed on her prison wall as a fresco, was an elaborate
composition, epitomizing "ses idées de représailles et de vengeance, sym-
bolisées par des anges exterminateurs et des épées de justice" (106). It
is also relevant here to mention the extensive commissions, many of them
from women artists, which accompanied the decision to create an historical
museum at Versailles in 1833 (107). There were 58 women among the artists
whose work fulfilled the official programme of representing eminent
historical and contemporary personnages and important episodes in French
history. (Appendix X).

Very few works with mythological themes were exhibited in the 1830s
and even these were unambitious. There were rather more with Biblical
subject-matter. The Virgin Mary and Jesus were frequently represented and
other figures were Susannah, Judith, Martha and Mary Magdalen (W). Mme
Déherain, who also exhibited historical works, was the author of most of
these.

Understanding of the art of the 1830s is deepened by a knowledge of the
literature of the period. The predominance of historical themes among
classical works of the 1820s and 1830s is reflected in the popularity of
historical novels and plays, a vogue largely created by Sir Walter Scott
whose works were first translated in 1822. In literature the 1830s may be
distinguished from the 1820s in the emergence of a social conscience
stirred by the consequences of the industrial revolution and this is visible
not only in novels of contemporary life but also in historical novels
and plays. A good example of an historical work with a "thesis" is Hugo's
"Angélo" of 1335, in the preface to which he wrote: "Aujourd'hui plus que

jamais le théâtre est un lieu d'enseignement". The work is particularly
relevant in this context because in it the author intended to expose and
comment on the present condition of women, an intention which should be
seen in the light of Saint-Simonism which attached great importance to the
role of women and also the more recent publications of early feminists such
as Clair Demar (108). Hugo described his aim as follows: "Mettre en
présence, dans une action toute résultante du coeur, deux graves et
douloureuses figures, la femme dans la société, la femme hors de la
société; c'est-à-dire, en deux types vivants, toutes les femmes, toute la
femme. Montrer ces deux femmes, qui résument tout en elles, généreuses
souvent, malheureuses toujours". But although his theme was contemporary,
the setting was to be firmly historical and in addition "princier et
domestique; princier, parce qu'il faut que le drame soit grand; domes-
tique, parce qu'il faut que le drame soit vrai " (109). Now while it would
be bold to attribute this intention of commenting on woman's present
position through historical examples to the numerous women artists who por-
trayed historical women in their works, the strong emphasis on female
suffering and heroism in women's historical contributions does suggest
something more than an academic interest in women of the past. "Mal-
heureuses toujours" wrote Hugo, and this statement receives strong corro-
boration from women's art of the period.

Historical works remained numerous at exhibitions of the 1840s. Very
few of these took men as their main subjects (X) and in contrast to the
1830s when several works by women were based on contemporary history, par-
ticularly events of 1830, in the 1840s only one drew inspiration from the
present: Mlle Louise-Eudes de Guimard's "Un enfant de Paris, 24 février,
1848" (1849 no.982). The theme of suffering, and particularly female
suffering, persisted. Approaching death was the subject of works involv-
ing Mary Stuart, Agnès de Méranie, Madame Elisabeth de France, "La folle
du Luxembourg", Gabrielle d'Estrées, Sainte Perpetua, Anne Boleyn, the
Princess de Lamballe, the wife of the superintendent at a prison which
housed Silvio Pellico, Cazotte and his daughter and three men: Lavoisier,
Antoine Allegri and Eustache Lesueur. A number share the theme of danger
(Y). In one of these, by Mme Edmond Flood, Mme Denoyer is shown in a small
boat with her children and servant, rapacious sailors having murdered her
husband and left her to the mercy of the waves; in another, by Mme Sophie
Fig.47 Rude, the Duchesse de Bourgogne and her son are seen leaving Bruges in a
carriage, surrounded by threatening revolutionaries. Other paintings por-
trayed the misery of Mlle de La Vallière when she was ordered out of her
convent by Louis XIV, the suffering of the imprisoned Marie de Médicis, of

the persecuted "Protestantes de Cévennes", of Valentine de Milan, of Anne
d'Autriche when Richelieu tried to take away her son and of the condemned
Cazotte's daughter powerless to save her father (Z). Some of the most
sorrowful of these works were based on the French Revolution (110). For
instance Mlle Adèle Tardieu's "Madame Elizabeth (10 mai 1794)" (1841 no.
1859) which included the following description: "Madame Elizabeth bénit sa
nièce à l'instant où elle la quitte pour aller au tribunal révolutionnaire".
In 1842 Mlle Clara Filleul portrayed "La folle du Luxembourg"; "Pendant
la terreur, une jeune femme suivit un jour le tombereau qui se rendait du
Luxembourg à la place de la Révolution; son mari était au nombre des vic-
times. Après l'exécution, elle revint s'agenouiller à la porte fatale, et
continua chaque jour d'accompagner la sanglante charrette. Enfin on ne la
vit plus; la pauvre folle avait cessé de souffrir" (111). In 1843 Lavoi-
sier the chemist, executed in 1793, was the subject of a much acclaimed
picture by Mlle Elise-Marie-Thomase Journet (112). In 1846 Mme Louise
Desnos exhibited two pictures illustrating scenes from the French Revolu-
tion and her choice of subjects was harshly criticized in the "Magasin des
Demoiselles" (113). The first was entitled "Interrogatoire et condamnation
de la princesse de Lamballe (3 septembre 1792)" (114). The second, "Le
journal du soir, ou l'appel des condamnés", showed the reading out of the
names of those prisoners destined to die on the morrow (115). Finally,
in 1848 Mlle Elise Allier exhibited three works depicting the condemned
writer Cazotte and his daughter in what a critic described as "trois des
scènes les plus émouvantes de la Révolution" (116): "Cazotte et sa fille
à la prison de l'Abbaye" in which his daughter tries to distract him from
their misfortunes (117); "Cazotte sauvé par sa fille" in which she begs
"Les septembriseurs" that he may be pardoned (118) and "Mort d'Elisabeth
Cazotte" which included the following lines: "En apprenant la mort de son
père qu'on lui avait cachée pendant un an, elle tomba dans un état de
langueur qui la conduisit un mois après au tombeau" (119). Persecution was
also the subject of an interesting work exhibited by Mlle Elisa Allier in
1845: "La vieillesse indigente secourue par l'enfance pauvre" (120). Very
few works of the decade showed women as effective or contented in public
life. Philippa de Hainaut saving the lives of the six burghers of Calais
was the subject of a work by Mme Amélie Cordellier-Delanoue in 1842 and
Novella d'Andrea - a 13th century figure whose knowledge of the law was so
exceptional that she occasionally took her father's place as professor -
was depicted in 1843 by Mlle Godefroid (121).

The two other main themes which emerge from historical works by women
in this decade provide an interesting counterbalance to these bleak rep-
resentations of women's experiences in public life. Firstly the decade

witnessed the exhibition of a considerable number of works depicting
saints, particularly female saints, and positing a religious life (A1).
In three works religion is threatened and women are the subjects in each
case: in 1843 Mme Clémentine de Bar portrayed "Sainte Perpétue dans sa
prison" with her father entreating her to sacrifice her religion to save
her life (122); in 1844 Mlle Virginie Dautel exhibited "Mlle de la
Vallière au couvent de la Visitation, à Chaillot" in which Mlle de la
Vallière, driven by "la crainte de déplaire à d'augustes personnes" to
seek refuge in a convent where she sought to forget "l'amour du roi et
les séductions de la cour", is ordered by Louis XIV to leave and follow
him (123). Finally in Mlle J. Fabre D'Olivet's "Les protestantes de
Cévennes" exhibited in the same year, protestant women, who hid themselves
in caves to escape the persecutions resulting from the revocation of the
Edict of Nantes, find "la résignation nécessaire pour supporter leurs
inquiétudes et leur douleur" in the reading of the Bible (124).

The other major category consists of works devoted to the lives of
artists: Rubens, Eustache Lesueur, Jean-Baptiste Louis Gresset, Lully,
Antoine Allegri, Silvio Pellico, Tasso, Leonardo da Vinci, Raphael,
Veronese, Haydn, Thomas Lawrence, Brauwer and Craesbeke and Cazotte were
all represented by women artists (B1). As the religious life was seen to
be threatened in a number of works, so was the artistic life. In 1840
Mlle Elise Journet exhibited "Eustache Lesueur" with the following quotation:
"Resté veuf à l'âge de 36 ans, abandonné de tous, Lesueur, profondément
découragé, se retire à la Chartreuse de Paris, où, malgré les soins les
plus empressés, une maladie de langeur termina bientôt sa vie" (125).
Jules Janin amplified this description: "il n'a pas eu le courage de
supporter les clameurs de l'envie; il a renoncé à ce grand art qui faisait
sa gloire et sa force, et maintenant il ne songe plus qu'à mourir". The
same writer paid high tribute to Mlle Journet who, he wrote, "a très-bien
compris et très-bien rendu le dernier abattement de ce pauvre homme de
génie". The work was widely acclaimed and in his view "un des meilleurs de
l'Exposition, sans contredit" (126). The writer Silvio Pellico in
prison was twice portrayed by women artists in this decade: firstly in
1844 by Mlle Octavie Rossignon and secondly in 1847 by Mlle Adèle Grasset
(127). Mlle Elisa Allier's three pictures representing the imprisoned
Cazotte and his daughter have already been mentioned and also in 1848 Mme
Ernestine Bigarne exhibited "Le Tasse dans la prison de Ferrare".

Persecution, then, was an important theme in historical works by
women in the 1840s and the three main categories among the persecuted
were women, religious people and artists - all, broadly speaking, apolitical
and dependent **groups.** The emphasis on the two latter categories in works
by women evokes the traditional view of women as guardians of religion and
culture in times of stress and furthermore suggests that after the exper-
iences of the last five decades, refuge was taken in these as constant
values. Further evidence for this is provided by the fact that there was
a huge increase of works based on Biblical themes, particularly from the
New Testament, at exhibitions in the 1840s. Mme Aimée Brune (née Pagès),
Mme Calamatta, Mme Cavé, Henriquetta Girouard and Clémentine de Bar were
the most frequent exhibitors of such works. The Virgin Mary, Jesus and
John the Baptist remained popular as before, but many other figures, mostly
female, were singled out. The penitent Mary Magdalen who was forgiven many
sins because of the extent of her love, was often portrayed and among
others, Martha, Hagar and Jephtha's daughter were recurrent subjects (C1).
The Virgin Mary was represented in two unusual pictures exhibited by Mme
Marie-Elisabeth Cavé in 1846: "La Consolation" in which "Dieu envoie le
sommeil à la Madone désolée" and "Le Songe" in which "La Madone endormie
se voit au ciel dans toute sa gloire", works which a critic described as
"d'un ordre plus élevé que les tableaux de genre". The same writer
pointed out the uniqueness of the works: "C'est la première fois qu'un
peintre nous montre la Vierge consolée après la mort du Christ par la vue
du ciel qui s'ouvrira aussi pour elle" (128). Mlle Félicie de Fauveau was
probably the most prolific among women artists specializing in religious
subjects (129). Her most important exhibit of the decade was the
unusual "Judith montrant au peuple de Béthulie assemblé sur la place
publique, la tête d'Holopherne; bas-relief en marbre" exhibited in 1842
(130). The theme of persecution was appropriately taken up by Mlle Léonie
Taurin in 1841 in a "Sujet tiré de l'Evangile" which bore the following
quotation: "Bienheureux ceux qui souffrent persécution pour la justice;
parce que le royaume des cieux est à eux" (131).

The few allegorical works of the 1830s and 1840s crystallize the
themes of grief and its antidote, religion. In 1837 Mme Dehérain exhibited
"La foi et l'espérance abandonnent la terre. La charité reste pour la con-
soler et lui enseigner la fraternité et l'amour" (no.484), a work which
reflects the strong social conscience of the 1830s. In 1838 Mme Céleste
Pensotti exhibited "La Foi consolant la Douleur" (no.1371), in 1841 Mme
Laure de Léomenil "Un ange recueillant les larmes du repentir" (no.1277) and
in 1844 Mlle Annette Chedin "La Douleur soutenue par l'Espérance" (no.333).

Since fewer Salons were held in the 1850s there were fewer exhibited works. However the drastic decline in the number of classical works is not sufficiently explained by the fact of fewer exhibitions. From the 1840s critics had commented on the declining popularity of classical themes and in particular of "grandes machines" (132). In 1851 the critic F. Sabatier-Ungher voiced an opinion which was steadily gaining ground: "La peinture antique, la peinture religieuse et la peinture historique ne doivent pas occuper plus d'espace dans l'art moderne que l'esprit religieux, l'étude de l'antiquité et de l'histoire n'en prennent dans la vie. Il ne faut point les proscrire. Nouse en aurons toujours besoin. - Que chacun suive ses attractions. - Mais il faut encore moins les ériger en système et vouloir y forcer son génie ... Le sujet de l'art moderne est la vie réelle sous toutes ses faces, du foyer familial à la place publique". He then observed of the Salon of 1851: "Le Salon de 1851 a une grande significa-tion, parce qu'il fournit la preuve que l'art français procède de la vie et non plus des livres .." (133).

Mythological subjects remained extremely scant. Among historical works the lives of saints constituted the largest category (E1). Saint Genevieve was still popular but two of the most ambitious works were devoted to less well known saints. Martyrdom was the subject of Mme de Guizard's "Sainte Affre, martyre, patronne d'Augsbourg" of 1852 (134) and of Félicie de Fauveau's "Le Martyre de Sainte Dorothée, groupe marbre avec fond d'architecture" of 1855 (no. 5120). Other historical works included an "Elisabeth de France faisant l'aumône" by Hélène-Juliette Crespy-Leprince (1850 no.693), a dramatic work exhibited by Mlle Léonie Lescuyer in 1857 representing the "Enlèvement de Mme de Beauharnais-Miramion" which depicted this brave and saintly lady attempting to escape from her abduc-tors (135), and finally, in the same vein of virtuous women, "la fille de Cromwell reprochant à son père la mort de Charles 1er" by Mlle Maria Chenu (1859 no.586). Death was the subject of two works: Mme Doutreleau's "Hiver de 1855" a very moving picture which represented the death of three beggar children in the snow (136) and the "Funérailles de Buon del Monte" by Mme Marie-Henriette Bertaut (137). Children figured in four other pictures devoted to the childhood of the famous. Two of these were by Mme Cavé who was particularly fond of such themes and two represented artists (F1) (138).

The popularity of Biblical themes, already observed in the 1840s, per-sisted in this decade; indeed, more Biblical than historical subjects were exhibited. Scenes from the lives of Jesus Christ and the Virgin Mary were the most usual and other figures included Susannah, Mary

Magdalen and Jephtha's daughter. Two points emerge from an examination of
these works. As before, female figures predominated and attention should
also be drawn to the number of children represented. Jesus, the Virgin
Mary and Moses were all portrayed in their childhood and two works depicted
Christ and the little children (G1). Allegorical works were also on reli-
gious themes, Faith, Hope and Charity being the most favoured images (H1).

With the re-emergence of a classical school of painters classical
themes increased somewhat in the 1860s. Among historical works, which pro-
vide a substantial category, saints, mostly female, remained numerous and, as
in the previous decade, several of these focused on their martyrdom and
grief. Examples are Mlle Amada Fougère's "Sainte Julitte, martyre" of 1863
(139), "Sainte Catherine condamnée à mourir de faim est nourrie par les
anges" by Mme Collard of 1864 (no.422), Mlle Léonie Dusseuil's "Sainte
Clotilde implore du ciel la guérison de son fils" of 1865 (no.742) and
"Sainte Agnès, vierge et martyre" by Mme Thérèse Donnet-Thurninger of 1866
(no.598) (I1). Most other works with historical subjects represented female
figures: Joan of Arc, Catherine de Médicis, Bianca Capello, Jeanne la Folle,
Elisabeth de France, Marie Antoinette, the Empress Joséphine, Madame de
Pompadour, Princess Farrakanoff and Charlotte Corday (J1). As martyrdom
was a common theme among representations of saints, so was suffering in
works portraying these women from history. In 1863, for instance, Mme
Malvina, Duchesse d'Albufera exhibited a "Jeune juive conduite au supplice
(scène de l'inquisition espagnole)" (no.22); in the same year, at the
Salon des Refusés, Mlle Elise Moisson Desroches exhibited "Jeanne la Folle,
mère de Charles V, née en 1482, morte en 1555" trying to grasp the fact of
her husband's death (140). A third striking example is "La princesse
Farrakanoff noyée dans sa prison par suite d'une crue subite des eaux de
la Newa en 1777" also by Moisson-Desroches, of 1868. Four of these women
- Catherine de Médicis, Bianca Capello, Joan of Arc and Charlotte Corday -
were remarkable for their intrepidity. In addition, at least ten works of
the decade depicted famous artists and scenes from their lives (K1).

Among works on Biblical themes - of which a considerable number were
again exhibited in this decade (L1) - several were devoted to scenes from
the life of Christ, particularly his childhood. One of these, "Jésus
montré au peuple et insulté" by Mme Marie-Henriette Bertaut of 1861,
received high praise from critics (141). The Virgin Mary was frequently
represented and among other subjects, female figures were favoured as
before. Particular mention need only be made of Mary Magdalen who fig-
ured in three works, Mme Dentigny's "Agar chassée par Abraham" of 1863
which may be aligned with historical works portraying suffering and

Fig.48

persecuted women and finally "Judith venant de couper la tête d'Olopherne"
by Mme Collard of 1865. Judith resembles three of the historical figures
mentioned above - Bianca Capello, Catherine de Médicis and Charlotte
Corday - in her ruthlessness and intrepidity.

Mythological works remained rare and unambitious in this decade. The
majority portrayed female figures and of these only one point need be made.
In contrast to the 1820s when women artists chose helpless and persecuted
women from mythology, in the 1860s such figures were more powerful and inde-
pendent. Examples are Mme Elisabeth Jerichau's "La sirène du nord" of 1861
(142), Mme Roslin's "Les filles de Minée" of 1863 (143), Marcello's "La
Gorgone; buste, marbre" (1865 no.3067), Mme Adélaide Salles-Wagner's
"Psyché montant à l'Olympe" (1866 no.1735), Mme Anaïs Beauvais' "Vénus et
l'Amour" (1867 no.91), Mme Salles-Wagner's "Les Parques" (1867 no.1355),
Mlle Hélène Saunier's "Une muse; pastel" (1868 no.3304) and Mme Lemaire's
Fig.49 "Diana et son chien" (1869 no.1480). Marcello's "La Gorgone" was accorded
highest praise. Balthasar Robin wrote: "Il y a dans cette figure je ne sais
quoi d'énergique et de sauvage; je ne sais quelle expression hautaine et
superbe; je ne sais quel grand air répandu sur tous ses traits, qui charme
l'esprit et excite le regard ... La coiffure encadre admirablement la figure
de la déesse;l'oeil semble regarder, tant, par un artifice sculptural, l'
artiste lui a donné de vie; les narines sont légèrement délatées; les coins
de la bouche relevés dédaigneusement, et tout cela est empreint d'une beauté
étrange, qui unit la vigueur à la délicatesse, la grâce à la fermeté" (144).

Religious subjects dominated the 1860s. They include scenes drawn
from the Bible and from the lives of the saints and also the small number
of allegorical works most of which were on religious themes (M1). In these
and in historical and mythological works female figures remained most
usual, but they were associated not only or even mainly with suffering and
persecution as was the case previously, but also, as we have seen, with
unusual daring and resolve.

From the 1870s fewer and fewer paintings with classical themes were
exhibited. On the other hand numerous sculptures, water-colours, minia-
tures and paintings on china with classical subjects appeared at the
salons. Also, titles became shorter, often containing no more than the
names of the principal figure or figures, suggesting that many of these
works were simply portraits and indeed in the case of both sculptures and
small-scale works such as miniatures and china paintings, elaborate compo-
sition and numerous figures were not feasible (145).

Female subjects remained popular with female artists. In the histor-
ical category, which shrank considerably, Joan of Arc was most frequently
represented (N1). At least 22 portraits of her were exhibited between

1870 and 1900 and in 1879 a critic remarked: "Quand une femme s'avise de sculpter ou de peindre, il y a toujours un moment où elle veut représenter Jeanne d'Arc. On lui dit autour d'elle qu'il n'y a qu'elle qui puisse rendre la foi et la candeur, le dévouement et le courage de l'héroine française" (146). Of the other historical figures depicted by women over these three decades, several were also remarkable for their courage and had, like Joan of Arc, met with unusual deaths: Charlotte Corday, Marie Antoinette, Mme Elisabeth de France and the Princesse de Lamballe were all portrayed several times and single works were devoted to the unfortunate daughter of Virginius, the funeral of Beatrice, Bianca Capello and Rose Doise, "victime d'une erreur judiciaire" (O1). Female saints were the subjects of numerous works and in this connection mention should be made of a number of works depicting anonymous female Christian martyrs (Q1).

Portraits of artists of the past and scenes from their lives were still popular with women artists and amongst these Sappho was the most favoured figure; she appeared at least nine times in different works over these 30 years. Another female poet, Corinne, was represented twice and Clotilde de Surville, once (R1).

Unlike the first half of the century when contemporary history was often recorded and commented on in art, during the second half, despite dramatic events such as the Franco-Prussian War and Siege of Paris, few artists took the modern political world as their theme. The following are
Fig 50 the only apparent instances: Henriette Browne's "Alsace! - 1870" (1872 no.221), Mme Domenica Monvoisin's "P. Chevalier, blessé mortellement à la bataille de Champigny, le 2 décembre 1870; - miniature" (1873 no.1081), "La France en deuil de l'Alsace et de La Lorraine" (1875 no. 453) by Mme Marie Thérèse, vicomtesse H.de Clairval, Mme Doutreleau D'Amsinck's "Sans mère: sans foyer (1870-1)" (1880 no.1215), Mlle M. Fresnaye's "La République présidant à l'instruction de ses enfants; médaillon plâtre" (1881 no.3900), Mme C. Hugues-Royannez's "L'enfant de l'année terrible" (1893 no.2990) and "Martyre (3 mai 1897)" by Mme R.M.A. Harouard (1899 no. 3570).

Although Christ, the Virgin Mary, John the Baptist and scenes from their lives continued to predominate among Biblical subjects (S1), daring and unorthodox women from the Bible also furnished women artists with subjects over this period. Salome, Herodias and Judith, all involved in murder, were portrayed several times and so was the independent Eve. Most popular, however, as in previous decades, was the penitent Mary Magdalen who was depicted at least fifteen times. One artist who

described her fascination with this figure was Marie Bashkirtseff: On
May 25th 1880 she wrote in her diary of her intention to portray Mary
Magdalen and Mary of Nazareth outside the sepulchre in which Jesus had
been laid: "Seulement pas de convention, ni de sainteté, mais faire
comme on croit que c'était et sentir ce qu'on fait". Until her death
this subject constantly preoccupied her and she even considered travell-
ing to the middle east to execute it. Her view of the two Mary's was of
"des révolutionnaires, les Louise Michel, les réprouvées de ces temps-là".
Revolt and grief were the emotions she wished to convey. The following is
her description of the work as she saw it and as she may even have sketched
it; the picture was certainly never completed. "Je sais à quelle heure
il faut que ça se passe, à l'heure où les contours se brouillent; le
calme contraste avec ce qui vient de se passer. -Et, au loin, des formes
humaines qui s'en vont après avoir enseveli le Christ; les deux femmes
seules sont restées plongées dans la stupeur. - Madeleine, de profil,
le coude sur le genou droit et le menton dans la main, avec son oeil qui
ne voit rien, attaché à l'entrée du sépulchre, le genou gauche touche la
terre et le bras gauche pend.

"L'autre Marie est debout, un peu en arrière; la tête dans les mains
et les épaules soulevées, on ne voit que ses mains, et la pose doit
révéler une explosion de larmes, de lassitude, de détente, de désespoir;
la tête tombée dans ses deux mains et le corps où on sent l'abandon,
l'évanouissement de toutes les forces. Tout est fini . . .

"La femme assise sera la plus difficile. Il doit y avoir là de la
stupeur, de l'ahurissement, du désespoir, de la prostration et de la
révolte. Et c'est cette révolte qui est la chose délicate à rendre. Un
monde, un monde!" (147). Among other biblical figures depicted by women
artists over these years were two more outcasts, Hagar and Ishmael, who
appeared in five works (T1). Male figures constituted a small minority (U1).

The theme of strong and independent women also emerges from mytholo-
gical works, of which an increasing number were exhibited during the last
three decades of the century. Diana, goddess of the hunt, and her
followers became extremely popular in the 1880s and twenty versions of this
theme were exhibited between 1880 and 1900 (V1). The wilful Psyche was the
Fig.51 subject of seven works one of which was Mme Léon Bertaux's "Psyché sous
l'empire du mystère" now in the Luxembourg and awesome figures such as the
Sibyls, Medusa, Undine, the Loreley, Electra, Medea, Circe and particu-
larly the three Fates, were all represented (W1). The female sculptor
Marcello was especially fond of this type of subject. In 1870 she
exhibited "La Pythie" .. "qui s'agite et se démène sur un socle dont les

arêtes sont décorées de serpents et de dragons. C'est un morceau à
grand fracas, et bien fait pour épouvanter le spectateur timide. Le
profil de cette terrible prophétesse appartient au type nègre, sa main
redoutable est une patte crochue etc." (148). Female figures were most
usual in other mythological works a large number of which portrayed
Bacchantes, Nymphes and Amours (X1).

Symbolist thought often made use of the female form to personify
ideas and mythology provided many of the images such as Minerva, goddess
of wisdom, Juno, goddess of marriage and Hebe, goddess of youth, all repre-
sented several times over these years (Y1). Allegorical works became
numerous and the human form, mostly woman, was widely used as a symbol:
for the seasons and times of day; concepts such as innocence, hope, love,
charity, youth, grief, destiny, the soul; the arts including music, dance,
poetry, ceramics, tragedy, comedy and even science and electricity (Z1).
As we have said many of these were sculptures or small-scale works and
indeed works of these types were ideally suited to allegory and symbolism.

The strongest impression given by an examination of classical works
by women in 19th century France is women's sympathy for women. There can
be no doubt that women artists favoured female figures and they appear to
have done so for different reasons at different periods of the century.

Touching, domestic scenes from classical sources were prescribed and
executed between 1800 and 1820 but from these emerge two themes both in the
context of female experience; separation and death, the former often being
the result of the latter. As in England the most obvious explanation for
this is the Napoleonic Wars which enforced separation and mourning on a
large number of women.

After a short reprieve in the 1820s when the main theme in classical
works was love, misery and death re-emerged, crystallizing, between 1840
and 1848, into the more active theme of persecution. In the 1830s, these
grim subjects were offset by a few works showing historical women as
active and effective in public life and also by a rapid increase in works
with Biblical subject matter. Religious themes also contrast with the
idea of persecution, which arises mainly from histoircal works, in the
1840s. This duality of suffering counterbalanced by religion - so succinctly
conveyed in the 1840s by titles such as "La Foi consolant la Douleur" -
prevails right through to the 1860s, suggesting that despite the influ-
ence of Positivism on intellectuals (149), for many religion remained vital
and perhaps even a refuge.

From the 1860s the focus changed. Suffering was still an under-
current, particularly in historical works, but the most striking theme

in classical works of all types over the last three to four decades of
the century is that of powerful, independent and sometimes awesome female
figures. There was a revival of mythological themes which had almost died
out between 1820 and 1850 and allegorical works were also numerous.
Explanations for the popularity of such subjects include the growing
interest in past religions, the currency of the Femme Fatale image in Sym-
bolist thought and the deification of Woman as one of the many substi-
tutes for orthodox religion. But when such themes are considered as the
work of women artists, another explanation is possible. Passing considera-
tion at least should be given to the emergence of women in public life. It
was in the 1860s that organized feminism emerged in France and numerous
societies and publications succeeded the "Société pour la Révendication
des Droits de la Femme" founded in 1866 (150). Progress was achieved
in female education and women gradually began to infiltrate the professions
(151). Many independent "emancipated" women became famous between the
1860s and 1890s: Louise Michel, Maria Deraismes, Rosa Bordas, Séverine
and Rachilde to name but a few (152). Positions of power were gradually
being achieved by women and some of these new strong images surely resulted
from an awareness of this. One example, at least, is Marie Bashkirtseff
who saw Mary Magdalen as a revolutionary and the only figure through whom
she would show herself truly (153).

Section B - Literary subjects

Romance, frequently set in the past, was the subject of almost all
works of art by women illustrating scenes and characters from literature
during the first two decades of the century.

Broadly speaking the sources during the first twelve years were
Italian and medieval. The main exception, James Macpherson's purported
translation of poems by Ossian, was first published in France in 1777 (154).
Four works by women at the Salon illustrated scenes from the Ossian
collection. In 1802 Mme Franque exhibited "Gaul et Evirchoma; sujet
tiré à Ossian" (1802 no.969). The other three took Malvina and her grief
at Oscar's death as their theme. In 1806 Mlle Elisabeth Harvey, an English
artist but resident at that time in France, exhibited "Malvina pleure la
mort d'Oscar; ses compagnes cherchent à la consoler" (no.247), a small
work which was praised in the "Annales du Musée" for "un charme d'expres-
sion" (155). Mlle Delaval's "Malvina. Chant de douleur sur la perte de
son cher Oscar - Poésies d'Ossian" appeared in 1810 (no.215) and "Ossian
chantant à Malvina les exploits d'Oscar, mort en combattant" by Mlle
Revest, in 1812 (no.759). A similar theme was chosen from Ariosto by Mme
Rumilly: "Zerbin blessé à mort, expire dans les bras de sa maîtresse.
Sujet tiré de 1''Arioste'" (1808 no.544) and a writer of the same period,
Tasso, inspired two works: "Herminie écrivant le nom de Tancrède sur
l'écorce des arbres" by Mlle Bouliard (1802 no.30) and Mlle Forestier's
"Armide et Renaud" of 1810 (156), both from the "Jerusalem Delivered"
and both love scenes. Finally in 1812 Mme Giacomelli exhibited "Dessins
et gravures d'une suite de 100 sujets du Dante" (no. 1352) (157).

Between 1812 and 1820 the sources for illustration changed somewhat.
We have already considered the Romantic interest in medieval French history
and legend inspired by Mme de Stael (158). The borderline between histor-
ical and literary works becomes very slight here since many of the sources,
for instance medieval romances, are an inextricable mixture of fact and
legend. The story of Adelaide de Coucy and Gabrielle de Vergy, for instance
- the subject of two works by women artists (159) - was probably taken from
a 13th century romance by Jakemon le Vinier, the hero of which was an his-
torical character, Gui, châtelain de Coucy (160). Other sources fall more
easily into the literary category. In 1814 Madame Servières exhibited a
"Lancelot du Lac et Geneviève visitant les tombeaux d'Iseult et de Tristan"
(161), the subject of which was taken from a poem, "La Table Ronde" by
M. Creuse de Lesser. In 1819 Mlle Alexandrine Delaval exhibited "Corisandre"
(162), another romantic subject, taken from "Amadis des Gaules" which was
the title of certain Spanish romances about an imaginary knight (163) and

in the same year Mlle Muller illustrated a "Sujet tiré de la romance du Rocher de Ste.Avelle" (164).

Medieval romances, then, and works based on these, were one of the main literary sources between 1812 and 1820. Another was recent French works, particularly novels, and of these the most popular was "Mathilde" by Mme Sophie Cottin, published in 1805 (165). The work was first Fig.53 illustrated by Madame Servières in 1812 (166). She depicted the vital scene when Mathilde promises to marry Malek-Adhel if he will agree to adopt the Christian religion. She won praise: "Il était impossible de tracer plus clairement le caractère, l'intention et l'action de ces personnages que l'a fait Madame Servières dans cette agréable composition" (167). Other scenes from the work were chosen by Mlle Rosalie Caron and Mme Davin-Mirvault in 1814 and Mlle Rosalie Caron in 1817 (A2). Chateaubriand's "Martyrs", first published in 1809, provided themes for two pictures and other sources for occasional works were Rousseau, Beaumarchais, Voltaire and Bernardin de Saint-Pierre (B2). Recently performed plays also supplied subjects, works illustrating these tending to combine portraits of contemporary actors and actresses with the literary theme (C2).

The majority of literary works over this first period were pure illustrations. In only one was literature used to embellish a scene from real life (168). The theme of "Un vers de Virgile" by Madame de Lental (1810 no.219) is suggested by the verse: "Commence, petit enfant, à reconnaître ta mère à son sourire" (169). The work probably depicted a simple maternal scene.

Considering the intermittency of Salons in the 1820s an extraordinary number of literary works were exhibited in this decade. Novels gradually eclipsed medieval poetry and romances (D2) and there was a growing interest in narrative and exciting, dramatic incidents.

Among novelists two were particularly popular. Mme Cottin's "Mathilde" remained in favour and was illustrated in four exhibited works of the decade (E2). Other subjects were drawn from Madame de La Fayette's "Princesse de Clèves", Chateaubriand's "Atala" as well as his "Martyrs" and "Le Renégat" by the vicomte d'Arlincourt (F2). All these were outnumbered by Alain-René Lesage and Walter Scott. The attention attracted by Lesage's "Gil-Blas", first published in four volumes between 1715 and 1735, may be explained firstly by the fact that it was set in a sufficiently remote period of time for it to appeal to the prevalent historical taste and secondly by the picaresque aspect of the work. Exotic narratives full of incident and adventure were favoured at this time, the fashion being particularly noticeable in the drama of the period (170). Eight exhibited

works of the decade illustrated scenes from this romance: four by Mme
Haudebourt-Lescot, engravings of which, by Reynolds, served to popular-
ize her work; two, each involving a number of separate scenes, by Mlle
d'Hervilly, and one each by Mlle Sarrazin de Belmont and Mlle Grandpierre
(G2). Walter Scott, whose historical novels are commonly credited with
considerable influence on French literature and French Romantic thought,
was first translated in 1822 (171). In the very same year Mlle Inès
d'Esménard exhibited a "Sujet tiré du château de Kenilworth" depicting the
scene in which Amy Robsart falls into a trap devised by Sir Richard Varnet
(172). In 1824 there were no illustrations of his works by women, but in
1827 four appeared: one by Mlle Gallemant-Desmarennes from "Ivanhoe",
one by Mlle Grandpierre from "Quentin Durward", one by Mme Morlay from the
"Officer of Fortune" and a sculpture entitled "Sujet tiré du roman de
l'Abbé , par Walter Scott" by Mlle de Fauveau (H2). One other English
writer furnished a subject. Shakespeare was first translated by Guizot in
1821 and three more French versions appeared in the 1820s. His plays were
performed in English in Paris in 1822 and 1827. In 1824 Mme Servières
illustrated a "Scène du 4ième acte de l'Othello de Shakespeare" in which
Desdemona sings her willow song (173).

Among more poetic sources were Gessner's "Idylles": Daphne and
Alexis provided a romantic subject for Mlle Alexandrine Delaval and Phyllis
and Daphnis for Mme Adèle Romany de Romance, both in 1822. Casimir
Delavigne's poem about Danae and Perseus was illustrated by Mme Guimet in
1824 and Lafontaine and Perrault were also occasional sources (174)(I2).

Although no literary works of the second type were exhibited in this
decade - literary works in which quotations are used as a gloss on the
works of art -, in three pictures rather more general themes were drawn
from literature. In two of these, both exhibited in 1824, the subject was
poor children. Mme Guimet's "Le dévouement fraternel" (no. 855) carried
a quotation from Madame de Genlis: "Pendant un hiver très-rigoureux, deux
enfans s'étaient égarés dans une forêt. L'ainé voyant son jeune frère
prêt à succomber au froid, se dépouille de ses habits pour l'en couvrir,
et se jetant lui-même sur son corps, afin de la réchauffer, il lui sauve
la vie aux dépens de la sienne". The title of Mme Sauvageot's picture
was "La pauvre fille, d'après l'élégie de M. Alexandre Soumet":

> "'Adieu, ma mère, je t'attends
> Sur la pierre où tu m'as laissée ...'
> La pauvre fille, hélas! n'attendit pas long-temps;
> Plaintive, elle mourut en priant pour sa mère.
> " (no.1531).

The third, exhibited by Mme Delorme in 1827, was entitled "Les feuilles du saule" and illustrated a verse from Mme Tastu in which the writer, sad and introverted, compares her fate with that of falling leaves in a typically Romantic strain (175). These pictures, unlike the other illustrations we have mentioned, carried a general reference; as subjects they were sufficient in themselves and no knowledge of the context of the quotations was necessary for enjoyment of the visual work.

1830 to 1850 was a peak period in the exhibition of literary works. Novels predominated as sources, particularly historical novels, reflecting the contemporary vogue for such works largely created by the influence of Sir Walter Scott.

Sir Walter Scott's own novels, translated from the previous decade as we have seen, were more frequently illustrated than those of any other writer. 25 pictures illustrating these were exhibited by women over this period (J2). The artists were various, particular preference for his novels appearing in the work of only one artist - Mme Verdé-Delisle, who exhibited six. Most commonly chosen were female characters in moments of high tension and emotion. One example is the "Arrestation d'Effie Deans" exhibited by Mme Rimbaut-Borrel in 1841 which depicted Jenny Deans attempting to console poor Effie just before her arrest (176). A critic commented: "L'affliction de la malheureuse Effie est bien naturelle; l'attitude des deux jeunes filles est touchante; l'intérêt est réel, car on pressent l'arrivée prochaine des soldats et le triste dénouement de ce drame si douloureux" (177). As in England representation of character and emotion was the yardstick for criticism (178).

The same preferences for female characters and dramatic emotional incidents emerge from women's illustrations of scenes from other novels and studies. Authors, and it will be observed that they are almost all contemporary, include Mme de Genlis, Chateaubriand, Victor Hugo, James Fenimore Cooper, Mme la duchesse d'Alrantès, Michel Masson, Alfred de Vigny, Mme Sophie Gay, Alexandre Dumas, Jules Janin, Albert de Saint-Amand, M. le Comte Victor Du Hamel and Florian (K2).

Among purely fictional novels which were illustrated, those of two other earlier English writers should be mentioned: Oliver Goldsmith's "Vicar of Wakefield" and Samuel Richardson's "Clarissa Harlow" (L2). Despite the influence of German literature on French Romanticism very few German writers, with the exception of Goethe, inspired works by women artists (M2). Scenes and characters from Bernardin de Saint-Pierre's "Paul et Virginie" were depicted three times and "Manon Lescaut" by the Abbé Prévost, once. Eugene Sue's "Les Mystères de Paris" published in 1842-3 was illustrated

three times

by women in 1844 and 1845. More popular among women artists than any of
these was George Sand. Her first novels appeared in the 1830s and between
1837 and 1852 her works were illustrated seven times by women (N2).

Playwrights included Racine, Molière, Byron, Shakespeare (whose
"Othello" and "Hamlet" were illustrated), Goethe, and among contempor-
aries, Scribe and Casimir Delavigne whose historical plays were the subject
of three works (O2). The popularity of theatrical sources over these
20 years is a symptom of the general interest in dramatic scenes in
literature.

The most striking development over this period is a rapid increase in
the number of works illustrating poetry, particularly contemporary poetry.
Dante, Tasso, Petrarch and Gessner were occasionally illustrated and
fables and fairy tales remained popular (P2) but most sources were 19th
century. Byron's "Don Juan" and "The Corsair" furnished themes for three
works by women (179) and other narrative subjects were taken from shorter
poems by Béranger, Victor Hugo, Lamartine, Soumet, M. le comte Jules de
Rességnier, Ed. Bruguière, Millevoye, Mme Sanson, Mme Duchambre and Arnaud
(Q2). Less frequently the source was contemporary lyrical poetry and once
again attention should be drawn to the difficulty of telling whether such
works are illustrations or pictures with glosses. Mme Tastu's "Les
feuilles du saule" was the subject of a second work by a woman in 1831 (180)
and Lamartine provided themes for two works: in 1841 Mlle Le Prévost
exhibited "L'isolement":

"De colline en colline en vain partant ma vue

Du sud à l'aquilon, de l'aurore au couchant,

Je parcours tous les points de l'immense étendue,

Et je dis: nulle part le bonheur ne m'attend" (no.1291)

Introspection and sadness were also the subject of the second: "La tristesse"
by Mlle Alexandrine Martin:

"De mes jours pâlissants le flambeau se consume,

Il s'éteint par degré au souffle du malheur,

Ou s'il jette parfois une faible lueur,

C'est quand ton souvenir dans mon sein le rallume" (1846 no.1264)

In at least five works the use of literature as a gloss is more certain.
The first of these was Mme Elise-C Boulanger's "La pauvre femme" with the
quotation: "Ces enfants vont mourir! car tout nous abandonne; on exige un
prix pour notre pain grossier; enfin l'on nous vend la vie. Dieu nous la
donne, mais les hommes la font payer" (Anais Ségalas) (1836 no.214) (181).
Poverty was again the subject of a second version of M. Soumet's "La

pauvre fille" by Mlle Ducluseau in 1838 (182). Miss Henriette Kearsley's
"La jeune mère" of 1838 with a quotation from Bergin on the happiness of
childhood had already been exhibited two years previously in England (183).
In 1842 Mme de Sénevas de Croix-Ménil exhibited "Méditation" with a sober
quotation from Thomas à Kempis's "Imitation of Jesus-Christ" (184).
Finally in 1849 Mlle Irma Martin sent a work to the Salon which recalls
several in England on the theme of mothers grieving over dead children:
"Un ange au ciel":

 "La Religion:

 Consolez-vous, oh! pauvre mère,

 Un enfant de moins sur la terre

 Est un ange de plus aux cieux" (no.1426)

 Sadness as a result of death, separation, thwarted love and poverty
and occasionally unmotivated Romantic sadness and ennui, emerge as major
themes from all literary works of the period.

 From 1850 until the end of the century literary works suffered a
sharp decline. The titles of those that were exhibited either consisted of
the names of characters suggesting that the works of art were mere portraits
or simply stated that they were illustrations of particular literary works.
While it is therefore impossible to draw definite conclusions as to the type
of scene and subject favoured, the very inexplicitness of these titles
suggests an interesting change in the nature and function of the literary
work of art. Those which preceded, the numerous representations of scenes
in Walter Scott for instance, illustrated particular incidents which were
described in lengthy titles presupposing in the public a considerable know-
ledge of the context. As the art public became larger and less educated
and as the volume of literature increased, fewer people, proportionately,
would have been able to locate such isolated scenes. As a result, literary
works of art ceased to be illustrations in the strict sense of the word.
Instead they either referred vaguely to the literary work - thus the emer-
gence of generalized portraits - or gave up the idea of being self-
sufficient as works of art and sent the spectator to the piece of litera-
ture in question - thus the appearance of titles such as "Illustrations pour
les contes de Mme d'Aulnoy" (185).

 In comparison with the period 1820 to 1850, very few subjects were
taken from novels. Portraits of characters from these included le neveu
de Rameau (Jules Janin), Fadette (George Sand), Dona Carmen (Mérimée),
Bravo (Fenimore Cooper), Esméralda (Hugo), Atala (Chateaubriand), four repre-
sentations of Manon Lescaut (Prévost), Lucia (Manzoni), Jean Valjean (Hugo),
Pamela (Richardson), Fantine (Hugo), Paul et Virginie (Bernardin de Saint-

Pierre), Manette Salomon (Goncourts), Salammbô (Flaubert) and the Pêcheurs
d'Islande (Pierre Loti) (R2). General illustrations were exhibited of
Mme d'Aulnoy's contes, "Les Vaincus" by Doctor A.C., "La Mouche" by
Alfred de Musset, the "Mousquetaires" by Alexandre Dumas, the "Confidences
d'une Aieule" by Abel Hermant and "Le Baiser gascon, l'Illusion" by
Georges d'Esparbès (S2).

Among the few exceptions to these two categories, in other words,
among works depicting particular incidents in literature, several were based
on recently published works which were popular enough to have achieved
some public currency. Théophile Gautier's "Le Capitaine Fracasse" (186)
and Emile Zola's "La faute de l'abbé Mouret" (187) are instances. Par-
ticular scenes were also illustrated from fashionable works like "Don
Quixote" (T2) and fairy tales and fables remained favourite sources among
women artists (U2).

There are two particularly interesting cases of female activity in
this field of novel illustration. In 1860 the "Gazette des Beaux-Arts"
reported that Mme Frédérique O'Connell was considering "une suite de sujets
puisés dans la 'Comédie Humaine' de Balzac". She had completed one
already: "Esther sauvée par Vautrin, au moment où elle s'asphyxiait en
rentrant du bal" and was in the process of doing another. Philippe Burty
remarked: "Ce projet de faire entrer le peinture dans la vie moderne
pour en exprimer les passions et les drames, et surtout de s'inspirer dans
cette lutte d'un des plus grands observateurs de notre société, nous
intéresse trop vivement pour que nous n'y revenions pas un jour dans une
étude spéciale" (188). Of interest, too, is the fact that Marcel Proust's
first published work, "Les Plaisirs et les Jours", privately printed in
1896, was illustrated by a woman - Madeleine Lemaire.

Among dramatic sources, Shakespeare was the most popular. 24 works
exhibited by women between 1850 and 1900 were based on scenes and charac-
ters from his plays. As in England, Ophelia was by far the favourite
figure, 15 out of the 24 being devoted to her (V2). Molière's plays were
illustrated in six works, Goethe's in four, and there were occasional repre-
sentations of plays by Chénier, Rostand and Hugo (W2). Names of characters
constituted the titles of almost all of these.

Poetical sources were more numerous than either novels or drama.
Portraits and unspecified titles were current here too, but in many cases
the works of art simply illustrated short and self-contained descriptive
passages from poems (X2). The use of literature as a gloss on a work of
art became more popular although never to the extent that it did in
England. The subjects chosen for poeticization were similar. Maternal love,
for instance, was the subject of Mlle Amelie Fayolle's "Souci et Inquiétude"

with a quotation from Millevoye: "De la bonté céleste un rayon éternel/ Semble se réfléchir dans le coeur maternel" (SR 1863 no.167). A plaster bust by Mme Nelly Constant was given a further dimension by a line from Victor Hugo: "Ses yeux plongeaient plus loin que le monde réel" (1886 no. 3721) and in several works - still-lives and figurative compositions - poetry emphasized death and transcience (Y2). An unusual instance of this type of work is Mlle Elise Voruz' "Casseur de pierres" at the Salon of 1880 (no. 3864) with the following quotation from Victor Hugo:

"Toutes les passions s'éloignent avec l'âge,

L'une emportant son masque et l'autre son couteau,

Comme un essaim chantant d'histrions en voyage

Dont le groupe décroît derrière le coteau"

Literary subjects and lengthy literary titles were never as popular in France as in England. A good idea of the position occupied by literary works in the hierarchy of genres is given by a passage from "L'Artiste" of 1843 in which a critic expressed pleased surprise at Mme Calamatta's success in the rendering of certain Biblical themes: "Mme Calamatta est une toute jeune, toute jolie, toute gracieuse femme; elle est encore, qualité plus rare, toute modeste. A la voir, on la croirait destinée à reproduire quelques tendres épisodes de la vie poétique, quelques scènes amoureuses de Walter Scott" (189). In other words literary subjects were on a par with the modest talents of the average woman artist.

Section C - Portraits

An examination of Salon catalogues can give no idea of the extent of female activity in portraiture. Firstly many commissioned works were not exhibited; Mme Vigée-Lebrun, for instance, remained prolific until her death in 1842 and yet she was sparsely represented at the Salons in the nineteenth century (190). Secondly, portraiture was extremely popular among non-exhibiting amateurs. There can be no doubt, however, that female portrait painters were numerous. Most women artists essayed portraiture even if they did not specialize in the genre to the extent of portraitists such as Elizabeth Vigée-Lebrun, Marie-Eléonore Godefroid, Marie-Guilhelmine Benoist, Gabrielle Capet, Madame Davin-Mirvault, Mme de Mirbel and the sculptor, Mlle Julie Charpentier.

Napoléon's family, members of his army and eminent professional people of the day, especially scientists, were frequently represented by women artists between 1800 and 1813. During the year 1803-4, Mme Marie-Guilhelmine Benoist, best known for her "Portrait d'une négresse" in the Louvre, received her first official commission to paint Napoléon's portrait for the Palais de Justice at Ghent. Only two official portraits by her were Fig.54 exhibited at the Salon: her "Portrait en pied de S.A. la duchesse Napoléon Elisa, princesse de Piombino, fille de S.A.I. Mme la grande duchesse de Toscane" (1810 no.34) and "Portrait en pied de S.M. l'Impératrice et Reine" (1812 no.43). She produced at least seven others before 1812 (191). Her work was highly appreciated at the time. In reference to one of her portraits at the Salon of 1806 a critic wrote of her "talent incroyable" and expressed the view that if her work was anonymous "on ne balancerait pas à l'attribuer à l'un des plus forts élèves de David" (192). Of her 1812 portrait of the Empress, Durdent wrote: "Il est impossible de ne pas combler d'éloges l'habile artiste qui a si bien su faire passer sur la toile les grâces de cette auguste princesse" (193). The best proof of her reputation is the fact that she was awarded an annual stipend by the Napoleonic Government (194). After 1812 she ceased to exhibit having been forced to give up her career for the sake of her husband's (195).

Other women artists who portrayed the official world of the Consulat and Empire are Pauline Auzou (196) and Mlle Marie-Eléonore Godefroid who exhibited a "Portrait en pied des enfants de Mgr. le maréchal duc d'Elchingen" (Marshall Ney) in 1810 (no. 379, West Berlin, Staatliche Museen Preussischer Kulturbesitz, Gemäldegalerie) and "S.M. la Reine Hortense, avec les princes ses enfans" (no.418) and "Portrait des enfans de S.Ex. le duc de Rovigo" (no. 419) in 1812. Mme Janinet exhibited a "Portrait du consul Bonaparte au lavis" in 1800 (no. 628), Mlle Julie Charpentier portraits of "Le

colonel Morland, tué à la bataille d'Austerlitz, buste en plâtre" (1806
no. 571) (197), and "Le Roi de Rome" (1812 no. 1029) and Mlle Thibault
Fig.55 a "Portrait en pied de S.M. le Roi de Rome, peint d'après nature" (1812
no. 891). Also in 1812 Mlle Sophie Guillemard exhibited a "Portrait du
colonel Gaspard Thierry" (no. 460) (198). There were several representa-
tions of professional men of the period, four of these being portrait busts
by Mlle Julie Charpentier (Z2). Among professional women Mme Campan was
a popular subject. She formed part of Marie Antoinette's household, in
1794 opened the "Institution National de Saint-Germain", a girls' school
of her own, and in 1807 she became directress of the "Maison Impériale
Napoléon" at Ecouen, a boarding school for daughters of members of the
Legion of Honour. In 1824 she advanced new theories on female education
in her "De l'éducation, suivi de conseils aux jeunes filles". She was
the subject of several works by Marie-Eléonore Godefroid, a pupil of Gérard
who taught drawing at the "Maison Impériale Napoléon", the first of these
dating from 1801 (199). Julie Duvidal de Montferrier painted at least
Fig.56 four portraits of Mme Campan (200) and Hortense de Beauharnais portrayed
her a number of times, the last being in 1821 (201).

The itinerant Vigée-Lebrun, faithful to the old régime, continued
to paint portraits of royalty and members of the aristocracy during this
period. She even executed portraits of her original patron, Marie-
Antoinette, from memory (202). Under the Restoration, Marie-Antoinette was
the subject of an allegorical work by her entitled "Apothéose de la Reine"
depicting the Queen rising to Heaven where she is welcomed by her two dead
children and the King (203). Several other women artists portrayed royalty
under the Restoration (A3). The most famous of these was the miniature
painter, Mme de Mirbel. In 1818 Mme de Mirbel (then Lizinska Rue) was per-
mitted to paint Louis XVIII from the life and acquitted herself so
brilliantly that she was nominated "peintre en miniature de la Chambre de
Sa Majesté" (204). In 1819 she accompanied the Court to Saint-Cloud where
Fig.57 she painted another portrait of the King (205). She was a prolific artist
and portrayed many members of the aristocracy. She won second class medals
in 1819 and 1822 and a first class medal in 1827, in which year she is said
to have been granted sittings by Charles X (206). By 1831 a critic could
write : "Ses miniatures rivalisent avec ce que l'école a produit de plus
beau en portraits. On ne savait pas ce que c'était que la miniature avant
que Madame de Mirbel parût" (207).

There were numerous portraits of artists during this period. Fine
artists, male and female, will be considered in Section E. In addition
Fig.58 one should mention Mme Favart's "Portrait de feu le C. Favart père com-
posant sa comédie de l'Anglais à Bordeaux" (1800 no.141), Mme Davin-Mirvault'

"Portrait del signor Bruni, compositeur, ancien chef de l'orchestre de
l'opéra Buffä"(1804 no.114) (208), Mlle Harvey's "Portrait de Bernardin
de Saint-Pierre entouré de sa famille" (1804 no.227) (209) and Mme
Benoist's "Portrait d'homme" (1806 no.23) which appears to have been a
portrait of Desfaucherets, author of the "Mariage Secret" (210). In
1808 Mme Vigée-Lebrun painted a portrait of Mme de Stael as Corinne (211);
in 1814 Mlle Constance Mayer exhibited a portrait of Mme Elise Voiart,
the author and in 1817 a portrait of Mme Tastu, the poet (212). Mlle
Gabrielle Capet executed several portraits of artists,mostly visual
ig.59 artists, between 1800 and 1815. Only her portrait of Marie-Joseph Chénier,
brother of André, and author of tragedies and hymns, is relevant here.
The work was probably executed in 1800, but was not exhibited (213).
Actresses were also popular subjects for portraiture. Mme Vigée-Lebrun
painted several, the most famous being her portraits of Mme Lucia Elizabeth
Vestris of 1804, of Giuseppa Grassini as "Zaïre" in the title role of
Peter von Winter's opera (214) and of the singer Mme Catalini in 1806. Of
the many other women artists who depicted actresses, the most prolific
ig.60 was Mme Adèle de Romance (B3).

In the 1830s a huge impetus was given to official portraiture when
Louis-Philippe decided to open a museum devoted to French history at
Versailles. Many of the portraits were historical and based on previous
works but a considerable number, also, portrayed contemporary figures.
Numerous women received commissions in this project (Appendix X). In
this context brief mention should also be made of Mme Louise Kugler and
Mme Victoire Jacquotot who, earlier in the century, had executed official
commissions to portray famous people of the day, on enamel and porcelain
respectively (215).

In 1836 the author of an article on women artists wrote: ".. dans la
peinture en miniature seulement les femmes de talent se multiplient sur
les traces de Mme de Mirbel. C'est Mme de Mirbel qui tient la place
qu'occupait Isabey il y·a a trente ans. Sa réputation a acquis toute
l'étendue à laquelle elle pouvait prétendre". It was as important in
society to be painted by her as it had been to be painted by Isabey pre-
viously. He offered two examples of other talented female miniaturists:
Mlle de la Morinière and Mlle Soye, a pupil of Mme de Mirbel. Such was
female talent in this genre, wrote the author,"qu'elle leur appartiendra
bientôt presque tout entière" (216).

Although there were many female portrait painters during the July
Monarchy, most discussions of the performance of women artists in this
genre centered round Mme de Mirbel and another miniaturist who gradually

eclipsed her - Mme Herbelin (née Jeanne-Mathilde Habert) (217). The
former continued to exhibit regularly until 1849, her most important
exhibited works of the period being a "Portrait du Roi" (no. 1572) and
"Portrait de la Reine des Belges" (no.1573) at the Salon of 1835. In
1834 she painted Louis-Philippe (218). Mme Herbelin, who exhibited from
1840, depicted aristocratic subjects and also professional people and
artists and won a string of medals over these years. When she was
awarded her third first class medal in 1855, it was decided that her work
should be admitted to the Salon without examination (219).

Actors and actresses were frequently portrayed as before and several
portraits of artists were exhibited. Charles Nodier, Alphonse Lamartine,
Mme Anaïs Ségalas, Alfred de Musset and the composer Esprit Auber were all
represented by women artists at this time, testifying, in part at least,
to the importance of the artist in Romantic thought (220) (C3).

Female miniaturists remained numerous during the second Republic and
second Empire (1848-1870). In 1859 Paul Mantz wrote: "La miniature. si l'on
n'y prend garde, va .. devenir un art féminin .. M. de Pommayrac soutient
seul l'honneur du drapeau; autour de lui se presse un groupe de miniatur-
istes aux doigts roses.." (221) and in 1861 attention was again drawn to
the number of women practising this genre (222). Mme Herbelin retained her
celebrity as a miniaturist and was likened, in the breadth of her execution,
to the 18th century miniaturist Hall, in contrast to Mme de Mirbel and
Isabey (223). Around 1860 she appears to have lost favour as a result of
"regrettable" attempts at works on a larger scale (224). Hall was also
evoked as a predecessor for another successful miniaturist of the day, Mlle
Eugénie Morin (Mme Parmentier), whose portrait of her brother in 1865 won
high praise from the critic Paul Mantz (225). She exhibited 21 miniatures
between 1859 and 1869 and won a medal in 1864. Other miniaturists worthy of
mention are Mme Camille Isbert, an extremely prolific artist who exhibited
between 1845 and 1880 and Mme Lehaut (née Mathilde Bonnel de Longchamp), who,
among other works, exhibited portraits of the Emperor Napoléon in 1859 and
1867, a portrait of the Prince Imperial in 1869 and a portrait of the
Empress Eugénie in 1870 (D3). Mme Monvoisin (née Domenica Festa), also
prolific, exhibited miniatures at the Salon from 1831 and won four third
class medals (226). She exhibited a portrait of the Emperor in 1861, a por-
trait of the Empress in 1863 and a portrait of the Prince Napoléon in 1865
(E3). Mlle Solon and Mme Lapoter were also successful in the genre (227) (F3)

Among portrait painters in oil, only Mlle Nélie Jacquemart and Mme
Frédérique O'Connell stand out with any clarity. Mme O'Connell (née
Frédérique-Auguste Miéthe) arrived in Paris in 1853 (228). An obituary

stated: "A son arrivée en France, Mme O'Connell avait été bien accueillie par l'entourage impérial. Les portraits de M. de Morny, de M. Sibour, du docteur Cabanis l'avaient, au reste, mise en lumière. Un moment elle connut presque la célébrité; mais sa raison se troubla, et, en 1871, elle dut être enfermée dans une maison de santé" (229). Her most popular works were portraits of Charles Edmond and Théophile Gautier and four portraits of the actress Rachel (230). Nélie Jacquemart (Mme Edouard André) exhibited portraits regularly between 1868 and 1877 and won medals in 1868, 1869, 1870 and 1878 (231). One critic referred to her as "quasi un peintre officiel" (232). Having exhibited a "Portrait de M. Benoit-Champy, Président du tribunal civil de la Seine" in 1868 (no.1307), she won success with her "Portrait de S.E.M. Duruy, ministre de l'instruction publique" (1869 no.1247) which was labelled as the second best portrait in the Salon: "le portrait de M. Duruy la place aujourd'hui au premier rang, et son nom va aux étoiles". Her main qualities were "le sentiment de la vie" and "un véritable talent d'observation" (233). In 1870 when she exhibited a "Portrait de M. le Maréchal Canrobert" (no.1432), for which she won a first class medal, the critic Térigny wrote: "Chose remarquable et nouvelle, tout signe hiérarchique a disparu. C'est l'homme seul, tout prestige d'uniforme à part, qui se présente à nous, et nous en félicitons le modèle et le peintre ... Mlle Nélie Jacquemart a su garder là une admirable mesure entre le laisser-aller de l'intimité et la froidure volontaire d'une physionomie officielle". He concluded: "tout concourt à la haute expression d'un caractère; pour la jeune artiste c'est là plus qu'un succès, c'est une victoire" (234). The seal was set to her reputation in 1872 when she exhibited a "Portrait de M. Thiers, Président de La République" (no. 845). Throughout the 1870s she exhibited portraits of eminent political and professional men (G3). Her work was often discussed in the press and time and again attention was drawn to her vivid rendering of moral character (235) (H3).

The most striking development of the period was the emergence of a large number of female sculptors. Among these Mme Lefèvre-Deumier, whose reputation was established under the Empire, deserves special mention. Having originally taken up art as an accomplishment, she began exhibiting in 1850. Thereafter she received many official commissions and also won a third class medal at the Salon of 1853 and an honorable mention at the Exposition Universelle of 1855. In 1852 she exhibited a marble bust

fig,61 commissioned by the Ministry of the Interior of "Le Prince-Président de la République" (no.1447), described as being "d'une ressemblance si

grandiose et si simple, que le suffrage unanime l'a consacré comme sa
plus vivante et sa plus sympathique image" (236). Her medal-winning
work of 1853 was a marble bust, also commissioned, of "Mgr. Sibour,
archevêque de Paris" (no. 1405) of which the same critic wrote: "Il
joint, au mérite d'une ressemblance frappante, celui de cette expression
profonde et ressentie qui moule, en quelque sorte, les traits du visage
sur les beautés de l'âme, et donne à l'empreinte de la vie plastique
l'animation et le souffle de la vie morale" (237). Other portrait sculp-
tures by her of the 1850s, several of them commissioned works, were a
bust of the poet Jasmin, a marble statuette of the Empress Eugénie, and
busts of Henri-Joseph Paixhans, the Empress Eugénie, Alfred Busquet and
Angran d'Alléray, "lieutenant civil" (I3). In 1860 she sollicited the
title of "Sculpteur de la Maison de l'Impératrice". In the margin of her
application were written the words: "Le titre, non, mais des commandes"
and indeed further commissions followed in the 1860s (238). Her most
successful work of the decade was a portrait of Lamartine, a marble bust
which was acquired by the State in 1869. This was described as "un vrai
chef-d'oeuvre de sentiment et de personnalité saisi. D'autres artistes
ont donné le buste héroïque de M. de Lamartine. Mme Le Fèvre-Deumier a
fait poser son illustre modèle sous le jour amical et doux de la vie
intime. Elle a sculpté M. de Lamartine au repos, dans une heure de
méditation et de rêverie. Ce style familier attendrit sans l'amoindrir,
l'idéale fierté de sa noble tête. Personne, selon nous, n'avait encore
plus heureusement rendu la sérénite recueillie de la physionomie de M. de
Lamartine, et ces belles lignes que le pensée et le travail ont imprimées
sur ses joues macérées, sur ses tempes pensives ..." (239).

One of the most prolific female sculptors was Mlle Marguérite Fanny
Dubois-Davesnes who exhibited works between 1853 and 1900 and in 1863
received an honorable mention. Three busts by her, of Béranger, Scribe
and Marivaux, were commissioned by the State. A plaster bust of Béranger
was exhibited in 1857 (240) and in 1861 a marble bust of the same subject
(no. 3312) (241). In 1863 she sent a terra cotta bust of "Scribe, de
l'Académie française" (no. 2340) and a marble bust of the same in 1865
(242). Also in 1865 she exhibited a marble bust of "Antoine Desboeufs
(1793-1862) statuaire et graveur en médailles" (no.2959). In 1866 her
exhibit was a "Portrait de Mlle Marie Roze, artiste du Théâtre de
l'Opéra-Comique; buste plâtre" (no. 2745) and in 1868 she exhibited two
busts, one terra cotta and one plaster, of the Empress Eugénie (nos. 3557
and 3558). She exhibited a marble bust of the same in 1869 (no. 3399),

which is now in the Musée National du Château de Compiègne. Her marble
bust of "Pierre Carlet de Chamblain de Marivaux" was shown at the Salon
of 1873 (no.1628) (243). Among other subjects chosen by the artist were
Mlle Marie Royer (1841-1873), "sociétaire de la Comédie Française",
Joseph Cabanès "Fondateur de l'oeuvre des malades assistés, à Moissac",
M. Ernest Desjardins "de l'Institut" and in the 1890s a number of Church
dignitaries (244).

Other female portrait sculptors were Mme Noémi Constant, born
Cadiot and known as Claude Vignon, Marie Goldsmid, Mme Dameron (née Olympe
Capoy), Mlle Pauline Bouffé and Mme Artaud de Trollay. In 1865 the latter
was described as being in the first rank of female sculptors (245). Two
of the most famous women artists in this genre at that time, Mme Léon
Bertaux and the cosmopolitan Elisabeth Ney, exhibited portrait sculptures
at the Salon only occasionally (246).

Again attention should be drawn to the large number of portraits of
artists, actors and actresses exhibited over this period (J3). A type of
sitter which, due to bienséance, was more exclusive to women artists, was
nuns (K3). Even women met resistance where the portrayal of such people
was concerned, as will be seen in the biographical sketch of Henriette
Browne (247).

Mlle Nélie Jacquemart appears to have been the most successful among
female portrait painters in oil of the 1870s. She was succeeded in the
public eye by four other artists, two of whom began exhibiting in the 1870s
and two in the 1880s: Louise Abbéma, Thérèse Schwartze, Anna Bilinska and
Amélie Beaury-Saurel. Unlike Nélie Jacquemart, none of these were official
painters; their subjects were members of the bourgeoisie, artists, actors
and actresses. Louise Abbéma exhibited at the Salon from 1874. Her works
were regularly exhibited at the Galerie Georges Petit in the 1890s and
1900s (248) and she came second among women artists in a vote for female
members of a proposed "Académie Féminine" in 1902 (249). Her first real
success was a "Portrait de Mlle Jeanne Samary, sociétaire de la Comédie
Française" in 1879 (no.2) (250). Her speciality was flattering and
"feminine" portraits of women with flowers of which perhaps the best
examples are the four decorative panels exhibited with the title "Les
Saisons" in 1882 (no.1). Although strictly speaking an allegorical series
in which various women represent the four seasons, the work may also be
considered as a tribute to the four most celebrated actresses of the day
of whose portraits the work consists. As a critic wrote: "Mlle Louise
Abbema a gracieusement personnifiées sous les traits de Mlle Baretta -
Le Printemps, - Mme Jeanne Samary - l'Eté, - Mme Sarah Bernhardt -

l'Automne, - Mlle Reichemberg - l'Hiver, - un hiver des plus doux" (251).
The artist favoured actresses as subjects and also exhibited a "Portrait
de Mlle Sarah Bernhardt, sociétaire" in 1876 (no.1), a 'Portrait de Mlle
Sarah Bernhardt; médaillon bronze" in 1878 (no.3990) and a "Portrait de
Mlle Baretta, sociétaire de la Comédie Française" in 1880 (no.4). Madeleine
Lemaire, who received most votes in the 1902 election, was also fond of
combining women and flowers in her pictures and the popularity of these
two artists suggests a public demand for this type of portraiture.

 Neither Thérèse Schwartze nor Anna Bilinska was French; the former
was Dutch and first came to Paris in 1878; Anna Bilinska was Polish and
was based in Paris from 1882 to 1892. Thérèse Schwartze's Portrait of
Fig.62 Dr. J.L. Dusseau, in the Rijksmuseum, is a striking instance of her ability
to characterize and suggest mental concentration. Perhaps the best exam-
ples of her and Anna Bilinska's skill in portraiture are their self-
Figs.63 portraits which will be considered in Section E (252).
and 64

 In 1887 a critic wrote of Amélie Beaury-Saurel: "On chercherait en
vain, parmi les portraits exposés par des artistes en renom, un seul qui
soit de force à soutenir la comparaison avec la fière peinture de Mlle
Beaury-Saurel. de la peinture mâle telle que ces Messieurs sont depuis long-
temps incapables d'en produire" (253). Her principal portraits were of
intellectuals and artists. Léon Say (1880 no.205), Barthélemy Saint-Hilaire
(1887 no. 146) and Félix Voisin (1888 no.162 ; illustrated) among men and
Mlle Barety (1886 no.2539), Madame Sadi Carnot (1889 no.164; illustrated),
Fig.65 Séverine (1893 no.101) and Daniel Lesueur (1899 no.124) among women.

 Further evidence of her interest in female intellectuals is provided by a
Fig.66 work entitled "Une doctoresse" exhibited at the Salon of 1892 (no.98). She
Figs.67 also exhibited three self-portraits (1887 no.2585, 1894 no.117 and UFPS
and 68 1889 no.44) and numerous portraits of unknown and anonymous women.

 In 1887 when portraits by Amélie Beaury-Saurel, Anna Bilinska and
Louise Breslau (254) were exhibited at the Salon, a reviewer in "L'Art"
reported that it was commonly believed that the portraits exhibited by
women were superior to those of male artists such as Léon Bonnat and
Carolus Duran (255).

 Female portrait sculptors remained plentiful. In 1875 a critic in
"Les Gauloises" wrote: "Le but du portrait est pratique, immédiat, les
femmes le reconnaissent et le prouvent ostensiblement. Elles poursuivent,
avec une légitime et louable ardeur, l'application de leur talent à un
travail offrant la sécurité d'un résultat sérieux, efficace .. Il est
urgent de rendre hommage aux labeurs modestes et silencieux de cette
pléiade de petits doigts qui manient à l'envi le pinceau ou l'ebauchoir"
(256). Among the owners of these 'petits doigts" were Mlle Charlotte

Gabrielle Dubray (later Mme Besnard) who exhibited portraits of Ernest
Daudet, Mlle Belza Delpha, Général Renault (for Versailles), Stanley the
explorer and Raymond Duez (L3); Marcello who was highly praised for a
"Portrait de Mme la Baronne de K..." in 1876 (257); Claude Vignon whose
major exhibited work, a commissioned one, was "Monsieur Thiers, premier
président de la République Française" in 1879 (no. 5412) (258) and Mme
Léon Bertaux who exhibited medallions of the composer Eugène Gautier and
marble busts of the singer Sophie Arnould (M3). Three other artists should
be mentioned. Camille Claudel exhibited three anonymous bronze busts in
1886, one of these being a portrait of her brother Paul Claudel, and
received full attention and praise from Paul Leroi in "L'Art" for her
rendering of character (259). The other two artists may be compared with
Amélie Beaury-Saurel in so far as they appear to have been interested in
famous and intellectual women. Elise Bloch exhibited a portrait of
"Madeleine Brès, docteur en médicine, buste plâtre" in 1885 (UFPS no.6), a
'ig.69 "Portrait de Mme Anaïs Ségalas; buste marbre, destiné au musée de Châlons-
'ig.70 sur-Marne" in 1894 (no.2798) (260) and a bust of Maria Deraismes in
1895 (no.2890) which was illustrated in the catalogue. Mme Martin-Coutan
exhibited a "Portrait de Mme Séverine; buste plâtre" in 1889 (no.4225)
(261); in the same year a "Portrait de Mlle Juliette Dodu; buste plâtre"
(no. 4226) (262) and a portrait of "Mlle Maillard, de l'Académie nationale
de musique; buste marbre" in 1891 (no.2412). Many more obscure women
artists, painters and sculptors, portrayed intellectual and professional
women over this period (N3), a vogue which is also reflected in the
literature of the period. From the 1880s numerous biographies were devoted
to famous women writers, intellectuals and "social workers" (263).

Actresses remained popular subjects (O3) and so did artists (P3) and
women were also the authors of several portraits of eminent men of the day
(Q3).

Women exhibited a large number of portraits of politicians, intellec-
tuals, writers and artists during the last three decades of the century as
well as portraits of people in society and these works were variously and
equally executed in oil, sculpture and small scale works like miniature.
Perhaps the most interesting category of portraits in this context is that
of those depicting extraordinary women many of whom were remarkable for
unusual professional achievements. Portraits of women artists, named and
anonymous, and self-portraits by women were also numerous over this period,
as will be seen in Section E. Such works justify the present study in so
far as they show that women artists had a particular interest in certain
themes and subjects, an interest which is largely explained by their sex.

Section D - Female Life

Whereas in England works portraying middle-class domestic scenes were relatively rare until 1830, in France, the main occupations and pre-occupations of the generally well-to-do nineteenth century woman appear frequently as the subject matter of works of art exhibited during the first three decades of the century. Women artists were constantly encouraged to choose such subjects for which the current epithets were "doux et naifs", and a prerequisite for which was "sensibilité", a word often used and an attribute commonly associated with women (264). Just as many of those women who essayed more ambitious subjects were advised to lower their sights, so those who specialized in domestic genre were praised for not attempting subjects "au-dessus de leurs forces" (265). But although such themes were considered ideally suited to women and although there were many female exponents of this class of subject, they did not monopolize the field. Greuze in the 18th century and Boilly, Drolling, Léopold Robert and Dumarne in the 19th, were also practitioners in this genre.

The growing importance of everyday subjects over this period emerges from two contemporary passages. Among genre painters, wrote C.P. Landon in 1822, "on y accorde le premier rang à ceux qui traitent les scènes familières et les sujets anecdotiques ou du moyen style. Le salon n'avait pas encore offert un aussi grand nombre d'ouvrages de cette nature. C'est dans ces sortes de compositions que l'artiste peut approcher le plus aisément du point de perfection qui les place au-dessus des ouvrages vulgaires, et ce sont les sujets auxquels le public s'attache ordinaire-ment avec le plus de complaisance. Nos dames artistes en font de préfér-ence l'objet de leurs études, et ne cèdent guère aux hommes l'avantage de les traiter avec goût et délicatesse" (266). The second passage is lifted from a discussion of the work of Mme Haudebourt-Lescot in "L'Illustration" of 1845 in which the author bestowed on her a significant place in the development of art: "Ce talent original exerça sur le goût public un vif ascendant. Jusqu'alors, et sous la direction de David, toutes les pré-occupations s'étaient portées vers les grandes toiles, vers la peinture historique, vers le portrait monumental. La route que suivit Mlle Lescot était toute différente et toute nouvelle. Le charme que l'on trouva dans ces gracieux petits cadres étincelants de couleur et d'esprit attira la foule, qui déserta les grandes pages mythologiques inaccessibles aux fortunes médiocres, aux salons rétrécis, et qui n'étaient plus en harmonie avec une société renouvelée. Ces petites toiles firent pénétrer le goût et le culte de l'art dans ces intérieurs modestes qui n'avaient pu jusqu'alors s'élever à lui, et qui s'effarouchaient d'ailleurs des poses plus qu'académiques et des nudités de la haute école" (267).

The main point to emerge from these texts is that the increasing
popularity of such subjects was mainly due to an increase in public demand.
As the middle classes became more prosperous, not only did the buying
public alter and increase in numbers, but there was also a change in the
nature of the work bought. Small-scale works portraying scenes from con-
temporary life were within the grasp of those with average fortunes and
were also comprehensible; in addition they relied on sentiment, a quality
which Romanticism gradually transformed into a virtue and which became a
touchstone both for human character and works of art.

The most prolific female exponent of such works during the first
three decades of the century was Mlle Marguerite Gérard, a pupil of
Fragonard and student of the small Dutch masters of the seventeenth cen-
tury. She painted small canvases depicting bourgeois interiors from the
1780s and exhibited 34 works on such themes between 1800 and 1830. Of these
18 featured mothers and children (R3), a typical example being "Les
Fig 71 Premiers Pas ou la Mère Nourrice" of 1804; at least seven were about love
and more particularly love letters (S3); seven more involved religion (T3)
and in two music was played (U3). One unusual work of 1810 represented
"Une jeune femme méditant sur la vie des grands hommes" (no. 363). Animals
and birds were ubiquitous, the constant companions of women and children.
In the majority of these works the mood was peaceful and sentimental;
only two, depicting illness, involved any stronger emotion (V3).

The reputation of this artist was quickly established. In 1802 she
was proposed as an example for those immodest and ambitious women artists
who attempted classical themes, by a writer whose adjectives are a useful
guide to the critical standards employed in reference to such works. She
exhibited three works at the Salon of that year and received highest praise
for "Une jeune femme allaitant son enfant" (no.113): "Chaque production de
Mlle Gérard est un nouveau témoignage de la douceur de ses moeurs, aussi
bien que de la délicatesse de son pinceau: les sujets de ses tableaux,
tirés des actions les plus simples et les plus ordinaires de la vie
domestique, présentent toujours l'expression de ces affections douces, et
quelques-unes de ces scènes touchantes, dont tout le monde est témoin
chaque jour, mais qu'il n'appartient qu'aux âmes honnêtes et délicates
d'observer et de peindre: c'est un exemple que devroient bien se proposer
du moins, cet essaim de femmes qu'on voit de nos jours courir les ateliers
des artistes et se livrer si hardiment, pour ne rien dire de plus, aux
études périlleuses d'un art peu fait pour leur sexe" (268). Most striking
is the importance attached to the moral character of the artist in
works of this type, a character summed up by the words "doux", "délicat"

and "honnête", and also sensibility, which is suggested by the insistance
that only such a being is capable of perceiving (and portraying) "ces
affections douces" and "ces scènes touchantes". Later reviews of her
work were equally personal and referred constantly to the artist's virtue
and purity which imprinted her works with "une teinte virginale"; "décent"
was a recurrent word (269).

Elisabeth Chaudet specialized in the portrayal of children and
animals. Her reputation was established at the Salon of 1799 to which she
sent "Un déjeuné d'enfans" (no.90), "Une petite fille jouant avec un chat"
(no. 91), "Une jeune femme occupée à coudre" (no. 92) and "Deux portraits,
sous le même numéro" (no.93). Children, often playing or eating with
animals, were the subject of 17 of the 25 genre subjects exhibited by her
between 1800 and 1817, her last year of exhibition (W.3). Time and again
critics praised her modesty and wise choice of subjects, which were within
her, and by implication, woman's scope. The operative word in her case
was "naif" (270).

In this context attention should be drawn to the frequent representa-
tion of animals and children in genre works by women artists, a vogue for
which Mlle Gérard and Mme Chaudet may have been partly responsible. In
1801 Mme Chaudet exhibited an unusually dramatic composition on the
theme of children and animals: "Un enfant endormi dans un berceau, sous
la garde d'un chien courageux qui vient de tuer près de lui, une énorme
vipère" (no.62) (271) which may be aligned with "Un enfant dans son berceau,
entraîné par les eaux de l'inondation du mois de nivôse an X" by Mme
Villers at the Salon of the following year (no. 310). In the latter another
faithful dog is shown swimming alongside the cradle (272). These two
works should also be borne in mind as precedents for a much later work by
Mme Dabos: "Le feu prend au lit d'un enfant par l'imprévoyance d'une
bonne qui s'endort; le chien s'efforce de la réveiller" (1831 no.429).
In 1804 Mlle Henriette Lorimier exhibited "Une jeune femme" (no.310) which
was described as follows in the title: "N'ayant pu continuer d'allaiter
son enfant, elle le regarde téter la chèvre qui la supplée, et s'abandonne
aux réflexions que sa situation fait naître" and in 1810 a pendant to this
work entitled "L'enfant reconnaissant" (no.527) (273). Her first exhibit
received the same critical reception as many of Mme Chaudet's works: "Ce
sujet convenait au pinceau d'une dame" wrote C.P. Landon and again: "le
choix du sujet honore la sensibilité de l'artiste" (274). The work was
bought by the Princess Caroline. Again these may be seen as precedents
for a later work by Mme Boulanger: "Jeune enfant pleurant une chèvre, sa

nourrice; aquarelle" (1835 no.220). Four other pictures from the many on
this theme are worthy of mention, all of them showing young people mourn-
ing the death of animals. In 1808 Mme Chaudet exhibited "Une jeune fille
Fig.72 pleure un pigeon qu'elle chérissait et qui est mort" (no.122) (275). Mme
Haudebourt-Lescot's "Un petit savoyard pleurant la mort de son chien"
(1822 no.683) was the work at issue when Landon, having remarked on the large
number of works portraying charity at the Salon, observed sarcastically but
perhaps justly: "La pitié qu'inspirent les souffrances de l'espèce
humaine, ne suffit même plus à l'expansion des âmes sensibles, et c'est en
faveur des bêtes que le sentiment est à l'ordre du jour" (276). In 1824
Mlle d'Hervilly exhibited "Un jeune berger pleurant son chien, tué par
un serpent" (no. 902) and in 1827 Mlle Emma Laurent sent an extremely
unusual composition called "Le retour au village" with the description:
"Une jeune femme, abjurant ses erreurs, revenant dans les bras de ses parens;
mails ils étaient morts de chagrin, et, de tout ce qu'elle aimait dans ses
jours d'innocence, elle ne retrouve que son chien près d'expirer" (no.1499).
In this a moving and moralizing theme is sentimentalized by the dying dog,
all that remains of the penitent's innocent childhood" (X3).

Scenes involving children and animals are always touching and fre-
quently moving and their popularity is surely explained, in part at least,
by the fact that one of the most important criteria in genre compositions
of this period was their power to move; the word "touchant" recurs in
criticisms of works just as "sensibilité" is praised in descriptions of the
artist (277).

Mothers and children were focal in the work of Mme Constance Charpen-
tier, Mlle Jenny Le Grand, Mlle Philiberte Ledoux, Mme Rumilly and Mme
Benoist, all of whom exhibited genre subjects over this period (Y3).

Not all works in the domestic genre category were merely touching.
Tragedy enters into a large number concerning death and illness and the
effect of these on members of a family. The effect on parents of the death
of their children was the subject of a work by Mlle Caroline Délestre in
1802 and also of one by Mme Bruyère in 1808 (278); it threatens in an
Fig.73 unusual picture by Mme Auzou at the Salon of 1810, "Daria ou l'effro
maternel" (no22) which included the following line: "Une jeune livonienne
venant cultiver l'arbre qu'elle a planté à la naissance de son premier né,
le trouve brisé" (279). In the same year Mlle Constance Mayer exhibited
Figs. two famous works: "L'heureuse mère" (no.554) and "La mère infortunée"
74,75 (no. 555). The latter depicted the following subject: "Une jeune femme
ayant perdu son enfant, lui a élevé un tombeau dans une vallée solitaire.

Une pierre couverte de mousse et de gazon, et surmontée d'une croix où
pend une couronne de roses, forme le modeste monument de l'amour maternel.
La mère infortunée contemple avec une expression douloureuse et les yeux
baignés de larmes le lieu qui renferme les restes d'un objet chéri. Près
d'elle est un vase dont l'eau vient de rafraîchir les fleurs qui croissent
sur le tombeau". She received praise for the ideas behind her work which
were described as "douces et toujours gracieuses" (280). The death of a
mother was the subject of a symbolic work by Mlle Pantin in 1802 (281) and
danger rather than death was present in an extraordinary picture by Mme
Chaudet which appeared at the Salon in 1806: "Une femme ayant attaché son
enfant sur son dos, est prête à s'échapper de sa prison" (282). The most
dreaded event, however, was the death of the father, the bread-winner, and
during the social upheavals of the early nineteenth century this was not a
rare occurrence. In 1802 Mlle Mayer exhibited "Une mère et ses enfants au
tombeau de leur père et lui rendant hommage" (no.205). In "La Sollicitude
maternelle" by Mme Auzou (1804 no.7) a dying mother and presumably widow,
places her daughter under the protection of her son in "un ouvrage rempli
de sentiment" (283). In the same year, 1804, Mme Chaudet exhibited "Une
veuve pleurant sur son enfant" (no.99) and Mlle Robineau "Une jeune femme
au tombeau de son époux". (no. 396). In 1806 Mme Auzou sent another inter-
esting work on the theme: "Départ pour le duel" which illustrated the
following passage: "Un jeune homme obligé de répondre à une provocation,
au moment de son départ, jette un regard sur sa famille encore endormie"
(no.11). This led a critic to reflect not only on the absurdity of duels,
but also on the unfortunate position of his wife in the event of his
death: "Abandonnée au milieu de la corruption, proie au malheur, à la
misère, pourra-t-elle résister aux pièges et à l'appât de la séduction?"
(284). Two other works were exhibited on the theme: "Une veuve près du
tombeau de son époux" by Mlle Delafontaine illustrating the lines "Elle
éprouve cette douleur profonde d'une peine sans espoir. Sa jeune fille,
à ses pieds, partage toute la douleur dont elle la voit accablée" (1814
no. 265) and secondly "La veuve du Vendéen" by Mlle Aurore de Lafond (1824
no. 992). A counterpart to these themes of widowhood is Mlle Eugénie Le-
brun's "Le retour du soldat dans sa famille" of 1824 (no.1063). Illness
was also a recurrent subject over this period and three pictures showed
children caring for their blind relatives (Z3).

As among classical and literary works, love was a popular theme and
the exchange of letters, the pain of separation and waiting were all illus-
trated (A4). Nine interesting and unusual works dealt with marriage. In
1804 Mme Varillat exhibited "Une jeune femme pleurant sur son acte de

divorce (no. 507). Mlle Jenny Désoras produced four pictures on the theme which may have been a sequence on the four phases experienced by woman in marriages based on money rather than love. The first was "Ni l'un ni l'autre"; "Une jeune fille entre deux vieillards, se bouche les oreilles" (1806 no.152). The other three were all exhibited in 1810: "C'en est fait, je me marie" (no.245), "L'hymen est un lien charmant" (no. 246) and "L'or ne vaut pas la sagesse" (no.247). Mlle Sophie Guillemard exhibited "Lorsque la misère entre par la porte l'amour s'envole par la fenêtre (Proverbe anglais)" in 1808 (no.278) and a pendant to this, "La Fortune qui ramène l'Amour" in 1810 (no.400). The role of money in marriage was also the subject of Mme Haudebourt-Lescot's "La dot" (1824 no. 883). Finally, in 1814 Mlle Louise Mauduit exhibited "La mère abandonnée" (no.677) which represented a woman with a portrait and letter in her hands and near her, a child sleeping in a cradle. Presumably she had been abandonned by an unfaithful husband (285).

Numerous works represented women engaged in daily occupations such as getting dressed, sewing, praying, playing musical instruments, reading and charity (B4). A few are worthy of attention. In 1804 Mme Auzou exhibited a variant on the theme of the toilette, entitled "Le premier Fig.76 sentiment de la coquetterie" (no.8) which depicts the awakening sensuality and worldliness of a young girl before her mirror. A conscious revanche by Mlle Jenny Désoras is possible in "La coquetterie punie, ou le miroir cassé" (1808 no. 176). Two works exhibited in 1800 and 1802 respectively portrayed young girls reduced to tears by moving passages in novels: Mme Davin's "Une jeune personne affligée du sort de Clarisse dont elle lit le testament" (1800 no.109) and Mlle Henriette Lorimier's "Une jeune fille près d'une fenêtre; pleurant sur un passage d'Atala'" (1802 no.200). Mlle Emma Laurent, author of "Le retour au village" (286) also made a social comment on "La manie des romans" in 1822: "Environée d'objets en désordre, et uniquement occupée de héros imaginaires, une jeune femme vient de passer la nuit à lire leur histoire" (no. 795). Mood compositions, usually representing figures dreaming, which were to become extremely popu- lar in the second half of the century, were rare during this period. There are three instances, all of them depicting the mood of melancholy. Mme Fig.77 Constance Charpentier's "La Mélancolie" (1801 no.58) might be more accur- ately described as an allegorical work than a scene from real life. In 1810 Mlle Hoguer exhibited "Une jeune fille"; "Assise sur le bord d'un ruisseau, elle réfléchit sur la courte durée de la beauté, en voyant s'effeuiller une rose dont le courant emporte les feuilles" (no.418). The third is Mlle Muller's "La mélancolie" also of 1810 (no. 592).

The quantity of works devoted to domestic genre over this period
cannot be questioned. Their importance is another matter. But while the
critical relegation of such themes to an inferior status (frequently placed
on a par with woman's supposed capabilities) should be borne in mind, one
cannot ignore a fact which we have already considered: the increasing
public demand for such works. The latter, as we have seen, is partly to be
explained by a new buying public which demanded and responded to these
themes because they were comprehensible, of a suitable size for interior
decoration and accessible financially. Another explanation is the gradual
popularization of the Romantic emphasis on sensibility. In 1808 Mlle
Pantin exhibited "Un jeune homme préférant la sensibilité à la frivolité"
(no. 458), a work which neatly states the change of emphasis between the
18th and the 19th centuries and draws attention, also, to the serious,
moral overtones of the word sensibility at that time. In art, domestic
genre expressed this new quality most effectively for it revealed the
artist's personal response to the actual world in terms which were readily
understood. Domestic genre therefore became the new art-form just as the
novel became the new form in literature and importance accrues to that
extent. Four explanations may be advanced for women's activity and success
in this genre. Many of them lacked the education and artistic training
which would equip them for more ambitious subjects and compositions; women
were encouraged to restrict themselves to this type of subject; women led
more domestic lives than men; finally sensibility was a feminine attri-
bute as well as an artistic one - women were expected to be sensitive and
they therefore cultivated their sensibility.

Before moving on to the period 1830-1850 a fuller account should be
given of an artist to whom reference has already been made and whose work
appeared at the Salons between 1809 and 1840. Mme Haudebourt-Lescot (1784-
1845)(287) was one of the most famous female painters of the first half of
the 19th century. The extent of her renown may be gauged from the fact that
in 1824 she was the only woman included in Heim's painting of Charles X dis-
tributing awards to artists at the Salon (288). Madame de Genlis cited her
(among others) as proof that women deserved more than a merely domestic
education (289). She won medals at the Salons, many engravings were made
after her works to satisfy public demand and her pupils included a large
number from the aristocracy (290). At her death she was not only described
as one who "dès son entrée dans la lice, avait conquis le succès et s'était
placé au premier rang des femmes qui ont cultivé glorieusement les arts en
France" (291), but also credited, as we have seen, with the popularization
of genre painting in France (292).

Her reputation was founded primarily on works devoted to Italian
genre, produced between 1807 when she first went to Rome with her teacher,

Léthière, and 1814, when she returned (293). Her first work to appear in Paris was "Les Charlatans" in 1809 (294). In 1810 she was awarded a second class medal when she sent eight scenes from Italian life to the Salon and was acclaimed for "Une Prédication dans l'Eglise-Saint-Laurent, hors des murs, à Rome" (no.511). Her name was finally established in 1812 by "Le baisement de pieds dans la basilique de St.Pierre, à Rome" (295) of which Durdent wrote: "Mlle Lescot a peint ce qu'elle a vu; et la vérité de son imitation est frappante jusque dans les moindres détails" (296). The artist favoured themes connected with the Church throughout her career (C4).

It was in the realism of her rendering of contemporary Italian genre scenes that Mme Haudebourt-Lescot stood out from her contemporaries in the field such as François Marius Granet, but at the same time she met the Romantic demand for the picturesque. In addition to the works mentioned above, "Une épisode de la foire de Grotto-Ferrata, pris sur nature" (1814 no. 648), "Des piférari jouant de leurs instrumens devant une Madone" (1814 no. 650), "Un Théatre de Marionettes sur la place du Panthéon, à Rome" (1822 no.669) (297) and "La danse du Saltarello" (1824 no.879), are examples.

She merits a place in this context because of the emphasis on women and children in her genre paintings. They were the usual subjects in her Italian genre scenes, the most dramatic of which was "Voeu à la Madone pendant un orage" (1817 no.530). This portrays a group of women and children "prosternés devant une image de la Vierge au moment où le tonnerre gronde, et où la foudre vient d'éclater" and was described by a critic as "disposé et rendu avec une vérité d'expression et une vivacité de pinceau remarquables" (298). Many other works by her may be aligned with the sentimental domestic genre described in previous pages: "Le premier pas de l'enfance", for instance, was one of the twelve works she exhibited at the Salon of 1819 (no. 767) in which year Landon praised her for devoting herself "aux scènes les plus riantes et les plus douces" (299). Among the fifteen works she exhibited in 1822 were "La mère malade" (no. 672), "Deux jeunes filles lisant un billet-doux" (no. 674) and "Une jeune dame et sa fille portant des secours à une famille indigente" (no. 677); in 1824 "La jeune malade" (no. 867) and "Le brocanteur" (no. 869) in which a peasant woman is shown trying to sell a painting, "Une jeune fille consultant une fleur" (no. 873) and "La dot" (no. 883); "La sollicitude filiale" (no. 539) and "L'enfant malade" (no. 546) followed in 1827 (300).

We have already seen how those women who specialized in domestic genre were praised for not attempting subjects which were beyond their scope (301). Equally , those who did try more ambitious themes were often blamed for venturing outside their sphere. When Mlle Lescot exhibited "Un condamné

exhorté par un capucin, au moment de partir pour le supplice" (302) an
unusually melodramatic work, and "François 1er" (303) in 1819, she was
doubly admonished for choosing themes which required "un trait austère et
prononcé" and advised to restrict herself to "les sujets légers et
gracieux" (304).

In 1843 Mme Fanny Geefs exhibited a most interesting and relevant work
entitled "La vie d'une femme. Piété, amour, douleur" (no. 476). It is an
apt point of departure for the period 1830 to 1850 since it epitomizes the
three main emphases in domestic genre by women artists during these years.

Works on pious or religious subjects were numerous. While many repre-
sented women praying or attending church, often for confession, the most
elaborate compositions were based on the first communion, the most impor-
tant religious event in the lives of most people, and also various aspects
of convent life. "La première communiante" was the subject of four works
(D4). Two of the several portraying nuns and convent life deserve special
mention. In 1844 Mlle Henriette Cousin exhibited "Une prise de voile" in
which a young girl, about to take the veil in a convent, is shown
surrounded by her grieving family. The scene is rendered still more dram-
atic by the presence of a weeping woman whose husband or lover the neophyte
had apparently loved and for whose sake she is entering the convent (305).
An interesting counterpart to this theme is provided by Mlle Anais Chirat's
"Les Regrets au couvent; pastel" (no. 1887) exhibited in the same year (E4).

After "Piété", "Amour" and love was a central preoccupation in domes-
tic genre. Courtship and marriage were, of course, recurrent themes and
many aspects of these subjects were illustrated. "Une Proposition" by
Mme Marie-Louise-Clémence Sollier (1846 no. 1643), "L'enlèvement" by Mlle
Aimée Pagès (1831 no. 1589), "L'art de se faire aimer de son mari" by Mme
Debay (1830 no.306) and "Le mari au bal" by Mlle Louise Marigny (1833 no.
1670), which, according to A. Jal, revealed "les dangers de l'adultère"
(306), were among the more unusual of these. Most interesting, however, is
a work - another trilogy - by Mme Fanny Geefs, exhibited in 1844 (no. 773).
It was called "Candeur - Confiance - Abandon". An innocent young girl is
induced by flattery to place trust or confidence in a man, who then,
possibly having made her pregnant, abandons her (307) (F4). Maternal love
was also a popular theme and numerous happy mothers were exhibited (G4).
Three unusual variants on this theme were "La visite à la nourrice" (no.
567) and "Les adieux de la nourrice" (no. 690) by Mlle Adèle Ferrand at
the Salon of 1840 and Mlle Clara Nargeot's "Le retour de nourrice" (no.
1364) at the Salon of 1844. The most comprehensive work on the subject of
love was a series of five water-colours exhibited under the same number by
Mme Anais Toudouze in 1846: 1. L'amour filial; 2. l'amour de prochain;

3. L'amour maternel; 4, l'amour divin; 5.L'amour paternel (no. 2085).

The third element in woman's life, according to Mme Fanny Geefs, was grief and there was no shortage of works of art by women to illustrate this fact. The July Revolution may be advanced as a main cause behind the several works depicting widows between 1830 and 1834. Examples are Mme Thurot's "Une jeune fille en deuil de son père reçoit la bénédiction de sa mère malade" (1830 no. 246), Mme Eléonore Delaunay's "Une veuve" (1830 no. 511), Mlle Louise Marigny's "Une veuve de l'année 1830" (1831 no. 1446), Mlle Volpelière's "Une veuve et ses enfants" (1833 no. 2418), Mme Brune's "Une jeune femme, près de son père et de ses enfans, vient d'apprendre la mort de son mari" (1834 no.235) and "Un mariage" by Mlle E. Pénavère in which "La veuve d'un militaire accorde la main de sa fille à un ancien ami de son mari" (1834 no.1492). More imaginative was Mlle Hubert's lithograph: "Des brigands, après avoir assassiné le mari de la jeune femme qu'ils ont entrainée dans leur caverne, la tirent aux dés" (1835 no. 2488). Mme Adèle de la Pons' "Regrets; fleurs jetées sur une tombe" (1849 no. 1689) may not have been a figurative subject. The most moving work about death was Mlle Clara Henry's "Une mère pleurant sur son enfant mort" exhibited at the Salon in 1843 (no. 602) when the artist was only seventeen years old. The scene is a poor attic room in which a desperate young woman, presumably without a husband, clasps her dead child to her and looks up, with wide open eyes, towards the light filtering through a grilled attic window. A critic in "L'Artiste" was astounded by the artist's precocity and capable rendering of "le déchirant épisode qu'elle a lu dans le livre de la destinée humaine". His subsequent remarks could only have been made to a woman artist and are worth quoting on that account: "Mais, intelligente et poétique enfant, cachez-nous cette science désolante que vous avez trop tôt apprise; levez vos beaux yeux vers le ciel bleu et pur, abaissez-les vers la terre fertile, verdoyante et fleurie, dites-nous les joies des anges et les plaisirs des hommes, voilà votre partage à vous" (308). In addition, at least seventeen works exhibited over these two decades by women artists portrayed illness (H4). The suffering of poor women and children, particularly female orphans, was the theme of numerous pictures exhibited at this time and they will be considered in detail later (309). One of these works may be mentioned here, however, as being especially relevant in the context of the theme of women's life: Mlle J. Ribault's "Une pauvre jeune mère épuisée de fatigue et de besoin est tombée évanouie sur un chemin, avec l'enfant qu'elle portait. Cette infortunée est aperçue par deux dames qui s'empressent de descendre de leur calèche pour lui donner secours" (1835 no. 1828).

In explanation of this focus on the principal constituents of female
life during the reign of Louis-Philippe (1830-1848) and the occasional
appearance of works, such as those by Mme Fanny Geefs, commenting on their
position, mention should be made of certain political movements of the
period and the literature surrounding them. Saint-Simonist thought, for
example, which gained currency in the 1830s through the activities of
Saint-Simon's followers, particularly Enfantin, attached great importance
to the role of woman where the moral regeneration of society was concerned
(310). The ideas of the social theorist Charles Fourier, who as early as
1808 had described the emancipation of women as a gauge of social progress,
were also more widely known. He died in 1837 and in 1838 the first "phalan-
stère" was established in France (311). Like Fourier, female political
thinkers of the period such as Clair Demar, Jeanne Deroin and Flora Tristan
associated the emancipation of the proletariat and of women and writers like
George Sand, Louise Colet and Victor Hugo, to name but a few, drew attention
to woman's position (312). In other words an awareness of women was
created, as of a different class, and this awareness may well have affected
artistic representations of female life during this period.

Although religion, love and misery emerge as the three main ingre-
dients of a woman's life, family scenes and daily occupations like getting
dressed, reading, sewing, walking, resting, music and consulting fortune-
tellers were also illustrated (I4). In addition, there were numerous por-
traits of anonymous women from foreign countries, a vogue which may have
been due in part to Mme Haudebourt-Lescot's success in portraying Italian
genre scenes and particularly the women of that country (J4). Children
remained popular subjects (K4). The most interesting new development was
the emergence in significant numbers, of what can only be described as
Romantic mood pictures. From the late 1830s titles such as "Espérance et
regrets", "Une jeune rêveuse", "La méditation", "L'heureuse rêverie", "La
tristesse", "Le contentement" and "Souvenir" became more and more frequent (L4)

Having generalised on domestic genre by women in this period, some
space should be accorded its most successful exponent - Mme Elise Boulanger
(313), who exhibited regularly at the Salon from 1835 to 1849, after which
date she sent only two more works, in 1855. Her work, then, falls almost
entirely within this period. Like her most successful predecessors in
domestic genre - Marguérite Gérard, Mme Chaudet and Mme Haudebourt-Lescot
- Mme Boulanger specialized in the portrayal of children. Her first exhibit,
"Jeune enfant pleurant une chèvre, sa nourrice" (1835 no.220), added one
more to the gallery of works depicting children and animals and specifically
recalls two works by Mlle Henriette Lorimier of 1804 and 1810 in which a
goat also acts as nurse to a child (314). The majority of her works

represented the happiness of childhood: in "Les enfants du moissonneur"
(1837 no.179), "Le matin de Noël" of 1837 (315), "Les oeufs de Pâques" (1837
no. 181), "Les étrennes" (1842 no.229), "Le mardi-gras" (1848 no.788) and
"Les plaisirs de la convalescence" (1849 no.340) for instance. Social
comment enters into three unusual works, however: "La Pauvre Femme" (1836
no. 214) (316), "Les enfants du pauvre et les enfants du riche" (1838 no.
174) which recalls similar works, also based on contrast, exhibited in
England in the 1850s, and finally "L'orpheline et son petit frère" (1849
no. 338). From 1839 she concentrated more on themes from history and liter-
ature, but in these again children were the usual subjects (317).

According to critics the attraction of her work lay in its naivety
and charm and she was also recognized as being highly proficient in water-
colour (318); in later life she published works on artistic technique (319).
Like other artists we have mentioned she was praised for not venturing out-
side her sphere (320). In 1837 a critic wrote: "Ce dont il faut la louer
surtout, c'est de comprendre très-bien la nature de son talent, et de ne
s'exercer qu'à des sujets dont la simplicité naïve et le sentiment délicat
peuvent être rendus dans les limites d'une aquarelle" (321). She won a third
class medal in 1836, a second class medal in 1839 and in 1838 six of her
water-colours were engraved in a "Livre d'Or" (322). Her works were much
admired in Holland and the highest honour conferred on this artist was her
election, in 1845, as a member of the Amsterdam Academy (323).

During the peaceful and prosperous Second Empire (1852-1870) the main
occupations in woman's life - what one critic referred to as "sujets féminins"
- remained popular material with women artists. Such themes were particularly
favoured by Henriette Browne, Louise Eudes de Guimard, Lucile Doux, Emilie
Leleux and Uranie Colin-Libour. Religion (M4), love (N4), maternity (O4),
children (P4) and everyday activities (Q4) were extensively portrayed.
Simple mood pictures depicting states of mind with titles such as "Rêverie"
were recurrent (R4). Again portraits of anonymous women from provincial
France and foreign countries constitute a strong theme (S4). But in contrast
to the previous decade fewer works involved drama or strong emotion and
death and illness entered into only a small number of pictures between 1852
and 1865 (T4). The influence of teachers such as Chaplin, who ran a studio
for women artists, should not be under-estimated here (324). His own pro-
ficiency in domestic genre doubtless encouraged many of his pupils to choose
similar subjects, just as his scorn for titles may have helped to popularise
brief, inexplicit designations such as "Rêverie" (325).

The work of Henriette Browne will be considered in detail later. Her
considerable reputation was based on a series of large genre pictures on

themes connected with the Church which she exhibited simultaneously with
smaller domestic genre scenes, and on work devoted to foreign genre. As
Mme Haudebourt-Lescot drew many of her themes from Italian life, so
Henriette Browne concentrated on genre scenes, mostly with female figures,
from Turkey, Morocco, Egypt and Syria, all of which countries she visited
between 1861 and 1876. She deserves special mention in this context on
account of the dimensions of her works, which for genre subjects were
unusually large. "Les puritaines" (1857 no.394) for instance, was five
feet wide and four feet three inches high and "Les soeurs de charité" (1859
no. 433) was five feet ten inches wide and four feet three inches high.
Their size is an indication of the growing importance of genre pictures in
the thematic hierarchy (326).

During the last three decades of the century domestic, "feminine"
subjects ceased to be associated so closely with the limited powers of women
artists. Such themes were prevalent in the work of the Impressionists,
the Nabis, the Intimists and the Symbolists as well as in that of artists
who were less innovatory stylistically such as Bastien-Lepage. The fact
that one can associate so few women artists directly with these movements
- Berthe Morisot, Mary Cassatt, Marie Bracquemond and Jacques-François are
the exceptions (327) - may be explained firstly by the social nature of
these groups from which bienséance would have excluded many women, and
secondly by the emphasis on style within them. In so far as the latter
emerged in opposition to the Academic system, they owed their existence to
it. As women were excluded form the Ecole des Beaux-Arts they lacked the
basis for reaction.

Despite the small degree of their participation in movements, women
artists should be given a place in any discussion of subject matter during
the last three decades of the century. Over this period, domestic genre,
which always had had and still counted a large number of female exponents,
was regarded less and less as an inferior class of subject matter. Instead
the female genre par excellence became the most vital mode of expression as
corresponding most closely with contemporary theories of art (328).

Every aspect of woman's life was widely illustrated in women's art
between 1871 and 1900. Maternity (U4), love and marriage (V4), religion (W4)
death - which usually took the form of widowhood - and illness (X4) as well
as the ordinary everyday occupations of women (Y4), were recurrent subjects
in the work of women artists. Foreign women, also, remained popular
figures (Z4). In 1870 the critic Castagnary had written that while male
artists remained lost in abstractions, the work of women artists was firmly
rooted in reality: "Pour elles, elles sont de leur temps, font ce qu'elles

ont yu ou senti" (329). Virgine Demont-Breton, Berthe Morisot, Mary
Cassatt and Louise Breslau were the most successful women in this genre
and their work will be considered in detail in Chapter Five.

Motherhood was the most favoured theme. I have examined the popular-
ity of this theme towards the end of the century elsewhere and offered some
explanations, particularly of the tendency to make the mother and child into
a symbol of fertility, charity and socialist ideals (330). The charity
image was conventional and several examples exist in the work of women
artists at that time (331). More abstruse symbolization, however, is not
apparent. There are a few exceptions such as Virginie Demont-Breton's "Alma
Mater" (1899 no.615) and the several Mater Dolorosa's should also be borne
in mind as some, if not all of these, may have had a general rather than
religious theme (332). But on the whole maternities by women artists were
simply about motherhood and were not statuesque images but informal scenes.
Berthe Morisot, Mary Cassatt and Virginie Demont-Breton all specialized in
the mother and child theme and their work provides the best examples of
realistic motherhood portrayed with sympathy and insight. Instances in
the work of other women artists are Mlle Elizabeth Gardner's "Deux mères
de famille" of 1888, Mme Besnard's "Mère et enfant; buste plâtre" of 1890,
Mme Delacroix-Garnier's "Loin de Paris" of 1896 and "Heureuse mère" of
1898 and two more works by Mlle Landré: "Jeune mère" of 1897 and "Amour
maternel" of 1900, all of which were illustrated in the exhibition cata-
logues. Huysmans', in his "Salons", commented on women artists' superior
rendering of maternity (333).

As before, children were often the subjects. Louise Breslau was
probably the most famous female artist where the portrayal of childhood was
concerned and her work will be considered in detail in Chapter Five (A5).
A new theme which emerges in connection with this, is that of the old
woman, often in the company of children. "L'aieule" was the title of nine
works over this period and grandmothers were frequently portrayed (B5).

A few works do not fit into the above categories. Several were
entitled "Martyre" and "Captive" and it is impossible to establish whether
these were shown in a contemporary or an historical setting (C5). Two
interesting works of the period portrayed magdalen figures: "Le retour de
la fille repentante" by Mlle Cathinca Engelhart (1878 no.863) and a trip-
tych by Mme Elise-Desirée Firnhaber exhibited at the Salon des Indépendants
in 1895: "Innocence" (no.527), "Désobéissance" (no.528) and "Repentance"
(no. 529) (334).

Women's life was exhaustively illustrated by women. In a few works,
and the several "aieules" should be included among these, the images are

larger than life. One of the first instances was Mlle Adélaide Wagner's
"Fille d'Eve" of 1863 (no.1879). Then in 1875 Mlle Marie Lebrun exhibited
"Les trois âges" (no.1283), which a critic described as "cette intelli-
gente et très-artiste allégorie de la vie féminine" (335). Other examples
are "Femme; - buste terre cuite" by Mme Mathilde Bianchi (1885 no. 3370),
"Une Contemporaine; buste marbre" by Mme Léon Bertaux (UFPS 1885 no.2)
and "Elle" by Mlle Georges Achille-Fould (1896 no. 3).

The most striking development over this period is the continuation of
a trend which we have already observed in the two previous decades: the
increasing popularity of works illustrating a mood such as thought, dream,
sadness, memory, hope, melancoly, misery and resignation. The borderline
between domestic genre and allegory here becomes extremely slight and in
the context of the upgrading of the former this is surely no accident; for
domestic themes to transcend mere anecdote they needed a general applica-
tion and this was most effectively suggested by abstract nouns and adjec-
tives. The majority of works with titles like "Mélancolie", "Tristesse",
"Rêverie", "Penserosa", "Souvenir" and "Attente" portrayed single figures,
mostly female, who epitomized the mood: "Solitude" and "Seule" became
extremely popular as titles (D5). A considerable number of such works
were sculptures and understandably so for sculpture is particularly suited
to personification. The most striking examples of this type of subject
matter are five works by Marie Cazin: "La Tristesse" of 1880, "Meditation"
of 1884, "Le Regret; statue bronze" of 1885, a tomb sculpture and an
Fig.78 undated drawing entitled "Désolation".

In reference to the first of these, the critic Philippe de Chenne-
vières instructed his public: "allez aux dessins, et voyez cette tête de
femme crayonnée puissamment, cette nuque nerveuse, avec ses cheveux rabattus
sur son morne profil, et que le livret intitulé "La Tristesse". Je ne crois
pas que, parmi nos plus grands artistes aujourd'hui vivants, il s'en
trouve un capable de nous retraduire avec une telle vigueur profonde la
terrible mélancolie de Michel Ange" (336). A bronze mask with the same
title and possibly based on the drawing, was exhibited by the artist in
1882 (no.4191). Fourcaud described her drawing "Méditation" in 1884: "Ici
une jeune femme, à la physionomie austère, assise à l'écart, un livre sur
les genoux, s'interrompt un moment pour suivre ses pensées graves et doulour-
euses". He drew attention to "une impression de profonde et rêveuse
humanité" given by her works; they had "quelque chose de si saillant, je
dirais volontiers de si poignant, qu'elles s'imposent au souvenir" (337).
Similarly of her "Regret", André Michel wrote: "C'est une des oeuvres
imprévues et poignantes, qui semblent faites d'instinct, qui vous arrêtent

au passage et dont le souvenir s'enfonce dans le coeur. Sur un tertre,
une femme est affaissée encore plus qu'agenouillée, enveloppée dans une
lourde cape de paysanne, les épaules serrées, la tête à demi couverte
d'un capuchon, inclinée sous le poids d'une douleur silencieuse, qui ne
pleure plus mais qui n'oubliera jamais". Her works were characterized by
"un sentiment profond qui s'exprime comme il peut, sans art ou plutôt sans
artifice, et arrive, par la seule puissance de l'émotion, à l'éloquence et
à la poésie" (338). The artist had previously sculpted a similar figure,
specifically for a tomb. Again a peasant woman, this time seated on a
tree trunk "revivant avec ses morts aimés et comme leur parlant d'abondance
de coeur au-dedans d'elle-même". Fourcaud wrote: "Je n'ai jamais vu un
plus pur et plus doux hommage rendu par ceux qui vivent à ceux qui ne sont
plus. Ce n'était point l'image du regret; c'était l'image de la consola-
tion, ou, mieux encore, celle de la foi, de l'affection, de la communauté
des sentiments qui brave toutes les funérailles" (339). The drawing
"Désolation" depicts a pregnant working class woman seated on a bench in an
attitude of total despair with her two sleeping or exhausted children.

These are all, as the critics describe, poignant images rendered with
great depth of feeling and their poignancy is surely due, in part at least,
to the fact that these female images of suffering are peasant or working
class women. "Sorrow" by Van Gogh, is an interesting counterpart (340). At
a time when attention was continually drawn to the condition of the working
classes and to the particular problems facing poor women, such images would
have been very striking. Although Marie Cazin was not the only woman artist
to portray working women in works of this sort (341), most mood works
depicted middle class women. Among these, a good example of a much repeated
Fig.79 theme is Mlle Durruthy's "Encore seule!" (1897 no.593).

Judging from reviews, illustrations and located works of this type, men
were focal in very few works which come under the heading of domestic genre;
thus the rubric "Female Life". Knowledge of the sex of the artist is
especially illuminating in such works as it suggests a personal and sympa-
thetic approach to the subject. The effect of death on women and the various
aspects of love and marriage were vital themes in the first four decades of
the century. In the 1840s the religious revival which we have already
observed in classical works of art is also reflected in domestic genre.
"Piété" was the first theme in Mme Ganny Geefs' trilogy on woman's life:
"Piété, Amour, Douleur" of 1843. Religion, love, marriage, grief, and par-
ticularly maternity, remained strong themes during the second half of the
century as well as the daily occupations of women which always constituted

a substantial category. Most striking, however, as in England, is the
gradual increase in mood pictures and sculptures, with titles such as
"Rêverie", "Solitude" and "Tristesse". These acquired a particular poig-
nancy in the 1880s when several of Marie Cazin's images reflected the
strong social conscience of the period. Many of these works approach
allegory during the last three decades of the century and should be seen
not only as personifications of various moods, but also as embodiments,
formulated by women, of some of the principal constituents of female life.

Section E - Women and Art

The importance of the artist in Romantic thought has already emerged
from two sections in this chapter: from historical works portraying
artists of the past in the classical section and from portraits of writers
and musicians in the section devoted to portraiture. It will be most
apparent in the present study which is concerned with self-portraits and
portraits of named and anonymous artists.

Where women artists are concerned self-portraits have a particular
interest. Firstly self-portraits are the only form of figurative painting
from the life which can be done alone and women artists, many of whom
worked non-professionally at home would frequently have resorted to por-
traying themselves. Secondly, in view of the fact that women artists were
generally treated as a distinct and inferior minority group, self-portraits
may be seen as a form of self-assertion, an emphasis of the fact that the
artist is a woman. Portraits of specific women artists may also be seen
as a sort of mild propaganda, as may the numerous portrayals of anonymous
women artists, painting, drawing and sculpting.

Art and artists were popular subjects in works of art by women during
the first three decades of the century. The large number portraying
specific artists included 27 self-portraits (E5), six portraits of female
artists (F5) and sixteen of male artists (G5). The most ambitious work in
the first two categories was Mlle Capet's "Tableau représentant feue Mme
Vincent (élève de son mari). Elle est occupée à faire le portrait de M. le
Sénateur Vien, comte de l'Empire et membre de l'institut de France, régénér-
ateur de l'Ecole Française actuelle, et maître de M. 'Vincent'. L'auteur
qui s'est représenté chargeant sa palette, a placé dans ce tableau les
principaux élèves de M. Vincent" (1808 no.89). From the titles it is imposs-
ible to judge whether these self-portraits and portraits of named women
artists portrayed the subjects in an artistic context. The only exceptions,
apart from the work described above, are a "Portrait en pied de l'auteur
dans son atelier" by Adèle de Romance of 1810 and Mme Haudebourt Lescot's
Fig.80 "Portrait de l'auteur" of 1825 in the Louvre.

The most interesting category of works about art exhibited over this
period comprises those portraying anonymous women engaged in painting or
drawing. Of these women exhibited at least eighteen (342). The majority of
these simply depicted women artists (H5). Others were more explicit about
the nature of their occupations. Three, for instance, showed women sketching
outside from nature (I5). In three more women were painting (J5) and in two

drawing (K5). In one other a woman is engaged in a self-portrait (L5).
Two unusual works involved instruction. The first of these was by Mlle
Fig 81 Constance Mayer: "Portrait en pied d'un père et de sa fille. (Il lui
indique le buste de Raphael, en l'invitant à prendre pour modèle ce
peintre célèbre)" (1801 no.238). This,despite the anonymous title,
depicted her father, Mayer La Martinière, "employé supérieur des Douanes",
showing the Raphael bust to Constance Mayer herself. The second was by
Madame Dabos: "Première leçon de dessin d'une mère à son fils. Elle lui
donne l'Empéreur pour modèle" (1810 no.185).

The main observation to be made about these works portraying anony-
mous women artists is that they show women pursuing art on their own; not in
art schools and seldom in studios, but at home, occasionally with a friend.
This mirrors the actual situation in which numerous difficulties faced
women who wished to study art professionally. Most of these women - paint-
ing, drawing and sketching - are surely amateurs passing the time in a
fashionable accomplishment (343). Three exceptions should be emphasized:
in 1806 Mme Kugler (veuve Weyler) exhibited a number of enamel paintings,
one of which was entitled "Un intérieur d'atelier" (no. 282); in 1814
Marguerite Gérard exhibited "Un atelier de peinture" (no. 427) which almost
certainly portrayed a woman or women and in 1822 Adrienne Marie Louise
Fig 4 Grandpierre-Deverzy sent an "Intérieur d'atelier de peinture" to the Salon
(no.605), depicting the studio for women artists run by her husband, Abel
Pujol. Thirteen students were included, some of them working from an
elegantly dressed female model, a few others listening to criticisms from
Pujol himself (344).

Works on these themes exhibited between 1830 and 1860 stand in marked
contrast. There were only two pictures of single anonymous women artists
(M5) (345). The subject of a work by Mlle Pauline Caron entitled "Le
premier tableau" (1857 no.443) is open to question. On the other hand, there
were as many as eleven studio scenes. The majority of these were simply
called "Intérieur d'atelier" (N5). I have found a description of only one
of these works in a review: the "Intérieur d'atelier" by Mlle Célestine
Faucon of 1845: "La disposition et l'arrangement sont heureux, les têtes
de jeunes filles ont du naturel. J'en dirai autant du modèle; mais il y a
un peu de sécheresse, un peu de raideur. J'en accepte les jeunes filles
vues de dos à gauche du tableau sur le premier plan: elles sont fort bien"
(346). This interpretation of the word "atelier" as a studio where a
number of students worked in common, perhaps under the direction of a master,
was current at the time and one may therefore assume that some if not all

of the other works with the same title portrayed similar scenes. Since the
studios depicted were most probably the studios where the artists themselves
worked, the artists or students represented were almost certainly female.
Five more pictures portrayed specific classes: "Cours de peinture de
M. Redouté dans la salle de Buffon, au Jardin des Plantes" by Mlle Ribault
(1831 no.1761), "Intérieur de l'atelier des élèves de M. Léon Cogniet,
pendant le repos" by Mlle Biet (1834 no.131), "Intérieur de l'atelier de
M.A.P. ..., peintre d'histoire" by Mlle Grandpierre (1836 no. 890),
"Intérieur d'un des ateliers de M. Léon Cogniet" by Mlle Henriette Nolet
(1849 no.1546) and "Intérieur de l'atelier de M. Abel de Pujol, membre de
l'Institut " again by Mlle Grandpierre, or, as she appears in the catalogue,
Mlle Adrienne-Marie-Louise Grandpierre-Deverzy (1855 no. 3211). The latter
is in the Musée des Beaux-Arts, Valenciennes. All these pictures depicted
female classes. Mlle Grandpierre-Deverzy's two works were second and third
versions of the picture exhibited in 1822 which we have already considered.

Just as during the first three decades of the century the numerous
portrayals of single women painting or drawing mirrored the actual situa-
tion in which women were excluded from professional involvement in the arts,
so during the period presently under discussion, 1830 to 1860, the prepon-
derance of atelier scenes corresponded with the new and improved position
of the woman artist. By this time classes had opened to cater for women's
needs and if the standard of instruction was still not equal to that avail-
able to men, at the very least these classes provided an opening to pro-
fessionalism. It should also be mentioned that the subject of women
artists - their work and opportunities - was frequently discussed in the
press from the 1830s, creating an awareness of them, as a distinct group,
which may have been a contributing factor behind the numerous representations
of women art students (347).

Women exhibited 30 self-portraits over the same period (O5), five por-
traits of named women artists (P5) and fourteen portraits of named male
artists and artists whose initials only were given (Q5). As we have already
seen, artists of the past were the subjects of a considerable number of
historical works over the same period (348).

Many atelier scenes were exhibited by women between 1860 and 1900.
Again, in the case of unspecified studios, one may safely assume - consider-
ing the general segregation of male and female students at that time - that
these depicted either the artist's own studio or the studio where she worked
or attended classes with other women; in other words that where artists
were portrayed, they were usually female (R5). In a number of cases one

may be certain of female subjects. The following works, for example,
showed female art classes: "Intérieur d'atelier; portrait de Mlles ***"
by Mlle Laure de Châtillon (1870 no.546), Marie Bashkirtseff's represen-
Fig.5 tation of the art class for women in the Académie Julian, painted in 1881
on Julian's suggestion and exhibited at the Salon of that year (349),
"Cours de dessin dans une école communale de jeunes filles, à Paris" by
Mme Marie-Adrien Lavieille, née Petit (1885 no.1485), "Cours de dessin de
Mme Mac'Nab" by Mlle Marie Gacoin (1889 no.3222), "Un coin d'atelier" by
Mme Uranie Colin-Libour (1891 no.380) which was illustrated in the catlogue,
Fig.82 "La Leçon" by Mme Josephine Houssay (1894 no.944) and perhaps "Italiennes à
l'atelier" by Mme Fanny Fleury (SN 1894 no.454). Drawing lessons were por-
trayed in several works (S5).

There were also numerous pictures of individuals painting, drawing and
sketching and a few of sculptors and engravers. At least 20 depicted
female artists (T5). Many bore inexplicit titles which suggest that the
subject was artists (U5). Others took the artist's model as their theme (V5).

A few male artists also portrayed women artists. Félix Bracquemond's
"La terrasse" for instance, of 1878, shows a woman sketching a female figure
on a terrace (350). In Fantin-Latour's "Portraits" of 1879, two girls are
represented, one working at an easel, the other drawing (351). "L'étude en
plein air" by G-P-M Van den Bos (1899 no.1933), which was illustrated in
the catalogue, shows a woman seated at an easel outside, sketching a peasant
girl, and a female engraver was the subject of "Une mauvaise épreuve" by
L. Olivié-Bon (1899 no. 1488), also illustrated in the catalogue. Other
works by men contrast strikingly with women's representations of women
seriously engaged in art: attending art classes and painting or sculpting
on their own. Examples are the two series, each entitled "Dames Artistes",
exhibited by Paul Renouard at the Salon of 1880 (352) which are comic
drawings ridiculing the efforts of women artists in the Louvre (353) and
also three works exhibited by men in 1887 and 1888: "La leçon de peinture"
by P-E Metzmacher (1887 no.1676), "La salle des Etats au musée du Louvre;
fragment" by L. Béroud (1887 no.198) and "Une leçon d'amateur" by H.
Schlésinger (1888 no.2255). All three were illustrated in the exhibition
catalogues and show women, apparently aristocratic amateurs, being
privately instructed by men.

Women exhibited well over 100 self-portraits between 1860 and 1900 (W5).
Fig.64 Mlle Anna Bilinska's self-portrait, exhibited in 1887, was considered unus-
ually unflattering and honest for a woman artist. One review is worth
quoting at length because it shows a typical dilemma of the male critic when

presented with such works: "elle n'a pas un instant songé à se flatter;
elle s'est représentée en costume d'atelier; du caractère - ce qui est
loin d'être à dédaigner - au lieu de la beauté; la pose est très juste;
la touche plus virile que dans la plupart des portraits dus aux pinceaux
du sexe fort". He begins, then, with praise for her honesty and "virility"
of execution. He goes on: "La coloration générale, voilà ce qui est le
moins à louer; ce n'est pas qu'elle manque d'harmonie, mais c'est une
harmonie quelque peu terreuse; un point lumineux est tout au moins
désirable, un je ne sais quoi qui vienne éclairer d'un sourire plus féminin
cette peinture où le rayon de jeunesse est fort assombrie par les soucis
manifestes d'une vie d'épreuves. Les épreuves! elles n'ont pas manqué
à la jeune artiste" (354). So, while admiring her honesty in self-portraiture,
an honesty which included making visible the trials of her life, the critic
simultaneously wished for "un sourire plus féminin" - more youth and
happiness. The objectivity of his criticism is impaired by his knowledge
of the artist as a woman (355).

Fig.67 Mlle Amélie Beaury-Saurel also exhibited a self-portrait, a drawing, at
the Salon of 1887, a work which received superlative praise. Like Anna
Bilinska she was admired for the "virility" of her technique: "On chercher-
ait en vain, parmi les portraits exposés par des artistes en renom, un seul
qui soit de force à soutenir la comparaison avec la fière peinture de Mlle
Beaury-Saurel" (356). And she was also criticized for the ugliness of her
self-portrait (357). Equally unflattering was Mlle Thérèse Schwartze's
Fig.63 "Mlle Thérèse Schwartze faisant son portrait" of 1888, a work commissioned
by the Italian Government for the Uffizi Gallery (358). When exhibited at
the Salon it missed the gold medal by only two votes. Three more self-
portraits, of the 1890s, are realistic portrayals of the artist as an artist:
Mme Moutet-Cholet exhibited a "Portrait de l'auteur" in 1894, Mlle J-M
Favier another in 1895 and Mlle M. de Montille the third in 1898; all were
illustrated in the exhibition catalogues.

The balance between portraits of specific male artists and specific
female artists was almost equal over this period. 30 portraits of named
female artists were exhibited by women; Sarah Bernhardt, famous for her
paintings and sculptures as well as her acting, Louise Abbéma and Rosa
Bonheur were all portrayed more than once (X5). There were at least 29
portraits of specific male artists (Y5).

Women were not alone in favouring art and artists as themes for their
works and nor were visual artists. The Artist occupied a central place in
Romantic thought as the supreme embodiment of feeling and emotion and was

frequently the subject of fictional biographies and poems (359). Women artists were exceptional, on the other hand, in their numerous portrayals of anonymous women artists sketching, painting, sculpting and engraving - at home, in the open air and in art classes. Most unusual are the latter - representations of women students in classes - and obviously so, for men, apart from the teachers, were excluded from these. While the artist was of general interest during the 19th century, the woman artist was of partic-ular interest to women.

Section F (a) - Working class life

 Most genre scenes by women during the first thirty years of the
century were the product of two artists: Mlle Jenny Legrand and Mme
Haudebourt - Lescot (360). The former specialised in peasant interiors
and kitchen scenes and was particularly fond of representing children.
Fig.83 Her "Intérieur de Cuisine" is an example (Z5). The latter concentrated
on subjects from popular Roman life and favoured beggars and street-
sellers as subjects (A6). It is impossible to comment on the nature of
these and other genre scenes as visual records are not forthcoming but
one of the most moving works in this category was surely Mlle Constance
Mayer's "La famille malheureuse ou l'ouvrier mourant" of 1822 (361) (B6).

 While picturesque scenes from peasant life became increasingly pop-
ular between 1830 and 1850 (C6), over this period a greater social aware-
ness emerged which is particularly noticeable, as in England, in represen-
tations of female orphans and poor children, who, with beggars, were
recurrent subjects. The titles of a number of these suggest extremely
bleak images. For instance, "Une orpheline au tombeau de sa mère" by
Mlle Rosine Parran (1838 no.1360; now in the Musée d'Angers), "L'orpheline
du choléra" by Mme Leprévost (1839 no.1349), "La fille de l'aveugle morte
de la peste" by Mlle Valentine d'Anican (1342 no. 461) and "L'orpheline
découragée" by Mlle Elise Allier (1844 no.18). Some even imply a propa-
gandist intention: Mme Elise C. Boulanger's "Les enfans du pauvre et les
enfans du riche" (1838 no.174) and Mlle Sophie Berger's "Riche et pauvre"
(1849 no.129) (D6).

 Between 1850 and 1885 such titles disappeared. Orphans, beggars and
the poor continued however (E6) and more and more scenes from rural life
were exhibited (F6). A number of artists, such as Louise Eudes de
Guimard, Pauline-Elise Léonide de Bourges and Marie Cazin, specialized in
these themes. The most successful was a Belgian artist, Marie Collart,
who first exhibited in Paris in 1865. The work was called "Une fille de
ferme" (no. 485) and she was instantly acclaimed by Paul Mantz: "Le
réalisme flamand triomphe cette fois dans l'oeuvre hardiment naïve d'une
jeune fille de Bruxelles, Mlle Marie Collart. Il n'y a rien d'idyllique
dans la 'Fille de ferme', et je crois savoir que les brutales audaces de
ce tableau ont étonné le jury. Sans trop se soucier de l'abbé Delille et
de ses périphrases, Mlle Collart a peint une robuste et vulgaire servante
qui, entrée dans un parc à cochons, retourne avec une fourche le fumier
bruni et odorant de la basse-cour; elle apporte à son travail la plus

belle ardeur du monde, et ne se laisse pas distraire par le grognement
des bêtes impures qu'elle arrache un instant à leur rêverie ... Le tableau
de Mlle Collart est la glorification du fumier ... il y a de la sève, du
tempérament, une sorte de mâle courage dans cette étude qui nous arrive
tout droit du pays de Jordaens". He concludes with a comparison, in
Collart's favour, with other genre painters: "A côté de cette page d'une
saveur si exubérante et qui, je le sais, appellerait tant d'objections,
les autres peintures de genre, même les plus familières et les plus
intimes, semblent l'oeuvre de petits-maîtres musques et anodins" and the
others he names are Vollon, Bonvin, and Armand Leleux (362). Collart
exhibited in Paris throughout the latter part of the century and con-
tinually drew praise from critics for the realism of her representations
of rural life (363).

From the 1880s Collart's success as a genre painter was rivalled by
that of Virginie Demont-Breton who, from 1880, exhibited a long succession
of works on the lives of fisherfolk and particularly the women and
g.84 children. Her "Femme de pêcheur venant de baigner ses enfants" of 1881
g.85 (no. 675) and "La famille" of 1882 (no.799) were typical subjects and she,
like Collart, was praised for the realism of her subjects (364).

A list of female genre painters during the last three decades of the
century would be extremely long. The most recurrent names, apart from
Marie Collart and Virginie Demont-Breton, were Eugénie Salanson, Marie
Petiet, Elisabeth Gardner, Emma Herland and Marguerite Pillini all of
whom concentrated on the picturesque aspect of rural life (G6).

During the 1880s social realism re-emerged. We have already dis-
cussed the work of Marie Cazin in the section on women's life for although
her subjects were mostly peasant women, many of her images were so general-
ized in theme that they do not fit easily into the categories of genre or
social realism (365). She should be borne in mind in this context, how-
ever, because of her association of suffering with poor women, an associa-
tion which was recurrent in social realist works of the period. A work
which has not yet been mentioned and which appears from the title to fit
into this context is "La vie obscure; - dessin" exhibited in 1885 (no.
2524). In a note this was described as the "troisième dessin en cours de
publication sous le même titre".

Uranie Colin-Libour had exhibited scenes from domestic life from the
1860s. In 1885 she turned to social commentary with a work called
ig.86 "Emigration" (366). It represents a poor woman, sad and lonely, with her
child and baggage, seated against a wall on which one can just distinguish
notices about emigration to America. Her loneliness is made more poignant

by the glimpse of a smart carriage beyond her to the right. In 1886 the
titles of a number of works suggest sober renderings: "Sans travail" by
Anna Bilinska (at the "Blanc et Noir" exhibition), "Misère" by Mlle
Marie-Madeleine Del Sarte (no. 728), "Seule ressource d'une orpheline" by
Mlle Amélie Lacazette (no. 1312), "Misère! - plâtre" by Mlle Fanny Crozier
(no. 3736) and an unusual work by Mlle Thérèse Schwartze called "A l'église"
(no. 2169) with the gloss: "J'élève mes yeux à toi, qui demeures aux cieux
- Aie pitié de nous, Eternel. Notre âme est foulée de la moquerie de
ceux qui sont à leur aise et du mépris des orgueilleux (Psaume cxxiii, 1,
Fig.87 3,4)". Another moving image was Mlle I. Venat's "Les deux orphelines"
(1887 no.2372) which was illustrated in the catalogue.

Poor children and orphans were frequently exhibited from the 1880s (H6)
and the theme of "Out of Work" was also illustrated a number of times: Anna
Bilinska's version was succeeded by "Sans ouvrage" by Mlle M-N Flandrin
(1889 no.1030), "Sans ouvrage et sans pain" by Mme Doutreleau d'Amsinck
(UFPS 1890 no.253) and "Sans travail" by Mlle Charlotte Mésange (UFPS 1891
Fig.88 no. 557). One of the most interesting works is "Le soir de la paye" by
Mlle M-B Mouchel (1897 no. 1232): a poor woman carrying a baby stands
forlornly outside a public house within which her husband can be seen
spending his earnings on drink and apparently resisting the entreaties of
his elder child to come home. The subject is identical to that of a work
exhibited at the Royal Academy in 1883 by Louise Jopling and called
"Saturday Night: searching for the breadwinner" (367). Similar in theme
Fig.89 was "Le lendemain de la paye" by Mme Uranie Colin Libour, exhibited at the
Salon in 1896 (no.488). A woman nursing a child is shown watching
anxiously out the window for her husband's return. Four other works by
Mlle Mouchel are worthy of note. Charity is sought in "La part à Dieu,
s'il vous plaît" (1895 no. 1405) and "La complainte" (1896 no. 1471) which
depicted a poor family trying to earn money by singing in the streets.
Both these were illustrated in the catalogues. In 1899 she exhibited a
work entitled "Les temps durs; autour du brûloir à café" (no.1452) and in
1900 a work which indicates her sympathetic attitude towards the poor: "Il
n'achèvera pas, le roseau brisé.. " (no. 973) was the title and the work
shows Christ standing over a poor woman who is lying on the ground (368).

Many works exhibited from the late 1880s depicted or drew attention to
poverty (I6). Charity was a popular theme (369) and several works portrayed
institutions for the poor: orphanages were the subject of four pictures,
two exhibited in 1888 represented crèches and others are Mlle M. Heyermans'
"Hospice des vieillards à Bruxelles" of 1891, Marie Huenes d'Alheim's
"Asile de nuit à l'impasse du Maine" of 1895 and Mlle Marc Mangin's "Soupes
populaires" of 1897.

Section F (b) - Working Women

During the first three decades of the century very few representa-
tions of women workers appeared at the Salon. Female street sellers were
the subjects of seven works, three of them by Mlle Jenny Legrand. Mlle
Sohier l'aînée exhibited "Une servante tricotant dans sa cuisine" in 1812
and Madame Haudebourt-Lescot "Une maîtresse d'école italienne" in 1825.
In addition, three pictures - two exhibited in 1824 and one in 1827 - por-
trayed spinners (J6).

Works on such themes increased between 1830 and 1850 as a result, no
doubt, of the increasing social awareness which succeeded the July Revolu-
tion of 1830 and more specifically of publications by writers like Claire
Demar, Jeanne Deroin and Flora Tristan which drew attention to the condi-
tion of women workers (370). Street sellers remained popular although the
degree of realism in their portrayal must be open to question (K6). Eight
spinners were exhibited, three of them entitled "Vieille fileuse". One,
exhibited by Mme Céleste Pensotti in 1846, bore the title "Pauvre Fileuse"
and was described in the "Magasin des Demoiselles" as "une des meilleures
productions de cette année" (371) (L6). Six more unusual works were "Le
déjeuner des repasseuses" by Mme Dabos (1833 no.515), "Cuisinière de
retour du marché" by Mlle Le Baron (1833 no.3101), "Une ferronnière" by
Mlle Aimée Perlet (1840 no.1271), "Une jeune servante; étude" by Mme Emma
Blanche (1847 no.156) and two works by Mlle Eugénie Henry: "Les Lavandières"
(1840 no. 882) and "L'aumône de l'ouvrière" (1841 no.975).

Street sellers, spinners and domestic servants appeared regularly at
the Salon between 1850 and the mid 1880s but the titles, being unexplicit,
are unilluminating where the realism of the portrayals is concerned (M6).
"La petite ouvrière" by Mlle Sophie Van den Haute (1865 no.2116) and "Une
jeune ouvrière" by Mlle Louise Eudes de Guimard (1869 no. 895) were unique
titles.

In the 1880s a change occurred. On the one hand there was a sharp
increase in subjects of this sort and secondly a considerable number come
under the heading of social realism in so far as they appear to be general-
isations on the condition of certain types of working woman. The emergence
of literature examining the condition of the working woman is an important
factor here (372).

Spinners, washerwomen, street sellers and domestic servants were the
largest categories (N6). Only a few works on these themes were illustrated:
"Les derniers jours" by Mme Gonyn de Lurieux of 1900 depicts a sorrowful old
spinster who appears to be reflecting on her past life and Mme M. Petiet's

"Vieille femme d'Aulus" of 1884 also shows an old spinster dreaming; in her "Blanchisseuses" of 1882 Mlle M. Petiet portrayed seven girls ironing on a table in front of a laden washing line and "A la buanderie" by Mlle A-E Klumpke of 1888 shows four women around a tub scrubbing. Mlle M.

Fig.90 Carpentier's "Marchande de fleurs, au faubourg" (1899) was an exceptional work in the category of street sellers in suggesting the hardship of the trade; the woman looks sad and has three children to provide for. More usual were the street-sellers exhibited by Mlle Georges Achille-Fould and Mlle Consuelo Fould: "Marchande de pommes de terre frites" (1888) by the

Fig.91 former and "Marchande de fleurs à Londres" (1892) by the latter were typical.

Seamstresses, milliners and embroideresses provided new themes (O6). In 1883 Mlle Marie Petiet, who favoured the subject of the working woman, depicted an "Ouvroir", a charitable institution in which young girls and women earned their living through the needle. In the following year she sent "Lingerie" to the Salon. Also in 1884 Mlle Jeanne Rongier exhibited

Fig.92 "La Mansarde", showing two young women sewing in a sparsely furnished attic; once has fallen asleep through exhaustion. Mlle Amélie Lacazette's "Seule ressource d'une orpheline" of 1886 may have portrayed a seamstress

Fig.87 and in Mlle I. Venat's "Les deux orphelines" of 1887, one is making a shirt. There were also several representations of female lace-makers and weavers (P6). An unusual subject was chosen by Mlle Juliette Manbret in 1883: "Plâtrière à Neuilly-sur-Seine; gravure sur bois" (no. 4792).

A particular interest in the condition of working women is suggested by those works with general titles such as "L'ouvrière". Mlle Watternau exhibited "Une ouvrière" in 1884 (S.I. no.37) and a work with the same title in 1886 (UFPS no. 318); "L'ouvrière parisienne" by Mlle L-A Landré appeared at the Salon of 1891 (no. 933); also in 1891, Mme Marie Cazin exhibited an "Ouvrière (étude à la fresque)" at the Société Nationale (no. 1016); an "Ouvrière fleuriste" by Harriet Campbell Foss appeared in 1892 (S.N. no.415); in 1893 Mlle L-A Landré exhibited "Le déjeuner de l'ouvrière" (no. 1022) and Mlle C.A. Lord sent "La gagneuse de pain" (no. 1150).

Section G - Still-life

Throughout the 19th century, portraiture, sketching from nature and
still-life painting were the main pursuits in accomplishment art because
they could be pursued without infringing the codes for proper female
behaviour. No estimate can ever be reached of the number of women who
practised these genres as amateurs. An idea of the extent of more pro-
fessional activity in these fields is given by an examination of exhibi-
tion catalogues.

A number of women artists were successful in flower and still-life
painting in the nineteenth century, but none achieved the renown of Anne
Vallayer-Coster who exhibited her last works in 1810 and 1817 (373). The
first name to emerge is that of Mme Elise Bruyère who exhibited works
between 1798 and 1844, mostly flower paintings but occasionally portraits
and works on classical and domestic themes. A pupil of her father and of
Vandael, she was described as a worthy rival of the latter in 1819 (374) and
in 1827 won a second class medal at the Salon. Other female painters of
flowers and fruit during the first four decades were Mme Deharme, Mlle
Mélanie de Comoléra and Mlle Natalie D'Esménard, a pupil of Redouté, none
of whom were prolific. Among still-life painters Mlle Jenny Legrand who
exhibited between 1801 and 1839, stands out for her choice of the humblest
objects in her compositions; at least thirteen of her works portrayed
"ustensiles de ménage" (Q6). In the 1830s fame was acquired by Mme Camille
de Chantereine, a flower painter, and Mlle Elise Journet, who specialised
in still-life. Both were praised for the vigour of their technique. Mme
de Chantereine was, like Mlle D'Esménard, a pupil of Redouté whose flower
painting class was depicted by Mlle Ribault in 1831 in her "Cours de pein-
ture de M. Redouté dans la salle de Buffon, au Jardin des Plantes" (no.
1761). Mme de Chantereine exhibited between 1827 and 1844 and won a third
class medal in 1835 and a second class medal in 1840. In 1836 she started
a course of her own in flower painting at her home (375). A reviewer in
"L'Artiste" described her contribution to the Salon of 1836 as "un tableau
de fleurs d'une forme si belle et de si vives couleurs, qu'il est impossible
de mieux faire. Cette jeune femme possède un pinceau tout viril. Rien de
cherché, rien de niais; tout cela est ferme et net, et bien compris" (376).
Equally Mlle Elise Journet, a pupil of Gigoux, who exhibited not only
still-lives but also portraits and genre pictures between 1833 and 1845, was
praised for her vigorous and masculine execution. In reference to her
still-life at the Salon of 1837 a critic wrote: "Il y a dans sa manière
quelque chose de ferme et de mâle qu'on ne retrouve pas toujours dans la

peinture des femmes ... Il y avait longtemps que nous n'avions vue une "nature morte" aussi bien compris et aussi bien rendue. Sur une table, on voit un lièvre, une perdrix, un plat d'étain et une aiguière flamande. Chaque chose est traité avec le plus grand soin, reproduite avec la plus scrupuleuse vérité" (377). Again in 1842 the objects in a still-life by here were "rendus avec une vérité inouie dans un effect des plus vigour-eusement accentués" (378).

The number of still-lives exhibited by women between 1840 and 1850 increased considerably. I have counted nine at the Salon of 1831, 21 at that of 1840 and 58 at that of 1850. Mme Elise Bruyère, Mme de Chantereine and Mlle Elise Journet were still exhibiting. New names were Mlle Suzanne Béranger who later acquired fame as a painter on porcelain and Mme Rosine-Antoinette Delaporte, another pupil of Redouté. A branch of roses exhibited by her in 1846 drew high praise from a critic for its freshness: "A la bonne heure, voilà de vraies roses telles que le printemps les donne; elle ont fleuri, celles-là, dans quelque petit coin de jardin, loin, bien loin des serres, et Mme de La Porte, en les peignant, a trouvé de belles couleurs bien franches; nous l'en félicitons d'autant plus sincèrement que, depuis quelques années, on s'efforce de mettre les fleurs malades à la mode" (379). Mlle Henriette Longchamps exhibited flowers from 1841 and was awarded a third class medal in 1847 and a second class medal in 1848.

In 1851 the large number of female flower painters exhibiting at the Salon moved Albert de la Fizelière to generalize on the suitability of flowers as subjects from women artists and also on their excellence in the portrayal of these: "Ici la peinture a beau jeu pour plaire. Fleurs et fruits, écrin de la nature dont chaque forme est une poésie, dont chaque nuance est un attrait. Voilà, si je ne me trompe, le vrai, le seul genre qui convienne aux femmes. Là elles sont en famille; il n'est pas un trait, pas une fraîcheur, pas un tendre velouté qu'elles ne connaissent, qu'elles n'aient surpris quelque matin, au sortir du repos, dans leur miroir sincère, ou le soir dans le cristal limpide du bain discret qui coule sous les mystérieux ombrages. Et puis cette peinture n'a que des joies et des illusions radieuses. Là point de drame qui souille l'âme ou émousse les fibres de la sensibilité. La vie y est jeune et poétique, la morte elle-même n'y a rien de terrible, à peine inspire-t-elle une mélancolie rêveuse qui n'est pas sans charme" (380). Flowers were suitable, then, because in the first place women led home-bound, idle existences and as a result were highly sensitive to slight variations and details in flowers. His second point is less acceptable in that it is based on a personal view of what

women should be: joyful, young and poetic. Flowers were all these and
lacked drama and strong emotion "qui souille l'âme ou émousse les fibres
de la sensibilité".

Mlle Virginie Hautier who exhibited flowers and still-lives from 1848
to 1863 and Mme Marie-Octavie Paignée who exhibited fourteen works, thirteen
of them flower paintings, between 1844 and 1855, were the most successful
female artists in these genres in the 1850s. In 1853 Mme Paignée, who
appeared in catalogues as Mme Sturel-Paignée, won a third class medal and
was given a place of some importance by a critic in "L'Artiste": "C'est
une chose à remarquer, que les peintres de l'école de Lyon, qui ont pris la
représentation des fleurs pour spécialité, négligent la nature et tombent
dans le métier tandis qu'une femme assez expérimentée jusqu'à ce jour, avec
des moyens beaucoup plus restreints, leur donne la vie et l'irradiation de
la nature. Je lui sais un gré infini d'avoir rendu les fleurs en personne
qui les aime et d'avoir évité les banalités niaises de trompe-l'oeil .."
(381). It will be recalled that in 1846 the flowers of Mme Delaporte were
praised for the same reason. In 1859 a Mlle Mélanie Paignée, perhaps the
daughter of the latter, was also set up as an example. Her flowers were
described as "délicates et vigoureuses merveilles qui pourraient servir de
leçons à nos meilleurs 'fleuristes' et à M. Saint-Jean plus qu'à tout
autre" (382).

In 1870, in which year 85 flower paintings and still-lives were
exhibited by women at the Salon, the critic Térigny wrote: "C'est surtout
dans la peinture des fleurs qu'on peut apprécier la révolution complète qui
s'opère dans l'éducation féminine en matière d'art. Mmes Escallier, Louise
Daru, Madeleine Lemaire et beaucoup d'autres peuvent être rapprochées, sans
trop de désavantage, de nos meilleurs peintres de fleurs, les Chabal-
Dussurgey, les Petit, les Kneyder, et leurs émules ..." (383).

Mme Eléonore Escallier was a pupil of Ziegler and exhibited 31 works,
mostly flowers, between 1857 and 1880. She won a medal at the Salon of
1868. A number of her exhibits were decorative panels. One, exhibited in
1875, was for "le palais de la Légion d'Honneur" and her contribution in
1880 was entitled "Art monumental. 'Le printemps', modèle exécuté en tap-
isserie de Beauvais pour le grand escalier du palais du Luxembourg". Also,
according to her obituary in 1888, "Mme Escallier s'était placée au premier
rang des peintres-décorateurs de la Manufacture nationale de Sèvres" (384).
In 1874 she was described as "un de nos trois ou quatre premiers peintres de
fleurs" (385) and in 1875 as "l'un des maîtres du genre" (386). Madeleine
Lemaire, a pupil of her aunt Mme Herbelin and of Chaplin, was an extremely
prolific artist who exhibited at the Salon from 1864. In 1877 she was

accorded an honorable mention. She was one of three female members
of the "Société d'Aquarellistes Français" between 1880 and 1900 (387), the
only female exhibitor at exhibitions of the "Société des Pastellistes"
(388) and in 1890 was a member of the "Société Nationale des Beaux-Arts"
(389). In 1900 she won a silver medal at the Exposition Universelle and
in 1906 was elected a member of the Légion d'Honneur. Although known as
"L'Impératrice des roses" (390) she was by no means a specialist in still-
lives. The majority of her works involved figures, albeit with flowers
Fig.93 as important accessories. It was for her painting of flowers, however,
that the artist received most praise.

Other successful female artists in thes genres during the last two
decades of the century were Mlle Blanche Pierson, Mme la comtesse de Nadaillac
Mme Léonie Barillot-Bonvalet, Mme Euphémie Muraton and Victoria Dubourg.
The latter was the wife of Henri Fantin-Latour from 1878 and exhibited flower
and fruit compositions and portraits between 1869 and 1909. Mme Muraton won
a third class medal in 1880 and a bronze medal in 1889 at the Exposition
Universelle. Mlle Barillot's "Chrysanthèmes"at the Salon of 1879 inspired
one critic to remark on the general progress of women artists: "Elles
luttent, non plus en amateurs mais en artistes véritables, et pour peu
qu'elles continuent elles donneront du fil à retordre au sexe fort. Mlle
Léonie Barillot est de celles dont la belle manière de peindre, le faire
large et souple imposent l'éloge sans que la courtoisie s'en mêle" (391).
Madame la comtesse de Nadaillac's "Mou de veau" and "Crabes", also of 1879
were described as "des tours de force et d'adresse. Je ne crois pas qu'on
puisse aller plus loin dans la représentation de la nature, avec les moyens
restreints dont dispose l'aquarelle" (392).

Section H - Landscape

Where the exhibition of landscapes and views by women is concerned,
the peak period in the 19th century was from ca.1830 to ca.1840. Very
few were exhibited before 1830. In 1831 49 appeared at the Salon and in
1840, 33. In 1850 and 1861 the numbers reduced again to 13 and 14 respec-
tively and then from 1870 when 46 were exhibited, they gradually increased,
as did all genres towards the end of the century.

The three main exhibitors of landscapes before 1830 were Claire
Robineau, a pupil of Regnault, who exhibited between 1804 and 1824, Mme
Clerget-Melling who exhibited over 30 landscapes between 1814 and 1841 and
most important Mlle Sarrazin de Belmont. The latter was a pupil of
Fig.94 Valenciennes and exhibited 77 works, all but three of them landscapes,
between 1812 and 1868.

In the 1830s two of these artists achieved recognition. Mme Clerget-
Melling was awarded a second class medal in 1831 and so too was Mlle
Sarrazin de Belmont. In 1834 the latter won a first class medal. In 1833
the critic A. Jal wrote: "Beaucoup de femmes s'adonnent au paysage;
quelques-unes y réussissent, comme mesdames de Vins-Peysac, Sarrazin de
Belmont et Clerget-Melling; d'autres cherchent encore et réussiront,
comme Madame Empis .." (393). Mme la Marquise de Vins-Peysac exhibited
thirteen landscapes between 1833 and 1838. Mme Empis exhibited 56 works,
most of them landscapes between 1831 and 1875 and she also won a second
class medal in 1831. Unlike the majority of female landscape painters,
she and Mlle Sarrazin de Belmont also attempted historical landscapes (394).
Four other names emerge in the 1830s. Like Mme Empis, Mme Laure Colombat
de l'Isère was a pupil of Watelet and exhibited views at the Salon from
1835. Mlle Eulalie Caillet exhibited 24 works, all views and marines between
1831 and 1837 and won a third class medal in 1836. In an imaginary conver-
sation construed by A. Jal in 1833, M.D. mentions Mlle Caillet together
with Mme de Stael, Mme Tastu, the poet and Mlle Hortense Allart in justi-
fication of his statement that "la force ne manque pas aux femmes" (395).
In 1837 when she exhibited marines and landscapes a critic in "L'Artiste"
wrote: "C'est un talent vraiment masculin dont la touche est ferme et
peut-être trop sure d'elle-même" (396). Mme Fort-Siméon, née Elisabeth
Collin, a pupil of M. Rémond, sent 52 works, mostly landscapes, to the
Salon between 1835 and 1865 and in 1845 was described as "à la tête des
femmes qui peignent le paysage" (397). Finally, Mme Langrand, née Adèle
Michel, exhibited 29 works, 26 of them views, between 1836 and 1850 and
won a third class medal in 1843.

As has been said before the work of Berthe Morisot will be examined
in detail later. She and her sister Edma exhbited mostly landscapes in

the 1860s and their works reveal the influence of Corot who taught them from 1862. From the early 1870s Berthe Morisot appears to have lost interest in what she once referred to as "le paysage tout nu" (398) and from then on introduced figures more frequently into her landscapes. One of the most interesting criticisms of her work is relevant here. In his "Propos de Peintre" of 1921 Jacques-Emile Blanche suggests that her choice of landscape motifs may have had some influence on the other Impressionists: "Je croirais qu'elle suggéra peut-être à Claude Monet et à Sisley qu'un paysage parisien ou des environs de Paris, un jardin, un pont de chemin de fer, des coquelicots dans l'avoine pâle de Seine-et-Oise, étaient des motifs picturaux et il semble qu'elle aît parfois prêté ses modèles, pour les figurines à chapeaux de paille et à jupes claires, qui remplacent enfin les paysans, les bucheronnes, dans le paysage 'impressioniste'" (399).

Most female landscape painters during the last quarter of the century included figures in their compositions. The most successful were the Belgian, Marie Collart, who exhibited rural scenes, mostly with figures, but some pure landscapes, from 1865; Marie Cazin, a pupil of Mme Peyrol-Bonheur and her husband Michel Cazin, who was also a mainly figurative artist and exhibited from 1876; Anna Boch, another Belgian, who exhibited landscapes in the Impressionist style in Paris from 1875 and finally Georgette Agutte who exhibited from 1887 and later claimed membership of the Fauves group. Strictly speaking, Lucie Cousturier is outside our period. She was a pupil of Paul Signac in 1898 and exhibited at the Salon des Indépendants from 1901.

Conclusion

Between 1800 and 1848, love (in classical, literary and domestic
works) and grief (in classical, literary, domestic works and those based
on working class life) were the main themes in women's art. In the 1840s
there was an extraordinary crystallization of mood, particularly evident
in the theme of persecution in classical works, sadness in literary works,
in the focus on love, religion and grief as the principal constituents of
female life in domestic genre and in works generalizing on the condition
of the working class. In "De l'Allemagne" Mme de Stael had written: "La
Nature et la société donnent aux femmes une grande habitude de souffrir"
(400) and in 1835 Victor Hugo tried to epitomize all women in "deux graves
et douloureuses figures" (401). These literary views are strongly corro-
borated in women's art during the first half of the century.

In the prosperous Second Empire, a period which Hippolyte Taine
characterized as a superficial, apolitical period of frivolous pleasure
(402) few strong emphases emerge. Women, however, remained the main sub-
jects. Significantly perhaps, there was a rapid increase in still-lives at
the Salons (403) and also of mood pictures (Rêverie) often poeticized by
quotations from literature.

During the last three decades two main themes emerge. Firstly
social realism, evident in works illustrating aspects of working class life;
secondly and in strong contrast to the latter, as if a counterbalance was
needed, the theme of powerful female figures. The most extreme instances
of these are among classical works for which mythology and allegory provided
many of the images. In portraiture, important women of the day, many of
them artists, were frequently represented and in domestic genre, the wise
old woman, the "aïeule", became a popular figure. Many works were general-
izations on certain types of woman - the woman worker and the woman artist,
for example - and many with female figures personified moods. As we have
said before, it would seen appropriate to see these not merely as objective
symbols, but also, in view of the sex of the artists, as images rendered
with sympathy for their relevance at a time when women were finally winning
some rights and emerging in all walks of life.

CHAPTER FIVE - BIOGRAPHIES

1. MARGARET SARAH GEDDES(MRS WILLIAM CARPENTER) (Fig.95)

Margaret Sarah Geddes was born in 1793, the second of six children
of Captain Alexander Geddes. The latter came from an Edinburgh family
and was cousin to Andrew Geddes, an important figure in Scottish art at
the beginning of the nineteenth century. From the late 1790s Alexander
Geddes and his wife Harriet leased a farm on the edge of Lord Radnor's
Estate near Shute End where they stayed for forty years. It was there
that their children were born.

In early youth Margaret Sarah received instruction in figure draw-
ing and painting from a master at Salisbury. Lord Radnor gave her per-
mission to copy in his gallery at Longford Castle and on his advice she
sent pictures for three successive years to the Society of Arts, on each
occasion receiving an acknowledgement of her talent. For a study of a
boy's head, subsequently purchased by the Marquis of Strafford, she was
awarded a gold medal. In 1814 she acted on further advice of Lord Radnor
and went to London where, in the same year, she exhibited a portrait at
the Royal Academy and two genre pictures at the British Institution.
This pattern remained constant until 1830. She sent portraits to the
Royal Academy and genre pictures and landscapes to the British Institu-
tion, the nature of her gift becoming apparent as the yearly output of
portraits increased.

Of the 41 portraits exhibited between 1814 and 1830, 17 were of men,
23 of women, two of the latter portraying mothers and children, and one
of children on their own. Of the genre pictures exhibited over the same
period there is little to be said apart from remarking that they were
mostly anonymous portraits of types of people, such as fortune-tellers,
peasants, spinners, gleaners and children. Two of her exhibits at the
British Institution, which did not accept portraits, have identifiable
sitters: "Devotion" (1822 no. 199) (Fig.96) is a life-sized portrait of
Anthony Stewart, the miniature painter and "The Children in the Wood"
(1828 no. 183) is almost certainly the work now known as a "Portrait of
the artist's daughters" (1) (Fig. 97) , Even the few works with classical
or literary titles at the British Institution do not suggest much narrative
content. "Ariadne" (1820 no.279), "Head of a Bacchante" (1824 no.45) and
"Psittica" (1828 no.142) may well have been disguised portraits, as may
"Cheerfulness" (1823 no.186) with a quotation from Collins. The artist
comes closest to a subject picture in "Cupid" of 1824 with four lines from
Michael Drayton (2).

In 1817 she married William Hookham Carpenter, the son of James
Carpenter, a prosperous book-seller in Old Bond Street and publisher also
of books and engravings. William was in the same trade until 1845 when
he became Keeper of Prints and Drawings in the British Museum. Mrs
Carpenter's children were born in close succession: William Junior in
1818, Percy in 1820, Henrietta and Mary, twins, in 1822 and Jane around
1824. The three artists of the family, William, Percy and Henrietta,
received their initial training from their mother.

Between 1831 and 1836, over which period she was also represented
at the Society of British Artists, Mrs Carpenter exhibited 18 female por-
traits, including three of mothers and children and nine portraits of
men at the Royal Academy. During these years her talent gradually became
recognized. As we have seen she was often praised for the naturalness
and life-like qualities in her portraits and those of women were some-
times nominated the best in the exhibition (3). In 1833 engravings after
her works appeared in Burke's "Gallery of Distinguished Females" (4). But
it was in reference to two male portraits that highest tribute was paid.
Van Dyck was evoked by critics describing her portraits of J.P. Ord, Esq.
(RA 1831 no. 157) and Spencer Smith Esq., (SBA 1833 no.211) (5). Her most
celebrated exhibit of the decade was also a male portrait - of the late
R.P. Bonington (S B A 1833/4 no.68) (Fig.29) which was considered an
excellent likeness (6). Anonymous children were favourite subjects, "The
Spring Nosegay" being a charming example of this type of work (Fig.98) ,
Her only portrait of a named child was "Master Brownlow Bertie Mathew"
(RA 1832 no.458) (7).

Mrs Carpenter's fame was at its peak between 1837 and 1853. She
exhibited 37 female portraits and 17 male portraits during these years. Her
portrait of Lady Slade at the Royal Academy in 1837 (no.17) was described
as superior to Sir Martin Shee's whole length portrait of the Queen and
evidence of Mrs Carpenter's rights to Academic honours. Again Van Dyck
was mentioned as the only suitable comparison (8). Her female portraits
continued to "bear the bell" at exhibitions, an example being her portrait
of the Hon. Mrs Henry Marshall (RA 1841 no.385) (Fig.99) and the same tri-
bute was also paid to one male portrait, of Mr Thomas Chapman (RA 1844 no.
288) (9). Her portrait of Patrick Fraser Tytler, the historian, (RA 1845
no. 79) is possibly her best known work form this period (10). The reasons
for this acclamation were various. Her technical prowess and in particular
the "vigour" of her execution were often admired (11) and so too was her
portrayal of unaffected female beauty (12). But her main quality was per-
haps the simplicity of her portraiture. As has already been seen the lack

of "those extraneous 'aids' which are so frequently considered advan-
tageous to a picture" was a strong point in the favour of her portrait of
Lady Mordaunt in 1839 (13); in 1840 her "Portrait of a lady" (RA no.4)
was designated "the perfection of simple portraiture" (14) and a subject
picture, "Portia" (RA 1848 no. 1054) was similarly praised, relying as
it did for its effect "on its own integrity of form and colour,
unassisted by background and accessory" (15).

One other important reason for the artist's renown was her skill in
the representation of children and maternities. 27 exhibited works over
this period depicted children or mothers and children, nine of these being
named portraits. "First Love" (BI 1842 no.25), of a young child nursing
her doll, and "A Fairy Tale" (BI 1842 no.131) of a mother reading to a child,
received superlative praise, the former giving rise to the remark: "How
very few of our British painters are there who can surpass this work in
any one of its qualities; indeed, in the whole range of modern Art we
could scarcely name one who, in this style, could go beyond it" (16). A
critic wrote of her portraits of the Lady of Colonel Michael and children
(RA 1844 no.56): "Mrs William Carpenter expresses the charm of infancy and
maternal delight so sweetly, that her portraits of ... are interesting
independently of the resemblances" (17). Of a portrait of Mrs Frewin and
her infant son (RA 1853 no.154) it was written that "the relation between
the mother and child is very felicitously established" and the same critic
considered the work to be the best she had ever exhibited (18). In 1847
children were the subjects of two works shown at the British Institution:
"Ah! may'st thou ever be what now thou art,/ Nor unbeseem the promise of
thy spring" (no.40) and "Playmates" (no. 205). The following review
appeared in the "Athenaeum": "It may with justice be affirmed, that she
is one of the few, of her sex the only one - who, in the representation of
infantine form and beauty, conveys it to the canvas with such an expression
of its pose and movement as reminds us of Reynolds. No one represents the
naiveté of childhood so well: as is evidenced in the latter of these sub-
jects - a child gambolling with his dog. It is a study full of playfulness
and spirit, expressed in a style vigorous yet refined" (19). One more
review, of many, should be given as evidence of her reputation in this
department: "There is no one who surpasses Mrs Carpenter in the delinea-
tion of juvenile form. Her children speak of an observation which has
watched their movements and entered into their feelings. She gives us none
of the attitudinizing which is characteristic of more mature age, when the
sitters desire to look their best, - but the unconscious, simple and candid
airs of unacted aspect: the children of George Smith Esq. (RA 1849 no.376)

excellently exemplify Mrs Carpenter's powers as well of observation as
of art" (20).

Between 1837 and 1853 Mrs Carpenter sent work to the Royal Academy
and the British Institution. From 1854 to 1866 she exhibited at the Royal
Academy, in 1855 at the Exposition Universelle in Paris, and in 1858 and
1863 at the Society of Female Artists. During these last twelve years of
her exhibiting career, she was represented by almost equal numbers of male
and female portraits and children remained popular subjects. Her portrait
of John Gibson Esq. R.A., in the National Portrait Gallery, dates from
this period (RA 1857 no.537). Subject pictures constituted a small but not
unsuccessful minority, a work entitled "Absence" (RA 1855 no.448), "of a
single female figure, of which the features wear an air of grief" being
worthy of special note (21).

William Carpenter died in 1866 and his wife was then granted a
pension. She died in 1872.

Mrs Carpenter has been described as "one of the most distinguished
portrait painters of England" (22). Although she studied the work of
Thomas Lawrence and Sir Joshua Reynolds she was never considered an
imitator of either. I have found no instance of doubt shed on the origin-
ality of her work and no denial of her claim to fame. In her day her
renown was considerable and as has already been shown, she was the main
argument advanced in favour of the admission of women as members of the
Royal Academy; the injustice of her exclusion was constantly pointed out
(23). After her death, however, she was forgotten. It is perhaps worth
mentioning that those works by which she is chiefly known - the twenty
Eton leaving portraits and her four portraits at the National Portrait
Gallery - are all of men. Her works have been valued for their photographic
value - as records of the famous. But the majority of Mrs Carpenter's
243 exhibited works portrayed women and children and it was in these that
she achieved most contemporary success.

2. THE MISSES SHARPE (Fig.100)

Charlotte, Eliza, Louisa and Mary Ann Sharpe were the four
daughters of William Sharpe, a Birmingham engraver. Nothing is known of
their childhood but they presumably received some if not all of their
instruction in art from their father. In 1816 William Sharpe moved his
whole family to London where they lived at 13 King Street, Covent Garden.
They were among the 71 students who studied at the British Institution in
1818 (24). According to E.C. Clayton, the Duke of York was their first
patron (25). They all began as miniature painters.

CHARLOTTE B. SHARPE (MRS BEST MORRIS)

The eldest of the four daughters, she exhibited seven portraits, of
men and women, at the Royal Academy, between 1817 and 1820. In 1821 she
married a Captain Morris and is said to have then given up painting for a
while until domestic troubles forced her to resume work for the support of
her family. As Mrs Best Morris, described in the catalogues as an Honorary
Exhibitor, she then sent twelve more portraits to the Academy exhibitions,
including a portrait of her husband in 1823 and one of her deceased son,
J.B. Morris, in 1839. She died in 1849.

ELIZA SHARPE

The second of the daughters was born in August 1796. From 1817 to
1823 she exhibited 21 portraits at the Royal Academy, only three of these
being listed in the catalogues as portraits of specific subjects. Two por-
trayed mothers and children. She continued exhibiting at the Royal Academy
until 1829 but from 1824 varied her repertoire with literary works and
genre scenes. In 1829 she switched allegiance to the Old Water-colour
Society of which she became a member in the same year and exhibited her
first work in the style which was to make her popular: "The Unhoped for
Return" (no.346) (26). Between 1830 and 1832 she sent single works to the
Society's exhibitions, all three illustrating passages from poetry. The
most typical was "The Widow" in 1832 (27). In 1833 the artist was very
active. She exhibited five pictures at the Old Water-colour Society, three
of these on literary themes and two depicting domestic scenes. A "touching
passage" from "The Vicar of Wakefield" on the occasion of the father's
arrest (no. 115) was the only one which appealed to critics although this
same work was criticized for inappropriate expressions (28). In the same
year an exhibition of "Original Drawings and Sketches" at the Print Rooms
of Messrs Moon, Boys and Graves in Pall Mall included "a most exquisite

(copy) by Miss Sharpe, of Christ in the Temple by Rembrandt, in the
National Gallery" (29). Also in 1833, two engravings after her pictures
"Flora" and "Belinda" appeared in the "Keepsake" and Heath's "Book of
Beauty" respectively (30).

In 1834 Eliza's younger sister, Louisa, married and went to live
in Dresden. It is probable that the whole family accompanied her there
for a short while at least (31). It was on account of this, perhaps, that
Eliza Sharpe did not exhibit in 1834. The only sign of artistic activity
is an engraving, in the "Keepsake", of her picture "The Widowed Bride"
(Fig.101) which illustrated an extremely moving scene from a tale by
Sheridan Knowles: a young widow resolves to remain true to her dead hus-
band by taking the veil rather than marry a prince (32). In 1835 she again
sent work to the Old Water-colour Society. "The Phrenologist" (no. 308)
was bought by the King of Prussia and both this work and "The Dying Sister"
(no. 322) - another typically emotional domestic scene - were engraved (33).
Also in 1835 an engraving of her picture, "The Love Quarrel" appeared in
the "Keepsake" (34).

Between 1836 and 1839 Eliza Sharpe attempted to raise her style at
the Old Water-colour Society. She tried her hand at classical subjects -
notably scenes from the Bible: "Ruth and Naomi" in 1836 (no. 178), "The
Flight of Lot and his Daughters" and "Christ and the Mother of Zebedee's
children" in 1838 (nos. 68 and 94) and "Christ Raising the Widow's Son" in
1839 (no. 241). But she received such adverse criticisms, such condescend-
ing descriptions of her limited powers that from 1839 she abandonned such
themes and reverted only occasionally, with "The Ten Virgins" in 1847 (no.
157), "Charity" in 1851 (no.318) and "Hebe" in 1859 (no.111) (35). She
also started exhibiting at the Royal Academy again and was represented by
three portraits in 1838.

1840 was a lean year where production was concerned, a fact which may
have had something to do with the critical reception of her works on
Biblical themes. An engraving of a picture called "The Somnambulist"
appeared in the "Keepsake" - the last time her work was included in the
Annuals of the period (36). From 1841 until her death she continued
occasionally to exhibit portraits at the Royal Academy. At the Old Water-
colour Society she went back to literary and domestic themes, her "Little
Dunce" of 1843 (no.110) (Fig. 102) being the only work from this period of
which an illustration exists. She painted scenes from Shakespeare,
Dickens, Scott, Tennyson and Spenser. In three works poetry was used
to amplify the subject of her pictures: "Childhood" of 1845 (no.328),
"Prayer" of 1849 (no. 363) and "The path of sorrow" of 1854 (no. 271) (37).

In the category of domestic genre the artist concentrated on themes such as solitude, love, motherhood and death - subjects like "The Soldier's Widow opening for the first time the wardrobe of her late husband" of 1853 (no.53) and "A Bride taking leave of her widowed sister" of 1867 (no. 196) recalling works which had proved so popular in the 1830s. But the artist did not regain favour. The "Little Dunce" of 1843 was said to be "calculated seriously to disappoint those who have admired her talent, and hoped for its progress. Prettiness of feature, and humour of expression, but imperfectly compensate for want of clearness in telling the story, for a glossy meretriciousness of colour, and least of all, for more than negligent drawing" (38). These criticisms occurred again and again in reference to her works (39). From 1862 she sent far more sketches and studies than finished pictures to the Old Water-colour Society's exhibitions and from 1868 she resorted to copying to earn her living. She was employed as a copyist in the South Kensington Museum and executed several copies of works from the Vernon and other collections for the "Art Journal" (40). She exhibited five copies at the Society of Female Artists to whose exhibitions she sent work from 1860. Her last works were a set of copies of Raphael's cartoons.

Catalogues of the Society of Female Artists' exhibitions are the main source of information as to the prices paid for her works. Among original pictures she asked most for "Christ Raising the Widow's Son" (1861 no.214) which was almost certainly the same work as that exhibited at the Old Water-colour Society in 1839. This was priced at £84. Other original subject pictures commanded far less, prices ranging from five guineas each for a pair entitled "The Astronomer and the Philosopher" (1860 no. 272) to £26 5s. for "Praise" (1860 no.139). The highest price asked for a copy was £105 for Maclise's Play Scene in "Hamlet" (1868 no.308). This is perhaps an appropriate place to introduce a humorous drawing by the artist, entitled "Miss Eliza Sharpe presented with a very long bill by a remorseless creditor" (Fig.103).

Eliza Sharpe resigned her membership of the Old Water-colour Society in 1872 but continued to exhibit at the Society of Female Artists. Her last exhibited works were two original pictures shown at the Society's exhibition in 1874. She died on June 11th 1874 at her nephew's house in Burnham, Maidenhe

Clayton described Eliza Sharpe as "a woman of unusually original and marked character - tenderhearted and pitiful, though plain-spoken, and full of stern contempt for meanness, of generous anger against evil-doers. Many instances of her enthusiastic benevolence are still remembered in the family" (41).

LOUISA SHARPE (MRS WOLDEMAR SEYFFARTH)

Born in 1798, Miss Louisa Sharpe exhibited 26 portraits at the Royal Academy exhibitions between 1817 and 1829. One of these, exhibited in 1824, was of her sister Charlotte: "Mrs T.B. Morris, her son and deceased infant daughter" (no. 598). She also exhibited three subject pictures: "A mother and dead child" in 1818 with a quotation from Darwin (no. 830), "Titania and the Indian Boy" in 1827 (no.835) and "And the world's so rich in resplendent eyes, etc." in 1828 (no. 923). Like her sister Eliza, in 1829 she abandonned the Royal Academy and became a member of the Old Water-colour Society to whose exhibition that year she sent two works: "Juliet" from Shakespeare (no. 365) and "The Wedding" (no.358). Also in 1829 an engraving after a picture called "Ellen Strathallen" appeared in the "Forget-me-not" (42).

Like Eliza she specialized in scenes from literature and domestic themes and like Eliza also, she favoured female subjects in emotional situations, but unlike the former she never attempted classical subjects. Her reputation dates from 1830 when she exhibited a "Scene in the Vicar of Wakefield" (no.211), a "Girl with a Guitar" (no. 127) and a "Girl with a letter" (no. 225). The latter was described as "admirable throughout - the figure for its expression, the whole for its arrangement of colour. It is full of sentiment, yet devoid of sentimentality, free and masterly" (43). In 1831 she exhibited four works at the Old Water-colour Society. Two of these (nos. 181 and 279) portrayed Scott's heroines. "The Arrival of the New Governess" (no. 149) was acclaimed by the "Athenaeum" and the "Spectator" and was described at length in the latter paper who labelled it "much the best picture of its class in the exhibition"; "her colouring is fresh and brilliant, her style tasteful and natural, and she evinces both feeling and understanding" (44). Her fourth exhibit bore as its title a quotation from Lord Byron's "Giaour" (45) and a description of one of Louisa Sharpe's pictures by Mrs Jameson in her "Visits and Sketches at Home and Abroad" may well apply to this work. Mrs Jameson thought the idea for the work was the artist's own. It portrayed a "young, forsaken, disconsolate, repentant mother, who sits drooping over her child, 'with looks bowed down in penetrative shame', while one or two of the rigidly-righteous of her own sex turn from her with a scornful and upbraiding air - I believe the subject is original; but it is obviously one which never could have occurred, except to the most consciously pure as well as the gentlest and kindest heart in the world. Never was a more beautiful and Christian lesson conveyed by woman to woman: at once a warning to our weakness, and a rebuke to our

pride" (46). These last two pictures both suggest a moral intention. In the first the artist enlists the spectator's sympathy for the poor and lonely governess and in the second for an unmarried mother.

In 1831 and 1832 several of her works were engraved to serve as illustrations in the Annuals of the period. "The Wedding" (Fig.104) which was engraved for the "Keepsake" to illustrate a tale by the Honourable Charles Phipps, is an example of the type of picture she was to specialize in: elaborate compositions with numerous figures and great attention to detail (47). Most typical, perhaps, on account of the inclusion of a dramatic element, is her illustration of a story published in the "Spectator" and exhibited at the Old Water-colour Society in 1832 (48). Her main exhibit in 1833, also based on a story form the "Spectator", was another work singled out for praise by Mrs Jameson as evidence of the "high tone of moral as well as poetical feeling" in the artist's work. "Her picture of the young girl coming out of church after disturbing the equanimity of a whole congregation by her fine lady airs and her silk attire, is a charming and most graceful satire on the foibles of her sex" (49). In 1833 and 1834 six of the artist's works were engraved for Heath's "Book of Beauty" and one, in 1833, for the "Keepsake " (50). The latter, entitled "The Unlooked-for Return" (Fig.105) offers the most interesting subject. It portrays an emotional domestic scene in which the returning officer, presumed dead, surprises his wife and three children, who, with an elderly couple, perhaps the grandparents of the children, have been reading around a table. The drama of the scene is enhanced by the glimpse of a stormy moonlit night outside.

In 1834 Louisa Sharpe married Professor Woldemar Seyffarth and went to live in Dresden. Although resident abroad, Mrs Seyffarth continued to send work to the Old Water-colour Society and engravings of her work appeared in Annuals until 1839 (51). Dramatic, often amusing incidents from literature furnished much of her subject-matter, the most striking instances being "An Evening in Miss Stewart's Apartments" of 1837 (no.191), "The Tourney" of 1838 (no. 99), "Will Honeycomb's Dream" and "William and Betty" of 1840 (nos. 209 and 270) and "The Glove" of 1841 (no. 199) (52). Another major theme in her work is death and in particular widowhood. Some of her paintings on this subject, such as "Two sisters contemplating the Portrait of their deceased mother" of 1832 (no. 272) and "The Soldier's Widow" of 1837 (no. 209), are scenes from real life, and some, such as "The New Page" of 1838 (no. 152), are based on literature (53). But the moral tone remarked upon by Mrs Jameson is most apparent in two works on the theme of marriage. In "The Good Offer" of 1835 (no. 241) there is implicit criticism of an angry mother who scolds her daughter for not marrying for money; in "The

Wedding" of 1842 (no.216) with a quotation from the ballad "Oh; ye shall walk in silk attire" the criticism is far more harsh for here we see a marriage bargain completed - a young girl actually married to a rich old man (54).

Mrs Seyffarth died in Dresden on January 28th, 1843, leaving a daughter, Agnes, who was also an artist and who exhibited occasionally between 1850 and 1859.

MARY ANN SHARPE

The youngest of the four sisters was born in August 1802. Between 1819 and 1827 she exhibited portraits (mainly) at the Royal Academy and copies at the Society of British Artists. In 1830 she became an Honorary Member of the Society of British Artists and thereafter painted subjects as well. Unlike her sisters, Eliza and Louisa, Mary Ann was only temporarily influenced by the vogue for literary subjects in the 1830s: she depicted a scene from Scott in 1835 (SBA no.747) and one from Shakespeare in 1838 (RA no.713). In the main her subjects were unambitious and bore titles such as "Expectation" (RA 1840 no. 529) and "Reading the News" (SBA 1856 no.640). An illustration exists of only one of her works and it is possible that this is the "Girl Sketching" exhibited at the Society of British Artists in 1830 (no. 721) (Fig. 35). She was also the only one of the sisters to execute still-lives, which she sent to the Society of British Artists from 1844. In the 1850s she exhibited portraits regualrly again, two of these being portraits of her sister Louisa's daughter, Agnes Seyffarth (RA 1852 no. 773 and SBA 1856 no. 638). Like her sister Eliza, Mary Ann also exhibited copies at the Society of Female Artists in the 1860s.

Clayton wrote: "Mary Ann Sharpe was a gentle, refined, retiring lady, beloved by all who knew her, talented and industrious. She died, 1867, of the same painful disorder that had carried off her sister Louisa" (55).

In 1834 Mrs Jameson wrote of the three youngest Sharpe's who were in Dresden at the same time as herself: "These three sisters, all so talented and so inseparable, - all artists, and bound together in affectionate communion of hearts and interests, reminded me of the Sofonisba and her sisters" (56). This was after the marriage of Charlotte and presumably shortly before or after Louisa's marriage to Dr. Woldemar Seyffarth. Thereafter Eliza and Mary Ann lived together in the North of London.

The most successful and prolific of the four were Eliza and Louisa. Not only were their subjects similar, but also their technique. As the

colouring in their works was always a matter for congratulation, so was
their finish criticized for being "too china-like": "Mrs Seyffarth and
Miss Sharpe skilfully blend opaque and transparent colours, but use gum
to deepen the shadows too freely. The result is an enamel-like brilli-
ancy and vitreous hardness, only fit for ornamental purposes" (57).
As subjects they both favoured female figures particularly in emotional
situations and these were based on real life and on literature. Atti-
tudes to their subject matter varied. One critic wrote that they delighted
too much in "drawing rooms and artificial manners" (58). For Mrs Jameson,
however, they supplied the main evidence for her argument that women's
art has different but not inferior qualities to that of men: "You must
change the physical organization of the race of women before we produce a
Rubens or a Michael Angelo. Then, on the other hand, I fancy, no man
could paint like Louisa Sharpe, any more than write like Mrs Hemans.
Louisa Sharpe, and her sister, are, in painting, just what Mrs Hemans is
in poetry; we see in their works the same characteristics - no feebleness,
no littleness of design or manner, nothing vapid, trivial, or affected
- and nothing masculine; all is supereminently, essentially feminine,
in subject, style, and sentiment." (59).

3. MARGARET GILLIES

Margaret Gillies was born on August 7th, 1803, in London. She was
the third daughter of a Scotsman, William Gillies, who was the brother of
two illustrious men: Lord Gillies, a Judge of the Court of Session in
Scotland and John Gillies LLD, an historian and scholar. Her father's
family came from Brechin in Forfarshire and her mother's from Gloucester-
shire. At the time of her birth her father was a successful merchant in
London.

When Margaret was three she accompanied her mother to Lisbon as the
latter's health required a warmer climate. When she was eight her mother
died and she and her sister Mary were sent with a governess to Brechin.
Then, her father having lost a lot of money, the sisters were adopted by
their uncle, the Judge, and came to live in Edinburgh. Margaret received
a year's schooling in Doncaster and paid occasional visits to her father
in London. With these exceptions she lived and grew up in Edinburgh.
At social gatherings there she is said to have met Sir Walter Scott and
Lord Jeffrey among others. "But amidst the charms of literary society, a
passion for art, which she had acquired without any regular training, grew
up within her, and proved too strong to resist. When still under age, she
resolved to make art her profession, and so was allowed to travel south
again and try her fortune in London with the pencil, in company with an
elder sister, who had in like manner devoted herself to the pen" (60). By
this time her father had remarried and her eldest sister had also married
and gone to live in India.

In London she maintained herself by executing portrait miniatures .
She obtained good introductions and never lacked for sitters. According
to her obituary in "The Times": "When she undertook her first miniature
she had to take a lesson in the art before each sitting in order to enable
her to achieve the task" and "thus had to get her training as she went
along, learning and working at one and the same time" (61). Around 1820
she received some instruction from Frederick Cruikshank. Gillies first
exhibited at the Royal Academy in 1832 and for the first five years she
sent only portraits.

In the early 1830s she and her sister Mary, a writer, became
associated with the intellectual and literary group surrounding the
Unitarian W.J. Fox who took over the "Monthly Repository" in 1831. Other
members of the group were Sarah Flower Adams, a poet, and her sister,
Eliza Flower, a composer; John Stuart Mill who at that time was interested
in Saint-Simonist views on women; Harriet Taylor who around 1831 wrote

and spoke passionately against marriage; Harriet Martineau who con-
tributed to the "Monthly Repository" and was the first female journalist
writing frankly for her living under her own name, and Robert Browning.
The "Monthly Repository" had a distinct feminist bias. W.J. Fox and W.B.
Adams, the husband of Sarah Flower, wrote extensively on the subject and
their writings were strongly influenced by Harriet Taylor. Gillies por-
trayed three members of this group. There is an undated drawing of
Sarah Flower Adams by the artist (62). In 1832 she executed her first
portrait of Harriet Martineau (Fig.106). Others followed but none of them
pleased the subject, as emerges from a passage in her autobiography:
" .. I must say that I have been not very well used in this matter of por-
traits. It signifies little now that Mr Richmond's admirable portrait and
the engraving from it exist to show what I really look like: but before
that, my family were rather disturbed at the 'atrocities' issued, without
warrant, as likenesses of me; and especially by Miss Gillies, who
covered the land for a course of years with supposed likenesses of me, in
which there was (as introduced strangers always exclaimed) 'not the remot-
est resemblance'. I sat to Miss Gillies for (I think) a miniature, at her
own request, in 1832; and from a short time after that, she never saw me
again. Yet she continued, almost every year, to put out new portraits of
me, - each bigger, more vulgar and more monstrous than the last, till some
of my relatives, having seen those of the 'People's Journal', and the 'New
Spirit of the Age' wrote to me to ask whether the process could not be put
a stop to, as certainly no person had any business to issue so-called
portraits, without the sanction of myself or my family, and without even
applying to see me after the lapse of a dozen years" (63). In 1833
Gillies exhibited a portrait of W.J. Fox at the Royal Academy (no. 787)
and in 1836 executed a drawing of the same (64). Other notable sitters
were the physician Dr Southwood Smith (RA 1835 no. 725) and Richard Hengist
Horne (RA 1837 no. 794) (65). W.J. Linton's "Memories" provide a glimpse
of her in 1837 at the house of Thomas Wade, a poet who contributed to the
"Monthly Repository": "On Sunday evenings he gave receptions ... where I
would meet Horne, Douglas Jerrold, W.J. Fox .. , Dr Southwood Smith ..,
Margaret Gillies (the miniature painter), and her sister Mary (a writer
of the Mary Howitt class, and a most amiable woman), and others " (66).
The Gillies sisters moved in select and intellectual circles and many of
the artist's portraits were of people with whom she was socially
acquainted.

By the end of 1837 Gillies had exhibted 17 portraits at the Royal
Academy and two at the Society of British Artists. She had already

achieved a certain notoriety, for in Leigh Hunt's "Blue-Stocking Revels
or the Feast of the Violets" published in the "Monthly Repository" in
July she was mentioned among many other women artists and notables (67).
In 1837 she exhibited her first subject picture at the Royal Academy,
"The captive daugther of Zion" (no. 914) and in the following year she
sent a series of sketches of "The daughter of Zion" to the Society of
British Artists (no. 150). The latter were described in the "Spectator"
as a "series of highly wrought miniatures" in which "the pathos is marred
by an exaggerated theatrical expression" (68). It was in 1838 that Gillies
wrote to Leigh Hunt - in response presumably to a request for a portrait
- giving her prices for miniatures which were "from ten guineas to twenty
according chiefly to the size" and agreeing to execute one immediately
for a locket. She also offered Hunt her "best thanks for the kind inter-
est that you and Mrs Hunt have taken in me". The request which followed
has already been mentioned: she asked if she might paint a portrait of
Hunt which she hoped he would accept as a gift, her reason being that
she preferred portraying genius rather than "the nobility of wealth and
rank". Her ideals of portraiture were high. By painting portraits of
gifted people she hoped to achieve a moral purpose: to set forth the
intrinsic nature of genius, which labours "to call out what is most beau-
tiful and refined in our nature", as the "guide and standard of human
action" (69). In another letter to Hunt, dated March 7th, 1839, she
wrote: "I am working day and night for the approaching Exhibition and
striving very hard for success in my way" (70). She exhibited six por-
traits at the Royal Academy in 1839, including the portrait, which she had
been permitted to paint, of Leigh Hunt (no. 947) (71). The "Art Union"
published praise: "The lady will hold place among the most successful
exhibitors in the gallery. Her touch is free and firm; she designs with
masculine boldness, and finishes with feminine delicacy. She knows her
art well; and though she draws upon imagination, she does not sacrifice
truth" (72). In the same year she exhibited three works at the Society of
British Artists: a portrait of Miss Myra Drummond who was most probably
the artist who exhibited in London between 1832 and 1849 (73), yet another
"Captive daughter of Zion" (no. 524) and "Lady Macbeth reading the letter"
(no. 149) which was her first literary subject.

In October, 1839, Gillies went to stay with William and Mary Words-
worth at Rydal Mount for the purpose of painting the poet's portrait.
There is some doubt as to who approached who as Gillies claimed that she
was invited while Wordsworth wrote to Susanna Wordsworth that she came down

from London "on purpose at her own earnest request communicated to me by a common friend" (74). She stayed over a month and painted not only William Wordsworth but also Mary and their daughter Dora. Her first miniature was of Wordsworth alone. It was a romantic composition representing the poet against an elaborate background with a view through a window of the lake and mountains. The work was finished by November 1st. "It is thought she has succeeded admirably" wrote Wordsworth and Dora described it as "decidedly the best likeness that had ever been taken" (75). This is thought to be the portrait celebrated in a poem by Thomas Powell (76). It is the most famous of her portraits of the poet and an engraving after it, by Edward McInnes, was published in 1841 and again in 1853 (77). Her next portrait, of Mary Wordsworth writing, was also a success. Dora described it as "perfect" and Wordsworth reported that everyone considered it an excellent likeness (78). Her third work was a combination of the two miniatures mentioned above and of this the artist made two replicas for members of the Wordsworth family, suggesting that this also was well appreciated (79) (Fig. 107). Her miniature of Dora was not as good in Wordsworth's opinion, but this was probably due to an absence of flattery. In any event, when on a visit to London, possibly in August, 1841, Dora sat again for Miss Gillies "to have my nose reduced a little which she has done without at all injuring the original effect of the drawing" (80). Gillies' third portrait of Wordsworth himself presented him in profile, the figure wrapped in a dark cloak, against a simple dark background (81). This was the poet's favourite. He wrote to Thomas Powell: "I think you will be delighted with a profile Picture on ivory of me, with which Miss Gillies is at this moment engaged. Mrs Wordsworth seems to prefer it as a likeness to any thing she has yet done" (82). The head from this was also engraved and published in R.H. Horne's "The New Spirit of the Age" of 1844 (83). Two other miniature portraits were done by Gillies during her stay at Rydal Mount: a second of Mary (84) and one of Isabella Fenwick, a neighbour and close friend of the Wordsworths (85). Two sketches from this period should also be mentioned: a fourth portrait of Wordsworth in water-colour on paper (86) and a pencil sketch of Kate Southey in Dora Wordsworth's autograph book (Fig.108).

The Wordsworths were not only pleased with the Gillies portraits but also very fond of the artist herself (87). Early the following year, 1840, Wordsworth wrote to Thomas Powell: "When you see Miss Gillies pray tell her that she is remembered in this house with much pleasure and great affection, and a hundred good wishes for her success" (88).

In 1840 she exhibited seven portraits at the Royal Academy including one of William Wordsworth (no. 716). Judging from a review in the "Athenaeum" which criticized the mouth as a feature "for which she has a

fixed pattern, which whether the person to be drawn be man, woman or child, never fails to be repeated", this must have been the first full-face portrait of the poet rather than the profile. The same reviewer praised her "disposition to catch those deepest and most intellectual expressions of countenance, which are beyond the ken, and consequently the management of many artists (89).

Between 1841 and 1851 Gillies exhibited 46 portraits at the Royal Academy and one at the Society of British Artists, 1842 being the last year she was to send to the latter institution. The most famous of these were one of Charles Dickens (RA 1844 no. 660) (90), a second of R.H. Horne (RA 1846 no. 843) (91), one of Mrs Marsh, the authoress (RA 1851 no. 1000) and three of members of the Howitt family: William and Mary Howitt (RA 1846 no. 931) (92), Mary Howitt (RA 1847, no.919) and Miss Howitt (RA 1849 no. 762). The portrait of William and Mary Howitt bears some compositional resemblance to her other double portrait of William and Mary Wordsworth. In both the women are seated, writing, to the right of the picture. Her portrait of Mrs Marsh, author of "Emilia Wyndham", was considered very successful: "As a resemblance it is extremely felicitous, and in merit as a work of Art the best we remember to have seen exhibited by this accomplished artist" (93). In 1844 engravings after her portraits of Wordsworth, Dickens, Southwood Smith and Harriet Martineau were repro-duced in R.H. Horne's "The New Spirit of the Age" and in 1846 the "People's Journal" published engravings of her portraits of Dickens, Wordsworth, Southwood Smith, Harriet Martineau, theHutchinson family, Leigh Hunt and the Miss Cushmans (94). Over the same period, 1841 to 1851, she also exhibited six subject pictures. In all of these, except perhaps "Comus and the Lady" (SBA 1842 no. 545), women were the main subjects. "Ruth and Naomi" (BI 1846 no. 393) was considered "successful" by the "Art Union" (95) and E.C. Clayton wrote admiringly of "Domine in te speravi" (RA 1850 no. 1170), "representing a youthful figure seated with an open Bible upon her knees, her eyes upraised with a look of intense yet chastened devotion. Form, attitude, expression, alike evidenced judgment and good taste" (96). This was one of the artist's first oil paintings. Religion is also the subject of "The Martyr of Antioch" (PG 1851 no. 216) with a quotation from Milman (97).

The only sign of the artist herself during this period is on July 31st, 1847, when Mary Howitt took Hans Andersen to Hillside, Highgate where the Gillies sisters were living. She described them in her Autobiography: " - the one an embodiment of peace and an admirable writer, but whose talent, like the violet, kept in the shade; the other, the warm-hearted

painter". They made their guest "cordially welcome" (98). In this
context it is relevant to mention an unexhibited water-colour by the
artist entitled "The Annual Haymaking at Hillside, Highgate - the home
of the artist" (99).

In 1851 Gillies went to Paris and studied in the studios of Henri
and Ary Scheffer for a short while. According to Roget, Ary Scheffer
influenced the artist's future development: "A general elegance of treat-
ment as well as the leaning towards a special type of features suggest
the influence of her teacher Ary Scheffer, whose example she also followed
in the purity of her motives" (100). Certain it is that following her
return she exhibited and presumably executed fewer and fewer portraits.
She exhibited only 17 between 1852 and 1859 and therafter they ceased com-
pletely with two exceptions at the Grosvenor Gallery in 1880.

From 1852 to 1863 the sisters lived at 6 Southampton Street and
1852 also marked the beginning of her association with the Old Water-
colour Society of which she was elected a Lady Member that year. In addi-
tion she sent two works to the Exposition Universelle in Paris in 1855 and
from 1858 she exhibited at theSociety of Female Artists. In the 1850s the
artist was at the peak of her fame and by 1859 was referred to as "the best
known representative of the female artists of England" (101). Prices are
an indication of her notoriety and during this decade her literary subjects
commanded up to £52. 10s. (102). Excluding portraits the works she
exhibited over this period were of three types. First, those illustrating
scenes from literature, particularly the novels of Sir Walter Scott, old
ballads and Shakespeare's plays. In all these, of which she exhibited 15
between 1852 and 1861, heroines were focal and in the majority the dominant
emotion was suffering. Thus "Jeanie Deans visiting her sister in prison
from "The Heart of Midlothian" (OWS 1852 no. 66) and Jeanie pleading for
her sister's life before Queen Caroline (OWS 1853 no. 47); the other
Jeanie from "The Ballad of Auld Robin Grey" whose lover Jamie died at sea
and who finally married Auld Robin Grey - a subject depicted at least three
times by the artist (103); poor Jenny Coxon, from "The Antiquary", wait-
ing for a letter (OWS 1857 no.213); Vivia Perpetua "on the eve of her
martyrdom" from a poem by Sarah Flower Adams (104) and Shakespeare's
unhappy Imogen "after the departure of Posthumous" (OWS 1860 no. 180). Her
representations of Jeanie Deans were highly praised for feeling and in 1853
she was credited with "a deep womanly sympathy for Scott's peasant heroine"
(105). The second type consists of works in which literature is used as a
gloss on the picture and it was in these that the artist was most success-
ful. Again female figures were usual. The main themes to emerge from

these works - of which 16 were exhibited over the same period - are sad-
ness, whether caused by death, parting or memory and secondly hope, which
often takes a religious form. In some works such as "The Past and the
Future" (OWS 1855 no. 193), "A Father and Daughter' (OWS 1859 no. 51),
"Beyond" (OWS 1861 no. 78) and "The Ministering Spirit" (OWS 1856 no. 236)
these moods are closely juxtaposed in the same work. In the first three
of these, two figures are portrayed - one conveying sadness and one hope;
in "The Ministering Spirit" the succeeding moods are given by extracts
from Longfellow (106). Thus in the same picture the problem and the solu-
tion are given and a positively moral effect is achieved. It was in works
of this type that the artist was most highly motivated and most original.
The degree of her public success should briefly be indicated. Of "The
Mourner" with lines from Tennyson (OWS 1854 no. 182) the "Art Journal"
critic wrote that "the expression of the features is a triumph in one of
the most difficult acquisitions of Art" (107). The same magazine described
"The Past and the Future", mentioned above, as "the most meritorious work
this lady has ever produced" (108). It was said to be the chief attraction
at the exhibition and was later engraved by Francis Holl. "From Marcello's
Anthem" of a woman looking up to heaven (OWS 1856 no. 163) was also
engraved (109). "A Father and Daughter", given above, and "The Merry
Days when we were young" (OWS 1860 no. 80) - another work involving con-
trast - received full praise and "Beyond", also given above, was described
as "the most successful essay she has yet produced in that quasi-classic
kind of art, in which she seems to stand without a competitor" (110).
"Trust" (RA 1860 no. 776), portraying a female figure whose sad thoughts
are suggested by three lines from Fanny Kemble Butler, is the only presently
known work of this type (Fig. 26).

In her third type of picture Gillies depicted ordinary, everyday
scenes from real life unembellished by literary quotations. Between 1852
and 1859 these bore titles such as "Waiting for News" (OWS 1855 no. 322),
"The Parting" (OWS 1856 no. 191), "The Absent Thought" (OWS 1852 no. 73) and
"The Young Mother" (OWS 1859 no. 230) - in other words they focused on
the main constituents of female life which have already been considered in
Chapter Three (111). The only available example of her portrayal of mother-
hood is her portrait of "Lady Charlotte Portal and child" which was exhibited
at the Royal Academy in 1859 (no. 783) (Fig. 109). In 1859 or 1860 the
artist visited Scotland and in particular the Isle of Arran. This was the
first of many trips over the next three decades and it marks the beginning
of a long succession of works devoted to rustic genre. Between 1860 and

1862 she exhibited many pictures of the Scottish peasantry at the Old
Water-colour Society. Two of the most moving of these works on Scottish
themes were "The Highland emigrant's last look at Loch Lomond" (OWS 1859
no. 20) which may possibly have been executed before her visit to Scotland
and "Waiting for the Return of the Herring Boats" (SFA 1860 no. 120). The
former portrayed an old man "absorbed in mournful thoughts" and was,
according to the "Art Journal", a very touching picture (112). The
latter's subject was presumably a group of women and children waiting for
the return of their men-folk. There is one exception to these three
categories among her subject pictuers of this period. From 1858 she con-
tributed work to the Society of Female Artists and from then on was to
exhibit some of her most interesting works at exhibitions of this society.
In 1860 one of her two exhibits was "Rebekah at the Well" (no. 196), a
successful work which was, however, to be the last of her few pictures on
Biblical themes (113).

Gillies spent the 1860s in almost continuous travel. 1861 was the
last year in which she sent work to the Royal Academy and during the rest
of the decade the Old Water-colour Society and the Society of Female
Artists were the sole recipients of her pictures. Due perhaps to her reg-
ular summer excursions she exhibited a large number of sketches and
studies at the Old Water-colour Society's Winter exhibitions. Between
1862 and 1869 literary subjects faded out, her only illustrations being
two pictures of Nell and her grandfather from Dickens' "Old Curiosity Shop"
(OWS 1866/7 no. 141 and 1868 no. 5). Equally she exhibited only six of
those moral or philosophical works in which she explained the content of
her pictures by poetical quotations. But although few in number these
were extremely successful. "Awakened Sorrows - Old Letters" with a quota-
tion from Barry Cornwall (SFA 1863 no. 70) may be aligned with those works
of the previous decade in which two figures expressing contrasting moods
are brought together. In this a girl consoles an old woman "borne down
by some painful remembrance". The "Art Journal" put this into "the class
of high Art" (114). "Youth and Age" (OWS 1865 no. 197), also with a
quotation, was similarly based on contrast (115) as was "Sorrow and Con-
solation", without a gloss, of 1866 (OWS no. 39). "Desolation", with four
lines from Wordsworth (SFA 1864 no. 181), portrayed another sorrowful
female figure, this time alone on the seashore. According to the "English
Woman's Journal" this was "the most attractive picture in the gallery" (116).
It was priced high, at £84. Two other works with glosses, exhibited at
the Old Water-colour Society in 1868, depicted single women more or less
distraught: "The Wanderer" (no. 61) and "Expectation" (no. 146) (117).

Finally, in "Leaving the Highlands" (OWS 1869 no. 180) she emphasized the pathos of a pet subject by a quotation from Alaric A. Watts (118). One other work should be mentioned - and this her only historical one of the period - as an instance of the artist's insistence on woman's role in life, and as an example also of her concern with elevating themes and moral effect. The wife of the anti-royalist, Judge Cook, is prepared to endure "want or any misery" with her husband rather than cause him to betray his conscience (OWS 1867 no. 210) (119).

In considering the artist's total output between 1862 and 1869 these works are exceptional. The vast majority of her exhibited pictures were travel sketches based on her visits to Florence in 1862, Northern France in 1864, Ireland in 1865, the Isle of Wight in 1866 and the South of France in 1867. Judging from titles she would seem to have been interested mainly in the peasantry for artistic purposes. In only four cases do the titles suggest mood pictures: "An Emigrant" (OWS 1865/6 no. 403), "In a church at Normandy (Priez pour les pauvres prisonniers)" (OWS 1866 no. 105), "Loin de mon pays - a Girl from Toulouse" (OWS 1867/8 no. 248) and "An Emigrant Mother" (OWS 1868/9 no. 329) in all of which there is the idea of separation from home. Every now and then she resumed her delineation of typical female life, in works with titles such as "A Romance" (SFA 1864 no. 72), "The Welcome Letter" (OWS 1864 no. 185), "Waiting for Father" (OWS 1864 no. 243) and "Daydreams" (OWS 1864 no. 291).

Gillies appears to have maintained her popularity in the 1860s by virtue of pictures such as "Awakened Sorrows - Old Letters", "Desolation" and "Sorrow and Consolation". She remained "eminent for the sentiment of her female figures" and "most happy in the diversity of her subjects and the success with which she sets forth her ideas" (120).

From 1863 the sisters had been living at 25 Church Row, Hampstead. In 1870 Mary Gillies died and thereafter the artist lived alone, for the first time in her life. Two of her exhibits that year should perhaps be seen in the light of this event: "Doubt not; go forward!" (OWS no. 150) and "Alone" (OWS no. 259) (121). Later in 1870 she visited Venice and Verona and to the Old Water-colour Society's exhibition of sketches and studies during the winter of 1870/1 she sent seven Italian subjects. Between 1871 and 1884 she exhibited five works depicting scenes from literature (122). Thematic pictures with glosses were also scant, the main instances being "Remembered Tones" (OWS 1872 no. 218) and "Suspense" (OWS 1873 no. 76) (123). Unpoeticized scenes from real life constituted her main output. Some of these were on favourite themes such as waiting, parting, dreaming and motherhood but travel sketches were again in the

majority and in the 1870s these were mostly based on trips to Brittany in
1874, and Rome and Albano in 1877; Mary Howitt mentions meeting her in
Rome in the latter year (124). Again two exceptional works on historical
themes provide good instances of the general direction of the artist's
sympathies. Both were about Lez-Briez, "the Sir Lancelot of Brittany",
but both focused on the women in his life. In the first (GG 1879 no.255)
Gillies portrayed his mother's sadness when she knew that he would become
a knight and "depart and leave her lonely"; in the second (OWS 1880/1
no. 63), the knight returns after many years to find his sister and old
nurse the only survivors of his family (125). A further exception is pro-
vided by the only presently known example of the artist's later work:
"Cercando Pace" is a drawing in three compartments, "founded on the old
story of the Italian friars who went about 'seeking peace'" (126) and one
if not all of the parts was exhibited at the Old Water-colour Society in
1873 as "The end of the pilgrimage" (127) (Figs. 110,111,112).

Gillies did not exhibit in 1885 or 1886. In 1887 "The Pilgrimage",
possibly the "Cercando Pace" mentioned above, was exhibited at the Royal
Jubilee Exhibition in Manchester. She also sent to the Old Water-colour
Society in 1887 - "a drawing which she felt was to be her last, her adieu
to art, and which she felt to be typical" (128): "Christiana by the River
of Life" (129). She died of pleurisy at the Warren, Crockham Hill, Kent,
on July 20th, 1887, after a few days illness, at the age of 83. An
obituary in "The Academy" wrote: "Those who know the story of her life
will honour the perseverance, the energy, the self-denial, the cordiality
of feeling which were with her from first to last" (130).

One of the finest contemporary tributes comes from E.C. Clayton:
"At all times Margaret Gillies aimed at making art a minister to the
loftier and nobler feelings of mankind; her associations have ever been
such as were calculated to elevate not only her own mind but the minds of
all who came within the influence of her pure spirit. She has painted
always well, and always with a high motive" (131). The only serious
criticism of her work is in keeping with this view: in 1856 she was
accused of being "rather prosy" and "solemn" (132).

Margaret Gillies began as a portraitist and her ideal of portrai-
ture as a moral instrument, expressed in her letter to Leigh Hunt, was
responsible for the fact that she portrayed more celebrated writers and
intellectuals of her day than possibly any other artist. Some attempt
should be made to explain why two of her least successful portraits were of
women. Harriet Martineau's opinion of Gillies' portraits of her has
already been given (133). Now the engraving in "The New Spirit of the
Age" (Fig. 106) does not appear particularly "monstrous" or "vulgar";

neither can it be called the portrait of a beautiful woman. A criticism
of one of Gillies' representations of Jeanie Deans has its place here.
In this the reviewer commented that the subject's plainness verged on
caricature, "the artist's aspirations after intellectual expression
having (as may be remarked with her portraits) betrayed her some hair's
breadth beyond the boundary line of Beauty" (134). While the degree of
likeness in the Martineau portrait cannot be established, it is probable,
in view of her ideal of portraiture, that Gillies was more at pains to
stress intellect than beauty in this portrait. One other female portrait,
of Dora Wordsworth, was considered unsuccessful on account of the artist's
failure to flatter her subject physically (135). While to stress intellect
or dominant features in men was acceptable, in women, beauty and charm were
essential. If it was important for men to have character, it was equally
important for women to have beauty. Gillies did not truckle to artistic
custom with her female subjects.

Like many other women artists of the period - the Misses Sharpe for
instance - Gillies later changed to subject pictures. An examination of
these, including even her travel sketches, reveals a passionate interest
in women; in 1891 Roget wrote: "Miss Gillies's art was essentially
feminine; dealing almost exclusively with maiden's sentiment and woman's
sorrow" (136). She portrayed peasant women, the solitary, daily lives of
women of her own class, and the trials and suffering of literary and
occasionally historical women. The emphasis was on sorrow. Secondly one
notices the theme of separation, caused by death, absence and perhaps
closest to the Scotswoman's heart - emigration. Her solution to suffering,
wherever one is given, is always religion and the afterlife. In the 1850s
and 1860s she dwelt on the problem, to which the remedy of hope and
religion was sometimes appended. In the 1870s the emphasis changed and
the solution became paramount. Thus the serene peasant who reflects: "It
was too hard for me, until I went into the Sanctuary of God"; thus
"Cercando Pace" and "Christiana by the River of Life" (137).

4. SARAH SETCHEL

She was born in 1803 in King Street, Covent Garden. Her father had
wanted to be an artist but he "unselfishly resigned this ambition and
followed his own father's profession of bookseller". He did, however,
collect numerous books about art and he was also very anxious that his
two daughters should adopt art as a career, a most unusual attitude in
the period. Apparently Sarah showed no particular inclination until she
left school but then she began to study earnestly. She learned by copy-
ing in the National Gallery and British Museum and also received some
lessons in miniature painting on ivory from Miss Sharpe (138). She bene-
fitted greatly from her father's criticisms. His advice on subject
matter is interesting. She longed to execute works on classical subjects,
but her father advocated "scenes of home-feeling and affection" in the
belief that "domestic feeling" was her strong point (139).

In 1829 she was awarded a premium by the Society of Arts and in 1831
she exhibited her first work, at the Royal Academy. Between 1831 and
1840 she also exhibited at the Society of British Artists and once at the
New Society of Painters in Water-colour . During the first three years
her main subjects were children. She also favoured cottagers and this
interest in humble life was to be the dominant note of her entire output.
From 1834 she broached literary subjects and illustrated scenes - mostly
with female subjects - from Scott, Shakespeare, Bulwer Lytton and Howitt.
On one occasion she appended four lines from Kirke White to a work depict-
ing the effect of music.

In 1841 she became a member of the New Society of Painters in Water-
colour and in the following year she exhibited the work which was to bring
her fame. "The Momentous Question" is the title by which it came to be
known but when first exhibited it appeared with a long quotation from
Crabbe's "Tales of the Hall" of which it was an illustration (NSPW 1842 no.
58) (Fig. 19). The success which greeted this work has already been con-
sidered (140). It was sold for 25 guineas, engraved by Bellin and the
copyright sold for the same amount. Shortly after the exhibition it was
represented on the stage. Her next exhibit was a miniature portrait of her
father in 1845 (NSPW no. 305). This was said to contain "that proper ideal-
ization of truth which constitutes portraiture of the highest order". Not
only was it the "most interesting drawing in the exhibiton" but it placed
Setchell, according to the "Athenaeum"'s critic, "at the head of all lady
miniature painters" (141). The same critic inquired why her works were so
seldom seen at exhibitions. The reason was bad eyesight from which she

suffered throughout her career. 1846 was another blank year. Her
father died and she gave lessons in water-colour painting to Mrs Criddle,
whose eyes also gave her trouble, forcing her to give up oils (142).

Between 1848 and 1856 Setchel exhibited works at the New Society of
Painters in Water-colour approximately every other year. Her last two
literary subjects - "And ye shall walk in silk attire" (1848 no. 54) (Fig.
18) and "Jesse and Colin" (1850 no. 258), another subject from Crabbe,
were both successful and both engraved (143). Two portraits followed - of
the Rev. T. Image (1852 no. 161) and of Henry Cooke (1854 no.314) - and
these upheld her renown (144). 1856, when she exhibited a "Sketch for a
picture of an English Cottage Home", was the last year she sent work to the
Society's summer exhibitions. In 1854 she was one of four female artists
mentioned by Bessie Rayner Parkes to exemplify what women could achieve
"for the interests of art, and the lesser, but important, aim of pecuniary
independence" (145).

In the hope that an operation might improve her eye-sight, in the
autumn of 1860 she went to Graefruth, Switzerland, to have her eyes
examined by the German oculist, Dr. Vedenne. The hope was disappointed and
she was presumably told that if she continued her career her vision would
deteriorate still further, for on her return she abandoned professional art
and went to live in the country with her sister. After this she exhibited
only twice more, at exhibitions of sketches and studies held by the New
Society of Painters in Water-colour during the winters of 1866/7 and 1867/8.
She exhibited 17 works in the former year and four in the latter; studies
for her former works were included among these. She died on January 8th,
1894.

Throughout her brief career, Sarah Setchel favoured subjects from
humble life. Most of her literary works portrayed "homely" subjects -
Jeanie and Effie Deans (NSPW 1834 no. 28), "The Pride of the Village" (SBA
1835 no. 662), her scene from Howitt's "Rural life in England" (SBA 1840 no.
601) as well as the "Momentous Question", "And ye shall walk in silk attire"
and "Jessie and Collin". In addition she exhibited several "cottage"
subjects. She excelled in the rendering of expression - this is evident
also in her portraits - and in the representation of emotional situations.
The "Momentous Question" was said to "distance beyond possible overtaking
the male professors of the Jemmy Jessamy school of art" (146).

5. MARY ANNE ALABASTER (MRS H. CRIDDLE)

Mary Anne Alabaster was Welsh . She was born in Chapel House,
Holywell, Flintshire, in 1805. Her father's profession is not known but
according to Roget he was "a man of inventive ingenuity, who used to make
caricatures to amuse his children of an evening" (147). She attended a
Miss Master's school at Colchester until she was thirteen at which time
her father died. Even as a child she was very keen to take lessons in
art but her mother disapproved of art as a profession. It was not until
she reached the age of nineteen that she was allowed to receive a proper
training for the career of artist.

From 1824 to 1826 she worked in Hayter's studio and in the latter
year won the silver palette of the Society of Arts for a chalk study from
the antique. Three more medals followed, her greatest success being the
large gold medal which had not been awarded for ten years, for an original
picture called "The Visit to an Astrologer" in 1832. She first exhibited
in 1830, at the British Institution, a work called "The artist's painting
room" (no. 379). This was a self-portrait and was sold to the Marquis
of Stafford (148). In 1836 she married a Mr Harry Criddle of Kennington
and in 1844 gave birth to a son (149).

From 1830 to 1848 she sent work to the Society of British Artists,
the Royal Academy and the British Institution and her contributions were
mostly oil paintings. The twelve portraits exhibited over this period were
of women and children exclusively. Domestic genre subjects with titles
such as "The Music Lesson" (BI 1832 no.456) and "A Lady's Dream" (BI 1842
no. 338) were popular with the artist as were poeticized scenes from real
life like "Ah, me! for aught that ever etc." (BI 1841 no.259) and "The parent
rose etc." (SBA 1843 no.32) (150). But her largest and most elaborate
works - nine in number - depicted scenes from literature. Shakespeare,
"Macbeth" in particular, and poets like Spenser and Crabbe were popular
sources and again female subjects were frequent. Her most ambitious work of
the period, "The Banquet Scene in 'Macbeth'" (BI 1840 no.436), measured
seven feet seven inches by nine feet four inches. In 1841 she exhibited a
St. Catherine (RA no. 1106) destined for St. Catherine's Hall, Cambridge
University - which is no longer there - and in 1847 she sent a large car-
toon to the competitive exhibition in Westminster Hall for the decoration
of the new Houses of Parliament - her subject being taken from the
"Epithalamium" of Spenser.

In 1846 Mrs Criddle's eyes began to suffer from constant exposure to
oil paint and she took some lessons in water-colour from Miss Sarah Setchel
(151). On February 12th, 1849 she was elected a member of the Old Water-
colour Society to whose exhibitions she sent work regularly and exclusively

until 1880. Her eyes were again infected in 1852 but the cause on that occasion was an attempt to practise miniature painting; her sight was impaired for several seasons.

Between 1849 and 1861 the artist exhibited numerous unambitious works which may be described as domestic genre. She also exhibited many illustrations of poems, particularly those of Crabbe. A number of these literary works had moving subjects and women were always the protagonists in such cases: "With him she pray'd etc." (1849 no. 73) from Crabbe, "Lavinia and her Mother" (1849 no. 226) from Thomson, which was sold to the Baroness Burdett-Coutts, and "The Sisters" from Crabbe (1854 no.15) for instance (152).

In 1857 her husband died and she then moved out of London, to settle, in 1861, in the village of Addlestone, near Chertsey. An exceptional work exhibited in the year of her husband's death should perhaps be seen in the light of that event. It depicted the Night Watch and bore the following line from St. John: "Let not your heart be troubled. I will not leave you comfortless; I will come to you" (no. 195). This was the first of a total of three religious works exhibited by the artist.

In contrast to her first period, 1830 to 1848, when she had favoured Shakespeare's plays, between 1849 and 1860 she exhibited no Shakespearian subjects at all. In 1861 she returned to them and Shakespeare's heroines were present and usually focal in 24 works exhibited between that year and 1880. Among her numerous other literary sources, most were poetic and many portrayed women. Very occasionally she explained and deepened titles such as "The Vacant Chair" (1861 no. 37) and "Retrospection" (1864 no. 123) with poetical quotations (153). She exhibited two works on religious and two on historical themes over this period; women or children were central in each (154).

It is probable that her return to Shakespeare and her attempts at classical subjects had something to do with the gradual upgrading of water-colour art. It should not be forgotten that having begun as an oil painter she was forced to give up this medium for the sake of her health. The change from oil to water-colour in the late 1840s cannot have been easy and she would have found water-colour quite inadequate for subjects such as "The Banquet Scene in 'Macbeth'" which she had previously executed on so vast a scale. Closer acquaintance with the medium and greater respect for it among the art establishment must have influenced her later development. Another factor may have been the emphatic distinction between water-colours and sketches created by the co-existence of a summer show of finished works and a winter exhibition of sketches and studies at the Old Water-colour Society. Like other members Mrs Criddle sent not only sketches for

previously exhibited works to the latter, but also genre pictures, reserv-
ing her finished literary works for the summer. Whatever the correct
order of causes may be, from the 1860s Mrs Criddle felt able to execute
more elevated subjects in water-colour.

 The artist exhibited a total of 149 works at the Old Water-colour
Society. Her patrons included the Marquis of Landsdowne, the Baroness
Burdett - Coutts, the first Duke of Sutherland (previously the Marquis of
Stafford) and Richard Hoare Esq. She died on December 28th, 1880, in
Addlestone, having shortly before resigned her Associateship of the
Society of Painters in Water-colour . It is an extraordinary fact that
so prolific an artist can be so totally unknown (155).

6. LOUISA AND FANNY CORBAUX

Louisa (born 1808) and Fanny (born 1812) were the daughters of Mr
Corbaux, an Englishman who spent much time abroad. He was a Fellow of the
Royal Society and well-known in the scientific world of England and
France as a statistician and mathematician. The daughters' taste for art
emerged early. In 1827 their father lost a lot of money and his health
being affected they were forced to earn a living. They studied alone,
copying at the National Gallery and the British Institution and came to
specialize in water-colours and miniatures.

LOUISA CORBAUX

Louisa, the eldest, exhibited sixteen works at the Society of British
Artists between 1828 and 1850 and three at the Royal Academy between 1833
and 1836. She exhibited mostly at the New Society of Painters in Water-
colours between 1832 and 1881 and was also represented at exhibitions of
the Society of Female Artists between 1857 and 1865. An examination of the
subject matter of her work reveals no development. Children and animals
were her favourite subjects, an example being "Friends" of 1864 (Fig. 113)
and she was also fond of portraying figures dreaming, thinking and praying,
an instance of which is an undated work entitled "Remembrances" (Fig. 114).
In the 1840s she occasionally added glosses to her titles - to poeticize a
figure thinking, idealize childhood or even sentimentalize a picture of a
donkey. Her most unusual works were two portraits of Indian girls exhibited
in 1844 (NSPW nos. 206 and 281) to one of which was added a line from
Cooper: "Very sorrowful is the lot of woman". Female sorrow was also the
subject of an undated engraving called "The river of Yarrow" - presumably
an illustration of one of Wordsworth's three poems on the subject (Fig. 115).
"Twelve Studies of Heads, drawn from nature" by her were published in 1851,
twenty stone drawings of "Sculpture from the Exhibition of 1851" in 1852
and an "Amateur Painting Guide" in the same year. She last exhibited at
the New Society of Painters in Water-colour in 1881.

FANNY CORBAUX

Fanny Corbaux, four years younger than her sister, was both more
prolific and more gifted. Between 1827 and 1830 she won five medals from
the Society of Arts, her last being a gold medal for a portrait miniature.
She exhibited 49 works at the Society of British Artists between 1828 and
1840 and in 1830 was elected an Honorary Member of the Society. In addition
she exhibited 86 works at the Royal Academy (1829-1854), fifteen at the
British Institution (1830-1841) and 38 at the New Society of Painters in

Water-colour (1832-1854). Two of her works were shown at the Exposition Universelle in Paris in 1855.

Her first exhibits were portraits. Then, having shown "Orphans" in 1829 (SBA no.671), in 1830 she exhibited two genre subjects, two works based on literature and one religious picture at the Society of British Artists. In the 1830s and early 1840s she specialized in subjects from literature. 32 works exhibited between 1830 and 1843 either were illustrations of literature, or, in a few cases, used literature as a gloss. In addition she illustrated Finden's "Byron's Beauties", published in 1836, Thomas Moore's "Pearls of the East or Beauties from Lalla Rookh", published in 1837 and "Cousin Natalia's Tales" of 1841. Several of her works were engraved and used as illustrations in the Annuals of the period (156). Among her exhibited works Shakespeare, Scott, Byron and female poets such as Mrs Hemans, the Hon. Mrs Norton and Letitia Elizabeth Landon (known as L.E.L.) were favourite sources. Throughout she favoured female subjects. One of her most moving pictures was "The Victim Bride" (BI 1832 no.163) from a poem by the Hon. Mrs Norton (Fig.116) (157). During the same period, 1830-1843, she exhibited over 50 portraits, almost all at the Royal Academy and the majority of which represented children. Peasants and domestic genre scenes like "Retirement" (SBA 1833 no. 452) and "The first lesson" (SBA 1837 no. 92) constitute a minor category. According to the "Spectator" her first attempt at a large composition was her illustration of Will Honeycomb's story, exhibited in 1837 (NSPW no.131) (158). In 1839 she exhibited her second religious work - "Elijah restoring the Widow's Son" (NSPW no. 293) (159) which was considered a "praiseworthy attempt at a lofty theme" (160). "Properzia Rossi", exhibited two years later (NSPW 1841 no.65), was described as the best realization "of a subject of serious interest" in the exhibition (161).

Her success over this period and the encouragement she was given to attempt more ambitious compositions led her in the 1840s to abandon literary subjects in favour of Biblical ones. These were "Ruth and Naomi" (NSPW 1846 no. 333), "The wolf also shall dwell with the lamb" (NSPW 1847 no.144), "Leah" and "Rachel" (NSPW 1848 nos. 187 and 206), "Hagar" (NSPW 1849 no.234) and "Hannah" and "Miriam" (NSPW 1852 nos. 298 and 312)(162). The last two were considered the best contemporary examples of female art (163). But her most successful exhibits from the mid 1840s to the mid 1850s were occasional literary compositions with poetical quotations and works belonging to the category of domestic genre. "A very particular Confidence" (NSPW 1845 no.48), of a girl showing her love letters to her sister or mother, was callied "a pure and powerful piece of water-colour painting" (164). According to the "Art Journal", "The Convalescent" (NSPW 1850 no.47)

was the best work she had ever exhibited (165). "The Stranger", from Mrs Hemans, of 1851 (NSPW no.55) was another record (166) and her crowning success was one of her last two exhibits in England: "After the Ball", with a line from Proverbs, of 1854 (NSPW no. 159) (167). The catalogue for the latter exhibition provides the only indication of the prices fetched by her works. The cost of "After the Ball" was high - £57. 15s. - and her other exhibit, a poetical subject called "The Close of Day" (168), was priced at £28. 5s. Between 1841 and 1854 all her subject compositions were seen at the New Society of Painters in Watercolour . To the Royal Academy she sent only portraits among which the majority were of women and children.

She last exhibited in 1855, in Paris. Fanny Corbaux also wrote and contributed many geographical Bible studies to the "Athenaeum" and the "Journal of Sacred Literature". In 1870 she was accorded a pension of £30 a year "in consideration of her researches in sacred literature and attainments in learned languages". She died at Brighton, on February 1st, 1883. Women and children were her main subjects and the most common mood in her works was sadness, particularly in those pictures illustrating poetry or making use of poetry in glosses.

7. LOUISA STUART (MARCHIONESS OF WATERFORD)

Louisa Stuart was born in Paris on April 14th, 1881, the second
daughter of Sir Charles Stuart, Great Britain's Ambassador to France. His
first daughter, Charlotte, was born the year before, in 1817. In 1824
they returned to England and lived at Highcliffe Castle in Hampshire and
Louisa's earliest recollections were of the farmhouse of Bure Homage
where her paternal grandmother lived. In 1828 the family returned to
Paris when Sir Charles Stuart, now Lord Stuart de Rothsay, was reappointed
Ambassador in Paris for another two years. The children's governess in
Paris was a Miss Hyriott and under her care both revealed early artistic
talents; Charlotte drew landscapes and buildings and Louisa specialized
in figures. They received little instruction. They were taught to copy
large chalk heads after French pictures and also received a few lessons in
landscape from a Mr Page. At the age of ten, Louisa finished a copy from
a large picture by Sir Joshua Reynolds under the supervision of an artist
called Shepherdson. In the main she worked alone, doing endless drawings
of the human figure from prints and accurate copies in pencil or pen and
ink from leaves and flowers. After a tour to the Pyrenees and the South
of France in the summer of 1830, at the end of that year the family left
Paris and visited Louisa's maternal grandparents at Wimpole, Tittenhanger,
near St. Albans. They then settled at Highcliffe Castle, which was
enlarged and elaborately decorated by Lord Stuart de Rothsay. He also
built a village church, the East window of which was designed and painted
by Charlotte and Louisa.

In 1835 Charlotte married Charles Canning who became a Member of
Parliament in 1836 and Viscount in 1837 and in the Autumn of 1835 Louisa
was presented at Court. It was at this time that George Hayter painted her
portrait. Also in the Autumn her parents took her on a trip to Naples and
Rome where she benefitted greatly from her detailed study of Italian art.
In 1837 they returned to England and Lord Stuart bought a house in Carlton
House Terrace. Louisa was widely admired in Society and among her suitors
were Lord Redesdale, Lord Maidstone (heir to the Earl of Winchelsea) and
Lord Douglas (heir to the Duke of Hamilton). It was in 1839, when she was
in Scotland for the Eglinton Tournament, that she met her future husband
- Henry de la Poer Beresford, third Marquess of Waterford. They were
married in 1841 at the Chapel Royal, Whitehall.

The couple went to live at Curraghmore in the South of Ireland where
Lord Waterford owned an Estate on which 600 men found employment. Louisa
devoted much of her time to helping the poor: she started a cloth factory,
had two churches built, planted trees and even painted inn signs. All the

time she worked and her sketch books contain careful studies from peasant girls and cabin life around her home as well as many family groups and portraits of Lord Waterford (Fig.117). She made friends with a Miss Grace Palliser, of Tipperary, who was also an artist and together they painted from models and practised classical music. Letters of 1843 and 1844 refer to "her painted-glass mania" and tell of the elaborate cartoons she made beforehand (169).

In the Spring of 1844 she spent six weeks in England and afterwards went to Carlsbad for a tour in Germany. From Curraghmore on November 26th, 1846 she wrote to her mother that she was doing a frontispiece for Mr Alexander, publisher of an Irish translation of King's "History of the Irish Church" (170). In 1847 the Irish famine was at its worst and they did all they could to relieve the problem in their area. Her work elicited a public acknowledgment from the House of Commons. In 1848 there were menaces of general inusrrection and she was personally threatened but she remained in Ireland until sent back to England by her husband in June. By September she had returned.

A letter to Lady Jane Ellice of September 19th, 1848, mentions that she has been correcting her "Babes in the Wood" for publication (171). Now this work was the first of Lady Waterford's to come before the public eye. It was published by Mr Cundall and consisted of ten designs illustrating various stages of the story. She said that it would be "open to many criticisms" but when it appeared it was greeted with enthusiasm. The "Spectator"'s critic was astonished: "If this is really by the hand of the young Marchioness, she has a genius for art such as few women have displayed; and even if she has been aided the designs are invented with a feeling of the highest order". Both composition, which was "informed by the true symmetry of art" and the figures of the children - "large-limbed, full-proportioned, with ample brows" - reminded him of Raphael. "We say that throughout this charming work there is the highest feeling of art - a thorough conception of the subject, a perfect faith in the simple forms and actions of nature, and no inconsiderable power of embodying the artist's idea" (172). The work soon became an essential part of every well-to-do Victorian nursery. In 1852 her sister wrote from Osborne: "The 'Babes" have been much admired here. The Prince is quite delighted with it. Both he and the Queen say that Lou ought to learn to etch, and etch it herself" (173). In November 1849 she was meditating subjects for a series of "Virtues and Contrasts" and wrote to her mother of an idea of rendering "Thirsty and ye gave me to drink" as a stripped soldier calling to women

with pitchers who refuse water: "I was so glad to think of a subject without the eternal ragged people as a type of poverty and misery which is, in general, so far from the truth in reality" (174).

In 1851 Lady Jane Ellice criticized her for giving up so much time to art (175). Her defence must be given in full for it not only shows to what extent she was committed to her work but also her moral interpretation of the artist's function: "The love of Art must not be treated as a sin. All that is great and beautiful comes from God, and to God it should return. It is the misuse of great gifts which is the sin, not the gifts themselves. Oh, never say the best parts of humanity are not gifts of God. That would be wrong. If used for badness they may be turned to sin, but that would be by man's freewill; the gifts, in their goodness and purity, are God's" (176)- And on November 14th she wrote of her own work: "I do love my art (dare I call it mine?) far more than ever, and long to do a great work. Meantime I labour at the merest correctness, which leads me to discover more and more in every work of Nature; a dead leaf in all its curves seems to disclose so much more than one sees at first" (177).

Around 1852 Lady Waterford was introduced to Ruskin who suggested that she seek tuition from Rossetti. The latter refused. She had a lengthy correspondence with Ruskin from 1853 right up until the 1870s and he con- tinually criticized her careless work, suggesting Titian as a model (178). In 1853 she visited Holman Hunt and in 1854 Millais's sketching club project was to include Mrs Boyle (EVB)and Lady Waterford.. "The two ladies closing the list are great on design" Rossetti informed Bell Scott (179). The pro- ject came to nothing. In 1854 she expressed great curiosity "to see what the Pre-Raphaelites have done this year, whether they are beginning to allow themselves a little beauty in moderate quantities. I respect them for abstaining from the pretty, and am sure theirs is the only school which will come at real beauty at last, so we must be content to let them pass through all their phases of ugliness first" (180). According to her sister Charlotte, these recent acquaintances had a bad effect on her work. She "lost a little of her spirited style" and instead there was "a degree of cramped Pre-Raphaelitism which is quite unsuitable in water-colours" (181). Ruskin gave encouragement at this time and even compared her gifts with those of the Pre-Raphaelites to her advantage" (182).

Meanwhile she continued to work. In 1855 six of her works were shown at an exhibition of water-colour drawings and pictures by Amateur Artists.. in aid of the Fund for the relief of the Widows and Orphans of British Officers engaged in the War with Russia. It was held at Burlington House,

Piccadilly. Her exhibits included a "Disciples sleeping in the Garden"
(no. 347) and an illustration of the Ballad of Auld Robin Gray (no. 920).
In April 1856 she wrote of trying to portray the funeral of the martyr
- the blind girl - in "Fabiola", a novel of early Church history by
Nicolas Wiseman which had been published two years previously (183). On
December 30th, 1857, she wrote at length to Mrs Bernal Osborne on the
importance of making teaching picturesque, like the parables, and not dull.
"How full of beautiful images are the old prophets" she wrote, "and one
knows well how a graphic image would awake attention" (184). In the Spring
of 1858 she travelled abroad with her mother for health reasons. In Menton
in March she made careful drawings of fishermen and shepherds (Fig.118).
They travelled to Genoa, Venice and Verona where she saw Giulio Romano's
frescoes but the trip was cut short by the death of her maternal grand-
mother. Back in Curraghmore on October 30th, 1858 she wrote to Mrs Bernal
Osborne of another idea for a picture - an illustration of Mrs Southey's
poem, "The Pauper's Deathbed" - which would convey ideas such as the
equality of souls and the levelling effect of death (185).

In March 1859 Lord Waterford was killed while out hunting. Louisa
then moved to Ford, Northumberland, Waterford's second estate, to the
improvement of which she devoted herself. For some months she did hardly
any work at all, an interesting exception being a copy of a crucifixion by
Antonella da Messina (186). In April and May of 1860 she travelled in
Europe and drew from a fresco of Lippi's at Prato. In the winter of 1860
she was hard at work again. Her letters refer to a painting of the
"Sleeping Disciples" (Fig. 119) and she also executed three frescoes in
distemper on religious themes (187). In January 1861, Mrs Dixon, the
miniature painter, came to stay with her (188).

In November, 1861, her sister died in India and shortly afterwards
Canning himself also died. In March 1862 she began a work by which she is
now chiefly known: "I am beginning a great experiment on a large drawing
board. It is to paint some compartments of the school in fresco, but I
doubt if I can accomplish it" (189). All the subjects were to concern
children from the Bible and her models were to be the inhabitants of Ford,
depicted life-size. Her method was to stretch paper on wooden frames, wash
this over with distemper and then paint on top in water-colour. This pro-
ject occupied her for the rest of her life and her letters constantly refer
to her progress and plans. The "frescoes" still exist in the hall and are
ten in number. The most ambitious are "Christ blessing the Little Children"
and "Jesus Christ among the doctors" which occupy the end walls (Fig. 120)
(190). Ruskin continued to give advice, and more particularly in the case

of her school project, criticism. He complained of the lack of perspective, chiaroscuro and outline and even disagreed with the basic idea of teaching Bible stories to children (191). In 1865 she spent several months copying a print from Van Eyck on his instigation. She did receive encouragement, however, and not from obscure sources: Watts, Burne-Jones and Landseer all praised her efforts (192).

A few other pictures and ideas for pictures of the 1860s and 1870s should be mentioned. "The Christmas Offering" of 1862 portrayed a poor woman with her child arriving exhausted at an Alms House on Christmas morning (193). In January 1863 she wrote: "I want to do a modern representation of the Holy Family, represented by a real poor cottage mother and child, who have taken refuge in a snowy barn, and are found and comforted by the love of poor neighbours, who bring their offerings, as the shepherds and kings of old, taking the composition of the old masters exactly as a model, and trying to treat modern dress and rags as picturesquely as I can" (194). In the 1870s she planned a series on Romeo and Juliet and the "times" in Ecclesiastes and wrote of painting a picture of "Hope painting the future in the brightest colours. It will be such a beautiful subject. A rainbow will pour into the room, and all its colours be reflected on her palette" (195). Her numerous duties did not allow her as much time for work as she would have liked. In 1878 she wrote "Art only comes in with the dregs and then I am tired out in body and mind, and a book is the only rest. No, a poor woman who is a proprietress has no power to make anything of Art etc." (196). She referred to herself as an amateur incapable of finishing a work properly and also complained of lack of encouragement (197).

Three noteworthy events occurred over this period. In 1865 she became a patroness of the Society of Female Artists. In 1867 her mother died and Lady Waterford succeeded to Highcliffe. From then on she divided her time between the two properties, spending her summers in Hampshire. Also she began exhibiting in London. In April 1873 she mentioned having four drawings at Sir Coutts Lindsay's Gallery and from 1878 she exhibited regularly at the Grosvenor. A criticism of the 1878 exhibits in the "Art Journal" was extremely encouraging: "One of the lady exhibitors, however, has, we think, excelled herself this year and that is the Marchioness of Waterford. For largeness of design, originality of invention, and purity of sentiment, we think her group of five children which she calls 'A Recollection' (167) and her 'Christmas', a poor madonna-like mother and child, seated in a wooden gallery, receiving gifts from peasants, because the "Lord of the Season always sends his representatives to receive

hommage and an offering", are surely two of the finest compositions in
the exhibition" (198). "Christmas" is presumably the work she wrote of
doing in 1862 - "a modern representation of the Holy Family" (199).

In 1879 she paid another visit to Italy and wrote of her love for
the work of Giotto, Ghirlandaio and Fra Bartolomeo. She continued to send
pictures to the Grosvenor Gallery until 1882 and then from 1883 exhibited
at the Dudley Gallery; she was amused to find herself referred to as L.A.
Waterford Esq. in the Dudley's exhibition catalogues. From 1886 she
exhibited at the Society of Lady Artists of which she became an Honorary
Member in 1887. She also exhibited at the Duchess of Leeds' exhibition
at Spencer House in 1887 and the Lowther exhibition in 1889 (200). Several
of her works were sold and she made full use of the proceeds for charities,
the income from her Ford Estates having diminished considerably. Her draw-
ing of "The Seven Ages of Man" of 1881 was so popular that she had to copy
it four times and refused the fifth request (201). She continued to favour
religious subjects and subjects involving the poor, whether from the Bible
or real life. In 1890 she visited the Queen at Osborne in the Isle of
Wight and gave her a picture of Time with a scythe over his shoulder (Fig. 121).
Before him were little children playing and beckoning him on and behind some
old people trying to hold him back for one wanted to go on reading and
another to finish a drawing. The work is a fitting conclusion to her life.
She died in April 1891. In 1892 an exhibition of her work was held at
Carlton House Terrace, for charity.

Two striking facts emerge from Lady Waterford's life. She had a
strong social conscience, a great awareness of her duties as a wealthy and
privileged lady to help those around her and to improve the living condi-
tions of the people on her estates. She greatly admired charity and altru-
ism in others. Her letters speak warmly of Edward Denison who taught the
Bible, "simply" to working men in the East End, of Augustus Hare her bio-
grapher who set up a "home" hospital, and of Octavia Hill. It is relevant
here to mention what she described as her "liberal" politics. She was
greatly in favour of industrialization, of the spread of railroads and
factories. She wanted progress, not temporary remedies for constant pro-
blems. She is also remarkable for her strongly religious interpretation
of life. After the death of her husband she wrote to Mrs John Leslie of her
belief in a positive, religious purpose behind all human events. Consis-
tently she also saw artistic ability as a gift from God. Her letter of
1851 to Lady Jane Ellice has already been quoted (202). One other, of
1889, is relevant. In contrast to Lady Jane Ellice, the Countess of Pembroke

had written to her expressing the hope that she would devote herself to
Art; she replied that her real duty in life was part of her situation
- to care for her two estates. She was not in a position to live for
Art although her artistic gift "like all gifts, is a great blessing to
be thankful for, and, as such, to be perfected as a talent, not hidden
under a napkin (through the bane of indolence), but used and fructified
as far as it can be in God's service, not for vanity, or emulation, or
rivalry, but simply with thankfulness" (203).

Augustus Hare's list of her works, mostly executed at Ford, makes it
possible to generalize on the themes favoured by Lady Waterford although
the absence of dates makes a discussion of development impossible (204).
Her primary source was the Bible, not only for Ford Village School but also
for numerous water-colours and drawings. Allegory is also a recurrent theme
in this list and in this context it is worth recalling her views on the
importance of making teaching picturesque, like the parables. Many of her
allegorical works were based on contrast: "Hope and Fear", "The Six
Virtues and Six Vices", "Hope and Memory", a pair called "War" and "Peace"
and another pair on the Fates and a young child: in the first they are old
and bring doom, in the second they are young and bring joy (205). Two of
her allegorical works were exhibited. The "Three Ages of Life" was shown
at the Grosvenor Gallery in 1881. It depicted a long flight of steps with
lovers clinging together at the top; in the middle "they are seen again,
still hand in hand, yet half-drifted apart, he engrossed in literature or
politics, she occupied with her children" and at the foot they are again
completely involved in each other with the old man helping his wife into
the boat which is to take them to the beyond (206). Her "Blackberry
Children" or "Blackberry Gatherers" was exhibited at the Duchess of Leeds'
exhibition in 1887. In this the image of children picking blackberries with
one hand and with the other holding fast to their father's hand becomes
an allegory for how men ought to conduct their lives, never losing sight
of God in the midst of worldly affairs (207). Attention should be drawn
to Lady Waterford's occasional reinterpretation of Biblical themes and
traditional allegorical images. Her "Christmas" of 1878 as a modern
version of the Holy Family has already been considered (208). An example
from among her allegorical works is "Autumn with a Winnowing Sieve" which
portrayed "not the usual glowing rich grape-crowned woman, but a haggard
toiling matron, middle-aged etc." (209). Throughout her life the poor
were her main subjects and her main models. Titles like "A Pauper's
Deathbed", "Helpless, Homeless, Hopeless", "The Dead Child" and "Poverty"

abound (210). Much of her work had a moral purpose and this presumably
is what she meant by using art "as far as it can be in God's service" (211).
She also completed some literary works. Her first main artistic project
after her husband's death was for a series of frescoes, by different
artists including herself, depicting scenes from Scott's "Marmion". This
was never finished but she did execute works on the theme. Finally her
work is remarkable for the number of children portrayed. Like several
other women artists who specialized in their portrayal, she had none her-
self. They enter into numerous pictures, the most notorious being "The
Babes in the Wood" and the village school frescoes - her main achievement.
They tend to be the subjects of her most harrowing pictures about death
and illness. Unlike her sister, Charlotte, Lady Waterford was not inter-
ested in landscapes or buildings; her main interest was people and
physiognomy.

Of all the contemporary tributes paid to Lady Waterford - and these
came from people such as Millais, Burne-Jones, Ruskin, Henry James and
Landseer (212) - the most extreme was that of G.F. Watts. In the mid 1850s,
Watts' first idea for his fresco in Lincoln's Inn had been to use designs
of Lady Waterford "and paint them on a scale in accordance with their grand
character, thinking them greater than any things produced since the time of
Michaelangelo" (213). Together with Burne-Jones he wished that she would
complete one fair-sized painting to "satisfy posterity that in 1866 there
lived an artist as great as Venice every knew" (214). Later, in his
"Memoir" to the catalogue for the 1892 exhibition, he wrote that "she was
born an artist greater than England has produced, the circumstances of her
life alone preventing her from working on to the full achievement. What
work she did accomplish was, as far as it went, of the very highest order".
In colour, proportion, movement and the disposition of masses her instinct
was always true. Her subjects he described as "always poetical, imaginative
and dignified" (215). It was her colour sense that was most frequently
praised and compared, on more than one occasion, to that of Venetian
painters. Another quality to be singled out was the massiveness of her
figures and here Michaelangelo was the only fit simile. George Moore's
opinion of the artist was not high but he acknowledged that for more than
a quarter of a century she was spoken of as "the one amateur of genius" (216).

8. ELIZA FLORENCE FOX (MRS FREDERICK LEE BRIDELL)

Eliza Florence Fox was born around 1825 in Hackney and was the daughter of W.J. Fox, Esq., M.P. for Oldham, the eloquent advocate of the Repeal of the Corn Laws and the first man to bring forward in the House of Commons a bill for National Education. She had one brother, Franklin, and a sister Florence. Her parents separated in 1835 and her father then lived with Eliza Flower, the composer. In the 1830s, as has already been seen in the biography of Margaret Gillies, Fox was editor of the "Monthly Repository" and was closely connected with many famous writers and intellectuals of the day. Eliza's childhood was presumably passed in the company of such people - she had "no youthful companions" (217) - and the feminist bias of the group, particularly of her father, must surely have influenced her desire to adopt a career. Influence aside, there can be no doubt about her views on the present condition of women. Harriet Taylor wrote of her: "... when I knew her in her early youth she appeared to interest herself strongly in the cause of which for many years my life and exertions have been devoted, justice for women" (218). Her first ambition was to be an actress but Macready, a friend of her father, advised against it. Her second choice was art and although this went unopposed, she was denied a formal art education. According to Clayton: "Her father gave her a good general education, but, unhappily for a girl eagerly desirous to study drawing and painting, he had the idea firmly implanted in his mind that 'to be an artist did not require special training; that observation and steady practice were all that was necessary'" and he was confirmed in this view by an eminent artist of the day to whom some of her early attempts were shown (219). She was given Albinus' "Anatomy" however and obtained permission to copy at the British Museum and National Gallery. Like most women artists of the period, she set out to be a portrait painter and by the age of nineteen, "had taken the portraits of all the friends and relations who were good enough to favour her by sitting" (220). A drawing of Eliza Flower may date from this period (Fig.122). An early glimpse of the self-taught artist is afforded by her first memory of Robert Browning: "I see myself, a child, sitting drawing at a sunny cottage window in the then rural suburb of Bayswater. ... I remember that I was trying to copy Retsch's design of a young knight surrounded by Undines, who seek to entice him down with them into the waves, when Mr Browning entered the little drawing-room." (221). A year or two later Browning told dazzling stories about Venice whence he had just returned. She wrote: "My own passionate longing to see Venice dates from those delightful well-remembered evenings of my childhood" (222).

When she was nineteen, an artist friend of the family took pity on
her lonely efforts and persuaded her father to send her to "the only good
academy at that time open to women" (223). So around 1844 she was
allowed to attend Sass's School in Bloomsbury, then conducted by Mr Cary
and visited by Mr Redgrave. She studied there for three years (224) and
about a year after leaving, started classes of her own at which women
could practice drawing from the nude. As has already been seen in Chapter
One this was instigated by strong feelings, fired by personal experience,
about the inadequacy of the art education available to women (225). She
was also one of the first to complain of the injustice of women's
exclusion from the Royal Academy Schools (226). These practice sessions,
held in her father's library, continued for some years and afterwards she
even gave instruction up until the time of her marriage in 1859.

Between 1846 and 1858 Eliza Fox sent work to the Royal Academy, the
Society of British Artists and the Society of Female Artists to which
she contributed from its foundation in 1857. She exhibited sixteen por-
traits during this period, including at least two of her father (227). She
also exhibited subject pictures, the most notable of which were "The
Soldier's Bequest" - presumably a mother and child - of 1848 (SBA no.109)
and "The Patriot" of 1857 (RA no. 522) (228). Her "Study of a Factory
Child" of 1850 (RA no. 197) is best seen in the light of her father's
"Lectures addressed chiefly to the Working Classes" of 1849. In the same
year, 1849, Eliza Fox met Elizabeth Gaskell and the two became intimate
friends. Their correspondence dates from May 16th and where Eliza is con-
cerned the most interesting letter is dated February, 1850, when she wrote
to Mrs Gaskell of a scheme for visiting Munich for six months art training
(229). It is not known whether she went but the intention alone reveals
her constant desire to improve.

In the Autumn of 1858 she went to Rome to study art. Two incidents
which occurred during this trip are worthy of mention. The first may be
given in the artist's own words: "In 1858-9 I paid a visit to Rome, where
Mr and Mrs Browning were also spending the winter on account of her health,
and I saw a good deal of them; more especially, I had the great felicity
of passing many hours in the company of Mrs Browning, for she kindly sat to
me for her portrait in chalks .. The portrait, I may be excused for mention-
ing, was exhibited at the Royal Academy the same year, and was considered
successful by most of those who knew her. She seemed to me to be an
angel on earth, so modest, so unselfish .." (230) (Fig. 123). At the same
time she met her future husband, Frederick Lee Bridell, an artist who

specialized in poetic landscape. On March 9th, 1859 it was announced in "The Times" that Eliza Fox had married the landscape painter in Rome. She sent a portrait of her husband to the Royal Academy in 1859 (no. 853). A pencil sketch in the Southampton Art Gallery may relate to this portrait (Fig. 124).

After her marriage the artist exhibited fewer portraits and more subject pictures, a change which Clayton attributed to the influence of her husband (231). The couple spent long periods in Italy and many of her themes were drawn from Italian life. During the four years of her marriage to Mr Bridell she achieved fame, chiefly on account of her main contribution to the Society of Female Artists in 1861: "Saint Perpetua and Saint Felicitas" (no. 83) (232). It will be recalled that Margaret Gillies had already depicted the martyr, Saint Perpetua, two years earlier, on the basis of a literary version by Sarah Flower, the sister of W.J. Fox's mistress (233). This also had been shown at the Society of Female Artists. Mrs Bridell's version was acclaimed mainly on account of her rendering of St. Felicitas as an African (234). It was priced at £36. 15s., her most expensive work to date.

In 1863 her husband died and she made a prolonged visit to Algiers. According to Clayton, her life there was "full of interest and novelty" and Madame MacMahon, wife of the Governor of Algeria, "rendered Mrs. Bridell much assistance in obtaining insight into the native Arab life" (235). She painted genre scenes and also executed portraits of resident notabilities.

Between 1864 and 1866 Mrs Bridell exhibited only four works. Two of these were literary subjects, a new area for the artist, and both "The Love Letters" (RA 1864 no. 456) with a quotation from Tennyson (236) and "Little Ellie" (RA 1865 no. 608) from Elizabeth Barrett Browning's "Romance of the Swan's Nest" received favourable reviews (237). In 1866 she sent "Restitution" to the Paris Salon (no. 261). Her Arab subjects did not come before the public eye until 1867 when she sent ten works to the Society of Female Artists, eight of which depicted people in Algiers. In the same year she began exhibiting at the Dudley Gallery and similar subjects appeared at this institution, the Royal Academy and the Society of Female Artists until 1871. Her most highly priced exhibited work was "An Arab Epithalamium" at the Dudley Gallery in 1870 (exhibition of oil paintings no. 127) which commanded £45. The main exception to these themes was a third literary subject, this time from Robert Browning's "Men and Women", at the Royal Academy in 1870 (no. 427) (238). In 1866 or 1867 she resumed the profession of art teacher and ran classes for the study of

the living model under the aegis of the Society of Female Artists (239).
Her continuing interest in "justice for women" and close association
with the movement's main supporters emerge from a passage in A.J. Munby's
diary, dated February 11th, 1869. On this date he attended a conversa-
tion party at Mme Bodichon's and there found "a small and agreeable gather-
ing of cultivated and accomplished women" such as Frances Power Cobbe, Mrs
Malleson, Emily Davies, Harriet Taylor and Eliza Bridell. The conversa-
tion centred on the progress of women's liberation (240). In 1868 Mrs
Bridell had exhibited a portrait of Mme Bodichon at the Royal Academy in
addition to a third portrait of her father, recently deceased (nos. 573
and 606) (241).

In 1871 Mrs.Bridell married her cousin Mr George Edward Fox, thereby
resuming her maiden name, but henceforth exhibiting under the double name
of Bridell-Fox. Between 1872 and 1887 she sent only one work to the Royal
Academy, in 1883. Her works were mostly seen at the Society of Lady Artists
and the Dudley Gallery. Children, always a popular subject with the
artist, figured in many of these and from 1877, after two years absence
from exhibitions, Italian themes reappeared suggesting that these two
years were spent in Italy. Her most ambitious exhibit was "Ave More" (SLA
1879 no.257) with a quotation from Horace (242).

She last exhibited in 1887. In 1890 an article by her on Robert
Browning was published in the "Argosy" (243) and in 1895 Miss Beatrice
Smallfield exhibited a portrait of her at the Royal Academy (no. 1219).

By the end of her exhibiting career Eliza Bridell-Fox was best known
for her scenes from Arab life. An examination of her total oeuvre, how-
ever, reveals a different emphasis. The artist was particularly interested
in children, whether from history, literature, fairy-tales or everyday life.
The latter category included the documentary, as in her "Study of a
Factory Child", sentimental genre as in "We're going to the field with
father's dinner" and "News from Baby's Father" (SLA 1879 no.48 and 1874
no. 554) and also emotional scenes such as "The Soldier's Bequest" (SBA 1848
no. 109). Unfortunately the only presently known examples of her work are
portraits. Eliza Bridell-Fox deserves tribute as the first active and
vocal advocate of improvement in women's art education in England.

9. SUSAN D. DURANT

This artist was born in Devonshire in the 1820s. She took up sculp-
ture as an amateur but success encouraged her to adopt art as a profession.
She went to France for her art education and became a pupil of the Baron
Henri de Triqueti. From 1847 she lived in London and exhibited at the
Royal Academy. For the first ten years, until 1857, she exhibited exclu-
sively at that institution, sending eight busts including one of herself in
1853 (no.1449) and one of Harriet Beecher Stowe in 1857 (no.1353). The
latter was thought to be a striking likeness and won her fame (244). She
also exhibited two subject pictures: "The chief mourner; statue of a girl"
in 1850 (no. 1346) and a "Statue in marble, of Robin Hood" in 1856 (no.1271)
which was thought to show promise (245). From 1858 she also exhibited at
the Society of Female Artists and in 1860 sent her only work to the British
Institution. Her main exhibits between 1858 and 1865 were "The Negligent
Watchboy of the Vineyard catching locusts" a subject from Theocritus which,
when exhibited at the British Institution, was priced at 250 guineas
(1860 no.648), "The Faithful Shepherdess", a marble statue executed by
order of the Corporation of London for Mansion House (RA 1863 no.1025)
(Fig. 125) and three marble bas-reliefs portraying Thetis exhibited at the
Society of Female Artists in 1863. In 1864 she was in Paris again, work-
ing in the studio of her former teacher, of whom she exhibited a portrait
in 1864 (RA no. 890). While there she executed a head of Homer which was
to be placed over the front door of a country house recently purchased by
Mrs Grote, founder of the Society of Female Artists (246). Her connection
with the Grotes was close at this time. She exhibited a medallion por-
trait of George Grote in 1863 (RA no.1135) (Fig. 126) and in 1865 Grote
was reported to have "stepped out" with Miss Durant, after emerging from
32 years' labour on his "History of Greece", to the dismay of his wife (247).

Around 1865 Durant was introduced to the court of Queen Victoria and
became the second female sculptor to receive royal patronage (248). In
1866, in addition to a subject from Chaucer, she exhibited seven portrait
medallions of members of the royal family, including one of the Queen (RA
nos 855, 875-877, 890-893). She also executed one of the Prince Consort.
In 1866 she was commissioned by the Queen to execute a Cenotaph for King
Leopold I of Belgium who had died in 1865, to be erected in St. George's
Chapel, Windsor (249) and in the same year she was given another commission,
together with her teacher Triqueti, to decorate the Wolsey Chapel, an order
which took two years to fulfil. She also instructed the Princess Louise in

sculpture. The Diary of A.J. Munby provides an interesting glimpse of Miss Durant at about this time. He met the sculptor at the Theodore Martin's on February 11th, 1866: "Miss Durant is a very striking person: she was alone; she sailed in upon us - Mrs Martin and me - a tall and very comely young woman, apparently under thirty, well-made, with rounded limbs, full bust, flashing face, and massive rippling chestnut hair; erect, high-couraged, and superbly drest. And her talk was worthy of all this: she dwelt with airy ease, but without parade of learning, upon art works, art subjects, upon Italy and Dresden and the like; upon Michaelangelo, and Gian Bellini, and whether Benvenuto Cellini ever worked in marble; upon Roman and Pompeian art, and the 'points' of that new and noble Sileno, a copy of which in bronze stood in the centre of the dinner table; .. And withal she was full of graceful fun, and told happy stories of the Queen and Princesses, with whom it seems she is a favourite". He also wrote that in contrast to working class women, "in a drawing-room creature, such self-asserting strength looks somewhat masculine and out of place" (250).

Between 1867 and 1873, the year of her death, Durant exhibited nine portrait sculptures, five of which portrayed royalty. Two of the latter were part of the decoration of Wolsey's Chapel and one, of the Queen, was executed for the benchers of the Inner Temple (RA 1872 no. 1517). It is possible that "Ruth", exhibited in 1869, was a Biblical subject. Her last exhibited work, which was shown posthumously, was a portrait of Mrs Garrett Anderson, M.D. (RA 1873 no. 1577). She died on January 1st, 1873, at Triqueti's house in Paris (251).

10. ANNA BLUNDEN (MRS FRANCIS MARTINO)

Anna Blunden was born in St. John's Square, London, on December
22nd, 1829. Her father, Mr. James Blunden, was a bookbinder in Clerken-
well. In 1833, on the birth of the second daughter, Charlotte, the
family moved to Exeter where Mrs Blunden owned a house in the Cathedral
Close. In 1834 a third daughter, Emily, was born. The children went to
a Quaker School in Exeter. Anna's early desire to become an artist has
been attributed to the influence of her mother, who, although untaught,
painted figures and flowers in water-colours with some proficiency.
Despite this her parents were sceptical about art as a profession and
she was sent for training as a governess to the school of a Miss Harvey
at Babbicombe, then a rural village near Torquay. Having left the
school she occupied a place with a doctor's family in Torquay for a year
and then another at a farm-house near Crediton. The latter she found so
unpleasant that, fired with enthusiasm by Ruskin's "Modern Painters", she
sought, and this time obtained, her parents' consent to study art in
London. James Matthew Leigh's Academy in Newman Street was recommended
and she went there on days appointed for ladies, learning anatomy and study-
ing from the living model. She also drew from the Antique in the British
Museum and copied old masters in the National Gallery.

In 1854 she exhibited "Love" at the Royal Academy (no. 229) and a
picture illustrating Hood's "Song of the Shirt" at the Society of British
Artists (no. 133) (252). The latter was engraved the same year and repro-
duced in the "Illustrated London News" (253) (Fig.24). In 1855 she
exhibited two works, also at the Society of British Artists: "The Emigrant",
another social theme again with a female subject, and "The Mother's Tale"
(SBA nos. 40 and 445) (254). In the same year she returned to Exeter where
she lived with her sister until 1867. From the Autumn of 1855 dates her
correspondence with John Ruskin to whom she first sent examples of her
writing and poetry asking if they should be published (255). In 1856 she
exhibited four works, including another scene of poverty, "A sister of mercy"
(RA no. 125) (256) and one of death which was priced at £25 (257). Probably
for financial reasons, Anna Blunden's parents were anxious that their
daughter should execute more portraits. Ruskin's advice - and she was
heavily dependent on this by now - was to do this by all means but to make
some small part of the portrait into a study, whether it be drapery or
background (258). Although not a portrait, her next Royal Academy exhibit,
"The daguerrotype" (RA 1857 no. 490), provides an instance of her doing
exactly this. The picture portrayed a mother and child looking at a

photograph of the absent father; a richly painted garden is visible through a nearby window and this Ruskin praised as evidence of her having an eye for colour (259). In the same year she sent two works to the British Institution and exhibited five works, four of them already shown at former exhibitions, at the Society of Female Artists to which she sent work for two more years. With "Past and Present" of 1858 (RA no. 428) in which the past was exemplified by a picturesque ruin and the present by two children making bouquets of flowers, the artist received warm praise from Ruskin in his Academy Notes: "There is not a more painstaking nor sincere piece of work than this in the room" he began, and went on to commend certain pieces of the old manor house and foreground (260). Anna Blunden soon fell in love with Ruskin and from October 1858 for several months, Ruskin's letters to her were no more than repeated rebuffs (261). "God's Gothic" (RA 1859 no. 441) which depicted an old boat on a beach won Ruskin's praise in his Notes, particularly for its colour. As so often in his letters, however, he complained of harshness in the treatment and recommended that she should make her handling "a little more tender" (262). The picture was bought at the Private View by David Roberts RA and Ruskin hearing of this, said: "Mr Roberts might learn something by that picture if he would but study it" (263). Mr Roberts afterwards presented the work to Sir Roderick Murchison who had admired it on account of its geological accuracy. After this, figurative subjects became rarer and rarer among the artist's exhibited works and mood pictures were even more infrequent. "The returning penitent" of 1860, her unique contribution to the British Institution (no.38), was her last work on an emotive theme. This development was fully in line with Ruskin's recommendations. He thoroughly disapproved of the common run of women who "let their feelings run away with them, and get to painting angels and mourners when they should be painting brickbats and stones" (264). In May 1862 he told her to "give figures up at once" for she would never succeed in this line owing to her lack of taste (265). From March 1860 she executed copies for Ruskin in the Kensington Museum, mostly of Turner. In 1861 she obtained a reference from him for the position of art teacher at Cheltenham, presumably the Ladies' College (266). Apparently she did not obtain, or did not accept the post. His letters of the early 1860s - they ceased corresponding in May 1862 - were not entirely critical. In one of his last letters he told her that she had "a power of colouring which I have rarely seen equalled" (267) and this point - her colour sense - was echoed by other critics throughout her career (268).

Between 1860 and 1867 most of her exhibited works were landscapes
and "Mullion Cove, near the Lizard" at the Royal Academy in 1864 (no. 520)
was widely praised. One critic referred to it as "a true rendering of
terrestrial anatomy" (269). She also exhibited at the Society of British
Artists and, from 1865, at the Dudley Gallery. Her most ambitious work
of this period was "The Fairy Glen" at the Society of British Artists
(1866 no. 391) which was priced at £100.

In 1867, having exhibited a successful work, "Tintagel", at the Royal
Academy (no. 672) (270) she went abroad: "I had myself no wish to go abroad,
but I was strongly persuaded to leave England by some friends, who thought
the change would be likely to relieve or cure a nervous illness from which
I suffered" (271). This was almost certainly an illness resulting from her
unhappy relationship with Ruskin. She went to Paris at the time of the
Exposition Universelle and then on to Lucerne where she spent the whole
summer "doing what subjects I could find in the immediate neighbourhood"
(272). That winter she passed at Dusseldorf and in the summer of 1868 she
travelled in the Alps, settling the following winter in Rome where she re-
mained until 1872. According to an art critic visiting Rome in 1870 her
reputation in that city was considerable and she did not lack for pur-
chasers (273). While in Rome she made friends with a Danish woman artist,
presumably Elizabeth Jerichau (274). Throughout this period her land-
scapes continued to appear in London, mostly at the Dudley Gallery.

Anna Blunden returned to England because of the death of her sister
in April 1872. In 1869 Emily Blunden had become the second wife of
Francis Richard Martino, a successful Birmingham manufacturer of Italian
origin, but she died shortly after the birth of a son. The father was left
with the young child of his earlier marriage and a baby of two weeks. Anna
then married her brother-in-law, thereby providing a home for his children.
The marriage took place in Altona, near Hamburg in December 1872, English
law necessitating a foreign wedding and in 1874 she gave birth to a
daughter at the age of forty-five. 1872 was the last year she exhibited
at the Royal Academy. She sent landscapes to the Dudley Gallery from
1873 to 1877 and in the winter of 1876-7 exhibited at the Society of
British Artists. From 1861 she had also exhibited with the Birmingham
Society of Artists; she was to show a total of 133 works at this institu-
tion before her death in 1915. In later life she became concerned with
local social problems and also wrote on such subjects. Although she
remained an admirer of Ruskin she was not without bitterness where his

influence on her own work was concerned. She intended to write an autobiography and include some of Ruskin's letters to her, in order "to show by a detailed account of all his influence on myself the mistakes Mr. Ruskin has made" (275).

Under the influence of Ruskin Anna Blunden became a landscape painter and as such was particularly fond of distant views of mountains over water (Fig. 127). But she is known and was possibly more popular as a figurative painter of emotive and occasionally social themes in the 1850s.

11. JOANNA MARY BOYCE (MRS H.T. WELLS)

This artist was born in Maida Hill, London, on December 7th, 1831, the second daughter of George J. Boyce, a leading pawn-broker of the neighbourhood. Her elder brother, George P. Boyce (1826-1897) also became an artist and was an early purchaser of Pre-Raphaelite works.

Until the age of eighteen she worked at home and from early child-hood made numerous portrait sketches. Ruskin's writings stimulated her as did the works of Millais, D.G. Rossetti and Holman Hunt, and she would have come into close contact with these through her brother. According to an obituary in the "Critic": "From their works she derived valuable stimulus assimilating to herself much that is best in the spirit of them, borrowing nothing of the 'letter' as the common run of so-called Pre-Raffaelites do" (276). When she was eighteen she entered the school of Mr Cary and subsequently that of Mr Leigh and there, according to another obituary, "she undoubtedly acquired that firm and definite manner that characterized all her works" (277).

Her first finished picture was executed in 1852 and portrayed a Welsh boy at Bettws-y-Coed. Over the next two years children were her main subjects and her first exhibited work, at the Society of British Artists in 1853, was a "Study of a Welsh Boy" (no. 7). Her reputation dates from 1855 when she sent a study, known as "Elgiva", to the Royal Academy (no. 131). Ford Madox Brown referred to this in his diary as "the best head in the Rooms" (278) and Ruskin devoted a paragraph of his "Academy Notes" to criticism of the work: "The expression in this head is so subtle, and so tenderly wrought, that at first the picture might easily be passed as hard or cold; but it could only so be passed, as Elgiva herself might have been sometimes seen, - by a stranger - without penetration of her sorrow. As we watch the face for a little time, the slight arch of the lip begins to quiver, and the eyes fill with ineffable sadness and on-look of despair. The dignity of all the treatment - the beautiful imagination of faint, but pure colour, place this picture, to my mind, among those of the very highest power and promise" (279).

In the same year, 1855, her father died and in September she went to Paris. There she joined a ladies' class in the atelier of Thomas Couture but found his style of art so uncongenial, so remote from what she herself wanted to achieve, that she left after a few weeks. She remained in Paris, however, and worked on her own. She began a picture of "Rowena offering the Wassail Cup to Vortigern" and also executed a portrait of Mme Hereau, reader to the Empress Marie Louise, a work which has been described as "a vigorous transcript of a head strongly marked by character and energy .."(280

From Paris, during the winter of 1855/6, she contributed articles to the "Saturday Review" on the Paris Exposition Universelle. On her return she completed the series with reviews of the Royal Academy and the Water-colour exhibitions (281). Her portrait of Mme Hereau was exhibited at the Royal Academy in 1856 (no. 205) and a work entitled "Our housemaid" at the same institution in 1857 (no. 385). Her picture of Rowena, begun in Paris, was also sent to the latter exhibition, but rejected.

In May 1857 she travelled through France to Italy where she began a lengthy tour. She spent the summer months at Todi and afterwards visited Florence and the other cities in Tuscany. Her future husband, Mr Wells, was one of the party. In December they were married in Rome and they then visited Naples and the surrounding neighbourhood. While in Rome she executed a portrait of her hostess, Margaret Piotti and several genre subjects. She also began an important picture known as "The Boy's Crusade". Towards the end of March 1858 she returned to England and soon afterwards began a future Royal Academy exhibit called "Peep-bo". The Autumn she spent at Holmbury Hill in Surrey where she painted "The Outcast", a work which has already been described in Chapter Three (282). This work was rejected at the Royal Academy exhibition of 1859 and afterwards exhibited at the Winter Exhibition together with "Do I like butter?" which was "a charming study of a little girl making that enquiry of a buttercup" (283). "The Outcast" was bought by the Leeds collector T.E. Plint.

Having exhibited "A homestead in the Surrey hills" at the Royal Academy in 1859 (no. 352) she spent the Autumn at Hindhead Common and painted local subjects. In 1860 she exhibited a work which she had begun in Rome in 1857, at the Royal Academy: "The departure - an episode of the Child's Crusade" (no. 466) and in 1861 another long-studied subject: "Peep-bo" (no. 463) (Fig. 128). She exhibited two other works at the latter exhibition: "The Veneziana" and "Heather Gatherer, Hind Head" (nos. 94 and 489), the latter of which was greatly appreciated by G.F. Watts (284). These were the last works exhibited during the artist's life-time. She died on July 15th, 1861 after giving birth. Her last exhibited work was "A Bird of God" which was shown posthumously at the Royal Academy in 1862 (no. 661). She left several unfinished works: "Sibyl" ("the head exceedingly grand and bearing the direct impress of mental elevation and force in the artist"), a full length study of a German woman ("the head of astonishing intensity as to character and style ..") (285) and Gretchen, now in the Tate Gallery.

Her death was bitterly regretted in the press and much was written about the extraordinary combination of power and sensitivity in her work (286). The greatest tribute comes from William Michael Rossetti. In his "Academy Notes" in "Fraser's Magazine" he described her as "the best painter that ever handled a brush with a female hand and also predicted that she would "long probably remain the leader of our female art, and, indeed, the most richly gifted of all women painters" (287). In "Some Reminiscences" he recorded: "All the artists whom I best knew and valued deplored her death as a real loss to art; they had looked upon her as the leading hope for painting in the hands of a woman" (288). In 1935 a retrospective of her work was held at the Tate Gallery, a unique event where nineteenth century women artists in England are concerned. A sentence of high praise was published in the "Times" review: "Miss Boyce was, in fact, much more of a 'painter' than most of the Pre-Raphaelites, her work being remarkable for warm, deep colouring and a true feeling for pigment" (289).

12. HENRIETTA MARY ADA WARD (MRS EDWARD MATTHEW WARD)

Henrietta Ward was born on June 1st, 1832, into a family of strong
artistic tradition. Her grandfather was James Ward RA, the animal painter
and engraver and she had several eminent paternal grand-uncles by birth or
marriage including William Ward A.R.A., George Morland, H.B. Chalon, the
sporting painter and Edward Williams the engraver. Her aunt, James Ward's
daughter, married John Jackson R.A., Henrietta was the daughter of George
Raphael Ward, the engraver and miniaturist who copied Thomas Lawrence on
ivory and of Mary Webb, an accomplished miniature painter (290).

In her autobiography she wrote: "Much has been said about the
strictness and repression of children in Victorian times. My youth was an
exception to this rule" (291). At her home in Fitzroy Square she saw much
of eminent men such as Thomas More and Edwin Landseer and spent a great deal
of her time with her grandfather. Her mother taught her to draw but it was
James Ward who encouraged her most to develop her gifts and she could draw
and paint before she could read. At the age of six or seven she copied her
grandfather's lithographs of horses and she also sketched animals from
nature. Her predilection for such subjects remained and she often intro-
duced animals into her later works (292). When ten or eleven, she drew some
illustrations for "Robinson Crusoe". She also painted portraits of friends
and relations.

Around 1842 she met the twenty-seven year old Edward Matthew Ward,
a painter of historical genre who bore no relation to Henrietta's family and
who lived with his parents in a street adjoining Fitzroy Square. "Finding
that I was interested in Art, Edward Ward became my critic, my drawings were
shown, and he gave me many valuable casts to help me in my studies. He
taught me much that was helpful in drawing, and we soon became fast friends"
(293). Both were gifted muscially as well as artistically. According to
her autobiography Henrietta first exhibited at the Royal Academy in 1846,
when "Elizabeth Woodville parting from the Duke of York" was shown and she
also states that two still-lives were hung at the Academy in 1847 (294).
They are not listed in the catalogues.

In the winter of 1846/7, at the age of fourteen and a half, she
became engaged to Edward Ward against the wishes of her parents and was cut
off by her mother and friends. She continued to work and in 1849 exhibited
"A study of heads" at the Royal Academy (no. 885). In 1849 she married
Ward who was already distinguished as an historical painter, having in 1848
become an Associate of the Royal Academy. Looking back on this time the
artist wrote: "the joy of following a profession entirely to one's

satisfaction is a privilege known only to a few. My husband was a
rising man, broad-minded enough to take pleasure in the fact that I too
was an artist. I worked on my own lines, but found him always the kindest
teacher, the most unfailing friend I have ever known" (295). In 1850, at
which time she was studying at Sass's school in Bloomsbury, they moved to
33 Harewood Square where she had her own studio and from there she sent
"Result of an Antwerp Marketing" to the Royal Academy (no. 495). It was
a still-life done from a sketch made during her honeymoon and was des-
cribed in the "Athenaeum" as a "vigorously executed and truthful perfor-
mance" (296). In the same year she gave birth to a daughter, Alice, and
in 1851, having exhibited two works at the Royal Academy, she bore a son,
Leslie. After the birth of her second child she devoted a year to domes-
tic duties which she hated. She then took apartments in Bloomsbury to be
close to Sass's school and spent six months studying anatomy and drawing
"assiduously" (297). It may have been around this time that she became
the first female to attend the Royal Academy Lectures for students despite
the determined opposition of Mr Jones R.A., Keeper of the Schools (298).
Her Royal Academy exhibit of 1852, "Antwerp Market" (no. 444), was bought
by Mr Bashall of Preston.

From 1853 to 1879 Mrs Ward exhibited a long succession of successful
and popular works at the Royal Academy, all of them including and most of
them featuring women and particularly children. Between 1853 and 1857
these were mainly genre scenes: "Scene from the Camp at Chobham .." of
1854 (no. 582), "The Morning Lesson" of 1855 (no. 348), "The intruders" of
1856 (no. 330) and "God Save the Queen" of 1857 (no. 122) were all anonymous
scenes with children as their main subjects (299). She also exhibited two
"May Queen"'s, one based on the event at Langley near Cheshunt where her
grandfather lived (RA 1853 no. 1071) and one from Tennyson's poem (RA 1856
no. 556)(300). Her highly detailed style which probably derived from
training under her father, won praise, and so too did her conception of the
subject (301). In 1854 the "Art Journal" wrote of "great intellectual power"
and in 1856 and 1857 her contributions were described as among the most
successful works in the exhibition (302). Both the "May Queen" of 1856
and "God Save the Queen" of 1857 were engraved. In 1857 she was visited
by Queen Victoria who gave her some important commissions; among the first
were portraits of Princess Beatrice and Prince Leopold. From then on she
worked intermittently at Windsor. In 1858 Mrs Ward exhibited her first
historical subject: "Howard's Farewell to England.." (RA no.360), the
first of many touching historical anecdotes. Typically it included women
and children (303). This was considered to be her most important work to

date and was even described as superior "in vigour of execution" to the work of many of her famous colleagues (304). After this she added success to success in the same style. The childhood of the great was a favourite theme: she portrayed the Princes in the Tower (Fig. 129) two incidents from the childhood of Frederick the Great of Prussia, the childhoods of Joan of Arc (Fig. 10) the Old Pretender, Chatterton, the poet James Hogg and the Princess Charlotte of Wales (305). Another major theme was the suffering and bravery of historical women: Henrietta Maria mourning the death of her husband Charles I, Mary Queen of Scots saying goodbye to her son at Stirling Castle (Fig. 8), Lady Jane Grey submitting reluctantly to the title of Queen, Empress Josephine meeting her son as the King of Rome for the first time and the bravery of the Countess of Derby and her two daughters during the defence of Latham House (306). In 1864 James Dafforne wrote a monograph on the artist and claimed to know of no lady, "attaining so high a position as a painter of history as Mrs Ward" (307). Several of these works were engraved (308) and among those that were sold, "The Princes in the Tower" of 1864 (RA no. 565) (Fig. 129) fetched 200 guineas (309). The latter also won a first class medal when exhibited in Vienna. One of her most successful works was "Palissy the Potter" of 1866 (no. 385), a moving picture showing Palissy stricken with grief after the failure of an experiment which was to have enabled him to pay off his creditors; this was engraved and sold and described by the artist herself as "one of my best efforts" (310) (Fig. 9). But she achieved most fame with "Newgate 1818" (RA 1876 no. 120) which portrayed Elizabeth Fry taking Mary Sanderson to see the female prisoners (311). This was also engraved and even taken to Osborne for the Queen to see privately. She exhibited at the Society of Female Artists from its foundation in 1857 and became an Honorary Member in 1877. She sent works previously exhibited at the Royal Academy and also small scale pictures mostly belonging to the category of domestic genre.

Having exhibited "Melody" in 1879 (RA no. 1394), depicting a young lady playing the violin, the artist did not exhibit again for three years. In 1880 she began teaching at her studio at 6 William Street, Lowndes Square. She started with four pupils "and soon had more than I could possibly cope with. When I used to arrive in the morning from Windsor, I was soon accustomed to finding the hall full of parents and guardians, wishing to place their daughters under my charge.. My school was the only one of its kind in London, and I had the sole monopoly, I believe" (312). She had royal patrons and visiting professors included many Academicians.

After three years teaching at William Street, she left Windsor where she had been living since 1876 and bought a house in Gerald Road. To this she added a studio and taught her pupils there. She gave private lessons to many daughters of royalty and the aristocracy (313).

"One of the last lays of Robert Burns" of 1878 (RA no.380) was Mrs Ward's last historical work to appear at exhibitions. From the 1880s she exhibited only occasionally and towards the end of her career - her last appearance was in 1921 - she turned to landscape. She died in 1924.

Mrs Ward's appeal is not easy to define. She was often praised for the instructive element in her works and this was an important factor in Victorian art of the period. It was particularly strong in her most popular work, "Newgate 1818". Here she was at one with her husband of whom she wrote: "He never began a work without being persuaded that it had the right elements to teach some truth" (314). She was also adept at what she called conjuring up "past events and making them a living reality" (315). This is most evident in works like "The Queen's Lodge, Windsor, in 1786" (RA 1872 no.510) which portrayed the King and Queen at home with their children during a visit from Mrs Delaney (316). But most of all her success is due to a combination of these two things. She appealed because of her ability to reduce the great to average domestic size whether by showing them as children or as adults in a domestic context, while at the same time making them examples of good conduct. Her subjects were easy to relate to and models of good behaviour. An explanation of why she became a successful painter is not so difficult. Talent aside she had the advantage of being born into a family of artists and marrying an artist who appears to have been as anxious for her success as for his own. The following is her account of her privileged situation: "In my young days most people would have agreed with Mrs Collins that a wife and mother had no right to be a practitioner in paint, and I think in most households it would have been rendered impossible by the husband's and relations' combined antagonism to the idea. Edward was greatly in advance of his age in broad-mindedness, and this fact spurred me on to success. My work required great concentration, and orders were strictly enforced that I was not to be disturbed during certain hours of the day" (317). At a time when the "disabilities of sex" were strongly marked (318), she had every opportunity. One of the few injustices from which she suffered personally was the failure of the Royal Academy to admit her as a member despite constant prompting from the press (319).

13. EMILY MARY OSBORN

This artist was born in 1834, the eldest of nine children. Until she was fourteen the family lived at West Tilbury, Essex. They then moved to London where her father, a clergyman, had obtained a curacy. After some hesitation her parents allowed her to attend an evening class at Mr Dickinson's Academy in Maddox Street (320). Mr Mogford, her teacher, was very encouraging and under his successor, James Matthew Leigh, she went to morning classes. Three months later her father wished her to stop these lessons for a while, presumably for financial reasons, but Leigh made this unnecessary by offering to teach Emily, together with another girl, privately at his house. For a year she worked directly under him, first paying daily visits to his house and afterwards attending his Academy in Newman Street. "To the kindness of Mr Leigh she acknowledges herself indebted for almost all the instruction she has received" (321).

Her first exhibited works appeared at the Royal Academy in 1851. One was a genre subject, "The Letter" (no. 409), and one a portrait of Mrs Benjamin Goode (no. 1192). From the following year she also exhibited at the British Institution. Over the next three years she sent four poetical subjects to exhibitions: three of these, from Byron (RA 1852 no. 89), Collins (BI 1853 no. 388) and Tennyson (BI 1854 no.444), were direct illustrations and portrayed female figures; one was a mood picture, "Evening" (BI 1852 no. 358), poeticized by verses of E. Haydon Osborn (322). "Pickles and Preserves" exhibited in 1854 (RA no. 558) was bought by a Mr C.J. Mitchell "as an encouragement to the artist to go on" (323).

1855 was an important year. Mr Mitchell's brother, a Mr William Mitchell, commissioned a group of life-sized portraits of Mrs Sturgis and children and for this work, which was exhibited at the Royal Academy in 1855 (no. 266) he paid the sum of 200 guineas which he gave to Mrs Sturgis (324). Her other Royal Academy exhibit of the year, "My cottage door" (no. 25) was bought by the Queen. On the strength of these successes she acquired a studio. In 1856 she added a gloss, from the same source – Haydon Osborn – to a second melancoly mood picture, this time called "Home thoughts" (RA no. 519) (325) (Fig. 23). Her first public success was "Nameless and Friendless" at the Royal Academy in 1857 (no. 299) "a work that attracted the notice of many a visitor by the pathetic story it told" (326) (Fig. 25). This picture has already been described in Chapter Three (327). It was bought by Lady Chetwynd. One of her next major exhibits, of 1859 (RA no. 943), was also a work of social interest: the title was "Presentiments", the gloss was from Charles Kingsley and the subject was poverty (328).

From 1860 to 1870, during which time she exhibited at the Royal
Academy and the Society of British Artists, Emily Osborn enjoyed extra-
ordinary success. The first of these triumphs was "The governess" (RA
1860 no. 405) which was bought by the Queen - a work already discussed
(329). The second, also previously considered, was "The escape of Lord
Nithisdale from the Tower, 1716" (RA 1861 no. 258) an historical subject
which was thought "bold for a lady" but in the rendering of which she
achieved "a most triumphant success" (330) (Fig. 11). In 1861 the
artist travelled to South Germany and studied in Munich. Her four Royal
Academy exhibits in 1862 were all on German themes. "Tough and tender",
a work previously exhibited at the Royal Academy in 1859 (no. 481) and
shown at the Society of British Artists in 1862 (no. 487), was awarded a
medal by the Society of Arts in the latter year and was bought by Mr
William Mitchell (331). The scene was a family group in which emphasis
was placed on the contrast between the age of the seaman and the tender
youth of the child. Each year brought greater fame. "Sunday morning,
Betzingen, Wurtemburg" of 1863 (RA no. 579) was also based on the contrast
between youth and age. It depicted an old woman being supported by her
granddaughter on their way to church and was considered "an addition to
her former merits" (332); "For the last time" of 1864 (RA no. 555)
(Fig. 130) portraying two girls about to take a last look at a dead
relative, was thought to teach "a wholesome lesson" (333); "Half the world
knows not how the other half lives", a scene of death and poverty exhi-
bited at the Crystal Palace in 1864, was awarded 60 guineas as "the best
Historical or Figure subject in oil by a British Artist" (334); "Of course
she said 'Yes'!" (SBA 1865 no. 45), a rustic love scene set in Germany
was priced at £105 and engraved (335); "God's Acre", at Mr Wallis's
Winter Exhibition in Pall Mall of 1866 depicted two young girls struggling
through snow and wind to visit a grave - the work was engraved and an
illustration published in the "Art Journal" of 1868 (336) (Fig. 131). She
exhibited two works at the Royal Academy of 1867 but nothing appeared at
exhibitions in 1868 or 1869 and it is probable that she returned to
Germany during this period. "Lost" of 1870 (RA no. 458) was sent to the
Royal Academy from Munich and was described as "masterly" in the "Art
Journal" (337).

In the 1870s her successes became rather thinner. "In the twilight"
of 1872 (RA no. 921) and a typically sad subject described by two lines
from George Macdonald of 1875 (RA no. 545) (338) were well reviewed but she
was criticized on two occasions for want of finish, a defect attributed to
the style of Piloty, then leader of the Munich School (339). Her works

became slighter. In 1873/4 she exhibited her first flower piece (SBA
no. 843) and several works were on themes such as "A Golden Day-Dream"
of 1878 (340) (Fig.132). For some time in the 1870s she divided her
time between London and Glasgow where she also had a studio. She may
have visited Venice in 1876 (341). She sent her work to a wide variety
of exhibitions during this decade: the Royal Academy, the Society of
British Artists, the Dudley Gallery (from 1872), the Society of Lady
Artists (from 1875) and she also exhibited at the Royal Birmingham Society
of Artists and the Glasgow Loan Exhibition in 1878 and the Paris Salon in
1879 and 1881. Then in the 1880s she exhibited at the Grosvenor Gallery
from 1882, at the Royal Manchester Institution's Autumn Exhibitions from
1883, at the New Gallery from 1888 and she sent one work to the Society
of Portrait Painters in 1896. Her works also appeared in exhibitions
held at Crystal Palace (342). In 1884 portraits reappeared, one of these,
at the Grosvenor Gallery, being a portrait of Mme Bodichon to be presented
by some friends to Girton College (No. 197) (Fig.133). But from the mid
1880s to 1908 the majority of her exhibits were landscapes. Some of these
were Algerian subjects based on a visit there, possibly in 1881 or 1882
and many others portrayed the English countryside. She did occasionally
exhibit subject pictures, such as "An Algerian Mirror" of 1889 (SLA no.
255), "A Pause in the Dance" of 1890 (SLA no. 341), "Her last Home" of
1893 (SLA no. 76) and "Bedtime" of 1896 (SLA no. 150) and judging from
their prices these exceptional works were considered more important than
the rest: the foregoing were priced at £50, £200, £50 and £300 respec-
tively, in contrast to prices ranging from six guineas to £40 for landscapes.
 During her peak period Emily Mary Osborn specialized in moving and
sometimes sentimental scenes and her main subjects were young women and
children. Her popularity appears to have been due to the fact that her
picures were considered to have a moral or educational effect stemming from
her truthful representation of certain subjects of current interest. The
poor, orphans, governesses, old people, children and death - particularly
the effect of death on young girls - were all subjects calculated to move
the Victorian heart. Three of her works, "The Governess" (1860), "For the
last time" (1864) and "Half the world knows not how the other half lives"
(1864) were praised for conveying valuable lessons (343).

14. LUCY MADOX BROWN

Lucy Madox Brown was born in Paris on July 19th, 1843, the eldest child of Ford Madox Brown and his first wife, Elizabeth Bromley. They remained in Paris until 1845 and then moved to Italy where Brown intended to study for three years. In 1846, however, Mrs Brown's health forced them to return and she died on the way home. The father and daughter and Lucy's younger brother Oliver then settled in London and Lucy's early education was conducted by the widow of Madox Brown's brother, Mrs Helen Bromley, who kept a school at Gravesend. In 1850 she first met William Michael Rossetti, her future husband and became a close friend of his family; she received further education from his mother and more particularly Maria Rossetti. During her childhood and early youth she showed no special inclination for art and practised for no more than two or three months at the age of eight or nine. Then, in the 1860s, she offered to take the place of one of her father's assistants who had omitted to do a piece of routine work and acquitted herself so well that she was encouraged to study art seriously. Her father became her instructor and she, her own half-sister Catherine (the daughter of Brown's second marriage), her brother Oliver and Marie Spartali who became Lucy's closest friend, studied from the antique together under his supervision (344).

Towards the end of 1868 she began a water-colour drawing called "Painting" showing a young lady painting an old woman with faggots. This was given a good position at the Dudley Gallery in 1869 (no.239) and was well reviewed, harmonious colouring being the main quality of the work (345). In the same year Lucy travelled to Belgium and Cologne with William Morris and his wife and then in 1870 exhibited her only contribution to the Royal Academy: "A duet" (no. 612). This was a period piece set in the 18th century showing a young lady playing and singing at a spinet accompanied by her lover (346). "Après le bal" (DG 1870 no.12) is a mood picture in which a verse from Théophile Gautier evokes the disillusionment of two girls after the ball is over (347) (Fig. 134). The figures were based on Catherine Brown, Marie Spartali and a friend, Miss Nesbitt, showing the extent to which the three students were dependent on each other for models. It was priced at £84. According to the "Art Journal", colour, again, was the main point in its favour (348). The artist's major work, illustrating the moon-lit tomb scene in Romeo and Juliet, was executed in 1870 and exhibited at the Dudley Gallery in 1871 (no.336) (349) (Fig. 28). Dante Gabriel Rossetti considered this "a nearly perfect picture" (350) and it also won

the admiration of the French critic Ernest Chesneau. It was bought by
a Mr Wilson of Ambleside for £105. The artist exhibited only two other
major works: another Shakespearian subject, "Ferdinand and Miranda" in
1871 (DG(oil) no.98) and "How Cornelius Agrippa showed the Fair Geraldine
in a mirror to the Earl of Surrey" in 1872 (DG no. 295) (351). Both were
priced at £105.

In May 1873 she travelled to Italy in the company of William Michael
Rossetti, Mr and Mrs Bell Scott and Agnes Boyd. The group visited Rome,
Florence, Venice, Verona, Padua, Milan and Como. Clayton reported that as
much as she enjoyed this trip, on returning through Paris she felt "that
it must be the living art of our own times which is necessary as a motive
impulse for work, and for carrying on the art towards its best present and
highest future development" (352). While they were abroad, William Michael
Rossetti proposed to Lucy and they were married on March 31st, 1874. At
that time Rossetti was Assistant Secretary to the Board of Inland Revenue
but better known to the public as a leading critic of art and poetry. After
the marriage the couple went on another tour, this time to Naples and
returned to spend the summer at Endsleigh Gardens where Rossetti's mother
and Christina still lived. The Rossettis were apparently dismayed to find
that Lucy was as unorthodox in her opinions as her husband; in politics
they were both inclined to socialism (353). Lucy in her turn was irri-
tated by Christina who could be extremely narrow-minded and priggish - as
when she refused to meet the second Mrs Holman Hunt, the deceased wife's
sister. Her behaviour upset Lucy to such an extent that she had a mis-
carriage (354). She is known to have drawn only one member of the family -
Maria, her former tutor (355). In November, 1874, Lucy's brother Oliver
died at the age of nineteen. He was already a novelist and a painter and
his loss was felt deeply by the family. The following year Lucy and her
husband visited various cities in Belgium and Holland with Ford Madox Brown
and his wife and in September Lucy gave birth to a daughter, Olivia. Her
last exhibited work, shown in Manchester in 1875, was "Margaret Roper
receiving the Head of her Father, Sir Thomas More, from London Bridge".
This was another moonlit scene, like Romeo and Juliet, in which Margaret
Roper is seen in a barge with her husband, her arms outstretched to take the
head (356).

Lucy gave birth to a son in 1877, another daughter in 1879 and twins
in 1881 and she did not find time to continue her painting. In 1885 she
had an attack of bronchial pneumonia and spent much of the last decade of
her life travelling for her health. During this period, she
wrote. She translated Petrarch and in 1890 published an account of her

father and his works in the "Magazine of Art" (357). She wrote a bio-
graphy of the writer, Mary Wollstonecraft Shelley, daughter of Mary
Wollstonecraft who wrote the "Vindication of the Rights of Woman" and
wife of the poet. This was published as one of the Eminent Women Series
in 1890. Mrs Ingram, who ran the series, wanted her to undertake Mrs
Browning and Mrs Radcliffe but these did not materialize. She also began
a biography of her father while in Pallanza in 1893. She died in San
Remo on April 15th, 1894.

In a Reminiscence written shortly after her death, William Hardinge,
whose views on Lucy Madox Brown are substantiated in W.M. Rossetti's
Reminiscences, described the artist as "a woman of wide and varied taste,
with unerring admiration for the beautiful, unerring contempt for the
sordid, large-hearted, vehement in partisanship, strong in dislikes, almost
intemperate in her zeal for justice: and this broad impassioned nature of
hers had for its channel a quiet life narrowed by illness and a rather
specialized view of art" (358). In this context, only her views on art
need be elaborated.

According to her husband, Lucy had "an exalted idea of art and its
potencies" (359). She herself described the artist as one who "raises
life from the apathy which assails even the most worldly-minded and con-
tented" and takes us "out of the common life" (360). She shared Mary
Shelley's view that art should express "the grand feelings of humanity, the
love which is faithful to death, the emotions such as Shakespeare describes"
(361). Her own work substantiates this belief for love enters into all her
pictures, two of which are on Shakespearian themes (362). At the time of
their appearance, the subject-matter of her works was not discussed beyond
description. But one thing which was constantly referred to was her predi-
lection for what Clayton called "peculiar and striking effects of light"
(363). All her major works provide examples: the unusual light of dawn
after the ball; the moonlit scene in Romeo and Juliet in which the artist
so vividly illustrated Shakespeare's words: "Her beauty makes this vault a
feasting presence full of light"; in "Cornelius Agrippa.. " she took great
care to contrast the delicate light of the mirror scene in which Geraldine
is glimpsed in a pleasure garden, with "the sombre glow of lamplight within
the chamber" (364); in "Margaret Roper" again, "the broad and mellow beams
of the moon, clouded and cloudless as the anxious moments succeed, illumine
a sombre scene" (365). These effects of light give her pictures strangeness
and drama which do remove the scenes from "the common life".

Lucy Rossetti exhibited only eight works in her entire life and yet when she died she was described - and in France - as "une artiste de grand talent" (366). Her style was no doubt influenced by Ford Madox Brown as were, most probably, her views on the use of art. But in her subject matter and in her dramatic rendering of this, she was original.

15. MARIE SPARTALI (MRS W.J. STILLMAN)

Marie Spartali, who was born in Hackney, London, in 1844, was one
of two daughters of Michael Spartali, an important Greek merchant in
London and Consul-General for Greece. Her mother was also Greek. She
and her sister were given an extremely careful education at home and mas-
ters and professors were employed to instruct them in Greek, Latin and
several modern languages as well as accomplishments like music and drawing.
Marie's gifts soon became apparent and in 1864 she was allowed to study
under Ford Madox Brown whose daughter, Lucy, became one of her closest
friends (367). She and her sister first met Dante Gabriel Rossetti at the
Ionides in 1862 and in 1864 he expressed the hope that she would sit for
him in a letter to Ford Madox Brown (368). Her contact with the Pre-
Raphaelite painters was close. In the middle of 1870 she was the model for
the girl on the right in Rossetti's "Dante's Dream" completed in 1871 and
towards the end of 1877 when Jane Morris was too ill to sit, she modelled
for his "Vision of Fiametta".

Her first exhibited works were three water-colours at the Dudley
Gallery in 1867. All three portrayed romantic female figures from litera-
ture or history and according to W.M. Rossetti and E.C. Clayton, the
quality most apparent in these works was that of colour (369). Two land-
scapes and a portrait in 1868 were followed by two works which were larger
and more elaborate than her previously exhibited pictures. One of these,
"Brewing the Love Philtre" (DG 1869 no. 380) portrayed two Greek girls
brewing a transfixed heart and a pair of dead doves in a deserted garden
at evening. According to W.M. Rossetti, "this subject was felt with great
poetic intensity" and he remarked on the artist's "fine power of fusing the
emotion of her subject into its colour" (370). Her other exhibit, "Nerea
Foscari" (DG 1869 no. 461) was described in the "Gazette des Beaux-Arts"
as "une scène d'histoire très énergique" (371). In the same year she
exhibited her one contribution to the Society of Female Artists, "Procne
in search of Philomela" (no. 131), which was priced at £60. In 1870 she
exhibited at the Royal Academy for the first time; her exhibits were
"Saint Barbara" (no. 530) and "The mystic tryst" (no. 838).

During these first few years of her career she specialized in class-
ical subjects and particularly themes from ancient Greece. As with Lucy
Madox Brown most of her subjects were female and like the former also she
favoured the theme of love. Her most ambitious work was "Antigone" of
1871 (DG no.75) for which £160 was asked (372); the "Art Journal" des-
cribed this as being "a reflex from Venetian harmonies" (373). According

to Clayton, around 1871 she painted another important subject which was
not exhibited: "Buondelmonte riding to his wedding and passing the
house of the Donatis, the mother tearing off her daughter's veil" (374).

In 1871 the artist married W.J. Stillman, an American journalist who
helped to popularize Ruskin and the Pre-Raphaelite painters in America.
They travelled to Florence and Rome and in the former city became friends
with Vernon Lee and Sargent. From 1872 her subjects became more medieval
than classical and Italian themes, especially from Dante, Petrarch and
Boccaccio were more and more frequent. An example is her picture of
Messer Ansaldo's Garden, from the "Decameron", of 1889 (NG no. 177) (375)
(Fig. 135). She started painting many groups of flowers both alone and
in her figurative compositions and she also executed several portraits some
of which were sent to America. She exhibited in America from 1875 and at
the Grosvenor Gallery in London from 1877. She sent work to the New
Society of Painters in Water-colours in 1886 and 1887 and from 1888 her
work was seen exclusively at the New Gallery. In 1901 her husband died
and she then lived with her two step-daughters, Lisa - also an artist -
and Mrs Middleton. She died in 1927.

Henry James writing about the artist in 1875 described her as a
"profound colourist" and William Michael Rossetti agreed that this was her
main quality (376). The latter associated her with Lady Waterford in this
respect, writing: "These are the two who have given a certain feminine
status and feminine (but not the less seriously artistic) expression to
colour". Henry James also wrote that she worked "under the shadow of Messrs
Burne-Jones and Rossetti". Her medieval subjects and love themes certainly
associate her with these two artists. The best examples are her picture
of "Fiametta singing" (GG 1879 no. 158) (377) which was exhibited in 1879,
the year after Rossetti completed his "Vision of Fiametta" in which Mrs
Stillman was the model and also her several works depicting Dante and
Beatrice, Rossetti's favourite theme (378). She executed at least one work
"after" Rossetti (379). Technically also her work is comparable. The rich
colouring, divided and flattened space exemplified in such works as "Upon
a day came sorrow unto me" of 1887 (GG 1887 no. 303) (Fig. 136) and her
picture of Messer Ansaldo's Garden of 1889 (Fig. 135) are characteristic of
Rossetti also. But Henry James did not describe her as an imitator. In his
view she came "into her heritage in virtue of natural relationship". She
was "a spontaneous, sincere, naive Pre-Raphaelite" (380).

16. ELIZABETH THOMPSON (LADY BUTLER)

Elizabeth Thompson was born in 1846 in Lausanne when her parents,
James and Christina Thompson, were living in Switzerland. Her father,
having left Cambridge, failed to find a career in England - among other
efforts was a half-hearted attempt to enter Parliament - and being of
independent means he then indulged his love of travel. He was a friend of
Charles Dickens and through him met his future wife, Christina Weller,
when she was playing the piano at an "entertainment" in Liverpool. She
was not only a musician but an artist also and her drawings won the
praise of Ruskin. Elizabeth had one sister, Alice, born in 1847, later
to become the famous poet and essayist Alice Meynell.

During Elizabeth's childhood the family alternated between the
English countryside and Genoa where winters were spent. The education of
the two daughters was conducted entirely by James Thompson. That they
learned mathematics is known through an amusing account by Charles Dickens
of the disorderly family in Italy, but Mr Thompson's favourite subject was
history and this he would teach out loud which Elizabeth sketched. In July
1851 he wrote to his wife who was in England at the time: "The children's
greatest amusement is writing History - the history of their respective
Islands. Mimi (Elizabeth) illustrates hers with portraits of the sover-
eigns, not without variety and character" (381). She was drawing with fac-
ility at the age of five and was particularly fond of portraying animals;
in these and other studies the most striking quality was her ability to
render movement (382). In later life two memories of her childhood were
particularly vivid. One was of a moonlit night when there was a ball at
the Thompson's Italian villa and, looking out of the window, she and Alice
saw a small barque carrying a detachment of Garibald's Redshirts on their
way to liberate Southern Italy. The other was of being shown over the field
of Waterloo by a French pensioner who had fought there, an experience which
she described as having "an awful glamour" (383). A record of the sisters
at the age of five and six exists in the form of a portrait by Margaret
Sarah Carpenter (384). It is possible, considering the artist's precocity,
that a charitable exhibition of the work of amateur artists held at Burling-
ton House in 1855 included two copies by Elizabeth Thompson. A Miss E.
Thompson is listed as the author of a "Head of Psyche, after Raphael" and a
work "From Fra Bartolomeo" (385).

In 1862 she attended the South Kensington Art School, but, as we have
already seen, she became impatient with copying and longed to study from the
life (386). She therefore left the school and worked at home, often sketch-
ing with her mother and taking private lessons in oil painting from a Mr.

Standish. In 1866 she presented herself at South Kensington again and
was admitted straight away to the antique and life classes. While pursuing
her studies there, in 1868 she also attended the Society of Female Artists'
class for study of the costumed living model and received warm praise from
Mr Cave Thomas (387). The only known painting by her from this early
period is a self-portrait of 1866 which portrays her painting soldiers on
a canvas (388) (Fig. 137).

In 1867 she exhibited her first military work, a water-colour called
"Bavarian Artillery going into action", at the Dudley Gallery (no. 181) and
in the same year she sent three pictures to the Society of Female Artists.
She also sent a work to the Society of British Artists, but was rejected.
Her home at this time was 8 Sumner Terrace, Onslow Square. In 1868 she
exhibited three works: an oil portrait of her sister at the Dudley Gallery
(no. 305) and "Resting" and "On the Look Out" which were possibly military
subjects, at the Society of Female Artists (nos. 320 and 380); the latter
were priced at eight and twelve guineas. In March of this year Ruskin came
to tea with the Thompsons and annoyed Elizabeth by expressing the view that
the subject of a picture did not matter: "I did not like that; my great
idea is that an artist should choose a worthy subject and concentrate his
attention on the chief point" (389). He gave high praise to a work which
was to be exhibited the following year, 1869, at the Society of Female
Artists: "The Crest of the Hill" (no. 114) (390).

According to Viola Meynell's biography of Alice Meynell, visits to
Genoa, Florence and Rome during Elizabeth's studentship were undertaken not
only to further the artist's studies but also for Alice's health (391). In
1869 they went to Florence where Elizabeth became a pupil of Bellucci, an
historical painter and professor in the Academy of Fine Arts. She worked
extremely hard and among other studies copied the frescoes of Andrea del
Sarto and Franciabigio in the cloisters of the Church of Santissima
Annunziata. Her autobiography records her great admiration for Del Sarto's
"Cenalolo" in which each head is highly individualized, for the artist had
already formed her opinion about "the rendering of individual character
being the most admirable of artistic qualities" (392). Where studies from
the life were concerned, the Italian peasant was her main subject and it
was not for artistic reasons alone that she favoured rural themes. "I love
and respect the Italian peasant" she wrote. "He has high ideas of religion,
simplicity of living, honour" (393). In October, 1869, she left Bellucci
and the family went to Rome where Elizabeth spent much time sightseeing.
Here she finished a work which she had begun in Florence - the "Magnificat"
or "Visitation" - which portrayed Saint Elizabeth paying hommage to the

Virgin (394). The models for this were Elizabeth's mother and a peasant woman. The picture was exhibited at the Pope's International Exhibition in Rome in January 1870 and received an honorable mention. She also sketched local scenes and events and began a work which was later exhibited: "Roman Shepherds playing at 'Morra'". The family then returned to Florence and travelled through Padua, Venice and Paris on their way back to England. On her visits to Paris, through which city she travelled frequently during these trips abroad, Elizabeth became acquainted with the work of Rosa Bonheur and with that of a small group of military painters of the Second Empire: Ernest Meissonnier, Edouard Détaille, Alphonse de Neuville and Aimé Morot, a pupil of Horace Vernet. In contrast to earlier glorious representations of war, these artists emphasized the realistic and often horrifying aspect of battles and military life. An additional stimulus to the artist in 1870 was the Franco-Prussian War. It was this, she wrote, "and a return to the Isle of Wight that set me back on the military road with ever diminishing digressions" (395).

By this time the family was based at Ventnor in the Isle of Wight. From here she sent her "Magnificat" to the Royal Academy exhibition in 1871, but the picture was rejected and returned to her damaged. In the same year she executed another religious subject: an altar piece for St. Wilfrid's Church at Ventnor (396). It is perhaps relevant here to mention a rumour reported by the "Art Journal" in 1876, after the artist had achieved fame as a military painter. This was her supposed intention of "turning her attention in future to sacred Art" (397). This may indeed have been a real intention in which case her entry into the Roman Catholic Church in the early 1870s would be an appropriate factor, but certain it is that it remained unfulfilled. Religion does, nonetheless, enter into her work. Religion and religious practices were recurrent themes among her numerous genre pictures and also obtruded in a few of her later military paintings (398).

She exhibited a total of five works in 1871, two at the Dudley Gallery and three at the Society of Female Artists. All but one of these were Italian peasant subjects, the exception being "Wounded and taken prisoner" at the Dudley Gallery (no. 113). One of her exhibits at the Society of Female Artists was priced at £31. 10s. (no. 369) and one - her "Roman Shepherds playing at 'Morra'" (no. 443) which she had begun in Rome - was the first work that she sold. It was bought by R.L. Chance, a Birmingham Glass manufacturer, for £26. 5s. In 1872 she sent another work to the Royal Academy: a water-colour of Papal Zouaves saluting two bishops in a Roman Street, but once again it was rejected. She exhibited seven works in 1872 and as in the previous year she appears to have made a distinction

between pictures sent to the Dudley Gallery and those sent to the Society of Female Artists. At the former she was represented by three military subjects including an oil painting, "Chasseur Vedette" (no. 282), which was priced at £52. 10s. and also a Roman scene and at the latter by three Italian genre scenes. Judging from prices she did not value genre any less than military art. A religious subject entitled "Veneration of the Chains of St. Peter in the Church of San Pietro in Vincoli, Rome" was priced at £42 (SFA no.320). In the latter half of 1872 she attended the Autumn military manoeuvres at Southampton and made many life sketches.

In 1873 she exhibited ten works including the first to be accepted at the Royal Academy - "Missing" (no. 590) (399). This is an imaginary scene from the Franco-Prussian War in which two wounded officers with one horse are making slow progress across a desolate country. Her father and a young Irish officer acted as models. The picture was sold during the exhibition. Her nine other exhibits were divided as before and in the same manner between the Dudley Gallery and the Society of Lady Artists (previously the Society of Female Artists). The Dudley Gallery received three military subjects one of which, an oil painting called "French Artillery on the March" (no. 298), was priced at the record figure of £84. A second was a water-colour called "Drivers watering their Horses - Infantry Camp. Autumn Manoeuvres 1872" (no. 84) and was based on her eyewitness studies of the event at Southampton the previous year. This was bought for £42 by Mr Charles Galloway from Manchester, a wealthy manufacturer of boilers and heavy engineering equipment, and led to a vital commission. On the strength of this work, Galloway commissioned the artist to paint a picture for £100 apparently on a subject of her choosing. This was to be her most famous work, the "Roll Call". Only one of her six contributions to the Society of Lady Artists in 1873 had a military theme: "Prussian Uhlans returning from a Raid" (no. 311) and this was sold before the exhibition opened. Of the other five one was a male portrait and four were Roman genre scenes. Two of the latter were sold: "The Boys' Class al fresco" (no. 266) for £36. 15s. to a Mr J.M. Saunders and "Salutations, Rome" (no. 191) for £21 to William Atkinson, Honorary Treasurer of the Society for the Encouragement of Fine Arts. Also in 1873 she visited France where she made sketches of the Sacred Heart Pilgrimage at Paray-le-Monial and in the same year she contributed to the "Graphic" (400).

Following her return from France she took a studio in the Fulham Road and in December began the work commissioned by Mr Galloway. The "Roll Call", or as it was named in the catalogue, "Calling the roll after an engagement, Crimea" (RA 1874 no. 142) (Fig.138) , was painted during that winter. To

make the scene as historical and realistic as possible she acquired many
items of equipment and uniform worn by soldiers in the Crimean War. She
also studied written accounts, and interviewed veterans who had taken
part in the kind of scene she was going to depict (401). Galloway paid
for the picture before it was exhibited and on the good report of his
agent increased payment from £100 to 100 guineas. It was sent to the
Royal Academy in March 1874 and her success began the moment the picture
had been accepted. The Selection Committee gave her "a round of huzzas"
in her absence; on varnishing day she found her work surrounded by
artists who also congratulated her - Millais, Calderon, Val Prinsep and
Herbert all paid tribute; at the Royal View the Prince of Wales wanted
to buy it but Galloway refused; at the Private View, for Society, she was
fêted and focal; at the Academy Banquet the Prince of Wales pronounced
the picture deserving of the highest admiration and predicted a great
future for her; then there was Open Day and the policeman who had to
restrain the throng of admirers. On the day after Open Day the Queen sent
for the picture to be shown at Buckingham Palace and she also expressed a
wish to buy it. To this Galloway yielded, on various conditions including
that Elizabeth Thompson's next Academy picture should be his for the same
price. Later the Queen sent for the work again in order that she might
show it to the Czar at Windsor and it was also taken to Florence Nightingale's
bedside after the exhibition had closed. The Queen had the last word in
this concatenation of tributes. As a mark of her esteem she presented the
artist with a gold and emerald bracelet. The engraving rights were bought
by J. Dickinson and Co. for £1,200 (402).

The press was extreme in its praise. The sobriety of the work, its
lack of the over-emphasis usual in scenes of suffering, was the chief
quality. Then there was the degree of realism and truth and the extra-
ordinary individuality and variety in the expressions of the soldiers.
Finally, of course, there was the fact that the artist was a woman. Such
was the popularity of her success that a quarter of a million photographs
of her were sold in a few weeks (403). The following is her own account
of the effect this had upon her : "It is a curious condition of the mind
between gratitude for the appreciation of one's work by those who know,
and the uncomfortable sense of an exaggerated popularity with the crowd.
The exaggeration is unavoidable, and, no doubt, passes, but the fact that
counts is the power of touching the people's heart, an 'organ' which re-
mains the same through all the changing fashions in art" (404).

In the same year, 1874, she exhibited seven other works; four at
the Dudley Gallery, one at the Society of Lady Artists and two at the New

Society of Painters in Water-colour of which she was elected a member. "The Ferry - French Prisoners of War 1870" (DG no. 151), like the "Roll Call", was praised for the rendering of "every phase of feeling possible to the occasion" (405). "Halt! a reminiscence of Aldershot", exhibited at the Dudley Gallery's "black and white" exhibition, was sold to Mr. Whitehead of Manchester and "Gallop! A Reminiscence of Woolwich", shown on the same occasion, was either sold or given to Mr Galloway (406). Two of these works depicted the 10th Bengal Lancers Tent-Pegging (SLA no. 247 and NSPW no.351) and a third on the theme known as "Missed", was published in the Colour Supplement of the "Graphic" in 1875 (407).

Immediately after the Academy closed, Elizabeth Thompson began work on her next picture for Mr Galloway: "The 28th Regiment at Quatre Bras", a subject based on Sibourne's account of the Waterloo campaign. She did studies for this in June and July at Chatham and Henley and was fastidious about making preparatory sketches of "particularly tall rye" from nature in order to follow Sibourne's account to the letter. The army lent valuable assistance: a four deep square was formed and rifles fired for her benefit and a horse was thrown in order that she might catch the effect. The uniforms were specially made and many models were sent to her. In 1874 also she visited Paris where she met two artists for whom she had great admiration: Jean-Léon Gérome and Edouard Détaille (408). It is relevant here to mention that she would also have had the opportunity of seeing Alphonse de Neuville's battle pictures at the French Gallery in London in the 1870s. In December of 1874 she returned to England and between January and March, 1875, resumed work on "Quatre Bras" at her London studio. Her success of the previous year was repeated. Reviews of the Royal Academy exhibition again dwelt on her work (no. 853) (409), the most unexpected and extreme praise coming from John Ruskin (410). The artist herself had written of this work: "I had a welcome opportunity of showing varieties of types such as gave me so much pleasure in the Old Florentine days when I enjoyed the Andrea del Sarto's, Masaccio's, Francia Bigio's and other works so full of characteristic heads" (411). It was this aspect of the work - the extraordinary variety of expressions - that received most praise. At the Lord Mayor's Banquet for Royal Academicians, Sir Henry Cole alluded to her possible election as an Associate. Mr Galloway did not keep to his original condition and instead of £126 he paid her £1,126 for the work complete with copyright. The copyright he then sold to Messrs Dickinson and Co. for £2,000. Later in the year the picture was exhibited in Newcastle and during a visit to the city at the same time the artist was treated with great honour. In 1884, Galloway sold it to

the Museum of Melbourne for £1,500 (412). She executed another work for Mr Galloway in 1875 as compensation for ceding the "Roll Call" to Queen Victoria: this was "The Dawn of Sedan (1870)" (413). Six of her works appeared at other exhibitions in 1875. One of these, "'On Duty' - A trooper of the Scots Greys" (NSPW no.243) was bought by Agnew and another was loaned by a previous purchaser - "Roman Shepherds playing at 'Morra'" (SLA no. 594) - an indication of her renown. Later in the same year she went on a trip to Florence.

Her major work in 1876 was "Balaclava", a Crimean subject which showed the 11th Hussars and 21st Lancers returning after battle (October 24th, 1854) (414). It was executed in the summer of that year and was a commissioned work, her patron this time being the Mr.Whitehead who had purchased "Halt! A Reminiscence of Aldershot" in 1874. The Fine Art Society gave Mr Whitehead £3,000 for the copyright and engaged Stacpoole to do the engraving. This was exhibited independently at the Fine Art Society. Her only other exhibited work in 1876 was an Italian genre subject at the New Society of Painters in Water-colour.

While in Italy in September 1876 she began her third Crimean subject, "The Return from Inkermann" (Fig. 139) , a battle incidentally, which was also depicted by Lady Waterford (415). This was yet another after-the-battle scene. "Missing" (1873), the "Roll Call" (1874), "The Ferry" (1874), "Balaclava" (1876), "Inkermann" (1877) and several minor works all focused on the effect of the battle rather than the event itself. Again she stressed the individuality of the soldiers: some still upright and disciplined, some exhausted, some nonchalant and smoking pipes, some carrying the wounded. "Inkermann" was exhibited at the Fine Art Society in 1877 and at the Exposition Universelle in Paris in 1878 (416). Also in 1877, the Fine Art Society organized an exhibition of her three most famous works. The "Roll Call" was here viewed for the third time, the second having been at Oxford in aid of flood victims in the South of France. The other two were "Quatre Bras" and "Balaclava". By this time the Fine Art Society owned the copyright of all three. 1877 was the last year she exhibited at the Society of Lady Artists; her two contributions were Italian genre scenes, each priced at £42. She became an Honorary Member of the Society in 1878. In the winter of 1876/7 she also sent her last works to the New Society of Painters in Water-colour: a Scots Greys subject and two sketches of Tuscan scenes.

An important event in 1877 was her marriage to Major (later General) William Francis Butler C.B. who had been distinguished in overseas actions and who later held important staff appointments under Lord Wolseley. He

had seen the "Roll Call" in 1874 and afterwards been introduced to the
artist by the Duchess of St. Albans. Having been married, in 1877, by
Cardinal Manning, they spent their honeymoon in Tipperary where the
Butler family lived. Here she began a work commissioned by her second
important Northern patron, Mr.Whitehead: "Listed for the Connaught
Rangers" (Fig. 140). The subject was set in Connemara but painted in
Kerry and portrayed recruits leaving their poor homes for the regiment.
This was exhibited at the Royal Academy in 1879 (no. 20) together with a
subject from the Afghan War: another after-the-event scene in which Dr.
Brydon featured as "The Remnants of an army: Jellalabad, January 13th,
1842" (no. 582) (417) (Fig.141). This was bought by the Fine Art Society
who published many engravings of the work. As we have seen, it was in
1879 that Elizabeth Butler came closest to election as a Royal Academician
(418).

　　Her next work, "Scotland for Ever" (Fig. 142) showing the charge of
Scots Greys at Waterloo, was begun in 1879 and finished at Plymouth in
1881. To grasp her subject as realistically as possible she witnessed two
charges of the Greys, standing in front "to see them coming on" (419). While
at Plymouth in 1880 she executed a royal commission to portray a subject
from the Queen's own reign. The incident proposed and finally depicted
was an episode from the Zulu War in which eleven VC's were won: "The
Defence of Rorke's Drift, January 22nd 1879" (420). It is interesting to
read in her autobiography that at first she was unwilling to depict this
incident, "because it was against my principles to paint a conflict. In the
'Greys' the enemy was not shown; here our men would have to be represented
at grips with the foe" (421). This was exhibited at the Royal Academy in
1881 (no. 899) with the Queen's permission. "Scotland for Ever" was shown
independently at the Dudley Gallery the same year. Her next Royal Academy
exhibit in 1882 was the first of several extremely moving subjects in which
the artist specifically associated death with youth. "Floreat Etona" (no.
499), set in the Boer War in 1881, showed two young men - old Etonians -
bravely leading the charge at Laing's Nek in which one was to die (Fig. 143).

　　In 1885 after the Gordon relief expedition, Mrs Butler joined her
husband in Egypt. Here she painted many water-colours of the local inhabi-
tants and scenery some of which are included in her "From Sketchbook and
Diary" published by Adams and Charles Black in 1909. She also painted
"After the Battle" portraying General Wolseley and others after the Battle
of Tel-el-kebir (1882) in which Arabi Pasha's forces were defeated. It
included a portrait of her husband who had been involved in the action.
This was the only work he disliked. He considered it "an unworthy theme"

because of the impression it gave of triumph over the enemy. It was
exhibited at the Royal Academy in 1885 (no. 1081) and at the Victoria
Cross Gallery in Crystal Palace in 1896 (no. 45), but was destroyed by
the artist after her husband's death in 1910 (422).

From the mid 1880s Mrs Butler (Lady Butler from 1886 when her
husband was knighted) travelled constantly with her husband and many of
her works were based on historical events involving the English in the
places which she visited. She executed three other major Egyptian subjects:
"A Desert Grave: Nile Expedition 1885" (RA 1887 no. 466) (423) was
another sad ending and "The Camel Corps" (RA 1893 no. 848) (Fig. 144)
recalls the violent charge of the Scots Greys in "Scotland for Ever"
(Fig. 142) (424). This followed a second stay in Egypt from 1890 to 1892.
The third, "The Mid-day Meal. Egyptian Cavalry Horses at Berseem" of 1896
was her only contribution to the New Gallery (no. 3). Another famous work,
"Evicted", was executed in Ireland in 1889 and portrayed an Irish peasant
woman outside her cabin after eviction (RA 1890 no. 993) (425). The
Peninsular War featured in two important works of 1892 and 1897: "Halt
on a forced march: "Peninsular War" (RA 1892 no. 27) (426) and "Steady the
Drums and Fifes" (RA 1897 no. 663) (427) which recalls "Floreat Etona" of
1882 in its portrayal of heroic youth. Waterloo remained a favourite
theme and she twice depicted the morning of the battle, in 1895 (Fig.145)
and 1913 (428). In "On the Morrow of Talavera - bringing in the dead" of
1898 (RA no. 303), based on the British victory in 1809, she represented
another grim aftermath; this was illustrated in Henry Blackburn's
"Academy Notes" for the year. In 1898 she accompanied her husband to
South Africa and this may have instigated her second work on the Boer War:
"Within sound of the guns" of 1903 (RA no. 412) (429).

From 1893 they were based at Aldershot and from 1896 at Dover Castle.
Then in 1905 when her husband retired they moved to Bansha, Tipperary but
continued to travel until his death in 1910. Lady Butler's married life
had been an extremely full one. Not only did she accompany her husband on
numerous postings abroad but she also had to entertain and observe social
etiquette and it is said that she found this very taxing as it interrupted
her work (430). In addition she had six children five of whom survived
her. In 1911 she visited Italy. With the outbreak of war in 1914 she
resumed her military art for war charities. She sketched at army camps
and recorded mostly recent military events in oil paintings (431). One-
man shows of her work were held in 1904, 1912, 1915, 1917 and 1919 (432).

During her travels she always sketched and many of these studies were reproduced in her two travel books: "Letters from the Holy Land" of 1903, based on her visit in 1891, and "From Sketch Book and Diary" of 1909. Her activities as an illustrator extended beyond this. She illustrated the first edition of Alice Meynell's "Preludes" in 1875, her husband's account of the Gordon Relief Expedition - "Campaign of the Cataracts" - in 1887 and the 1879 edition of Thackeray's Ballads (Smith, Elder and Co). In addition her work appeared in the "Graphic" in the 1870s and the "Daily Graphic" in the 1890s (433).

Lady Butler found it hard to explain why she should be impregnated with "the warrior spirit" in art (434). Given this bias, the most important aspect of her approach to art is her emphasis on "a worthy subject" and "moral qualities" (435). She wrote: "I never painted for the glory of war, but to portray its pathos and heroism. If I had seen even a corner of a real battlefield I could never have painted another war picture" (436). The "pathos" of war she depicted in all those works, from "Missing" and the "Roll Call" (Fig. 138) onwards, which focused attention on the aftermath of war - not the event itself but the effect of the event on individuals (437). In the "Roll Call" she showed the effect in a whole line of highly individualized soldiers; in "The Remnants of an Army" (Fig.141) she portrayed one individual, Dr Brydon, in a work which stresses more than any other that for her the importance of war lay in the individual soldier. In her works it is relatively unimportant who has won; the effect is always devastating on the man. The "heroism" of war she portrayed in scenes show- ing soldiers just before the conflict. The first of these was her first exhibited military picture: "Bavarian Artillery going into Action" of 1867 (438). The same theme is exemplified in works depicting numerous figures such as "Scotland for Ever" (Fig. 142) and "The Camel Corps" (Fig. 144) and also in those portraying a few specific individuals such as "Floreat Etona" (Fig. 143). In this latter category of "heroic" pictures she tended to focus attention on young soldiers, the heroism of youth being a particularly moving theme. A further distinction between these two aspects of war emerges from another statement by the artist: "I have always had a great liking for the representation of movement, but at the same time a deep well of melancholy existed in my nature, and caused me to draw from its depths some very sad subjects" (439). Her heroic paintings - her before-the-battle scenes and charges - nearly always involved movement, "Scotland for Ever" being the best example of this; in works portraying the pathos of the aftermath, on the other hand, the effect is of quietude: heroic impulse before and sad thought afterwards.

Lady Butler stands out from previous military artists because of her
view that the glory of war, the idea of winning and triumph, was <u>not</u> a
worthy theme. The element of triumph in "After the Battle" of 1885 was
exceptional and possibly had something to do with the fact that the work
portrayed specific heroes including her husband who had been involved in
the action. It was presumably on account of her dislike of the glory of
war that it was against her principles to paint a conflict, for in this the
"base" impulses called forth by war (440) - the desire to kill, the triumph
- would be evident. In only two works did she portray scenes in the midst
of battle. In one of these,"Quatre Bras" of 1875, she showed only one side
of the conflict; "Rorke's Drift" of 1881 was the other and as we have seen,
this she was reluctant to paint (441). One of her most famous pictures, —
"Scotland for Ever!", executed between 1879 and 1881 - was instigated by
disgust at the contents of the Grosvenor Gallery, "the home of the
'Aesthetes' of the period, whose sometimes unwholesome productions preceded
those of our modern 'Impressionists'" (442). Her works are the very
reverse of these new trends. They are pre-eminently "wholesome" and vig-
orous and must rank as some of the most thoughtful and highly motivated
examples of military art.

17. FELICIE DE FAUVEAU

Félicie de Fauveau was born around 1802 in Florence of French
parents. Her father was a banker and her mother an aristocrat who had
left France during the Revolution: a proud royalist with vivid memories
of France under the guillotine. Her mother was also accomplished in both
music and painting. In 1812 or 1813 her father suffered heavy financial
losses and the whole family moved to Paris where M. de Fauveau adopted an
administrative career in the civil service. He became a sub-prefect in
Limoux (Aude), then Bayonne and finally a secretary general at Besançon.
Félicie was expelled from several schools and refused the alternatives of
marriage or a convent. She studied widely and deeply with particular atten-
tion to ancient history, classical and modern languages and above all arche-
ology and heraldry. Her favourite books were the Bible and the works of
Milton, Shakespeare, Walter Scott, Byron, Dante, Tasso and Ariosto. Like
her mother she was a passionate legitimist and felt particularly close to
the Middle Ages of which she made a detailed study. Her first contact
with the modern political world was in Besançon in 1823. Here she met many
partisans of the current war in Spain in the course of which the Duc
d'Angoulême re-established an absolute monarchy, Ferdinand VII having had
to swear allegiance to the French Constitution in 1820.

Félicie de Fauveau learnt the rudiments of art from her mother but
most of her art education was acquired independently. In 1824, when in
Besançon, she executed some oil paintings. Then, finding this medium unsat-
isfactory for her ideas she turned to sculpture, receiving no more instruc-
tion than that gleaned from local workmen who produced images of virgins
and saints for neighbouring churches. In the same year, 1824, her father
died leaving one son and three daughters and it became necessary for her to
earn a living. This she prepared to do, as an artist, despite the dis-
approval of some noble relations who thought such a career beneath her.
Her proud answer to one of these was: "Déroger! sachez qu'une artiste telle
que moi est un gentilhomme" (443).

The family then moved to Paris where they were welcomed at the court
of Charles X. She took some lessons in drawing from Louis Hersent and
Bernard Gaillot but soon devoted herself exclusively to sculpture. Dela-
roche and Ingres and many other famous artists visited her studio in the
Rue La Rochefoucauld and Ary Scheffer painted a portrait of her (Fig.146).
She became known for her interest in the Middle Ages - she is said to have
initiated Paul Delaroche in these studies - and also for her strong
royalist beliefs and esteem for the Duchesse de Berri. Her first known
works are her two Salon exhibits of 1827: a subject from Walter Scott's

"The Abbot" (no. 1784) (444) and a low relief portraying Christine of
Sweden refusing to grant Monaldeschi's life (no. 1785) (Fig. 45). Both
should be seen in the light of her political views. The scene from Scott
depicted the page Roland Graeme prepared to kill in defence of Mary Queen
of Scots. In her representation of the inflexible Christine of Sweden -
which, incidentally, was historically exact - her sympathy was with the
Queen. The latter made a strong impression on Charles X and he personally
conferred the second class medal awarded to the artist. Both works were
praised for their drama and energy and for beauty in detail (445). She
executed two more major works and began two others before the revolution
of 1830. One of the first was a Holy Water basin showing "Saint Denis
ressuscitant pour bénir l'eau baptismale de la France" which won a medal at
the Salon in 1830 (446). The other was a bronze lamp commissioned by the
Count Portalès. "It represents a bivouac of archangels armed as knights.
They are resting round a watch fire, while one, St. Michael, is standing
sentinel. It is in the old Anglo-Saxon style ... Beneath is a stork's
foot holding a pebble, symbol of vigilance, and surrounded by beautiful
aquatic plants" (447). The work bore three mottoes in explanation of the
theme: "Vigilate et orate", "Vaillant veillant; veillant vaillant" and
"Non dormit qui custodit". It was said to be "poetically conceived, and
executed with great spirit and finish" (448). Her Monument to Dante, also
known as "Francesca de Rimini", was begun before 1830 but not finished until
1836. It was based on the fifth Canto of Dante's "Inferno". Unlike most
versions of the story of Paolo and Francesca which dwelt on the romance of
their love and the tragedy of their death, Félicie de Fauveau saw the
lovers as justly punished by Minos through his instrument, Malatesta, and
sent to hell. The composition was in three parts. The severe Minos and the
lovers' guardian angels weeping at the loss of their souls were shown above
a dais beneath which the lovers were seated reading. Malatesta could be
seen half hidden by a curtain with his hand upon his dagger. In the lower
part of the composition Francesca and Paolo were seen clinging together in
turbulent hell while a black demon tried to separate them. The composition
was extremely elaborate, with pinnacles, columns, shields and crests and
a verse of Dante explaining the punishment: "di qua, di la, di qui, di su
gli mena". The work was executed in marble and measured two metres, forty
centimetres high. This also belonged to Pourtalès. Her second uncompleted
work was an equestrian statue of Charles VIII. In this the Monarch was
shown returning from his expedition to Naples and looking back from the
Alps with "sadness and yearning" (449). Unfortunately the model for this
had to be destroyed on the breaking up of her studio in 1834. Royalty then,
and religion - particularly the religion of the Old Testament - were her
main themes.

An article on Mlle de Fauveau in "L'Artiste" of 1842 described her as a sculptor "non pas à la manière antique de Canova ou de Bosio, mais dans la ligne tracée par Benvenuto Cellini et Michel-Ange, dans le sens et l'esprit de la Renaissance; à la fois statuaire, architecte et coloriste, embrassant l'art comme monument, comme décoration et comme industrie" (450). By 1830 she had already executed works of all three types and many more belonging to the industrial category than have been mentioned above. One of the main social activities at her mother's home was modelling ornaments, sword handles, scabbards and dagger-hilts in clay or wax. This became a fashion in Paris as a result and Félicie de Fauveau was credited with the popularization of sculpture (451).

By 1830 she had achieved considerable success. She had been given numerous private commissions and even some public ones: she was to have modelled two doors for the gallery in the Louvre in the manner of Ghiberti's Gates of Paradise and also a baptistery and pulpit in a Paris Church. Before the latter were even started, the Revolution of 1830 broke out and the whole course of the artist's life was changed. After the overthrow of Charles X whom she considered to be the legitimate King and his replacement by the bourgeois Louis-Philippe, Félicie de Fauveau felt unable to remain in Paris and she took the first opportunity of leaving. This was an invitation from Félicie de Duras (comtesse de la Roche Jaquelein) to accompany her on a visit to her estates in La Vendée. Intended as a relaxing holiday, this visit soon became a counter-revolutionary conspiracy, a "chouannerie". It was discovered and the authorities arrested the two ladies. On their way to prison, however, Félicie de Duras escaped with the aid of a maid-servant and Félicie de Fauveau was taken to the prison of Fontenay-le-Comte alone where she remained for seven months in 1832 (452).

During her imprisonment she executed two works. The first of these was "Le Combat de Jarnac et de la Chataigneraye" a 16th century historical incident involving a duel (453). The second was a deliberately modern theme and took the form of a monument to the legitimist Louis de Bonnechose who had recently died in La Vendée in a fight with some soldiers sent to arrest him. She executed the work in fresco on the prison wall. The idea of vengeance in this work recalls her earlier Monument to Dante. The principal figure was St. Michael, holding a bloody sword in one hand - with which he has just killed a dragon with a cock's head, image of the French Republic - and a pair of scales in the other, in which a single drop of the victim's blood was seen to outweigh numerous representatives of the law. Below was the device: "Quam gravis est sanguis justi inultus". On either

side of the figure were gothic inscriptions explaining the circumstances
in which the work was executed and naming those to whose memory it was
done (454).

After seven months captivity Félicie de Fauveau was taken before a
jury in Poitiers and acquitted. She then returned to work in Paris. But
in the same year, 1832, the Duchesse de Berri arrived in the Western
departements and gave new hope to the royalists. Félicie de Fauveau and
Félicie de Duras, together again, made another excursion to La Vendée and
became involved for a second time in subversive activities. She was not
inactive artistically during this period and once again took to modelling
small items such as bracelets and sword-guards covered with emblems and
devices; these were worn and used by sympathisers in the cause. When
the partisans of the Duc de Bordeaux were defeated and the little army
dispersed the two women hid and managed to escape to Belgium. In France
they were condemned to life imprisonment. Félicie de Fauveau then risked
a return to Paris in order to break up her studio before going to live
permanently in Florence with her brother and mother. This was in 1834.
The move had entailed great financial losses and at first they stayed with
Lorenzo Bartolini, Professor of Sculpture in the Academy of Florence. They
then found a house of their own and Félicie set up a new studio. They
were extremely poor at this time but did not lack for friends. Mme
Catalini, the singer, was one of these and the Queen of Naples, Murat's
widow, another. Commissions gradually came in.

Articles on the artist in "L'Artiste" make it possible to attribute
several works to the latter half of the 1830s. She finished the Monument
to Dante and on August 15th, 1836 the Florentine public were admitted to
her studio to view the work. In 1837 it was sent to the Count Portalès in
France (455). The following were her principal commissions. She executed
a funerary stone in medieval style for a noble Piémont family; a marble
statue of Saint Genevieve for the chapel of the Duchesse de Berri in which
the saint was shown placing Paris under the protection of God, Paris being
represented by a directionless ship with a torn sail; a bronze group of
"Saint Georges délivrant La Cappadoce" for Félicie de Duras in which the
saint delivers a fatal blow to the dragon from a gallopping horse, thereby
freeing the oppressed Cappadocia; a large funerary stone for the widow
of Sir Coutts Trotter; a sword guard for the King of Sardinia; also
numerous portrait busts, her subjects including the children of the Duc
de Rohan, the Duchesse de Berri, and the Duc de Bordeaux of whom she
executed six. On a visit to Rome in January 1840 she was warmly received
by the Duc de Bordeaux and a month later he visited her studio in Florence.

Also while in Rome she met Peter von Cornelius and Pietro Tenerani who
conceived a high opinion of her work. Mme de Krafft, a friend of Félicie
de Fauveau, later wrote of her as "cette femme remarquable dont j'avais
tant entendu parler à Rome par deux grands maîtres, Cornelius et Tenerani,
qui la citaient sans cesse comme une rivale .., une rivale dont ils
étaient fiers et non jaloux" (456).

Meanwhile she was not forgotten in France. When engaged on a group
of "Saint Michel terrassant le Démon" she was visited by a French artist
who offered to buy the work for 6,000 francs. She later discovered, to
her dismay, that he bought it on behalf of the French government. One
enterprising man in Paris made a fortune by selling walking sticks manu-
factured from her designs. She also sent works to the Salon. In 1839 she
sent her "Vanité du Miroir" which was rejected as a piece of
furniture rather than a work of art, to the great indignation of several
art critics (457). On one side of the mirror the artist carved a self-
satisfied fop and on the other a vain and beautiful coquette both of whom
are shown admiring themselves in the glass, unaware that their feet are
being ensnared by a demon. Again the subject was explained by a device:
"Parfois en ce cristal maint galant qui s'admire,
Va droit au trébuchet que lui tend un satyre,
Et la coquette aussi trop facile aux appeaux,
Livre son pied mignon au lacet des oiseaux"
As with the bronze lamp executed for the Count Portalès in the 1820s all the
details were appropriate. In the former the lamp became a symbol of man's
duty to watch and be ready for God's coming; the "Vanité du Miroir" was a
reminder to the user of the folly and dangers of vanity. Although
rejected the work was visible for a short period in the office of a M.
Falempin near the Place Vendôme and in the gallery of Durand-Ruel. Another
work on show in Paris in 1839 was a Holy Water basin representing "Un ange
sortant de l'eau purifié" in which the angel is mirrored in the Holy Water
beneath (458).

In 1841 a short notice on the artist appeared in "L'Artiste" (459).
M.F. Fayot praised her work to date and regretted that her talents had not
been employed in the decoration of French churches and monuments. "Judith
parlant aux Béthuliens", a marble work executed for the Baronne Gros, was
sent to the Salon of 1841 but arrived too late. It was exhibited at the
Salon of 1842 as "Judith montrant au peuple de Béthulie assemblé sur la
place publique la tête d'Holopherne, bas-relief en marbre" (no. 1945) and
measured 33 centimetres high. One other work of the 1840s was a monument

to the memory of Baron Gros, commissioned by Mlle Sarazin de Belmont (Fig. 147) Above two arched arcades is a figure of Saint Genevieve seated on a ship representing Paris. The banners sculpted round the ship carry the inscriptions: "Sancta Genofeva ora pro pictore tuo; ora pro conivge sua" (460). In 1842 a long article in three parts was published in "L'Artiste" giving details of the artist's life and work (461). In 1843 her portrait was painted in Florence by Madame Beaudin; characteristically she was portrayed in 15th century clothes. "L'Artiste"'s comment on this work was: "Les traits du sculpteur féminin ont une énergie qui manque à bien des hommes" (462).

From the 1850s her works appeared more rarely. Her "Combat de Jarnac avec la Chataigneraie", a bronze low relief which she had begun in prison, was exhibited at the Salon of 1852 (no. 1385) and in the same year a bust of Monsieur Dudon was exhibited in Florence. She was represented by three works at the Exposition Universelle in 1855: a silver crucifix (no. 5119), "Le Martyre de Sainte Dorothée - groupe en marbre avec fond d'architecture" (no. 5120) and also a marble fountain "avec figures et ornements" (no. 5121). These, and "Le Martyre de Sainte Dorothée" in particular, won her the praise of Théophile Gautier: "C'est à l'école d'Orcagno, de Nicolas Pisano, de Donatello et de Ghiberti que s'est formée Mademoiselle de Fauveau: elle a un sentiment très-fin de l'art du moyen âge, assoupli déjà par l'approche de la Renaissance, et personne mieux qu'elle n'a compris le gothique italien, si différent du gothique septentrional; elle donne à ses figures une grâce fluette qui ne va pas jusqu'à l'ascétisme émacié des sculptures de cathédrales, mais s'éloigne tout autant des formes épanouies du paganisme. Sa 'Sainte Dorothée', avec les meutrissures et les gouttelettes de sang qui perlent sur son dos, semble sculptée, dans son arcade à trèfles découpés, par un pieux ciseau du quinzième siècle" (463). In 1857 she completed a monument also in the style of the fifteenth century, which an obituary described as her greatest work. This was erected in the Medici chapel in Santa Croce Church by the parents of Louise Favreau, a young West-Indian who died at Fiesole. Mme de Krafft wrote the following about this work: "Après avoir contemplé un moment la figure principale, on se sent entraîné vers le ciel avec elle. Jamais le marbre n'a si bien exprimé l'espérance chrétienne, la transfiguration de la beauté mortelle .. " (464).

In 1859 the "English Woman's Journal" published a long article on the artist (465). The author had visited Félicie de Fauveau personally in Florence and gleaned many details of her life and work. At that time the family lived in a convent which the artist had bought in 1852. Her studio

was full of work, hitherto unmentioned works including a carved wooden crucifix, a terra cotta statue of Saint Reparata, several busts including one of the Marquis de Bretignières, the founder of the reformatory school colony of Mettray, three monuments to the memory of three members of the Lindsay family and also smaller items. Among the latter were an Hungarian costume with belt, sword and spurs for the Count Zichy and a silver bell ornamented with twenty figures for the Empress of Russia: "It represents a medieval household in the costumes of the period and of their peculiar avocations, assembling at the call of three stewards. The three figures form the handle. Round the bell is blazoned in Gothic characters 'De bon vouloir servir le maître'". This last should be aligned with the bronze lamp and "Vanité du Miroir" as evidence of the ingenuity with which she decorated objects of use.

Shortly after this her mother died and Félicie deFauveau modelled her tomb in the Carmès cloister in Florence. From then on she lived a solitary life and appears to have been forgotten in France until her death in 1887. She designed her own tomb with the inscription: "Vendée, Labeur, Honneur, Douleur".

Where subject matter is concerned Félicie de Fauveau's work is notable as a close reflection of her passionate beliefs in the value of religion and royalty. She is a supreme example of the artist using art as a vehicle for ideas. "Ce qu'elle a sculpté surtout, ce sont des pensées utiles et des sentiments charmants et profonds" wrote one critic, and another described her as "une artiste qui a sincèrement cherché l'ordre moral dans ce qu'il a de plus noble et de plus élevé, et l'a introduit dans ses oeuvres avec une conscience qui commande l'estime et le respect" (466). In her work every detail was made symbolic and to deepen the idea she accumulated detail upon detail, all the time making constant use of her extensive heraldic know-ledge with emblems and devices. All her works, even her portrait busts, included architectural backgrounds and these not only gave relief to the principal subject but also provided an opportunity for meaningful elabora-tion. She is also noteworthy for her example and influence in making sculp-ture an art of use. Her lamp, mirror, bell, bracelets, swordguards and numerous other small items created a fashion for such things in Paris. In 1839 she was described as "le plus grand artiste dans ce genre de la petite sculpture qui redevient si fort à la mode de nos jours" (467). On two technical points she was particularly successful. Firstly for her use of terra cotta in sculpture - her Saint Reparata was described as a beautiful example of her work in this medium - and secondly in the matter of casting. Her English visitor in 1859 reported that her life-long endeavour had been

"to cast a statue entire instead of in portions, and with so much preci-
sion as to require no further touch of the chisel; to preserve inviolate,
as it were, the idea, while it is subject to the difficult process of
clothing it with form .. In bronze, by means of wax, she has succeeded
after incredible perseverance and repeated failures" (468).

18. ROSA BONHEUR

Rosa Bonheur was born on March 16th, 1822. Her mother came from an aristocratic family, her father from more humble origins, a duality which is reflected in the parentage of George Sand, her most striking parallel in the literary world. At the time of her birth her father, Raymond Bonheur, was a drawing master in Bordeaux and also a landscape painter who sympathized strongly with the new school of naturalist landscape. She was the eldest of four children all of whom became artists specializing in animal subjects. In 1829 the family moved to Paris and lived in conditions of extreme poverty, particularly after the death of M. Dublan de Lahet, her maternal grandfather, in 1830. In April 1833 her mother died and until her father's second marriage in the early 1840s the children were brought up by him alone. He was a committed Republican and in the early 1830s espoused the Saint-Simonist cause, attending Enfantin's phalanstère at Ménilmontant. He shared Enfantin's belief in the messianic role of woman and impressed this on his daughter. His views doubtless had an effect not only on Rosa Bonheur's highly independent development but also on her own opinions about women's role. She believed in the moral and intellectual equality of the sexes and that progress in civilisation would only be achieved as this was recognized. She later stated in connection with her belief in women's future development - what she called "cette fière doctrine": "Je l'ai conçu quant à moi dès le début de ma carrière et je la soutiendrai aussi longtemps que je vivrai" (469).

Rosa was sent to a school run by the nuns of Chaillot. Then for a short while she was apprenticed to a dressmaker - an experience which she hated - and afterwards worked as a colourist of engravings. She finally entered a girls' boarding school where her father taught drawing but was soon expelled for naughtiness, having distinguished herself in nothing but drawing for which her father was obliged to award her prizes. She was then allowed to concentrate on art which had always been her favourite pursuit. From the age of ten she had sketched in the Bois de Boulogne and animals were her chosen subjects. Her father instructed her and his method was not to impose the copying of engravings but drawing from the round. She worked from casts, particularly those of animal bronzes by Mène and was soon allowed to copy in the Louvre. By 1839 she was making substantial contributions to the family income with copies of the old masters. These included "Henri IV" by Porbus, "Bergers d'Arcadie" by Poussin, "Les Moissonneurs" by Léopold Robert and also the works of Carl Dujardin and Salvator Rosa. Her favourite artists were Paul Potter, Wouvermans and Van Berghem because of

their portrayal of animals. The first things she bought with the money she earned from copying were engravings after the works of Landseer. She studied animals wherever she could: in the veterinary school at Alfort, in the Jardin des Plantes and later she even went to slaughterhouses to complete her anatomical knowledge. It was on account of her habitual visits to such places and her studies at horse fairs and cattlemarkets that she wore men's clothes, partly because it was more comfortable and convenient and partly because such attire made her less obtrusive at places where a woman's presence was extremely rare. In 1852 she obtained a "Permission de travestissement" from the police. Her interest in animals was not limited to the purely physical although her views on the soul of animals were not entirely consistent. When asked what she thought about this she once replied that in her youth her father had made her read Lamennais and he gave expression to her ideas: "Il se mêle toujours, quelque chose de nous aux choses que nous voyons. L'impression physique que nos sens reçoivent se transforme en dedans de nous-mêmes, et y suscite, pour ainsi parler, une image idéale en harmonie avec nos pensées, nos sentiments, notre être intime" (470). This Romantic view was counterbalanced by an equally strong belief in the natural intelligence of animals formed after constant association with many varieties. When describing her studies of the 1840s she wrote: "Une chose que j'observais avec un intérêt spécial, c'était l'expression de leur regard; l'oeil n'est-il pas le miroir de l'âme pour toutes les créatures vivantes; n'est-ce pas là que se peignent les volontés, les sensations des êtres auxquels la nature n'a pas donné d'autre moyen d'exprimer leur pensée" (471).

In 1836 she met Natalie Micas whose portrait her father was commissioned to paint and they soon became inseparable. When Rosa was allowed to hire a studio, on Monsieur Micas' advice, Nathalie worked there with her and transposed Rosa's drawings to the canvas to save her friend time. Here she enthusiastically pursued her studies of animals, "au triple point de vue myologique, ostéologique et physiologique" and executed sculptures as well as paintings (472).

She first exhibited at the Salon of 1841 and thereafter sent work yearly until 1850. In 1843 she won a bronze medal at Rouen and in 1845 was distinguished at four different exhibitions: she was awarded a third class medal at the Salon to which she sent six works, a silver medal at Rouen, a bronze medal at Boulogne and a diploma of honour at Toulouse. Henri Vermot in "L'Artiste" described her "Brebis et son agneau égarés pendant l'orage" and "Taureau et vaches" at the Salon as "remplies d'une tendresse et d'une fraîcheur ineffables" and drew attention to her remarkable portrayal of

"l'âme de la bête" (473). In 1847 she was awarded a second silver medal
at Rouen. In 1846 and 1847 she went to stay with her step-mother's
parents in the Auvergne and executed numerous sketches during her stay.
Her gold medal winning work at the Salon of 1848, one of eight exhibits,
was based on these sketches. It was called "Boeufs et taureaux, race du
Cantal" (no. 460) and was bought by an Englishman (474). This success was
the immediate cause of her subsequent State commission to paint a ploughing
subject for 3,000 francs. She worked on this picture during the winter of
1848 at La Nièvre where she stayed with a sculptor friend of her father.
It was exhibited at the Salon of 1849 shortly after her father's death,
which occurred on March 23rd, and was listed in the catalogue as "Le
Labourage Nivernais: Le Sombrage" (no.204) (Fig. 148). A copy of this work,
partly painted by her brother Auguste Bonheur, was later sold for the
higher figure of 4,000 francs.

During this first period her works were landscapes and representa-
tions of rural life as well as of animals. The animals are focal but the
landscape and peasants are there also. The proportions of sky and land are
almost equal and the artist sometimes introduced distant scenes, of a man
ploughing for instance, which give an impression of the life of the
countryside . Even in these early works, however, it was thought that she
paid less attention to context than other animal painters of the period
such as Constant Troyon, Jacques-Raymond Bracassat and Charles Emile Jacque.
An early example of her work is "Le Pâturage" (Fig.149), a calm, peaceful
scene, as was typical of the period and in which atmosphere, light and per-
spective are important elements. Peasant life is also evoked by the
woman standing beneath the tree and by the ploughman in the distance. Sim-
ilarly in the "Labourage Nivernais" (Fig.148) - a work which invites com-
parison with George Sand's "Mare au diable" of 1846 with its evocative
descriptions of ploughing - here also land and sky are equal, four
peasants are represented and an impression of depth is given by the diagonal
movement of the plough and animals. George Sand, observing such a scene,
wrote: "malgré cette lutte puissante où la terre était vaincue, il y avait
un sentiment de douceur et de calme profond qui planait sur toutes choses"
(475) and this is precisely the feeling given by Bonheur's picture. Two
other qualities emerge from the work. First there is the representation of
powerful regular movement completely lacking in previous works. Also the
oxen are individualized. The first pair are calm, experienced animals
looking straight ahead. The middle pair are less disciplined and one even
seems to be disturbed by the spectator's presence.

In 1848 Rosa Bonheur took over her father's drawing school for girls
in the Rue Touraine-Saint-Germain. She ran it in new premises at 7 rue
Dupuytren until 1859 with the assistance of her sister Juliette (476).
After her father's death in 1849 she went to live with Nathalie Micas and
her mother and the result was strong ill-feeling on the part of her step-
mother even though she continued to help her brothers and sisters finan-
cially. During the summer of 1850 Rosa and Nathalie went on a sketching
holiday to the Pyrenees at Mme Micas' expense.

The 1850s were a period of constant success. In 1850 she was recom-
mended by the government. In December 1851, a few days after the coup
d'état, the State commissioned her "Fenaison" for 20,000 francs as a pendant
to "Le Labourage Nivernais". In 1852 her portrait was painted by Edouard
Dubufe. In 1853, on the strength of her "Marché aux chevaux de Paris" at
the Salon (no. 134) (Fig.150) she was exempt from the jury and at the
end of that year she acuired a large studio in the rue d'Assas. In 1854
her "Marché aux chevaux" was exhibited at Gent and she was presented with a
cameo brooch by the city's Société royale d'encouragement des Beaux-Arts.
The work was also exhibited at Bordeaux in the same year. In 1855 the
picture commissioned by the State, "La Fenaison", was exhibited at the
Exposition Universelle (no. 2587) and won a gold medal. 1855 was the
last year she exhibited at the Salon until 1867. Owing to its dimensions,
her "Marché aux chevaux" did not find an immediate purchaser (477). The
city of Bordeaux having refused to buy it for 15,000 francs, Bonheur sold
it, for 40,000, to Gambart, the London picture dealer, who promised to give
the work maximum publicity in England and to have it engraved by Thomas
Landseer. She and Nathalie Micas then painted a copy, quarter the size,
to be used by the engraver while the original picture travelled to England
(478).

In July 1856 "Le Marché aux chevaux" was exhibited in London and
Bonheur and Micas yielded to Gambart's persuasions that they should visit
England at the same time. The highlight of her stay in London was a meet-
ing with Edwin Landseer arranged by Lady Eastlake, wife of the President of
the Royal Academy, in July: "This was the comble of her happiness; her
whole sympathy and admiration as an artist, and her whole enthusiasm as
a woman having long been given to Landseer" (479). The previous year, in
1855, Landseer had been awarded one of the two large gold medals given to
Englishmen at the Exposition Universelle. Landseer and Bonheur collabor-
ated on one work, entitled "The Stray Shot", portraying a dead deer (480).
"Le Marché aux Chevaux" was then exhibited in Birmingham and Gambart took
the two Frenchwomen to the city - where they were enthusiastically received

- on their way to Scotland. Landseer's numerous Scottish subjects probably stimulated Bonheur's desire to see the country. They stayed two weeks in Ballachulish and then in September attended the fair at Falkirk where the artist bought seven cattle and five sheep which unfortunately she had to sell as the Customs would not allow them into France.

When she returned to France at the end of 1856, Bonheur's fame had reached extraordinary heights. Her Thursday receptions at the Rue d'Assas were attended by the most eminent people and she was continually besieged by visitors. Although she did not exhibit at the Paris Salon after 1855 her works were shown elsewhere. In 1857 she was represented by three works at the fourth French exhibition in Pall Mall. In 1858 she exhibited in England, in Brussels for the second time - the first being in 1851 -, in Toulouse where she was awarded a silver medal and in the same year her "Marché aux chevaux" was seen in America (481). In 1860 her first proper one-man exhibition was held at the German Gallery in Bond Street; it was called "Scenes in Scotland, Spain and France" (482). Between 1855 and 1859 her life and work were discussed at length by E. Perraud de Toury, E. de Mirecourt, F. Lepelle de Bois-Gallais and E. Cantrel (483).

"Le Marché aux Chevaux" and "La Fenaison" stand out from works of the 1840s in several respects. First, in the representation of violent movement in the former work, a characteristic also of Géricault's "Course de chevaux libres" which is said to have exerted considerable influence (484). Second in the marked focus on the horses in the first picture and on the principal haymaking scene in the latter at the expense of sky and surroundings. In both, and in other works of the period, the action is centrally placed horizontal to the picture plane and also extremely compact, the close interaction of figures and animals giving a feeling of drama quite lacking in her earlier works.

In 1859 she gave up her position as head of the drawing school and in 1860 bought By, a château in the forest of Fontainebleau. This was instigated by continual disturbances at her studio in the rue d'Assas. She did not cut herself off completely, however, and kept a pied-à-terre in the city. Nathalie Micas and her mother came to live with her and she gradually collected a large number of animals of several types, sheep being her favourite species. She executed a "Berger des Pyrénées" for the Duc d'Aumale and a "Moutons au bord de la mer" for the Empress Eugénie in 1864 (485), having in the same year received her first visit from the Empress. In the 1860s tribute was finally paid to her achievements by the French

authorities. For a long time discussions took place about the proposed
awarding of the Cross of the Legion of Honour. Her merit was univer-
sally recognized but no one agreed on the nature of the honour which
should be bestowed, her sex being, in the eyes of many, a serious draw-
back. It was then decided that a special medal should be invented for
her exceptional status as a successful woman artist, and for a while
matters were left. Then the Empress Eugénie insisted on the artist's
claims to the Cross and in June 1865, she conferred the decoration per-
sonally (486). In the same year she was honoured with the Order of San
Carlos of Mexico. Her third distinction of the decade was her election as
a Member of the Institut d'Anvers in 1868 (487).

Her works continued to appear in London in the 1860s. She exhibited
at the Society of Female Artists in 1861, 1862, 1865, 1867, 1870 and 1873.
To the first three of these exhibitions she sent bronzes almost exclusively
and the prices asked for these stand in marked contrast to those asked for
her drawings. The highest price for a bronze was £3. 13s.6d. whereas a
drawing of animals in chalk commanded £60. Her paintings fetched higher
figures. In 1861 a small painting of "A Flock of Sheep in Repose in the
midst of the Heath, in the Mountains of Scotland" was sold for 14,550 francs.
In the early part of her career in particular Rosa Bonheur's interests
appear to have been divided fairly equally between painting and sculpture
but she played down her gifts in the latter medium in order not to compete
with her brother Isidore (488). In 1865 an article devoted to the respec-
tive talents of her brother and herself was published in "Le Courrier
Artistique" (489). She sent ten contributions to the Exposition Universelle
in 1867, five of them Scottish subjects and was awarded a second class
medal. "La Fenaison" was shown in a pavillion devoted to retrospective
works.

During the 1860s her work underwent a further development. Over
this period her focus on the animals became even greater, in some cases to
the extent of portraiture. They were centrally placed, with surrounding
objects often sketchily indicated and the sky receded even further up the
canvas. Her "Sheep" of 1869 (Fig.151) is a beautiful example of this
new style. The group is an entire family of sheep with the black ram
standing protectively over his ewe and lambs. This increasing emphasis on
the animal did not pass unnoticed. In 1871 René Ménard placed Rosa
Bonheur at the head of a group of artists who "s'attachent à reproduire
l'animal pour lui-même et en étudient jusqu'au moindre détail, au point de
lui sacrifier quelquefois l'air ambiant dont doit être enveloppé le tableau,
qui sans cette condition n'est plus qu'un compte rendu exact et dénué de

poésie" (490). Lack of poetry was a criticism frequently levelled at the
artist, from the "Labourage Nivernais" onwards. As landscape , peasants
and ambiance were gradually eclipsed by the animals themselves - which
throughout her career she always portrayed with extreme realism and
detail - so criticism of the "prosaic" style grew stronger (491).

The Franco-Prussian War and the Siege of Paris barely interrupted
her work as the Prince Royal of Prussia ordered that her house at By
should not be disturbed (492). In 1871 she exhibited a Fontainebleau sub-
ject - "Groupe de chevreuils dans une forêt" - at an international exhibi-
tion in London (493). The artist does not appear to have exhibited at all
between 1874 and 1880, but her pictures continued to fetch high prices par-
ticularly in America. After the death of Mme Micas in May 1875, Rosa and
Nathalie rented and then bought a villa in the South of France where they
spent their summers. Meanwhile at By her range of subjects widened.
According to the artist it was the feeling of tragedy inspired by the
Franco-Prussian War which caused her growing preference for lions and tigers
as subjects, as opposed to more pacific beasts (494). Landseer had already
painted lions from the 1860s. In 1880 she looked after two lions for two
months and sketched from them daily and later, in the 1890s, she brought
up a lion whom she called Fathma. A picture entitled "Jeune Prince" - por-
traying a lion's head - won her the Commander's Cross of the Royal Order of
Isabella the Catholic from the King of Spain in 1880. In January 1881 an
exhibition in Nice in the Salons of Mr. Gambart included little known works
by her from France and England (495) and in the same year she exhibited in
Brussels. In addition there was an exhibition of her recent works at
Lefèvre's gallery in King Street, St. James's,in July. These included a
"Cerf en alerte" and two "Sangliers fourrageant" in the Fontainebleau
forest which were engraved by Lefèvre (496). In April 1882 another
exhibition of her recent work at the Lefèvre Gallery included "Le Lion chez
lui" (Fig.152). In 1885 she was awarded the Order of Merit for Fine Arts
in Saxe-Cobourg-Gotha; in 1887 the high figure of 55,500 dollars was given
for her "Marché aux chevaux" in America (497) and in 1889 she made a rare
appearance in Paris with two works - one of them "Le Labourage Nivernais"
- at the Exposition Universelle. Also in 1889 a long tribute was paid to
the artist in the "Art Annual" (498).

In many works of the 1880s the sky has completely disappeared and
landscape is reduced to a minimum. "Le Lion chez lui" (Fig. 152) provides
the most effective illustration of this final development. Like the "Sheep"
of 1869 it is a family scene and again the parents are brilliantly charac-
terized, but here the animals fill the entire picture space. Typically,

the few scenic details are extremely realistic and suggest the native
habitat of the animal rather than, as was the actual case, their home
at By.

In 1889 Nathalie Micas died and her death had a shattering effect
on the artist. She sold the villa in the South of France and for
several years lost the inclination to work. Two events interrupted her
mourning in 1889. She was introduced to Buffalo Bill and two Indians who
were in Paris for the Exposition Universelle and this stimulated her
interest in American prairie subjects. It is worth mentioning as an
example of her attention to detail that she would not complete her pic-
ture of buffalo on the prairie without an actual sample of prairie grass.
She asked the American artist, Anna Klumpke - who she met for the first
time in 1889 - to obtain this for her. In the 1890s more honours were
conferred. In 1890 she received the Order of Saint-Jacques of Portugal.
In September of that year she was visited by President Carnot whose father,
like hers, had been a Saint-Simonien. During the visit he dwelt at
length on his faith in the future role of women and on his appreciation of
the contribution Rosa Bonheur had made to the advancement of her sex. In
1893 she exhibited four works at the World Exhibition in Chicago including
"Le Roi de la Forêt" and in 1894, as a result of the Chicago exhibition,
she was elected an Officier de la Légion d'Honneur. For Carnot this award
had a particular meaning. It was addressed to Rosa Bonheur not only as
an artist but also as an exceptional and exemplary woman. In the same
year she was nominated Officer of the Order of Saint-Jacques in Portugal.
In 1896 her most recently completed work, "Le Duel", was exhibited at the
Lefèvre Gallery in London (499) and in 1897 her first one-man exhibition
was held in Paris. This was an exhibition of pastels at the GeorgesPetit
Gallery in the rue de Sèze in June. Four large pastels were shown, in
all of which animals were focal : two of deer, one of bisons and one of a
shepherd and sheep. Again the French response was critical, the main
points at issue being excessive anatomical accuracy and inadequate atten-
tion to ambiance and poetry. She was likened to Landseer as opposed to
Troyon (500). The fact that her works were exhibited more frequently in
England and America than in France caused considerable ill-feeling in her
home country. Her explanation for the rarity of her Salon appearances was
that her dealers, Gambart and Tedesco, removed her pictures as soon as
they were completed and thus she never had any works to send. In 1898
her works were seen in Pittsburgh, Birmingham and at the Guildhall, London.
In the winter of 1898-9 she sent a sketch to the Union des Femmes Peintres
et Sculpteurs of which institution she was honorary President and in 1899
her last work appeared at the Salon - "Vaches et taureau d'Auvergne" (no.
228). In June 1898, Anna Klumpke came to live with her in order to paint

her portrait. She executed two during the last eleven months of the
artist's life. These were the second and third of the decade, the
first having been by Mlle Georges Achille-Fould in 1893. During the last
years of her life Bonheur was working on a huge canvas, "La Foulaison",
for which Tedesco was prepared to pay 3,000,000 francs on completion. In
size and as a scene of horses in violent movement it strongly recalls
"Le Marché aux Chevaux" and would doubtless have met with similar acclaim
had the artist lived to finish it (501). She died on May 26th, 1899. An
inventory of her studio after her death consisted of 1835 numbers - 892
paintings, 200 water-colours and 742 pastels and large drawings. In 1900
two exhibitions were held of her paintings and drawings at Georges Petit's
gallery and the total sum fetched was 1,180,880 francs.

In 1900 a critic wrote: "Parmi les artistes de ce temps il n'en est
pas, même des plus grands, Corot, Millet, Rousseau, Ingres, Delacroix, etc.
qui aient conquis une célébrité pareille à celle de Rosa Bonheur: imméd-
iate, universelle, grandissant sans cesse, et devenue rapidement une popu-
larité, puis une gloire incontestée" (502). Just as Mme Vigée-Lebrun was
cited as an example for her to follow, so she herself became an inspira-
tion for succeeding women artists, in particular Virginie Demont-Breton
and Louise Abbéma both of whom attributed their early enthusiasm and ambi-
tion to her example (503). The numerous medals awarded to her put an end to
the tacit exclusion of women from high honours. An obituary of the artist
by Virginie Demont-Breton remains the truest and most sympathetic tribute
to the artist. Other animal painters, she wrote, had paid equal attention
to landscape as to the animals themselves, but Rosa Bonheur was "l'artiste
qui pénétra le plus profondément et avec le plus de tendresse et de con-
science, l'intimité, ce qu'on pourrait appeler, le sentiment, l'âme de la
bête et l'interpréta en peintre de figure; celui qui rendit le mieux la
candeur d'un regard d'agnelet pressé contre la chaleur de sa mère, la bonté
de cette mère nourrice qui l'effleure de son museau tiède, la fierté pui-
ssante du mâle, la relation familiale de ces êtres entre eux; celui qui
raconta le plus simplement et de la façon la plus touchante tous ces
épisodes de la vie ruminante au soleil" (504).

19. HENRIETTE BROWNE

Sophie Bouteiller was born in Paris on June 16th, 1829, the daughter
of the Comte de Bouteiller who came from an old Brittany family. He was
an amateur musician of some talent having in 1806 won a prize for composi-
tion. It was her mother's second marriage. She had been widowed at a
very young age and left with a son for whose education her jointure did
not adequately provide. So, being one of the most accomplished singers
in Paris, she gave lessons in singing for several years in order that her
son might receive a good education. As a result of these experiences she
strongly believed that women should have some potential means of earning
money. In bringing up the daughter of her second marriage she constantly
encouraged her to choose one of the arts both on account of the intrinsic
value of serious study and because she wanted her to be prepared should
she ever have to earn her own living.

Sophie was brought up in Paris with yearly visits to her father's
relations in Brittany. She was never sent to school but taught entirely
at home by her mother and tutors. She received a thorough training in
music and also took drawing lessons for several years. When she was seven-
teen her mother urged her to choose between music and painting and to make
a professional study of whichever art she chose; Sophie is said to have
slightly preferred drawing to music and so her future career was determined.
In 1849 she was taught drawing by M. Perrin, later Director of the
Théâtre-Français, and in 1851 she entered Chaplin's female class which she
attended twice a week. Here she painted from the living model and at the
same time copied old masters in the Louvre. Her mother accompanied her
everywhere and gave constant encouragement and advice.

Although by this time committed to a career in art, Sophie did not
want her private and professional lives to be connected, both from modesty
and because for one of her social standing professional art was not entirely
proper. She therefore assumed a pseudonym and it was as Henriette Browne -
the name of her maternal grandmother - that she first appeared at the Salon
in 1853. When she next exhibited, at the Exposition Universelle in 1855,
her success was immediate. She sent five works, all of which were sold and
was awarded a third class medal. Her most important contribution, "Un
frère de l'école chrétienne" (no. 2640) (Fig.153) was bought for 4,000
francs by an Englishman and the "Ecole des Pauvres, à Aix (Savoie)" (no.
2641) was purchased by the Emperor Napoléon. The following review
appeared in the "Revue Universelle des Arts": "Quant à Mademoiselle Browne,
je dois avouer avoir eu de la peine à me persuader que les quatre tableaux

catalogués sous son nom sortissent réellement de l'atelier d'une femme.
Ils ont un feu, une hardiesse, un jeu de brosse, surprenants et extra-
ordinaires pour la délicatesse et la mignardise présumées d'une main
féminine". The author was particularly impressed by "Un Frère de L'Ecole
chrétienne": "Les traits du visage, les yeux, la bouche sont rendues
avec une fonte de teintes, une franchise de pinceau - l'expression bien-
veillante et tranquille respire un sentiment de réalité - que vous cher-
cherez en vain dans les tableaux que préventions souvent imméritées font
payer au poids d'or" (505). 1857 and 1859 brought further successes.
In the former year she exhibited five works all of which were sold, "Les
Puritaines" (no. 394) to the Empress Eugénie for 6,000 francs and again
she received a third class medal. One of her five contributions in 1859
was particularly successful and won her a third class medal for the third
time. "Les Soeurs de Charité" (no. 433) (Fig. 154) was a large painting
measuring five feet ten inches long by four feet three inches high and
portrayed two nuns tending a sick child. The extreme pathos of the scene
was once explained by the fact that the child was cared for by calm
strangers rather than his mother; his loneliness made the spectator's res-
ponse and sympathy all the stronger (506). Charles Kingsley described
it as a supreme example of the golden mean between realism which repro-
duces everything and naturalism which selects the best specimens from
nature: here "beauty and homely fact are perfectly combined". He pre-
dicted that the picture "will surely be ranked hereafter among the very
highest works of modern art" (507). The work is said to have caused a
sensation second only to Rosa Bonheur's "Marché aux chevaux" and was pur-
chased at 12,000 francs by the director of a lottery in which it featured
as the first prize. As a result of the lottery it passed into the possess-
ion of a Monsieur Laperche of Paris. Her three genre scenes at the same
Salon were all bought by Englishmen. In 1859 also, an exhibition of her
work was held at the French Gallery in Pall Mall. This comprised a
second smaller version of "Les Soeurs de Charité" which sold for the
extraordinary figure of 30,000 francs, as well as her other Salon exhi-
bits of that year and also "Les Puritaines" lent by the Empress Eugénie.
The exhibition was well reviewed in the "Art Journal" where the principal
characteristic of her work was said to be "realistic simplicity" (508).
By 1860 at least eight of her works had been bought by the English (509)
and the exhibition in Pall Mall established her reputation in this country.
Her renown was cemented by an extremely long article about the artist and
her work in the "English Woman's Journal" of April 1860 (510). By that

time she was married to Comte Jules de Saulx, a diplomat, and had
already travelled to Holland, Italy and Constantinople where she spent
a fortnight in 1860.

Up until 1860 Henriette Browne had specialized in genre scenes many
of which were on themes connected with religion. Her first exhibit at
the Salon, the "Lecture de la Bible" of 1853 (no. 187), portrayed an old
woman reading from a heavy Bible on her lap (511); "Un frère de l'école
chrétienne" followed in 1855 (no. 2640); "Les Puritaines" of 1857 (no.
394) depicted "two fair and high-born maidens" in 15th century costume
studying from numerous heavy volumes at a richly carved oaken table (512)
and in the same year she exhibited "Le Catéchisme" (no. 395), a scene in
a village church showing children preparing for their first communion (513).
"Les Soeurs de Charité" was next in 1859 (no. 433) and to the same exhi-
bition she sent "Une soeur" (no. 434) (514). Children were also recurrent
subjects and were often vehicles for much pathos and sentiment (515).
Three other aspects of her work should be indicated. Firstly the size of
her pictures, which, as we have already mentioned, was extremely large for
genre scenes (516). Secondly, certain characteristics of her work recall
Dutch art of the 17th century: her division of receding planes, most
evident in "La pharmacie, intérieur" (1859 no. 436) (517) and a later work
called "The Children's Room" (Fig. 155) and also the centralization of light
in her interiors. Finally, the realism of her works: "She never invents;
she observes, combines, and reproduces. In all her paintings every face
is a portrait; every detail, however minute, is copied from Nature with
literal fidelity. Though each of her pictures in its wholeness is a
creation of her own mind, all the elements of which it is composed are
borrowed from real life" (518). The "English Woman's Journal" also des-
cribed a striking instance of her attention to realistic detail. Having
planned her "Soeurs de Charité" she would not begin work until she had
procured the actual habit worn by nuns of the Order. This involved numer-
ous interviews and letters of recommendation as it was considered sacri-
legious for a habit to be used for such a purpose and over a year passed
before she was able to secure the costume (519). She attached great impor-
tance, then, to accuracy of detail. One other feature of her work should
be seen in the light of her realist approach. In many of her works, par-
ticularly those involving single figures or small groups, the subjects
fill a large area in the picture space and are nearly always presented
full-face. Perspective being thereby minimalized every part of the figure
and face is painted with equal attention to detail. Such figures, real-
istically painted and frontally placed on a large scale and on large canvases

would have been extremely imposing at a time when genre subjects were mostly rendered on small canvases with the emphasis on incident rather than type portraiture. The only contemporary parallel for such bold and frontal realism in interior settings is Manet, her junior by four years.

The 1860s were a period of travel and success. Following her first trip to Constantinople in 1860, Henriette Browne exhibited many Eastern subjects and three of these, exhibited in 1861, received warm praise from Théophile Gautier. The realism of "Une visite (intérieur de harem; Constantinople 1860)" (no.462) he considered unique for although men often painted odalisques, none could possibly have done so from nature. Of this and "Une joueuse de flûte (intérieur de harem; Constantinople 1860)" (no. 463) he wrote: "Ces deux scènes ont un caractère d'intimité orientale qui les distingue de toutes les turqueries fantaisistes" (520). She won a second class medal this year. One other woman artist painted harem scenes in Constantinople in the 1860s. In 1869 the "Art Journal" reported that Elisabeth Jerichau, the Danish artist, was about to visit Constantinople where she was "commissioned to paint portraits of the ladies of the sultan's harem " (521). Morocco was Henriette Browne's next destination and from 1865 subjects from Tangiers appeared at the Salon. Her third major trip was to Egypt and Syria in the winter of 1868/9. Children were frequently the subjects in such works, particularly school scenes. Her liking for frontal, horizontally arranged compositions emerges strongly from these pictures (522).

Henriette Browne was also a professional engraver. She won a third class medal for engraving in 1863 and was the first to execute steel engravings after the Eastern and scriptural drawings of Alexandre Bida. Her works were said to be extremely faithful and literal transcriptions of the originals (523).

Several other events of the 1860s should be mentioned, all indicative of her growing renown. In 1862 she was one of three women listed as Founder Members of the Société Nationale des Beaux-Arts (524). At the International Exhibition in London in 1862, "Les Soeurs de Charité" - presumably the smaller version - was offered once again to public inspection. Engravings of the work by Mr T.O. Barlow were published by Messrs Moore, McQueen and Co. of Berners Street simultaneously (525). In 1865 "Le catéchisme" sold at the Duc de Morny Sale for 16,000 francs. In 1866 "Une Soeur" was exhibited as "The Nun" at the French Gallery in Pall Mall as part of an

exhibition of "Artists of the French and Flemish Schools" and was reviewed
as follows in the "Saturday Review" : "It is extremely simple and would be
a mere study were it not for the very high conception of purity and piety
which it embodies. Madame Browne possesses, though in a far stronger and
nobler way, that religious sentiment which in feebler forms has given
popularity to so many artists .. Wherever one of her works is hung, a
silent power is exercising itself perpetually, and leading people from
frivolous desires and vain ambitions to the contemplation of lives whose
activity is beneficient, and whose rest is intended to be a sacrifice.
That these lives are higher than lives passed in mere amusement we cannot
deny, and Madame Browne must have a greater moral influence than Horsley
or Frith" (526). In 1867 she exhibited at the Society of Female Artists
in England and in 1868 the original version of "Les Soeurs de Charité"
was sold at the Hotel Drouot for £1,320 (527).

In the 1870s she exhibited portraits as well as genre scenes and her
female portraits were considered particularly successful (528). Her
"Portrait de Mme P..." (1874 no.273) (Fig.156) is an excellent example of
her psychological insight. Her last works at the Salon, both well reviewed,
were "Une grand'mère" and "Convalescence" of 1878 (nos. 354 and 355) (529).
By the 1870s her reputation was well established. Wilhelm Leibl lived in
her house during his stay in Paris in the Winter of 1868/9 and in 1874
Elizabeth Butler made a point of visiting her studio (530). Articles dis-
cussing her life and work appeared in "L'Art" in 1877 and in the "Musée
Universel" in 1878. In these she was given a distinguished position among
orientalist painters (531). In 1882 Sarah Tytler described her as "a
gifted and accomplished contemporary painter, holding - not indeed so high
a place as Rosa Bonheur, but an honourable place among her brother artists,
and becoming well known and appreciated in this country" (532). She won
a silver medal at Amsterdam in 1883 (533). Her works continued to fetch
high prices, particularly in England, the record during her lifetime being
32,810 francs paid for her "Visite au harem" in 1886 (534). Her last work
to be shown to the public was "Une soeur" at an exhibition of "Modern
Oil Paintings by Foreign Artists" at the Liverpool Art Club in 1884 (no.27)
(535). She died in Paris in 1901 (536).

Henriette Browne is notable for the boldness with which she depicted
genre scenes. Their scale, realism and imposing frontal presentation
were unusual characteristics at the time and may have contributed to the
elevation of genre in the hierarchy of styles. Although she specialized in
the portrayal of children, she occasionally used her style to make serious
statements as in "L'Alsace! 1870!" of 1872 (no. 221) (Fig.50) in which a

nurse stands looking at us from behind a table on which is a bowl of coins. The element of pathos and sentiment in her works - most noticeable in "Les Soeurs de Charité" (Fig. 154) and in another work, apparently not exhibited, entitled "Pendant la guerre" (Fig. 157) as well as in scenes involving poor children such as her "Ecole des Pauvres, à Aix" of 1855 and "La Bénédicité" (537) - was the main reason for her success in England.

20. BERTHE MORISOT (Fig. 158)

Berthe Morisot was born in Bourges on January 14th, 1841, the youngest of three daughters of a rich upper-middle class family. Her father had attended the Ecole des Beaux-Arts and then turned to an administrative career, his first post being Prefect in the Cher region. He was also a brilliant hellenist. Artistic tradition was on her mother's side, the latter being a granddaughter of Fragonard. Between 1841 and 1848 the family lived in Limoges and then moved to Paris, Caen and Rennes before finally settling in Paris in 1852. They lived in the Passy suburb.

In 1857 Berthe and her sister Edma received some instruction in art from a painter called Geoffroy Alphonse Chocarne, but they found his lessons boring and in the same year they were given a new master, Joseph-Alexandre Guichard, a pupil of Ingres and Delacroix. Under his guidance they copied some Gavarni drawings from reproductions. Impressed by their talent, Guichard told Mme Morisot the effect that his teaching would have upon them - they would become artists not amateurs - supposing that this would be considered socially unacceptable. She was unmoved by the spectre of social consequences and insisted that their instruction be continued. Guichard taught them all the basic principles and supervised their visits to the Louvre where they copied old masters, principally Titian, Veronese and Rubens. The sisters greatly admired the Barbizon painters - Corot in particular - and inspired by their example they expressed a desire to paint out of doors to Guichard. He was not encouraging but in 1861 they were introduced to Corot who invited them to watch him paint at Ville d'Avray. He became their adviser and friend and in 1863 his pupil Achille Oudinot took over the instruction of Berthe and Edma. They were taught to follow Corot's basic principle of observing nature in masses as opposed to detail and to paint in the morning when forms are simplified. In addition Berthe took lessons in sculpture from Aimé Millet. Through Oudinot the circle of their artist acquaintance was broadened. They met Daumier, Charles Daubigny - who was one of the earliest painters to work direct from nature - and Jean-Baptiste-Antoine Guillemet. The sisters also travelled in the early 1860s - to the Pyrenees in 1862 and to Normandy in 1864 and summers were spent at Pontoise and in Brittany.

Berthe Morisot first exhibited at the Salon in 1864, sending two landscapes painted the previous summer between Pontoise and Anvers, and she exhibited a total of twelve pictures at the Salon between this year and 1873. Until 1868 these were mostly landscapes, apart from one still-life in 1865. In greyness and delicacy of colouring and in composition these reveal the influence of Corot although already her style is distinctive on

account of the freedom of her brushstrokes. Then in 1868 while copying
a Rubens in the Louvre, she was introduced to Manet by Fantin Latour,
a fellow copyist. Manet asked her to pose for "Le Balcon" - the first
of several works in which she served as model - and soon the Manets and
Morisots became familiar. Through him Morisot got to know the circle
of artists who met at the Café Guerbois. Manet's effect on her work
was twofold. Where subject-matter is concerned it is noticeable in
the growing importance of figures and portraiture in her work; techni-
cally his example may have stimulated the increasing fluidity of her
brushstrokes, broader planes and an elimination of detail. Her letters
show that she was conscious of his influence throughout her life (538).
She in turn encouraged Manet to lighten his palette and to work out of
doors. In 1869 she executed her first important figure subject, "Les
soeurs" (Fig. 159) showing two identically dressed girls seated on a
patterned sofa. She may have been aware of works on similar themes by
Manet and Fantin-Latour (539). The main impression of the work is of
the extreme closeness of the sisters. They are seated apart, each immersed
in her own thoughts and their features are carefully differentiated and yet
they are in total sympathy with one another. This is primarily the result
of composition. The figures face inwards and are connected by a fan paint-
ing between and slightly above their heads and their arms curving inwards
below. The movement of the paintings, then, is circular, enclosing the
sisters and this circularity is reflected in the shape of the sofa and
that of the fan held by the girl on the right. The mood is one of quiet-
ude and repose. It is also informal, resulting from the partial represen-
tation of objects on the edge of the canvas such as the plant on the left
and the painting above, a characteristic also of Manet's "La Lecture" of
1868. Relevant perhaps to this portrayal of close sisterhood is Edma
Morisot's marriage to Adolphe Pontillon, a naval officer stationed at
Lorient, in 1869, after which Edma gave up painting. Her letters to Edma
following their separation are a useful source of information for her
views on contemporary artists. In May she expressed guarded appreciation
of Manet, a strong liking for the works of Puvis de Chavannes - whom she
also met in 1868 - and most significantly, she wrote of Bazille's Salon
exhibit: "Il cherche ce que nous avons si souvent cherché: mettre une
figure en plein air" (540).

She exhibited at the Salon until 1873 and her last four exhibits,
from 1870 onwards, were informal interior portraits. Between 1874, the
year of her marriage to Edouard Manet's brother, Eugène, and 1882, she

contributed to six out of the seven Impressionist exhibitions, her
absence in 1879 being due to the birth of her daughter. She travelled
frequently within France - often to stay with her sister - visited
Madrid in 1872 and England in 1875. Her works of the 1870s are of two
main types: interiors with large figures like "Les Soeurs", and land-
scapes with small figures. Manet and Fantin-Latour provide the best
parallels for the first category and the Impressionists for the latter.
In both cases the models were usually members of her family, particularly
her sister Edma and her two children. Her palette became lighter, details
were omitted and objects were increasingly integrated by broad brush-
strokes and pervasive effects of light. In this her development corres-
ponded with that of the Impressionists.

In her "Vue de Paris des Hauteurs du Trocadéro" (Fig.160) of 1872,
Corot's influence is still apparent in the greyness of colouring. There
is a clear distinction between planes, and brushstrokes, although summary,
define forms: the foreground figures are clearly indicated and so are
large buildings in the background. In "La chasse aux papillons" (Fig.161)
and "Les Lilas à Maurecourt" (Fig.162) of 1874 and in "Dans le Parc" (541),
a pastel of the same period, all of which show Edma Pontillon with her two
children, the figures stand out, still with clarity, against sketchy wood-
land settings. Light here is more important but it is not pervasive for
it is filtered through trees. "Dans les blés" (Fig.163) of 1875 is a much
brighter work. The scene is open and a third of the canvas is devoted to
sky. The child's body blends with the corn and is only vaguely suggested.
Still, however, there is clarity, particularly in the background where
houses and even chimneys are easily distinguishable. "Jour d'été" (Fig.164)
of 1879 shows a further development. Like "Dans les blés" this is an
unshaded scene in the wide open but unlike the former, no sky is indicated
- only the broad effect of light from the sky on the figures in the boat
and the river behind them. Here every part of the canvas is treated with
the same sketchiness and light pervades everything. Her indoor scenes
show the same tendency. Like "Les Soeurs", "Le Berceau" (Fig.165) of
1872 is a quiet restful scene with psychological interest. The subject
is Edma Pontillon with her child whose face is barely indicated behind
white gauze. As in "Les Soeurs" there is a feeling of enclosure and
communion and there is the same circular movement within the picture. But
in execution the pictures differ. In the later painting brushstrokes
are freer, particularly in the representation of the white net over the
child and in front of the window behind. In "Jeune femme se poudrant"
(Fig.166) of 1877 light is more obtrusive and is even reflected in the
mirror on the left. The handling here is extremely free, the figure's

hands being barely defined and her dress rapidly indicated in broad
strokes. In "Jeune femme de dos à sa toilette" (Fig 167) of 1880 an
extreme is reached and the figure is almost dissolved in the surrounding
atmosphere. In this work and in "Jeune femme se poudrant" psychological
interest has yielded to effects of light.

Berthe Morisot's contributions to Impressionist exhibitions were
almost always well reviewed. She was praised for her colour sense, for
the spontaneity of her execution and for the grace and charm of her sub-
jects - qualities described as essentially French - and in 1877 her work
was placed in the centre room with that of Cézanne (542). In 1882
Philippe Burty called her "l'artiste impressioniste par excellence" (543).

In the 1880s she continued what she later called "mes tentatives
d'impressions en couleur" (544) and her landscapes gradually disinte-
grated under increasingly nervous brushstrokes. Her habit of summer
travel persisted and many of her motifs came from provincial France. But
at the same time new characteristics emerged. Already in 1879 her "Jeune
femme en toilette de bal" (Fig.168) stands out from preceding works in
the outlining of the figure's shoulder and arms. It is also remarkable
as one of her first portrayals of a large figure out of doors. In the
1880s the human figure became more defined in her works. In 1886 she
recorded a visit to Renoir on which occasion he showed her a red crayon
and chalk drawing of a woman suckling which she described as "charmant
de grâce et de finesse" (545). Of other drawings she commented: "Je ne
crois pas qu'on puisse aller plus loin dans le rendu de la forme; deux
dessins de femmes nues entrant dans la mer me charment au même point que
ceux d'Ingres" (546). Her attempts at sculpture in 1887 and request for
an introduction to Rodin are also signs of her growing appreciation of
form. In her portrait of Louise Riesener of 1888 (Fig.169) the subject's
arms, neck and face are all carefully modelled and outlined and the
figure stands out clearly against the background. In the 1880s and early
1890s she started drawing her paintings first and many sketches and
studies preceded the final product. Her daughter Julie and her niece
Paule Gobillard were her favourite subjects during this period and her
portrayals not only reveal a greater attention to form but also a return
of psychological interest. "Julie Manet et son lévrier, Laerte" (Fig.170),
a beautiful study of her daughter, is an example. Paintings executed
during the last few years of her life strongly recall Renoir both in the
sculptural rounded shape of her models and in her preference for contrast-
ing colours, particularly reds and greens. Renoir was with her at Mézy

when she painted "Le Cérisier" (Fig. 171) of 1890, one of the most
striking instances of their affinity at this time.

By the 1880s Berthe Morisot was well-known and her position well-
established in artistic circles. The Manets' house in the Rue de Ville-
just, where they lived from 1883, was a centre of intellectual and
artistic life. In addition to painters - Degas, Monet and Renoir in
particular - the house was also frequented by Baudelaire, Zola, Chabrier,
Henri de Régnier, Théodore de Wyzewa and above all Mallarmé who was one
of her closest friends at this time. In 1887 a project was mooted for the
Impressionist painters to illustrate his prose poems. The public had
frequent opportunities of seeing her work: in 1883 her pictures were
exhibited at Durand-Ruel's group show in London and also in Boston; she
exhibited in Brussels in 1885; in 1886 and 1887 her works were included
in Durand-Ruel's exhibition in America and in 1887 also, she exhibited
paintings and a bust at Georges Petit's International Exhibition; in 1888
her works were shown again at Durand Ruel's; in 1892 her first one-man
show was held at Boussod and Valadon's gallery on the boulevard Montmartre
and the preface to the catalogue was written by Gustave Geffroy; in 1894
she exhibited again in Brussels and in the same year her "Jeune femme en
toilette de bal" (Fig. 168) was bought for the Luxembourg.

She died on March 2nd, 1895, three years after her husband. In
March 1896 an exhibition of her work was held at the Durand-Ruel Gallery
which included 74 paintings and approximately the same number of drawings,
pastels and watercolours. Six more one-man exhibitions were to follow
before 1914.

A recurrent theme in discussions of Berthe Morisot as an Impression-
ist was the correspondance between Impressionism and traditionally femin-
ine attributes such as intuition, spontaneity and delicacy of vision and
feeling (547). She herself wrote of her sex: "Vraiment nous valons par
le sentiment, l'intention, la vision plus délicate que celle des hommes
et si, par hasard, la pose, la pédanterie, la mièvrerie ne viennent à la
traverse, nous pouvons beaucoup" (548). She believed in the importance
for art of "des sensations nouvelles, personnelles" and in the value of
capturing even the slightest piece of reality: "une attitude de Julie,
un sourire, une fleur, un fruit, une branche d'arbre, une seule de ces
choses me suffirait" (549). For such sensations to occur and in order to
capture moments of reality in art, a peaceful life of contemplation was
essential; "le rêve, c'est la vie", she once wrote (550). For this
reason Morisot did not seek unusual motifs and she rarely hired models.
She portrayed what was around her and her figure subjects were nearly
always based on her family and friends. The degree of realism and of

psychology in her representation of people corresponds strikingly with
the closeness of her relationship to the subject. When her sister Edma
was at home and during their reunions after her marriage, she paid
attention to expressions and attitude even when portraying figures in
landscape. Then, when she herself left home after her marriage in 1874
and in particular when she visited England with her husband in 1875, she
was placed in the unusual situation of being without close female com-
panions and children to use as subjects. In a letter from England she
regretted the absence of children as models (551). It was surely as a
result of this experience that for a short while figures lost importance
in her work. As a married woman her daily life did not include constant
female company. Instead formal considerations and effects of light came
to the fore. Then in the 1880s her daughter Julie took the place formerly
occupied by Edma and human interest re-emerged in her work. She wrote:
"J'ai toujours eu beaucoup de peine à me detacher des lieux, des personnes,
même des bêtes, et le plus joli c'est qu'on me croit l'insensibilité même"
(552). Her work is an exact record of all the places and people to which
she was most attached and for this reason Berthe Morisot must rank as one
of the most personal artists of her time.

21. MARY CASSATT

Mary Cassatt was born on May 22nd, 1844, in Pittsburgh, Pennsylvania. From her parents, Robert Sympson Cassatt and Katherine Kelso Johnston, she inherited a mixed nationality, mostly Scottish and Irish but there were elements also of Dutch and French blood. French was given a particular emphasis in her childhood, her mother having been partly educated by an American woman who had studied under Mme Campan in France (553). Her father was a banker in Pittsburgh. Between 1851 and 1858 the whole family travelled abroad to Paris, Heidelberg and Darmstadt in order that a son, Robbie, might see specialists for a knee complaint and to further the technical training of another son, Alexander. Due to these trips and her mother's fluency in French, Mary learnt the language early. In 1861, at the age of seventeen, she decided to become an art student and entered the Pennsylvania Academy where she studied for four years. Drawing from casts and still-lives was followed by copying oil paintings in the Academy, but apparently no teaching was offered. From 1866 to 1867 she spent a year travelling in Europe with her mother and then from 1868 to 1870 she lived in Paris. During this time she went on sketching tours with a friend from Pennsylvania. A trip to Haute-Savoie produced several studies of women outdoors revealing an interest in effects of light and also a painting of a Savoyard child on his mother's arm, an early instance of one of the main themes in her work (554). During the Franco-Prussian War of 1870-1 her parents insisted that she should return to Philadelphia. Two portraits remain from this visit (555). At the end of 1871 she sailed for Italy. She went to Rome but finally settled in Parma for eight months where she worked under Carlo Raimondi, a painter and engraver who was head of the Department of Engraving in the Art Academy. During this period she made a detailed study of the works of Correggio whom she admired for the realism of his child figures and also Parmagiano. Their influence is evident in works of the period (556).

Her first Salon exhibit was "Pendant le carneval" (no. 1433) which she sent from Rome in 1872 (557). A professional academic work, it was well received and hung on the line. In 1873 she went to Spain and in the same year "Offrant le panal au toréro" was accepted at the Salon (no. 1372) (558), a picture which marks a distinct advance over earlier efforts in breadth of execution and the representation of light. In Spain she was attracted to the work of Velasquez and more especially Rubens, whos paintings she also studied in Antwerp. The result was a greater intrusion of light and clear colours in her work. In the same year she visited Holland and copied the

"Meeting of the Officers of the Cluveniers-Doelen, 1633" by Frans Hals
(559). Cassatt's travels were instigated by a strong belief in the
value of copying in art education and her Hals copy she later showed to
students as an example of how she learnt her art. One of her most inter-
esting early works is a portrait of her mother executed at Antwerp in
1873 (Fig.172). Character is effectively portrayed and the mood - as in
many of her later works - is one of peaceful thought.

In 1874 she settled permanently in Paris. That year her two pre-
vious Salon exhibits were shown at the National Academy of Design in New
York and she also sent a third work to the Salon. "Ida" (no. 326) (560)
was a portrait of Mme Cortier and it was this work which attracted the
attention of Degas who felt instant affinity with the artist. His artistic
sympathy was as spontaneously reciprocated and Cassatt also responded
strongly to the work of Courbet and Manet. She was unmoved by more conven-
tional artists such as Chaplin whose class for women she attended for a short
while in 1875 at the suggestion of her family. She exhibited one portrait
at the Salon of 1875 and two more in 1876, one of the latter being, it is
thought, a toned down version of a work called "La jeune mariée" rejected
at the previous Salon (561). In 1877 her Salon entries were again
rejected and she never sent work again. While exhibiting more conventional
works at the Salon she also executed several head studies of women and
children outdoors, and it is in these and in works such as "Picking flowers
in a Field" (562) that her sympathy with the Impressionist emphasis on
light is most apparent. Throughout her life she was to prefer working out
of doors.

In 1877 she joined the Impressionist group on Degas' invitation,
becoming the third member of the group, with Degas and Berthe Morisot, who
did not rely on the sale of their work to earn a living. Later that year
her parents and sister Lydia came to live with her in Paris. Between
1875 and 1878 she specialized in the theme of women indoors. These were
mostly members of her family and friends seated on sofas and engaged in
peaceful occupations such as reading and sewing. Of these her portrait of
her sister Lydia reading the morning paper of 1878 (Fig. 173) is an excellent
example. The handling is free, the colours extremely light, but at the same
time she has taken great care in the painting of the hands and face: the
work is not only a study of lighting effects, nor simply a mood picture -
it is also a psychological study. Her self-portrait leaning against a
striped sofa is also successful as a representation of character (563). It
is in works such as these that she comes closest to Manet. Degas' influ-
ence is most apparent in her "Woman and Child Driving" of 1879 and in her

"Enfant dans le salon bleu" of 1878 (564). He not only advised her on
the background for the latter but also worked on it and to him presumably
may be attributed the unusual diagonal arrangement of the chairs and the
cutting of their shapes on the edge of the canvas. According to her
father these works were not a commercial success (565). Later in 1878
however, he did write of a sale and a commission (566). Meanwhile she
was becoming more widely known in America. She exhibited in Pennsylvania,
New York and Massachusetts in 1878.

In 1879 she worked on the theme of women, mostly her sister, in
boxes at the opera and one of these, entitled "Dans la loge" (567), was
exhibited that year at the fourth Impressionist exhibition, the first at
which she was represented. Lydia is shown seated against a mirror in
which are reflected her own form and the lines of boxes which curve drama-
tically up to the top right hand corner of the picture. She also exhibited
"Le thé" (568) portraying her sister seated in a pose very similar to that
in "Lydia reading the morning paper" of 1878. With these two works she
won success and several critics, including J.K. Huysmans, drew attention
to her work (569). By this time the circle of her acquaintance had
widened and in addition to Degas and Manet she also saw Pissarro, Renoir,
Mallarmé and Clemenceau. In the same year her works were exhibited in
Pennsylvania and New York. In the summer she travelled to the Isle of
Wight and to Italy and in October Mr Cassatt reported that she was "very
much occupied in 'eaux-fortes'" (570). This new interest may have been
instigated by Degas who in 1879 planned to start an art publication called
"Le Jour et la Nuit". Although this never materialized Cassatt did pro-
duce a contribution, a soft-ground etching and aquatint depicting another
opera-box scene. From 1879 graphic work constituted an important part of
her output.

To the fifth Impressionist exhibition in 1880 she sent another
"Femme au théâtre" (571), to which Gauguin was greatly attracted, "Le Thé"
(572) in which Lydia is shown in profile as so often before and "La
toilette de l'enfant" (573). The latter and "Caresse maternelle" (574)
were the first in a long series of works portraying mothers and children
in simple everyday activities. This interest was fed by regular visits
from her nephews and nieces. In the summer they stayed in a villa at
Marly-Le-Roi and in the winter Cassatt spent much time looking for a new
apartment, an activity which, together with visiting health resorts for
her sister's benefit, wasted much of her time over the next few years
until they settled at Rue Marignan in 1887. Her contributions to the
sixth Impressionist exhibition were very well received (575). The most

important of these were an unusual horizontal composition portraying Mrs
Cassatt reading to her grandchildren (576) and also a portrait of Lydia
crochetting in the garden at Marly (577). In these and in other works
of the period such as "Susan comforting the Baby" of 1881 (578) and
"Lydia working at a tapestry frame" (579), brushstrokes are extremely free
and colours are bright and contrasting, but at the same time character
and the substantiality of form are conveyed; however free her handling
became it was always used to define form. In her last two important works
in this style - "Susan on a Balcony holding a dog" (580) and "Reading
'Le Figaro'" (Fig. 174) - the handling is quieter and the colours less
strident. In "Reading 'Le Figaro'" the spectator's attention is focused
on the newspaper - like the subject's - by compositional means: the lines
of the chair, the mirror and the woman's arm all converge on the paper she
is reading. Due to the closer correspondence between technique and subject
matter in these works - both are quiet peaceful scenes - they are in many
ways her most successful pictures of the period.

Neither Cassatt nor Degas took part in the Impressionist exhibition
of 1882. At the end of the same year Lydia Cassatt, the model for so many
of her sister's previous works, died, and from 1883 a new development is
apparent in her work. Another visit from her brother and his children
inspired a series of aquatints and dry point etchings of children and
maternal scenes and from 1883 the characteristics of her graphic work
gradually impinged on her painting. Beginning with her "Lady at the Tea
Table" (581), painted between 1883 and 1885, compositions became more
linear and surfaces flatter, an extreme example in this new style being
"The Family" of 1886 (Fig.175),an outdoor scene of a mother and two chil-
dren. Between 1882 and 1885 her works were not exhibited in Paris at all.
In 1883, however, three pictures were included in an exhibition of
Impressionist art at the Dowdeswell Gallery in London. Then in 1886 she
exhibited in America and also sent work to the eighth Impressionist exhi-
bition, an event financed by Berthe Morisot, Degas, Lenoir and herself.
One of her exhibits was "Girl arranging her hair" (582) and this illus-
trates another aspect of her new style. From the mid 1870s to the mid
1880s her subjects were always relaxed, never engaged in any more exerting
occupation than crochet or reading. Most frequently they were just think-
ing. From "Girl arranging her hair" there is far more activity in her
work and even when there is no actual movement the arms and legs of mothers
and children create a sense of flow within the picture. Cassatt executed
numerous maternity scenes in the late 1880s and 1890s and in all of these
she conveyed the close relationship of the mother and child by formal

means; not only is the child's form physically close to that of the mother but the lines of the child's body are continuous with hers; together they create a form made up of harmonious flowing lines in which the chief emphasis is always placed on the line of the mother's encircling arm. A pastel maternity of around 1890 (Fig. 176) is an excellent example of this. She achieved this abstract synthesis of the idea of maternity at the expense of individual psychology. In her most informal and intimate maternity scenes the sitters are anonymous. Frequently they are peasant women and sometimes faces are not represented at all. In portraits of specific mothers and children such as "Emmie and her child" (583) of 1889 and "Madame H. de Fleury and her Child" (584) of 1890, there is less abandon and more attention to the features of the subjects; there is also less closeness. Her individual portraits of the period are perhaps more success- ful. Her portrait of her mother of 1889 (Fig.177) is a brilliant psycholo- gical study in which full attention is focused on her features. The lines of her shawl, of her arm and of the picture behind all converge on the head and the repose of the figure and face is offset by a more nervously painted background.

In 1890 Cassatt was greatly impressed by a large exhibition of Japanese art held at the Ecole des Beaux-Arts in April and May which included 725 prints and 362 books all lent by French collectors. The exhi- bition inspired a series of ten aquatints which she executed between 1890 and 1891 at the Château Bachivillers on the Oise river. These were shown at her first one-man exhibition at Durand-Ruel in 1891 which comprised a total of twelve prints and five paintings. In 1893, in which year she settled at the Château de Beaufresne, she had a second exhibition at Durand-Ruel; it was extremely large, consisting of 98 items, many from earlier periods in her work. About 60 of the exhibits were prints and it was these which attracted attention, especially her dry-point etchings. Her draughtsmanship rather than her colour sense was praised (585).

The Japanese exhibition also accelerated the development towards linearity and flatness of design in her paintings. This is evident in the mural on the theme of modern woman which she was commissioned to execute for the Woman's Building at the Columbian Exhibition in Chicago in 1893 (586). Two important works should be seen in the light of her graphic skills and in the context of the broad influence of Japanese art. "Le Bain" (Fig.178) of 1892, another informal maternity scene, is notable for the high vantage point from which the scene is portrayed. The result is a flattened space and flatness is further emphasized by the patterning

of background areas and of the woman's dress and by the bold contours of
the jug and basin. Like her other anonymous maternity scenes of the
period, this work is not a character study; the features of the woman
and child are unimportant in the composition. What is important is the
enclosing figure of the woman and also gesture - her hand washing the child's
feet in water. "The boating party (Antibes)" (Fig.179) of 1893, in which
the view point again is high, is an extremely unusual work as it effec-
tively combines the linearity of her graphic works and paintings on
maternity themes with the focus on feature and expression characteristic
of her portraits. Although the largest figure is that of the man with
his back to us in the foreground, all the main contours - describing the
outline of the boat, the sail and the man's arm - converge on the central
group of the mother and child seated at the end of the boat, and their
faces, unlike in many of her maternity scenes, are painted with care and
psychological insight. In 1914 she wrote to Durand-Rual that she did not
want to sell this picture: "I have already promised it to my family. It
was done at Antibes 20 years ago - the year when my niece came into the
world" (587). This, then, is a unique example of a portrait placed within
a more abstract linear composition. It is an effective combination of her
powers as portraitist and as designer.

In 1895 Durand-Ruel organized an exhibition of her work in New York
and in 1898 she returned to America for the first time since the Franco-
Prussian War. She executed numerous portraits during this trip, of the
children of Mrs Gardiner Greene Hammond in Boston and of various members
of the Whittemore family in Connecticut amongst others. None of these
were ambitious artiscally. In 1899, the year of her return to Paris,
Durand-Ruel organized another exhibition of her work. It included five
or six pastels and two paintings on the theme of a mother and another
young woman playing with a child (588). A second theme on which she
worked at this time was that of women nursing (589). On the whole these
works show a more realistic approach to the maternity theme; there is less
linearity and less emphasis on composition. From 1901 she began to choose
older children as models and consequently forfeited the informality and
abandon characteristic of earlier works portraying younger children. Older
models like Jules had straighter limbs, and more formed features and did not
lend themselves so readily to pleasing abstract designs. Again there is an
interesting and successful exception, which won Degas' appreciation. In
"Baby Charles looking over his mother's shoulder" of ca. 1900 (Fig.180),
the strong curve of a mirror in the top right hand corner is the starting

point of a graceful arabesque running through the baby's head, along his right arm and down round the left curve of the mother's body. The mirror frame leads the eye to their heads and the mirror itself enables the artist to suggest the features of the mother whose back is turned to us. Form and line serve both psychology and the generalized mother image.

In 1901 Cassatt travelled round Europe with the Havemeyers, advising them on purchases for their art collection. This she had done ever since she first met Mrs. Havemeyer, then Miss Louisine Elder, during her first years in Paris. Her works were exhibited in 1903 in Paris with those of the other Impressionists and in the same year at a one-man exhibition arranged by Durand-Ruel in New York. In 1904 she declined the Lippincott prize awarded by the Pennsylvania Academy as she wished to observe the Impressionist principles of "no jury, no medals, no awards" (590). In the same year, however, she received the Cross of the Légion d'Honneur. Between 1907 and 1915 she had three more one-man shows and her works also appeared at group exhibitions. She declined membership of the National Academy of Design in New York in 1909 but accepted a Gold Medal of Honour given by the Pennsylvania Academy in 1914 "for eminent services to the Academy" - a reference to her liberal advice on the purchase of modern works of art. During the later years of her life she suffered from an eye complaint which hindered her work. She became increasingly involved in politics and another subject which interested her - spiritualism. She died at the Château Beaufresne on June 15th 1926.

Mary Cassatt's works are of two main types. Broadly speaking until the mid 1880s her work was a combination of her powers as a portraitist and as an intimist. She painted women indoors, most frequently her sister, engaged in the peaceful everyday occupations of women of her class. In these, character, expression and mood were important elements. Technically, these were distinguished by close attention to the effects of light, broad execution and thirdly monumentality of form, all characteristics of the work of Manet also. In psychology, mood and painting and compositional ability her most successful essay in this early style was a portrait of her mother "Reading 'Le Figaro'" (Fig.174) of 1883. Her 1879-1880 series on women at the opera was an exception and is the first indication of her later preoccupation with linear composition. These works reveal the influence of Degas.

From the mid-1880s new themes took over and new formal interests. After Lydia's death mothers embracing and holding children became her main subjects. At first the models for these were her nephews and nieces but gradually the idea of maternity,of the relationship between mother and child, took over from the portrait aspect. Psychology in the sense of expressive features yielded to the idea of maternity as expressed by attitude.

Critics often praised the truth with which she captured the posture of
children. They are abandoned, uncontrolled and completely true to their
age. Where technique is concerned she lost interest in the three-
dimensional aspect of form and in paint as a medium. Prints and pastels
became more and more numerous and in her paintings line eclipsed mass.
In her maternity pictures curving lines, particularly that of the mother's
enclosing arm, are used to define attitude which, unlike in her earlier
period, is more important than facial expression. At the turn of the
century there was a return to realism, to form. Her maternal scenes
became portraits of specific mothers and children rather than general
maternities and she also painted many pictures of children alone.

Her main achievements are perhaps those works which combine her two
principal styles. Her portrait of her mother of 1889 (Fig.177) is success-
ful as a psychological study and as an evocation of mood. The background
is extremely painterly with broad nervous brushstrokes and these act as a
foil to the flat linear rendering of the figure of the subject whose
stillness and calm are thereby emphasized. At the same time all the lines
in the picture converge on the sitter's head, drawing attention to her
thoughtful expression. "The Boating Party" (Fig.179) of 1893 consists of
a similar but more complex combination. Here again the background of water
is painterly, constrasting strongly with the flatness and linearity in her
rendering of the boat and the man in the foreground, and again all lines
lead to the mother and child who are in effect a portrait group in the
top centre of the canvas. Mary Cassatt was indeed brilliant in her repre-
sentation of the attitudes of childhood and in her suggestion, by formal,
linear means, of the close relationship between mothers and children, but
she also excelled in portraiture and in the evocation of mood. Camille
Mauclair accurately described her as one of those who had best succeeded
in "la constatation de la pensée à travers la constatation de la forme" (591)

22. EVA GONZALES

Eva Gonzales was born in 1849, daughter of the novelist Emmanuel Gonzalès (592). The latter had many friends in the artistic world and in 1870 became an honorary President of the Comité de la Société des Gens de Lettres. It was on the advice of Philippe Jourde, director of "Le Siècle" and that of Théodore de Banville, that Eva Gonzalès entered the studio of Chaplin at the age of sixteen. Her sister Jeanne was also an artist (593). She soon became acquainted with the future Impressionists and in 1869 was introduced to Manet by the painter Alfred Stevens. Attracted possibly by her Spanish origins and appearance, Manet then painted a portrait of her painting a still-life which was exhibited at the Salon of 1870 and a close friendship was formed between the two. They worked together and Gonzalès received informal instruction from Manet. Until this meeting her work was realistic in style: in "Le Thé" (Fig.181), showing a woman in a black dress taking tea, many details are included and the space is deep. Her "Enfant de troupe" at the Salon of 1870 (no. 1219) (594) already suggests Manet's influence and specifically recalls his "Fifre" of 1866. The boy stands against a plain dark background in which only shadows suggest the existence of space. The figure itself, however, is realistically modelled and mass is emphasized by light coming from the left. The work was bought by the State after the exhibition. The subject matter of this picture is unusual in Gonzalès' oeuvre. More typical was "L'indolence" (Fig.182), a successful exhibit at the Salon of 1872 (no.723) depicting a woman resting by a window (595). Like Berthe Morisot and Mary Cassatt, Gonzalès' most frequent model in her figure compositions was her sister, Jeanne, engaged in ordinary, everyday occupations.

Unlike Manet's, Gonzalès' palette did not lighten in the 1870s and she remained deliberately apart from the Impressionist group. Even in outdoor compositions such as "Miss et Bébé" (1878 no. 1046) (596) and "Promenade à âne" of 1882 (597) her colours remained grey. Manet's 1860s style, characterized by flat broadly painted areas, strong tonal contrasts and clear contours, remained the closest comparison. "Une Loge aux Italiens" (Fig.183), rejected at the Salon of 1874 and finally exhibited at that of 1879 (no. 1405), is an example of her affiliation. The man's face in the top right hand corner, the woman's figure in the centre and the bouquet of flowers in the bottom left hand corner form a broadly lit diagonal arrangement parallel to the picture plane which stands out against a background of total darkness. Huysmans praised the natural attitudes of the figures and the intrepidity of her painting (598). Throughout her career her oil paintings remained sober in colouring. Her pastels, however, were lighter

and it was in these that her love of colour was most apparent. In 1880 she was described as foremost amont pastellists on the basis of her "Demoiselle d'Honneur" (599). In 1882 her works were shown at the offices of the magazine, "L'Art" and in 1883 at Georges Petit's "Exposition Internationale des Peintres et des Sculpteurs" in the Rue de Seze (600). In 1876 she had become engaged to the engraver Henri Guérard. They married in 1879 and in 1883 she bore a son. She died five days after the birth.

In January and February 1885 a retrospective consisting of 88 pictures was held at the Salons de la Vie Moderne in the Place Saint-Georges and the exhibition was accompanied by an illustrated catalogue containing a preface by Philippe Burty and poetry by Théodore de Banville. Her work was acclaimed by several critics (601) and "La Nichée" of 1874 (no. 2180) and "Entrée au jardin" were bought by the State (602). Commercially, however, the exhibition was a failure and her husband kept nearly all her work (603). Other exhibitions followed in 1889 at the Théâtre d'Application, in 1907 at the Salon d'Automne and in 1914 at the Bernheim Jeune Gallery.

Théodore Duret wrote that her work portrayed "un monde ayant le calme et la tranquillité des gens de vie paisible" and in this respect Gonzalès may be compared with Berthe Morisot and Mary Cassatt (604).

23 LOUISE BRESLAU

Louise Breslau was born in Munich in 1856, the daughter of a doctor.
In 1858 the family moved to Zurich where her father had been offered a
univeristy post. He died five years later, when Louise was seven years
old. Having received some instruction in art from Ed. Pfyffer in Zurich
in 1875 Breslau moved to Paris to continue her training, the early death
of her father having made it necessary for her to earn her own living.
She entered the studio for women run by Tony Robert-Fleury at the
Académie Julian and studied there until 1881. The journal of Marie Bash-
kirtseff, who attended the same studio from 1877, provides some glimpses
of the artist during this period. There are constant references to her
skill in drawing and she appears to have been the most successful artist
in the class (605). Bashkirtseff described one work executed by Breslau
during her studentship: "'le Lundi matin ou le Choix du modele'. Tout
l'atelier est là et Julian à côté de moi et Amélie, etc. etc./ C'est
correctement fait, la perspective est bien, les ressemblances, tout./
Quand on sait faire une chose comme ça, on sera un grand artiste" (606).

Breslau first exhibitied at the Salon in 1879 and was a member of
the Société Nationale from 1881. She exhibited at GeorgesPetit's gallery
from 1883 and in 1884 at the Union des FemmesPeintres et Sculpteurs. On
leaving Julian's in 1881 she went to Brittany, the first of many trips
outside Paris and during the next two decades she was to visit Italy,
Germany, Holland, Belgium and England. Holland attracted her most: she
later referred to "ces petits peintres hollandais, infinis comme noms et
comme nombre, simples comme sujets, comme ils nous font désirer une vie
pareille toute de bien-être, de charme, de propreté et de joie calme" (607).
In Paris she moved in artistic circles. She knew Bastien-Lepage, J-L.
Forain and Degas and profited from their advice. She specialized in por-
traits which were said to be extremely cruel in their realism (608) and
also genre scenes which were mostly pictures of middle class women and
children in domestic interiors. These were notable for the large-scale
representation of figures and for the success with which she rendered
character. "Le Portrait des Amis" of 1881 (no. 289) (Fig.184) is a study
of character and of mood in which dark colours and the horizontal shape
of the canvas stress the intimism of the scene. It was her first successful
work and was reproduced in "L'Art" (609). In 1882 her reputation was
established with a Salon exhibit entitled "Pêcheuse guettant la marée; baie
du Mont-Saint-Michel" (no. 379) (610), a realistic and unidealized portrait
of a fisherwoman lying on the grass. Paul Leroi described this work as "de

bien meilleur aloi que la très-grande majorité des tableaux auxquels on a
fait les honneurs de la cimaise" (611). Her main achievement during this
early period was a portrait of "Le sculpteur Carriès dans son atelier" of
1887 (no.342) (Fig. 185) which was praised as a striking likeness of the
artist. "Sincérité" was the quality most frequently referred to (612).
From 1886 Breslau became close friends with Mlle Madeleine Zillhardt who
had been a fellow student at Julian's and shortly afterwards the two
artists moved to a house at Neuilly where they lived for many years.

Between 1887 and 1893 Breslau specialized in pastels and the change
of medium brought a change of style. Children became her main subjects,
often portrayed with flowers and animals, and her works grew much lighter:
"tout chez elle se traduit en symphonies dont le groupement constitue l'
arc-en-ciel. Ce sont des enfants blonds, des filles mauves, des filles
blanches, des demoiselles vertes; la sensation visuelle s'y abstrait
complaisamment de toutes les conventions ou de toutes les vraisemblances
graphiques" (613). In 1893 she returned to oil painting but light
remained an important element in her work and children her main subjects.
By the late 1890s she was a well-known and successful artist. In 1896
she was referred to as "un des talents féminins les plus vigoureux et
les plus originaux de ce temps" (614); she won her second gold medal
at the Exposition Universelle in 1900 (the first was at the Exposition
Universelle in 1889); in 1901 she became a chevalier de la Légion d'
Honneur and in the same year her first one-man exhibition took place at
the Zürich Künstlerhaus; her first one-man show in Paris was held at
Georges Petit's gallery in 1904. In 1905 a long article on the artist by
Emile Houclaque was published in the "Gazette des Beaux-Arts" (615) in
which the author referred to "cette poésie de l'intimité", a"rare péné-
tration psychologique" and to the extraordinary strength of her execution
- qualities which were evoked again and again by future critics. Her
second one-man exhibition in Paris was held at Durand-Ruel's in 1910 and
won impressive praise from J.F. Schnerb, Charles Saulnier and Arsène
Alexandre (616). Three more one-man exhibitions occurred before her
death in 1927, one of these, in 1918, consisting of eleven portraits of
soldiers painted during the war. In 1928 an important retrospective was
held at the Ecole des Beaux-Arts (617).

During her life-time Louise Breslau was acclaimed chiefly as a
portrait painter who succeeded not only by a realistic and psychologically
penetrating portrayal of face and figure but also by close attention to
detail in decor; colours and surrounding objects were important aids in

her evocation of character. She considered portraiture to be the most basic artistic impulse: "essayer de sauver de l'anéantissement l'image de ce que l'on a aimé, vénéré, admiré" (618). Artists and writers were favoured subjects and it is worth noting that women constitute a small category among these. She exhibited a "Portrait de Julie Feurgard" in 1886 (no. 336) (Fig. 186) and a "Portrait de Mlle Schaeppi peignant des faïences" in 1888 (no. 368). She was also commissioned to execute portraits of the most famous women of the time for "La vie Moderne" (619). She was successful in evoking the peaceful, domestic life of the middle classes, particularly the attitudes and expressions of children, and "intimiste" was an adjective constantly used to describe her work. Her theory of art was close to that of Berthe Morisot, whose work she greatly admired and the realization of her ideal she found in the work of Fantin-Latour: "Noter tous les événements de notre vie, en un langage individuel, nous fiant à notre oeil propre, il est à croire que cela ne sera pas sans valeur , ce coeur et cet oeil n'ayant existé que cette fois-là, ne se retrouverant jamais" (620).

24. VIRGINIE BRETON (MADAME DEMONT-BRETON)

Virginie Demont-Breton was born on July 26th, 1859, in Courrières,
Pas de Calais. Her father was the painter Jules Breton and her mother
the daughter of the Belgian painter Félix de Vigne, who was Breton's
first master. Artist relations included a paternal uncle, Emile Breton,
her maternal uncles Edouard de Vigne (a landscapist) and Pierre de Vigne
(a sculptor) and also the latter's three daughters and son. She had a
sister and twin brother and all three drew and painted from an early age.
Her childhood was extremely privileged. Not only was she encouraged to
become an artist - Rosa Bonheur was given as an example of what women
could achieve - but she also enjoyed the intellectual conversation of her
parents, "où, même aux choses les plus ordinaires de la vie intime se
mêlaient presque inconsciemment des questions d'art, de poésie, d'obser-
vation" (621). A love of nature in the tradition of Jean-Jacques
Rousseau and religious belief were early instilled. From 1865 the family
spent summers at the bay of Douarnenez where Jules Breton had a studio.
Virginie was first educated at the Ecole communale des garçons in
Courrières. Then, after the deaths of her brother and godfather she and
her sister Julie were taught at home by a Monsieur Peru. She also learnt
German from a female pupil of her father's, Mlle Léontine Saulson.

Until she was thirteen or fourteen, her father allowed her to draw
when and how she pleased. Then he made her work seriously from nature.
In 1873 she began painting, at first still-lives and then in 1876 she
progressed to figure painting. On February 7th, 1880 she married one of
her father's pupils, Adrien Demont, whom she had first met in March 1873,
and shortly after their marriage the couple went to live in Montgéron.

She first exhibited at the Paris Salon in 1880 and was awarded an
Honorable Mention. In 1881 her "Femme de pêcheur venant de baigner ses
enfants" (no. 675) (Fig. 84) won her a third class medal and in 1883 when
she exhibited "La Plage" (no. 740) (Fig.187) she won a second class medal
and was placed "hors concours". In the same year she received a gold medal
at the World Exhibition in Amsterdam for "Le Premier Pas" (622). Around
this time the couple spent their summers at Wissant a small fishing village
in Normandy and many of her subjects were based on local scenery and fisher-
folk. Women and children were her main subjects, but as Eugène Montrosier
pointed out in 1884 her figures were far from being simple transcriptions
from nature (623). They were larger and more noble than life. Her women
were always mothers and frequently suggested ideal figures such as the
Virgin Mary or Charity. In "la Plage" of 1883 (Fig.187) the woman's white

bonnet resembles a halo and in "La Famille" of 1882 (no. 799) (Fig.85), portraying a man with a hoe in one hand and with the other encircling his wife and child, each figure is stereotyped. According to Montrosier, this work was a symbol for "le point de départ des sociétés naissantes : le père, la mère, l'enfant" (624).

As we have already seen, in the 1880s Demont-Breton became involved in the issue of women's art education (625). From 1887 she exhibited at the Union des Femmes Peintres et Sculpteurs and Sunday visitors at her home in the Rue de Vaugirard included numerous women artists (626). In 1886 and 1888 her two daughters were born - Louise and Adrienne. She continued sending genre scenes to the Salon, mostly featuring children and in 1889 won a gold medal at the Exposition Universelle in Paris. In 1891 they bought land in Wissant and built a house there. "Etre constamment au milieu de la nature que nous aimons, est absolument nécessaire à notre travail; et, quant à moi, je vis à Wissant en intimité avec la mer et ses travailleurs" (627). In the 1890s her subject matter broadened and in addition to works depicting the lives of fisherfolk she also exhibited historical and religious subjects: "Giotto" of 1891 (no. 480), "Jeanne à Domrémy" of 1893 (no. 554) and the popular "Jean-Bart" of 1894 (no. 576) (628) among the former and "Le Messie" of 1891 (no. 479), "Le Colombier d'Isa" and "Ismaël" of 1896 (nos. 627 and 628) (629) and "Le Divin Apprenti" of 1897 (no. 506) (630) among the latter. But her most ambitious work of this period was "Stella Maris" of 1895 (no. 575) (Fig.188) which was inspired by the death at sea of the model for "Fils de Pêcheurs" of 1894 (no. 577) (631). A man and a boy are strapped to a mast which appears in the shape of a cross just above the water; in the top right hand corner of the picture the Virgin Mary and child appear in a circle of light.

In 1894 Virginie Demont-Breton achieved recognition. She won a medal of honour at Anvers and was elected a Member of the Royal Academy of that town; she received the red ribbon as an Officier de la Légion d'Honneur and was also elected President of the Union des Femmes Peintres et Sculpteurs in which capacity she gave several speeches on the necessity of equal art education for women (632). In 1895 she was awarded a diploma of honour at Anvers, in 1898 she became a chevalier de l'Ordre de Léopold de Belgique and in the same year exhibited at the New Gallery in London (633) and in 1900 she was awarded a gold medal at the Paris Exposition Universelle. In 1902 she came fourth among artists in the imaginary female academy proposed by the "Annales Politiques et Littéraires" (634). "Le Divin Apprenti" of 1897 was her last classical subject; thereafter she returned to real

life scenes involving women and children. In 1905 she exhibited "Les
Tourmentés" (no. 580) (Fig.189) which she considered to be her best work.
It was the second, after "Stella Maris", to deal directly with death.
The scene is set after a shipwreck and women and children are shown down
by the sea shore where three drowned men have been laid. A third
daughter, Elaine, was born in 1901. In 1913 she was elected an active
Member of the Royal Academy of Anvers and in 1914 received the rosette
as an Officier de la Légion d'Honneur. She died in 1935.

Virginie Demont-Breton believed that art should be based on instinct:
"C'est dans nos sentiments instinctifs que nous trouverons les inspirations
les plus originales et les plus personnelles" (635). She also believed
that the sexes were quite distinct and as President of the Union des Femmes
Peintres et Sculpteurs, hoped that women would contribute something
instinctively feminine (636). She saw motherhood as "le plus naturel des
instincts du coeur féminin" (637). Motherhood is a striking theme in her
own work and her maternities range from the realistic "Femme de Pêcheur
venant de baigner ses enfants" of 1881 (Fig.84) to the visionary "Stella
Maris" (Fig.188) and her symbolic "Alma Mater" of 1899 (no. 615). The
artist's own maternal instinct emerges from her numerous portrayals of
children. Sympathy for women is also evident in works depicting fisher-
men's wives. They are shown waiting for the return of their husbands as
in "L'homme est en mer" of 1889 (no. 796) (Fig.190) and mourning their
death as in "Les Tourmentés" of 1905 (Fig.189). In "Even in a home des-
troyed the hearth fire may burn again" of 1900 (638) it is a woman who is
shown despairing over the destruction of her house. In addition to her
focus on women another interesting aspect of the artist's work is her ten-
dency to introduce an ideal or visionary element. She wrote: "Sans être
mystique, j'adorais le merveilleux et je le cherchais partout dans la
nature, même en plein soleil" (639). It is this that distinguishes her
work from that of her father Jules Breton and her uncle Emile Breton both
of whom chose similar themes. Even when she does not show the Virgin Mary
directly as in "Stella Maris" her women are larger than life. They are
perhaps best seen as symbols of the home and of protection in the eyes of
fishermen at sea.

25. MARIE BASHKIRTSEFF

Marie Bashkirtseff was born in Poltava in 1859 (640). Both
her parents were from the Russian gentry class. Her father was a wealthy
landed proprietor and also a "Maréchal de Noblesse" in Poltava (641).
A few years after marriage, her parents separated and Marie and her
brother, Paul, accompanied their mother to Tcherniakowka, the home
of their maternal grandparents. In 1870, on the death of the grandmother,
the whole family left Russia for Europe and in 1872 settled in Nice.
Using this town as their base, they were to continue travelling
constantly over the next four years - within France, and also to Italy,
Germany and back to Russia. Wherever they went, they moved in high
social circles.

Marie's early instruction was given by governesses, one of whom,
a Mme Brenne, was French. She sketched a great deal, and, discovering
that she had a good voice, conceived the ambition of becoming a great
singer. In 1872 she began to study seriously. She asked for tutors
and rapidly acquired an extensive knowledge of ancient and modern
languages, literature and history. Her published journal begins in
January 1874 (642). From the start two main preoccupations are evident.
First, an intense will to excel, to become famous, and secondly a love
for glamorous social life which at the time in question took the form
of a romantic and unrequited passion for the Duke of Hamilton.

The first indication of a particular interest in the fine arts
is in Florence in September, 1874, when she wrote : "J'adore la peinture,
la sculpture, l'art enfin partout où il se trouve" (643). Raphael she
was unable to appreciate; Rubens, Titian and Van Dyck on the other hand,
all supported her view that art should be an imitation of nature (644).
When in Rome, in January 1876, she wrote of having lessons from a
Polish drawing master called Katorbinsky under whose supervision she
sketched and then painted a model's head with extraordinary speed (645).
Also in 1876, the family visited Naples, Berlin, Paris and Russia. In
the latter country, she sketched two successful portraits of her father
and brother (646). At Nice in June 1877 she began her first proper
subject picture, of card players by candlelight, a subject which
attracted her because of the focus on gesture and expression within a
confined space (647). After more travels to Rome, Naples and Florence,
in September of that year the family settled in Paris. In October,
she registered as a student at the Académie Julian (648).

Bashkirtseff later wrote that she took up art "par fantaisie
et ambition" and continued her studies "par vanité" (649). She was
indeed a brilliant pupil . She made rapid progress and received

frequent praise from Julian and Tony Robert-Fleury who taught in
the women's class. By October 11th Julian had described her as one
of the two most promising students in the group (650). Her main
rival was Louise Breslau (651). In November she began lessons in
anatomy ; in September 1878 she executed her first "peinture
officielle"; by February 1879 she was attempting ambitious subjects
such as Adam and Eve and the Death of Orpheus and in 1880 she exhibited
at the Salon for the first time : her contribution was a portrait of
her cousin Dina reading which measured five feet high with the frame(652)
By this time she was totally committed to art. Her next Salon exhibit
was a picture of her fellow students working in the Académie Julian
(653) (Fig.5).

During a trip to Spain in the Autumn of 1881 she was strongly
impressed by the works of Velasquez, Goya and Ribera. Back in Paris,
in 1882, Bastien-Lepage became her main contemporary idol and it was
with him in mind that she began the first of her three major works
showing children in the streets. "Le Parapluie" was painted out of
doors and depicted a small girl under a huge umbrella, her face
expressive of "mute suffering" (654). She exhibited two works at
the Salon in 1883 including "Jean et Jacques" (Fig. 191), showing
two small and scruffy boys walking by a wall, apparently on their way
to school. She herself described it as follows : "Ce sont deux gamins
qui marchent le long d'un trottoir en se tenant par la main: l'aîné
a sept ans et regarde dans le vague, devant lui - une feuille entre
les lèvres; le petit regarde le public, une main dans la poche de son
pantalon de gamin de quatre ans" (655). Her other exhibit was "Une
Parisienne". In 1884 Bashkirtseff exhibited at least seven works.
At the Salon she was represented by a landscape and also "Le Meeting",
possibly her best known picture (Fig. 192). This was her third and
most ambitious street scene and it provides the best evidence of her
interest in gesture and expression, so frequently expressed in the
Journal. She won praise, but not an award, apparently because of a
suspicion that she had been helped (656). She also exhibited four
works at the exhibition of the Union des Femmes Peintres et
Sculpteurs and at least one, "Jean et Jacques", in Nice. On the latter
occasion she was given an honorable mention. The next subject she
undertook was a fourth street scene. It was to portray a public bench
in a poor quarter of Paris : "quelle poésie que le déclassé au bord de
ce banc. Là l'homme est vrai, là c'est du Shakespeare" she wrote;
and again : "Tout ce que contient un banc, quel roman ! quel drame !
Le déclassé avec un bras appuyé au dossier et l'autre sur le genou -

le regard fuyant. - La femme et l'enfant sur les genoux; la femme
du peuple qui trime - Le garçon épicier très gai qui s'est assis,
lisant un petit journal, - l'ouvrier endormi, le philosophe ou le
désespéré qui fume" (657). This was never to be completed. She
died on October 31st, 1884, having become close friends with
Bastein-Lepage who died shortly after her.

Two of her works were exhibited at the Salon posthumously,
in 1885 : "Avril" and a "Portrait de l'Auteur". In 1885 also the Union
des Femmes Peintres et Sculpteurs organised an exhibition of her work
which included 100 paintings, 6 pastels, 118 drawings and 5 sculptures.
The catalogue contained the first of many effusive tributes in prose
and poetry (658). In 1908 her mother gave 84 paintings, 2 pastels, 55
drawings and 3 pieces of sculpture to the Russian Museum of St.
Petersburg (659).

Existing works by Marie Bashkirtseff are of two main types :
portraits and genre scenes. Her portraits, which are mostly of women,
include at least six self-portraits reflecting the tendency to constant
self-analysis revealed by her Journal. One of these shows her as both
painter and musician, recalling Angelica Kauffman's portrait of herself
hesitating between the arts of music and painting (660)(Fig.193). Another
shows the subject reading by a piano (661). A drawing of the artist
looking straight at the viewer is possibly the most successful as a
psychological study (Fig. 194).

Bashkirtseff's interest in genre themes may be substantiated by
numerous passages in her Journal. One of her first genre compositions was
a life-size picture of a peasant girl begun in June 1881 (662). From
the summer of the following year her attention moved to city life and
in August she set herself the goal of being an urban Bastien-Lepage (663).
She was concerned with specific aspects of the city. Firstly people.
In 1880 she had written : "Comment peut-on préférer quoi que ce soit
à la figure?" (664) and her oeuvre testifies to an overriding interest
in humanity as opposed to land or cityscape. "Mon Dieu que c'est intéres-
ssant que la rue !" she wrote ; "les physionomies des gens, les particu-
larités de chacun, les plongeons que l'on fait dans les âmes inconnues"
(665). And again : "Oh ! la rue !! ... les attitudes, les gestes, la
vie prise sur le fait, la nature vraie, vivante ... Oh ! surprendre la
nature et savoir la rendre !" (666). This fascination was behind her
admiration for Bastien-Lepage and also for Balzac and Zola (667). The
type of people she was interested in was specific. She was not attracted
by the smart quarters of Paris but by the poor areas frequented by
"déclassés". This focus is apparent throughout the journal. Having read

Zola's "L'Assommoir" in February 1881, she was extremely moved : "Qui
donc a nié la question sociale? .. Oh ! oui, il faut que tout le monde
s'y mette.." (668). In Grenada in 1881 she longed to paint the
inmates of the local prison who inspired her with pity and "attendrisse-
ment" and she did in fact sketch "une tête de forçat" (669). The
gypsies in the same town, despised by the Spanish, also attracted her :
"Je suis folle de ces types Gitanes. Ils ont des poses, des mouvements,
des attitudes d'une grâce si naturelle et si étrange"(670). In Paris
in January 1882 she wrote of going to see the madwomen in the Sainte-
Anne Asylum and in August of the same year she made several visits to
a children's home. In December 1882, while painting at La Grande-
Jatte her attention was transfixed by a poor family who came to the
water's edge : "Le père et quatre ou cinq enfants déguenillés avec un
pauvre paquet de hardes; ça avait l'air d'un déménagement de misère"
(671). Her interest in such subjects was sharpened by contrast with
her own comfortable position(672). The same contrast is apparent in
her Salon exhibits. Portraits of rich and elegant women were juxtaposed
with genre scenes like "Jean et Jacques" and "Le Meeting" showing
poor children in the streets.

Her ideas on the rendering of such subjects were precise and are
exemplified by extant works on these themes. She viewed herself as a
naturalist and as such defined high art as that which "tout en peignant
la chair, les cheveux, les vêtements, les arbres, en perfection, de
façon à nous faire toucher pour ainsi dire, peint en même temps des
âmes, des esprits, des existences" (673). First, then, she attached
importance to an extremely detailed and life-like portrayal of the
objects represented. She considered form important and on more than one
occasion described sculpture as the medium most suited to her ideas
(674). She wrote disparagingly of modern artists, the Impressionists
in particular, who did not define forms: "On dédaigne la précision des
décors et on produit une espèce de dépravation des lignes, on estompe
trop ... Ce qui fait que les figures contrastent peu et semblent aussi
mortes que les objets qui les entourent car ces objets n'ont pas
assez de précision et semblent ne pas être complètement assis et
immobiles" (675). The rendering of life - of "des âmes, des esprits,
des existences" was in her view a matter of selecting from Nature : "Il
s'agit de saisir la nature sur le fait, de savoir choisir et de la
saisir. Le choix fait l'artiste"(676) and it was also important to
allow the painting to be apparent. This was why she disliked Raphael :
his painting was too smooth, too lifeless. Velasquez, on the other hand,
and Goya, who she denominated "les vrais naturalistes" led her to

conclude .. "Le sentiment , mais c'est la pâte, c'est la poésie de l'
exécution, c'est l'enchantement de la brosse"(677). Finally, for the
spectator to be impressed with the life of the subject, she thought
it was important for it to be shown in repose : "Un sujet au repos peut
seul donner des jouissances complètes, il laisse le temps de s'absorber
en lui, de le pénétrer, de le voir vivre" (678).

Marie Bashtirtseff's exhibited works consist of portraits and
genre scenes. Another important category is formed by works on
classical themes. Few of these were completed; mostly they were
projects which remained at the sketch stage. Her preoccupation with
the Holy Women at Christ's tomb after the Crucifixion has already been
considered (679). She wished to show them as modern outcasts, epitomies
of grief and loneliness. Another important subject was Ariadne whom she
intended to execute in sculpture. Theseus having fled during the night,
Ariadne wakes to find herself alone and glimpses the sail of Theseus'
ship on the horizon : "alors elle tombe sur le rocher, la tête sur le
bras droit, dans une pose qui doit exprimer toute l'horreur de l'abandon,
du désespoir, de cette femme laissée là, lâchement ... Je ne sais pas
dire, mais il y a là une rage d'impuissance, un abattement suprême à
exprimer, qui m'empoignent complètement" (680). Another subject - of the
same type - was "La Douleur de Nausicaa", which she did execute. The
artist's sympathy was totally with this figure who fell in love with
Ulysses, hearing him tell of his adventures. "Aucune parole n'est
échangée entre eux;il s'en va, ce bourgeois, retrouver son pays et ses
affaires. Et Nausicaa reste sur le rivage à regarder s'éloigner la
grande voile blanche, et lorsque tout, à l'horizon bleu, est désert, elle
laisse tomber sa tête dans ses mains, et, les doigts sur la figure,
dans les cheveux, sans souci de sa beauté, les épaules soulevées et le
sein écrasé par les bras, elle pleure"(681). Grief, as a result of
being left alone by death or departure, was the sentiment she hoped to
express in these classical scenes. This is perhaps an appropriate point
at which to introduce her views on the condition of women. In her Journal
she often complained of the restrictions surrounding women of her class
and she was also extremely indignant about the lack of equal opportunities
for women in art education (682). One other project may be mentioned.
In 1880 she wrote that she would like to paint a portrait of Mlle
Hubertine Auclerc, a campaigner for women's rights, for the Salon(683).

Bashkirtseff's projects are perhaps more interesting than her
completed or exhibited works. The latter, one feels, were intended to
fit into the artistic context of Bastien-Lepage and Cazin. Her genre
scenes belong unquestionably to the school of Naturalism. The picture

she was at work on at the time of her death would have been her most
complete and personal work in this style - showing not just children
but a wide variety of people brought into incongruous proximity on
a public bench. She had favoured group scenes before, in her card
players and in "Le Meeting", and she appears to have valued such
compositions because of the way contrasting gestures and expressions
emphasized the individuality of each member of the group. In her last
work not only gesture and expression but also types of people would have
been brought into contrast.

CONCLUSION

In the nineteenth century the artist's profession was one
of the very few open to women of the upper and middle classes who
needed to earn a living, chiefly because it could be practised at
home without public exposure. There is much evidence of the extent
to which women resorted to this profession. Some, like Anna Maria
Charretie, Félicie de Fauveau, Fanny and Louisa Corbaux, Annie Dixon,
Maria Harrison, Ann Mee, Louise Breslau and Elizabeth Jerichau,
acquired a reputation ; many more, like George Sand, who having
separated from her husband tried briefly to support herself by art,
made no mark at all in the artistic world (684). In the Hon. Mrs.
Norton's "Lost and Saved" of 1863, a girl who has been lured into
a sham marriage is abandoned by her lover. To support herself and her
epileptic son she resolves : "I will exert myself, for my dear son's
sake. I will not sink; I will teach music and drawing. I know I am
a good musician. I know my drawings are as good as many an artist's.
It is only humbling myself a little..". She does not teach but
instead tries to sell her works. She takes her sketches and water-
colour drawings to a picture dealer and like the heroine of Emily
Osborn's "Nameless and Friendless" of 1857, is humiliated both by
the shop-owner and by customers (685). The extent of failure cannot
be attributed solely to the kind of mediocre art education which
George Sand received (686)- many women hoping to make a living out
of art must have lacked aptitude - but art education, as has been
seen in Chapter One, is an important factor where the quality of
women's art is concerned. During the greater part of the nineteenth
century women were not admitted to the Royal Academy Schools or the
Ecole des Beaux-Arts and the facilities available were in the main
of a much lower standard than those open to men. The focus was
on portraiture and still-life painting and opportunities for
thorough study of the human figure were rare. Marie Bashkirtseff,
one of the most eloquent objectors to the standard of women's art
education, wrote : "Ceux qui se moquent des talents féminins ne
sauront jamais combien de dispositions sérieuses, de tempéraments
réels et remarquables ont été découragés et atrophiés par une éducation
vicieuse ou incomplète" (687). Even when facilities did improve
towards the end of the century, the less tangible obstacle of prejudice
remained. Gertrude Massey in England and Virginie Demont-Breton in
France both remarked on this (688). Women's productions were not
judged by a general standard; they were assumed to be intrinsically

inferior. Critics estimated them therefore :
"Not as mere work, but as mere woman's work,
Expressing the comparative respect
Which means the absolute scorn" (689).
Despite these disadvantages an increasing number of women were
represented at exhibitions , particularly in the classes of water-
colour and miniature painting (690) and a considerable number, also,
received awards and medals for their work (691).

No attempt has been made in this thesis to distinguish
between the subject matter favoured by women and that favoured by
men. A description of recurrent themes in women's art and the more
obvious explanations for these emphases have been given. A subject
connected with this and which has not yet been considered is that
of art theories held by women. Numerous women wrote about art in
the last century. Among those who wrote about art in general and
on artistic periods (as opposed to monographs and exhibition reviews)
were Mrs. Grote, Lady Eastlake, Anna Brownell Jameson, Lady Amelia
Dilke, Vernon Lee, Emily Barrington, Mrs. Callcott, Mrs. Arthur
Bell (Nancy d'Anvers) in England and Mme de Stael, Flora Tristan,
Claude Vignon, Olympe Andouard, Daniel Stern (Mme la comtesse d'
Agoult) and Alice Berthet in France (692). A common feature of the
writings of the majority of these is the concept that art should have
a high and moral purpose, an ennobling effect on life. Anna Brownell
Jameson was one of the most didactic of these writers and a brief
account may be given of one of the most important ideas in her theory.
Her view of art was essentially humanistic. In 1854 she wrote : "Art,
used collectively for painting, sculpture, architecture and
music, is the mediatress between and reconciler of, nature and man.
It is, therefore, the power of humanising nature, of infusing the
thoughts and passions of man into everything which is the object
of his contemplation . Colour, form, motion, sound, are the elements
which it combines, and it stamps them into unity in the mould of a
moral idea" (693). Art then, is nature, humanised. An interesting
example of the importance she attached to humanisation, is afforded
by her views on allegory. Allegorical art in the conventional
sense she considered cold : "Now there are occasions, in which an
abstract quality or thought is far more impressively and intelligently
conveyed by an impersonation than by a personification. I mean that
Aristides might express the idea of justice ; Penelope that of conjugal
faith; Jonathan and David (or Pylades and Orestes), friendship;
Rizpah, devotion to the memory of the dead; Iphigenia, the voluntary

sacrifice for a good cause". Jephtha's daughter would convey heroic
resignation and self-denial. Eve would be represented not after
Milton but as "the sublime ideal of maternity", Hagar as an outcast,
Rebekah as an exulting bride and Rachel as a mild pensive wife.
These figures "would represent, in a very complete manner, contrasted
phases of the destiny of Woman, connected together by our religious
associations, and appealing to our deepest human sympathies" and "would
have this advantage, that with the significance of a symbol they would
combine all the powers of a sympathetic reality" (694).

Anna Brownell Jameson, like many other writers, also believed
in the existence of a specific and separate female art, equal to that
of men but different from it: "I wish to combat in every way that
oft-repeated, but most false compliment unthinkingly paid to women,
that genius is of no sex; there may be equality of power, but in
its quality and application there will and must be, difference and
distinction" (695). This idea had already been expressed in an interes-
ting article in Blackwood's Edinburgh Magazine in 1824 (696) and it
was to be echoed by Mrs. Ellet in 1859, Francis Turner Palgrave in
1865, Berthe Morisot in 1890, Mme Léon Bertaux and Virginie Demont-
Breton as Presidents of the Union des Femmes Peintres et Sculpteurs
in the 1890s, Ouida (Marie Louise de la Ramée) in 1895, Lady Eastlake
in 1895 and it received final emphatic expression at the International
Congress of Women in 1899 (697). The characteristics of the feminine
art they wished to foster were several. Humanisation, pivotal to
Anna Brownell Jameson's theory of art, was important, and so too was
the idea that "the proper study for womankind is woman" (698). Women
were considered gifted with intuition and ready sympathy and therefore
they were apt in the representation of character and emotion. Finally ,
the idea of moral purpose was important. Mme Léon Bertaux and Louisa
Starr both conjured women to save art from the degeneracy brought about
by the "Art for Art's sake" doctrine, "cette fureur de singularités
modernes", and uninhibited or unmotivated realism (699). Louisa Starr
said that the real object of art was to give us "high ideals" and "to
open our perceptions to the charms of common life around us . . to
bring beauty into our lives". If ugly aspects of Nature were shown,
"surely it is only for the sake of the lessons which they teach . .
We must not depict the ugly or degraded, without the saving spirit of
the pathos which underlines all ugliness and degradation" (700). Equally
Mme Bertaux wrote : "Par nous femmes, par le caractère de nos travaux,
que l'Art redevienne avec force civilisatrice, qu'il redonne au monde
ce qu'on lui demandait à l'origine, ce qu'il a donné : l'oubli des

réalités, l'éblouissement de la pure lumière en place de la nuit
profonde" (701).

The extent to which these theories corresponded with reality
is a separate issue. Certainly women favoured female subjects from
history, the Bible, mythology, literature and real life and, as has
been seen in Chapters Three and Four, distinct emphases on types of
stiuation and emotion emerge during different periods of the century.
These appear to have been due to experiences more or less particular
to women: the absence and death of men in times of war; the emergence
of women in public life; a growing consciousness of the condition of
working class women, a condition which women, increasingly active as
charitable workers and visitors among the poor, would have been the
first to appreciate, and most important, perhaps, the effects of
industrialization and Victorian codes of conduct on the home. A
concomitant of the growth of the middle classes was a growth in the
number of women fulfilling the idle, but prescribed role of "the angel
in the house"; thus the proliferation of works depicting women alone -
thinking, dreaming, remembering and waiting. In accordance (probably
unconscious) with Mrs. Jameson's suggestion several women rendered
female classical figures in a new and personal way (702). During
the middle years of the century women contributed in no small degree
to the growth of art with a moral purpose and again it was mainly
female problems - the plight of the governess, the seamstress, the
widow and the unmarried mother - which received attention.

Some women excelled in the areas outlined above: Harriet
Jackson's "Mars subdued by Peace", Henriette Lorimier's "Jeanne de
Navarre", Sarah Setchel's "Momentous Question", the Duchesse de
Wurtemburg's "Jeanne d'Arc", Emily Osborn's "The Governess", Anna
Blunden's "Song of the Shirt", Henriette Browne's "Les Soeurs de
Charité", Henrietta Ward's "Elizabeth Fry visiting Newgate" - all
these were highly successful works (703). Margaret Gillies achieved
repute as a specialist in the depiction of female emotion. Two of
the most famous women artists of the century, however, hardly portrayed
women at all, yet it is not impossible to associate Rosa Bonheur and
Lady Butler with the theories of women's art mentioned above. Bonheur
characterized animals and suggested relationships between them -
particularly the relationship between male and female animals and their
offspring - in a way which readily evokes human sympathy. Lady Butler
was very concerned with moral purpose in her battle pieces and was
anxious not to show war in a negative light. The works of Berthe
Morisot, who is usually and most easily considered in the context of

artistic technique, may be seen as an extremely personal and psycholo-
gically penetrating account of the most pleasant aspects of her ambiance;
more literally than the work of any other hers fulfils Mme Bertaux's
dictum of art as "l'éblouissement de la pure lumière en place de la nuit
profonde".

Although women's art in the nineteenth century provides excellent
illustrations of current theories of women's art, and indeed even
without such theories would present a coherent corpus of work with
common emphases, male artists also, could provide perfect examples for
such theories. It cannot be claimed that the art of men and that of
women is totally different. It may be asserted, however, that women
thrived in the type of art mentioned above. This was partly due to
a social context which encouraged women in particular to develop their
sensibility and moral qualities and incidentally encouraged girls to
take interest in and model themselves on women in literature and history.
One of the most commonly held views on woman in the nineteenth century ,
in England and France, was that she should have a civilising influence
on society. It was also, in some measure, due to women's art education.
It was easier for women to find female models than male models and more
proper for them to portray their own sex; It was more proper also to
show them in a mundane context than in a classical one which so often
involved representation of the nude. When classical subjects were
chosen by women, they were usually couched in domestic circumstances.

During the greater part of the century theories of women's
art and much of the actual art produced by women corresponded with the
general taste in art and men as well as women catered for this taste.
Traditionally feminine attributes such as sentiment and a highly develo-
ped moral sense - not necessarily innate but consistently encouraged
in women - became general values while remaining associated, most
specifically, with women. It was through women, as subject-matter,
that these values were most frequently conveyed. It has been shown
that such values were also represented by women, as artists, with
degrees of success which to some extent must relate to the restricted
opportunities for women in art education.

VOLUME TWO

*NOTES - CHAPTER ONE

(1) An attempt to define accomplishment art is made on page 9

(2) For the Brontë sisters, for instance, who were destined to become
 governesses, drawing was a necessary skill. They received instruc-
 tion at the same time as their brother Branwell from the portrait
 painter William Robinson of Leeds. According to Elizabeth Gaskell
 this was in the early 1830 s (Elizabeth Gaskell: "Life of Charlotte
 Bronte" London 1905, p.122).

(3) In Maria and R.L. Edgeworth's "Essays on Practical Education",
 first published in 1798, the authors regretted the ousting of the
 domestic arts by this "current exhibitionism with music and drawing"
 and also wrote: "Comparative excellence is all to which gentle-
 women artists usually pretend; all to which they expect to attain;
 positive excellence is scarcely attained by one in a hundred" (A
 new edition,London 1922, vol. 2, pp.377-8). See also the Rev. W.
 Shepherd, Rev. J. Joyce and Rev. L. Carpenter's "Systematic Educa-
 tion" London 1815, vol.1, p.19; "Monthly Repository" 1833, vol.VII,
 pp. 492-497; "Quarterly Journal of Education" 1834, vol.8, pp.214-
 234; "Educational Magazine" 1838, pp.327-8; "Fraser's Magazine"
 1845, vol.31,pp.703-712.

(4) Hannah More: "Strictures on the Modern System of Female Education
 - with a view of the principles and conduct prevalent among women of
 rank and fortune" (originally published in 1799) the Complete Works,
 London 1830, vol.5, pp.47-8, 77-8, 225-6 and also her "Coelebs. In
 Search of a Wife, comprehending Observations on Domestic Habits and
 Manners, Religion and Morals" (first published in 1809) the Complete
 Works, vol.7, p.398.

(5) "Old Water-colour Society's Club" vol.8, pp.10-11, quoted in Trenchard
 Cox's "David Cox" in the British Painters Series, London 1947, pp.35-6.

(6) Quoted by William T. Whitley in his "Art in England, 1800-1820"
 Cambridge 1928, p.263.

(7) Elizabeth Gaskell: "Life of Charlotte Brontë" London 1905, pp.122,
 note 2, 88, 135, 619 and also Winifred Gérin's "Emily Brontë" Oxford
 1971, pp.43-4
 For a discussion of the practice of copying from prints in the eight-
 eenth century, relevant also for the early years of the nineteenth,
 see Elizabeth Wheeler Manwaring's "Italian Landscape in Eighteenth
 Century England" (first published in 1925) London 1965, pp.86-7.
 For criticism of the importance attached to copying in female art
 education see the "Quarterly Journal of Education" 1834, vol.8, p.233;
 Metropolitan Magazine" 1838, vol.22, p.25; "Educational Magazine"
 1838, pp.327-8.

(8) "The Complete Novels of Jane Austen" London, 1932, pp. 819-821.

(9) Catherine Sinclair: "Modern Accomplishments" Edinburgh 1836, p.116.

(10) Hannah More: "Coelebs. In Search of a Wife" the Complete Works,
 London 1830, pp.224-5.

* a. (+ see ..) means that the quotation is given on the page specified
 b. Unless otherwise stated cross references are to volume 1

(11) "The Life and Works of Charlotte Brontë and her Sisters" London, 1900 vol.5, p.419. For a fuller picture of the importance and nature of female accomplishments at this time see Charlotte Smith's "Rural Walks: in Dialogues" in two volumes, London 1795, vol.1, pp.70-1; Hannah Robertson's "The Ladies' School of Arts containing instructions in every useful and ornamental branch of a lady's education", 10th edition, Edinburgh 1806, vol.1; "Remarks on Female Education adapted particularly to the Regulation of Schools" London 1823, pp.312-316. The novels of Jane Austen are also useful sources on this subject: see note 8 and also pages 264 and 344 ("Pride and Prejudice") and 10 to 13 ("Sense and Sensibility") in the same publication.

(12) See "Remarks on Female Education adapted particularly to the Regulation of Schools" London 1823, pp.312-316; "Quarterly Journal of Education" 1832, vol.4, p.71 in which, under the heading "On Teaching Drawing", it was written: "We can hardly look at a school advertisement of the present day without finding 'drawing' included among the useful things to be taught"; "Fraser's Magazine" 1845, vol.31, p.703 under the heading "An inquiry into the state of girls' fashionable schools".

(13) Ann Brontë's Agnes Grey is an example (see note 11). For a detailed discussion of governesses and their skills in the nineteenth century see Alicia C. Percival's "The English Miss To-day and Yesterday" London 1939, pp.98-121.

(14) For a discussion of drawing-masters at the turn of the century see Elizabeth Wheeler Manwaring's "Italian Landscape in Eighteenth Century England" London, 1965, p.89 and also Trenchard Cox's "David Cox" London 1947, p.41.

(15) Trenchard Cox: "David Cox" London 1947, p.41. See also H.M. Cundall's article on "David Cox as a Drawing Master" in the "Art Journal" 1909, p.177.

(16) Advertisement in the "Norwich Mercury" August 2nd, 1823. p 1

(17) The following is a select list of other drawing and painting books published during the first four decades of the century:-

James Malton:	"The Young Painter's Maulstick, being a Practical Treatise on Perspective" London 1800
James Sowerby:	"A Botanical Drawing-book or an easy introduction to drawing flowers according to Nature" London 1807
William Oram:	"Precepts and Observations on the Art of Colouring in Landscape Painting" London 1810.
George Hamilton:	"The Elements of Drawing .. for the Use of Students" London 1812.
David Cox:	"A Treatise on Landscape Painting and Effect in Water Colours, from the first rudiments to the finished picture" London 1814
Louis Francia:	"A Series of Progressive Lessons, intended to elucidate the Art of Flower Painting in Water Colours" London 1815.
John Varley:	"Studies for Drawing Trees" London 1818-1819
J.W. Alston:	"Hints to Young Practitioners in the study of Landscape Painting.." London ca. 1820.
Francis Nicholson:	"The Practice of drawing and painting landscape from nature, in water colours" London 1820.

Samuel Prout: "A Series of Easy Lessons in Landscape-Drawing" London 1820.

David Cox: "The Young Artist's Companion, or Drawing-Book of Studies and Landscape Embellishments" London 1825.

John Clark: "The Amateur's Assistant, or a Series of Instructions in Sketching from Nature, the Application of Perspective, Tinting of Sketches, Drawing in Water-Colours" London 1826.

Charles Taylor: "A Familiar Treatise on Drawing, for Youth" London 1827

Nathaniel Whittock: "The Youth's New London Self-instructing Drawing-Book in colours, comprising a series of progressive lessons" London 1836.

G.F. Phillips: "A Practical Treatise on Drawing, and on Painting in Water Colours" London 1839.

James Andrews: "The Art of Flower Painting in Easy Lessons" London 1842.

(18) Mrs. Ellis: "The daughters of England, their position in society, character and responsibilities" London 1845, p.108.

(19) ibid.p.99

(20) ibid.p.112

(21) ibid.p.118

(22) Mrs Loudan: "The Lady's Country Companion" London 1845, p.376. She discusses sketching on pages 370-372.

(23) See page 34 and notes 211 and 212

(24) "The Life of Frederick Denison Maurice" edited by Frederick Maurice, London 1884, vol.2, p.116. Also Frederick Denison Maurice: "Learning and Working" London 1968, p.126 (first published in 1855).

(25) It should be said that drawing was not taught with a view to a profession in design at these institutions. It was viewed as elementary culture.

(26) Gordon Sutton: "Artisan or Artist" Pergamon Press, 1967, p.46 (quoted)

(27) PP. 2nd Report of the Council of the School of Design 1842-3, p.6.

(28) PP. 3rd Report of the Council of the School of Design 1843-4, p.23.

(29) For the rules applicable to men at the Head Government School of Design see Quentin Bell's "The Schools of Design" London 1963, pp. 66, 71-2.

(30) PP. 3rd Report of the Council of the School of Design 1843-4, p.23.

(31) PP. 2nd Report of the Council of the School of Design 1842-3, p.6. See also the "Spectator" Dec.9, 1843, p.1171 for views on the suitability of wood-engraving for women.

(32) "Athenaeum" March 8, 1845, p.249.

(33) PP. 4th Report of the Council of the School of Design 1844-5, p.16. Report of the Select Committee on the School of Design 1849, p.120.

(34) "English Journal of Education" 1843-4, p.94 and see also Mrs. Anna Brownell Jameson's "Memoirs and Essays illustrative of Art, Literature, and social Morals" London 1846, p.245.

(35) PP. 4th Report of the Council of the School of Design 1844-5, p.16.

(36) ibid. p.31

(37) PP. Report of the Select Committee on the School of Design 1849, Appendix II, p.364.

(38) PP. Copies of Reports on the state of the Head or Provincial Schools made to the Board of Trade since August 1849, 1850, p.38.

(39) See Quentin Bell op.cit. pp.121, 109, 135.

(40) ibid. pp.121, 134-5

(41) PP. 5th Report of the Council of the School of Design 1845-6 p.11.

(42) PP. Report of the Select Committee on the School of Design 1849, pp. 115-120.

(43) For the Circumstances of the School's removal see Stuart Macdonald "The History and Philosophy of Art Education" London 1970, p.134,

(44) ibid. p.157

(45) PP. 1st Report of the Department of Practical Art, 1853, pp.17-18

(46) ibid. p.21

(47) ibid. p.18

(48) ibid. Appendix IV, p.221 and Appendix III, p.122.

(49) Quentin Bell op.cit. p.250. See also the "English Woman's Journal" July 1, 1861, vol.7, p.359.

(50) PP. 1st Report of the Department of Science and Art 1853, Appendix E pp.170, 174-6.

(51) ibid. pp. 174-6 and also the 2nd Report of the Department of Science and Art 1854, p.157.

(52) PP. 2nd Report of the Department of Science and Art 1854, p.157

(53) PP. 1st Report of the Department of Practical Art 1853, Appendix 3, pp. 123-5.

(54) Ellen C. Clayton: "English Female Artists" London 1876, vol.2, p.148

(55) "Art Journal" 1860, p.62

(56) "A Brief History of the Origins and Progress of the School". A sheet probably composed in 1885, to be found in the back of the "Reports of the Female School of Art, 1863-1906" in one volume published by the Chiswick Press

(57) ibid.

(58) PP. Report of the Select Committee on Schools of Art 1864, Appendix 16, p.421.

(59) PP. 7th Report of the Department of Science and Art 1860, p.89; Report of the Select Committee on Schools of Art, 1864, p.421.

(60) "Reports of the Female School of Art 1863-1906" One volume. "Annual Meeting and Distribution of Prizes" July 9th, 1863, p.6.

(61) ibid. October 1867, p.11.

(62) ibid. p.12.

(63) PP. Report from the Select Committee on the Schools of Art 1864, p.421.

(64) "Art Journal" 1866, p.94.

(65) ibid. 1868, p.16.

(66) PP. Report of the Department of Science and Art 1875, p. 338.

(67) "Art Journal", 1889, p.64.

(68) Others admitted before 1885 were: Blanche Jenkins, Blanche Macarthur, Rosalie Watson, Alice Hanslip, Ida Lovering, Alice Miller, Jennie Moore, Susan Ruth Canton, Frances Binns, Louisa Jacobs, Florence Clow, Edith Gibson, Norah Waugh, Florence Reason, Elizabeth Harding, Blanche Mabel Whitney and Agnes Lee. This select list was given in the back of the volume of "Reports of the Royal Female School of Art 1863-1906".
It should be said, however, that this list does not correspond with the Royal Academy's list of entrants to their Schools. The artists given above may have attended the Female School of Art but the latter did not necessarily sponsor them for admission to the Royal Academy Schools. See Appendix V for the actual sponsors.

(69) E.C. Clayton (op.cit.) mentions Eliza Turck, Mary Gow, Alice Elfrida Manly and Elinor Manly. C.E. Clement (op.cit.) mentions Henrietta Rae (Mrs Ernest Normand). Margaret Isabel Dicksee should also be singled out.

(70) These include Miss Louisa Gann, Miss Wilson, Miss Naomi Burrell, Miss Pocock, Miss De La Belinaye and Miss Welby. These names are taken from a list of teachers at the school given at the back of the volume "Reports of the Female School of Art 1863-1906".

(71) DNB vol.III, p.1149 under Francis Stephen Cary

(72) "Journals and Correspondence of Lady Eastlake" edited by her nephew Charles Eastlake Smith. London 1895, p.8.

(73) E.C. Clayton op.cit. vol. 2, p.22.

(74) ibid. vol. 2, p.259

(75) ibid. vol. 2, p.82

(76) ibid. vol. 2. p.147

(77) ibid. vol. 2, p.44

(78) ibid. vol. 2, p.164

(79) ibid. vol. 2, p.83.

(80) "Illustrated Exhibitor and Magazine of Art" 1852, vol.2, pp.262, 263 and 288.

(81) Gertrude Massey: "Kings, Commoners and Me" London 1934, p.135.

(82) ibid. pp.133, 135.

(83) "Spectator" Jan. 18, 1845, p.67 and see also Gertrude Massey op.cit. p. 130.

(84) "Art Journal" 1864, p.261

(85) Gertrude Massey op.cit. p.130.

(86) ibid. pp.131, 133

(87) ibid. pp.131, 148

(88) ibid. p.135.

(89) Virginia Surtees: "Sublime and Instructive. Letters from John Ruskin to Louisa, Marchioness of Waterford, Anna Blunden and Ellen Heaton" London, 1972, p.80.

(90) Mary Gow, Anna Blunden, Emma Cooper, Frances Fripp Rossiter, Laura Herford, Elizabeth Campbell Collingridge, Rebecca Coleman, Augusta Walker and Louise Jopling-Rowe (E.C. Clayton op.cit)

(91) E.C. Clayton op.cit. vol.2, p.317.

(92) C.E. Clement op.cit, p.150

(93) Walter Crane: "An Artist's Reminiscences" London 1907, p.80

(94) Johnston Forbes-Robertson: "A Player under Three Reigns" T. Fisher Unwin 1925, p.53.

(95) Gertrude Massey op.cit. pp.138, 145.

(96) Gertrude Massey op.cit. p.145.

(97) Baroness Orczy: "Links in the Chain of Life" London 1947, pp.53-4

(98) See Appendix V

(99) "Spectator" October 9, 1847, p.979

(100) ibid. The other new feature, apparently for the benefit of men only, was practice in "the rapid sketching of the figure in violent action"

(101) "Athenaeum" Sept. 30, 1848, p.985.

(102) ibid. October 9, 1847, p.1060.

(103) Quoted in R.G. Grylls: "Queen's College 1848-1948" London 1948, p.29

(104) Quoted in Elaine Kaye: "A History of Queen's College 1848-1972"
 London, 1972, p.44.

(105) R.G. Grylls op.cit. p.29.

(106) Elaine Kaye op.cit. p.37

(107) ibid. p.93 and R.G. Grylls op.cit. pp.8, 47

(108) Elaine Kaye op.cit. p.45.

(109) "The Victoria History of the Counties of England" edited by R.B.
 Pugh. The University of London Institute of Historical Research.
 Vol.1 "A History of the County of Middlesex" edited by J.S.
 Cockburn, H.P.F. King, K.G.T. McDonnell. Oxford University Press
 1969, p.345.

(110) M.J. Tuke: "A History of Bedford College for Women 1849-1937"
 Oxford, 1939, p.223.

(111) ibid.

(112) "The life", in the context of Bedford College, almost certainly
 means the draped living model. An advertisement for the College's
 Art Department in "The Year's Art" for 1894 (p.399) gives a detailed
 description of all the classes held at the college and a class for
 the study of the undraped living model was not included. That such
 a class should be abandoned, having once been established, is
 extremely unlikely and particularly in the 1890 s when classes for
 study from the nude figure were more numerous. Given this inter-
 pretation of "the life" in relation to Bedford College it was by no
 means the first school to offer such a facility.

(113) M.J. Tuke op.cit. p.223.

(114) ibid. pp.223-4 and see also Hester Burton: "Barbara Bodichon"
 London 1949, p.29.

(115) M.J. Tuke op.cit. p.224

(116) Hester Burton: "Barbara Bodichon" London 1949, p.30.

(117) Quoted by M.J. Tuke op.cit. p.224.

(118) "The Year's Art" 1894, p.399

(119) M.J. Tuke op.cit. pp.224-5, 158

(120) See Appendix IV under F.S. Cary and Appendix V.

(121) Assuming that it was still functioning in the 1850 s. No evidence
 of this has been found

(122) See note 112

(123) "Art Journal" 1858, p.143.

(124) ibid. 1857, p.215: See also "Westminster Review" 1858, vol. XIV,
 p. 163.

(125) PP. Art Directory, containing Regulations for Promoting Instruction in Art 1857-1885. 1857 App. C1, p.36.

(126) ibid. 1885, p.56.

(127) E.C. Clayton gives Helen J. Arundel Miles, Catherine Adeline Sparkes, Elizabeth Thompson, Mary Tovey, Augusta Walker, Mary Backhouse, Mary Ellen Edwards, Susannah Soden, Gertrude Jekyll, Alice Elfrida Manly, Frances Redgrave, Jessie Macgregor, Miss Brooks, Clara Montalba, Ellen Montalba, Harriette A. Seymour, Grace Cruikshank, Margaret Thomas, Elizabeth Campbell-Collingridge.

C.E. Clement gives Jessie King, Ruby Winifred Levick, Ada M. Shrimpton, Margaret Murray Cookesley and Kate Greenaway.

(128) E.C. Clayton gives Harriette A. Seymour, Mary Tovey (both Bristol), Rebecca Solomon (Spitalfields), Helen Allingham (Birmingham), Georgina Bowers, Martha Darley, Annie Mutrie (all Manchester); all studied in the 1860 s.

C.E. Clement gives Annie R. Merrylees Arnold (Edinburgh), Mrs. Edith Grey (Newcastle), Mary McCrossan, Edith Martineau (both Liverpool), Katherine Cameron, Jessie King, Mrs. J.G. Laing (all Glasgow).

(129) "Lady Dilke" A biography by Betty Askwith London 1969, p.8.

(130) Wilfred Meynell: "The Life and Work of Lady Butler (Miss Elizabeth Thompson)" Special edition of the "Art Annual" 1898, pp. 2-3.

(131) E.C. Clayton op.cit. vol.2, p.242.

(132) Baroness Orczy: "Links in the Chain of Life" London 1947 p.53.

(133) "Laura Knight: "The Magic of a Line" London 1965, p.77.

(134) ibid.

(135) See Appendix IV under Richard Burchett and John Sparkes and Appendix V.

(136) E.C. Clayton op.cit. pp.111, 131.

(137) ibid. pp. 190, 293.

(138) G.C. Moore Smith: "The Story of the People's College, Sheffield" Sheffield 1912, pp.13, 21.

(139) "Working Men's College Magazine" October 1st, 1859, p.153.

(140) ibid. Jan. 1st. 1860, pp.2-4.

(141) ibid. March 1st. 1860, p.55.

(142) "Elizabeth Malleson 1828-1916" Autobiographical notes and letters, with a memoir by Hope Malleson. Printed for private circulation in 1926 by Billing and Sons of Guildford and Esher pp.57-8. See also "The Working Men's College 1854-1904. Records of its history etc." edited by the Rev. J. Llewelyn Davies, London 1904, pp.141-2.

(143) "English Woman's Journal" 1862, vol. 8, p.432.

(144) ibid.

(145) "Life of Octavia Hill, as told in her letters" edited by C.E. Maurice, London 1913, p.216. See also "Elizabeth Malleson 1828-1916" (see note 142) p.59.

(146) "Art Journal" 1862, p.210.

(147) ibid. 1865, p.381 and 1872, p.242; "Year's Art" 1880, p.100.

(148) "Year's Art" 1888, p.177, 1896, p.187 and 1900 p.428.

(149) "Illustrated London News" March 23, 1861, p.272; "Free Press" Nov. 14, 1913.

(150) "Free Press" Nov. 14, 1913.

(151) ibid.

(152) E.C. Clayton (op.cit) gives Helen J. Arundel Miles, Catherine Adeline Sparkes, Linnie Watt, Emily J. Edwards, Florence E. Lewis, and Hannah Bolton Barlow; C.E. Clement (op.cit) gives Gertrude E. Spurr.

(153) "Free Press" Nov. 21, 1913.
See Appendix IV for female students admitted to the Royal Academy Schools on the recommendation of John Sparkes and Appendix V.

(154) E.C. Clayton op.cit. vol.2, p.131.

(155) "Free Press" Nov. 21, 1913.

(156) Sheet in the Lambeth Public Library on the Lambeth School of Art.

(157) Appendices III to V are relevant for the following survey of women's presence at the Royal Academy Schools. Appendix III shows the yearly intake of female students between 1860 and 1914; Appendix IV shows the main sponsors of female students who were admitted; Appendix V gives details, in chronological order, of the female students who were accepted by the Schools.

(158) William T. Whitley: "Art in England, 1800-1820" Cambridge 1928 pp. 84-5.

(159) "Art Journal" 1857, p.215.

(160) Mrs. E.M. Ward: "Memories of Ninety Years" London, 1939, pp.58-9.

(161) E.C. Clayton op.cit. vol. 2, p.84.

(162) ibid. vol. 2, p.2 and see also the "Art Journal" 1859, p.194.

(163) Royal Academy Council Minutes Aug. 3, 1860 vol. XI, p.371. For other accounts of this event see E.C. Clayton op.cit. vol.2, pp.2-3; George Dunlop Leslie: "The Inner Life of the Royal Academy" London 1914, p.42, note 1 and p.43 and the "English Woman's Journal" March 1861, pp.71-2.

(164) See Appendices III and V

(165) Royal Academy Council Minutes Dec. 18, 1861, vol. XII, pp.52-3

(166) Royal Academy Council Minutes Jan. 25, 1862, vol. XII, p.64

(167) Royal Academy Council Minutes Dec. 21, 1863, vol. XII, p.160
 and also May 14, 1864, vol. XII, p.181.

(168) Royal Academy Council Minutes,Aug. 3, 1860, vol. XI, p.371

(169) W.S. Spanton: "An Art Student and his teachers in the Sixties"
 London 1927, p.28.

(170) Royal Academy Council Minutes May 14, 1863, vol. XII, p.138. The
 reason was that numerous women were applying for admission and
 there was not enough space to accommodate them. This explanation
 was given later in the Annual Report from the Council of the Royal
 Academy to the General Assembly of Academicians for the year 1867,
 Section VII, pp.16-17.

(171) "Art Journal" 1863, p.230; "English Woman's Journal" Sept. 1864,
 vol. XII, p.72 and Dec. 1864, vol. XII, p.288.

(172) Annual Report from the Council of the Royal Academy to the General
 Assembly of Academicians for the year 1867 - 1868, Section VII,
 pp. 16-17.

(173) See Appendix V.

(174) Royal Academy Council Minutes Jan. 22, 1869, vol. XIII, p.8.

(175) Royal Academy Council Minutes Jan. 9, 1872, vol. XIII, p.246.

(176) Annual Report from the Council of the Royal Academy to the General
 Assembly of Academicians for the year 1872, p.7.

(177) Annual Report from the Council of the Royal Academy to the General
 Assembly of Academicians for the year 1873, pp.17-18.

(178) Annual Report from the Council of the Royal Academy to the General
 Assembly of Academicians for the year 1881, p.25.

(179) One active rebel against the exclusion of women from life studies
 at the Royal Academy was Margaret Collyer. See her "Life of an
 Artist" London 1935, pp. 78-82.

(180) Annual Report from the Council of the Royal Academy to the General
 Assembly of Academicians for the year 1893, p.18.

(181) "Education and Professions" volume 1, of the Women's Library, edited
 by Ethel M.M. Mckennon, London 1903, pp.129-130.

(182) Annual Report from the Council of the Royal Academy to the General
 Assembly of Academicians for the year 1903, p.16.

(183) W.P. Frith: "My Autobiography and Reminiscences" London 1888,
 p. 469, See Appendix III.

(184) See Appendix III.

(185) See Appendix IV.

(186) E.C. Clayton op.cit. vol.2, p.131.

(187) Louisa Starr's success at the Schools provoked a plea for the admission of women as Royal Academicians in the "Art Journal" (1871, p.100). For evidence of the celebrity of this artist as an Academy student see Mrs. E.M. Ward's "Memories of Ninety Years" London 1939, p.59.

(188) C.E. Clement op.cit. p.156.

(189) W.P. Frith: "My Autobiography and Reminiscences" London 1888, pp. 469-470.

(190) Henry Stacey Marks remarked on this in his "Pen and Pencil Sketches" London 1894, vol.2, pp.37-8

(191) "Art Journal" 1907, p.275.

(192) ibid. 1909, p.46.

(193) Details of this class are given on pages 89-90

(194) H. Hale Bellot: "University College London 1826-1926" London 1929, p.347.

(195) University College Calendar. Session 1871-2, p.43.

(196) ibid.

(197) ibid. In reference to a class for the draped living model, it is written: "this class is especially adapted for ladies who cannot, of course, work from the nude model"

(198) ibid. p.45.

(199) University College London. Proceedings at the Annual General Meeting of the Members of the College Feb. 28, 1872. Report of the Council and Financial Statements, p.16.

(200) University College Calendar. Session 1872-3, p.44.

(201) ibid. pp.44-5

(202) Univeristy College London. Proceedings at the Annual General Meeting of the Members of the College Feb. 26, 1873, p.16.

(203) University College Calendar. Session 1898-9, p.91.

(204) University College London. Proceedings at the Annual General Meeting of the Members of the College, Feb. 26, 1873, p.15.

(205) ibid. Feb. 1874, p.123.

(206) ibid. Feb. 1875, p.20.

(207) The other six are : Lady Dorothy Stanley, Jane Mary Dealy, Countess Gleichen, Isobel Lilian Gloag, Mary Hogarth and Mrs Alice Mott. See C.E. Clement op.cit.

(208) H. Hale Bellot: "University College London 1826-1926" London 1929,
 p.389 and see also Vincent Lines: "Mark Fisher and Margaret
 Fisher Prout" London 1966, p.35.

(209) Augustus John: "Chiaroscuro" London 1952, p.48.

(210) See pages 21-2, 27-8

(211) Bessie Rayner Parkes: "Essays on Woman's Work" London 1865, pp.124-5

(212) Phillis Browne: "What Girls can do. A Book for Mothers and Daughers"
 London 1880 pp. 239-40. For further evidence of the continuing
 popularity of art as an accomplishment see the "London Review" 1861,
 vol.III, p324; "Bow Bells" 1864, vol.1, p.379; Miss Sewell's
 "Principles of Education" in 2 volumes, London 1865, vol.2, pp.288,
 295-6; "Sixpenny Magazine" 1866, vol. XII, pp.62, 257-259;
 "Quarterly Review" 1866, vol. 119, p.503; Mrs Henry Mackarness:
 "The Young Lady's Book. A manual of amusements, exercises, studies
 and pursuits" London 1876 pp.54-5; Charlotte Yonge: "Womankind"
 London 1877 pp.30, 39; Ellis A. Davidson: "Pretty Arts for the
 Employment of Leisure Hours. A Book for Ladies" London 1879 and see
 also PP. Taunton Report (Schools Inquiry Commission) 1867-8 vol.IX
 pp. 792 and 813.

(213) Gertrude Massey op.cit. p.3

(214) ibid. p.128.

(215) "Times" 1885: May 20, p.10; May 21, p.6; May 22, p.5; May 23, p.
 10; May 25, p.10; May 28, p.5.

(216) "Pall Mall Gazette" Nov. 12, 1888, p.5.

(217) ibid. Oct. 19, 1888, p.6.

(218) ibid.

(219) "Art Journal", 1878, p.190

(220) Ibid.

(221) "Year's Art" 1882, p.115

(222) "Art Journal" 1879 p.98

(223) ibid. p.119. For further details of the School in the 1890 s,
 see "Year's Art" 1892, p.384.

(224) Louise Jopling: "Twenty Years of my Life 1867-1887" London 1925,
 pp. 266-7, 307.

(225) "Year's Art", 1892, p.382.

(226) Charlotte Yonge: "Womankind" London 1877 (2nd edition) p.54.

(227) See pages 31, 33

(228) "Year's Art" 1892, p.383

(229) ibid.

(230) See Appendix IV under A.A. Calderon, B.E. Ward, C.M.Q. Orchardson and F.D. Walenn.

(231) See Rex Vicat Cole: "The Art and Life of Byam Shaw" London 1932 pp.23, 27; "Year's Art" 1890, p.335, 1892, p.384, 1905, p.529 and also Stuart Macdonald op.cit. pp.34-5.

(232) Charlotte Yonge: "Womankind" London 1877 (2nd Edition) p.226.

(233) Margaret Collyer: "Life of an Artist" London 1935, pp.25-7; "Year's Art" 1905, p.527

(234) A different establishment, apparently, to that founded by Miss E. Digby Williams in the 1870 s (see page 35). The later School was first advertised in "Year's Art" in 1895, p.123.

(235) "Art Journal", 1899, pp.274-5

(236) "Year's Art" 1896, p.415

(237) For details of these schools see the following entries in "Year's Art": 1890 p.333; 1894 p.399; 1896 p.420; 1899 p.472; 1900 p.426; 1900 p.427; 1905 p.535.

(238) "Year's Art" 1890, p.334.

(239) ibid, 1895 pp.123, 412.

(240) The following schools specialized in landscape painting: Spenlove School of Painting, Beckenham, Kent ("Year's Art" 1896, p.419 and for fuller accounts see the same magazine for 1905, pp.168-9 and 1910, p.181); Cornish School of Landscape Painting run by Mr. Julius Olsson ("Year's Art" 1896, p.421); Newlyn School of Painting run by Mr and Mrs Stanhope Forbes ("Year's Art" 1900, p.426); Richmond School of Landscape Painting ("Year's Art" 1900, p.426); Newlyn and Penzance Art Students' School (Year's Art" 1905, p.534). The following in animal painting: Herkomer School, Bushey, founded in 1883 ("Year's Art 1896, p.417); Grünewald Atelier at Cheadle near Manchester ("Year's Art" 1896, p.419); School of Animal Painting run by W. Frank Calderon at 54 Baker Street ("Year's Art" 1905, p.526).
The following in the applied arts: Camden School of Art ("Year's Art" 1896, p.416); Henry Blackburn Studio ("Year's Art" 1896, p.418); Decorative Art Studio ("Year's Art" 1905, p.532)
Miss Marie Low ran a studio "for the study of flowers and their surroundings in the French method" ("Year's Art" 1896, p.421).

(241) E.C. Clayton op.cit. vol.2, p.160.

(242) "Art Journal" 1886, p.244

(243) "Studio" 1904, vol.30, pp.225-33

(244) "Self-Portrait of an Artist" from the Diaries and Memoirs of Lady Kennet, London 1951, p.23. Cecilia Beaux, a student at the Académie Julian in the 1880s remarked on the bravery and energy manifested by Englishwomen who "broke away from custom and tradition" in going to Paris to study art (Cecilia Beaux: "Background with Figures" Boston and New York 1930, p.118).

(245) "Education and Professions" volume 1 of the Women's Library
 edited by Ethel M.M. Mckennon pp.117-148.

(246) ibid. pp.118, 131.

(247) "In the Open Country. The Work of Lucy Kemp-Welch" with an intro-
 ductory note by Professor Hubert von Herkomer R.A. Artists of the
 Present Day Series edited by W.S. Sparrow, London 1905, p.11.

(248) Gertrude Massey op.cit. p.13.

(249) "In the Open Country. The Work of Lucy Kemp-Welch" London 1905,
 p.11.

(250) Vollmer op.cit. vol.3. p.35 and see also "The Life and Work of Lucy
 Kemp-Welch" a catalogue for an exhibition held by David Messum in
 May 1976, p.24.

(251) E.C. Clayton op.cit. vol.2, p.335.

(252) ibid. vol.2. p.130.

(253) C.E. Clement op.cit. p.150.

(254) E.C. Clayton op.cit. vol.2, pp.189-190.

(255) ibid. vol.2, p.189.

(256) For Mary Ellen Edwards and Anna Blunden Martino see E.C. Clayton op.
 cit. vol.2, pp.76, 197. The former attended the South Kensington
 School, the latter studied at J.M. Leigh's Academy.
 Evelyn de Morgan (Miss Pickering), according to the "Connoisseur"
 (1922 vol.63, p.183) was thwarted in her desire to learn art by her
 parents. She was finally allowed to attend an art school accom-
 panied by a maid and then went on to the Slade.

(257) Ford Madox-Brown taught study from the antique to his daughter, Lucy,
 Marie Spartali and his other daughter, Catherine, in rooms of the
 Branch Government School of Art in Bolsover Street, Portland Road,
 for three mornings a week when ordinary pupils were not present (1860 s
 Nellie Gosse also studied under him (E.C. Clayton op.cit. vol.2.
 pp. 94, 118).
 John Ruskin gave instruction and advice to Mrs. Hugh Blackburn from
 the 1840 s (E.C. Clayton op.cit. vol.2, p.399), to Octavia Hill from
 1855 ("Life of Octavia Hill" edited by C.E. Maurice 1913, p.21), to
 Anna Blunden from 1855 (Virginia Surtees: "Sublime and Instructive"
 London 1972, pp.79-141), to Louisa, Marchioness of Waterford from
 1855 (Virginia Surtees op. cit. pp.1-79) and also to Louise Blandy,
 Kate Greenaway and Isabella Jay (PhD Thesis by Catherine Willimas:
 "Ruskin and the Guild" - University of London) in the 1870 s and
 1880 s.
 William Bell Scott taught Laura Alma Tadema and Alice Boyd in the
 1850 s (E.C. Clayton op.cit. vol.2, pp.6, 38-9)
 Frederick Cruikshank instructed Margaret Gillies and Charlotte Grace
 Dixon (E.C. Clayton op.cit. vol.2, pp.91, 255) and also his daughter
 Grace Cruikshank.
 William Collingwood Smith taught Joanna Samworth in 1850 and Mrs
 Harding (E.C. Clayton op.cit. vol.2, pp.290, 410).
 Edwin Landseer taught Mrs. Hugh Blackburn in the 1840 s and Queen
 Victoria (E.C. Clayton op.cit. vol.2, pp.399, 429)
 William Callow taught Mrs. Harding and Mrs. F.J. Mitchell in the
 1850 s (E.C. Clayton op.cit. vol.2, pp.410, 414.)

(258) To give an exhaustive list is of course impossible. The most
that can be done in this context is to mention the most successful
of those women who come under this heading. The following all
had artistic parents: the Hon. Eleanor Vere Boyle, Emma Eleonora
Kendrick, Madeleine Marrable, Mary Gow, Mary Newton, Elizabeth
Campbell-Collingridge, Anna Blunden, Lucy Madox Brown, Mary
Backhouse, Henrietta Ward, Anna Lea Merritt, Laura Alma Tadema,
Mary Francis, Countess Gleichen and the Misses Sharpe.

(259) Again it is impossible to give full details. A few examples from
extreme cases are: Mrs Gould, Anna Maria Charretie, Edith Courtauld-
Arendrup, Annie Dixon and also, despite occasional advice from
Ruskin, Louisa Marchioness of Waterford.

(260) George Moore: "Modern Painting" London 1893, p.223.

(261) François De Salignac De La Mothe-Fénelon: "Traité de l'Education des
Filles" (first published in 1687) Paris 1902, p.125.

(262) Jean-Jacques Rousseau: "Emile ou de l'Education" (first published
in 1762) Paris 1951, p.460.

(263) "Journal des Femmes Artistes" May 1896, no. 4, p.4.

(264) Edouard Lepage: "Une Page de l'Histoire de l'Art au dix-neuvième
siècle. Une Conquête Féministe. Madame Léon Bertaux" Paris 1912,
p.170.

(265) See page 10

(266) Madame Necker de Saussure: "L'Education Progressive ou Etude du
Cours de la Vie" vol. 3 "Etude de la Vie des Femmes" Paris 1838,
p.152.

(267) ibid. p.154.

(268) ibid. p.155

(269) ibid. p.158

(270) ibid. p.160. For an elaborate discussion of this idea that women
in Society should not excel in art see the "Journal des Jeunes
Personnes" March 1, 1833, pp.415-418. The author, De Peyronnet,
wrote: "J'en approuverais donc l'étude et l'usage, mais un usage
borné, modeste, intérieur, qu fût pour soi, et non pour autrui; pour
son propre et intime plaisir, non pour le bruit et la montre...
Sitôt que vous peignez assez correctement pour faire étalage de votre
peinture, vous êtes trop loin et passez déjà votre mesure d'habileté
et de perfection" (p.417)

(271) Madame Necker de Saussure op.cit. p.161.

(272) ibid. pp.163-4

(273) ibid. p.165.

(274) See page 12 and note 27

(275) Short anonymous history of the Ecole de Dessin pour les Jeunes
Filles in the Archives Nationales, Paris

(276) "Discours prononcés le premier messidor an XI (June 30th, 1803) dans une des salles du onzième arrondissement de la municipalité de Paris, lors de l'ouverture de L'ECOLE GRATUITE DE DESSIN EN FAVEUR DES JEUNES PERSONNES" Paris, Baudouin 1803 "Discours par le citoyen Boulard, Maire du 11e arrondissement de Paris, le premier messidor an XI lors de l'ouverture de l'Ecole de Dessin pour les jeunes desmoiselles" pp.3-4.

(277) ibid. "Discours prononcé par Madame Frère-Montizon, née Turben, Fondatrice et Directrice de l'établissement" p.10.

(278) ibid. pp.10-11.

(279) C.P. Landon: "Nouvelles des Arts. Peinture, Sculpture, Architecture et Gravure" 1802, vol.2, pp.223-4

(280) "Discours prononcés le premier messidor an XI, etc." op.cit. pp.12-13.

(281) ibid. pp.13-14

(282) ibid. p.4

(283) ibid. p.5

(284) ibid. pp.5-7

(285) William Dyce: "The Report made to the Council of the School of Design" 1838, p.19 (manuscript in the Art Library of the Victoria and Albert Museum)

(286) This subject is considered in some depth, particularly in reference to the School in Lyons, in Harrison C. White and Cynthia A. White's "Canvases and Careers" New York, 1965, pp.27, 56.

(287) William Dyce: op.cit. p.12.

(288) Sheet on the Ecole de Dessin pour les Jeunes Fills in the Archives Nationales, Paris.

(289) Miss Anna Klumpke: "Rosa Bonheur" Paris 1908, p.217.

(290) ibid. p.218 and "Gazette des Beaux-Arts" Aug. 15, 1860, vol.6.p.255.

(291) E.C. Clayton op.cit. vol.2, p.291

(292) Madame Marie-Elizabeth Cavé: "La Femme Aujourd'hui, La Femme Autrefois" Paris 1863, p.31.

(293) "Gauloises", Sept. 1874, no.9, pp33-4

(294) ibid. Sept. 1875, no.7, pp.25-6. For a tribute to Mlle. Marandon de Monyel's achievements in the field of art education see "Chronique des Arts" Aug.12, 1893, no.27, p.215.

(295) Antony Valabrègue: "Les Princesses Artistes" Paris 1888, p.83.

(296) "L'Art" 1881, vol.4, p.70.

(297) ibid. pp.70-71.

(298) "Chronique des Arts" April 17, 1909, no.16, p.129.

(299) "Courrier Artistique" Feb. 5, 1865, no.36, pp.141-2

(300) "Chronique des Arts" Dec. 6, 1868, no.49, p.2.

(301) ibid. Feb.7, 1869, no.6, p.4.

(302) "Gazette des Beaux-Arts", Feb.1, 1869, p.199.

(303) "Reminiscences of Rosa Bonheur" edited by Theodore Stanton.
 London 1910, p.276.

(304) "Gauloises" Sept. 1874, no.9, pp.33-4

(305) In the Salon catalogue of 1875, for instance, Mlles. Clothilde Bricon,
 M.L.M. Bourse, Camille Choizeau, Eugénie Delahaye, Marie Girard,
 Augusta Granier, Marie Roux, Julia Granier, Clothilde Grenez, M-C
 Ribaut, Claire Hildebrand, Hortense Ricard, Madame Adrienne Peytel
 and others were described as her pupils.

(306) "Gauloises" Sept. 1874, no.9, p.34.

(307) "Fémina" June 1, 1903, vol.3, p.562.

(308) See for instance the "English Woman's Journal", Nov.2, 1863, vol.12,
 p.216 and also M. Allard's "L'Art Department et l'enseignement du
 dessin dans les écoles anglaises" Rouen 1867, p.25.

(309) Edouard Lepage: op.cit. pp.53-4

(310) ibid. pp.140-1 (quoted)

(311) See page 41 and note 264

(312) For an interesting case of women's exclusion from the field of art
 teaching during the French Republic (1796) see the "Revue Universelle
 des Arts" 1863, vol. 17, pp.55-61.
 There are three striking cases of female appointments in this field
 before the 1860 s. Marie Eléonore Godefroid taught drawing at
 Mme. Campan's exclusive girls' school at Saint-Germain-en-Laye for
 about eleven years between 1795 and 1805 (approximately) (see
 "Gazette des Beaux-Arts" Jan. 1, 1869, vol.1, p.44); Elizabeth
 Swagers taught drawing at the Maison Impériale Napoléon at Ecouen -
 a girls' school for daughters of members of the Legion of Honour run
 by Mme. Campan in the early years of the century (Bénézit op.cit);
 in 1824 Mlle. Louise Bouteiller was appointed professor of drawing
 and painting at the Maison Royale de St. Denis, also for daughters
 of members of the Legion of Honour (Bénézit op.cit).

(313) "Kunstchronik" Dec. 13, 1867, p.31.

(314) ibid. and see also "Chronique des Arts" Nov. 24, 1867, no.200, p.276.

(315) "Gazette des Beaux-Arts" Feb. 1, 1869, vol.1, p.199.

(316) For Mlle. Virginie Hautier see "Chronique des Arts" April 17, 1909, no. 16, p.129; for Mme. Jules Héreau see "L'Art" 1881, vol.1, p.240; for Mlle. Camille Aderer see "Chronique des Arts" Jan.9, 1892, No.2 p. 13; for Mme. de Callias see "Chronique des Arts" Sept.9, 1905, no. 29, p.247; for Louisa Chatrousse see "Le Congrès International de l'Enseignement du Dessin tenu à Paris, 29 août à 1 september 1900. Procès-Verbaux sommaires par Madame L. Chatrousse". Louisa Chatrousse was Professeur de dessin dans les écoles de la Ville de Paris and Vice-President of the Association des Professeurs de dessin de la Ville de Paris. Among the latter's 25 members, three were women: Mlle. Bastien, Mlle. Eugénie Luneau and Mme. Myskowska-Dubreuil, all with similar qualifications; for Delphine de Cool and other female drawing teachers in the 1860 s and 1870 s see pages 45-6

(317) Albert Boime op.cit. p.23.

(318) "Chronique des Arts" Feb. 21, 1903, no.8, p.59.

(319) Marie - Juliette Ballot: "La Comtesse Benoist, L'Emilie de Demoustier 1768-1826" Paris 1914, p.164.

(320) "Pausanias Français" 1806, p.258.

(321) See "Gazette des Beaux-Arts" Feb. 1962, vol. 59, p.97.

(322) Bénézit op.cit.

(323) "L'Artiste" 1836, vol.11, p.256.

(324) ibid. 1836-7, vol. 12, p.187.

(325) For David's female pupils see Jules David: "Le Peintre Louis David. Souvenirs et documents inédits" Paris 1880, pp.625-630. See under the relevant headings in Thieme-Becker and Bénézit op.cit. and see also Marius Vachon: "La Femme dans l'Art" Paris 1893, p.592.

(326) François Rude gave instruction to Sophie Rude (later his wife) and Uranie Colin-Libour; Eugène Delacroix gave advice and instruction to Marie-Elizabeth Cavé, Madame Hélène Marie Antigna and Madame Herbelin. See under the relevant headings in Thieme-Becker and Bénézit op.cit.

(327) See pages 237-8

(328) See page 238

(329) See page 238

(330) E.C. Clayton op.cit. vol.2, pp.290-1

(331) Joanna Mary Boyce attended this in 1855. See "Art Journal" 1861, p.273.

(332) Mrs Grote: "Memoir of the Life of Ary Scheffer" London 1860. She gives his account in full on pages 40-1.

(333) ibid. p.40

(334) ibid. p.41

(335) Anthony Valabrègue: "Les Princesses Artistes" Paris 1888, pp.6-8.

(336) ibid. p.7.

(337) See page 41 and note 270.

(338) The following are a few examples:-

 1802 "L'Ecole de la Miniature, ou l'Art d'apprendre à peindre
 sans maîtres, et les secrets pour faire les plus belles
 couleurs"(a new edition)
 ca. 1820 Johann Daniel Preissler: "Abrégé de l'Anatomie à l'usage
 des Peintres .. traduit de l'Allemand"
 1823 Antoine Chrysotome Quatremère de Quincy: "Essai sur la
 nature, le but et les moyens de l'Imitation dans les
 Beaux-Arts"
 1827 J.T. Thibault: "Application de la Perspective Linéaire
 aux Arts du Dessin, ouvrage posthume"
 1841 C. Boutereau: "Nouveau manuel complet du Dessinateur"

(339) Marius Vachon op.cit. p.593

(340) "Grand Larousse Encyclopédique" in 10 volumes; vol.6 (1962) p.675

(341) Alexis Lemaistre: "Nos Jeunes Filles aux Examens et à l'Ecole"
 Paris 1891, p.271.

(342) They are described as pupils of the Schools in the Salon Catalogues.
 Mlle. Eugénie Kieffer and Mlle. Marie Larsonneur in 1875, Mlle.
 Juliette Manbret in 1883 (also Mlle. Joséphine-Marie-Jeanne
 Girordiet in the same year) and Mlle. Marie Rouget in 1884.

(343) See "Gazette des Beaux-Arts" Aug. 1, 1869, vol.2, p.168 and "Revue
 Internationale de l'Art" 1870, pp.473-4.

(344) Alexis Lemaistre op.cit. p.267.

(345) ibid. p.271.

(346) ibid. pp.303-4

(347) ibid. p.306

(348) ibid. p.313

(349) Albert Boime op.cit. p.219.

(350) Madame Marie-Elizabeth Cavé: "La Femme Aujourd'hui, la Femme
 Autrefois", Paris 1863, p.110.

(351) See page 47 and see also "L'Art" 1877 vol.4, p.47 in which the
 following report was given on primary schools in Paris: "L'étude du
 dessin est devenue réglementairement obligatoire pour tous les
 élèves qui suivent le cours moyen et le cours supérieur". There
 was a new supplementary course for boys and ten new courses for
 young girls. From the end of the school year of 1877/8, competitors
 for the certificat d'études primaires would have to take a drawing
 exam, "conforme au programme de l'enseignement du cours supérieur".

(352) "Gazette des Beaux-Arts" 1860, vol.5, p.349.

(353) On Oct. 18 1891, an interesting article appeared in the "Times" in which
 it was claimed that the revolution which had taken place in the art

education of women in France was due to American influence
(354) Louise Jopling-Rowe: "Twenty Years of my Life 1867-1887"
London, 1925, p.3.

(355) ibid. p.5

(356) ibid. p.133

(357) J.K. Huysmans: "L'Art Moderne: Salons 1879-1882" Paris 1883, p.57.

(358) "Journal des Femmes Artistes" Feb.15, 1891, no.6, pp.3-4

(359) See under the relevant headings in Thieme-Becker and Bénézit op.cit.

(360) Martine Hérold: "L'Académie Julian à cent ans" Paris 1968, p.1

(361) According to Bénézit, Amélie Beaury-Saurel was a pupil of Jules
Lefebvre, Tony Robert-Fleury and Jean-Paul Laurens at Julian's and
according to Marie Bashkirtseff she was there with the latter in
October 1877 ("Le Journal de Marie Bashkirtseff" Paris 1887, vol.2,
pp. 13, 15. She is referred to as the Spanish girl).
Louise Breslau studied under Tony Robert-Fleury at the School from
1875 to 1881 (see "Le Journal de Marie Bashkirtseff" vol.2, p.18
in which Bashkirtseff wrote that when she first went to Julian's in
October, 1877, Louise Breslau had been working there for two years
and see also Thieme-Becker op.cit.)
Emma Herland was a pupil of Jules Lefebvre and Benjamin Constant in
the 1870 s (see Thieme-Becker op.cit)
Marie Bashkirtseff attended from October, 1877 (see "Le Journal de
Marie Bashkirtseff" vol.2, p.3.)

(362) "Le Journal de Marie Bashkirtseff" vol.2, pp.5, 227-8.

(363) ibid. p.25

(364) ibid. p.109

(365) ibid. p.228 and see also Martine Hérold op.cit. p.2

(366) Ludwig Hevesi: "Altkunst - Neukunst 1894 - 1908" Vienna 1909, p.580

(367) See under the relevant headings in Thieme-Becker and Bénézit op.cit.

(368) Martine Hérold op.cit. pp.2-3.

(369) "Fémina" Feb 15, 1903, no.50, p.439-40. The other facilities will
be considered separately.

(370) ibid. p.439.

(371) "Cyclopedia of Education" edited by Paul Monroe PhD. New York 1911,
pp. 233-4.

(372) Martine Hérold op.cit. pp.2, 4

(373) Edouard Lepage: op.cit. p.55

(374) ibid. p.56.

(375) ibid. p.58

(376) ibid. p.51

(377) ibid. p.135

(378) ibid.

(379) See page 47

(380) Edouard Lepage op.cit. p.136.

(381) ibid.

(382) ibid. p.140

(383) ibid. p.136.

(384) "Gauloises" May, 1874, no.4, p.18.

(385) Marius Vachon op.cit. p.593

(386) Edouard Lepage op.cit. p.123.

(387) Virginie Demont-Breton: "Les Maisons que j'ai connues" Paris, 1926,
 vol.2, p.197.

(388) The Union and Mme. Bertaux's position within it will be considered on
 pages 98-105

(389) "Journal des Femmes Artistes" Dec. 1890, no. 2, pp.2-3

(390) ibid. p.3 and see also Edouard Lepage op.cit. p.124.

(391) Edouard Lepage op.cit. p.124 and see also Virginie Demont-Breton op.
 cit. vol.2, p.197

(392) Virginie Demont-Breton op.cit. vol.2, p.198.

(393) "Journal des Femmes Artistes" Nov. 1892, no.30, p.3

(394) ibid.

(395) ibid. Dec. 1890, no.1, pp.1-2

(396) ibid. Nov. 1892, no.30, p.3

(397) ibid. Feb. 1892, no.23, pp.1-2

(398) See pages 98-102

(399) "Journal des Femmes Artistes" Nov. 1892, no.30, pp.3-4

(400) Edouard Lepage op.cit. p.170 and see also page 41

(401) Edouard Lepage op.cit. p.170

(402) "Journal des Femmes Artistes" April 1896, no.63, p.2.

(403) "Chronique des Arts" April 10, 1897, p.137.

(404) "Cyclopedia of Education" edited by Paul Monroe, New York 1911, Vol.1,
 p. 233.

(405) "Journal des Femmes Artistes" Jan. 1898, no.74, p.2.

(406) ibid. Nov. 1897, no.72, p.2.

(407) ibid. Jan. 1898, no.74, p.2.

(408) "La Fronde" Jan. 20, 1900.

(409) Edouard Lepage op.cit. p.186.

(410) In June 1897, there were 46 female applicants; in October, 1897 - 43;
 in April, 1898 - 41; in October, 1898 - 36; in April, 1899 - 28;
 in October, 1899 - 27; in April, 1900 - 26; in October, 1900 - 33;
 in April, 1901 - 55. These figures are compiled from a document
 entitled "Ecole Nationale et Spéciale des Beaux-Arts. Section de
 Peinture et de Sculpture. Inscriptions pour les Epreuves d'admission
 - Femmes" (Manuscript in the Archives Nationales, Paris(AJ (52) 73bis)).

(411) "Fémina" Feb. 15, 1903 no.50, p.440

(412) "Journal des Femmes Artistes" Jan, 1893, no.34, pp.2-4

(413) Edouard Lepage op.cit. p.192.

(414) "Chronique des Arts" Feb.14, 1903, p.49

(415) ibid. Feb.28, 1903, p.68.

(416) "Kunstchronik" Jan. 9, 1902, no.12, p.192.

(417) "Evening Standard" July 20, 1925

(418) "Journal des Arts" Nov. 12, 1880, no.44, p.2.

(419) "Journal des Femmes Artistes" Nov. 1895, no.58.

(420) Run by Madame de la Riva-Munoz, Madame Berthe Perrée, Madame
 Frédérique Vallet, Madame E. Faux-Froidure, Mlle. Blanche Pierron,
 Mlle. Andrée Nautre, Mlle. Moria, Mme. Bullot-Eicher (and Mlle.
 Thomas), Mlle. Marguérite Arosa, Mme. Jeanne Amen, Mlle. Magdeleine
 Popelin, Madame Flore Piton-Guitel, Madame Roullet-Fauve, Madame
 Chardon-Debillemont, Mlle. Bonnefoi.
 See "Journal des Femmes Artistes" Nov. 1897, no.72, pp.3-4.

(421) "Studio" 1904, vol.30, pp.225-233: "A Lady Art Student's Life in
 Paris"

(422) ibid. p.227.

(423) ibid. p.228.

(424) ibid. p.229

(425) ibid.pp.228-9

(426) ibid. p.229

(427) ibid. p.230

(428) ibid.pp.227, 230

(429) ibid. p.233

(430) Although this information has, in some cases, been taken from primary sources, it is, in all, available in Thieme-Becker and Bénézit op.cit.

(431) See page 351

(432) See page 41

(433) See page 59

(434) The efforts of Madame Bertaux and Virginie Demont-Breton have already been considered. For Louise Abbéma see an interview with the latter reported in the "Journal des Femmes Artistes", May 15, 1891, no.12, p.3.

NOTES - CHAPTER TWO

(1) In France in particular catalogues often ran into several editions.
The Salon of 1831 is an example. On this occasion the exhibition
opened on May 1st and works were admitted until the closure of the
exhibition on June 1st. Thus it was impossible to produce a com-
plete catalogue until the exhibition was over. The catalogue I
have used in this instance is the final complete one in which there
are seven supplements. It is not always clear which edition one
is using. The existence of supplements and the inclusion of infor-
mation only available in retrospect, such as medals awarded at the
exhibition, are often the only indications that there were more than
one.

(2) The following are some examples. The majority, it will be observed,
are French:

Claude Vignon	- pseudonym for	Mme. Noémie Rouvier (sculptor)
Marcello	- "	" La Duchesse Adèle de Castiglione-Colonna (Sculptor)
Anselma	- "	" Mme. Marie Lacroix, née de Gessler (painter)
Manuella	- "	" La Duchesse de Luynes (Duchesse d'Uzès) (sculptor)
Allélit	- "	" Héléna Hébert (Mme. Léon Bertaux) (sculptor)
Jacques -Marie	- "	" Marie Jacques (Painter)
Marlef	- "	" Marthe Lefèbre (painter)
Jacques-François	- "	" woman artist who exhibited with the Impressionist group in 1876 and 1877
Jack	- "	" Marianne Godwin (caricaturist)

Some women artists exhibited anonymously. An example is Mme. de
Guizard (née Clémence Duresne) (see "Chronique des Arts" Sept. 10,1866,
no.154, p.221).

(3) "English Woman's Journal" May 1, 1858, vol.1, no.3, p.208. This is
corroborated by the fact that at the exhibitions of Amateur Artists
at 121 Pall Mall, women's works constituted a much higher proportion
of the total than at the larger and more professional exhibitions.
In 1852, for instance, out of a total of 276 works, 127 were by women.
Works were contributed by 61 Gentlemen, 3 Ladies, 12 Mistresses, and
35 Misses.

(4) The British Institution exhibited only oil paintings and sculpture;
water-colours were held in low estimation and paintings on china
were not admitted until 1879.

(5) See Chapter 1, page 34

(6) Many women were being trained as designers and as art teachers by
this time. See pages 24-5

(7) C.P. Landon: "Nouvelles des Arts, Peinture, Sculpture, Architecture
et Gravure" 1802, vol.2.p.54.

(8) C.P. Landon: "Annales du Musée et de l'Ecole Moderne des Beaux-Arts"
1808, vol.1, part 2, p. 91.

(9) "Magasin des Demoiselles" 1847, vol.3, p.210.

(10) Monuments Publics have not been included in this survey of the
 official Salon.

(11) "Chronique des Arts" May 31, 1873, no.22, p.213: "Le Salon:
 Essai de Statistique" by E. Muntz.
 "Gauloises" June 1875, nos. 4, 6, pp.17, 21: "Les Femmes Artistes
 au Salon de 1875" by J.A.
 "Gauloises" June 1, 1876, no.26, p.1: "Salon de 1876: Talents féminins"
 "Gauloises" May 18, 1877, no.32, p.2: "Salon de 1877: Femmes Exposantes"
 "Gazette des Femmes" June 16, 1878, no.44, p.3: "Salon de 1878"
 Jean Alesson: "Les Femmes Artistes au Salon de 1878 et à l'Exposition
 Universelle" Paris 1878.
 "Gazette des Femmes" June 1881, nos. 76-7: "Salon de 1881"

(12) "Chronique des Arts" May 31, 1873, no.22, p.213

(13) "L'Art" 1880, vol.3, p.35

(14) "Chronique des Arts" June 18, 1910, no.24, p.188.

(15) The low percentage of works by women at the British Institution is
 almost certainly a reflection of the Institution's policy of exclud-
 ing portraits, one of the most popular subjects with women artists.

(16) "L'Art" 1880, vol.3, p.35.

(17) "Art Journal", 1880, p.188

(18) "Pausanias Français" 1806, p.573.

(19) "Courrier Artistique" May 14, 1865, no.50, p.198.

(20) "Revue Internationale de l'Art et de la Curiosité" 1870, vol.3-4, p.365.

(21) "Gazette des Beaux-Arts" Aug 1, 1879, vol.20, p.152.

(22) ibid. 1877, vol.15, p.529

(23) It is difficult to produce statistice on women's contributions in
 porcelain painting and miniature as the former was never, and the
 latter rarely (apart from at the very beginning of the century in
 England) listed separately.

(24) "Art Journal" 1866, p.71

(25) ibid. 1873, p.87

(26) A.Jal: "Esquisses, croquis, pochades, ou tout ce qu'on voudra sur
 le Salon de 1827", 1828, pp.526-7

(27) "L'Artiste" 1841, vol.7, p.347.

(28) "Gazette des Beaux-Arts" July 1, 1859, vol.3, p.23.

(29) ibid. Aug. 1, 1861, vol.11, p.154.

(30) "Courrier Artistique" Aug. 7, 1864, no.10, p.37.

(31) "Chronique des Arts" May 31, 1873, no. 22, p.213.

(32) Like water-colour, engraving was relegated to an inferior level
 at the Royal Academy. It was not until 1853 that Engraver
 Academicians were admitted; previously they were acknowledged as
 Associates only.

(33) "Gazette des Beaux-Arts" Aug.1, 1868, vol.25, p.122.

(34) This is revealed by an examination of volume 1 of the Royal Academy
 Council Minutes.

(35) Annual Report from the Council of the Royal Academy to the General
 Assembly of Academicians for the year 1879, p.8. In 1805, when
 Benjamin West was re-elected President of the Royal Academy, the
 voting was unanimous with the exception of one vote; Fuseli voted
 for Mary Moser (Samuel Redgrave op.cit. p.464).

(36) These Members were not elected, nor did the honour entail any rights
 or responsibilities. Presumably they paid for such status.

(37) "Athenaeum" May 11, 1833, no.289, p.298.

(38) "Art Union", 1839, vol.1, p.86.

(39) "Art Union", 1842, p.58

(40) "Athenaeum" June 17, 1843, no.816, p.571

(41) "Art Union" 1846, p.176.

(42) "Art Journal" 1859, p.166

(43) ibid. 1873, p.6.

(44) "Blackwoods Magazine" Aug. 1866, p.191

(45) "Art Journal" 1870, p.169.

(46) ibid. 1871, p.100

(47) E.C. Clayton op.cit. vol.1, p.388

(48) William Sandby: "The History of the Royal Academy of Arts" London
 1862, vol.2, p.379.

(49) Annual Report from the Council of the Royal Academy to the General
 Assembly of Academicians for the year 1879, p.8.

(50) "Art Journal" 1874, p.93.

(51) This artist's work is considered in detail in chapter 5

(52) Wilfred Meynell: "The Life and work of Lady Butler"; a special
 edition of the "Art Annual" 1898, p.11

(53) George Dunlop Leslie R.A.: "The Inner Life of the Royal Academy"
 London 1914, pp.222-3

(54) "The Instrument of Foundation of the Royal Academy" of 1768 is re-
 produced in Sidney Hutchinson's "The History of the Royal Academy
 1768-1968" London 1968 Appendix A (Paragraph 1, p.209)

(55) Annual Report from the Council for the Royal Academy to the General
 Assembly of Academicians for the year 1879, pp.7-8

(56) Annual Report from the Council of the Royal Academy to the General
 Assembly of Academicians for the year 1880, pp.5, 20

(57) Catalogue of an exhibition at David Messum, London, May 1-22, 1976:
 "The Life and Work of Lucy Kemp-Welch", p.19.

(58) "British Architect" Jan.11, 1884, vol.21, p.14.

(59) Susan Isabel Dacre was the first female Member of Council and in 1895
 Miss M.F. Monkhouse and Miss E. Magnus were elected.

(60) Mrs. Christina Robertson was made an Honorary Member in 1829 and
 Mrs. Fanny McIan of the Female School of Art was similarly elected
 in 1854. Miss Phyllis Bone, a sculptor, was the first female
 Academician in 1944. Miss Anne Redpath was the second in 1952.

(61) Hesketh Hubbard R.B.A., R.O.I.: "An Outline History of the Royal
 Society of British Artists" Part 1, 1823-40, London 1937, p.15.

(62) John Lewis Roget: "A History of the Old Water-colour Society"
 London 1891, vol.1, p.209.

(63) "Microcosm of London" vol.2, p.33.

(64) John Lewis Roget op.cit. vol.1, p.425.

(65) ibid. p.554.

(66) "Spectator" Feb. 18, 1837, no.451, p.164.

(67) "Athenaeum" May 11, 1850 no.1176, p.510

(68) "Art Journal" 1878, p.55

(69) John Lewis Roget op.cit. vol.2, p.430

(70) Catalogue of the Society of Painters in Water-colours' exhibition
 1904, p.8.

(71) ibid.

(72) John Lewis Roget op.cit. vol.1, p.229.

(73) "Athenaeum" May 1, 1852, no.1279, p.495.

(74) In 1883 there were 10 female Members of the Dudley Gallery Oil
 Painting Society, out of a total of 97 . In 1888 the figures
 were 13 and 67

(75) At the Society of Portrait Painters, however, they were poorly repre-
 sented. At the time of the Society's first exhibition in 1891,
 there were 4 female Members - Mrs. Louise Jopling, Mrs. Anna Lea
 Merritt, Mrs. Annie Louisa Swynnerton and Mrs. Mary Waller - and 24
 male Members. Mrs. Merritt's name was withdrawn in 1894, and Mrs.
 Swynnerton's in 1900.

(76) "Athenaeum" Oct. 30, 1847, no. 1044, p.1128.

(77) See page 10

(78) Catherine Duchemin (April 1663); Geneviève and Madeleine de
 Bollonge (Dec. 1669); Sophie Chéron (June 1672); Mlle. Anne-Marie
 Strésor (July 1676); la veuve Godequin (Nov. 1680); Catherine
 Perrot (Jan.1682); Rosalba Carriera (Oct. 1720); Marguérite
 Havermann (Jan. 1722); Mme. Vien (July 1757); Anne Dorothée
 Lisiewska/Therbousch (Feb. 1767); Anne Vallayer-Coster (July 1770);
 Mme Giroust(Sept.1770);Mme Vigee Lebrun and A.Labille-Guiard(1783)

(79) Anatole de Montaiglon: "Procès-Verbaux de l'Académie Royale de
 Peinture et de Sculpture 1648-1793" Paris 1889, vol.8, p.53.

(80) "Revue Universelle des Arts" 1855, vol.2, p.356.

(81) ibid.

(82) Anatole de Montaiglon op.cit. vol.9. pp.155-7.

(83) "Mémoires et Journal de J-G. Wille" ed. G.Duplessis Paris 1857,
 vol.2, p.268. His description runs as follows: "C'est alors que
 Mme. Guyard, assise à côté de moi, fit un discours très-bien motivé
 sur l'admission des femmes artistes à l'Académie, et prouva que le
 nombre indéterminé devrait être le seul admissible (sous l'ancien
 régime le nombre de quatre femmes artistes seulement pouvoit être
 admis). La motion de Mme. Guyard fut décrété par la pluralité au
 scrutin. Autre motion de Madame Guyard (soutenue par M. Vincent)
 c'étoit que, comme aucune femme, quelque talent qu'elle pût avoir,
 ne pouvoit cependant jamais parvenir à être professeur dans les
 écoles, ni avoir de gouvernement quelconque dans l'Académie, il
 seroit cependant juste que telle ou telle, par de bonnes et valables
 raisons, fût récompensée par une distinction académique et honori-
 fique seulement, et qu'il n'y en avoit d'autres que celle d'être
 admise parmi et au nombre des conseillers. Cet article, malgré
 l'opposition de M. Lebarbier, fut approuvé et passa au scrutin, tout
 aussi bien que le premier".

(84) Jules David: "Le Peintre Louis David. Souvenirs et documents
 inédits" Paris 1880, p.102 (quoted)

(85) Henry Lapauze: "Procès-Verbaux de la Commune Générale des Arts de
 Peinture, Sculpture, Architecture et Gravure. De la Société Popu-
 laire et Républicaine des Arts 1793-5" Paris 1903 pp xlviii-xlix

(86) ibid. p. L and Part 3, pp.183-4

(87) "L'Artiste" 1853, vol.10, p.31

(88) "Englishwoman's Review" April 1872, no.10, pp.138-9.

(89) "Journal des Femmes Artistes" Jan.1, 1891, p.3.

(90) ibid. April 15, 1891, no.10,p.1.

(91) ibid. June 1891, no.13, p.1.

(92) "Titres de Mme. Léon Bertaux, statuaire, pour se présenter aux
 suffrages de Messieurs de l'Académie des Beaux-Arts" Short leaflet
 of 6 pages in the Bibliothèque Nationale, pp.5,6.

(93) "Fémina" July 1st, 1902, no.35, p.212.

(94) ibid. Sept.1, 1901, no.39, p.276.

(95) ibid. Oct. 15, 1902, no.42, pp.316-7

(96) Mary Cassatt (1904), Madeleine Lemaire (1906), Yvonne Serruys (1906),
 Louise Abbéma (1908) and Hélène Dufau (1909)

(97) Catalouge of the exhibition held by the Société Nationale des Beaux-
 Arts in 1864, p.8.

(98) ibid. pp.9-10.

(99) "Courrier Artistique" (organ of the Society) March 15, 1862, no.19,
 p.74 and April 1, 1862, no.20, p.77.

(100) ibid. May 22, 1864, no.49, p.193

(101) This information is given in the preliminary pages of the exhibition
 catalogues for the relevant years.

(102) Berthe Morisot was absent only one year - in 1879; Jacques-François
 exhibited in 1876 and 1877; Marie Bracquemond in 1879, 1880 and
 1886; Mary Cassatt in 1879, 1880, 1881 and 1886.

(103) "Correspondance de Berthe Morisot avec sa famille et ses amis"
 Ed. Denis Rouart, 1950, p.128.

(104) "Salon de la Rose-Croix. Règle et Monitoire" Paris 1891.

(105) "Fémina" 1901, no.1, pp.110-11

(106) Details given in the catalogue of the exhibition in that year.

(107) ibid.

(108) Lady Eastlake: "Mrs. Grote. A Sketch" London 1880, p.98 and see
 also Mrs Grote: "The Personal Life of George Grote" London 1873,
 pp.241-2 and "The Lewin Letters. A Selection from the Correspondence
 and Diaries of an English Family 1756-1885" London 1909, vol.2,
 pp. 227, 231, 233, 240, 253 for evidence of Mrs. Grote's involvement

(109) "English Woman's Journal" May 1, 1858, vol. 1, no.3, p.205.

(110) See for example the "Spectator" April 7, 1838, no.510, p.331;
 "Art Journal" 1866, p.168; "Spectator" May 16, 1840, no.620, p.476.

(111) Mrs Grote: "The Personal Life of George Grote" London 1873, p.150.

(112) "English Woman's Journal" March 1, 1859, no.13, p.53.

(113) "Art Journal" 1857, p.215.

(114) ibid. 1857, p.163

(115) ibid. 1857, p.384

(116) ibid. 1858, p.254

(117) ibid. 1859, p.193

(118) The Members were:- Mrs Bartholomew, Mrs J.W. Brown, Miss A.
 Burgess, Miss Burchell, Mrs A.J. Buss, Miss H. Harrison, Miss
 Irvine, Miss C. James, Miss Kettle, Miss E. Mills, Mrs H. Moseley,
 Mrs Elizabeth Murray, Mrs D. Murray, Mrs Musgrave, Florence Peel,
 Miss Stoddart, Miss M. Stone, Mrs Swift, Miss K. Swift, Miss G.
 Swift, Miss Tekusch, Mrs Thornycroft, Miss E. Walter, Mrs Withers.
 The Honorary Members were:- Mrs Blackburn, Lady Belcher, Mrs
 Holford, Mrs Blaine, Mrs Higford Burr, Mrs Sturch, Miss Blake,
 Miss Fraser.

(119) "Art Journal" 1862, p.242.

(120) ibid.

(121) ibid. 1863, p.95

(122) ibid.

(123) ibid. 1865, p.30. Mrs Grote worte of her withdrawal on August 24,
 1864. See "The Lewin Letters" London 1909, vol.2, p.253.

(124) E.C. Clayton: op.cit. vol.2, p.301.

(125) "Art Journal" 1866, p.383

(126) ibid. 1868, p.78

(127) ibid. 1878, p.121

(128) "Year's Art" 1880, p.48

(129) ibid.

(130) "Year's Art" 1905, p.120

(131) "English Woman's Journal" May 1, 1858, vol.1, no.3, p.205

(132) ibid.

(133) "Art Journal" 1858, p.143

(134) "English Woman's Journal" May 1, 1858, vol.1, no.3. p.206

(135) "Art Journal" 1858, p.143

(136) ibid. p.254

(137) ibid. 1859, p.83

(138) "English Woman's Journal" March 1, 1859, vol.3, no.13, pp.53-5

(139) "Art Journal" 1850, p.85

(140) "English Woman's Journal" March 1861, vol.7, no.37, pp.56-7

(141) "Art Journal" 1862, p.72

(142) ibid. 1863, p.95

(143) "Art Student" 1864, vol.2, pp.53-4

(144) "Art Journal" 1864, p.97.

(145) "English Woman's Journal" April 1864, vol.13, no.74, pp.127-8

(146) "Art Journal" 1865, p.68. For other examples see "Art Journal" 1867, p.88; ibid. 1868, p.46; ibid. 1869, pp.82-3; ibid. 1870 p.89; ibid. 1871, p.62.

(147) "Art Journal" 1878, p.121

(148) ibid. 1900, p.93 by Frank Rinder

(149) Elizabeth Thompson (Lady Butler) exhibited three works at the Society of Female Artists in 1867, the first year she was represented at exhibitions

(150) "Art Journal" 1868, p.46

(151) "British Architect" Oct.3, 1879, vol.12, p.135.

(152) "Manchester Guardian" Feb.21, 1933

(153) "British Architect", Jan 27, 1882, vol.17, p.39.

(154) ibid.

(155) ibid. 1883, vol.20, p.252

(156) Information contained in a letter in the Manchester Public Libraries, from A.H. Forrester, secretary of the Attic Club, to C. Nowell, Esq.

(157) "Art Journal" 1900, p.282

(158) In the possession of the Women's International Art Club

(159) "Art Journal" 1900, p.283

(160) See the catalogue for this exhibition.

(161) "Art Journal" 1900, p.283

(162) With the opening of an art school in 1863 and the resignation of Mrs Grote and the original lay founder members in 1865, the aims of the Society altered.

(163) The Glasgow Society of Lady Artists' Club was founded in 1882 by 8 women: Miss Greenless, Miss Patrick, Mrs Robertson, Miss Nisbet, Mrs Agnew, Mme. Rohll, Mrs Provan and Miss Katherine Henderson. They were largely pupils of the Glasgow School of Art of which Robert Greenless was Headmaster and he strongly encouraged their action as he did not wish their art school training to be dissipated in painting "for bazaars, on terra-cotta plaques, tambourines, etc." They originally met at Mr Greenless' studio and it was there that they held their first exhibition. In May of that year members increased to 38. The President was Miss Greenless, the Hon. Sec. Miss C. Henderson and the Hon. Treasurer Mme. Rohll. In 1886, Mrs Joseph Agnew became President. Exhibitions were held yearly. The Society was created for the benefit of the woman art student and lectures on various artistic topics were held at the monthly meetings. This information has been taken from the "History of the Glasgow Society of Lady Artists' Club" Glasgow 1950.

(164) Catalogues of the first and fourth exhibitions are in the Art
 Library of the Victoria and Albert Museum.

(165) Catlogues of exhibitions held between 1881 and 1883 are in the Art
 Library of the Victoria and Albert Museum.

(166) It was in 1879 that the Royal Academy admitted paintings on china
 to exhibitions.

(167) The copy referred to is in the Art Library of the Victoria and
 Albert Museum

(168) See page 53

(169) Edouard Lepage op.cit. p.62.

(170) ibid. p.63

(171) "Henri IV" Aug. 7, 1881, p.1

(172) "Gazette des Femmes" Jan. 25, 1882, no.2, p.1

(173) ibid.

(174) See for example the "Chronique des Arts" Jan. 28, 1882, no.4, p.27;
 "L'Art" 1882, vol.2, p.97; "Gazette des Femmes" Feb.10, 1882,
 no.3, pp.17-18.

(175) "Chronique des Arts" Feb. 3, 1883, no.5, p.34.

(176) "Journal des Femmes Artistes" Dec. 1, 1890, no.1, p.3.

(177) "Gazette des Femmes", March 10, 1884, no.5, pp.35-7

(178) "Chronique des Arts" Feb. 13, 1886, p.50

(179) ibid. March 8, 1890, no.10, p.75.

(180) "Fermée pour l'attaque, ouverte pour la défense, cette sorte de
 tribune nous aidera à développer de plus en plus l'esprit de
 solidarité, base de notre association" ("Journal des Femmes Artistes"
 Dec. 1, 1890, no.1, pp.1-2)

(181) ibid. Jan. 1, 1891, no.3, p.1.

(182) ibid. p.3.

(183) ibid. Feb. 1, 1891, no.5, p.2

(184) ibid. Feb. 15, 1891, no.6, p.3.

(185) The Société des Femmes Artistes will be considered later in the
 chapter

(186) These are listed in the "Journal des Femmes Artistes": Dec.15, 1890,
 no. 2, p.4; Jan.15, 1891, no.4, p.4; Feb.1, 1891, no.5, p.4;
 Feb. 15, 1891, no.6, p.4; March 1, 1891, no.7, pp.3-4.

(187) Review reproduced in the "Journal des Femmes Artistes" March 1, 1891,
 no.7, p.2.

(188) ibid. April 1, 1891, no.9, p.3.

(189) ibid. June 1, 1891, no. 13, pp.3-4

(190) "Chronique des Arts" April 2, 1892, no. 14, p.106. For the award-
 ing of the decree see the catalogue of the exhibition held that year

(191) "Chronique des Arts" May 20, 1893, no.20, p.156.

(192) "Journal des Femmes Artistes" Nov. 1894, no.50, p.1.

(193) ibid. p.2

(194) ibid. Dec. 1894, no.51, p.1

(195) ibid. April 1895, no.55

(196) "Chronique des Arts" Feb. 6, 1897, no.6, pp.51-2. Mme. Bertaux,
 Virginie Demont-Breton, Elodie La Villette and Elise Voruz all
 sent work to the new group in 1897; the latter two simultaneously
 sent contributions to the Union. The reason seems to have been
 support rather than changed allegiance.

(197) "Chronique des Arts" March 12, 1898, no.11, p.90

(198) ibid. Feb. 11, 1899, no.6, pp.54-5

(199) "Kunstchronik" March 21, 1901, no.19, pp.297-8

(200) "Chronique des Arts" March 7, 1908, no.10, p.83

(201) ibid. Feb. 11, 1899, no.6, pp.54-5

(202) "Gazette des Femmes" March 25, 1882, no.6, p.42.

(203) "L'Art" 1882, vol.2, p.97.

(204) "Chronique des Arts" April 12, 1884, no.15, p.119

(205) ibid. Jan 23, 1892, no.4, p.27.

(206) "Gazette des Beaux-Arts" Nov.1, 1892, p.380

(207) "Chronique des Arts" Jan. 19, 1895, no. 3, p.18. Previous refer-
 ences to the Society may be found in "Chronique des Arts" Dec.30,
 1893, no.41, p.322 and ibid. Jan. 6, 1894, no.1, p.3

(208) ibid. Jan. 15, 1898, no.3, p.18.

(209) ibid. Jan. 12, 1901, no.2, p.11. See also "Chronique des Arts"
 Jan.11, 1902, no.2, p.12, and ibid. Jan. 21, 1905, no.3, p.20 and
 ibid. Jan. 12, 1907, no.2, pp.10-11.

(210) ibid. Jan 11, 1902, no.2, p.12.

(211) There are references to this Society in the "Chronique des Arts"
 Dec. 14, 1895, no.39, p.378; Dec. 18, 1897, no.40, p.388; Dec. 3,
 1898, no.38, p.351; Feb. 28, 1903, no.9, p.72; March 7,
 1903, no.10, p.75; Feb. 23, 1907, no.8, pp.59, 64; March 5, 1910,
 no.10, p.75.

(212) ibid. March 7, 1903, no.10, p.75.

(213) See note 211.

(214) Catalogue in the Bibliothèque d'Art et d'Archéologie, Paris.
 I have found no other reference to this Society.

(215) "Chronique des Arts" Jan. 26, 1895, no.4, p.26; ibid. April 27,
 1895, no.17, p.161.

(216) ibid. Dec. 31, 1898, no.42, p.383

(217) ibid. May 20, 1899, no. 20, p.184 and ibid. March 31, 1900, no.13,
 p.127 and ibid. May 25, 1901, no. 21, p.168.

(218) ibid. Dec. 8, 1900, no.38, p.376, and ibid. Nov. 20, 1901, no.37,
 p.304.

(219) ibid. June 21, 1902, no.24, p.196, and "Fémina" July 1, 1902,
 vol.2, p.VII

(220) "Fémina" Dec. 1, 1902, vol.2, no.45, p.362.

(221) "Kunstchronik" Jan. 30, 1903, no.14, p.231.

(222) "Fémina" Feb. 15, 1903, no.50, p.XV

(223) "Chronique des Arts" March 4, 1905, no.9, p.72

(224) ibid. May 19, 1906, no.20, p.164.

(225) ibid. Feb. 23, 1907, no.8, p.59

(226) ibid. May 9, 1908, no.19, p.188 and ibid. Jan. 11, 1908, no.2, p.16
 respectively. If Paul Jamot had not referred to the 1907 exhibi-
 tion as the first, it would be tempting to believe that the Inter-
 national Art Union's exhibitions were the Paris exhibitions organ-
 ized by the Women's International Art Club. See page 96

(227) ibid. May 15, 1909, no.20, p.159

(228) ibid. April 30, 1910, no.18, p.141

(229) ibid. March 25, 1911, no.12, p.91

(230) ibid. Nov. 30, 1912, no.35, p.280

(231) ibid. May 10, 1913, no.19, p.147

(232) ibid. Jan. 25, 1908, no.4, p.28

(233) ibid. Jan. 23, 1909, no.4, p.26

(234) ibid. Feb. 12, 1910, no. 7, p.50 and ibid. Feb. 4, 1911, no.5, p.35
 and ibid. Jan. 13, 1912, no.2, p.10

(235) ibid. Feb. 22, 1913, no.8, p.58

(236) ibid. May 18, 1907, no.20, p.184 and May 25, no.21, pp.187-8

(237) ibid. Feb.23, 1907, no.8, pp.59, 64

(238) There were a few isolated exhibitions of the work of two or more
 women artists which it is needless to describe in detail. See
 Appendix VII

(239) "Chronique des Arts" Dec. 5, 1908, no.38, p.392

(240) ibid. Feb. 22, 1908, no.8, p.72 and Feb. 15, no.7, p.60.

(241) ibid. April 25, 1908, no.17, p.164.

(242) ibid. March 6, 1909, no.10, p.80 ; ibid. Feb.19, 1910, no.8, p.64;
Dec. 2, 1911, no.35, p.280; Nov. 30, 1912, no.35, p.284; May 11,
1912, no.19, p.152; March 23, 1912, no.12, p.96.

(243) ibid. Dec. 11, 1909, no.37, pp.304 and 295

(244) ibid. May 15, 1909, no.20, p.164.

(245) ibid. March 13, 1909, no.11, p.88

(246) ibid. March 5, 1910, no.10, p. 80; June 18, 1910, no.24, pp.188,192

(247) ibid. Feb. 25, 1911, no.8, p.59

(248) For details see "Chronique des Arts" Feb. 11, 1911, no.6, p.48;
ibid. Jan.20, 1912, no.3, p.24; ibid. Feb.15, 1913, no.7, p.56,
ibid. May 23, 1914, no.21, p.168.

(249) ibid. April 16, 1910, no.16, p.128.

(250) ibid. Feb.4, 1911, no.5, p.35. For other references to this group
see "Chronique des Arts" Jan.21, 1911, no.3, p.24; ibid. April 26,
1913, no.17, p.136; ibid. Jan.3, 1914, no.1, p.8.

(251) ibid. March 25, 1911, no.12, p.96.

(252) ibid. Dec.9, 1911, no.36, p.288; ibid. Jan 6,1912, no.1, pp.2,8

(253) ibid. Nov. 2, 1912, no.33, p.268.

(254) 1. Exhibition of "Les travaux de la femme, ses ornements et ceux
de son foyer" organized by the Union Centrale des Arts décoratifs
at the Pavillon de Marsan ("Chronique des Arts" Jan.11, 1913 no.2,
p.10).
2. "Exposition de tableaux et d'objets d'art décoratif" at the
Galerie Boutet de Monvel, 18 rue Tronchet (ibid. Feb.15, 1913,
no.7, p.56)
3. "Exposition d'art appliqué à la femme" at the Galerie Manzi
Joyant (ibid. Oct. 25, 1913, no.33, p.264)

(255) Four examples will suffice: Madeleine Carpentier exhibited at the
Union in 1894, 1902, 1907; Société des Femmes Artistes in 1898,
1902, 1903; Les XII in 1899; Quelques in 1908
Mlle. Florence Esté exhibited at the Société des Femmes Artistes from
1898 to 1905; the International Art Union in 1912 and 1913; Quelques
in 1908, 1909, 1912 and 1913; the Association des Femmes Artistes
Américaines in 1903. Nanny Adam exhibited at the Union in 1901,
1905, and 1907; Société des Femmes Artistes in 1901 and 1902; Les
XII from 1899 to 1901
Mme. Galtier Boissière exhibited at the Société des Femmes Artistes
in 1906 and 1907; International Art Union from 1911 to 1913;
Quelques from 1907 to 1913

(256) "Chronique des Arts" May 31, 1873, no.22, p.213

(257) See page 65

NOTES - CHAPTER THREE

(1) Attention should be drawn to various points at the start of this
 chapter.
 (a) For details of works mentioned briefly in the text, the reader
 should consult the relevant alphabetical note, previously
 referred to. Normally this is the immediately preceding alpha-
 betical note; occasionally, however, it is not. In the latter
 case, if the work is on an historical theme, for instance, refer-
 ence must be made to the alphabetical note in which historical
 subjects of that decade are listed.
 (b) In this context classical subjects include works with mytholo-
 gical, biblical, historical and allegorical subject-matter.
 (c) When a work of art depicts a recent, literary account of classi-
 cal figures, the work has usually been included both in the
 present Section and in Section B. When the literary element does
 not extend beyond a brief poetical quotation appended to the
 title, however, the work has been given in the present section
 only.
 (d) Post-Biblical saints have been included in the historical category.

(2) PP The Taunton Report (Schools Inquiry Commission) 1867-8 Vol.IX
 General Reports by Assistant Commissioners, Northern Counties. Chapter
 VIII, p.791. Mr Bryce's report that "among people in easy circum-
 stances a much greater number of girls than of boys are educated at
 home by resident or visiting governesses" was typical of the findings
 of many other commissioners.

(3) Florence Nightingale, for example, was taught Latin, Greek, Mathematics,
 History and Italian at home by her father. Emily Shore, in her
 Journal (1831-1839) tells that her father taught her Greek and
 Grecian History, Arithmetic, English and Foreign History as well as
 introducing her to a wide range of English Literature. Elizabeth
 Barret Browning's Aurora Leigh (1857) learnt Greek and Latin, Mathe-
 matics, French and German as well as other subjects.
 For a fuller account of women of exceptional upbringing see Alicia
 Percival's "The English Miss To-day and Yesterday (ideals, methods,
 personalities in the education and upbringing of girls during the last
 hundred years)" (London 1939) and particularly chapter 1, "Eminent
 Women" and chapter 2, "Home education and the young lady".

(4) PP The Taunton Report (Schools Inquiry Commission) 1867-8 Vol.XXVIII,
 chapter VI pp.546-7.

(5) ibid. vol. IX, chapter VIII, p.792. Again a typical account.

(6) Charlotte Mary Yonge: "Womankind" London 1877, p.39.

(7) See Alicia C. Percival op.cit. chapters 2 "Home Education and the
 Young Lady", 3 "The Ladies' Seminary" and 4 "The Governess". And see
 also Amy Cruse: "The Englishman and his Books in the early nineteenth
 century" (London 1930) chapter 5 "The Schoolroom".
 These text books were frequently cited by the Schools Inquiry Commis-
 sion, op.cit. See for instance the reports of Mr J.G. Fitch on the
 West Riding of Yorkshire and City and Ainsty of York, Mr Hammond on
 Norfolk and Northumberland, Mr Bryce on Lancashire and Mr H.A.
 Giffard on Surrey (Extra-Metropolitan).

(8) PP op.cit. Vol. IX, Chapter VIII, p.812.

(9) ibid. p.810.

(10) There was nothing to prevent a girl researching any subject she chose to illustrate but acquisition of the artistic technique for rendering it was not so simple. Broadly speaking nude studies were taboo for women during the greater part of the century.

(11) "Connoisseur" 1931, vol.88, p.380. Quoted in an article by Lady Victoria Manners called "Catherine Read: The 'English Rosalba'".

(12) Anthony Pasquin: "Memoirs of the Royal Academicians, being an attempt to improve the National Taste", London 1796, p.115.

(13) See Chapter 1,

(14) E.C. Clayton op.cit. vol.1, p.384.

(15) See D and E

(16) "Ackermann's Repository" 1813, Vol. 9, p.218.

(17) ibid. 1815, Vol. 13, p.173

(18) ibid. 1815, Vol. 13, p.334

(19) Quoted in Frances Gerard's "Angelica Kauffmann" London 1893 p 76

(20) The definition is taken from the Oxford English Dictionary.

(21) "Ackermann's Repository" 1821 No.LXVI, pp.367-8

(22) The following quotation accompanied the title:
 "The hand that mingled in the meal
 At midnight drew the felon steel,
 And gave the host's kind breast to feel
 Meed for his hospitality.
 Then woman's shriek was heard in vain
 Not infancy's unpitied plain,
 More than the warrior's groan could gain
 Respite from ruthless butchery!"
 (Sir Walter Scott on the Massacre of Glencoe)

(23) "Spectator" April 7, 1838, no.510, p.331

(24) With the quotation:-
 " - Ella, il fatal suo giorno
 Tosto che vedea sorgere, ...
 Con bel decoro si fregiava. All'Ore
 Innanzi poschia standosi, esclamava:
 'O Dea d'Averno e mia, poich'ivi scendo,
 L'ultima volta ch'io qui mi ti prostro,
 Supplicherotti, O Dea, che protettrice
 Sovrana ti degli orfani miei figli,
 Licti gli renda, etc." (Vide L'Alceste di Euripide, tradotta da Alfieri Atto 1, Scene 4)

(25) According to a review in the "Art Union" of 1843 (p.67) the dying Cateran was represented in the arms of his sorrowing wife. The battle is over but he is still being pursued.

(26) "Soldiers' wives waiting the Result of a Battle" was described as
follows in the "Athenaeum" (March 31, 1849, p.335): "The group
of soldiers wives here depicted, placed in the rear of a contend-
ing army, are listening with eager and anxious looks to the boom-
ing of artillery, every peal of which may carry destruction to their
hopes and affections. While sufficient variety and contrast have
been secured in position of limb and direction of body, there is in
the whole a due amount of uniformity preserved to give the look of
simultaneousness and community of feeling. The intense anxiety in
the various heads takes nothing from their several characters of
beauty, and passion has in no one of them been allowed to degenerate
into caricature or grimace".

(27) "Spectator" April 24, 1841, no.669, p.404. In Mrs Felicia Hemans'
"Records of Woman" (Edinburgh 1837) Properzia Rossi is described as
"a celebrated female sculptor of Bolgna, possessed also of talents
for poetry and music, (who) died in consequence of an unrequited
attachment. A painting, by Ducis, represents her shewing her last
work, a basso-relievo of Ariadne, to a Roman knight, the object of
her affection, who regards it with indifference" (page 43).

(28) "Athenaeum" April 22, 1848 no.1069, p.418.

(29) "Art Union" 1846, p.78

(30) "Athenaeum" May 15, 1847, no.1020, p.527.

(31) "Art Union" 1842, p.76.

(32) ibid. 1843, p.67.

(33) "Spectator" Feb. 15, 1845, no.868, p.163

(34) A dramatic poem published in 1841.

(35) "Art Union" 1848, p.141

(36) ibid.

(37) "Athenaeum" Aprill 22, 1848, no.1069, p.418.

(38) The following quotation accompanied the title of the latter work:
"His parting with those humble friends who were never absent from
his thoughts, however far away, and however deeply involved in
his own private troubles, was extremely pathetic and interesting.
It was like the parting of a father from his children. He visited
every family separately, made some kind present to each, and gave
to all his last counsel and advice" - Hepworth Dixon's "Life of
John Howard". The original sketch for this work was exhibited at
the Society of Female Artists in 1860 (no. 274).

(39) With the following quotation: "On a Sunday evening, the mother of
Haydn would sometimes sing little simple airs, while the father,
taking his violin would accompany her voice; on these occasions the
little Joseph, seizing a piece of wood, in lieu of a violin, and
a twig for a bow, would imitate the action of his father, beating
time with his little foot, with a precision and accuracy really
wonderful at his age. In after life Haydn often recalled these
peaceful evenings and spoke of them with tears in his eyes" - vide
Life of Haydn.

(40) Ambrosini Jerome's picture of Rubens was described as follows in the title: "He painted a picture in which all the blessings of peace are represented in glowing colours, and wherein Minerva is exhibited, driving away Mars, with the concomitant miseries of war. This picture he presented to the king, and took an opportunity, in a delicate manner, of alluding to the then state of Europe, and the benefits which might result from an arrangement of the differences between England and Spain. The king, who had formed an esteem for Rubens, listened with attention to his suggestions, and expressed himself disposed to accede to a compromise. Rubens, who had hitherto abstained from shewing the true cause of his visit to England, now produced his credentials as envoy, and a treaty was shortly thereafter concluded" - Buchanan's Memoirs of Painting, vol.1, p.175.

(41) With the quotation: "Walking in my vicarial garden one Sunday evening, beneath the window of the house where Collins lay a-dying, I heard a female, the servant, I suppose, reading the Bible in his chamber; while she was reading, or rather attempting to read, he was not only silent but attentive likewise, and correcting her mistakes which indeed were very numerous".

(42) Praised in the "Athenaeum" May 1, 1852, no.1279, p.495 in the following terms: "There is no exhibition-room in which female talent and genius figure to such good effect as this. One of the screens alone shows them in, possibly, their highest contemporary manifestation. This praise is due to the 'Hannah' (298) and 'Miriam' (312) of Miss Fanny Corbaux; - a pair of more graceful and thoughtful presentments of the 'Women of Scripture' than probably, every before proceeded from female hand - the Elizabeth Sirani's and Agnes Dolce's and Angelica Kauffman's not forgotten. To the former, it is true, the smallness of the head might be objected; but this permitted to pass, as a piece of expression, aided by great judgement of taste, in what may be called its decorative accessories, - the figure demands no ordinary praise etc."

(43) "Art Journal" 1858, p.167.

(44) "The Ladies' Companion at Home and Abroad" May 25, 1850, no.23, p.352

(45) "Art Journal" 1850, p.140

(46) ibid. 1852, p.140

(47) ibid. 1863, p.106

(48) ibid. 1866, pp. 166-7

(49) ibid. 1867, p.138

(50) ibid. 1869, p.169

(51) ibid. 1861, p.169

(52) ibid. 1860, p.168

(53) See the criticism of Miss Harriet Jackson's "Mars subdued by Peace" (BI 1815, no.140) quoted on page 121

(54) "Art Journal" 1861 p.171

(55) See pp.318-28 for a fuller discussion of this artist's work

(56) "Art Journal" 1874 p. 201.

(57) ibid. 1876 p. 319

(58) ibid. 1875 p.163

(59) "L'Art" 1875 vol.3 p.252. For a more detailed discussion of this
 aspect of her work see p. 327

(60) Mrs. E.M. Ward : "Memories of Ninety Years" London 1939 p. 269

(61) See pp 322, 327-8

(62) For a discussion of which see pp. 318-28

(63) Clara Erskine Clement op.cit. p. 241

(64) "Times" May 5, 1894 p. 16

(65) "Art Journal" 1895 p.177

(66) See M1

(67) Illustrations of "News from Trafalgar" and "Arrested" by Jessie
 Macgregor are in the Witt Library. One other work is relevant.
 In 1885 Mrs. Louise Jopling exhibited "List of the Killed and
 Wounded, 1885" (SLA p 376)

(68) The following are examples :-
 Mary Hay : "Female Biography" 1803
 Mrs. Felicia Hemans' "Records of Woman" published in"Blackwoods"
 in 1828 , consisting of a series of poems about women including
 Arabella Stuart, Properzia Rossi and Joan of Arc
 Mrs. Anna Brownell Jameson's "Lives of Celebrated Female
 Sovereigns" of 1831
 Mrs. Elizabeth Sandford's "Lives of English female worthies" of
 1833
 Lady Morgan's "Woman and her Master" of 1840
 Miss Agnes Strickland's "Lives of the Queens" in 12 volumes pub-
 lished between 1840 and 1848
 Thomas Carlyle's "On Heroes, Hero-Worship and the Heroic in
 History" of 1841
 An anonymous work called "Tales of Female Heroism" of 1846
 Charles Kingsley's "The Saint's Tragedy" (about St. Elizabeth
 of Hungary) of 1848
 Miss Agnes Strickland's "Lives of the Queen's of Scotland and
 English Princesses connected with the regal succession of Great
 Britain" published between 1850 and 1859
 Charles Kingsley's "Hypatia" of 1853, "The Heroes" of 1856
 and "Andromeda" of 1859
 Miss Agnes Strickland's "Lives of the bachelor Kings of England"
 of 1861
 Charlotte Yonge's "Biographies of Good Women" of 1865 and
 "A Book of Golden Deeds" also of 1865

Miss Agnes Strickland's "Lives of the Seven Bishops committed to the Tower 1688" of 1866, "Lives of the Tudor Princesses including Lady Jane Grey and her sisters" (Mary Tudor and Arabella Stuart) of 1868 and "Lives of the last four princesses of the House of Stuart" (Mary Princess Royal of Great Britain, Princess Elizabeth, Princess Henrietta Anne and Princess Louisa) of 1872
Charlotte Yonge's "A Book of Worthies" (2nd edition 1872) and "The Seven Heroines of Christendom" of 1878

(69) Joshua Reynolds: "Fifteen Discourses Delivered in the Royal Academy" (London 1906, p.41).

(70) Walter Pater: "Plato and Platonism" N.Y.1901 pp 156-7(1st pub.1893)

(71) Illustrated books will not be examined in any depth here. Passing reference will be made to some of the most important examples in the alphabetical notes.

(72) "Spectator" April 23, 1831, no.147, p.405.

(73) ibid. May 2, 1835, no.357, p.425.

(74) William Macready: "Reminiscences" London 1875, vol.2, p.205

(75) "The Slave's Dream" was described in the "Art Union" 1847, p.195. See vol.3 p.77 for a similar instance of the artist changing the sex of the subject of a poem.

(76) "Athenaeum" April 30, 1842, no. 757, p.382

(77) ibid. April 22, 1848, no.1069, p.417.

(78) "The Momentous Question" was the short title given to this work following its success. For description and criticism of this work see page 140. Admittedly this work is a borderline case between our two types of literary work (that which illustrates literature and that in which literature is used as a gloss). It has been included in both of these categories chiefly on account of the critical reception given to the work: "The motto is from Crabbe's 'Tales of the Hall', but the scene might pass for a prison interior where a girl visits a young man whose life is in jeopardy" (see page 140). The work became extremely popular and soon transcended its source.
The second of these two pictures was Jessie Macleod's "The Prison Door" of 1848 for which see Z1.

(79) "Art Union" 1841, p.76

(80) ibid. 1842, p.162.

(81) See V1. under George Crabbe, Z1. and note 78.

(82) "Athenaeum" April 23, 1842, no.756, p.363

(83) "Athenaeum" May 1, 1852, no.1279, p.495

(84) "Athenaeum" March 18, 1854, no. 1377, p.346.

(85) See E2. under "death" (b)

(86) "Art Journal" 1855, p.106

(87) "Lady Clare", "Lady Macbeth" and "Clerk Saunders" are in the
 Fitzwilliam Museum, Cambridge; "The Lady of Shalott" is in the
 Maas Gallery London; "St. Agnes Eve" is at Wightwick Manor,
 Staffordshire; "Sir Patrick Spens" is in the Tate Gallery.

(88) For an account of her life and work see W.M. Rossetti's article
 on "Dante Gabriel Rossetti and Elizabeth Siddal" in "Burlington
 Magazine" March-May 1903, vol.1, pp.273-95.

(89) "Art Journal" 1857, p.168.

(90) "English Woman's Journal" Sept.1, 1861, vol.VIII no.43, p.143.

(91) Details of these last four works are given in F2e.

(92) See F2a, F2d and above in the text for the reviews.

(93) "Art Journal" 1860, p.168.

(94) "English Woman's Journal" March 1861, vol. 7, no.37, p.59.

(95) "Art Journal" 1866, p.71

(96) ibid. 1860, p.170

(97) ibid. 1864, p.152

(98) ibid. 1860, p.174

(99) ibid. 1861, p.173

(100) ibid. 1863, p.95

(101) "English Woman's Journal" April 1864, vol.13, no.74, pp.124-5

(102) PP The Taunton Report (Schools Inquiry Commission) 1867-8, vol.
 VIII, p.520.

(103) Some nineteenth century examples are "Elegant Extracts : being a
 copious selection of instructive, moral and entertaining passages,
 from the most eminent British poets" in six volumes (John Sharpe
 London 1810); "Elegant Extracts: being a copious selection of
 instructive passages, from the most eminent prose writers etc."
 (John Sharpe London 1810); "Twenty-six Choice Poetical Extracts"
 (R. Miller London 1820); "Extracts from ancient and modern
 authors, arranged so as to form a history or description of Man,
 in his natural, moral and spiritual character, embracing nearly all
 the most important subjects of the Christian religion" (London
 1828); "Extracts and Collections from various authors (Vestiges of
 truth among the heathen)" (Dorchester 1834).

(104) See page 9

(105) The work of Eliza Bridell-Fox, Margaret Gillies and the Misses
 Sharpe will be considered in detail in Chapter 5 . Miss M.
 Barret exhibited miniatures at the Royal Academy from 1797 to 1800.
 Then she exhibited pictures of birds, fish and fruit at the Old
 Water-colour Society between 1823 and 1835 (See J-L. Roget op.cit.
 Vol.1, pp.432 and 553).

(106) Among those women artists who supported themselves or their families by their profession are Charlotte Sharpe (see page 258) Mrs Mee (see E.C. Clayton op.cit. vol.1, p.391), Annie Dixon (E.C. Clayton vol.2, p.254), Fanny Corbaux (see page 281) Maria Cosway (J.J. Foster "British Miniature Painters and their Works" London 1898, p.85), Miss Biffin (E.C. Clayton op.cit. vol.1, p.396).

(107) Miss Biffin exhibited four miniatures at the Royal Academy in 1821, and according to A. Graves' "Dictionary of Artists", one more, also at the Royal Academy, in 1850. According to the "Dictionary of National Biography" and E.C. Clayton (Vol.1, pp.395-6) she was well-known, well patronized and quite prolific.

(108) All the appointments referred to above are mentioned under the relevant headings in Thieme-Becker op.cit. According to Thieme-Becker Mrs Mee was frequently commissioned by Royalty and the aristocracy. Miss Biffin was patronized "by George III, George IV, and William IV, by the Queen Dowager, by her present Majesty and the Prince Consort, and a large circle of the aristocracy and distinguished persons" (E.C. Clayton Vol.1, p.396).
Rolinda Sharples, Fanny Corbaux and Miss Beaumont were members of the Society of British Artsits; Eliza and Louisa Sharpe and Margaret Gillies were members of the Old Water-colour Society and Fanny Corbaux and Sarah Setchell were members of the New Water-colour Society. (See Tables 13,14,16)

(109) "Spectator" May 28, 1831, no.152, p.525

(110) ibid. April 23, 1831, no.147, p.405

(111) ibid. Oct. 12, 1833, no.276, p.960

(112) ibid. March 29, 1834, no.300, p.302

(113) ibid. May 6, 1837, no.462, p.427 and also May 13, no.463, p.451

(114) "Art Union" 1839, vol.1, p.67.

(115) For instance "Spectator" March 30, 1833, no.248, p.288; March 29, 1834, no.300, p.302; May 16, 1840, no.620, p.476; May 8, 1841, no.671, p.451; May 18, 1844, no.829, p.474. Also "Athenaeum", May 6, 1848, no.1071, p.464; June 9, 1849, no.1128, p.103. The work of Mrs Carpenter will be considered in greater detail in Chapter 5

(116) Of her "Portrait of the Hon. Mrs Pelham" (RA 1833, no.1) a critic wrote: "This is the best and most pleasing whole-length portrait in the Exhibition which is some praise - though we never saw so little justice done to beauty and grace in any of the annual displays of the R.A." ("Spectator" 1833, May 11, no.254, p.432). Her "Portrait of a Lady" (RA 1839, no.268) was called "one of the best portraits in the gallery" ("Art Union" 1839, p.101). In 1843 it was written of her "Full-length Portrait of Miss Herbert" (RA. no. 425) and her portrait of the "Baroness Lionel de Rothschild with her children" (RA no.426): "These are really perfect in their way, painted with breadth and power, as well as the utmost delicacy and finish. A hundred years hence, these little pictures may possibly be estimated as we now estimate a Mieris or a Metzu" ("Athenaeum" June 17, 1843, no.816, p.571).

(117) See Chapter 2 , pages 71-2

(118) See the review in the "Art Union" (1839, p.101) of Miss Fanny
 Corbaux's "Portrait of Mrs T.H. Vivian and her children" at the
 Royal Academy of 1839 and the review, also in the "Art Union"
 (1839, p.85), of Miss Margaret Gillies' "Portrait of Miss Helen
 Faucit as Julie de Mortemar" at the same exhibition.
 The work of both these artists is considered in detail in Chapter
 5

(119) This letter is reproduced in "My Leigh Hunt Library. The Holo-
 graph Letters" by Luther A. Brewer (University of Iowa Press,
 Iowa, 1938) p.232. She did paint Leigh Hunt and the work was
 exhibited at the Royal Academy in 1839 (no.947).

(120) Ambrosini Jerome's appointment is recorded in Algernon Graves'
 "British Institution" p.301; Mrs Robertson's appointment is men-
 tioned in Thieme-Becker; for that of Mrs Walker see J.J. Foster:
 "British Miniature Painters and their Works" (London 1898, p.81);
 for that of Mrs Dalton see Thieme-Becker; for commissions executed
 by Mrs Thornycroft see her obituary in the "Art Journal" 1895, p.96;
 for Annie Dixon's commissions see Thieme-Becker; there is a refer-
 ence to commissions given to Mrs Newton in Samuel Redgrave's
 "Dictionary of Artists of the English School" 1874 and to those
 bestowed on Miss Susan Durant in her obituary in the "Art Journal"
 1873, p.80.

(121) In 1853 a critic described Mrs W. Carpenter's portrait of Mrs Frewin
 and her infant son at the Royal Academy as "a most effective pro-
 duction; we think the best the lady has ever exhibited" ("Art
 Journal" 1853, p.143). In 1859 her portrait of William Carpenter,
 Esq., F.S.A. (RA. no.261) was described as "a picture that, with
 others by the same hand, will go farther than a volume of argument
 to compel the Royal Academy to acknowledge 'the rights of women',
 which they have been always disposed to ignore" ("Art Journal" 1859,
 p.166); full priase was given in her obituary in 1873 ("Art Journal"
 p.6.)
 Recognition of Sarah Setchel as a portraitist dates from 1845 when
 she exhibited a miniature of her father at the New Society of Painters
 in Water-colour (no.305). A critic wrote that the work "places her
 at the head of all lady miniature painters. Too rarely is anything
 so simple, broad, artistic, and carefully finished seen even at the
 Royal Academy. It is just that proper idealisation of truth which
 constitutes portraiture of the highest order" ("Athenaeum" April 26,
 1845, no.913, p.417). Her portrait of the Rev. J. Image at the same
 gallery in 1852 (no.161) received praise in two journals ("Athanaeum"
 May 1, 1852, no.1279, p.495 and "Art Journal" 1852, p.179). Her
 portrait of Henry Cooke (1854 NSPW, p.314) was called "pure, bright,
 and life-like in colour, and animated by life-like expression" ("Art
 Journal" 1854, p.176).
 Mrs Newton's self portrait at the Royal Academy in 1863 (no.464) and
 her "Head of Mrs Liddell" at the Royal Academy in 1865 (no.223) were
 both praised in the "Art Journal" (1863, p.110 and 1865, p.168).

(122) "Art Journal" 1853, p.143.

(123) Francis Turner Palgrave: "Essays on Art" London 1866, p.42.

(124) "Art Journal" 1857, p.176.

(125) ibid. 1869, p.204

(126) ibid. 1874, P·104
Although strictly speaking an historical work we are including this
in the portrait section because it was evaluated as a portrait, for
qualities of resemblance.

(127) "L'Art" 1877, vol.2, p.246

(128) "Director" May 23, 1807, no.18, pp.178-9

(129) "Examiner" 1810, vol.3, p.380.

(130) "Ackermann's Repository" 1818, vol.5, p.169.

(131) "Somerset House Gazette" 1824, no.51, p.385.

(132) Most landscapes by Miss Maria Pixell Ex. 1793-1811, Henrietta Sass
Ex. 1797-1813, Letitia Byrne Ex. 1799-1848, Mrs Charles Long Ex.
1807-1822, Mrs Keenan Ex. 1807-1813, Jane Steele Ex. 1810-1812,
Miss O.G. Reinagle Ex. 1824-1832 and Miss Frances Stoddart Ex. 1837-
1840 were entitled "Views". Many of Harriet Gouldsmith's works
were also so denominated. The word "Landscape" or a simple descrip-
tion of the subject was the rule with the five Misses Nasmyth -
Jane Ex. 1826-1866, A.G. 1829-1838, Charlotte Ex. 1837-1866,
E. Ex. 1838-1866, Margaret Ex. 1841-1865, Mrs William Oliver (late
Miss Emma Eburne, afterwards Mrs John Sedgwick) Ex. 1842-1886 and
Miss Catherine Maude Nichols Ex.1877-1891 - to name only a few
examples.

(133) This artist's work is considered in detail in Chapter 5,

(134) "Art Union" 1839, p.23 in an obituary of the artist.

(135) See Chapter 2, page 76

(136) "Examiner" 1810, vol.3, p.345

(137) J.C. Burgess: "Practical Essay on the Art of Flower Painting"
London 1811, pp.129-130.

(138) "Ackermann's Repository" 1812, p.333. For praise of her taste see
"Ackermann's Repository" 1824, p.363 and 1825, Jan-July p.359.

(139) ibid. 1825, Jan-July p.359.

(140) She is given these titles on the given dates in Algernon Graves'
"Royal Academy Exhibitors" op.cit. vol.2, p.119.

(141) E.C. Clayton op.cit. vol.1, p.413.

(142) ibid. vol.1, p.414.

(143) "Art Journal" 1876, p.47; E.C. Clayton op.cit. vol.1.p. 413

(144) E.C. Clayton op.cit. vol.1, p.414.

(145) Sarah Tytler: "Modern Painters and their Paintings" London 1882
(fifth edition) pp.301-2. One of these invidious critics was
Ruskin. For his criticisms of the Mutries' work see his "Academy
Notes" for 1855 (p.7), 1856 (p.19) and 1857 (pp.33-4)

(146) Clement and Hutton op.cit. vol. 2 p 140

(147) J.L. Roget op.cit. vol.2, p.424

(148) "Art Journal" 1884, p.127

(149) J.L. Roget op.cit. vol.2, p.425

(150) See page 144

(151) See M2b.

(152) The reader will be referred to appropriate parts of the literary
 section.

(153) See U1 and W1

(154) See U1, W1 and Y1

(155) A conclusion based on an examination of reviews and illustrations

(156) Miss Cole's work is given in M3. under "Correspondence"; for Miss
 Macirone's work see M3. under "Death"

(157) "English Woman's Journal" April 1864, vol.13, no.lxxiv, p.125.

(158) "Art Journal" 1864, p.152.

(159) "English Woman's Journal" May 1, 1858, vol.1, no.3, p.207.

(160) "Art Journal" 1866, p.56.

(161) "Sepctator" May 7, 1831, no.149, p.453.

(162) Reports of Special Assistant Poor Law Commissioners, on the Employ-
 ment of Women and Children in Agriculture - 1843.
 First Report of Commissioners for inquiring into the Employment and
 Condition of children in Mines and Manufactories - 1842.

(163) Mrs Jameson: "Memoirs and essays illustrative of Art, Literature,
 and Social Morals" London 1846, p.213.

(164) "The Song of the Shirt" was published in the Christmas number of
 "Punch" for the year 1843.
 Charlotte Brontë's "The Professor" was written by 1846; Anne
 Brontë's "Agnes Grey" was published in 1847; Charlotte Brontë's
 "Jane Eyre" was published in 1847; William Makepeace Thackeray's
 "Vanity Fair" appeared in monthly numbers in 1847-8 and in 1849 a
 work appeared called "Governess Life" by the author of "Memorials
 of Two Sisters"
 The relevant works by Richard Redgrave, all exhibited at the Royal
 Academy, are: "The Reduced Gentleman's Daughter" (1840), "The Poor
 Teacher" (1843), "The Sempstress" (1844), "The Poor Governess" (1845)
 and "Fashion's Slaves" (1847) on the exploitation of seamstresses.

(165) "Art Journal" 1852, p.137.

(166) See F2d for the full quotation.

(167) "Illustrated London News" July 15 1854 p. 37. Probably the same
 work as that exhibited at the Society of Female Artists in 1857
 (no. 89)

(168) In the early stages of the novel Ruth is a dressmaker's apprent-
 ice at Mrs. Mason's. All the girls are overworked and have what
 Mrs. Gaskell calls "a deadened sense of life, consequent upon
 their unnatural mode of existence, their sedentary days, and
 their frequent nights of late watching". One of them, Jenny,
 dies of consumption (Mrs. Gaskell : "Ruth" in 3 volumes, London
 1853 vol. 1 p. 18)

(169) Mrs. Jameson : "Memoirs and essays illustrative of Art, Litera-
 ture, and Social Morals" London 1846 pp. 254-5

(170) "Quarterly Review" 1849 vol. 84 no. 67 p. 176

(171) "Art Journal" 1854 p 167 .An engraving of this, by Alfred T Heath,
 was used to illustrate a story called "The Governess" by Mrs. E.
 W. Cox published in the "Keepsake" in 1856 (opposite page 123)

(172) See pp. 144-5

(173) "London Society" 1862 vol. 1 p. 433

(174) "Art Journal" 1875 p. 250

(175) ibid. 1850 p. 176

(176) "English Woman's Journal" May 1 1858 vol.1 no. 3 p. 208

(177) See pp. 165-6

(178) E.C. Clayton op.cit. vol. 2 p. 118

(179) See bibliography for the principal nineteenth century accounts
 of women artists

(180) Bessie Rayner Parkes : "Remarks on the education of girls"
 London 1854 p. 13

(181) "The Child restored to its mother" of 1858, "The Christening" of
 1863, "The Sick-room" of 1864 and probably "Christmas Day at the
 Foundling Hospital" of 1877 (known as "A Foundling Girl at
 Christmas Dinner") are at the Foundling Hospital

(182) See C3 and G3

(183) See p. 293 for the circumstances in which this was executed

(184) See F2d

(185) "Art Journal" 1864 pp. 263 and 250

(186) The sub-title of Benjamin Disraeli's "Sybil" published in 1845

(187) See p. 164

(188) See pp. 146, 271

(189) I have found three other works of art portraying factory
 workers by women in nineteenth century England : -
 1857 SFA Naomi Burrell : "Factory Girls" 357 sculpture
 1879 SLA F.M. Roberts : "A Factory Girl of Paisley" 116
 1881 RA Annie Louisa Robinson : "The factory girl's tryst" 985

(190) Louisa Jopling : "Twenty Years of my Life" London 1925 p 230

(191) John Stuart Mill : "A Prophecy" in "Dissertations and
 Discussions, Political, Philosophical, and Historical" vol. 1
 pp 284-5 (taken from his review of "Letters of Lucius Manlius
 Piso, from Palmyra, to his Friend, Marcus Curtius, at Rome"
 in "Westminster Review" 1838 vol. 28 pp 436-70)
 John Ruskin : "Modern Painters" vol. 3 (1856) (in "Works"
 Ed. E.T. Cook and A.D.I. Wedderburn London 1902-12, vol. 5
 pp 32-3)

(192) See page 153

(193) See Walter E. Houghton : "The Victorian Frame of Mind. 1830-
 1870" Yale University Press 1976 pp 64-76

NOTES - CHAPTER FOUR

(1) See Chapter 3, note 1

(2) The most comprehensive surveys of women's education in 19th
 century France are Paul Rousselot's "Histoire de l'Education
 des Femmes en France" Paris 1883, Alexis Lemaistre's "Nos
 Jeunes Filles aux Examens et à l'Ecole" Paris 1891 and
 Edmée Charrier's "Evolution intellectuelle féminine" Paris 1931

(3) "L'Artiste" 1836 vol. 11 p. 240

(4) The following are examples :-
 Jean-Jacques Rousseau : "Emile ou de l'Education" 1762 Book V.
 Although published before the period under discussion, this
 work exerted a considerable influence on education in the
 nineteenth century
 Louis Aimé-Martin : " De l'Education des Mères de Famille, ou
 De la Civilisation du Genre Humain par les Femmes" 1834
 Mme Necker de Saussure : "L'Education Progressive ou Etude du
 Cours de la Vie" 1838 vol. 3 "Etude de la Vie des Femmes"
 E. Legouvé : "L'Histoire Morale des Femmes" (conferences given
 in 1847 and 1848 at the Collège de France and afterwards
 published)
 Auguste Comte : "Politique Positive" (1851-4) vol. 1
 Mme Jenny Héricourt : "La Femme Affranchi" 1860
 Calmann Lévy : "Les Femmes et la fin du monde" 1877
 Dr. H. Thulié : "La Femme ; essai de sociologie physiologique"
 1885
 (All these were published in Paris)

(5) No. 207 in the catalogue in which it is listed with the following
 quotation : "Lorsque les Grecs entrèrent dans Troie, Andromaque
 renferma, selon quelques traditions, son fils Astyanax dans le
 tombeau de son père Hector. Ulysse l'apprit, força l'asile de
 ce malheureux enfant, et le fit arracher des bras de sa mère pour
 le précipiter du haut des murs de Troie". The term "vraiment
 historique" is used by C.P. Landon in his "Nouvelles des Arts,
 Peinture, Sculpture, Architecture, et Gravure" 1802 vol. 2 p. 54,
 and the phrase "traité avec toute la dignité historique" by the
 same in the "Annales du Musée .." an XI vol. 4 p. 80.
 An illustration of the work exists in C.P Landon's "Annales du
 Musée .." an XI vol. 4, Plate 36

(6) C.P. Landon : "Nouvelles des Arts .." 1802 vol. 2 p. 55

(7) No. 324 in the catalogue in which it is listed with the following
 quotation :"'Alexandre ayant mis en fuite Darius et son armée,
 sous les murs d'Issus, fit prisonnière sa mère Sysigambis, sa
 femme, son fils enfant, et ses deux filles. Pendant que le héros
 macédonien poursuivait le roi de Perse dans l'Assyrie, la femme
 du prince fugitif succomba sous le poids de sa douleur et des
 fatigues du voyage. Alexandre instruit de sa mort, ne put retenir
 ses larmes' (Quinte-Curce, livre 4, chap. 10). Il se rendit dans
 la tente où l'infortunée Sysigambis pleurait la reine de Perse"

(8) C.P. Landon : "Nouvelles des Arts .." 1804 vol. 3 p. 377
 (illustrated on page 376)

(9) ibid.

(10) "Le Pausanias Français" Salon de 1806, pp. 201, 203

(11) See, for instance, the "Examiner" 1807 vol. 1 p 45 and M.
 Michaud's "Biographie Universelle - Ancienne et Moderne"
 New Edition vol. XXI pp 466-8

(12) C.P. Landon : "Annales du Musée .." Salon de 1808 vol. 1,
 Part 2, pp. 91-2, Plates 50-1

(13) Probably the same work as that exhibited with a slight
 variation in the title, in 1814, no. 1378

(14) C.P. Landon : "Annales du Musée .." 1807 vol. 14 pp. 61-2,
 Plate 27

(15) "Pausanias Français" Salon de 1806 pp. 260-4

(16) Francis Haskell gives Richard Fleury's "Valentine de Milan
 pleurant son époux assassiné en 1407 par Jean duc de Bour-
 gogne" of 1802 as one of the earliest examples of this
 type of subject ("Past and Present" 1971 no. 53 pp. 109-20)

(17) C.P. Landon : "Annales du Musée .." Salon de 1808 vol. 2,
 Part 2, p. 97, Plate 57

(18) 1802, no. 7, with the following quotations : "En l'absence du
 guerrier qu'elle adore, troublée par un songe qui le lui
 représente infidelle, Thélaine vole au temple de l'Amour, et
 lui immole deux tendres colombes qu'elle-même avait élevées.
 Ce Dieu, touché de sa douceur et de son sacrifice, se présente
 et lui fait voir son amant regardant avec tendresse le
 portrait qu'elle lui donna à son départ ; dans son ravissement,
 elle s'écrie : 'Il respire ! .. et il m'aime ! ..'"

(19) 1802, no. 220, with the following description : "On y voit
 la Piété filiale soutenue par l'Amitié, et l'Hymen éteignant
 son flambeau". The work was a large miniature

(20) 1806, no. 515 : "Agée de 23 ans, elle se résout à quitter la
 cour pour embrasser la vie monastique". The work was described
 in the "Pausanias Français" 1806 p 406 ; she was represented
 holding a medallion of a man and looking at a convent out
 of the window.

(21) 1808 no. 552

(22) She painted a pendant to this : "L'Amour séduit l'Innocence, le
 Plaisir l'entraîne, le Repentir suit". See Edmond Pilon's
 "Constance Mayer" in "Les Petits Maîtres Français" series,
 Paris 1927 p 126.

(23) 1808 no. 417 with the description : "Cette déesse à son réveil
 invite toute sa cour à venir puiser des flammes à son flambeau.
 Les Amours accourent en foule autour d'elle, leurs expressions
 et leurs attitudes annoncent les différens caractères de la
 passion qu'ils inspirent". The work was criticized and
 illustrated in C.P. Landon's "Annales du Musée .." Salon de
 1808 vol. 2, Part 4, p 54, Plate 38

(24) C.P Landon : "Annales du Musée .." 1807 vol. 15 p 33, Plate
 19

(25) This subject of false attributions is considered by M. Charles
 Gueullette in the last of three articles about the artist
 in the "Gazette des Beaux-Arts" 1879 vol. 19 p 525
 See also Edmond Pilon op.cit. pp 125-9

(26) "Moniteur" 22 Frimaire, An X

(27) Mme de Stael's "De l'Allemagne" in which she recommends
 national and particularly medieval sources as opposed to
 classical ones for literature , was first published in France
 in 1810, but all except four of the copies were seized by
 order of Napoléon. The work was then published in England in
 1813 and for the first time effectively in France , in 1814.

(28) In 1812, when Mme Demanne exhibited two works, she appeared in
 the catalogue as Mad. De M***. The works in question were
 "Jeanne, fille de Raimond III, comte de Toulouse"(Ayant épousé
 Alphonse, comte de Poitiers et frère de St. Louis, elle fait
 ses adieux aux tombeaux de ses pères) (no. 272) and "Serment
 d'amour d'un chevalier avant son départ pour la Terre-Sainte"
 (no. 274). Both these were reexhibited in 1814 (nos. 1357 and
 1358). In 1817 she exhibited "L'Apparition du 'Sacré-Coeur' sur
 le tombeau du bienheureux Père Fournier, instituteur des
 religieuses de la Congrégation de Notre-Dame" (no. 222). The
 fourth is presently mentioned in the text.

(29) Several works with anonymous characters were exhibited in this
 decade. Apart from Mlle Hoguer's picture and Mme Demanne's
 "Serment d'amour d'un chevalier avant son départ pour la Terre-
 Sainte" mentioned in the previous note, examples are Mlle
 Béfort's "Une jeune Thébaine pansant son père blessé" (Un
 soldat blessé grièvement à Thèbes, prise d'assaut par Alexandre,
 fuyant avec sa fille les horreurs du pillage et de l'incendie,
 à peu de distance de la ville trouve un tombeau ; ils s'y
 reposent.Sa fille panse sa blessure et en étanche le sang avec
 son voile) 1810 no. 30 (a work with the same title but without
 the description was exhibited by the artist in 1814, no. 41) and
 Mlle Buet's "Les adieux d'un chevalier à sa dame" (Elle vient
 de détacher de son collier une croix qu'elle lui présente comme
 un gage de son amour) 1819 no. 188.

(30) 1808, no. 11; see page 177

(31) no. 745. The title includes the following description : "Philippe-
 Auguste répudia Isemburge pour épouser Agnès de Méranie ; il en
 eut un fils et une fille. Le pape Innocent II obligea Philippe
 à reprendre Isemburge ; il la rappela donc, et éloigna Agnès qui
 en mourut de douleur. Peu d'instans avant de mourir, elle envoya
 au roi, par la comtesse des Barres, ses tablettes sur les-
 quelles elle avait tracé ce peu de mots : 'Philippe, souviens-
 toi de nos enfans'. Isemburge avait reçu des mains de son époux
 les tablettes d'Agnès : touchée de la fin malheureuse de cette
 princesse, et de sa prière pour ses enfans, elle se les fit
 amener, les adopta, et les traita dès-lors comme les siens
 propres"

(32) C.P. Landon : "Annales du Musée .." Salon de 1819 vol. 2 p 24,
 Plate 12

(33) No. 1030. The title includes the following : "Une foule de serfs
 des officiers du chapitre de Chastenay avaient été plongés dans

les prisons de ce chapitre pour n'avoir pas payé la taille
attachée à leur condition. La Régente, touchée de compassion,
aux plaintes qu'elle en reçut, fit prier les officiers du
chapitre de les faire sortir de prison sur sa caution ;
mais elle éprouva un refus et apprit bientôt qu'une quantité
de ces malheureux allaient périr, soit par la faim, soit par
toutes les incommodités qu'ils souffraient dans un lieu à
peine capable de les contenir. Blanche, indignée, se transporte
aux prisons du chapitre, dont elle ordonne qu'on enfonce les
portes, et de son sceptre y donne le premier coup. Ce coup fut
si bien secondé qu'en un instant la porte tomba par terre. On
vit alors une multitude d'hommes, de femmes et d'enfans, avec
des visages mourans, pâles et défigurés, lesquels se jetant à
ses pieds, la supplièrent de les prendre sous sa protection
etc. etc." (Histoire des Reines et Régentes de France, tom.
1). The work is in the Musée de Libourne

(34) It was destined for the Galerie de Saint-Cloud or that of
 the Luxembourg

(35) 1819, no. 799. The description reads as follows : "Cette
 Princesse se voyant l'objet particulier de la haine des parle-
 mentaires, et menacée par l'approche de l'armée révoltée,
 entreprit de passer secrètement en France. S'étant dérobée aux
 recherches des soldats qui en voulaient à sa vie , il lui fallut
 pour regagner sa terre natale se confier de nouveau à une mer
 orageuse qui ne la mit pas à l'abri de ses ennemis. Poursuivie
 à coups de canon jusque sur les côtes de France, ce fut en
 montant dans une chaloupe, et traversant des rochers, qu'elle
 échappa à leur fureur, et aborda dans sa patrie. Des paysans
 français, en reconnaissant la fille d'un roi qu'ils avaient tant
 aimé, tombèrent à ses pieds, et lui offrirent leur chaumière.
 Sur les derniers plans, un paysan Breton montre à un jeune
 pâtre le vaisseau anglais qui ose encore tirer sur la fille d'
 Henri IV"

(36) C.P. Landon : "Annales du Musée .." Salon de 1819, vol. 2
 p. 58, Plates 37 and 38

(37) No. 561 : "En 1648 S. Vincent de Paule, pour engager à de
 nouveaux sacrifices les dames de la Charité qui, depuis
 plusieurs années, donnaient des sommes considérables pour de
 pauvres enfans abandonnés, pensa que la présence de ces petits
 orphelins serait plus puissante sur les coeurs que son éloquence.
 Il les fit entrer au moment où il plaidait leur cause. 'Entendez-
 vous', dit-il, 'ces innocentes créatures ? C'est vous qu'elles
 implorent, vous qui fûtes mères de ces enfans, vous ne les
 abandonnerez pas !..' Elles furent si attendries, qu'elles
 donnèrent à l'instant tout ce qui leur restait d'argent et de
 bijoux.
 Debout sur le premier plan, est le commandeur Brulard de Sillery,
 possesseur d'une grande fortune, qu'il consacra entièrement à
 cette bonne oeuvre, ne se réservant qu'une pension alimentaire.
 Madame de Miramion est assise près de lui : elle n'avait alors
 que 19 ans ; derrière elle, est assise mademoiselle Legras,
 supérieure et fondatrice des dames de la Charité. Mademoiselle
 de La Fayette détache son bracelet. La scène se passe dans une
 sacristie"
 For use of the term "touchant" see C.P. Landon's "Annales du
 Musée .." Salon de 1817 p. 111

(38) No. 694 with the description : "Mademoiselle de La Fayette se
promenant avec le Roi dans la forêt de Saint-Germain, rencontra
une vieille femme qui lui demanda l'aumône, en lui disant que
sa fille venait de rester veuve avec deux enfans et qu'ils
étaient tous dans la plus grande misère. Mlle de La Fayette lui
donna quelques pièces de monnaie, et lui promit d'aller bientôt
porter d'autres secours à sa fille et à ses enfans. Le lendemain,
le roi se rend à la chaumière de ces pauvres gens, où il ne
trouve que la fille de la vieille femme avec ses deux enfans - il
ne se fait pas connaître, et remet à cette jeune veuve une somme
d'argent de la part de Mlle de La Fayette. Celle-ci arrive
un instant après ; et, en rentrant dans la cabane, suivie de la
paysanne qui avait été retirer de la voiture un paquet d'effets,
elle aperçoit Louis XIII assis sur une mauvaise escabelle ;
berçant le plus jeune des enfans et laissant jouer l'autre
entre ses jambes. Elle est prête à exprimer sa surprise et son
admiration, mais le Roi lui fait signe de ne pas le nommer, et
semble vouloir s'excuser d'avoir contribué avec elle au soulage-
ment de cette pauvre famille"
The work is illustrated in C.P. Landon's "Annales du Musée .."
Salon de 1817, Plate 16

(39) C.P.Landon : "Annales du Musée .." Salon de 1817 p 29

(40) ibid. 1812 vol. 1 p 22

(41) Mme Haudebourt-Lescot from 1820

(42) No. 764 in the catalogue. The work was an official commission
destined for the Château de Fontainebleau where it is still to
be found

(43) C.P. Landon : "Annales du Musée .." Salon de 1819 vol. 2 pp
63-4, Plate 42
She did revert. Only two other classical subjects by her
appeared at the Salons, both in 1835 : "Mort de Marie de Clèves
etc." (no. 1040) and "La duchesse d'Angoulême, mère de François
1er, et Marguerite de Valois, sa soeur, recevant la fatale
nouvelle de la perte de la bataille de Pavie" (no. 1041)

(44) No. 577. Landon described the work as follows : "Mortellement
blessé par un sanglier furieux, le favori de Vénus vient de
rendre le dernier soupir. La déesse, en proie à la plus vive
douleur, cherche en vain à le rappeler à la vie. Des faunes,
des bacchantes, errant dans la forêt, s'arrêtent pour contempler
le corps inanimé du jeune chasseur. L'Amour, soulevant d'une
main celle d'Adonis, et de l'autre tenant son arc, leur fait le
récit de cet événement funeste. Le lieu de la scène est un site
sauvage, couvert d'arbres et hérissé de rochers" - "Annales du
Musée .." Salon de 1810 p. 75, Plate 53

(45) ibid. pp. 75-7

(46) No. 658 with the description : "Cassiopée, Reine d'Ethiopie,
mère d'Andromède, ayant eu la témérité de se croire plus belle
que les Néréides, Neptune voulut venger les nymphes de son
Empire, et envoya un monstre qui dévoroit les Ethiopiens. L'
oracle de Jupiter Ammon dit que le seul moyen d'appaiser
Neptune étoit de livrer Andromède à la voracité du monstre.
Il étoit près de la déchirer, lorsque Persée, protégé par
Mercure, qui lui avoit donné ses ailes et ses talonnières, tua

le monstre, et brisa les chaines de la princesse qui devint son
épouse"

(47) R.J. Durdent : "Galerie des Peintres français au Salon de 1812"
1813 pp 20-1
Similarly C.P. Landon described the picture as "l'un des plus
remarquables de l'exposition" and went on to say that it stood
out "par le grandiose et la correction du dessin. Il est d'une
couleur vigoureuse et d'une fort belle exécution" - "Annales du
Musée .." Salon de 1812 vol. 1 p 82, Plate 61

(48) In 1814 the title was simply "Persée et Andromède" (no. 707) with
no descriptive passage. Her "Mars et Vénus" showed how "Vénus,
fait de vains efforts pour retenir auprès d'elle Mars qui brûle
de voler au combat" (no. 708)

(49) The description accompanying "Une jeune Thébaine pansant son
père blessé" (1810 no. 30) is given in note 29
For criticisms of her 1812 exhibit see R. Durdent op.cit.
pp 61-2 and C.P. Landon's "Annales du Musée .." Salon de 1812
vol. 1 p 63, Plate 46

(50) "Thésée allant combattre le Minotaure, reçoit le peloton de fil
des mains d'Ariane" (no. 42)

(51) A work entitled "Les Adieux d'Hector et d'Andromaque" was also
exhibited by the artist in 1817 (no. 29) ; the title included
the following description : "Hector va prendre Astyanax dans ses
bras ; mais l'enfant, effrayé de l'éclat des armes et du
panache qui flotte sur le casque de son père, se rejete sur le
sein de sa nourrice"

(52) No. 498 with the description : "A peine avait-elle vu seize
printems qu'elle perdit sa mère. Un jour, les yeux baignés de
pleurs, elle alla visiter sa tombe isolée : elle y versa de l'
eau pure et y répandit des fleurs, etc."

(53) No. 190 with the description : "Elle se sauve de sa capitale
tombée au pouvoir d'un usurpateur, emportant son fils Lancelot.
Elle est surprise par l'orage"

(54) The first, no. 160, included the following : "Diane, prévoyant la
fin de Camille,que lui avait consacrée son père, ordonne à Opis,
l'une de ses nymphes, de venger sa mort. Les compagnes de
Camille accourent et la soutiennent ; sa main ne peut retirer
le trait qui l'a blessée - elle meurt en adressant à Acca, celle
de ses compagnes qui seule avait sa confiance, un dernier avis
pour Turnus" (Virg. En. Liv. XI)
"Cérès" (no. 231) depicted the following : "Elle allume ses
flambeaux sur le mont Etna pour chercher sa fille Proserpine
ravie par Pluton"

(55) No. 782 : "Le Sauveur lui dit : 'Ne t'arrête pas ici, va porter
plus loin la nouvelle de ma résurrection'"

(56) No. 800 : "La Veuve de Sarepta, après avoir offert au prophète
le peu de nourriture qui lui restait, vit mourir son fils !
Elysée le prit, le ressuscita et le porta à sa mère en lui
disant : Voyez, votre fils vit !..." (M.I.)

(57) See Edmond Pilon's "Constance Mayer" (Paris 1927) pp 58-60
(The picture is in the Louvre)

(58) Gros, for instance, was commissioned to portray a meeting
 between Napoléon and the Austrian Emperor in Moravia on
 the field of battle shortly before the marriage (The work
 is in the Musée National du Château de Versailles)

(59) Now in the Musée National du Château de Versailles

(60) C.P. Landon : "Annales du Musée .." Salon de 1810 p. 73, Plate
 51

(61) R.J. Durdent op.cit. p. 21
 The work is the Musée National du Château de Versailles

(62) At an exhibition "au profit des blessés" (no. 477)

(63) See p. 211

(64) See description in the following note

(65) No. 758. The title includes the following description :
 "Fleurette, la première femme qu'aît aimée le prince de Béarn,
 depuis Henri IV, est peut-être la seule de ses maîtresses qui
 l'aît aimé comme il méritait de l'être ; mais il oublia
 bientôt Fleurette. L'ayant revue quelque tems après, sa passion
 se ralluma, il lui donna rendez-vous à la fontaine ; mais quand
 il y vint, il ne trouva qu'une flèche et une rose qu'elle
 tenait de lui, avec un billet. La pauvre Fleurette s'était
 jetée dans la fontaine"

(66) No. 1190 with the following quotation : "Je suis coupable, dit
 cette mère malheureuse, d'avoir aimé votre fils ; je dois périr,
 mais ménagez votre sang, ne privez pas ces enfans de leur père ;
 ne vous privez pas d'un fils digne de vous. Je mourrai trop
 heureuse, et en bénissant votre clémence, si, avant de m'envoyer
 au supplice, vous daignez pardonner à don Pèdre, à mon époux,
 l'honneur de votre maison et l'espoir de la patrie"

(67) No. 1191. The complete quotation reads : "Après l'assassinat du
 duc d'Orléans, sa veuve inconsolable fit transporter dans son
 oratoire, l'armure, l'écharpe et l'épée de ce prince, et s'enferma,
 résolue de mourir en arrosant de ses larmes ces tristes restes
 de son époux. Elle résistait depuis trois jours à tous les efforts
 qu'on avait tentés pour l'arracher de ce lieu de douleur,
 lorsqu'on imagina d'y introduire l'aîné de ses enfans, le comte
 d'Angoulême. Ce moyen réussit ; le présence du jeune prince
 rappelle à l'infortunée Valentine, qu'elle n'a pas tout perdu,
 et vaincue par les instances de cet aimable enfant, elle se
 laissa entraîner en jetant un dernier regard sur les seuls
 objets qui lui restent de l'époux qu'elle a tant aimé"

(68) No. 1192 with the quotation : "Elle est sur le vaisseau qui la
 transporte en Ecosse, après la mort de François II ; elle
 aperçoit encore les côtes de France, et leur adresse ces mots
 si touchans, sujet de sa romance commençant par ces mots :
 'Adieux tant doux pays de France, etc.'"

(69) No. 888 with the quotation : "Alphonse de Lautrec, se décidant
 à partir pour l'armée d'Italie, s'éloigne à regret de Clémence
 Isaure, qui, l'arrêtant avec timidité, détacha sa ceinture
 violette et souci. Il comprit son intention, et s'agenouillant
 devant elle, il reçut le présent que l'amour offrait à la

victoire. A son écharpe bleue, elle joignit ses couleurs"

(70) No. 1286 with the quotation : "Clovis ayant entendu parler des
 vertus et de la beauté de Clotilde, éprouve pour elle un
 intérêt qui bientôt se change en amour. Il remet à son fidèle
 Aurélien un anneau pour cette aimable princesse. Aurélien arrive
 à Genève, et, pour tromper les regards du soupçonneux Goodeband,
 oncle de la princesse, il se déguise sous les habits d'un
 pauvre, se prosterne à ses pieds et lui présente l'anneau royal"
 (Gaule poétique) (Tableau commandé)

(71) No. 1062 with the quotation : "Louis XIV, se promenant un jour
 dans le parc de Versailles, aperçut dans l'orangerie ou l'on
 venait de placer sa statue, une jeune et belle paysanne (fille
 de son jardinier) qui l'admirait : 'La trouvez-vous ressemblante'
 dit Louis, en prenant par le bras cette jeune fille toute
 interdite de voir le Roi si près d'elle"

(72) "Stanislas annoncant à sa fille, Marie-Leczinska, qu'elle est
 demandée en mariage par Louis XV.."
 "Lorsque Stanislas reçut la lettre qui lui annonçait cette
 prodigieuse faveur de la fortune, transporté de joie, il entre
 dans la chambre ou étaient sa femme et sa fille. Ah, ma fille !
 lui dit-il, tombons à genoux et remerçions Dieu ! Mon père,
 s'écria celle-ci, seriez-vous rappelé au trône de Pologne ?
 Le ciel, reprit Stanislas, nous est bien plus favorable, ma
 fille, vous êtes Reine de France" (no. 1085)

(73) "La petite laitière de Madame Elisabeth"
 "Cette bonne princesse avait fait venir dans sa maison de
 Montreuil une jeune paysanne de Fribourg pour soigner ses
 vaches et en distribuer le lait aux orphelins. S'apercevant
 un jour que la petite Suissesse était triste, elle voulut
 connaître le motif de son chagrin, et elle apprit qu'elle aimait
 lorsqu'on la fit partir pour la France. Madame Elisabeth fit
 alors venir l'amant de sa jeune laitière, qui se nommait
 Jacques, les garda tous les deux à son service, et les maria.
 La jeune fille est représentée chantant la romance de 'pauvre
 Jacques', etc." (no. 464)

(74) No. 1758

(75) Mlle Grandpierre's "Vue d'une partie du château de Fontainebleau
 (Christine de Suède, fait assassiner son grand écuyer
 Monaldeschi)" was exhibited in 1824, no. 798
 In 1827 Mlle de Fauveau exhibited "Christine, reine de Suède,
 refusant de faire grâce à son grand écuyer Monaldeschi" (Le père
 Le Bel, supérieur du couvent des Mathurins, appelé pour préparer
 Monaldeschi à la mort, se jeta aux pieds de Christine et demanda
 la vie de son pénitent ; mais, inaccessible à ses prières et
 au repentir de son écuyer, elle refusa sa grâce. Il mourut percé
 de coups, dans la galerie des cerfs, à Fontainebleau, le 10
 novembre 1657) no. 1785

(76) "L'Artiste" 1842 vol. 1 pp 7-8. A plaster version is in the
 Musée de Louviers

(77) No. 1078 with the description : "Les Genevois repoussèrent les
 savoyards qui voulaient s'emparer de leur ville. Une femme jette
 un pot de fer sur la tête d'un savoyard qui était prêt à tuer
 son mari"

(78) No. 938 with the description : "Giaccomo Strazzieri fut enfin
 arrêté le 7 septembre 1816, ainsi que deux de ses complices, et
 leurs têtes exposées sur les piliers construits au lieu même où
 ils avaient commis leur dernier crime. La femme de Giaccomo
 Strazzieri se mit à la tête des compagnons de ce chef célèbre,
 pour aller enlever, malgré la présence des gendarmes, la tête
 de son mari"

(79) No. 1086 with the description : "Piron, fatigué d'une promenade
 au bois de Boulogne, s'assied sur un banc près de la porte de
 la Conférence ; bientôt il est salué par tous les passans. 'Oh !
 oh ! se dit-il, je suis beaucoup plus connu que je ne le pensais'!
 Mais une vieille femme survient qui se jette à genoux. Piron
 l'invite à se relever ; il s'aperçoit qu'elle remue les lèvres ;
 il se penche, prête l'oreille et entend que c'est un 'avé' que
 cette bonne femme adresse à une image de la Vierge, placée
 au dessus du banc où il était assis ; il voit aussi que c'est
 à cette image que s'adressaient tous les saluts qu'il avait
 pris pour lui. 'Voilà bien les poètes', dit Piron en s'en allant ;
 'ils croient que toute la terre les contemple, quand on ne songe
 seulement pas qu'ils existent'"

(80) No. 1429. Racine had previously been the subject of a work by
 Mlle Julie Philipault in 1819 (no. 895) See J

(81) No. 856 with the description : "Les procédés de Louis XIV envers
 Madame de Maintenon ne laissant aucun doute sur leur secret
 mariage, Mignard désira savoir du roi s'il pouvait la peindre
 revêtue du manteau doublé d'hermine. Sainte Françoise le mérite
 bien, répondit Louis XIV" (Historique)

(82) For a description of which see page 330

(83) The second was Mlle Henry's "Sapho en méditation" (1822 no. 1749)

(84) Two of the most famous examples are Mme de Staël's "Corinne"
 of 1807 and Alfred de Vigny's "Chatterton" of 1834

(85) These will be the subject of Section E

(86) 1822, no. 693 with the quotation : "Lorsque je me trouvai en
 présence de la reine, le peu de constance dont je m'étais armé
 m'abandonna. Elle me fit amener le roi dont les embrassements
 et les caresses furent un nouvel assaut auquel mon coeur eut
 bien de la peine à ne pas succomber.
 Je ne me souviens plus ni de ce que me dit ce jeune prince, ni de
 ce que je lui dis moi-même en ce moment ; je sais seulement qu'on
 eut beaucoup de peine à me l'arracher d'entre les bras, tant
 je le tenais étroitement serré" (Extrait des mémoires de Sully)
 (M.d.R.)
 The work was criticized and illustrated in C.P. Landon's "Annales
 du Musée .." Salon de 1822 vol. 1 p 84, Plate 52

(87) No. 897, with the description : "Ce monarque, sachant qu'il n'
 avait plus que peu de jours à vivre, fait venir son arrière petit-
 fils qui doit incessamment lui succéder, et après lui avoir
 adressé les plus sages exhortations, lui donne sa bénédiction.
 Madame de Maintenon soutient l'auguste vieillard et Madame
 la duchesse de Vantadour, gouvernante du jeune prince, l'approche
 de son bisaieul" (M.d.R.)

(88) No. 1621, with the description : "Ideberge, mère de sainte
Gertrude, étant dangereusement malade, donne sa bénédiction
à sa fille et prie la Sainte-Vierge de la protéger"

(89) No. 551 with the quotation : "Louis IX, dans sa capitale, fut
atteint d'une grave maladie. Déjà une des femmes de la Reine,
croyant voir sur le visage du Roi, l'empreinte de la mort,
jeta le drap sur sa tête, lorsque soudain il s'agita, soupira
et dit : 'La lumière de l'Orient s'est répandue du Ciel sur
moi par la grâce du Seigneur ; Dieu me rappelle du séjour des
morts'. Après avoir prononcé ces paroles, le Roi tournant ses
regards sur l'évêque de Paris, lui demanda la croix, la reçut
de ses mains, et fit voeu, par ce signe rédempteur, d'
affranchir la cité de Jésus-Christ du joug des infidèles"
(Histoire de Saint Louis par M. le comte de Ségur)
A.Jal abstained from criticisms of this work out of gallantry
("Esquisses , croquis, pochades, ou tout ce qu'on voudra sur
le salon de 1827" 1828 p 286)

(90) No. 854. A quotation from a poem by Casimir Delavigne on the
subject accompanies the title :
"O mon fils, il n'est plus d'espoir :
Déjà le gouffre nous dévore ;
Sur mon sein je te presse encore ,
Mais je ne dois plus te revoir"

(91) No. 1285 with the quotation : "Ainsi que Daphnis estait en ces
termes, une cigale poursuivie par une hirondelle, se vint jeter
en sauve-garde dedans le sein de Chloé, de quoi Chloé ne
sachant ce que c'était s'écria hault, et Daphnis, se riant de
sa peur, prit la gentille cigalle" (Traduction d'Amyot)
Also in 1824 Mlle Robineau exhibited "Daphnis et Chloé ;
paysage, soleil couchant" (no. 1459)

(92) No. 1522 with the quotation : "Cette nymphe, fille de l'Océan
et amante d'Apollon, se laissa mourir lorsque ce dieu cessa
de l'aimer, et fut métamorphosé en tournesol.
. . . Jamais elle ne remua de l'endroit où la douleur l'avait
contrainte de s'asseoir, elle tournait seulement la tête selon
qu'elle voyait aller le soleil, afin de suivre au moins des
yeux ce dieu qu'elle aimait encore" (Ovide)

(93) No. 735 with the description : "Après la mort d'Oedipe, roi
de Thèbes, Etéocle et Polynice, ses deux fils, convinrent
d'occuper le trône alternativement, chacun pendant une année.
Polynice y monta le premier, et le céda à Etéocle ; celui-ci,
après l'année révolue, gardant la couronne, au mépris de la
convention, Adraste, beau-père de Polynice, Tydée, son beau-
frère, le devin Amphiaraus, Capauée, Hippomédon et
Pharthénopée, fils d'Atalante, se réunirent à Polynice, et
marchèrent contre Thèbes.
A la vue de cette ville, les sept chefs immolent un taureau
noir, et jurent sur la victime de venger Polynice"

(94) A. Jal op.cit. p 270

(95) ibid. pp 268-9

(96) See page 178 and note 25

(97) The work of Mme Haudebourt-Lescot is considered on pages 226-7

The work of Jeanne Philiberte Ledoux has been confused with that
of her teacher, Greuze

(98) See page 181

(99) 1838 , no. 794, with the quotation : "Cette dame avait deux
biaux fils et une fille, laquelle estoit dedans le chastel de
la Rocheguyon, bien garnei de biaux meubles, belles terres
et seigneuries. Deuers laquelle le Roy d'Angleterre envoya
luy faire sauoir que si elle vouloit luy faire le serment,
qu'il estoit content que ses biens lui demaurassent, sinon,
il auroit sa place et tous ses biens. Laquelle, mue d'un noble
couraige, aima mieux perdre tout, et s'en aller desnuée et ses
enfans, que soy mestre, ni ses enfans ès-mains des anciens
ennemis du royaume et délaisser son souverain seigneur" (Juvenal
des Rusins, "Histoire du Roy Charles VI")

(100) "Une femme attente à la vie de Cromwell" (1839 no. 777) with
the quotation : "Lucrèce Greenwil avait été tendrement aimée
du duc de Buckingham, que Cromwell tua de sa propre main à la
bataille de St. Needs. Lorsqu'elle apprit sa mort, elle ne
songea qu'à le venger. Un repas que la ville de Londres donna
au Protecteur lui en fournit l'occasion : elle se plaça sur son
balcon avec plusieurs autres dames, et lorsque Cromwell vint
à passer, elle prit un pistolet caché sous ses vêtemens et le
tira contre lui ; la balle ne l'atteignit pas et alla frapper
le cheval de son fils Henri. Cromwell, étonné d'un coup si
hardi, tourna les yeux sur le balcon et vit plusieurs dames
qui criaient miséricorde, hors une seule, qui, debout et le
pistolet encore à la main, lui dit : 'C'est moi, tyran, qui ai
fait feu sur toi'. Cromwell, affectant une tranquillité qu'il
n'avait pas, dit d'un ton moqueur : ' Ce n'est rien, mes amis,
ce n'est que l'emportement d'une folle" (Histoire d'Angleterre)

(101) The work is in the Musée National du Château de Versailles
and was executed in 1837

(102) "Revue de Paris" 1837 vol. 42 pp. 253-4

(103) "L'Artiste" 1839 vol. 1 pp. 251-2

(104) No. 903 with the description : "LL.MM. , accompagnées de leur
suite, reçoivent la visite de l'empereur don Pedro dans l'île de
Neuilly, et se disposent à s'embarquer pour une promenade sur
la Seine"

(105) "L'Artiste" 1842 no. 1 p. 39

(106) ibid. pp. 41-2. The fresco was later destroyed. All that remains
is a lithograph of her original sketch

(107) The new museum was opened in 1837

(108) It was Saint-Simon's followers - Enfantin, Bazard and P.
Leroux - who drew attention to the position of women and stressed
that if the moral regeneration of society was to be achieved
they should have equal rights with men. In 1832 Enfantin
heralded the coming of a female Messiah who would inaugurate
a new era of Christianity : "Il se prépare en morale quelque
chose d'inattendu et d'inouï, nous attendons une Femme Messie"
("Le Globe" Jan. 12 1832)
Clair Demar's "Ma Loi d'Avenir" and "L'Appel d'une Femme au
peuple sur l'affranchissement de la femme" both written in

1833 were published in 1834.
The best examples of emancipated women of the 1830s are George
Sand and Louise Colet, both famous not only for their writings
but also for their liaisons with Alfred de Musset
See also notes 310, 311 and 312

(109) "Oeuvres Complètes de Victor Hugo" 1882 vol. 3 pp. 283-7

(110) A few instances from the 1830s should be cited. In 1838 Mlle
 Mélina Thomas exhibited "Charlotte Corday " (Interrogée dans
 sa prison par un membre du tribunal révolutionnaire, elle lui
 répond : 'Dieu seul est mon juge') (no. 1679) ; in 1839 a
 statue of Charlotte Corday by the Princesse Marie d'Orléans,
 Duchesse de Wurtemburg was installed at Versailles ("L'Artiste"
 1839 vol. 1 p 432) ; in 1839 also Mme Anna Rimbaut exhibited
 "Le général Marceau et Blanche de Beaulieu" (no. 1791) with
 a quotation from Alexandre Dumas' "La Rose Rouge" (+ see Q)

(111) No. 673 with the description : "Pendant la terreur, une jeune
 femme suivit un jour le tombereau qui se rendait du Luxembourg
 à la place de la Révolution ; son mari était au nombre des
 victimes. Après l'exécution, elle revint s'agenouiller à la
 porte fatale, et continua chaque jour d'accompagner la
 sanglante charrette. Enfin on ne la vit plus ; la pauvre folle
 avait cessé de souffrir"

(112) "Lavoisier en prison" (no. 663) with the quotation : "On dit
 que, condamné à mort par le tribunal révolutionnaire, Lavoisier
 demanda un sursis pour terminer quelques expériences importantes,
 et que ce sursis lui fut refusé. Il s'occupait encore d'études
 chimiques, lorsqu'on vint l'arracher à sa prison pour le conduire
 au supplice" ("Leçons sur la Philosophie chimique" par M.
 Dumas), with the note :
 "La plupart des instruments qui sont représentés dans ce tableau,
 ont appartenu à Lavoisier ; quelques-uns sont de son invention"
 For reviews, see "L'Artiste" 1843 vol. 3 pp 127 and 211 and
 "Les Beaux-Arts : Illustrations des Arts et de la Littérature"
 1843 vol. 1 p 92

(113) "Magasin des Demoiselles" 1846 vol. 2 pp. 234-5

(114) No. 527 with the quotation : "C'était à la Force que se trouvait
 l'infortunée princesse de Lamballe, qui avait été célèbre à la
 cour par sa beauté et par ses liaisons avec la reine. On la
 conduit mourante au terrible guichet. - Qui êtes-vous ? lui
 demandent les bourreaux en écharpe . - Louise de Savoie,
 princesse de Lamballe. - Quel était votre rôle à la cour ?
 Connaissez-vous les complots du château ? - Je n'ai connu aucun
 complot. - Faites serment d'aimer la liberté et l'égalité, faites
 serment de haïr le roi, la reine et la royauté, - Je ferai le
 premier serment : je ne puis faire le second, il n'est pas dans
 mon coeur.
 'Jurez donc', lui dit un des assistants qui voulait la sauver.
 Mais l'infortunée ne voyait et n'entendait plus rien. 'Qu'on
 élargisse madame', dit le chef du guichet. Ici, comme à l'Abbaye,
 on avait imaginé un mot pour servir de signal de mort" (Thiers -
 "Histoire de la Révolution française")

(115) No. 528 with the quotation : "On portait les noms sur autant d'
 actes d'accusation, et on venait le soir signifier ces actes aux
 prisonniers et les traduire à la Conciergerie. Cela s'appelait,
 dans la langue des geôliers, le journal du soir" (Thiers -

"Histoire de la Révolution française")

(116) "L'Artiste" 1848 vol. 1 p 105

(117) No. 41 with the quotation : "Elisabeth servit son père comme
 elle le servait autrefois ; elle le sauva du désespoir en
 ramenant sa pensée vers leurs travaux littéraires interrompus
 par leur arrestation. La jeune fille se montra aussi gaie,
 aussi heureuse, aussi calme que lorsqu'elle habitait sa jolie
 maison de Pierry, et parvint, à force de soins, à faire
 oublier au vieillard le malheur qui le frappait"

(118) No. 42 with the quotation : "Elle se précipite dans la cour
 de l'Abbaye, enlace son père de ses bras, le couvre de son
 corps et demande grâce pour lui. A l'aspect de cette jeune
 fille, si belle, si courageuse, qui vient ainsi braver la
 mort, les septembriseurs s'arrêtent, ils hésitent, se consultent
 du regard, et plusieurs voix s'écrient : Grâce pour le père,
 grâce pour la fille"

(119) No. 43. The quotations are taken from Michel Masson's "Les
 Enfants Célèbres". It will have been observed that several
 of these works were based on the French Revolution. The
 following is an unusual exception among the usually grim
 themes taken from this time :
 1841 Mme Lavalard née Berthelot : "Le duc de Penthièvre au
 château d'Eu, en 1891"
 "En 1791, le département de la Seine-Inférieure fit des
 représentations au corps législatif au sujet de l'état d'arres-
 tation du duc et de la duchesse de Penthièvre qui se trouvaient
 retenus au château d'Eu, et on assura que dans les comités
 il n'y avait eu qu'un avis, celui de rendre la liberté à des
 personnes qui en faisaient un si louable usage. Le département
 fit instruire M. de Penthièvre qu'il étoit bien le maître de
 quitter la ville d'Eu quand il le jugeroit à propos, et d'aller
 où il voudraoit dans ses terres et de rentrer dans l'intérieur.."
 (Portaire - "Mémoires pour servir à la vie de M. de Penthièvre")
 1215

(120) No. 8 with the description : "De pauvres petits orphelins ou
 indigents, qui, en s'installant naguère à la colonie de Petit-
 Bourg, dans les vieux débris de l'opulence, se virent traités,
 eux si purs, si innocents, par les gens d'alentour, comme des
 vagabonds et des voleurs qui devaient dévaster le pays et le
 déshonorer, eurent la pieuse pensée de repondre à cette
 calomnie par la plus noble vengeance. Ils se souvinrent qu'ils
 avaient, pour la plupart, laissé à Paris une famille que la
 misère nourrissait de larmes, et ils voulurent, en s'emposant
 certaines privations, tarir, avec l'obole multipliée du pauvre,
 qui égale alors celle du riche, tarir, disons-nous, dans le
 village qui les avoisine, cette source qu'ils savaient d'
 autant plus cruelle, qu'elle abreuvait des vieillards infirmes,
 délaissés et quelquefois privés même de la seule richesse que
 le ciel destine ici-bas à la classe laborieuse et pauvre, les
 enfants. Ils voulurent leur tenir lieu de famille, veiller à
 leur chevet, manger du pain noir pour qu'ils en eussent du blanc,
 faire maigre pour qu'ils eussent de la viande, se couvrir de
 coton pour qu'ils eussent de la laine, souffrir du froid pour
 qu'ils eussent chaud ; et si un sinistre venait à affliger le
 pays, si un accident ou une longue maladie devait amener la
 ruine d'une famille, les colons jurèrent de se dévouer. Ils
 accourront tous et éteindront l'incendie ; ils travailleront

jour et nuit et relèveront la chaumière abattue ; ils planteront
le jardin, laboureront et ensemenceront le champ ; ils feront
tant et tant que le malheur sera bientôt réparé, et que, s'il
y a encore dans cette famille place pour des larmes, que ce soit
seulement pour celles si douces de la reconnaissance"
(Nota. Toutes les têtes de petits garçons sont autant de portraits
de colons)
In 1848 the artist exhibited "Derniers moments d'un colon du
Petit-Bourg" (Toutes les têtes sont des portraits de colons)
no. 40

(121) Mme Amélie Cordellier-Delanoue née Cadeau : "Reddition de la ville
de Calais, en 1346" with the description : "Edward III, roi
d'Angleterre, irrité de la longue résistance de la ville de
Calais, résolut de mettre tous les habitans à mort ; cependant
il renonça à cette cruauté sur les remonstrances des barons et
chevaliers anglais, se réservant d'exiger du gouverneur de la
ville qu'il lui livrât six bourgeois des plus notables. On sait
de quelle manière se dévouèrent Eustache de Saint-Pierre, Jean
d'Aire, Pierre et Jacques Wissant, ainsi que deux autres dont
on ignore les noms. Lorsqu'ils se présentèrent devant le roi,
la tête et les pieds nus, la corde au cou, il ordonna qu'on leur
coupât la tête. A cet instant la reine Philippa de Hainaut, sa
femme, entra dans sa tente, et vint se jeter à ses pieds pour
demander la grâce des prisonniers. Après avoir hésité quelque
temps, Edward, vaincu par les larmes de la reine, répondit
ainsi : 'Tenez, je vous les donne, ; si en faites vostre
plaisir'" (Chateaubriand - "Etudes historiques") no. 415
Mlle Marie-Eléonore Godefroid : "Novella d'Andrea" with the
description : "Novella, fille de Jean d'Andrea, célèbre professeur
de droit à Bologne en 1300 : elle était si instruite dans cette
science, que quand son père était occupé ou malade, il l'envoyait
professer à sa place, et si jolie, que, pour éviter de distraire
l'auditoire, elle lisait et expliquait les lois, cachée derrière
un rideau ; c'est ce que rapporte une femme contemporaine
(Christine de Pisan)" (Sujet exécuté d'après un composition
du baron Gérard) no. 513

(122) No. 30 with the quotation : "Son père vient la conjurer, au nom
de son enfant, de sacrifier aux idoles, afin d'échapper au
supplice auquel elle est condamnée" (Godenard - "Vie de Sainte
Perpétue")

(123) No. 456 with the quotation : "Mlle de La Vallière avait quitté
la cour et s'était retirée au couvent de Chaillot. Là, assise
au fond d'une cellule, près d'un fenêtre qui donnait sur des
jardins, elle cherchait à oublier l'amour du roi et les séduc-
tions de la cour. Tout à coup un bruit confus se fait entendre ;
la porte s'ouvre, et Louis XIV parait accompagné de la
supérieure.
'Venez,dit-il à Mlle de La Vallière, le ciel ne vous appelle pas
dans ce couvent, et la crainte ne doit pas vous y retenir!'.
La pauvre fille tombe aux pieds du roi : 'Sire, s'écrie-t-elle,
il est vrai que la crainte de déplaire à d'augustes personnes
m'a fait chercher un asile dans cette maison ; mais souffrez
que j'y reste pour obtenir, hélas ! le pardon de mes fautes !'
'Mlle de La Vallière, répéta le roi avec un bruyant éclat de
voix, je vous ai priée de me suivre ; maintenant je vous l'
ordonne'.
La jeune pénitente cessa de répliquer. L'abbesse la releva et
l'aida à marcher jusqu'au carosse du roi" (Chronique de l'Oeil-
de-Boeuf)

(124) No. 646 with the description : "Pendant les persécutions qui
 suivirent la révocation de l'édit de Nantes, les femmes
 protestantes se réfugiaient dans les grottes des montagnes
 pour se dérober aux violences des soldats et aux dangers de la
 guerre civile. Elles y puisaient, dans la lecture de la Bible,
 la résignation nécessaire pour supporter leurs inquiétudes et
 leur douleur"

(125) No. 910. The quotation is from the "Biographie Universelle"

(126) "L'Artiste" 1840 vol. 5 p 222. Illustrated opposite page 233.
 The work was lithographed ; see "L'Artiste" 1841 vol. 7 p 81
 Elise Journet was also the author of "Lavoisier en prison"
 1843 no. 663 (+ see note 112)

(127) Mlle Octavie Rossignon : "Silvio Pellico au Spielberg" (1844
 no. 1573) with the quotation : "Après m'être d'abord un peu
 rétabli, je languissais par le manque de nourriture et j'avais
 à essuyer de nouvelles attaques de fièvre ; j'essayais de
 traîner mes chaines jusqu'au lieu de la promenade, et là, je
 me jetais sur l'herbe où je restais l'heure entière. Les
 gardes restaient debout ou s'asseyaient près de moi, et nous
 causions. La femme du surintendant était malade depuis
 longtemps et dépérissait lentement. Elle se faisait quelquefois
 apporter sur un canapé au grand air ; elle avait trois fils
 jolis comme des amours, un d'entre eux encore à la mamelle. La
 pauvre mère les embrassait souvent en ma présence, et disait :
 'Qui sait quelle femme deviendra leur mère après moi. Quelle
 qu'elle soit, que Dieu lui donne des entrailles de mère pour
 ces enfants, bien qu'ils ne soient pas nés d'elle ..', et
 elle pleurait. Elle languit encore quelque temps, puis
 mourut" (Silvio Pellico - "Mes Prisons")
 Mlle Adèle Grasset : "Silvio Pellico dans sa prison, à Venise"
 (1847 no. 748) with the line : "La fille du géolier baise un
 passage de la Bible qu'il vient de lui expliquer"

(128) "L'Artiste" 1846 vol. 6 p 40

(129) See, for instance, the summary of works at her studio in
 Florence in the "English Woman's Journal" 1859 vol. 2 p 89
 This artist's work will be considered in detail in Chapter 5

(130) No. 1945 with the quotation : "La veuve de Béthulie, montée au
 balcon de sa maison, découvre la tête d'Holopherne cachée sous
 son manteau, la plante sur une pique de fer, selon l'usage de
 l'Orient, et dit au peuple : 'Suspendite caput hoc super muros
 nostros'" ("Judith", chap. XIV)

(131) No. 1861 . The quotation is from Saint Matthew, chapter V,
 verse 10

(132) See, for example, "L'Artiste" 1840 vol. 5 p 217 and
 "L'Illustration" 1845 vol. 4 p 520

(133) F. Sabatier-Ungher : "Le Salon de 1851" Paris 1851 pp 6-7

(134) No. 601 with the quotation : "Durant le persécution de Dioclétien,
 dans la Rhétie, une courtisane nommée Affre se convertit au
 christianisme et fut condamnée à être brûlée. Lorsque les
 bourreaux eurent mis le feu au bûcher, on l'entendit prononcer
 distinctement cette prière : 'Jésus ! Dieu tout puissant qui

eûtes venu sur la terre, moins pour les justes que pour les
pécheurs, daignez, en expiation de mes crimes, accepter mes
souffrances et le sacrifice de ma vie'" (Vie des Saints)

(135) No. 1743 with the quotation : "Le comte de Bussy-Rabutin ayant
conçu une violente passion pour Mme de Miramion, restée veuve
à l'âge de seize ans et demi, et non moins distinguée par ses
vertus que par sa beauté, la fit enlever par vingt cavaliers
armés un jour qu'elle allait faire ses dévotions au Mont-
Valérien (aout 1648). Elle se défendit avec une incroyable
énergie, chargeant les agresseurs avec son livre d'heures, et
ayant les mains tout ensanglantées des blessures qu'elle
s'était faites avec leurs épées quand ils voulurent couper les
mantelets du carosse. Détenue quarante-huit heures dans le
château du comte de Bussy, son calme et son énergie ne l'
abandonnèrent pas un instant : elle fit voeu, en présence de
ceux qui l'avaient enlevée, de ne jamais se marier, et contint,
par sa fermeté, tout le monde dans le respect. Elle avait alors
dix-neuf ans. Le moment choisi est celui où elle s'élance hors
du carosse dans la forêt de Livry, pour tâcher de se dérober
à ses ravisseurs à travers les ronces et les épines qui la
déchirent. Mme de Miramion mourut en odeur de sainteté, après
avoir secondé Saint-Vincent de Paule dans nombre de bonnes
oeuvres" ("Vie de Mme de Miramion" par l'abbé de Choisy)

(136) 1857 no. 798 with the quotation : "Dans la nuit du 6 ou 7
décembre, près Werbomont, trois enfants ont péri de froid dans
la neige. Ces malheureux étaient allés mendier dans la commune
de Chevron. Le plus petit de ces pauvres enfants était couché
sous son frère et sa soeur : celle-ci, pour le réchauffer,
s'était en partie dépouillée de ses habits" (Extrait du "Journal
de Liège")

(137) 1859 no. 246 with the description : "En 1220, deux familles se
disputaient le premier rang à Florence, les Buon del Monte et
les Uberti. Le jeune Buon del Monte, s'étant marié, quoique
fiancé à une parente des Uberti, ceux-ci le firent tuer le jour
de Pâques.
Les Buon del Monte transportent sur un char, à travers les rues
de Florence, le corps de leur parent, qu'ils accompagnent en
poussant des cris de vengeance"

(138) A note is required here about Mme Cavé. Her "Convalescence de
Louis XIII" of 1855 (no. 2673) (+ see F1) may have been exhibited
twice before. Works with similar titles were exhibited in 1839 -
"Bataille d'Ivry" (no. 222) (+ see U) and 1847 - "Convalescence
de Louis XIII" (no. 288). Equally, her "Tournoi d'enfants"
of 1855 (no. 2674) (+ see F1) may have appeared at the Salon
previously. She exhibited "Un tournoi" in 1840 (no. 147) (+ see
X) and "Un tournoi" in 1847 (no. 289) (+ see X).
Three other examples may be given of her representation of the
childhood of the famous, all exhibited in 1845 : "Enfance de
Paul Veronese" (no. 275) (+ see B1), "Enfance de Haydn" (no.
278) (+ see B1) and "Enfance de Lawrence" (no. 279) (+ see B1)

(139) No. 174 with the quotation : "Après les édits de l'empereur
Dioclétien contre le christianisme, Julitte fut arrêtée pour sa
foi à Tarsi en Cilicie, où elle s'était enfuie avec son jeune
enfant et deux de ses femmes.
 Conduite devant le tribunal du gouverneur Alexandre, la
sainte proclame hautement qu'elle est chrétienne. Le juge ne

connaissant plus alors de limite à sa cruauté, ordonne au
bourreau d'arracher l'enfant des bras de sa mère ; puis il la
condamne au martyre .." (Vie des Saints)

(140) No. 745 with the description : "Ne sentant plus battre sous sa
 main le coeur de son mari, Philippe le Bon, qu'elle aimait
 passionnément, l'infortunée reine cherche à rassembler ses
 idées et commence à comprendre le malheur qui vient de la
 frapper"

(141) Théophile Gautier wrote : "Nous ne sommes pas de ceux qui
 s'étonnent de voir les femmes pratiquer les arts. Le fait, selon
 nous, devrait être plus fréquent; mais sans les réduire à la
 miniature ou au genre sous des proportions restreintes, on
 peut être surpris de voir une jeune femme aborder la grande
 peinture et brosser un tableau d'église avec une énergie et une
 solidité toutes viriles. Le 'Christ insulté', de Mme Henriette
 Bertaut, se distingue par des qualités farouches et violentes
 qui ne trahissent en rien son sexe. Autour de la pâle figure du
 Christ se pressent des types d'une bestialité cynique et
 méchante qui rappellent, pour le dessin et la couleur, la manière
 caractéristique de Gustave Doré" ("Abécédaire du Salon de 1861"
 Paris 1861 p 60) The work was also praised in the "Gazette des
 Beaux-Arts" 1861 pp. 272-3
 This is almost certainly the work known as "Le Christ aux
 outrages" presently in the Louvre

(142) No. 1658 with the line : "Quand la lune brille sur la surface
 des eaux, la sirène sort des profondeurs de l'Océan"

(143) Salon des Refusés, no. 497 with the line : "Elles furent changées
 en chauves-souris pour avoir travaillé le jour des fêtes de
 Bacchus"

(144) "Courrier Artistique" May 14 1865 no. 50 p. 199

(145) One artist who specialized in portraits of "classical" women was
 Juana Romani. Amongst others she portrayed Herodias (1890 no.
 2075), Judith (1891 no. 1421), the Magdalen (1891 no. 1422),
 Bianca Capello (1892 no. 1453), the daughter of Theodora (1893
 no. 1532), Primavera (1895 no. 1650), Faustolla da Pistoia
 (1897 no. 1453) and Salome (1898 no. 1745)

(146) "Gazette des Beaux-Arts" 1879 vol. 20 p. 56

(147) Many passages from her diary testify to her interest in this
 subject. She even described it as the only one in which she
 would show herself truly. See "Journal de Marie Bashkirtseff"
 (Paris 1887) vol. 2 pp 190, 366, 372, 373, 374, 375, 462, 463,
 483, 505

(148) "Revue Internationale de l'Art et de la Curiosité" 1870 vols.
 3-4, p 366

(149) Auguste Comte published his "Cours de philosophie positive"
 between 1830 and 1842

(150) "Société pour la Révendication des Droits de la Femme" (1866),
 "Association pour le Droit des Femmes" (1870), "Association
 pour l'Avenir des Femmes" (1873), "Société pour l'Amélioration
 du Sort de la Femme" (1881), "Société pour l'Amélioration

du Sort de la Femme et la Revendication de ses Droits"
(1882), "Ligue Française pour le Droit des Femmes" (1882),
"Société du Suffrage des Femmes" (1883) and "Solidarité des
femmes" (1891) for instance. The growth of a feminist press
from the early 1870s is the subject of a work by Evelyne
Sullerot : "La Presse Féminine" (Paris 1963)

(151) In 1879 girls' teacher training colleges were founded in all
the French departments. In 1880 a general system of girls'
education was established and women were admitted to the
Sorbonne. In 1882 there were seven female physicians in France
and the numbers increased rapidly ; by 1903 there were 95. The
first female "docteur ès sciences" qualified in 1888 and the
first female lawyer in 1900

(152) Louise Michel (1830-1905) joined the International, founded the
"Société démocratique de moralisation" for the relief of
working-women's poverty and played a large role in the Commune.
After banishment with other Communards, she returned to Paris
to be involved once more in Socialist activities. She wrote
much : novels and poetry. A collection of revolutionary
poems was published in 1888. She quickly achieved legendary
status as "La Vierge Rouge" and was celebrated as such in many
poems written during and after the commune by Achille Le Roy,
Victor Hugo, Clovis Hughes and Trahel
Maria Deraismes (1828-1894) was the first woman freemason. She
was a literary feminist in the 1860s and became an active member
of many women's rights groups
Rosa Bordas who sang popular songs in Parisian cafés during and
after the Commune was referred to in reviews of 1870 as the
singer of the people, "vraie déesse de la Liberté" (Jules
Clarétie : "L'Opinion Nationale" Jan. 24) "Une Ville, une
République, une amoureuse de tambours" (Tony Réveillon)
(See A. Burion : "Rosa Bordas" Paris 1870)
Séverine (1855-1929) campaigned against all forms of oppression
from an early age and wrote for "Gil Blas", "Le Gaulois",
"Le Cri du Peuple" and "La Fronde". When the Republic was
reestablished she took part in celebrations in person as an
embodiment of "La Jeune République". She became an apostle
figure
Rachilde (1860-1953) was a notorious figure in the literary
world at the end of the century. She held a salon and for many
years worked for the "Mercure de France"

(153) "Journal de Marie Bashkirtseff" Paris 1887 vol. 2 p 483

(154) The translation was by Letourneur. Another translation appeared
in 1810

(155) C.P.Landon : "Annales du Musée .." 1807 vol. 13 p 114, Plate 53
(The work is in the Musée des Arts décoratifs,Paris)

(156) No. 302 with the quotation : "Armide désespérée d'avoir inutile-
ment dirigé ses flèches et les coups de ses amans contre Renaud,
quitte le champ de bataille et fuit dans une vallée voisine de
Jérusalem. Elle tombe sur un rocher, jette à ses pieds son arc
et son carquois ; ses flèches se répandent ; elle en essaie
quelques-unes, leur reproche leur impuissance contre les armes
de Renaud, puis les brise ; enfin, elle en choisit une et va s'en
percer, lorsque Renaud, qui l'a vue disparaître dans la mêlée,
se rappelle la promesse qu'il lui a faite en la quittant, d'être

toujours son chevalier et vole sur ses traces. Il arrive au moment où Armide, déjà couverte de la pâleur de la mort, lève le bras pour se frapper ; il l'arrête d'une main et la soutient de l'autre : Armide se retourne et lève sur lui des yeux où se peignent tout à la fois l'orgueil blessé, la tendresse trahie, et la douce consolation d'être secourue par celui qu'elle aime. Elle lui fait de vifs reproches ; le jeune guerrier n'y répond que par une tendre compassion. D'un côté du tableau, un écuyer tient le cheval et le bouclier de Renaud ; de l'autre, s'aperçoit dans l'éloignement le tombeau de Clorinde ; derrière les montagnes s'élèvent les tours de Jérusalem"

(157) The same artist also exhibited "18 dessins. Sujets des tragédies de Sophocle" in 1808 (no. 255) and "Sujets tirés des tragédies de Sophocle" in 1814 (no. 1267)

(158) See page 179

(159) Mlle Rosalie Caron : " Gabrielle de Vergy" - "Venant de recevoir une lettre de Mlle de Coucy, elle est attendrie des témoignages d'amitié qu'elle contient. Livrée toute entière à sa tendresse, elle prend ses tablettes et ne peut se refuser au plaisir de relire les vers que Raoul a faits pour elle. Ensevelie dans ses pensées, elle ne s'aperçoit pas qu'elle est surprise par son mari" (1812 no. 170) ; Mlle Leduc : "Adélaide de Coucy" - "Elle surprend son frère Raoul écrivant sur ses tablettes les vers qu'il composait pour Gabrielle de Vergy, et se dispose elle-même à les copier" (1817 no. 508)

(160) In the romance he bore the name Renaut

(161) No. 838 with the quotation : "L'ermite à la garde duquel sont confiés les restes de ces deux amants, vient d'introduire leurs amis dans l'antique chapelle où ils reposent"
 "Ciel ! de Tristan le chien fidèle entre,
 Exporoit là près d'un maître expiré !

 Prenant racine au tombeau de Tristan ,
 Un lierre ami gravissoit la muraille ,
 Et s'inclinoit par le plus doux élan
 Sur le tombeau d'Yseult de Cornouaille"
 (discussed and illustrated in C.P. Landon's "Annales du Musée .."
 Salon de 1814 p. 62, Plate 43)

(162) No. 308 with the quotation : "Il fait répéter aux dames de sa suite, et devant Oriane, la romance plaintive chantée sur la Roche Pauvre par Amadis, qui avait pris le nom du Beau Ténébreux. Aussi touchée de la constance de son amant que du récit des maux qu'il éprouve, Oriane tombe évanouie dans les bras de Mabile, son amie" (Amadis des Gaules)

(163) Translated into French in the 16th and 17th centuries

(164) No. 854 with the quotation :
 "Il n'est ni croix ni rosaire
 Qui guérisse de l'amour"

(165) One single possible example of novel illustration in the first twelve years of the century is Mlle Mullen's "Camille dans le souterrain" - "Elle implore le ciel pour son fils prêt à périr

de besoin" of 1808 (no. 444) which may have been an illustration
of a novel by Mme de Genlis published in 1782 : "Adèle et
Théodore". There was also an opera bouffe based on this novel,
entitled "Camilla, ossia il Sotterraneo"

(166) "Sujet tiré du roman de 'Mathilde', par Mad. Cottin"
"Mathilde retirée dans son oratoire, priant Dieu d'appeler à lui
la grande âme de Malek-Adhel, est surprise par ce dernier, qui la
conjure de le nommer son époux. Mathilde cédant au penchant qui
l'entraîne, mais toujours fidèle à son Dieu, promet à Malek-
Adhel de ne pas prendre le voile et d'être à lui s'il veut à l'
instant jurer sur le livre des évangiles, d'embrasser la religion
chrétienne" (tôme 5, chap. 36) 845

(167) C.P. Landon : "Annales du Musée .." 1812 vol. 1 p 87, Plate 64.
For another favorable criticism, see R.J. Durdent : "Galerie des
Peintres français au Salon de 1812" 1813 pp 24-5

(168) For the distinction between works of art illustrating literature
and works of art in which literature is used as a gloss to
illustrate or explain the visual work , see page 135

(169) The verse is first given in Latin : "Incipe, parve puer, risu
cognoscere matrem" (Eglogue IV)

(170) Romantic drama, freed from classical conventions, dates from the
1820s. Theorists of the new drama were Manzoni (in a letter to
the critic Chauvet published in "Le Lycée Français", 1820),
Stendhal in his "Racine" and "Shakespeare" of 1823 and 1825, and
Hugo in the famous "Préface de Cromwell" of 1827. Instances of
the new drama are Dumas père's "Henri III et sa cour" (1829),
Vigny's adaptation of "Othello" (1829) and Hugo's lyrical
drama "Hernani" of 1830

(171) Defauconpret was the translator

(172) No. 464 with the quotation : "Amy Robsart, trompée par le son
du cor qui lui annonce ordinairement l'arrivée du comte de
Leicester, son époux, s'élance pour voler à sa rencontre et
périt victime du piège que lui a tendu le traître Sir Richard
Varnet"

(173) No. 1569 with the description : "Desdemona, agitée de noirs
pressentimens, avant de congédier sa suivante Emilia, s'est
assise auprès d'un balcon, et chante, en s'accompagnant sur son
luth, la romance 'du saule'. Un violent orage éclate en ce
moment sur Venise, et accroît encore la mélancolie de cette
infortunée, qui, dans peu d'instans, sera immolée à la fureur
jalouse de son époux"

(174) Fairy tales and fables were occasionally illustrated before the
1820s. Examples are :-
1802 Mlle Bounieu : "Tableau représentant Psyché" - "Psyché prête
à sortir du souterrain qui l'a conduite aux Enfers, ne peut
résister au désir d'ouvrir la boëte de fard de Proserpine ; il
en sort une fumée noire et fuligineuse" Lafontaine 34
1817 Mlle Lescot : "Le meunier, son fils et l'âne"
"Quand trois filles passant, l'une fit : c'est grand'honte
Qu'il faille voir ainsi clocher ce jeune fils,
Tandis que ce nigaud, comme un évêque assis,
Fait le veau sur son âne, et pense être bien sage" 765
1817 Mlle Lescot : "Le vieillard et ses enfans"

"Il sépare les dards et les rompt sans effort.
Vous voyez, reprit-il, l'effet de la concorde ;
Soyez joints, mes enfans, que l'amour vous accorde, etc."
(M.I.) 774

(175) No. 313 with the quotation :
"De mes ennuis, j'en bizarre et futile,
J'interrogeais chaque débris fragile
 Sur l'avenir.
Voyons, disais-je, à la feuille entraînée
Ce qu'à ton sort ma fortune enchaînée
 Va devenir"
Her first volume of poems, which included "Les feuilles du
saule", was published the year before, in 1826

(176) No. 1694 with the quotation : "En arrivant dans la maison
paternelle, la pauvre Effie, succombant à sa fatigue et à sa
douleur, se trouva mal dans les bras de sa soeur, qui apprit
alors la cause du changement qu'elle avait remarqué dans
sa chère Effie, naguère si charmante.
Jenny essaya de lui donner quelques consolations - mais des
soldats s'emparèrent bientôt de la malheureuse fille pour
la conduire dans les prisons d'Edimbourg" (Walter Scott -
"La Prison d'Edimbourg")

(177) "L'Artiste" 1841 vol. 7 p 284

(178) See page 136

(179) Byron's works were first translated between 1822 and 1825

(180) Mme Pourmarin : "Les feuilles du Saule"
"Au saule antique incliné sur ma tête ,
Ma main enlève, indolente et distraite,
 Un vert rameau ;
Puis j'effeuillai
.
Voyons, disais-je, à la feuille entraînée ,
Ce qu'à ton sort, ma fortune enchaînée
 Va devenir ?" (no. 1703)

(181) The same artist exhibited another work which may, perhaps, be
included in the category of literary works with glosses ; the
work appears to have been in two parts, contrasting a pious
girl and a coquette : -
"Le bon ange ; aquarelle"
"Quand elle prie un ange est debout derrière elle" (Victor Hugo)

"Le Mauvais ange ; aquarelle"
"Dans ce miroir, jeune fille !
Regarde ton oeil qui brille" (Alexandre Dumas) (1838 no. 171)

(182) "La pauvre fille"
"Reviens, ma mère ! je t'attends
Sur la pierre où tu m'as laissée" (Sujet tiré de l'élégie
de M. Soumet) no. 570

(183) No. 1011 with the quotation :
"Heureux enfant, que je t'envie
Ton innocence et ton bonheur !
Ah ! garde bien toute la vie
La paix qui règne dans ton coeur"

The work was previously exhibited at the Society of British
Artists in London in 1836 with the same quotation (no. 450)

(184) No. 1707 with the quotation : "Quand vous êtes au matin, pensez
que vous n'irez peut-être pas jusqu'au soir ; et quand vous
êtes au soir, ne vous flattez pas de voir le matin" ("Imitation
de Jésus Christ")
The following work by the same artist may also be included in
this category : "Les pélerins" - "Jetez les yeux,Seigneur ,
sur mon affliction et délivrez-moi, puisque je n'ai point oublié
votre loi" (Psaume de David) 1841 no. 1807

(185) Literary subjects were more popular in England throughout the
nineteenth century. Although portraits of literary characters
became popular in England too, especially from the 1870s,
illustrations of specific scenes from literature were also
numerous right up until the end of the century.

(186) The book was published in 1863 and in 1868 Mme Armand Leleux
depicted the "Souper des comédiens au château de Sigognac"
(no. 1535)

(187) The book was published in 1875 and in 1880 Mme Anaïs Beauvais
depicted "La mort d'Albine dans le paradou" (no. 206)

(188) "Gazette des Beaux-Arts" 1860 vol. 5 p. 353

(189) "L'Artiste" 1843 vol. 3 p. 274

(190) Bellier-Auvray (op.cit.) gives "Amphion jouant de la lyre"
(1817 no. 1052) and "Portrait de SAR Mme la duchesse de Berri"
(1824 no. 1055). A work exhibited by a Mme Lebrun in 1802 -
"Portrait du dernier roi de Pologne, mort à St. Petersbourg"
(no. 916) - should possibly be added.
She was in Russia, Berlin, England, Switzerland as well as
France during the first 10 years of the century.
An idea of the extent of her artistic activity may be gleaned
from an examination of the catalogue of her works given from
pages 185 to 225 in W.H. Helm's "Vigée-Lebrun. Her life, works
and friendships" London, 1916

(191) Details of the following works are taken from Mlle Marie-
Juliette Ballot's "Une élève de David. La Comtesse Benoist,
l'Emilie de Demoustier. 1768-1826" (Paris, 1914) pp 249-251
1804 "Portrait du premier Consul" commissioned by the
Emperor for the town of Ghent. Now in the Palais de Justice
there
1805 "Portrait du maréchal Brune" commissioned for the
Tuileries. The work was destroyed in 1871 and a copy by
Bataille exists in the Musée de Versailles
1806 "Portrait du grand-maître des cérémonies" commissioned
by the Emperor
1807 "Portrait de l'Empereur" commissioned for Brest. No
longer there
1807 "Portrait de l'Empereur" commissioned by the Emperor
for Mans. No longer there
1808 "Portrait de la princesse Borghese" commissioned by the
Emperor and given to Versailles in 1864 by the Emperor
Napoleon III as "Princesse Elisa" and so it appears in the
Clément de Ris catalogue (no. 5140)
1808 "Portrait de l'Empereur" commissioned by the town of
Angers

(192) "Pausanias Français" 1806 p. 369

(193) R.J. Durdent : "Galerie des Peintres français au Salon de
 1812" 1813 pp. 26-7

(194) R.B. Holtman : "Napoleonic Propaganda" (Louisiana State
 University Press : Baton Rouge 1850) p. 164

(195) Marie-Juliette Ballot op.cit. p. 212. The letter is dated
 October 1st 1814

(196) See pages 183-4, 190

(197) A marble bust of the same was exhibited in 1808 no. 650

(198) At the Exposition au profit des blessés in 1830 Mlle Emma
 Laurent exhibited a "Portrait du général Kléber" (no. 540)
 and "Portrait du maréchal Ney" (no. 541) and in 1831
 a "Portrait de Napoléon ; miniature" (no. 1255). Superposed
 profile busts of Lavalette, Ney and Labedoyere by Jenny
 Hamm are at Malmaison and a large portrait of Napoléon by
 Angélique Mongez at Avignon should also be mentioned.

(199) The portraits of Mme Campan by Godefroid are discussed in the
 catalogue for an exhibition devoted to works of art and objects
 connected with Mme Campan, held at the Château de Malmaison
 in 1972 (Catalogue par Yvan David et Monique Giot) p. 49
 A copy of one of these, commissioned in 1847, is presently
 at the Musée National du Château de Versailles, illustrated
 on page 51 of the catalogue

(200) ibid. p 71. One, illustrated on page 73 of the catalogue, is
 now at the Musée de Picardie, Amiens. One, exhibited in 1822,
 was destined for Versailles where it is still to be found.
 See page 71 of the 1972 catalogue for an account of the others.

(201) Malmaison 1972 catalogue, page 100

(202) See "Souvenirs de Madame Vigée-Lebrun" Paris 1867 vol. 2 pp.
 11-12

(203) ibid. p. 230

(204) "Moniteur Universel" August 21 1818 p. 993

(205) ibid. July 27 1819 p. 1016
 In 1819 "Une miniature, portrait du Roi" by Mlle Lysinska Rue
 appeared at the Salon (no. 1675)

(206) According to F. Reiset's "Notice des dessins du Louvre" Paris
 1883 p. 371

(207) "L'Artiste" 1831 vol. 1 p 291. For further evidence of her
 celebrity see Jean Gigoux's "Causeries sur les Artistes de
 mon temps" Paris 1885 p 229

(208) This work, in the Frick collection, was attributed to David
 until 1962. See Georges Wildenstein : "Un tableau attribué à
 David et rendu à Mme Davin-Mirvault ; le portrait du Violiniste
 Bruni" in the "Gazette des Beaux-Arts" 1962 vol. 59 p 93.
 She was awarded a 2nd class medal for the work

(209) A copy of this work by M. Carpentier is in the Musée National
 du Château de Versailles

(210) According to the "Pausanias Français" 1806 pp. 368-369

(211) Presently in the Musée d'Art et d'Histoire in Geneva
 An engraving of another oval half-length portrait of Mme de
 Staël by Vigée-Lebrun is in the British Museum
 She also depicted the "Margravine of Ansprach" while in
 London between 1802 and 1805. The latter was the author of
 plays, satires and a volume of translations and memoirs

(212) In the catalogues these appeared as "Portrait de Mad. V***"
 (1814 no. 683) and "Portrait de Mme T***" (1817 no. 566). The
 former is in the Musée de Nancy

(213) See Le comte Arnaud Doria's "Gabrielle Capet" (Paris 1934) p 81

(214) Painted in London between 1802 and 1805

(215) In 1802 Mme Louise Kugler exhibited "Un cadre renfermant une
 collection d'hommes célèbres, peints à l'huile, et en
 miniatures, et plusieurs portraits d'après nature" (no. 148).
 In 1804 she exhibited "Plusieurs portraits d'hommes illustres"
 (no. 253) and "Portraits et têtes d'étude d'après nature" (no.
 254), the which heading was accompanied by the following note
 in the catalogue : "Nota : M. Weyler, académicien, chargé
 par le gouvernement, en 1785, de transmettre, à la postérité,
 sur émail, les portraits des hommes célèbres, offrit avec le
 plus grand succès, aux regards du public, à l'exposition de
 1787, quelques émaux et une réunion d'ébauches de portraits en
 pastel, qu'il se proposait de rendre également sur émail ; mais
 sa mort prématurée arrêta ses travaux. Mme Kugler, son élève
 et sa veuve, encouragée par la protection que le gouvernement
 daigne lui accorder, a suivi le même plan, et soumet à l'
 indulgence du public ses premiers travaux en ce genre. Elle
 possède la collection d'ébauches en pastel faite par M.
 Weyler, et qu'il avait eu l'avantage de puiser dans les cabinets
 des amateurs. Elle ose réclamer le même service de ceux qui
 pourraient lui en confier : ils contribueront à porter aux
 siècles les plus reculés la ressemblance inaltérable des hommes
 qui ont illustré leur patrie". Similarly a note was added to
 Mme Victoire Jacquotot's "Portraits de personnages célèbres"
 exhibited at the Salon of 1819 (no. 629) to the effect that
 "Ils font partie de la collection commandée par le Roi, pour
 son usage particulière"

(216) "L'Artiste" 1836 vol. 10 p 16

(217) For criticisms of Mme de Mirbel see A Jal's "Salon de 1833. Les
 Causeries du Louvre" Paris 1833 pp 240, 258 and 259 : "L'Artiste"
 1833 vol. 5 p 194 ;"L'Artiste" 1834 vol. 7 pp 114, 137 ;
 "L'Artiste" 1835 vol. 9 p 186 ; "L'Artiste" 1834 vol. 8 p 47 ;
 "L'Artiste" 1836 vol. 11 p 167 ; "L'Artiste" 1839 vol. 2 p 258 ;
 "L'Artiste" 1841 vol. 7 p 335 ; "Magasin des Demoiselles" 1845
 vol. 1 p 238 ; Baudelaire - "Salon de 1845" ("Oeuvres complètes"
 Paris 1968 p 221) ; "Magasin des Demoiselles" 1846 vol. 2
 p 237
 And of Mme Herbelin : "Magasin des Demoiselles" 1846 vol. 2
 p 237 and "L'Artiste" 1849 vol. 3 p 27

(218) "L'Artiste" 1834 vol. 8 p 47

(219) Mme Herbelin won a 3rd class medal in 1843, a 2nd class medal in 1844 and 1st class medals in 1847, 1848 and 1855. For her exemption in the latter year, see "Moniteur Universelle" July 27 1855. She was the first miniaturist to have work admitted to the Luxembourg.
Other portraits of eminent figures tended to be on a small scale. Examples are Mlle Virginie Boquet's "Portrait du roi ; porcelaine" (1837 no. 159) and Mlle Aimée Perlet's "Portrait du Roi ; porcelaine" (1840 no. 1272)

(220) See pages 186-7, 194, 197, 199 and Section E

(221) "Gazette des Beaux-Arts" 1859 vol. 3 p 23

(222) ibid. 1861 vol. 11 pp 154-5. Part of this text is quoted on page 69

(223) "L'Artiste" 1851 vol. 6 p 50 ; "L'Artiste" 1852 vol. 8 p 147 ; "L'Artiste" 1853 vol. 10 p 177

(224) "Gazette des Beaux-Arts" 1861 vol. 11 pp 154-5

(225) The fullest discussion of her work is supplied by an obituary in the "Chronique des Arts" Dec. 19 1874 pp 383-4
For contemporary criticisms of her work see "Gazette des Beaux-Arts" 1859 vol. 3 p 23 ; "Gazette des Beaux-Arts" 1861 vol. 11 p 155 ; "Courrier Artistique" 1865 no. 56 p 30

(226) In 1841, 1857, 1861 and 1863

(227) "Gazette des Beaux-Arts" 1859 vol. 3 p 23

(228) She was born in Berlin in 1828 and received her art education in the studio of Ch. J. Begas. From around 1844 she worked in Brussels and finally moved to Paris in 1853

(229) "Chronique des Arts" Oct. 31 1885 p 262

(230) Her portraits of Rachel were exhibited in 1853 (no. 887), 1857 (no. 2009), 1861 ("Portrait de Mlle Rachel après sa mort ; dessin au crayon noir" no. 2396) and 1867 (no. 1152)

(231) After her marriage to the collector Edouard André in 1881, she ceased exhibiting and devoted herself to collecting with her husband. For a short review of her life see her obituary in the "Chronique des Arts" May 18 1912 p 157

(232) "Gazette des Beaux-Arts" 1879 vol. 20 p 56
Apart from portrait commissions she was also paid to decorate churches. See "Courrier Artistique" July 31 1864 p 39 and ibid. Sept. 11 1864 p 61

(233) "Gazette des Beaux-Arts" 1869 vol. 1 pp 501-2

(234) "Revue Internationale de l'Art et de la Curiosité" 1870 vol. 3-4 p 427. This portrait is in the Musée National du Château de Compiègne

(235) Apart from the reviews mentioned above, see J.A.K. Castagnary's "Salons de 1857-1870" Paris 1892 p 427 ; Th. Véron's "De l'Art et des Artistes de mon temps ; Salon de 1877" Paris 1877 p 268 ;

"L'Art" 1878 vol. 3 pp 182, 292 ; Maurice Du Seigneur's "L'Art et les Artistes au Salon de 1880" Paris, 1880 p 62

(236) "L'Artiste" 1852 vol. 9 p 187. A bronze copy is in the Musée d'Arras

(237) ibid pp 187-8. She did two other versions. See Stanislas Lami op.cit.

(238) Three of her four commissioned works of the decade were on classical themes. The fourth was a portrait of "Le Général Sibuet (1773-1813)" a marble bust exhibited at the Salon of 1869 (no. 3545), presently at Versailles. She also executed statuettes of Pie IX and the Queen of Naples and marble busts of the King and Queen of Holland (see Stanlis Lami op.cit.)

(239) "L'Artiste" 1852 vol. 9 p 188. At the Musée National du Château de Versailles

(240) No. 2861. Another plaster bust of the subject was exhibited in 1859 (no. 3200)

(241) Re-exhibited at the Exposition Universelle in 1867, group 1, class 3, no. 78. At the Musée National du Château de Versailles

(242) No. 2958 (Ministère de la Maison de l'Empéreur et des Beaux-Arts). This was re-exhibited in 1867 (no. 2230). Another marble bust of Scribe was exhibited in 1878(no. 4206). A marble bust is in the Théâtre Français, Paris

(243) In the Théâtre Français, Paris

(244) See Stanlislas Lami op.cit. for details

(245) "Courrier Artistique" 1865 no. 54 p 214

(246) Mme Bertaux exhibited mainly classical works over this period although she sent a "Portrait de M.P. de B..,, buste plâtre" to the Salon of 1857 (no. 2735), a "Portrait de Mme C...,, médaillon plâtre" to that of 1865 (no. 2871) and a "Portrait de Mlle Marie C.. , médaillon plâtre" in 1867 (no. 2136).
 Elizabeth Ney exhibited two portrait busts in 1861 : "Portrait de Arthur Schopenhauer ; buste plâtre" (no. 3520) and "Portrait de M. Eilhard Mitscherlich ; buste plâtre" (no. 3521)

(247) See page 347

(248) See Appendix IX

(249) See pages 84-5

(250) Described in "L'Art" as "un des plus heureux morceaux de peinture du Salon" (1879 vol. 2 p 146)

(251) "L' Art" 1882 vol. 3 p 168. "L'Automne" is illustrated on page 170, "L'Hiver" on page 171 and "L'Eté" in "L'Art" 1883 vol. 2 opposite page 197

(252) See pages 239-40

(253) "L'Art" 1887 vol.2 p 12

(254) Although Louise Breslau was fond of portraying children and domestic scenes, she was not strictly a portraitist. Her work will be considered in detail in Chapter 5

(255) "L'Art" 1887 vol. 2 p 10

(256) "Gauloises" June 1875 p 17

(257) Marble bust, no. 3458. For the review see "Gazette des Beaux-Arts" 1876 vol. 14 p 135

(258) Nélie Jacquemart had previously portrayed the president in 1872 (no. 845)

(259) "L'Art" 1886 vol. 2 pp 65-7

(260) The work is still in the Musuem. Anaïs Ségalas had already been portrayed by a woman artist, Mlle Elisa Guillaume, in 1844 (no. 894). Another portrait of her, a miniature, was exhibited in 1876 by Mme Antonine Lapoter, née Chéreau (no. 2636) Anaïs Ségalas, in her collection of poems entitled "La Femme", published in 1847, devoted one section to "La Femme Artiste"

(261) Other portraits of Séverine, a writer and journalist, by women, are Mme Camille Isbert's "Portrait de Mlle Séverine Dubray" (1885, 3rd of 8 miniatures all no. 2908) and Amélie Beaury-Saurel's work, already mentioned, of 1893. For details on Séverine see note 152

(262) The same subject was depicted by Mlle Marceline Horiot in 1880 (no. 4968)

(263) The following are examples :-
1880 M. Wendelen : "Les Femmes remarquables de la Belgique"
1886 Henri Carton : "Histoire des Femmes écrivains de la France"
1886 P. Jacquinet : "Les Femmes de France, poëtes et prosateurs"
1889 René Marcil : "Les Femmes qui pensent et les femmes qui écrivent"
1892 F. Lhomme : "Les Femmes Ecrivains. Oeuvres choisies"
1893 Pierre Bonnefont : "Nos grandes françaises"
1893 L. d'Alq : "Anthologie Féminine"
1893 Marius Vachon : "La Femme dans l'Art"
1896 A long study, entitled "La Femme Moderne par elle-même", appeared in the "Revue Encyclopédique" (p. 841) giving short biographies of all the eminent women of the time

(264) The following paragraphs will provide examples of the use of these words

(265) C Landon : "Annales du Musée .." 1814 p 44 in reference to Mlle Mauduit's "La mère abandonnée" (no. 677)

(266) C.P. Landon : "Annales du Musée" Salon de 1822 vol. 2 p 106

(267) "L'Illustration" 1845 vol. 4 p 520

(268) "Journal des Débats" 1802 (30 fructidor an 10) p 3. The other two were : "Une jeune fille dans un paysage. Elle pleure en

voyant le chiffre de son amant gravé sur un tronc d'arbre"
(no. 114) and "Une jeune femme embrassant son enfant" (no.
115)

(269) Of "La Rosière recevant le baiser de protection de la dame du
 lieu" (1806 no. 218) it was written : "L'âme candide et pure de
 Mlle Gérard a répandu une teinte virginale sur ce tableau, comme
 sur toutes les scènes domestiques auxquelles son pinceau prête
 tant de charme" ("Pausanias Français" 1806 p 216). Of "La
 tendresse maternelle" (1806 no. 220) : "Ce sujet convenait à
 sa sensibilité, à ses vertus" ("Pausanias Français" 1806 p 218)
 In 1822 C.P. Landon described her domestic scenes as being
 "d'un genre gracieux, toujours décent, et quelquefois roman-
 tique" ("Annales du Musée .." Salon de 1822 vol. 1 p 98)
 Of "Instruction d'une mère à sa fille avant la première
 communion" (1822 no. 577), Landon wrote : "Il se recommande
 surtout par la douceur de l'expression et par ce sentiment de
 décence et de grâce naïve que Mlle Gérard imprime à toutes les
 productions de son pinceau" ("Annales du Musée .." Salon de
 1822 vol. 2 p 16)

(270) "Une jeune fille donnant à manger à des poulets" (1802 no.
 903) was described as "une de ces scènes naïves qui plaisent
 dans la nature et qu'on aime à voir retracées par un pinceau
 aimable" (C.P. Landon : "Annales du Musée .." an.X vol. 3
 p 141)
 "Portraits de deux jeunes enfans" exhibited in the same year (no.
 902) portrayed a little girl trying to take away a vase of
 milk from her sister. Landon referred to this as "cette scène
 agréable" and wrote : "Le public fut charmé qu'une artiste
 aussi estimable que Mme Chaudet consacrât son pinceau à ces
 sujets doux et naïfs, qui semblent plus particulièrement
 réservés à son sexe" ("Annales du Musée .." an.X vol. 3 p 149)
 In 1808 when she exhibited "Une jeune fille pleure un pigeon
 qu'elle chérissait et qui est mort" (no. 122) Landon commented :
 "Madame Chaudet parait n'adopter que ceux (sujets) qu'elle sait
 être analogues à ses talens, et proportionnés à ses forces ;
 elle joint à cet avantage celui de n'exposer que des composi-
 tions douces, naïves, gracieuses et toujours nouvelles"
 ("Annales du Musée .." Salon de 1808 vol. 2 Part 3, p 16)
 "Une petite fille déjeunant avec son chien et lui faisant faire
 la révérence" (1812 no. 199) was praised for "La naïveté du
 sujet" (Landon "Annales du Musée .." Salon de 1812 vol. 1 p
 88)
 In 1814 Landon wrote : "Mme Chaudet se garde d'entreprendre des
 ouvrages au-dessus de ses forces, c'est-à-dire, de ces sortes
 de compositions qui exigent un dessin prononcé, un coloris
 fier, une touche vigoureuse" ("Annales du Musée .." Salon de
 1814 p 101)

(271) Landon wrote the following about this work : "Le sommeil dérobe
 à cet enfant la connaissance du péril auquel il vient d'échapper.
 Un serpent cherchait à se glisser dans son berceau ; mais un
 chien fidèle vient de déchirer le reptile. L'attitude du chien
 est calme et fière, et l'enfant a un abandon, une sécurité qui
 augmentent l'effet de cette scène touchante. Ce joli tableau
 reçut du public un accueil favorable au Salon de l'an IX.
 L'effet gracieux de l'ensemble, la légèreté et la facilité de
 la touche réunirent tous les suffrages" ("Annales du Musée .."
 an XI vol. 4 p 41) The work is in the Musée de Rochefort

(272) For reviews of this work see C.P. Landon : "Nouvelles des Arts.."

1802 vol. 2 p 10 and "Annales du Musée .." an XI vol. 4 p. 39,
Plate 16

(273) The artist exhibited another work entitled "L'enfant reconnai-
ssant", perhaps, the same work, in 1814 (no. 652)

(274) C.P. Landon : "Annales du Musée .." an XIII vol. 9 p. 147.
Plate 72 and also "Nouvelles des Arts .." an XIII vol. 4 p. 46

(275) In 1841 Mlle Henriquetta Girouard exhibited a similar work on
the theme "Jeune fille pleurant la mort de son oiseau ;
étude" 843

(276) C. Landon : "Annales du Musée .." Salon de 1822 vol. 1 p 63

(277) Mme Chaudet's "Un enfant endormi dans un berceau, sous la
garde d'un chien courageux qui vient de tuer, près de lui,
une énorme vipère" (1801 no. 62) was referred to as "cette
scène touchante" (Landon : "Annales du Musée .." an XI
vol. 4 p 41)
Mme Villers' "Un enfant dans son berceau, entraîné par les
eaux de l'inondation du mois de nivôse an X" (1802 no. 310)
was also described as "touchant" (Landon : "Nouvelles des
Arts .." an.XIvol. 2 p 10 and "Annales du Musée .." an XI vol.
4 p 39)

(278) Mlle Délestre (Caroline) : "Portraits du cit. *** et de son
épouse, près du tombeau de leurs enfans" (1802 no. 73)
Mme Bruyère (née Le Barbier) : "Une mère pleurant sur la
tombe de son fils" (1808 no. 82)

(279) Perhaps the same work as that exhibited, under a slightly
different title, in 1814 (no. 24) - "Effroi d'une jeune
Livonienne" - "Une jeune femme trouvant brisé l'arbre qu'elle
a planté à la naissance de son fils"

(280) C.P. Landon : "Annales du Musée .." Salon de 1810 p 23. "La
mère heureuse" and "La mère infortunée" exhibited as numbers
681 and 682 in 1814 were probably the same works

(281) No. 220 "Le tombeau de sa mère, grande miniature" - "On y
voit la Piété filiale soutenue par l'Amitié, et l'hymen
éteignant son flambeau"

(282) No. 103. Perhaps the same work as that exhibited in 1808
(no. 123) : "Une femme avec son enfant s'échappant, à l'aide
d'une échelle de corde, de sa prison dont elle a scié les
barreaux"

(283) C. Landon : "Nouvelles des Arts .." an XIII vol. 4 p 132
This picture may be compared with a work which has already
been mentioned in the classical section : "La Bénédiction
maternelle" by Mlle Hoguer (1819 no. 601) (+ see page 179)

(284) "Pausanias Français" 1806 pp 401-4

(285) C.P. Landon thought that the mother looked too happy for one
in her position and was uncertain as to whether the father
was unfaithful or simply absent ("Annales du Musée .." Salon
de 1814 p 44, Plate 30)

(286) See page 223

(287) Her real maiden name was Viel. She adopted Lescot in hommage
 to her mother's second husband ("L'Illustration" Jan. 18
 1845 p 520)

(288) In the Louvre

(289) "Mémoires de Madame de Genlis" (avec avant-propos et notes
 par M. Fs. Barrière) Paris 1857 (vol. XV of the Bibliothèque
 des Mémoires .. par M. Fs Barrière) pp 344-5

(290) See "L'Illustration" 1845 vol. 4 p 520 and "Les Lettres et les
 Arts" 1887 vol. 1 pp 102-9

(291) "Journal des Débats" Jan. 7 1845

(292) In "L'Illustration" 1845 vol. 4 p 520. The relevant quotation
 from this obituary is given on page 220

(293) "L'Illustration" 1845 p. 520

(294) See her obituary in "L'Illustration (see note 292)

(295) No. 576 with the description : "Il a lieu le jour de la fête
 et les deux jours suivants pendant lesquelles la statue de
 l'apôtre, en bronze, est revêtue des ornements pontificaux".
 Perhaps the same work as that exhibited in 1814 (no. 647) and
 called "Le baisement des pieds de la statue de Saint-Pierre
 dans la basilique de St. Pierre à Rome"
 This work, or one of them, is now in the Musée National du
 Château de Fontainebleau

(296) "Galerie des Peintres français au Salon de 1812, ou coup-
 d'oeil critique sur leurs principaux tableaux, et sur les
 différens ouvrages de Sculpture, Architecture et Gravure"
 1813 p 24

(297) Discussed and illustrated in C.P. Landon's "Annales du Musée .."
 Salon de 1822 vol. 2 p 41, Plate 23

(298) C.P.Landon : "Annales du Musée .."Salon de 1817 p 86, Plate 57
 The work is in the Musée Bertrand, Châteauroux

(299) "Annales du Musée .." Salon de 1819 vol. 2 p 48, Plate 31

(300) Needless to say this is only a small selection from her oeuvre

(301) See pages 221-2

(302) No. 766 with the note : "Une compagnie de pénitens, selon d'
 usage en Italie, doit l'accompagner"

(303) No. 764 with the description : "Ce prince accorde à Diane de
 Poitiers la grâce de M. Saint-Vallier, son père, condamné à
 mort" (M.d.R.)

(304) See C. Landon's "Annales du Musée .." Salon de 1819 vol. 2 pp
 63-4, 73, Plates 42 and 49

(305) No. 426 with the description : "Le sacrifice vient de s'
 accomplir ; une jeune fille parée encore d'habits somptueux,
 assise au milieu des religieuses, dont elle va faire partie,

livre aux ciseaux de l'une d'elles sa longue chevelure.
Déjà découronnée , son attitude annonce le recueillement
d'une pensée profonde. Trop émue pour se tenir debout, sa
mère, sans la regarder, étouffe ses sanglots. Sa soeur
s'appuie défaillante sur le coeur d'une vieille religieuse.
L'abbesse debout contre une table, contemple l'ordre de cette
scène. A l'autre bout, des enfants couronnés de fleurs
portent les habits ; une jeune religieuse impose silence à
leur étonnement. Le mystère de ce drame est dans la femme
éplorée, devant la néophyte tranquille. Une lettre et un
portrait révèlent le sacrifice que cette dernière vient d'
accomplir, en renonçant pour l'autre au choix invariable de
son coeur. Le bouquet virginal de la sainte victime s'effeuille
aux pieds de l'épouse heureuse qui pleure pourtant .."

(306) A. Jal : "Salon de 1833. Les Causeries du Louvre" Paris 1833
 p 184

(307) Other works on domestic themes by Fanny Geefs over this period
 were "Jeune fille conduisant ses soeurs à l'église" (1837 no.
 814), "Espérance" (no. 687) and "Regrets" (no. 688) of 1847
 and "L'attente" (Exposition Universelle 1855, no. 329 in the
 Belgium section)

(308) "L'Artiste" 1843 vol. 3 p 214 . Illustrated opposite page 212.
 Mlle Irma Martin also exhibited a work on this theme in
 1849 entitled "Un ange au ciel" (see page 208)

(309) See page 242

(310) Enfantin believed that the social individual should be a couple,
 a man and woman both equal in society and not restricted by
 conventional marriage ties ; thereby adultery and prostitution
 would be abolished. He also believed that the Woman Messiah,
 expected in 1833, would ressusciate Christianity and lead men
 to the Truth. See also note 108

(311) Fourier's "Théories des Quatre Mouvements" was first published
 in 1808. In this he wrote : "Les progrès sociaux et changements
 de période s'opèrent en raison du progrès des femmes vers la
 liberté" (1848 ed. p 132 and see also pp 146-8)

(312) Clair Demar's two works of 1833 have already been mentioned in
 the classical section (see note 108).
 Jeanne Deroin : "Cours de droit social pour les femmes" 1848
 Flora Tristan : "Promenades dans Londres" 1839
 Flora Tristan : "L'Union Ouvrière" in which a chapter is
 devoted to the position and rights of women - 1843
 Flora Tristan : "Emancipation de la Femme ou le Testament de
 la Paria" 1846
 See also page 192 and note 108

(313) Mme Cavé after her second marriage in 1846. Pierre Angrand has
 written a biography of this artist : "Marie-Elizabeth Cavé ;
 disciple de Delacroix" (Lausanne and Paris 1966)

(314) "Une jeune femme" no. 310, of 1804 and "L'enfant reconnaissant"
 no. 527, of 1810 (+ see page 222)

(315) No. 180 with the description : "Dans les campagnes, la veille
 de Noël, les enfans ont pour habitude de mettre leur sabot
 dans la cheminée. Noël est censé apporter quelque chose de bon

à ceux qui ont toujours été sages, et une poignée de verges
à ceux qui ont été méchans"

(316) No. 214 with a quotation from Anaïs Ségalas ; see page 207
In 1835 the artist had collaborated on an "Album d'Inspira-
tions poétiques" with Mmes Amable Tastu, Anaïs Ségalas,
Marceline Desbordes-Valmore, Mélanie Waldor and the daughter
of Charles Nodier (see Angrand op.cit. p 17)

(317) See for instance examples given in B1,F1,K2,N2,Q2
A few works on religious themes appear to be the only
exceptions. See C1 and G1

(318) See "L'Artiste" 1836 vol. 11 pp 170,332 ; 1837 vol. 13 p 197 ;
1845 vol. 4 p 34 ; 1845 vol. 5 p 51 ; 1846 vol. 6 p 127 ;
1849 vol. 3 p 131

(319) "Le Dessin sans Maître, Méthode pour apprendre à dessiner de
mémoire" (first published in 1850 ; the work went through four
editions in the 1850s alone) and "L'Aquarelle sans Maître"
(1851)
In "La Femme Aujourd'hui. La Femme Autrefois", published in
1863, the artist's interest in art education may be seen in the
larger context of the general education of girls

(320) Marguerite Gérard and Mme Chaudet for example ; see pages 221-2

(321) "L'Artiste" 1837 vol. 13 p 197

(322) In the Cabinet des Estampes of the Bibliothèque Nationale

(323) "L'Artiste" 1845 vol. 4 p 159. At the same time as Ingres,
Delaroche, Vernet and Robert-Fleury

(324) See page 51

(325) See page 51

(326) Charles Bigot commented on the increasing scale of genre
pictures in 1883 ("Gazette des Beaux-Arts" July 1883 p 5)

(327) All these exhibited in the Impressionist exhibitions .
See page 86

(328) The artistic theories surrounding "Intimism" provide the best
examples. The main organ for these was "La Revue Blanche"
published in the 1890s

(329) J.A.K. Castagnary : "Salons 1857-1870" (Paris 1892) vol.1 pp
427-8

(330) M.A. Report : "'Positive'Images of Women in France and Germany :
1870-1914) 1975 (Courtauld Institute)

(331) See Z1

(332) See S1

(333) J.K. Huysmans : "L'Art Moderne" Paris 1883 pp 201,232

(334) A previous instance is Mme B-Esther de Rayssac's "Une pénitente
de Port-Royal" of 1867 no. 1266

(335) "L'Art" 1875 vol.2 p 401. Two other works may be compared :
Mme A. Jacob's "Le passé et l'avenir" (1896 no. 1060 ;
illustrated in the catalogue) and Mlle Ottilie-W Roederstein's
"Les trois générations" (1897 SN no. 1070)

(336) "Gazette des Beaux-Arts" 1880 vol. 22 p 58

(337) ibid. 1884 vol. 30 p 107

(338) ibid. 1885 vol. 32 p 120

(339) ibid. 1884 vol. 30 p 107

(340) With the inscription : "Comment se fait-il qu'il y ait sur
la terre une femme seule - délaissée" (Michelet). The work
was done in April 1882

(341) Another example is Mme M. Escolier-Mamon's "Souvenir"
(1887 no. 874; illustrated in the catalogue)

(342) There were a few instances in the 1790s which should be
mentioned :-
1793 Emilie Bounieu : "Une femme qui peint" 201
1795 Adèle Romany : "Portrait de femme artiste" 438
1796 Marie Victoire Lemoine : "Intérieur d'un atelier de
 femme peintre" 284 (Metropolitan Museum of Art, New York)

(343) For the extent to which art was practised as such see pages 40-1

(344) This was the first of three works on the theme by the artist.
Others, in 1836 and 1855, will be considered presently

(345) Two other works on the theme were illustrated in current
periodicals : "Jean François Gigoux's "Portrait de femme
peignant un paysage d'après nature" at the Salon of 1833
(no. 1062) was illustrated in "L'Artiste" 1833 vol. 5
opposite page 181. It shows a young girl before an easel with
palette and brushes in hand, looking at her work. "Une Femme
artiste", illustrated in "L'Artiste" 1847 vol. 8 opposite page
80, simply depicts a seated woman. The name of the artist is
not given

(346) "Magasin des Demoiselles" 1845 vol. 1 p 237

(347) See Bibliography

(348) See pages 186-7, 194, 197, 199

(349) The subject for Marie Bashkirtseff's work was suggested to her
and another girl, Amélie, by Julian. He insisted that he should
own the picture and promised her fame on the basis of it.
"Jamais un atelier de femmes n'a été fait", she wrote in her
diary (wrongly as has been seen). The work included 16 people
and a skeleton and measured 4' 6" by 6' wide. She wrote about
the picture in her Journal. See "Journal de Marie Bashkirtseff"
Paris 1887 vol. 2 pp 238-268. The work was exhibited at the
Salon of that year, but was omitted from the catalogue
(see page 267 of the Journal)

(350) Illustrated in "L'Art" 1878 vol. 1 opposite page 292

(351) Illustrated in the "Gazette des Beaux-Arts" 1879 vol. 20
 opposite page 150

(352) "Dames artistes (no. 1)" -
 "Premiers éléments : - à Watteau ; - Dernière touche ; -
 A la Grâce ; - Huit têtes ; - La Justice et la Vengeance ; -
 Etude de nu ; - Peinture et cuisine ; - Entrée du musée ; -
 Sourire de Mme Angélique ; - Mme Angélique ; - Mme Angélique
 baîlle souvent ; - Sortie du musée" 5705
 "Dames artiste (no. 2)" -
 "A l'amateur ; - à Fragonard ; - Mlle Cequetas de Tétons ; -
 Le genre ; - Peinture ancienne ; - Outremer ; - A Rubens ; -
 la source ; - Prélude ; - Fin de la séance ; - Peinture reli-
 gieuse ; - Maîtresse-peintre"5706
 A humorous story about women artists in "L'Art" of 1880 by
 Paul Leroy was illustrated with drawings by Paul Renouard
 some of which, if not all, may have been based on the Salon
 exhibits. See "L'Art" 1880 vol. 1 pp .158, 182, 257, 277 and
 vol. 2 pp.9-16, 30-8

(353) Equally mocking are the cartoons illustrated in "Femina"
 1902 vol. 2 p.56

(354) "L'Art" 1887 vol. 2 p.10

(355) The artist also exhibited self-portraits, possibly the same
 work, at the Royal Academy in 1888 (no. 1326) and 1892 (no. 502)

(356) "L'Art" 1887 vol. 2 pp 11-12

(357) The artist also exhibited self-portraits at the UFPS in 1889
 (no. 44 ; fusain) and at the Salon of 1894 (no. 117) of which
 there is an illustration in the catalogue

(358) Clara Erskine Clement op.cit. p 393

(359) See page 187

(360) Works by these artists have already been considered in Section
 D. See Y3 and pages 226-7

(361) According to Edmond Pilon op.cit. p 121, this work was exhibited
 at the Salon of that year. It does not, however, appear in the
 catalogue . Illustrated in the "Revue de l'Art" February 1911

(362) "Gazette des Beaux-Arts" 1865 vol. 19 p 8

(363) See " Gazette des Beaux-Arts" 1869 vol. 1 pp 510-1 ; "Gazette
 des Beaux-Arts" 1870 vol. 4 p 56 ; "Gazette des Beaux-Arts'
 1872 vol. 6 p 44 ; "Revue Internationale de l'Art et de la
 Curiosité" 1870 vol. 3-4 pp 380-1 ; "L'Art" 1878 vol. 4 p 280

(364) This artist's work and the response it received will be considered
 in the following chapter

(365) See pages 234-5

(366) No. 596. The illustration was called "L'Emigrante" and the
 artist beneath the illustration L. Colin-Libour but this was
 surely an error for Uranie Colin-Libour is the only Colin-
 Libour listed in the catalogue

(367) See page 171 for a description of this work

(368) This was illustrated in the catalogue. The work recalls a
 picture exhibited by Jeanne Rongier in 1896 and called
 "'Christo in Pauperibus' ; Les Pauvres" (SFA no. 86)

(369) As it is impossible to tell whether certain works entitled
 "Charité" are allegorical or realistic, we have included these
 both in the classical section and in the present one.
 For allegories of charity which supply further evidence
 of the social consciousness of the period see Z1

(370) See note 312

(371) "Magasin des Demoiselles" 1846 vol. 2 p 236

(372) The following are examples :-
 1861 Jules Simon : "L'Ouvrière"
 1865 E. Boutigny : "Questions ouvrières. Du Travail des femmes
 dans les Imprimeries"
 1866 Julie V. Daubié : "La Femme Pauvre du dix-neuvième siècle"
 1871 Julie V. Daubié : "L'Emancipation de la Femme"
 1873 P. Leroy-Beaulieu : "Le Travail des Femmes au dix-
 neuvième siècle"
 1875 M. Aubrey : "Le Travail des Femmes dans les ateliers,
 manufactures et magasins"
 1877 Michel Lévy : "Les Femmes et la fin du monde"(see p.117)
 1883 Jules Grès and Paul Lafargue : "Le Programme du Parti-
 Ouvrier"
 1897 Léon Bloy : "La Femme Pauvre"

(373) 1810 "Des roses dans un vase de cristal" 796 ; "Anémones,
 reine-marguerites etc." 797 ; "Fleurs et fruits, même numéro"
 798
 1817 "Des Fleurs dans un vase de porcelaine de la Chine,
 enrichi de bronze doré" 736 ; "Une Table chargée d'un grand
 vase, d'un Homard et de différens Fruits, de Gibier etc." 737

(374) C.P.Landon:"Annales du Musée .." Salon de 1819 vol. 2 p 108

(375) "L'Artiste" 1836 vol. 11 p 256

(376) ibid.

(377) ibid. 1837 vol. 13 p 196

(378) ibid. 1842 vol. 1 p 323

(379) "Magasin des Demoiselles" 1846 vol. 2 p 237

(380) Albert de la Fizelière : "Exposition Nationale. Salon de 1850-1"
 Paris 1851 p 85

(381) "L'Artiste" 1853 vol. 11 p 17

(382) "Gazette des Beaux-Arts" 1859 vol. 3 p 23

(383) "Revue Universelle des Arts" 1870 p 451

(384) "Chronique des Arts" June 30 1888 p 192

(385) "Gauloises" July-August 1874 p 26

(386) "Gazette des Beaux-Arts" 1875 vol. 12 p 33

(387) See page 86

(388) See "Chronique des Arts" April 5 1890 no. 14 p. 106

(389) See page 86

(390) "Beaux-Arts" 1928 vol. 6 p 132

(391) "L'Art" 1879 vol. 2 pp 155-6

(392) "Gazette des Beaux-Arts" 1879 vol. 20 p 156

(393) A. Jal : "Salon de 1833. Les Causeries du Louvre" Paris 1833
 p 184

(394) For examples of these see page 186, E, Z, A1 and C1

(395) A. Jal op.cit. pp 233-4

(396) "L'Artiste" 1837 vol. 13 p 129

(397) "Magasin des Demoiselles" 1845 vol. 1 p 237

(398) "Correspondance de Berthe Morisot avec sa famille et ses amis ."
 Paris 1950 p 52

(399) pp 81-2

(400) Mme de Staël : "De l'Allemagne" Paris 1814 p 25

(401) "Oeuvres Complètes" Paris 1882 vol. 3 p 283 (in the preface to
 "Angélo")

(402) "Vie et opinions de M. Frédéric Thomas Graindorge" Paris 1867

(403) There were 21 by women at the Salon of 1840, 58 at that of
 1850, 60 at that of 1861 and 85 at that of 1870

NOTES - CHAPTER FIVE

(1) For the "Children in the Wood" see "Burlington Magazine"
 1936 vol. 69 p 196. The latter picture was sold to an
 American collector in 1932 by L. Knoedler. Before cleaning,
 the work was thought to be by John Hoppner

(2) No. 211
 "Love, banished heaven, in earth was held in scorn ,
 Wand'ring abroad in need and beggary ,
 And wanting friends ; though of a goddess born ,
 Yet crav'd the alms of such as passed by" (Sonnet xxiii)

(3) See pages 152-3

(4) "The Portrait Gallery of distinguished females, including
 Beauties of the Courts of George IV and William IV" with
 memoirs by John Burke, London 1833. An engraving of her
 portrait of Viscountess Eastnor appeared in vol. 1 (opposite
 page 79) and one of her portrait of Countess Ribblesdale
 in vol. 2 (opposite page 55)

(5) "Athenaeum" 1831 no. 185 p 316 and "Spectator" 1833 no. 248
 p 288

(6) "Spectator" 1833 no. 276 p 960. National Portrait Gallery

(7) Sold at Christie's London on November 22nd, 1974 .

(8) "Spectator" 1837 no. 462 p 427 and no. 463 p 451

(9) See Chapter 3 note 115

(10) National Portrait Gallery

(11) See for example the "Art Union" 1843 p 65 ; "Athenaeum"
 1847 no. 1019 p 495 and no. 1007 p 177

(12) See for example the "Spectator" 1840 no. 620 p 476 and
 "Athenaeum" 1849 no. 1128 p 603

(13) See page 153

(14) "Spectator" 1840 no. 620 p 476

(15) "Athenaeum" 1848 no. 1071 p 464

(16) "Art Union" 1842 p 59

(17) "Spectator" 1844 no. 829 p 474

(18) "Art Journal" 1853 p 143

(19) "Athenaeum" 1847 no. 1007 p 177

(20) "Athenaeum" 1849 no. 1128 p 603. For other examples see
 "Spectator" 1837 no. 449 p 114 and "Athenaeum" 1851 no. 1216
 p 195 and 1853 no. 1320 p 200

(21) "Art Journal" 1855 p 178

(22) E.C.Clayton op.cit. vol. 1 p 386

(23) See pages 71-2

(24) "Recollections of the British Institution" London 1860 p 44

(25) E.C. Clayton op.cit. vol. 1 p 379

(26) An engraving after a picture entitled "The Unlooked-for
 Returned" by Miss Louisa Sharpe was published in the "Keepsake"
 in 1833 and a print of the same is presently in the Castle Museum
 Nottingham. It is possible that both artists depicted similar
 subjects. Louisa's picture was never exhibited

(27) No. 369 in the catalogue. The picture illustrated a passage
 from an old ballad for which see T1

(28) See the "Athenaeum" 1833 no. 288 p 280 and the "Spectator"
 1833 no. 253 p 408

(29) "Spectator" July 6 1833 no. 262 p 623

(30) "Keepsake" 1833 opposite p 136, illustrating three stanzas from
 a poem by Ralph Bernal ; "Book of Beauty" (according to J-L
 Roget op.cit. vol. 2 p 206) illustrating six lines from "The
 Rape of the Lock". Both were love subjects

(31) Anna Brownell Jameson met three of the Sharpes in Dresden in
 the early 1830s. See her "Visits and Sketches and Home and
 Abroad" 1839 (3rd edition) vol. 2 p 136

(32) Page 284

(33) "The Phrenologist" appeared in the "Forget-me-not" in 1838
 (opposite page 107) and "The Dying Sister" in the same annual
 in 1836 (opposite page 117)

(34) Opposite page 60

(35) For criticisms of her classical subjects see "Spectator" 1838
 no. 514 p 423 and 1839 no. 566 p 423
 Other scriptural titles which appeared in catalogues from the
 second half of the 1850s either described previously exhibited
 works or studies for previously exhibited works : "Ruth and
 Naomi" (OWS 1856 no. 200), "Christ Raising the Widow's Son"
 (SFA 1861 no. 214), "Study for one of the Unwise Virgins" (OWS
 1863-4 no. 285), "Study for a Head of Christ. Executed in
 1838" (OWS 1868-9 no. 309)

(36) Opposite page 77

(37) For the quotations see A2 , F2e and Y1

(38) "Athenaeum" 1843 no. 810 p 443

(39) See, for example, the "Athenaeum" 1847 no. 1020 p 528, 1853 no.
 1331 p 535 and "Spectator" 1844 no. 827 p 425

(40) "Art Journal" 1874 p 232

(41) E.C.Clayton op.cit. vol. 1 p 380

(42) Opposite page 31

(43) "Athenaeum" 1830 no. 131 pp 268-9

(44) ibid. 1831 no. 182 p 268 and "Spectator" 1831 no. 149 p 453

(45) No. 327 in the catalogue. For the quotation see R1a

(46) Third edition 1839 p 136

(47) "Keepsake" 1832 opposite page 309. Others are "Juliet"
 ("Keepsake" 1831 opposite page 36), "Constance" and "Do you
 remember it ?" ("Keepsake" 1832 opposite pages 24 and 239)

(48) No. 224 in the catalogue. For the quotation see T1.
 There is an engraving of this in the Witt library

(49) Anna Brownell Jameson op.cit. vol.2 p 136

(50) Engravings of "Rebecca" (Scott's "Ivanhoe"), "Gulnare (Byron),
 and "The Orphan" appeared in the "Book of Beauty" for 1833 and
 "Chylena", "Margaret Carnegie" and "Flora" in that for 1834 -
 according to J-L Roget op.cit. vol.2 pp 43-4
 An engraving of "The Unlooked-for Return" was published in the
 "Keepsake" in 1833 (opposite page 27)

(51) "Edith" in Heath's "Book of Beauty" in 1835 (ref. J-L Roget
 op.cit. vol.2 p 44), "The Widowed Mother" and "The Gipsey
 Children" in the "Keepsake" in 1835 (opposite pages 275 and
 87), "Juliana" in the "Forget-me-not" in 1836 (opposite page
 153), "Caroline" in Heath's "Book of Beauty" in 1836 (opposite
 page 39), "Lalla" and "The Intercepted Letter" in the
 "Keepsake" of 1837 (opposite pages 139 and 227), "Calantha"
 in Heath's "Book of Beauty" in 1837 (opposite page 252), "The
 Keepsake" in Fisher's "Drawing-Room Scrap-Book" in 1839
 (opposite page 30)

(52) For respective quotations of the first four see T1 and V1

(53) The latter illustrated a passage from "Blackwood's Magazine"
 for which see T1

(54) For the quotations included in the title see U1 and page 138
 For description and discussion of the picture see the "Athenaeum"
 1842 no. 757 p 382

(55) op.cit. vol. 1 p 382

(56) Anna Brownell Jameson op.cit. vol. 2 p 136

(57) See "Spectator" 1833 no. 253 p 408 and 1839 no. 566 p 423

(58) "Athenaeum" 1831 no. 184 p 300

(59) op.cit. vol. 2 p 134

(60) J-L Roget op.cit. vol. 2 p 373

(61) July 26 1887 p 7

(62) Reproduced opposite page 128 of Richard Garnett's "The Life of W.
 J. Fox" London 1910

(63) Second edition, London 1877 vol. 1 pp 389-90

(64) Reproduced opposite page 176 of Richard Garnett's "The Life
 of W. Fox" London 1910

(65) An engraving after her portrait of Dr. Southwood Smith was
 published in Richard Hengist Horne's "A New Spirit of the
 Age" London 1844 vol. 1, opposite page 77 and also in the
 "People's Journal" Feb. 21 1846 no. 8 p 99
 Her portrait of Richard Hengist Horne is in the National
 Portrait Gallery

(66) London 1895 p 24

(67) "Monthly Repository" July 1837 p 41

(68) 1838 no. 510 p 331

(69) See page 153

(70) Given in Luther A. Brewer's "My Leigh Hunt Library. The
 Holograph Letters" Iowa, 1938 p 233

(71) In the National Portrait Gallery. An engraving after this
 appeared in the "People's Journal" May 16 1846 no. 20 p 267

(72) 1839 vol. 1 p 85

(73) She was a miniature and portrait painter and sister of the
 artists Eliza A. and F. Ellen Drummond. No. 724 in the
 catalogue

(74) Unpublished letter in the British Museum dated October 21st
 1839. For Gillies'claim that she was invited see "Wordsworthiana.
 A selection from papers read to the Wordsworth Society" edited
 by William Knight, London 1889 p 44. In the same statement
 Gillies recalled the year of the visit as 1841 which appears to
 be an error

(75) "The Letters of William and Dorothy Wordsworth. The Later Years"
 arranged and edited by Ernest de Selincourt, Oxford 1939
 vol. 2 pp 987-8. Dora's statement is quoted in Frances Blanchard
 op.cit. p 87
 The portrait is in the possession of the Dove Cottage Trustees

(76) "Poems by Thomas Powell" London 1842 p 283

(77) Engraved by Edward McInnes for Mr. Moon who published it on
 August 6 1841; re-published on Feb. 15 1853, for Miss Boyd,
 467 Oxford Street. A copy, probably by Mary Severn, is in the
 possession of the the Countess of Birkenhead

(78) Rydal Mount, Cumbria. Dora's verdict is quoted in Frances
 Blanshard op.cit. p 87. See also "The Letters of William and
 Dorothy Wordsworth. The Later Years" vol. 2 p 993 in a letter
 to Mr. Thomas Powell

(79) The original passed to a grandson, William Wordsworth of Bombay
 and was accidentally destroyed by fire. Gillies made two
 replicas (water-colour on ivory 11½ by 11") one for William
 Jr. Gordon Graham Wordsworth's father and the other for Miss

Quillinan, Dora Wordsworth Quillinan's step-daughter (in 1859).
These are in the possession of the Dove Cottage Trustees,
and Mrs. Dorothy Dickson respectively
The work was known in the family as "Darby and Joan". See for
instance an unpublished letter (in the possession of the Dove
Cottage Trustees) from Dora Quillinan to Mary Wordsworth dated
June 7 1841. The same letter suggests that the work was not
completed at that date

(80) For William Wordsworth's view on this miniature see "The
 Letters of William and Dorothy Wordsworth. The Later Years"
 vol. 2 p 993. For Dora's record of the second sitting see a
 letter from Dora to Isabella Fenwick undated but thought to have
 been written in August 1841 (see Frances Blanshard op.cit.
 p 87)
 The work is in the possession of the Dove Cottage Trustees

(81) Mrs. Dorothy Dickson collection

(82) "The Letters of William and Dorothy Wordsworth. The Later
 Years" vol. 2 p 994

(83) Vol. 1 opposite page 305

(84) Dove Cottage Trustees

(85) At Rydal Mount, Rydal, Cumbria. Wordsworth wrote a poem about
 this picture. See "The Poetical Works of William Wordsworth"
 edited by Ernest de Selincourt 1946 vol. 3 pp 411-2

(86) Painted from memory after her return from Rydal Mount. In the
 possession of Miss Joanna Hutchinson

(87) In the Rev. H.D. Rawnsley's "Literary Associations of the English
 Lakes" (Glasgow 1894 vol. 2 p 121) the author described an
 amusing incident related by Margaret Gillies to a friend.
 Apparently, just before she left, Wordsworth asked his wife's
 permission to kiss the artist

(88) "Letters of William and Dorothy Wordsworth. The Later Years"
 vol. 2 p 1001

(89) "Athenaeum" 1840 no. 657 p 436

(90) An engraving after this work was illustrated in Richard Hengist
 Horne's "A New Spirit of the Age" London 1844 vol. 1 opposite
 title page and also in the "People's Journal" Jan. 3 1846 no. 1
 p 8

(91) The first was in 1837 (RA no. 794). One of these, or perhaps a
 third, was exhibited at the Royal Manchester Institution in
 1852 (no. 166). A drawing of this subject is in the Department
 of Prints and Drawings in the British Museum

(92) Her portrait of William and Mary Howitt is in the Castle Museum,
 Nottingham. Her portrait of Mrs. Marsh was also exhibited at the
 Royal Manchester Institution in 1852, no. 610. Both these
 portraits were included in a Loan Exhibition at the New Gallery
 in 1892 (Algernon Graves : "A Century of Loan Exhibitions" vol.
 1 p 419)

(93) "Art Journal" 1851 p 161

(94) "New Spirit of the Age" : vol. 1 opposite page 305 ; vol. 1
opposite title page ; vol. 1 opposite page 77 ; vol. 2
opposite page 63
"People's Journal" 1846 : Jan. 3 no. 1 p 8 ; Jan. 24 no. 4 p 43 ;
Feb. 21 no. 8 p 99 ; March 14 no. 11 p 141 ; April 25 no. 17 p
225 ; May 16 no. 20 p 267 ; July 4 no. 27 p 29

(95) 1846 p 78

(96) E.C. Clayton op.cit. vol. 2 p 92

(97) For the quotation see Q

(98) Mary Howitt : "An Autobiography" London 1889 vol. 2 p 30

(99) Sold at Sotheby's, April 29 1971

(100) J-L Roget op.cit. vol. 2 p 375

(101) "English Woman's Journal" March 1 1859 vol. 3 p 55

(102) This figure was asked for "Leontes and Perdita" (PG 1852 no.336)
and for "Vivia Perpetua" (SFA 1859 no. 65)
One subject picture which she definitely sold during this
period was "Edith and Major Bellenden, watching from the battle-
ments of the Castle the approach of the Life Guards" (vide Old
Mortality) (SFA 1861 no. 153) which fetched £31. 10s (see
English Woman's Journal" 1861 vol. 7 no. 37 p 59)

(103) PG 1851 no. 442 ; BI 1853 no. 74 ; OWS 1853 no. 170 ; OWS 1854
no. 154. An engraving of one of these appeared in the "Keepsake"
of 1853 (opposite page 222) and another in the "Keepsake"
of 1856 to illustrate a French version of the ballad (opposite
page 161)

(104) SFA 1859 no. 65. The work is described in the "Art Journal"
1859 pp 83-4 and "The Dublin University Magazine" 1859 vol. 53
p 456

(105) "Athenaeum" 1853 no. 1331 p 535

(106) For the glosses belonging to these four works see F2a,F2b and pp.145-
For descriptions of the works see "Art Journal" 1855 p 185,
1859 p 173 and 1861 p 173

(107) 1854 p 174. For the gloss see F2a

(108) "Art Journal" 1855 p 185. This work was also exhibited at the
Royal Manchester Institution in the same year (no. 598)

(109) For the quotation see F2b. And see "Art Journal" 1856 p 176

(110) For the Wordsworth quotation accompanying "The Merry Days when
we were young" see page 145 . For the reviews see "Art Journal"
1859 p 173, 1860 p 174 and 1861 p 173

(111) See Section D(a)

(112) "Art Journal" 1859 p 173

(113) Praised in the "Art Journal" 1860 pp 85-6. She did exhibit
 another "Rebecca at the Well" at the Grosvenor Gallery in
 1881 (no. 308) which may have been the same picture

(114) For the gloss see page 146 . For the review see "Art
 Journal" 1863 p 95

(115) For the gloss see page 146

(116) For the gloss see page 146 . The work is described in the
 "Art Journal" 1864 p 97 and the "English Woman's Journal"
 1864 vol. XIII, no. lxxiv pp 124-5

(117) For the glosses see J2

(118) Her interest in this theme may be compared with that of Fanny McIan.
 See pp. 123-4 and R

(119) For the quotation see X

(120) "Art Journal" 1865 p 68

(121) For the gloss accompanying "Alone" see O2

(122) One from Tennyson's "Dora" (OWS 1871 no. 38), a work entitled
 "Marie" with a quotation for which no reference is given (OWS
 1873 no. 134), a scene from "The Tempest" showing Prospero and
 Miranda (OWS 1874 no. 83), Miss Hardcastle from Goldsmith's
 "She Stoops to Conquer" (OWS 1876 no. 129) and the knight and
 the lady from "The Nut-Browne Mayd" (OWS 1880 no. 160)

(123) For the glosses see O2 and R2

(124) Mary Howitt : "An Autobiography" London 1889 vol. 2 p 285

(125) For descriptions see E1

(126) E.C. Clayton op.cit. vol. 2 p 94

(127) No. 157 : "And when they asked him what he was seeking, he
 replied 'Cercando Pace' (seeking peace) ... And they laid him
 in an upper chamber whose windows were towards the rising sun
 ... And he found 'Peace'"

(128) "Times" July 26 1887 p 7

(129) No. 76. For the quotation see T2d

(130) July 30 1887 no. 795 pp 75-6

(131) E.C Clayton op.cit. vol. 2 p 93

(132) "Athenaeum" 1856 no. 1488 p 559

(133) See page 266

(134) "Athenaeum" 1853 no. 1331 p 535

(135) See page 268

(136) J-L Roget op.cit. vol. 2 p 375

(137) OWS 1875 no. 52

(138) There is no indication which of the four Miss Sharpes this was

(139) E.C. Clayton op.cit. vol. 2 p 126

(140) See pages 139-40

(141) "Athenaeum" April 26 1845 no. 913 p 417

(142) Mrs. Criddle will be the subject of the following biography

(143) For the quotations see Z1, E2a and page 139
 For reviews see "Athenaeum" April 22 1848 no. 1069 pp 417-8,
 "Spectator" April 22 1848 p 399 and "Athenaeum" May 18 1850
 no. 1177 p 536

(144) "Art Journal" 1852 p 179, "Athenaeum" May 1 1852 no. 1279 p
 495 and "Art Journal" 1854 p 176

(145) Bessie Rayner Parkes : "Remarks on the education of girls"
 London 1854 p 20

(146) "Athenaeum" April 23 1842 no. 756 p 363

(147) J-L Roget op.cit. vol. 2 p 337

(148) Unless she was the Miss M. Alabaster who exhibited a sculpture,
 "Head of Apollo", at the Society of British Artists in 1829
 (no. 840)

(149) She also adopted three sons of a deceased brother, two of whom,
 being good linguists, obtained consulships in the Far East.
 Her own son emigrated to North America

(150) For the full quotations see Z1 and Y1

(151) See page 277

(152) For the quotations see Y1, V1, E2d

(153) For the glosses see J2

(154) "And Jesus called a little child, and set him in the midst of
 them" (St. Matthew, ch. XVIII, v. 2) (OWS 1866/7 no. 279) ;
 "The Watch by the Cradle" (suggested by the 14th chapter of
 St. John,18th verse) (OWS 1877/8 no. 313) ; "St. Monica,
 Mother of St. Augustine" (OWS 1871 no. 202) ; "Study for
 Princess Elizabeth, daughter of Charles the 1st at Carisbrook"
 (OWS 1873 no. 226)

(155) Only four of her pictures - the four Seasons, painted in 1854
 and exhibited at the Royal Manchester Institution in 1855
 (nos. 551-4) - were engraved. The originals were bought by
 the Baroness Burdett-Coutts

(156) "Beatrice" in the "Keepsake" 1834 opposite page 67 ; "Maida"
 in the "Keepsake" 1839 opposite page 36 and "Mary of Mantua"
 opposite page 235 ; "Leila", also in the "Keepsake",1844
 opposite page 187

(157) For the quotation see U1

(158) For the quotation see T1.
 "Spectator" April 22 1837 no. 460 p 379

(159) For the quotation see K. Her first religious
 subject was a water-colour of "The Holy Family" (SBA 1830
 no. 728)

(160) "Spectator" April 20 1839. no. 564 p 576

(161) ibid. April 24 1841 no. 669 p 404 and see also the "Athenaeum"
 May 1 1841 no. 705 p 345

(162) For the quotations accompanying these titles see N, P, C2

(163) "Athenaeum" May 1 1852 no. 1279 p 495

(164) "Spectator" April 26 1845 no. 878 p 403

(165) 1850 p 180. See also the "Athenaeum" May 18 1850 no. 1177 p 536

(166) For the quotation see F2a . Review in the "Athenaeum"
 May 10 1851 no. 1228 p 507

(167) For the gloss see F2b . Review in the "Art Journal"
 1854 p 159

(168) No. 361. For the quotation see E2b

(169) See letter from Charlotte Canning dated Oct. 31 1843 (quoted by
 Augustus Hare op.cit. vol. 1 p 270) and a letter from the same
 dated Jan. 7th 1844 (Augustus Hare op.cit. vol. 1 p 276)

(170) Augustus Hare op.cit. vol. 1 p 295

(171) ibid. p 314

(172) "Spectator" Nvo. 18 1848 p 1118

(173) Augustus Hare op.cit. vol. 1 p 362

(174) ibid. pp 334-5

(175) ibid. pp 346-7. Jane Ellice kept a diary which was published
 in 1975 in Canada (ed. Patricia Godsell)

(176) Augustus Hare op.cit. vol. 1 p 347

(177) ibid.

(178) See for example letters written in June 1857 and July-August
 1857 (given in Surtees op.cit. Letters W.6. p 12 andW.8.
 p 14)

(179) "Letters of Dante Gabriel Rossetti" edited by Oswald Doughty
 and John Robert Wahl, Oxford 1965 vol. 1 pp 180-1

(180) Quoted in Surtees op.cit. p 4

(181) Letter quoted in Virginia Surtees' "Charlotte Canning" London
 1975 p 226. Three drawings entitled "Heroic Stories", depicting
 stiff figures in flattened space, may date from this period .
 (Sold at Sotheby's Belgravia on May 22 1979)

(182) Letter July-August 1857 (Surtees op.cit. p 15, Letter W.8.)

(183) Augustus Hare op.cit. vol. 2 p 103

(184) ibid. p 113

(185) ibid. pp 402-3

(186) She wrote that this subject interested her because of the
 concentration of grief in the Virgin Mary at the foot of the
 Cross. The Virgin is shown with her eyes shut and her hands
 placed simply on her knees, an attitude which Lady Waterford
 described as having " a truth which far surpasses the extra-
 vagant attitudes of the later painters" (Augustus Hare op.
 cit. vol. 3 p 77)

(187) Augustus Hare op.cit. vol. 3 pp 87-8

(188) She painted several portraits of Lady Waterford, on this
 occasion and during a second visit in 1867

(189) Augustus Hare op.cit. vol. 3 p 193

(190) For a list of the others, see Hare vol. 3 p 217
 It has been suggested that Lady Waterford may have been aware
 of William Bell Scott's contemporary designs for Sir Walter
 Trevelyan's house, Wallington, south of Ford. Bell Scott
 was commissioned to decorate the walls of the great hall with
 incidents in Northumbrian history, taking local inhabitants
 as models. Relevant also, perhaps, were the Pre-Raphaelite
 wall paintings at the Oxford Union in 1857 and Watts' frescoes
 at Lincoln's Inn : "Justice : A Hemicycle of Law-Givers"
 completed in 1859. See a letter from Virginia Surtees in
 "Country Life" 1978 vol. LLXIII p 155

(191) See Letters of Oct. 3 1863 and Jan. 20 1870 (Surtees op.cit.
 pp 54 and 73, Letters W.38 and W.58) and also Hare op.cit.
 vol. 3 p 261

(192) Augustus Hare op.cit. vol. 3 pp 278, 281

(193) ibid. p 221

(194) ibid. p 236

(195) ibid. p 358

(196) ibid. p 388

(197) ibid. pp 392, 399, 400-1

(198) "Art Journal" 1878 p 155

(199) See page 288

(200) Augustus Hare op.cit. vol. 3 pp 445 and 461. She also exhibited
 at the 2nd Autumn exhibition of the Royal Institution in
 Manchester in 1884 (nos. 564 and 958)

(201) Augustus Hare op.cit. vol. 3 p 420

(202) See page 286

(203) Augustus Hare op.cit. vol. 3 pp 462-3

(204) ibid. pp 193-216

(205) ibid. pp 206, 210, 213,205 and 208

(206) ibid. p 214

(207) ibid. p 207

(208) See page 289

(209) Augustus Hare op.cit. vol. 3 p 203

(210) ibid. pp 209, 203 and 205

(211) See page 290

(212) For Henry James's tribute see "The Middle Years" London 1917
 pp 108-118. For the others see pages 286, 288 and note 192

(213) An undated letter from Watts to Lady Somers quoted in Wilfrid
 Blunt's "England's Michaelangelo" 1975 pp 98-9

(214) Augustus Hare op.cit. vol. 3 p 281

(215) Catalogue of an exhibition of her works at Carlton House Terrace
 in 1892

(216) George Moore : "Modern Painting" London 1893 p 224
 When she exhibited at the Dudley Gallery in 1883 one newspaper
 accused her of adapting her figures from Michaelangelo (see
 Augustus Hare op.cit. vol. 3 p 420). In 1864 she was described
 in the "Fine Arts Quarterly Review" as being "of all our
 amateur painters, the one most capable of lofty design, composi-
 tion, and colour ; indeed rivalled in these respects by few
 of our professional artists" (vol. 2 p 198 ff)

(217) Given in Richard Garnett's "Life of W.J. Fox" London 1910
 p 191

(218) Given in F.A Hayek's "John Stuart Mill and Harriet Taylor"
 London 1951 p 122. Harriet Taylor continues : "The progress of
 the race awaits for the emancipation of women from their present
 degraded slavery to the necessity of marriage, or to modes of
 earning their living which (with the sole exception of artists)
 consist only of poorly paid and hardly worked occupations, all
 the professions, mercantile, clerical, legal and medical, as
 well as all government posts being monopolized by men. Political
 equality would alone place women on a level with other men in
 these respects". In 1848 Harriet Taylor sent a copy of John
 Stuart Mill's "Principles of Political Economy" to Elisa Fox
 because of her interest in woman's cause (also p 122)

(219) E.C. Clayton op.cit. vol. 2 p 81

(220) ibid. p 82

(221) "Argosy" February 1890 p 112

(222) ibid.

(223) E Clayton op.cit. vol. 2 p. 82

(224) Richard Garnett reports that in 1846 Eliza, "school days over,
 was training as an art student, occasionally visiting her
 aunts, Miss Sarah Fox and Miss Anne Fox, at Norwich"
 ("The Life of W.J. Fox" op.cit. p 276)

(225) See page 21

(226) See page 29

(227) Two were exhibited in London (RA 1853 no. 953 and SFA 1858 no.
 57) and one in Manchester at the Royal Institution (1857 no.
 154). An engraving from a portrait of her father appeared in
 the "People's Journal" in 1847 (vol. 3 p.68). It is possible
 that "A Portrait" exhibited at the Society of British Artists
 in the same year (no. 583) was the original

(228) "The Soldier's Bequest" was first exhibited at the Royal
 Manchester Institution in 1847 (no. 584).
 According to the "Art Journal". "The Patriot" depicted "a
 vaulted prison, not unlike the vaults of Chillon ; a prisoner
 is chained to one of the pillars" (1857 p 173). The work was
 also exhibited at the Society of Female Artists in 1858, no.
 71

(229) "The Letters of Mrs. Gaskell" edited by J.A.V. Chapple and
 Arthur Pollard, Manchester University Press 1966 p 106

(230) "Argosy" Feb. 1890 p.113. Her portrait of E.B. Browning is
 not mentioned in the catalogue for the Royal Academy exhibition
 in 1859. In 1866 a portrait of "The late Mrs. Barrett Browning,
 taken in Rome" was exhibited at the Society of Female Artists
 (no. 23*). This must have been the same work

(231) E.C. Clayton op.cit. vol. 2 p. 85

(232) For the quotation see X

(233) See page 270 and Q

(234) See X

(235) E.C. Clayton op.cit. vol. 2 p 86

(236) See "Art Journal" 1864 p. 164

(237) See "Art Journal" 1864 p.164 and 1865 p 169

(238) "Cleon the Poet"

(239) See page 90

(240) "Munby. Man of Two Worlds. The Life and Diaries of Arthur J.
 Munby 1828-1910" by Derek Hudson ; London 1972 pp. 265-6
 Like Eliza Bridell-Fox, Barbara Lee Smith Bodichon (1827-1891)
 was an artist and a feminist. Like the former also her father
 was a Unitarian - the Radical Member for Norwich at the time
 of the Repeal of the Corn Laws. In 1867 B.L.S. Bodichon also

visited Algiers. She was a landscape painter

(241) Her portrait of Mme Bodichon was said to have been painted
 "with force and simplicity" in the "Art Journal" 1868 p 108

(242) For the quotation see A1

(243) February pp. 112-3

(244) "Art Journal" 1857 p. 176

(245) "Athenaeum" 1856 no. 1492 p. 687

(246) " The Amberley Papers - Letters and diaries of Lord and Lady
 Amberley" edited by Bertrand and Patricia Russell 1937 vol.
 1 p. 314

(247) Given in Michael St. John Packe's "The Life of John Stuart Mill"
 London 1954 p. 434

(248) Mrs. Thomas Thornycroft (Miss Mary Francis) was the first.
 From 1846 or 1847 she received royal commissions and from
 1847 exhibited royal portraits (statues and busts) at the
 Royal Academy

(249) "Art Journal" 1866 p. 285

(250) Given in "Munby, Man of Two Worlds ; the Life and Diaries of
 Arthur J. Munby 1828-1910" 1972 pp. 218-9

(251) Obituaries in the "Art Journal" 1873 p. 80 and the "English-
 woman's Review" 1873 no. xiv p. 157. In the "Art Journal" she
 was referred to as "one of our most accomplished female
 sculptors"

(252) For the quotation see F2d

(253) "Illustrated London News" July 15 1854 vol. 25 p. 37

(254) "The Emigrant" is almost certainly the same work as that
 exhibited at the Society of Female Artists in 1858 (no. 33)
 on which occasion the author was listed as Emma E. Blunden-
 mistakenly. It portrayed "a girl, absorbed in grief, resting
 on the bulwark of a ship" - "Art Journal 1858 p. 143

(255) Ruskin's letters to Anna Blunden are given in Virginia
 Surtees' "Sublime and Instructive" London 1972. See letters
 B.1., B.2., B.3. and B.4. dating from Oct. 22 1855 to
 Feb. 3 1856 (pp. 84-6)

(256) "She is visiting the bedside of a poor woman, whose days seem
 numbered" - "Art Journal" 1856 p. 164

(257) "Hope in Death" (SBA no. 621)

(258) Surtees op.cit. Letter B.8. (p. 89)

(259) E.C. Clayton op.cit. vol. 2 p. 198

(260) "Academy Notes" London 1858 p 26. See also E.C. Clayton op.
 cit. vol. 2 p 198 and the "Art Journal" 1858 p. 168

(261) Surtees op.cit. from Letter B.22 (Oct. 8) to Letter B.38 (March
 7) (pp 97-110) this is the main substance of his letters

(262) "Academy Notes" London 1859 p. 29

(263) E.C. Clayton op.cit. vol. 2 p. 199

(264) Surtees op.cit. Letter B.11 (p. 90)

(265) ibid. Letter B.94 (p. 140)

(266) ibid. Letter B. 87 (p. 136)

(267) ibid. Letter B.94 (p. 140)

(268) See E.C. Clayton op.cit. vol. 2 p. 201 and "Art Journal"
 1867 p. 145

(269) E.C. Clayton op.cit. vol. 2 p. 200. See also the "Times" May 18
 1864 p. 10 and Francis Turner Palgrave's "Essays on Art" London
 1866 p. 75

(270) Review in the "Art Journal" 1867 p. 145

(271) E.C. Clayton op.cit. vol. 2 p. 203

(272) ibid. p. 206

(273) "Art Journal" 1870 p. 142

(274) E.C. Clayton op.cit. vol, 2 p. 221. Presumably Elizabeth Jerichau
 who spent many years in Rome. See "Journal des Arts" Sept. 9
 1881 no. 35 p. 4

(275) Surtees op.cit. p. 81

(276) "Critic" July 27 1861 p. 109

(277) "Art Journal" 1861 p. 273

(278) "Pre-Raphaelite Diaries and Letters" edited by William Michael
 Rossetti, London 1900 p. 183

(279) "Academy Notes" 1855 p. 31

(280) "Critic" July 27 1861 p. 109

(281) Perhaps the anonymous articles which appeared on Dec. 1 1855
 p 79, Dec. 29 1855 p 153 and May 10 1856 p. 31

(282) See pages 142-3

(283) Catalogue of an exhibition held at the Tate Gallery in 1935
 p. 6

(284) "Critic" July 27 1861 p. 109

(285) ibid. p. 110

(286) See the "Art Journal" 1861 p 273, the "Critic" July 27 1861
 pp. 109-10, the "English Woman's Journal" Sept. 1 1861 no. 43 pp

143-4

(287) "Fraser's Magazine" Nov. 1861 vol. 64 pp. 580-1

(288) William Michael Rossetti : "Some Reminiscences" London
 1906 p. 154

(289) "Times" June 19 1935

(290) One other connection is of interest. Her future husband,
 Edward Matthew Ward's elder brother, Charles James, married
 Margaret Sarah Carpenter's youngest daughter, Jane (born
 around 1824)

(291) "Memories of Ninety Years" London 1939 p.7

(292) The following are examples : "The pet hawk" (RA 1851 no. 160),
 "Pets" (RA 1854 no. 1081), "The intruders" (RA 1856 no. 330:
 described by E Clayton op.cit. vol. 2 p. 165), "A Good Meal"
 (SFA 1858 no. 139 ; described in the "English Woman's Journal"
 May 1 1858 vol. 1 p 208), "Scene from the childhood of Joan
 of Arc" (RA 1867 no. 523 ; the description in the "Art Journal"
 1867 p. 138 corresponds with an engraving after the picture,
 presently in the Witt Library), "The Poet's First Love"
 (RA 1875 no. 380 ; see E1 for the quotation) and "The
 ugly duckling" (RA 1876 no. 342)

(293) "Memories of Ninety Years" p. 33

(294) ibid. p. 34

(295) ibid. p. 41

(296) "Athenaeum" 1850 no. 1180 p. 615. See also "Art Journal"
 1850 p. 174 and "Memories of Ninety Years" p. 51

(297) "Memories of Ninety Years" p. 51

(298) See page 29

(299) No. 582 was described in the "Art Journal" 1854 p. 170 and
 the "Athenaeum" 1854 no. 1386 p. 626 ; no. 348 was described in
 the "Art Journal" 1855 p. 176 ; no. 330 was described in the
 "Art Journal" 1856 p. 168 and by E.C. Clayton op.cit. vol. 2
 p 165 ; no. 122 was described in the "Art Journal" 1857 p. 167

(300) The first of these was illustrated in "Apollo" March 1964

(301) See "Athenaeum" 1853 no. 1335 p. 654, "Art Journal" 1856 p. 172
 and "Athenaeum" 1856 no. 1190 p. 622

(302) "Art Journal" 1854 p. 170 ; "Art Journal" 1856 p. 168 and
 1857 p. 167

(303) For the quotation see Chapter 3, note 38

(304) "Art Journal" 1858 p. 167

(305) See S, X, Z, D1, E1 for details of these works

(306) See X and D1 for details of these works

(307) "Art Journal" 1864 p. 357. No. 77 of a series on "British
 Artists, their style and character"

(308) "Queen Mary quitted Stirling Castle etc." (RA 1863 no. 386),
 "Scene from the childhood of Joan of Arc" (RA 1867 no. 523)

(309) For the quotation see Z

(310) "Memories of Ninety Years" p. 119. For a review of the work
 see "Art Journal" 1866 pp. 166-7. The quotation accompanying
 the picture is given in X

(311) For the description accompanying the picture see D1. See
 the "Art Journal" 1876 pp. 216, 319 and 1879 p. 167. See
 also "Memories of Ninety Years" p. 121

(312) "Memories of Ninety Years" p. 196

(313) ibid. pp. 197-8

(314) ibid. p. 53

(315) ibid. p. 269

(316) For the quotation accompanying the title see E1. See also the
 "Art Journal" 1872 p 183. The picture is in the Walker Art
 Gallery, Liverpool

(317) "Memories of Ninety Years" p. 124

(318) ibid. p. 174

(319) See page 72

(320) See page 21

(321) "Art Journal" 1864 p. 261

(322) Byron's "Marion", Collins' "Alice" and see also E2a and F2b
 E. Haydon Osborn may have been related to the artist

(323) "Art Journal" 1864 p. 261

(324) Chicago. Collection of Robert Peerling Coale. The mother and
 three children are depicted on a sandy beach, in a closely
 knit but informal group. The scene is enlivened by the attempt
 of the smallest child on his mother's lap to remove the hat
 of his rather prim sister seated to the right

(325) See F2a for the gloss

(326) "Art Journal" 1864 p. 261. The work was also exhibited at the
 International Exhibition in London in 1862 (no. 765)

(327) See page 167 for a closer examination of this work

(328) See F2d for the gloss

(329) For the gloss and discussion see pages 144-5

(330) "Art Journal" 1861 p 169. For the quotation and discussion
 see X and page 128

(331) When shown in 1859 it was reviewed in the "Art Journal" 1859
 p 169

(332) "Spectator" May 23 1863 p 2035

(333) "Art Journal" 1864 p 263

(334) ibid pp 250,263

(335) This work was also exhibited at Crystal Palace in 1864.
 See "Art Journal" 1864 p 263.

(336) See page 148. The illustration is opposite

(337) "Art Journal" 1870 p 168. According to the same magazine she
 was still living in Munich in 1872 ("Art Journal" Jan. 1
 1872 p 10)

(338) See 02 for the gloss

(339) For good reviews see the "Art Journal" 1872 p 184 and 1875
 p 247 ; for criticism see "Art Journal" 1871 p 150 and
 1870 p 168

(340) Exhibited at the Royal Birmingham Society of Artists in 1878
 no. 431

(341) The reason for supposing this is that she exhibited two Venetian
 subjects in 1877 (RA no. 462 and DG(oil) no. 314)

(342) I have located only a few catalogues for the exhibitions held
 at Crystal Palace : for the year 1868 (Crystal Palace Picture
 Gallery) and 1895-1899 (Victoria Cross Gallery). Osborn
 exhibited in 1864 (see notes 346 and 347), 1868, 1895, 1897,
 1898, 1899

(343) "Art Journal" 1860 p 170 and 1864 p 263

(344) There may be some confusion over dates here. According to E.C
 Clayton (op.cit. vol. 2 p 118) she began instruction with her
 father in 1868. In a letter to Ford Madox Brown dated April
 1864, however, Dante Gabriel Rossetti wrote that Marie Spartali
 was about to become Brown's pupil ("Letters of Dante Gabriel
 Rossetti" edited by Oswald Doughty and John Robert Wahl ;
 Oxford 1965 vol. 2 p 504). Perhaps Brown first taught Marie
 Spartali on her own although there is no reference to any
 individual tuition and then in 1868 taught his three children
 and Marie Spartali together

(345) E.C. Clayton op.cit. vol. 2 pp 118-9

(346) This was illustrated in the "Magazine of Art" 1895 vol. 18 p 345

(347) For the gloss see 02

(348) "Art Journal" 1870 p 87

(349) For the quotation see N2

(350) Percy Bate : "The English Pre-Raphaelite Painters : their
 Associates and Successors" London 1899 p 22

(351) The latter was illustrated in the "Magazine of Art" 1895
 vol. 18 p 343. It was reviewed in the "Art Journal" 1872 p 74

(352) E.C. Clayton op.cit. vol. 2 p 121

(353) William Michael Rossetti : "Some Reminiscences" London 1906
 vol. 1 p 422

(354) This information was given by Lucy's daughter, Helen Rossetti
 Angeli in an annotation to the chapter on Christina Rossetti
 in Edith Sitwell's "English Women" (London 1942) p 143. The
 copy is owned by Mrs. Imogen Dennis

(355) Mrs. Imogen Dennis

(356) The work is presently in the Catholic Church, Burford
 It is described by E.C. Clayton op.cit. vol. 2 p 123

(357) "Magazine of Art" 1890 vol. 13 pp 289-96

(358) ibid. 1895 vol. 18 p 342

(359) "Some Reminiscences" 1906 vol. 1 p 432

(360) Lucy Madox Rossetti : "Mrs. Shelley" London 1890 p 41

(361) ibid. p 229

(362) "Romeo and Juliet" of 1871 and "Ferdinand and Miranda" of 1872

(363) E.C. Clayton op.cit. vol. 2 p 123

(364) ibid. p 121

(365) ibid. p 123

(366) "Chronique des Arts" April 21 1894 no. 16 p 127

(367) See page 312 and note 344

(368) "Letters of Dante Gabriel Rossetti" Oxford 1965 vol. 2 p 504

(369) E.C. Clayton op.cit. vol. 2 p 136 and "Portfolio" 1870 p 118

(370) "Portfolio" 1870 p 118

(371) "Gazette des Beaux-Arts" 1869 vol. 2 p 56

(372) "Antigone, in defiance of King Creon, gives Burial Rites to
 the body of her brother, Polynices", the picture's full title,
 was sold at Christie's, London on August 2 1978

(373) "Art Journal" 1871 p 85

(374) E.C. Clayton op.cit. vol. 2 p 137

(375) For the quotation see T2d

(376) Henry James : "The Painter's Eye. Notes and essays on the pictorial arts" London 1956 p 92 ; William Michael Rossetti in the "Portfolio" 1870 p 118

(377) For the quotation see N2

(378) GG 1880 no. 267 ; GG 1881 no. 267 and the "Beatrice" in the Delaware Art Museum

(379) Her "Joli Coeur" after Rossetti was sold at Sotheby's Belgravia on March 20 1979

(380) Henry James op.cit. p 93

(381) Given in Viola Meynell's "Alice Meynell. A Memoir" London 1929 p 22

(382) Early sketches by the artist are in the possession of Mr. Rupert Butler, London. Those of dance couples show her ability to portray movement. She herself wrote : "As a child, before I had ever thought of serious study, I could make my animals move" (Given by a correspondent to the "Times" on October 4 1933, p 17, the day after her obituary had been published)

(383) Given in "Country Life" Nov. 21 1952 vol. 112 p.1640

(384) Mr. Rupert Butler collection

(385) "Exhibition of water-colour drawings and pictures by Amateur Artists and Art contributions in aid of the Fund for the relief of the widows and orphans of British Officers engaged in the War with Russia" Burlington House, Piccadilly. The two works in question were listed as numbers 440 and 457 in the catalogue

(386) See page 25

(387) E.C. Clayton op.cit. vol. 2 p 140

(388) This is presumed in the Butler family to be a self-portrait. Her only other presently known work from the Kensington Schools period is a sketch of the Black Prince and King John also in the possession of Mr. Rupert Butler

(389) Lady Butler : "An Autobiography" London 1922 pp 51-2

(390) Unless she was the Miss E. Thompson who exhibited "A group of water-lilies" at the Society of British Artists in 1869 from a Teignmouth address - and this seems unlikely - this was her sole contribation to exhibitions that year

(391) Viola Meynell op.cit. p 44

(392) "An Autobiography" p 62

(393) ibid. p 61. Her enthusiasm for the Italian people may be compared with that of Anna Blunden who was in Italy at the same time (see E.C. Clayton op.cit. vol. 2 pp 216-9)

(394) This work is now in Ventnor Church, Bonchurch, Isle of Wight

(395) "An Autobiography" p 95

(396) The altar-piece depicting Young Franciscan Monks is still in the Church

(397) "Art Journal" 1876 p 190

(398) Religion and the Church enter into Italian genre scenes exhibited at the Society of Lady Artists in 1872 and 1873. Calvaries are depicted in two late military paintings : "Eyes Right" of 1916 , a water-colour frequently reproduced (see "Country Life" Jan. 18 1979 p 155) and her last painting (untitled) of 1928, a scene from the First World War in which a Light Cavalry Patrol halts by a Calvary (Mr. Rupert Butler collection). Her son, Dick, went into the Church and she painted a picture of him receiving a blessing before going to war (WW1). This work is in the possession of Mrs. Rhona Butler

(399) Reproduced in Alice Meynell's "Some Modern Artists" London 1883 . For full titles of her RA exhibits see F1, J1 and N1

(400) "Sketches by a Pilgrim on the way to Paray-le-Monial" - "Graphic" Sept. 20 1873 p 264 ; Sept. 27 1873 p 288

(401) The following are examples :-
"De la conduite de la guerre d'orient. Expédition de Crimée. Mémoire adressé au gouvernement de S.M. l'Empéreur Napoléon III par un officier général" Bruxelles 1855
"The Illustrated History of the Expedition to the Crimea, from the embarkation of the Allies at Varna etc." no.s 1-5, London 1854-5
"Letters from Head-Quarters - or, the Realities of the War in the Crimea. By an officer on the staff" London 1856 2 vols (2nd edition 1857 ; 3rd edition 1858)
"Scenes in the Camp and Field : being sketches of the war in the Crimea" 3 parts London 1857, '58
"Some observations on the War in the Crimea" London 1855

(402) Copyright was later sold to the Fine Art Society

(403) See for example the "Art Journal" 1874 p 163 ; "Athenaeum" May 16 1874 p 670 ; "Academy" May 23 1874 p 584 ; "Times" May 2 1874 p 12, May 4 p 8, May 26 p 6 ; "Daily Telegraph" May 4 1874 p 2, May 9 p 5

(404) "An Autobiography" p 113

(405) "Art Journal" 1874 pp 67-8

(406) At the posthumous sale of Galloway's collection (Christie's June 24, 26, 27, 1905) this was lot 289. This work and "Halt ! A reminiscence of Aldershot" are reproduced in the "Art Annual" 1898 p 17

(407) "Graphic" Oct. 16 1875 p 376

(408) "An Autobiography" pp 127-8. She also visited Henriette Browne's studio. See page 349

(409) See for example the "Art Journal" 1875 p 220 and "L'Art"

1875 vol. 3 p 252. She herself wrote of the reviews it
received : "It seems to be discussed from every point of
view in a way not usual with battle pieces. But that is as
it should be, for I hope my military pictures will have moral
and artistic qualities not generally thought necessary to
military genre" ("An Autobiography" p 135)

(410) "I never approached a picture with more iniquitous prejudice
against it than I did Miss Thompson's : partly because I
have always said that no woman could paint ; and secondly
because I thought that what the public made such a fuss about
must be good for nothing. But it is an amazon's work this ;
no doubt of it, and the first fine Pre-Raphaelite picture
of battle we have had .." ("The Works of John Ruskin"
ed. E.T. Cook and Alexander Wedderburn, London 1904 vol. 14
pp 308-9)

(411) "An Autobiography" p 126

(412) Victoria Art Gallery Melbourne. See "Art Journal" 1884 p 158

(413) A foggy scene depicting French Cuirassiers watching by their
horses on the morning of the battle

(414) Queen's Park Gallery, Manchester

(415) Augustus Hare : "The Story of Two Noble Lives" London 1893
vol. 3 p 203

(416) It was possibly as a result of this that "L'Art" reproduced
an engraving of the "Roll Call" in 1879 (vol. 1 p 170)

(417) Jellalabad, January 13, 1842. "One man reached Jellalabad.
Literally one man - Dr. Brydon etc." See F1

(418) See page 73

(419) "Art Annual" 1898 p 12

(420) Now at the Staff College , Camberley

(421) "An Autobiography" p 187

(422) After her husband's death she had the canvas cut to pieces.
See Joseph Lehman "All Sir Garnet, A Life of Field Marshall
Lord Wolseley" London 1964 p 331
The picture is illustrated on page 19 of the "Art Annual"
1898. A fragment, of Butler's head, remains in the possession
of Mrs. Rhona Butler

(423) See "Art Annual" 1898 p 15 for a description of the work

(424) One of her illustrations for her husband, Colonel Sir. W.
Butler's "The Campaign of the Cataracts .. being a personal
narrative of the Great Nile Expedition of 1884-5" (London
1887) may be compared with these charge scenes. In her
"Departure of the Desert Column from Korti" (opposite page
264) soldiers on camels are shown marching straight towards
the spectator

(425) At the Folk Centre, Stephen's Green, Dublin

(426) At the KSLI Depot, Shrewsbury

(427) School of Infantry, Warminster. See N1

(428) "Dawn of Waterloo. The 'Reveille' in the bivouac of the Scots
 Greys on the morning of the battle" (RA 1895 no. 853) (in
 Falkland House). In 1913 she painted "The Cuirassier's
 Last Reveil. Morning of Waterloo"

(429) The first was "Floreat Etona" of 1882, an incident in the
 South African Campaign of 1881, at Laing's Nek

(430) According to her daughter-in-law, Mrs. Rhona Butler

(431) "Eyes Right" of 1916 (a water-colour frequently reproduced
 and sold in aid of the Red Cross) ; "The Avengers" of 1915-
 16 (indignation at the execution of Nurse Cavell) ; "The
 Charge of the Dorset Yeomanry at Agagia, Egypt" of 1916
 (based on an incident in the Senussi Campaign near Sollum
 in 1916 ; owned by the Dorchester County Council) ; "Charge
 of the Warwickshire and Worcestershire Yeomanry at Huj" in
 Palestine (Nov. 8 1917) of 1918 (at Stratford-on-Avon Drill
 Hall. Yeomanry HQ)

(432) According to "An Autobiography" a one-man show of water-colours
 was held in 1904 (page 303). From May-June 1912 an exhibition
 of the "Roll Call" and water-colour drawings was held at the
 Leicester Gallery ; in 1915 she had a "Waterloo" exhibition
 at the Leicester Gallery (p 329) and "Khaki" exhibitions were
 held in 1917 and 1919 (p 329)

(433) For "Graphic" see notes 400 and 407. "Daily Graphic" Jan. 4
 1890 p 9 ; August 22 1890 pp 4-5 ; August 23 1890 pp 1,4 ;
 Oct. 3 1890 pp 1,4 ; Oct. 4 1890 pp 1,4

(434) "An Autobiography" p 46

(435) ibid. pp 52, 135

(436) "Times" Oct. 4 1933 p 17

(437) "Wounded and taken prisoner" (DG 1871 no. 113), "Missing" (RA
 1873 no. 590) ; "Prussian Uhlans returning from a Raid" (SLA
 1873 no. 311) ; "Roll Call" (RA 1874 no. 142) ; "The Ferry -
 French Prisoners of War 1870" (DG 1874 no. 151) ; "Balaclava"
 (FAS 1876) ; "The Return from Inkermann" (FAS 1877) ; "A
 Desert Grave : Nile Expedition, 1885" (RA 1887 no. 466) ; "On
 the Morrow of Talavera : soldiers of the 43rd bringing in the
 dead" (RA 1898 no. 303) ; "Rescue of the Wounded in Afghanistan"
 (RA 1905 no. 152) ; "Eyes Right" 1916

(438) Also "French Cavalry drawn up under fire, waiting to charge"
 (DG black and white exhibition 1872 no. 2) ; "Scotland for
 Ever" (DG 1881) ; "Floreat Etona" (RA 1882 no. 499) ; "To the
 Front ; French cavalry leaving a Breton city on the declaration
 of war" (RA 1889 no. 578) ; "Camel Corps" (RA 1893 no. 848) ;
 "Dawn of Waterloo" (RA 1895 no. 853) ; "Steady the Drums and
 Fifes" (RA 1897 no. 663) ; "The Colours : advance of the Scots
 Guards at the Alma" (RA 1899 no. 912) ; "Charge of the Dorset
 Yeomanry at Agagia" 1916 ; "Charge of the Warwickshire and
 Worcestershire Yeomanry at Huj" 1918

(439) "An Autobiography" p 46

(440) ibid. pp 46-7

(441) See page 325

(442) "An Autobiography" p 186

(443) "L'Artiste" 1842 p 7

(444) See H2 for the French title

(445) "L'Artiste" 1841 p 351 and the "English Woman's Journal" 1859
 vol. 2 p 86

(446) This work is not in the catalogue of the Exposition au profit
 des blessés and I have found no catalogue for any other Salon
 held that year. According to her obituary in the "Gazette
 des Beaux-Arts" (1887 vol. 35 p 515) however, she won a medal
 at the Salon of 1830 for this work

(447) "English Woman's Journal" 1859 vol. 2 p 87

(448) ibid. Bénézit gives all the mottoes

(449) "English Woman's Journal" 1859 vol. 2 p 87. According to an
 obituary of the artist Count Portalès first bought her Françoise
 de Rimini - presumably in its unfinished state-and then comm-
 issioned the bronze lamp mentioned above in the text ("Gazette
 des Beaux-Arts"1887 vol. 35 p 514)

(450) "L'Artiste" 1842 vol. 1 p 7

(451) "English Woman's Journal" 1859 vol. 2 p 87 and "L'Artiste"
 1839 vol. 2 p 233

(452) Apparently her mother was imprisoned with her. In an inscription
 on her Monument to Bonnechose (presently discussed in the text)
 executed while in prison, she wrote : "cy furent tenues à
 captivité les nobles femmes Anne-Hippolyte de la Pierre de
 Fauveau et demoiselle Félicie de Fauveau, son aimée fille .."
 Given in "L'Artiste" 1842 vol. 1 p 41

(453) This was later exhibited at the Paris Salon in 1852 (no.
 1385)

(454) The fresco disappeared but her original sketch was lithographed
 later

(455) "L'Artiste"(1837 vol. 13 p 12) heralded its arrival in Paris

(456) "Revue Brittannique" March 1857 p 356

(457) Jules Janin described this work in great detail in "L'Artiste"
 (1839 vol. 2 p 233) and called its rejection "une incroyable,
 une inexplicable cruauté du jury" ; see also "L'Art en Province"
 1839 vol. 4 p 49 and "L'Artiste" 1841 vol. 7 p 351 ; illustrated
 in the "Magasin Pittoresque" 1839

(458) "L'Artiste" 1839 vol. 1 p 316. In the Musée de Douai ; copy in
 the Kunstverein, Munich

(459) "L'Artiste" 1841 vol. 7 pp 350-1

(460) Signed and dated Florence 1847. See Catalogue des Collections de Sculpture et d'Epigraphie du Musée de Toulouse, Toulouse 1912 p 387

(461) "L'Artiste" 1842 vol. 1 pp 6-9, 39-43, 84-87 by D.M.

(462) "L'Artiste" 1843 vol. 3 p 275

(463) Théophile Gautier : "Les Beaux-Arts en Europe - 1855" Paris 1856 p 185

(464) "Revue Britannique" March 1857 pp 357-8. See also "Gazette des Beaux-Arts" 1887 vol. 35 p 520

(465) "English Woman's Journal" Oct. 1859 vol. 2 pp 83-94 by I.B.

(466) M.F. Fayot in "L'Artiste" 1841 vol. 7 p 351 and D.M. in "L'Artiste" 1842 vol. 1 p 6

(467) "L'Artiste" 1839 vol. 2 p 233. By Jules Janin

(468) "English Woman's Journal" 1859 vol. 2 pp 91-3

(469) Anna Klumpke op.cit. p 296

(470) "Gazette des Beaux-Arts" 1900 vol. 23 p 436

(471) Anna Klumpke op.cit. p 180 and see also p 323

(472) ibid. p 177

(473) "L'Artiste" 1845 vol. 3 p 246

(474) Two of her exhibits were bronzes. There was no jury at the Salon that year and the Bonheur family were represented by a total of twelve works

(475) George Sand : "La Mare au diable" Paris 1850 pp 15, 17

(476) See page 44

(477) It measures 8' ¼" by 16' 7½"

(478) This copy was bought from Gambart by Jacob Bell and the latter then gave it to the National Gallery of London. She painted another original hoping that the National Gallery would exchange, but bound by Bell's will, they were unable to do so. The third was sold to an Englishman. The original finally went to America and was sold in 1887 for 55,500 dollars to Cornelius Vanderbilt who gave it to the Metropolitan Museum of Art New York

(479) "Journals and Correspondence of Lady Eastlake" London 1895 vol. 2 p 43

(480) It is inscribed "Etude de Sir Edwin Landseer de Madmse.Rosa Bonheur" and is in the Sheffield City Art Gallery

(481) One of her exhibits at the French Exhibition in Pall Mall was "The Plough". Ruskin's criticism was that she shrunk from painting the human face : "if she cannot paint a man's face

she can neither paint a horse's, a dog's, nor a bull's"
("Academy Notes" 1858 pp 32-3)

(482) Announced in the "Art Journal" 1860 p. 184

(483) E. Perraud de Toury : "Notice biographique sur Mlle Rosa
 Bonheur" Paris 1855 ; F. Lepelle de Bois-Gallais : "Biographie
 de Mlle Rosa Bonheur" Paris 1856 ; Eugène de Mirecourt : "Les
 Contemporains" 1856 no. LXVII and Emile Cantrel in "L'Artiste"
 Sept. 1 1859 vol. 8 p. 5

(484) Charles Sterling and M. Salinger : "French Paintings in the
 Collection of the Metropolitan Museum" New York II 1966 pp.
 161-4

(485) "Moutons au bord de la mer" was exhibited at the Exposition
 Universelle in 1867

(486) This quandary about her award is described in the "Courrier
 Artistique" June 18 1865 no. 55 p. 219

(487) "Chronique des Arts" Jan. 12 1868 p. 7

(488) Anna Klumpke op.cit. p. 202

(489) "Courrier Artistique" June 4 1865 no. 53 p. 210

(490) "Gazette des Beaux-Arts" 1871 vol. 4 p. 447

(491) See for instance "L'Artiste" 1849 vol. 3 p.129 ; Théophile
 Gautier in "Les Beaux-Arts en Europe - 1855" Paris 1856 p.
 120 ; Mazure, writing of "Le Labourage Nivernais" in "Paysage
 (Dieu, la Nature et l'Art)" Paris 1858 pp 103-4, wrote that
 despite all the work's qualities "toutefois on regrette l'
 entourage naturel qui manque à cette oeuvre d'ailleurs
 vivante; on cherche la profondeur du ciel et le paysage" ;
 Clément de Ris in "Critiques d'art et de littérature" Paris
 1862 pp 466-7

(492) She and Nathalie ran a "soup kitchen". An offer to recruit
 a battalion which she herself would lead was turned down by
 the Mayor of Thoméry

(493) Review in the "Gazette des Beaux-Arts" 1871 vol. 4 p 447

(494) Anna Klumpke op.cit. p 278

(495) "Journal des Arts" Jan. 28 1881 no. 4 p 2. The funds from
 this exhibition were to go to L'Association des Artistes
 founded by Baron Taylor

(496) "Journal des Arts" July 29 1881 no. 29 p 1. See also "L'Art"
 1881 vol. 2 p 119

(497) See note 478

(498) René Peyrol was the author

(499) Announced in the "Art Journal" 1896 p 158

(500) See "Chronique des Arts" June 12 1897 no. 23 p 218 and June

26 no. 24 p 224

(501) The canvas on which "La Foulaison" was painted was originally
 intended for a scene she had witnessed in Scotland at
 Falkirk when a group of cattle went wild and trampled a herd
 of sheep. As she was not allowed to import these animals into
 France, the project never materialized. For a description
 of the subject of "La Foulaison" see Anna Klumpke op.cit.
 pp 328-9

(502) "Gazette des Beaux-Arts" 1900 vol. 23 p 435

(503) See Theodore Stanton op.cit. p 140 and Virginie Demont-Breton's
 memoirs, "Les Maisons que j'ai connues" Paris 1926 vol. 1 p 48

(504) "Revue des Revues" June 15 1899 pp 605-6

(505) "Revue Universelle. des Arts" 1855 vol. 1 p 458

(506) "Chronique des Arts" Nov. 22 1868 no. 47 p 3

(507) "Fine Arts Quarterly Review" Oct. 1 1863 pp 302, 306

(508) "Art Journal" 1859 p 291

(509) "Un frère de l'école chrétienne" (1855 no. 2640) was bought
 by a Manchester collector ; her two school-room scenes entitled
 "L'enseignement mutuel" (1855 nos. 2642 and 2643) were bought
 by the English ; "La leçon" (1857 no. 397), "Une soeur" (1859
 no. 434), "La toilette" (1859 no. 435) and "La pharmacie,
 intérieur" (1859 no. 436) were all bought by the English.
 In addition it is probable that her second, smaller version
 of "Les Soeurs de Charité"-sold at the French Gallery in Pall
 Mall for 30,000 francs in 1859 - went to an English purchaser.
 For this information see the "English Woman's Journal" April
 1 1860 vol. 5 p 87 and also "Chronique des Arts" Nov. 22 1868
 no. 47 p 3

(510) pp 85-92, written by A.B

(511) "English Woman's Journal" April 1 1860 vol. 5 no. 26 p 91

(512) ibid.

(513) The work is described in Mireur op.cit. (1865 Duc de Morny
 Sale)

(514) This work was subsequently exhibited in an exhibition of "Artists
 of the French and Flemish Schools" at the French Gallery in
 Pall Mall in 1866 (no. 30) on which occasion it was reviewed at
 length in the "Saturday Review" (June 16 1866 p 720) and then
 in 1884 at the Liverpool Art Club's exhibition of "Modern Oil
 Paintings by Foreign Artists" (no. 27). It is now in the Sudley
 Art Gallery, Liverpool

(515) In works such as her "Ecole des Pauvres, à Aix (Savoie)" (EU 1855
 no. 2641) and "Les Soeurs de Charité" (1859 no. 433)

(516) See pages 231-2

(517) In the Baroda Collection

(518) "English Woman's Journal" April 1 1860 vol. 5 p.89

(519) ibid. pp.90-91

(520) Théophile Gautier : "Abécédaire du Salon de 1861" Paris
 1861 pp.72-7

(521) "Art Journal" 1869 p.382

(522) Examples are "L'Ecole Juive à Tanger" and other school pictures,
 engravings of which are in the Witt library

(523) "Gazette des Beaux-Arts" Aug. 1 1866 p 186. 14 engravings by her
 were listed in Henri Beraldi's "Les Graveurs du XIXe siècle.
 Guide de l'amateur d'estampes modernes" Paris 1886 vol. IV
 pp.19-20. Her engravings from Bida appeared at the Salons
 of 1863, 1865 and 1866

(524) "Courrier Artistique" March 15 1862 no. 19 p.73

(525) "English Woman's Journal" 1863 vol. 10 p.216

(526) "Saturday Review" June 16 1866 vol. 21 p.720. Now in the
 Sudley Art Gallery, Liverpool. See note 514

(527) See "Chronique des Arts" Oct. 25 1868 no. 43 p 172 and Nov.
 22 no.47 p.3

(528) In 1878 Charles Tardieu wrote : "elle traite le portrait féminin
 avec une distinction toute particulière, avec un sentiment de
 l'élégance innée où l'on reconnaît à la fois l'élève de Chaplin
 et la femme du monde" ("L'Art" 1878 vol. 3 p.182)

(529) "Musée Universel" 1878 vol. 12 p 188 and "L'Art" 1878 vol. 3
 p.136. "Une grand-mère" was illustrated in "L'Art" 1878 vol. 3
 opposite p.136

(530) Lady Butler : "An Autobiography" 1922 p 128

(531) "L'Art" 1877 vol. 2 pp 98-103 by T. Chasrel with six illustra-
 tions ; "Musée Universel" 1878 vol. 12 p.66 by A.G.. In 1878
 Charles Tardieu wrote that she occupied "un rang distingué
 parmi nos peintres orientalistes" ("L'Art" 1878 vol. 3 p 182)

(532) "Modern Painters and their Paintings" London 1882 p 323

(533) "Chronique des Arts" Aug. 4 1883 no. 26 p 210

(534) At the M. Connell Sale in London (see Mireur op.cit.)

(535) See note 514

(536) Obituary in the "Chronique des Arts" March 30 1901 no. 13 p.103

(537) An engraving after "La Bénédicité" is in the Witt library. It
 shows a little girl clasping a knife and fork

(538) "Correspondance de Berthe Morisot" Paris 1950 pp.67, 110

(539) Manet's "La Lecture" for instance, of c. 1868 (Louvre) and
 Fantin-Latour's "La Liseuse" (Salon 1861) (Louvre)

(540) "Correspondance de Berthe Morisot" p. 28

(541) Also called "Sur la pelouse " Bataille and Wildenstein op. cit. no. 427 (Plate 50)

(542) See for example "La République Française" April 25 1874 p. 3 ; "Le Rappel" April 20 1874 p. 3 ; "Chronique des Arts" April 14 1877 no. 15 p. 147 ; "Le Temps" April 22 1877 p. 3 ; Théodore Duret in "Les Peintres Impressionistes" Paris 1878 pp 115-25(1922 edi "Gazette des Beaux-Arts" 1880 vol. 21 p. 487 ; "L'Art" 1880 vol. 2 p. 94 ; J-K Huysmans in "L'Art Moderne.Salons 1879-1882" Paris 1883 pp. 111 and 252 ; "Le Figaro" April 9 1880 p. 1 ; "Chronique des Arts" April 23 1881 no. 17 pp. 134-5

(543) "La République Française" March 8 1882 p. 3

(544) "Correspondance" p 157

(545) ibid. p. 128

(546) ibid.

(547) See for example Gustave Lecomte : "L'Art Impressioniste" Paris 1892 p 105 and Claude Roger-Marx in the "Gazette des Beaux-Arts" 1907 vol. 2 pp. 503-4

(548) "Correspondance" p. 156

(549) Given in Philippe Huisman op.cit. p. 56 and Monique Angoulvent op.cit. pp. 96-7

(550) Given in Monique Angoulvent op.cit. p. 61

(551) "Correspondance" p. 87

(552) Given by Philippe Huisman op.cit. p. 42

(553) See page 212

(554) Adelyn Breeskin 1970 op.cit. nos. 4,6,7,8

(555) Many of her works were destroyed in the Great Chicago fire of 1871

(556) Adelyn Breeskin 1970 op.cit. no. 15 ("The Bacchante" 1872) and no. 16 (Early Portrait 1872) for example

(557) ibid. no. 18

(558) ibid. no. 22

(559) ibid. no. 25

(560) ibid. no. 35

(561) ibid. p 9 and no. 44

(562) ibid. nos. 39 to 43

(563) ibid. no. 55

(564) ibid. nos. 69 and 56

(565) Letter reproduced in Frederick Sweet op.cit. p. 36

(566) ibid. p. 38

(567) Adelyn Breeskin 1970 op.cit. no. 64

(568) ibid. p. 65

(569) See "Chronique des Arts" April 19 1879 no. 16 p. 127 ;
 "L'Artiste" May 1879 vol. 11 p. 292 ; "Revue des Deux Mondes"
 May 1879 p. 481 ; J-K Huysmans : "L'Art Moderne" Paris 1902
 (2nd edition) p. 13

(570) Frederick Sweet op.cit. p. 47

(571) Adelyn Breeskin 1970 op.cit. no. 72

(572) ibid. no. 78

(573) ibid. no. 90

(574) ibid. no. 88

(575) See "Chronique des Arts" April 23 1881 no. 17 pp. 134-5 ; J-K
 Huysmans "L'Art Moderne" Paris 1883 pp. 231-4 ; "Le Figaro"
 May 1 1881

(576) Adelyn Breeskin 1970 op.cit. no. 77

(577) ibid. no. 98

(578) ibid. no. 112

(579) ibid. no. 115

(580) ibid. no. 125

(581) ibid. no. 139

(582) ibid. no. 146

(583) ibid. no. 156

(584) ibid. no. 175

(585) "Chronique des Arts" Dec. 9 1893 no. 38 p. 299

(586) The work was in three parts : "Young girls pursuing fame",
 "Young girls plucking the fruits of knowledge and science"
 and on the right "Young girls practising the arts" (Adelyn
 Breeskin 1970 op.cit. no. 213)

(587) Adelyn Breeskin 1970 op.cit. p. 112

(588) "Chronique des Arts" Jan. 14 1899 no. 2 p. 10

(589) Adelyn Breeskin 1970 op.cit. nos. 310, 311, 314, 315, 317

(590) Frederick Sweet op.cit. pp. 163, 164-5

(591) "L'Art Décoratif" Aug. 1902 vol. IV p. 185

(592) According to Thieme-Becker she was born in 1849 and according to Bellier-Auvray in 1850. The 1849 date is currently accepted

(593) Jeanne exhibited at the Salon between 1879 and 1887, and at the Société Nationale between 1890 and 1898

(594) Musée de Villeneuve-sur-Lot

(595) This was praised by Zola, Théodore de Banville, Duranty and Jules Claretie and Philippe Burty (Claude Roger-Marx op.cit.)

(596) Illustrated in Claude Roger-Marx op.cit.

(597) Bristol Art Gallery

(598) J-K Huysmans "L'Art Moderne" Paris 1883 p. 53

(599) "L'Art" 1880 vol. 3 p. 66 ; Maurice Du Seigneur : "L'Art et les Artistes au Salon de 1880" Paris 1880 p. 126
The picture is illustrated in Claude Roger-Marx op.cit.

(600) In "L'Art" (1883 vol. 3 pp 78-9) she and Louise Breslau were described as two of the best exhibitors

(601) See "L'Artiste" Feb. 1885 p. 131 ; "Chronique des Arts" Jan. 17 1885 no. 3 p. 18 and Jan. 24 no. 4 pp. 25-6

(602) "La Nichée", a pastel, is in the Louvre

(603) Most of her work is now in the collection of her son and heirs

(604) "Chronique des Arts" Jan. 24 1885 no. 4 pp. 25-6

(605) "Journal de Marie Bashkirtseff" Paris 1888 vol. 2 pp. 18, 27, 67, 99, 101

(606) ibid. p. 29

(607) Madeleine Zillhardt op.cit. p. 250

(608) ibid. p. 152

(609) "L'Art" 1881 vol. 3 p. 15

(610) It was illustrated in the catalogue

(611) "L'Art" 1882 vol. 2 pp. 97 and 187

(612) "L'Art" 1887 vol. 2 p. 10 and "Gazette des Beaux-Arts" 1887 vol. 36 p. 56

(613) "Gazette des Beaux-Arts" 1893 vol. 10 pp. 29-30

(614) "Revue Encyclopédique" Paris 1896 pp 841 ff.

(615) "Gazette des Beaux-Arts" 1905 vol. 2 pp. 195-206

(616) "Chronique des Arts" March 12 1910 no. 11 p. 84 ; "Les Arts" 1910 no. 99 pp. 12-17 ; "L'Art et les Artistes" 1910 vol. 11 pp. 208-13

(617) See "Les Arts" 1918 no. 164 p 22 ; "La Revue de l'art ancien
et moderne" 1921 vol. 39 pp 253-62 and "La Renaissance de
l'Art Français" 1926 vol. 9 p 241. The most interesting review
of her retrospective was by Arsène Alexandre in"La Renaissance
de l'Art Français" (1928 vol. 11 p 213). He described her as
one of those rare personnalities who fought for a feminine
art free from academic influences

(618) Madeleine Zillhardt op.cit. p 226

(619) ibid. p 100

(620) ibid. pp 82 and 170. For comparison with Berthe Morisot see
pages 355-6

(621) Virginie Demont-Breton op.cit. vol. 1 p 23

(622) In the Musée de Douai. First exhibited at the Paris Salon
in 1882

(623) Eugène Montrosier op.cit. pp 113-116

(624) ibid.

(625) See page 55

(626) Virginie Demont-Breton op.cit. vol. 2 p 189

(627) Emile Langlade op.cit. p 78

(628) Musée de Dunkerque

(629) "Ismaël" is in the Musée de Boulogne

(630) Illustrated in the Salon catalogue for that year

(631) Emile Langlade op.cit. p 80

(632) See pages 102a-3 for her role as president and Emile Langlade p.88

(633) She exhibited "Le Divin Apprenti" and "Le Gui" at the New
Gallery (nos. 160 and 173)

(634) See pages 84-5

(635) G. Maroniez op.cit p 22

(636) See G. Maroniez op.cit pp 22-3

(637) Virginie Demont-Breton op.cit. vol. 1 p 47

(638) The title is that belonging to an engraving after the picture,
presently in the Witt library

(639) Virginie Demont-Breton op.cit. vol. 1 p 52

(640) D.Moore : "Marie and the Duke of H.: The Daydream Love Affair
of Marie Bashkirtseff" London 1966 p.14. According to the
author she was born on January 12. Previously, writers had
maintained that she was born in 1860 (see for instance Mathilde
Blind's introduction to "The Journal of Marie Bashkirtseff"

London 1890 vol. 1 p.xi)

(641) Mathilde Blind op.cit. vol. 1 p.xi

(642) The Bibliothèque Nationale possesses much more of her diary
 (in manuscript form) than has been published.

(643) "Journal de Marie Bashkirtseff" Paris 1888 vol. 1 p.72

(644) ibid.

(645) ibid. p.90

(646) ibid. p.291

(647) ibid. pp. 385-6

(648) ibid. vol. 2 pp. 3-4

(649) ibid. p.195

(650) ibid. p.10

(651) See page 367 and note 605

(652) "Journal.." vol. 2 p.177

(653) See page 239 and note 349

(654) Mathilde Blind op.cit. vol. 1 p xxiv

(655) "Journal.." vol. 2 p 438

(656) ibid. p.567

(657) ibid. pp. 574, 577

(658) By Francois Coppée, Emmanuel Ducros, Robert de Souza, Saint-
 Aman and Paul Deschanel. See "Catalogue des Oeuvres de Marie
 Bashkirtseff" Paris 1885

(659) These were exhibited in 1930. See "Beaux-Arts" May 20 1930
 vol. 8 p.12

(660) Angelica Kauffman's picture is in Nostell Priory, Yorkshire

(661) Petit Palais, Paris

(662) "Journal.." vol. 2 p.279

(663) ibid. p. 376

(664) ibid. p.202

(665) ibid. pp. 563-4

(666) ibid. p. 382

(667) ibid.pp.417,476,497-8, 527-8, 537 (Bastien-Lepage) and pp.
 352, 422 (Balzac and Zola). See also "Nouveau Journal Inédit
 de Marie Bashkirtseff" Paris 1901 p.125

(668) "Journal.." vol. 2 p.254

(669) ibid. pp. 323-4 and see also "Catalogue des Oeuvres de Marie
 Bashkirtseff" 1885 no. 65

(670) "Journal.." vol. 2 p.328

(671) ibid. pp. 417-8

(672) See for instance "Journal.." vol. 1 p.184

(673) ibid. vol. 2 p.527

(674) ibid. vol.1 p. 231, vol. 2 pp. 150, 387, 423, 438-9

(675) ibid. vol.1 p 232

(676) ibid. vol.2 p 376

(677) ibid. pp. 305, 309

(678) ibid. p. 576

(679) See page 200

(680) "Journal.." vol. 2 p. 388

(681) ibid. pp. 473, 442 and see also "Catalogue des Oeuvres de Marie
 Bashkirtseff" 1885. No. 1 of 5 sculptures

(682) ibid. pp. 88, 105, 214 and also the "Lettres de Marie
 Bashkirtseff" Paris 1891 pp. 168-176

(683) "Journal.." vol. 2 p.233

(684) See article on George Sand as artist and art critic in "L'Art"
 1876 vol. 2 pp. 283-4

(685) Caroline E.S., the Hon. Mrs. Norton : "Lost and Saved" London
 1863, 3 vols. Vol. 2 pp 252-7
 See page 167 in the text for Osborn's "Nameless and Friendless"

(686) See note 684

(687) "Lettres de Marie Bashkirtseff" Paris 1891 p.173

(688) For Gertrude Massey see page 38 in the text
 For Virginie Demont-Breton see quotation given by Anton
 Hirsch op.cit. pp.128-9

(689) Elizabeth Barrett Browning : "Aurora Leigh" London 1903
 p.48 (first published in 1857)

(690) See Chapter 2, Part 1

(691) See for instance the list of prize-winners in "A History of
 the Royal Society of Arts" by Sir Henry Trueman Wood (London
 1913) pp. 162-212

Artists who received awards at the Salon were listed in Salon
catalogues from the 1860s and these included many women

(692) Mrs. Grote : "Collected Papers in prose and verse"
 1842-1862" London 1862
 Lady Eastlake : numerous articles in the "Quarterly Review"
 from the 1840s to the 1870s ; articles in the
 "Edinburgh Review" in the 1870s
 Anna Brownell Jameson : "Painters and Italian Painting" 1845;
 "Sacred and Legendary Art" (2 volumes) 1848 (second and
 third series appeared in 1850); "A Commonplace Book of
 Thoughts, Memories and Fancies, original and selected"
 Part 2,"Literature and Art" 1854 ; "The History of our
 Lord exemplified in works of Art" 1864
 Lady Amelia Dilke : "The Renaissance of Art in France" 1879;
 "Art in the Modern State" 1888 ; "French Painting in
 the Eighteenth Century" 1899 ; "French Architecture
 and Sculpture of the Eighteenth Century" 1900 ; "French
 engraving and draughtsmen of the Eighteenth Century"
 1902
 Vernon Lee (Violet Paget) : "Studies of the Eighteenth Century
 in Italy" 1880 ; "Renaissance Fancies and Studies" 1895;
 "Laura Nobilis" 1909; "Beauty and Ugliness" (with C.A.
 Thompson) 1912; "The Beautiful" 1913
 Also articles in the "Contemporary Review" from 1879
 to 1900, "Cornhill Magazine" in the 1880s and "Fort-
 nightly Review" in the 1890s etc.
 Emily Barrington (Mrs. Russell) : "Essays on the Purpose of
 Art. Past and Present Creeds of English Painters" 1911
 Mrs. Callcott : "Essays towards the History of Painting" 1886
 Mrs. Arthur Bell (Nancy D'Anvers) : "Representative Painters
 of the Nineteenth Century" 1899 ; "An elementary history
 of art, architecture, sculpture, painting" (2nd edition
 1882

 Mme de Stael : "De l'Allemagne" 1810 Part 2, chapter 32 "Des
 Beaux-Arts en Allemagne" and Part 4, chapter 10 "De
 l'Enthousiasme"
 Flora Tristan : articles in "L'Artiste" in the 1830s
 Claude Vignon : "Salon de 1850-1" Paris 1851 (see page 241 for others
 Olympe Andouard : articles in "L'Art Moderne" in the 1870s
 Daniel Stern : "Pensces, Reflexions et Maximes" 1860 , chapter
 9
 Alice Berthet : "L'Art et la Vie" 1910

(693) "A Commonplace Book of Thoughts, Memories, and Fancies, original
 and selected" op.cit. p. 279

(694) ibid. pp. 331-362

(695) Mrs. Jameson : "Visits and sketches at Home and Abroad" London
 London 1839 vol. 2 p.133

(696) "Blackwood's Edinburgh Magazine" October 1824 vol. 16 pp.389-90

(697) Mrs. Ellet : "Women Artists in all Ages and Countries"New York
 1859 (see page 219)
 Francis Turner Palgrave in "Women in the Fine Arts", an article
 published in "Macmillan's Magazine" 1865 vol. 12 pp.119-
 127, 209-221

Berthe Morisot - See page 355 of the text
Mme Bertaux and Virginie Demont-Breton - see page 100-102a
 of the text and also page 372 and note 636
Ouida : "Views and Opinions" London 1895 p. 211
Lady Eastlake : "Journals and Correspondence of Lady Eastlake"
 edited by her nephew Charles Eastlake Smith, London 1895
 vol. 1 p. 39
"International Congress of Women" (July 1899) Section on
 "Women in Professions" London 1900 pp. 64-93

(698) "Bow Bells" 1863-4 vol. 2 p.13

(699) See page 101 of the text and "International Congress of Women"
 op.cit. pp 83-4

(700) "International Congress of Women" op.cit. p. 84

(701) See page 101 of the text

(702) Many instances could be given. Select examples may be found
 in the text on pages 200 (the two Marys), 195 (the Virgin
 Mary), 127 (Rizpah), 189-90 (Joan of Arc) and see E (chapter
 3) (Eve)

(703) Details of these works are to be found on the following pages
 of the text : pp. 121, 176-7, 139-40, 189-90, 144, 164, 346,
 307

APPENDIX I

The following was printed in the "English Woman's Journal" (June 1859, vol. 3, p.287) where it was introduced to the reader as follows: "Most interesting to those who seek in our pages a record of matters affecting the welfare of English women, is the address presented to each of the forty Royal Academicians, by a number of female artists, who beg to be admitted to the privileges of the Schools. We subjoin the address and its signatures, and earnestly hope that it will meet with a favourable reception in high quarters":-

" Sir, - We appeal to you to use your influence, as an artist and a member of the Royal Academy, in favor of a proposal to open the Schools of that institution to women. We request your attentive consideration of the reasons which have originated this proposal. When the Academy was established in 1769, women artists were rare; no provision was therefore required for their Art-education. Since that time, however, the general advance of education and liberal opinions has produced a great change in this particular; no less than one hundred and twenty ladies have exhibited their works in the Royal Academy alone, during the last three years, and the profession must be considered as fairly open to women. It thus becomes of the greatest importance that they should have the best means of study placed within their reach; especially that they should be enabled to gain a thorough knowledge of Drawing in all its branches, for it is in this quality that their works are invariably found deficient. It is generally acknowledged that study from the Antique and from Nature, under the direction of qualified masters, forms the best education for the Artist; this education is given in the Royal Academy to young men, and it is given gratuitously. The difficulty and expense of obtaining good instruction oblige many women artists to enter upon their profession without adequate preparatory study, and thus prevent their attaining the position for which their talents might qualify them. It is in order to remove this great disadvantage, that we ask the members of the Royal Academy to provide accommodation in their Schools for properly qualified Female Students, and we feel assured that the gentlemen composing that body will not grudge the expenditure required to afford to women artists the same opportunities as far as practicable by which they have themselves so greatly profited. We are, Sir, your obedient Servants,
 "J.K. Barclay, A.C. Bartholomew, S. Ellen Blackwell, Anna
 Blunden, B.L.S. Bodichon, Eliza F. Bridell, (late Fox,)
 Naomi Burrell, M. Burrowes, Florence Claxton, Ellen Clayton,
 Louisa Gann, Margaret Gillies, F. Greata, Charlotte Hard-
 castle, Laura Herford, Caroline Hullah, Elizabeth Hunter,
 Charlotte James, Anna Jameson, F. Jolly, R. Le Breton, R.
 Levison, Eliza Dundas Murray, M.D. Mutrie, A.F. Mutrie,
 Emma Novello, Emma S. Oliver, E. Osborn, Margaret Robinson,
 Emily Sarjent, Eliza Sharpe, Mary Anne Sharpe, Sophia
 Sinnett, Bella Leigh Smith, Annie Leigh Smith, R. Solomon,
 M. Tekusch, Mary Thornycroft, Henrietta Ward".

APPENDIX II

The following is a transcript of a document (dated 1863) which is in the
Royal Academy library:-

To the Members of the
ROYAL ACADEMY OF ARTS

THE MEMORIAL OF THE UNDERSIGNED FEMALE STUDENTS AT
THE SOUTH KENSINGTON
AND OTHER ART SCHOOLS

SHEWETH,-
That it has long been the custom of the Council of the Royal Academy
to admit into their Schools new Students to supply any vacancies which
may have occurred therein.

That the Students have been usually selected for admission by means
of an examination of works executed for the purpose by those seeking that
privilege.

That for some years past and up to the year 1863, it was permitted
to Female Students to compete at those examinations, and the successful
female competitors were admitted to study in the Schools of the Royal
Academy.

That in the Month of June, 1863, two Female Students of the South
Kensington School of Art sent in to the Royal Academy, drawings executed
by them for the purpose of competition with a view to obtain entrance to
the Schools of the Academy as Students.

That by a resolution of the Council it was, however, determined that
their works should not be submitted to competition, and that no more
Female Students should be admitted into the Schools of the Academy.

That your memorialists complain of that resolution and seek to have
it reversed.

That the current opinion and feeling of late years, on the part of
the educated public, has been strongly in favor of the introduction of
women to such callings and pursuits as are, or seem to be, suitable to
their sex, capacities, and tastes, although the same may have been pre-
viously for the most part, or altogether, monopolized by men.

That one channel which has in modern times been opened for the enter-
prize of women, is the pursuit of the Arts of Sculpture and Painting, and
that many women have availed themselves of that opening and are at pres-
ent earning their livelihood as Artists; and many other young women are
preparing themselves by study and practice to follow their example.

That your memorialists merely ask your attention to the fact, that
many young women are now devoting their lives to that profession; and
since this is so, your memorialists trust that it will be readily con-
ceded that it is desirable that they should become good artists rather
than inferior artists, and that they should, with that view, receive the
best Art education compatible with their circumstances.

That it is well known that the schools of the Royal Academy are of
a much higher standard than the other Art Schools of the Kingdom, and
are in every way more suitable for advanced Students; they are also the
only Free Art Schools in this country which is a consideration of moment
to some of your memorialists.

That the reason, and the only reason, alleged for that excluding res-
olution was, that the accommodation for Students, at the disposal of the
Council, is limited in extent.

That your memorialists have heard that there is an early prospect of
increased space being placed at the command of the Royal Academy by the
removal of the National Gallery.

But even if that transfer does not happen, and in the meantime until it does happen, your memorialists submit,

That the limited accommodation need not be made a ground for adhering to the excluding resolution (if it be otherwise an undesirable one). - First, because the number of Female Students likely to become competitors will (at least for many years to come) be very small indeed in comparison with the number of male students, while the proportion of successful female competitors is, your memorialists fear, likely to be still smaller.

And Secondly, because that inasmuch as your memorialists neither ask nor desire that any preference or favor be extended towards the female competitors at the entrance examination, the result will be that the entire number of Students will not be increased.

That in thus asking nothing more than "a fair field and no favour", your memorialists are very far from intending to convey that they imagine that Female Art Students can, upon the whole, compare favourably with an equal number of Male Students; on the contrary, your memorialists are well aware that the average ability of female students is less than that of male students. But your memorialists appeal to the fact that in many exceptional instances female sculptors and painters have attained to a high degree of excellence; and your memorialists submit that it is sufficient for the present application to shew that such success is possible however rare; because by how much it is unusual, by so much greater need is there that female students should be deprived of none of the advantages which the more favoured sex possesses.

> Your memorialists therefore pray that liberty may be restored to Female Students to compete for admission into the Schools of the Royal Academy, upon the same terms and conditions, in all respects, as are granted to, or imposed upon, male students.

* * * * *

NB: The only Signatures appended to this Memorial are those of Students who purpose to become Professional Artists.

APPENDIX III

Female intake per year at the Royal Academy Schools 1860-1914
(Figures compiled from the Royal Academy Schools Students' registers)

1860 - 1	1880 - 11	1900 - 13
1861 - 4	1881 - 16	1901 - 11
1862 - 6	1882 - 17	1902 - 16
1863 - 3	1883 - 21	1903 - 14
1864 - 0	1884 - 21	1904 - 1
1865 - 0	1885 - 10	1905 - 7
1866 - 0	1886 - 10	1906 - 16
1867 - 0	1887 - 10	1907 - 6
1868 - 4	1888 - 21	1908 - 5
1869 - 6	1889 - 17	1909 - 5
1870 - 13	1890 - 7	1910 - 8
1871 - 12	1891 - 3	1911 - 7
1872 - 11	1892 - 7	1912 - 12
1873 - 9	1893 - 14	1913 - 13
1874 - 15	1894 - 10	1914 - 9
1875 - 2	1895 - 8	
1876 - 13	1896 - 10	
1877 - 11	1897 - 9	
1878 - 13	1898 - 11	
1879 - 13	1899 - 14	

PERIOD	TOTAL STUDENTS	FEMALE STUDENTS
1860 - 1881	945	163
1891 - 1900	373	99
1901 - 1914	493	130

APPENDIX IV

CHIEF SPONSORS FOR ROYAL ACADEMY STUDENTS (FEMALE)
(Figures compiled from the Royal Academy Schools Students' registers)

Heatherley	--- 28 ---	between	1860 and 1880
Richard Burchett From 1852 Headmaster of South Kensington Training School	--- 9 ---	"	1862 and 1873
John Sparkes From 1864 to 1905 Headmaster of Lambeth School of Art. By 1880 Headmaster of National Art Training School	--- 46 ---	"	1871 and 1893
W.P. Frith	--- 7 ---	"	1870 and 1879
A.A. Calderon Founder of St. John's Wood Art School in 1880s	--- 53 ---	"	1880 and 1902
B.E. Ward Principal of St. John's Wood Art School 1880s	--- 35 ---	"	1884 and 1906
A. Fisher	--- 9 ---	"	1876 and 1880
J. Watson Nicol Co-Principal with Cope at Painting Schools, Pelham Street, South Kensington Station	--- 62 ---	"	1893 and 1912
C.M.Q. Orchardson Principal of the St. John's Wood Art Schools	--- 15 ---	"	1902 and 1911
F.D. Walenn Principal of the St. John's Wood Art Schools	--- 13 ---	"	1911 and 1914 etc.
Louisa Gann Principal of the Female School of Art	--- 5 ---	"	1869 and 1886
E.J. Poynter Slade Professor from 1871-5.	--- 3 ---	"	1877 and 1878
F.S. Cary Art Professor at Bedford College from 1849- 1869	--- 3 ---	"	1863 and 1872
Mr Bone Crystal Palace Art School	--- 6 ---	"	1894 and 1899

APPENDIX V

FEMALE STUDENTS ADMITTED TO THE ROYAL ACADEMY SCHOOLS
(compiled from the Royal Academy Schools Students' Registers)

DATE	NAME	SUBJECT	AGE	RECOMMENDED BY
Dec. 1860	Anne Laura Herford	Painting	29	Heatherley
Apr. 1861	Emily Sarah Burford	P	25	Heatherley
Dec.	Charlotte Elizabeth Babb	P	30	Heatherley
Apr.	Helen Mary Johnson	P	23	Heatherley
Apr.	Rosa Le Breton	P	21	J. Williamson
Dec. 1862	Gertrude Martineau	P	25	Heatherley
Dec.	Edith Martineau	P	20	Heatherley
Mar.	Louisa Starr	P	16	Heatherley
Dec.	Charlotte Brown	P	21	R. Burchett
Dec.	Catherine A. Edwards	P	20	A. Cooper R.A.
Dec.	Constance Phillott	P	19	J.H. D'Egville (?)
May 1863	Harriet Kate Crawford Aldham	P	26	F.S. Cary
May	Annie Ridley (Miss)	P	26	M.W. Ridley
May	Mary Alice Thornycroft	Sculpture	18	J. Foley
1864	0			
1865	0			
1866	0			
1867	0			
Jan. 1868	Jane Kingston Humphreys	P	24	R. Burchett
Jan.	Helen Paterson (Miss)	P	18	Miss L. Herford
Jan.	Helen Thornycroft	Sculpture	19	J.H. Foley R.A.
May	M.H. Bowerlate	No Details		
June 1869	Annie Glasier (Miss)	P	26	Heatherley
June	Florence Eliz. Glasier (Miss)	P	22	Heatherley
June	Mary Cornelisson	P	19	F.S. Cary
June	Jane E. Hawkins (Miss)	P	21	Sir F. Grant
Jan.	Celia Manley (Miss)	P	22	Miss Gann
Jan.	Emily Susanna Ryder	P	-	Mr Burchett

DATE	NAME	SUBJECT	AGE	RECOMMENDED BY
June 1870	Eliza C. Collingridge	P	28	Heatherley
June	Harriette Mary Kempe	P	24	Heatherley
Jan.	Mary I.R. Backhouse	No details		
June	Agnes Bonham	Sculpture	33	Rev. I. Bonham
June	Julia Bracewell Folkerd	P	21	W.P. Frith R.A.
June	Clara Fell	P	25	H. Harley R.A.
Jan.	Anne Grose	No details		
June	Jessie Macgregor	P	24	J. Faed R.A.
June	Charlotte Cathne. Monro	P	32	C.M. Clarke
June	Julia Cecilia Smith	P	23	W.J. Muckley
June	Terese G. Thornycroft	P	17	F. Goodall R.A.
June	Mary Sympson Tovey	P	26	R. Burchett
June	Ellen Wilkinson	P	22	H. Weston (?)
Jan. 1871	Margaret E. Crow	P	22	Heatherley
Jan.	Catherine G. Cruikshank	P	25	Heatherley
July	Viola Carte	P	23	Heatherley
July	Cecil Oakes (Miss)	P	19	Heatherley
Jan	Marian B. Brooke	P	20	J. Sparkes
July	Florence Tiddeman	P	23	J. Sparkes
July	Mary Leamon Fowler	P	19	Rev. H. Fowler M.A.
Jan.	Mary Godsall	P	26	W.P. Frith R.A.
Jan.	Blanche Jenkins	P	19	R. Wyllie
Jan.	Mary Eliz. Martin	P	28	(Unreadable)
Jan.	Caroline Nettidge	Sculpture	25	H. Weekes R.A.
July	Margaret Thomas	Sculpture	26	E. Summers
June 1872	Eliz. Smyth Guiness	P	22	Heatherley
Jan.	Blanche McArthur	P	25	Heatherley
June	Ellen Conolly	P	22	J. Sparkes
Jan.	Emily J. Shepherd	P	26	J. Sparkes
Jan.	Janet Archer	P	22	F.S. Cary
June	Maria Brooke	P	37	Mr Burchett
Jan.	Julia Dickson	P	28	Admiral Burney
June	Eliz. F. Folkard	P	19	W.P. Frith R.A.
Jan.	Ellen Rooke	P	18	Burne-Jones
June	Emily Florence Spear	P	23	E. Landseer R.A.
June	Sarah Terry	Sculpture	28	J.S. Westmacott

DATE	NAME	SUBJECT	AGE	RECOMMENDED BY
Jan. 1873	Catherine Jane Atkins	P	26	R. Burchett
Jan.	Fanny L. Sethern	P	20	R. Burchett
Jan.	Fanny Sutherland	P	27	R. Burchett
Apr.	E. (Lizzie) Shutze	P	28	R. Burchett
Apr.	Catherine Harriet Coney	P	29	Westmacott, Esq.
Apr.	Anne Grace Fenton	P	27	S.A. Hart
Apr.	Georgiana F. Koberwein	P	17	P.H. Calderon R.A.
Apr.	Rosa J.A. Koberwein	P	18	P.H. Calderon R.A.
Apr.	Eleanor Eliza Manly	P	21	Miss Gann
Dec. 1874	Annie Louisa Beale	P	19	Heatherley
July	Jennie Moore	P	22	Heatherley
Dec.	Charlotte Constance Pierrepont	P	20	Heatherley
July	Ada Stone	P	21	Heatherley
Dec.	Rosalie Maria Watson	P	20	Heatherley
July	Mrs Agnes Schenck	P	35	J. Sparkes
Dec.	Ada Emma Taylor	P	19	J. Sparkes
Dec.	Fanny Blanche West	P	20	J. Sparkes
July	Lilian G. Blackburne	P	17	W.P. Frith
Jan.	Mary Eales	P	20	W.P. Frith R.A.
Dec.	Kate Hill	P	22	A. Elmore R.A.
Jan.	Ethel Matlock (Miss)	Drawing	18	Mr H. Parker
Dec.	Katherine E. May	P	26	J.E. Millais R.A.
July	Alicia J. Shellshear	P	22	C. Lidderdale
Dec.	Harriet Emily Vintner	P	16	Vintner
Apr. 1875	Frances Barrand	P	18	Heatherley
Apr.	A. Keeling (Miss)	P	No details	
Dec. 1876	Ethel Ellen Ellis	P	20	Heatherley
Jan	M.E. Greenhill (Miss)	P	27	Heatherley
Jan.	Miss H.E. Bell	P	23	J. Sparkes
Dec.	Mabel Green	P	20	J. Sparkes
Apr.	M. Joyce (Miss)	P	27	J. Sparkes
Apr.	Marie Prevost (Miss)	P	17	J. Sparkes
Apr.	Frances Elizabeth Grace	P	18	A. Fisher
Dec.	Harriet Edith Grace	P	16	A. Fisher
Apr.	Mildred Bonham Bond (Miss)	Architec.	19	C.W. Cope R.A.
Dec.	Emmeline Halse	Sculpture	23	G. Halse

DATE	NAME	SUBJECT	AGE	RECOMMENDED BY
1876 cont.				
Jan.	Alice Mott (Miss)	P	23	J.F. Lewis
Jan.	Mary Moody (Miss)	P	21	G.F. Watts
Dec.	Gertrude Mary Williams	P	20	H.C. Stewart
Dec. 1877	Henrietta Rae (Miss)	P	20	Heatherley
Dec.	Ellen Neillsen (Miss)	P	23	J. Sparkes
Dec.	Emma Louisa Black (Miss)	P	19	Mr Fisher
Dec.	Mary Katherine Benson (Miss)	P	19	E.R. Spence
Dec.	Margaret Jeffersen Buist (Miss)	P	24	E.J. Poynter R.A.
Dec.	Anne Grose (Miss) (see above)	P	49	No details
Apr.	Margaret Hickson (Miss)	P	20	F.R. Pickersgill
Dec.	Alice Hanslip (Miss)	P	25	E. Long A.R.A.
Dec.	Ida Lovering (Miss)	P	23	J.F. Dicksee
Dec.	Madena Moore (Miss)	P	20	G.A. Stewart
Dec.	Helen Mabel Trevor	P	34	E.J. Poynter R.A.
Apr. 1878	Miss Margaret Crow	P	29	Heatherley
Dec.	Eliz. Mary Chettle	P	20	J. Sparkes
Apr.	Mary Drew (Miss)	P	19	J. Sparkes
Apr.	Edith Savill (Miss)	P	19	J. Sparkes
Dec.	Frances Rachel Binns (Miss)	P	25	L. Starr
Dec.	Susan Ruth Canton (Miss)	Sculpture	29	T. Woolner R.A.
Dec.	Blanche Cottle (Miss)	P	26	J.V. Robertson
Dec.	Jane Mary Dealy (Miss)	P	21	J.R. Dealy
Dec.	Mary Eley (Miss)	P	22	E. Gauntlett
Dec.	Marion T. Ivey (Miss)	P	21	E.J. Poynter R.A.
Apr.	Eliza Knight (Miss)	P	34	A. Fisher
Dec.	Julia Melliss	P	20	No details
Dec.	Clara Jane Warman	P	22	S. Birch
Dec. 1879	Edith Annie Crosley (Miss)	P	17	J. Sparkes
Apr.	Helen Jackson (Miss)	P	23	J. Sparkes
Dec.	Agnes Alford	P	20	W.P. Frith
Dec.	Annie Mary Youngman (Miss)	P	19	W.P. Frith R.A.
Dec.	Anna M. Grace	P	16	A. Fisher
Dec.	Marion M. Reid	P	22	A. Fisher
Apr.	Lily Schell (Miss)	P	19	A. Fisher

DATE	NAME	SUBJECT	AGE	RECOMMENDED BY
1879 cont.				
Dec.	Florence Evelyn White	P	21	A. Fisher
Apr.	Margaret Isabel Dicksee (Miss)	P	20	T. Dicksee
Dec.	Edith Gibson (Miss)	P	25	J.F. Dicksee
Dec.	Eleanor Mary Keighley	P	22	A.D. Cooper
Apr.	Sarah Alice Miller (Miss)	P	26	W.Q. Orchardson R.A.
Dec.	Hannah McLachlan (Miss)	P	23	R. McLachlan
Dec. 1880	Beatrice Agnes Rust (Miss)	P	16	Heatherley
Apr.	Julia Isabel Saunderson (Miss)	P	23	J. Sparkes
Apr.	Nelly Erickson (Miss)	P	17	J. Sparkes
Dec.	Mary Groves (Miss)	P	26	J. Sparkes
Apr.	Henrietta Ethel Rose (Miss)	P	17	J. Sparkes
Dec.	Kathne Dorothy Mart. Bywater	P	25	A. Elmore R.A.
Dec.	Helen Howard Hatton (Miss)	P	19	L. Fildes A.R.A.
Dec.	Cecily Harper (Miss)	P	22	A. Calderon
Dec.	Eliza Kate Hitchcock (Miss)	P	23	C.H. Mills
Apr.	Amy Scott (Miss)	P	19	A. Fisher
Apr.	Louisa Wren (Miss)	P	30	J.L. Tomlin
Apr. 1881	Mary Helen Jones (Miss)	P	19	J. Sparkes
Apr.	Theodora Joan Noyes (Miss)	P	16	J. Sparkes
Apr.	Mary Noyes (Miss)	P	28	J. Sparkes
Apr.	Minna Taylor (Miss)	P	26	J. Sparkes
Apr.	Caroline F. Armstrong (Miss)	P	32	A. Calderon
Apr.	Ella Margaret Bedford	P	16	A. Calderon
Apr.	Ellen Gertrude Cohen (Miss)	P	20	A. Calderon
Dec.	Florence Clow (Miss)	P	19	A. Calderon
Apr.	Hannah Eliz. Edwards (Mrs)	P	27	A. Calderon
Dec.	Ethel Brooke Hinson	P	18	A. Calderon
Dec.	Constance Pitcairn (Miss)	P	28	A. Calderon
Dec.	Emily Constance Dunn (Miss)	P	22	C.I. Vaughan
Dec.	Ellen Evelyn Granville (Miss)	P	23	W.W. Ouless R.A.
Dec.	Clara Murray Hawkes (Miss)	P	-	W.C.T. Dobson R.A.
Dec.	Emily Merrick (Miss)	P	24	J.R. Burgess A.R.A.
Apr.	Edith Heckstall Smith (Miss)	P	19	F. Grace

DATE	NAME	SUBJECT	AGE	RECOMMENDED BY
Dec. 1882	Christine Connell (Miss)	P	18	J. Sparkes
Mar.	Elsie Southgate (Miss)	P	25	J. Sparkes
Mar.	Edith A. Cooper (Miss)	P	18	A. Calderon
Mar.	Christabel Cockerell (Miss)	P	18	A. Calderon
Mar.	Florence Mann (Miss)	P	23	A. Calderon
Dec.	Geraldine Martineau (Miss)	P	18	A. Calderon
Mar.	Agnes Pringle (Miss)	P	26	A. Calderon
Dec.	Harriette Sutcliffe (Miss)	P	26	A. Calderon
Mar.	Blanche M. Whitney (Miss)	P	25	A. Calderon
Dec.	Norah Waugh	P	25	A. Calderon
Dec.	Kate Bannin (Miss)	Sculpture	25	I. Parker (?)
Dec.	Monica Heaton	P	22	R.N. Shaw R.A.
Dec.	Mary Elizabeth Harding	P	25	Louisa Gann
Dec.	Miss Georgina Lawrence	P	23	?
Dec.	Jane Desanges Purcell (?)	P	19	E. Purcell
Dec.	Florence Reason	P	22	Louisa Gann
Dec.	Annie Sherriff (Mrs)	P	26	C. Lucas
Mar. 1883	Ada Currey (Miss)	P	30	J. Sparkes
Dec.	Frances Drayton (Miss)	P	21	J. Sparkes
Dec.	Elfrida Gardner (Miss)	Sculpture	22	J. Sparkes
Dec.	Emmeline Sarah McMillan (Miss)	P	33	J. Sparkes
Mar.	Margaret H.A. Simpson (Miss)	P	33	J. Sparkes
Mar.	Ida Rose Taylor (Miss)	P	24	J. Sparkes
Mar.	Anna Florence Williams (Miss)	P	28	J. Sparkes
Mar.	Edith Danvers Brinton (Miss)	P	21	A. Calderon
Mar.	Helen Coombe (Miss)	P	18	A. Calderon
Mar.	Margaret Fletcher (Miss)	P	20	A. Calderon
Mar.	Harriet Ford (Miss)	P	23	A. Calderon
Mar.	Beatrice Gibbs (Miss)	P	19	A. Calderon
Mar.	Edith Hayes (Miss)	P	22	A. Calderon
Mar.	Eva Caroline Jones (Miss)	P	23	A. Calderon
Mar.	Nelly Milner (Miss)	P	21	A. Calderon
Dec.	Harriett Maynard (Miss)	P	25	A. Calderon
Mar.	Marie Jane Naylor (Miss)	P	26	A. Calderon
Mar.	Ellen Troynam (Miss) (?)	P	20	A. Calderon
Mar.	Florence Fitzgerald (Miss)	Sculpture	22	(?)
Dec.	Henrietta Maria Hearn (Miss)	P	19	R. Ansdell R.A.(?)
Mar.	Minnie Jane Shubrook (Miss)	P	20	(?)

DATE	NAME	SUBJECT	AGE	RECOMMENDED BY
Mar. 1884	Annie Bowler (Miss)	P	25	J. Sparkes
Dec.	Harriett Elizabeth Ryder	P	23	J. Sparkes (extended to M 1891)
Dec.	Amy Clara Durell (Mrs)	P	19	J. Sparkes
Dec.	Gertrude E. Demain Hammond (Miss)	P	22	J. Sparkes
Mar.	Maud Porter (Miss)	P	20	J. Sparkes
Dec.	Mary Cath. Abercrombie	P	24	A. Calderon
Dec.	Beatrice Alcock (Miss)	P	23	A. Calderon
Dec.	Augusta Ada Bell (Miss)	P	22	A. Calderon
Dec.	Helena Florence Mary Burgess	Sculpture	22	A. Calderon
Dec.	Kate Ellen Cronin (Miss)	P	20	A. Calderon
Dec.	Beatrice Marion Hewitt (Miss)	P	24	A. Calderon
Dec.	Elizabeth Cameron Mawson (Miss)	P	35	A. Calderon
Dec.	Helen Margaret Plews (Miss)	P	22	A. Calderon
Dec.	Amy Wilson (Miss)	P	21	A. Calderon
May	Beatrice Angle (Miss)	Sculpture	24	B.E. Ward (?)
Mar.	Minnie Agnes Cohen	P	19	B.E. Ward
Mar.	Rose Le Duesne (Miss)	Sculpture	20	B.E. Ward
Mar.	Florence Emily Sherrard (Miss)	P	26	B.E. Ward
Dec.	N. de Renault (Madame)	Sculpture	35	B.E. Ward
Dec.	Sophia Harris (Miss)	P	22	H.J. Paull (?)
Dec.	Beatrice Mary Latham (Miss)	Sculpture	22	J. Parker
Dec. 1885	Alice Maria Dicker (Miss)	P	22	J. Sparkes
Mar.	Christina M. Demain Hammond (Miss)	P	23	J. Sparkes
Dec.	Mary Edith Durham	P	21	A. Calderon
Dec.	Helen Sarah Squire	P	23	A. Calderon
Mar.	Agnes Lee (Miss)	P	22	B.E. Ward
Dec.	Janet Connell (Miss)	P	20	W. Connell
Mar.	Anna Maria Gayton (Miss)	P	26	G.F. Cook
Dec.	Amy Henrietta Hunt (Miss)	Sculpture	28	C. Wake
Dec.	Florence Marks (Miss)	P	22	E. de Parr
Mar.	Katherine Stewart (Mrs)	P	19	G.F. Cook
Dec. 1886	Elizabeth Nichol (Miss)	P	23	J. Sparkes
Dec.	Beatrice Mary Bristowe	P	20	Bristowe
Dec.	Edith Laura Calvert (Miss)	P	21	(?)
Dec.	Bessie L.H. Gall (Miss)	P	22	W.P. Frith R.A.

DATE	NAME	SUBJECT	AGE	RECOMMENDED BY
1886 cont.				
Dec.	Mary C. Greene (Miss)	P	25	H. Power
Dec.	Alice Maria Hawes	P	21	J. Clifford
Dec.	Lydia Bacon King	P	27	Louisa Gann
Dec.	Mary E. Postlethwaite (Miss)	P	31	R. Williams (?)
Mar.	Edith Sprague (Miss)	P	23	Hyward
Dec.	Frances E. Thring (Miss)	P	23	H. Power
Mar. 1887	Marion Clarkson (Miss)	P	23	J. Sparkes
Mar.	Jessie Ada Morison (Miss)	P	21	A. Calderon
Mar.	Ella Brown (Miss)	P	23	G. Brown
Dec.	Alice Grace Brown (Miss)	P	20	G.T. Brown
Dec.	Margaret E. Carter (Miss)	P	24	A.S. Wood
Dec.	Helena M. Swaffield (Miss)	P	22	A. Wood
Mar.	Anne Dobson (Miss)	Sculpture	25	F. Bell
Dec.	Christine Pauline Hehl (Miss)	P	36	G.S. Law (?)
Dec.	Esther Stella Isaacs (Miss)	P	18	Joseph Isaacs
Mar.	Lucy Beatrice Power (Miss)	P	20	H. Power
Mar. 1888	Charlotte Amy Bernarr	P	24	J. Sparkes
Mar.	Esther Cath. Adlington (Miss)	P	23	E. James
Dec.	Isabel Campbell Anderson	P	23	J. Pettie R.A.
Mar.	Alicia Blakesley	P	26	H.E. Morice
Mar.	Emma Irlam Briggs	P	20	F. Barrett
Mar.	Frances Burroughs (Mrs)	P	30	K. Warrens (?)
Dec.	Ann Bell (Miss)	P	24	Gibson
Dec.	Edith Bateson (Miss)	Sculpture	21	A. Macalister
Dec.	Helen Dewe (Miss)	P	19	Bessie Wigan
Dec.	Florence Mary Georgiana Dimma (Miss)	P	29	Kingsford
Dec.	Florence Hannam (Miss)	P	20	G.F. Cook
Dec.	Annie Maud Hunteman (Miss)	P	27	(?)
Mar.	Minnie Wilhelmine Lawson (Miss)	P	20	Mclean
Mar.	Florence Lendrum (Miss)	P	20	A.J. Wood
Mar.	Emily Louisa Long (Miss)	P	25	A.J. Wood
Dec.	Clara May (Miss)	P	20	E. Howard
Mar.	Millicent Gabrielle Prelps	P	19	J. Prelps
Dec.	Annie G. Tarner (Miss)	P	21	J.M. Chapman
Dec.	Jessie Turner (Miss)	P	26	A. Legge

DATE	NAME	SUBJECT	AGE	RECOMMENDED BY
1888 cont.				
Mar.	Ursula Wood (Miss)	P	19	J.P. Clark (?)
Dec.	Florence Ada James (Miss)	P	26	A. Brown
Mar. 1889	Mabel Cockburn (Miss)	P	22	A. Calderon
Dec.	Isabel C. Pyke-Nott (Miss)	P	16	B.E. Ward
	Miss Margaret Eliz. Bunney	P	24	(?)
Dec.	Julia Meyer	P	21	Manning
Mar.	Margaret Boroman (Miss)	P	29	G. Marton (?)
Dec.	Mary Hamilton Burgess (Miss)	P	24	Burgess
Dec.	Maude Lee Cockburn (Miss)	P	24	J. Pyke-Nott (?)
Mar.	Ada Caroline Georgiana Dimma	P	29	Kingsford
Dec.	Edith Fortunee Jita de Lisle	P	22	R.C. Halse
Dec.	Rosabelle Drummond (Miss)	P	20	J. Sadler
Mar.	Mildred Laura Hancock (Miss)	P	20	(?)
Mar.	Isabel Margaret Hayward (Miss)	P	26	Hayward
Mar.	Edith Anne Norton (Miss)	P	23	P. Graham R.A.
Mar.	Beatrice Emma Parsons (Miss)	P	19	(?)
Mar.	Jane A. Ram (Miss)	P	35	E. Ram
Dec.	Emily Florence Watters (Miss)	P	23	J. Chillingworth
Dec.	Nora Field (Miss)	P	23	(?)
Mar. 1890	Mary Helen Shaw	P	27	B.E. Ward
Mar.	Minnie D. Darn(r?)son (Miss)	P	21	C. Burton
Mar.	Emily Norah Jones (Miss)	P	26	J. Norton
Mar.	Hannah Myers (Miss)	P	23	Gabriel
Mar.	Miss Evelyn C.E. Pyke-Nott	P	19	(?)
Mar.	Maud Beatrice Worsfold (Miss)	P	21	Hayward
July	Harriet Staite (Miss) (2nd term end July 1893, left July 1895)	P	22	A. Hewitt

DATE	NAME	SUBJECT	AGE	2ND. TERM	FINISH	RECOMMENDED BY
Jan. 1891	Edith Lydia Clink (Miss)	P	22	Jan. 1894	Jan. 1896	G. Clink
	Mildred Helen Collyer (Miss)	P	18	"	"	B.E. Ward
	Katherine Mary Willis (Miss)	P	21	"	"	W.J. Foster M.D.
Jan. 1892	Florence Kate Kingsford (Miss)	P	19	Jan. 1895	Jan. 1897	L.A. Smith
	Ethel Alice Kirkpatrick (Miss)	P	22	"	"	J.S. Kirkpatrick
	Rose Livesay (Miss)	P	17	"	"	Mrs G. Marsh
	Dorothy Woolner (Miss)	P	18	"	"	J. Woolner R.A.
July	Evelyn Mary Barrett (Miss)	P	22	July 1895	July 1897	B.E. Ward
	Janet Edward Buyers (Miss)	P	22	---------	"	O. Knox
	Adelaide Constance Thorp (Miss)	P	20	July 1895	"	B.E. Ward
Jan. 1893	Winifred Nest Hansard (Miss)	P	21	---------	Feb. 1896	Rev. S. Hansard
	Winnafred Wilberforce Smith (Miss)	P	22	Feb. 1896	Jan. 1898	E.C. Alston
July	Jeanie Elizabeth Bakewell	P	21	---------	July 1896	B.E. Ward
	Margaret Baring-Gould	P	22	---------	"	I. Watson Nicol
	Gertrude Isabella Cowper	P	20	July 1896	July 1898	B.E. Ward
	Theodora Mary Lana James	P	16	"	"	B.E. Ward
	Hilda Koe	P	21	"	"	W.M. Alderton
	Constance Mortimore	P	21	---------	July 1896	J. Watson Nicol
	Susette Peach	P	22	July 1896	July 1898	J. Sparkes
	Katherine Agnes Ross	P	20	July 1896	July 1898	B.E. Ward
	Agnes Mabel Sansom	P	20	"	"	B.E. Ward
	Edith Margaret Venn	P	22	---------	July 1896	B.E. Ward

DATE	NAME	SUBJECT	AGE	2ND. TERM	FINISH	RECOMMENDED BY
July 1893 Cont.	Phyllis Woolner	P	18	--------	July 1896	A.G. Woolner
	Margaret Caroline Godfrey-Thurlow (Mrs Lamb)	Sc	20	--------	"	J. Sparkes
Jan. 1894	Rose Evelin Clark	P	22	Jan. 1897	Jan. 1899	E.C. Alston
	Ethel Mary Coates	P	19	--------	Jan. 1897	B.E. Ward
	Alice Mary Ethel Groom	P	20	--------	"	B.E. Ward
	Kate Maud Jackson	P	22	Jan. 1897	Jan. 1899	B.E. Ward
	Mary Towgood	P	21	"	"	J. Watson Nicol
July	Hilda Blundell	P	21	July 1897	July 1899	H.G. Hewitt
	Margaret Agnes Collyer	P	22	--------	July 1897	J. Watson Nicol
	Agnes Olive Dangerfield	P	20	--------	"	H.A. Bone
	Grace Elizabeth Page	P	20	July 1897	July 1899	Rev. H. Stevens
	Maud Surtees Phillpotts	P	22	--------	July 1897	J. Watson Nicol
Jan. 1895	Ruth Fletcher	P	18	Jan. 1898	Jan. 1900	A.A. Calderon
	Mary Eleanor Fortescue-Brickdale	P	22	"	"	R.G. Hodson
	Agnes Ellen MacWhirter	P	21	--------	Jan. 1898	J. Watson Nicol
	Mary Isabel Phelps	P	19	Jan. 1898	Jan. 1900	A.A. Calderon
	Nelly Gertrude Saltmarshe	P	21	--------	Jan. 1898	J. Watson Nicol
July	Olga Morgan	P	22	--------	July 1898	J. Watson Nicol
	Mabel Willcocks	P	22	July 1898	July 1900 '	J.M. Pierce MD
	Anne Maria Bruce Wingate	P	22	"	"	H.G. Hewitt
Feb. 1896	Eliza Josephine Foulds	P	21	--------	Jan. 1899	A.A. Calderon
	Millicent Etheldreda Gray	P	22	Jan. 1899	Jan. 1901	J. Watson Nicol

DATE	NAME	SUBJECT	AGE	2ND. TERM	FINISH	RECOMMENDED BY
Feb. 1896 Cont.	Flora Marguerite Lion	P	17	Jan. 1899	Jan. 1901	B.E. Ward
	Agnes Francis Eleanor Vyse	P	22	"	"	R.G. Hodson
	Maud Marian Wear	P	22	"	"	A.A. Calderon
	Clotilde Kate Brewster	Archit.	21	--------	Jan. 1899	R. Blomfield
July	Florence Eleanor Chaplin	P	20	July 1899	July 1901	J. Watson Nicol
	Annie (?) Goddard	P	22	"	"	J. Watson Nicol
	Elizabeth Scott Jarvis	P	20	--------	July 1899	J. Mckeggie
	Harriet Eleanor Thomas	P	19	July 1899	July 1901	T. Robinson
Jan. 1897	Theodosia Selina Cochrane	P	21	Jan. 1900	Jan. 1902	H.A. Bone
	Muriel Duncan	P	21	"	"	B.E. Ward
	Edith Helen Ferneley	P	20	"	"	B.E. Ward
	Frances Amicia De Biden Footner	P	22	"	"	B.E. Ward
	Portia Swanston Geach	P	22	"	"	LB. Hall
	Elsie Gregory	P	19	"	"	B.E. Ward
	Emily Jane Harrington	P	20	"	"	L.C. Nightingale
	Mabel Catherine Robinson	P	21	"	"	J. Mckeggie
July	Annie Margaret Page	P	20	July 1900	July 1902	H.A. Bone
Jan. 1898	Alice Mary Barnett	P	21	--------	Jan. 1901	A.J. Eisley
	Maud Bevers	P	21	Jan. 1901	Jan. 1903	B.E. Ward
	Adrienne Lawson Chaplin	P	19	"	"	J. Watson Nicol
	Evelyn Mary Ferneley	P	22	"	"	B.E. Ward
	Elvina Kennedy Greenham	P	19	"	"	L.C. Nightingale
	Margaret Elizabeth Hall	P	22	"	"	B.E. Ward

DATE	NAME	SUBJECT	AGE	2ND. TERM	FINISH	RECOMMENDED BY
Jan. 1898 Cont.	Gertrude Lindsay	P	20	Jan. 1901	Jan. 1903	S. Lucas A.R.A.
	Catherine Isadore Miles	P	22	"	"	J. Howard Hale
	Enid Schroder	P	21	"	"	J. Watson Nicol
	Winifred Florence Hunt	Sc.	20	"	"	H.A. Bone
July	Dorothea Medley Selous	P	17	July 1901	July 1903	H.A. Bone
Jan. 1899	Alice Mary Appleton	P	21	Jan. 1902	Jan. 1904	J.W. Nicol
	Rose Caroline Cobban	P	22	"	"	Rev. Caren Daniell
	Ada Gladys Fuller	P	17	"	"	B.E. Ward
	Hjördis Gröntoft (Miss)	Archit.	20	---------	Jan. 1902	E. George
July	Nina Isabel Baird (Miss)	P	17	July 1902	July 1904	J. Watson Nicol
	Mary Bowyer	P	20	Jan. 1903	Jan. 1905	J. Watson Nicol
	Catherine Annie Jane Brebner	P	19	July 1902	July 1904	J. Watson Nicol
	Dorothy Alice Courtney	P	22	---------	July 1902	J. Watson Nicol
	Muriel Geary Dyer	P	21	---------	"	J. Watson Nicol
	Ethel Fanny Everett	P	21	July 1902	July 1904	J. Mckeggie
	Florence Jay	P	22	"	"	J. Watson Nicol
	Edith Maud Mair	P	21	"	"	H.A. Bone
	Catherine Ouless	P	19	"	"	B.E. Ward
	Mary Constance Buzzard	Sc	23	"	"	F.G.L. Lucas
Jan. 1900	Janet Brennand	P	22	---------	Jan. 1903	G. Morton
	Lilian Price Edwards	P	21	Jan. 1903	Jan. 1905	J. Watson Nicol
	Catherine Dawson Giles	P	21	---------	Jan. 1903	F. Marriott
	Ellen Constance Trewly	P	20	Jan. 1903	Jan. 1905	J. Mckeggie

DATE	NAME	SUBJECT	AGE	2ND. TERM	FINISH	RECOMMENDED BY
Jan. 1900 Cont.	Bernadine Van Mentz	P	20	--------	Jan. 1903	B.E. Ward
July	Mary Beatrice Boulter	P	19	died March 12th, 1902		A. Baldwin
	Eveleen Maud Fielding	P	19	--------	July 1903	W.P. Van Wyk
	Ethel Mary L. Kendall	P	22	July 1903	July 1905	J. Marriott
	Margaret Kemplay Snowdon	P	22	July 1903	July 1905	J. Watson Nicol
	Alice Palgrave Walford	P	21	"	"	S.J. Soloman A.R.A.
	Marjory Violet Watherston	P	18	"	"	K.J. Draper
	Evelyn Mary Watherston	P	20	"	"	K.J. Draper
	Beatrice Ellen Ann Woodhead	P	21	"	"	A.A. Calderon
Jan. 1901	Honor Charlotte Appleton	P	21	Jan. 1904	Jan. 1906	J. Watson Nicol
	Kate Elizabeth Olver	P	19	"	"	A.A. Calderon
	Elsbeth Cornelia Pauline Rommel	Sc.	24	--------	Jan. 1904	A.A. Calderon
July	Daisy Radcliffe Clague	P	21	July 1904	July 1906	Rev. C.J. Sharp
	Gertrude Conway Harding	P	20	--------	July 1904	A.A. Calderon
	Ethel Blanche Hope	P	20	--------	"	J.Q. Brown M.D.
	Florence Phoebe Johnson	P	22	July 1904	July 1906	A.A. Calderon
	Sylvia Frances Milman	P	22	"	"	J. Watson Nicol
	Ethel May Morgan	P	22	"	"	J.H. Olver
	Olive Gertrude Pye-Smith	P	21	"	"	A.A. Calderon
	Vanessa Stephen	P	22	--------	July 1904	J. Watson Nicol
Jan. 1902	Florence Mary Bevan	P	18	--------	Jan. 1905	Mrs L. Bennett
	Marion Alice Dibdin	P	19	Jan. 1905	Jan. 1907	J. Watson Nicol

DATE	NAME	SUBJECT	AGE	2ND. TERM	FINISH	RECOMMENDED BY
Jan. 1902 Cont.	Mildred Mai Ledger (first term extended to July 1905)	P	22	July 1905	Jan. 1907	A.A. Calderon
	Edith Margaret Leeson	P	20	Jan. 1905	"	J. Watson Nicol
	Susan Beatrice Lock	P	21	"	"	A.A. Calderon
	Ethel Violet Marriott	P	22	--------	Jan. 1905	A.A. Calderon
	Frances Kathleen Mathew	P	20	Jan. 1905	Jan. 1907	Mrs L.J. Bennett
	Rose Jessie Morten	P	22	"	"	A.A. Calderon
	Frances Catherine Spooner	P	18	--------	Jan. 1905	J. Watson Nicol
July	Emily Maud Ball	P	19	--------	July 1905	J. Watson Nicol
	Phillis Broster	P	20	July 1905	July 1907	J. Watson Nicol
	Dorothy Furniss	P	22	--------	July 1905	E. Bale
	Eva Emmeline Louisa Marsh	P	20	July 1905	July 1907	W. Fry
	Hilda Fraser Parker	P	19	"	"	J. Watson Nicol
	Florence Aline Rodway	P	20	"	"	B. Sheppard
	Christian Mary Wilbee	P	19	"	"	C.M. Orchardson
Jan. 1903	Sybil Cooper	P	22	--------	Jan. 1906	J. Watson Nicol
	Margaret Isabel Dovaston	P	18	Jan. 1906	Jan. 1908	J. Watson Nicol
	Hilda Jessie Hooper	P	22	--------	Jan. 1906	J. Watson Nicol
	Emma Muriel Middleton	P	22	--------	Jan. 1906	J. Watson Nicol
	Irene Sibyl Maude Roxby	P	18	Jan. 1906	Jan. 1908	J. Watson Nicol
	Ann Penelope Simpson	P	18	"	"	E.C. Clifford
	Dorothy Loveday	P	19	--------	Jan. 1906	J.A. Pearce
July	Mary M. Christison	P	21	July 1906	July 1908	Rev. A.E. Deacon

DATE	NAME	SUBJECT	AGE	2ND. TERM	FINISH	RECOMMENDED BY
July 1903 cont.	Marjorie Curwen	P	21	July 1906	July 1908	C.M.Q. Orchardson
	Mabel Genevieve Dicker	P	19	"	"	L.C. Nightingale
	Laura Sylvia Gosse	P	22	"	"	C.M.Q. Orchardson
	Jessie Holliday	P	19	"	"	J. Watson Nicol
	Oriane Sophy Tyndale	P	19	--------	July 1906	J. Watson Nicol
	Helen Frazer Rock	Sc	24	July 1906	July 1908	Miss S.J. Bennett
July 1904	Jessie Marion McConnell	P	20.2	--------	July 1907	J. Downes
Jan. 1905	Amy Joanna Fry	P	20.8	Jan. 1908	Jan. 1910	C.M.Q. Orchardson
	Ethel Ruth Prowse	P	21.5	--------	Jan. 1908	J. Watson Nicol
	Marianne Henriette Wilhelmine Robilliard	P	21.7	Jan 1908	Jan. 1910	M. Webb
	Millicent Wadham	Sc	23.3	"	"	G.P. Gaskell
July	Mabel Edwards	P	21.1	July 1908	July 1910	J. Watson Nicol
	Dorothea Joan Freeman	P	25.0	--------	July 1908	J. Watson Nicol
	Mrs Wyon (Eileen May Le Poer French)	P	21.11	July 1908	July 1910	J. Watson Nicol
Jan. 1906	Gertrude Ottilie Hadenfeldt	P	20.10	--------	Jan. 1909	B.E. Ward
	Dorothy Webster Hawksley	P	21.1	Jan. 1909	Jan. 1911	B.E. Ward
	Gertrude Rachel Levy	P	22.2	--------	Jan. 1909	B. Levy
	Elsie Grace Newth	P	21.4	--------	Jan. 1909	B.E. Ward
	Ethel Margaret Sheppard	P	21.7	Jan. 1909	Jan. 1911	J. Watson Nicol
	Amy Clare Waters	P	20.6	--------	Jan. 1909	B.E. Ward
July	Hilda Lennard	P	18.11	July 1909	July 1911	Thos. Muir
	Sybil Alkinson	P	24.11	--------	July 1909	Thos. Mckeggie

DATE	NAME	SUBJECT	AGE	2ND. TERM	FINISH	RECOMMENDED BY
July 1906 Cont.	Dorothy Deave	P	24.9	---------	July 1909	J. Watson Nicol
	Elizabeth Elsie Shenstone Farmer	P	21.7	July 1909	July 1911	C.M.Q. Orchardson
	Madeline Emily Green	P	21.10	"	"	John Crompton
	Ruth Alice Hobson	P	21.11	---------	July 1909	C.M.Q. Orchardson
	Mary Dorothy Maltby	P	20	---------	"	Lilian M. Faithfell
	Diana Metford Read	P	20.2	---------	"	C.M.Q. Orchardson
	Dorothy Marion Rushton	P	21.9	July 1909	July 1911	J. Watson Nicol
	Margaret Lindsay Williams	P	18	July 1909	July 1911	J. Watson Nicol
Jan .1907	Maria Eliza Emily de Montrayee Edwardes	P	19.7	Jan. 1910	Jan. 1912	J. Watson Nicol
	Grace Mary Hawkins	P	18.10	"	"	J. Watson Nicol
	Nellie Elizabeth Isaac	P	20.5	Jan. 1910	Jan. 1912	C.M.Q. Orchardson
July	Estella Louisa Michaella Albertina Canziani	P	20.6	July 1910	July 1912	J. Watson Nicol
	Gladys Mary Clark-Kennedy	P	20.6	"	"	J. Watson Nicol
	Joan Joshua	P	22.11	"	"	(?) King
Jan. 1908	Edith Mabel Bennett	P	18.6	---------	Jan. 1913	J. Bowyer, LCC Putney School of Art
	Hetty Muriel Bentwich	P	18.8	---------	"	C.M.Q. Orchardson
	Ethel Gertrude Webb	P	19.0	---------	"	J. Watson Nicol
July	Katherine Frances Clausen	P	22.3	---------	July 1913	C.M.Q. Orchardson
	Margaret Hodgson	P	20.8	---------	Dec. 1912	J. Watson Nicol
Jan. 1909	Madeline Graham Barker	P	22.5	---------	Jan. 1914	J. Watson Nicol
	Muriel Constance Foster	P	24.6	---------	"	J. Watson Nicol
	Edith Mary Hosking	P	24.11	---------	Jan. 1914	C.M.Q. Orchardson

DATE	NAME	SUBJECT	AGE	2ND. TERM	FINISH	RECOMMENDED BY
July 1909	Evelyn Muriel Young	P	b.1889	--------	July 1914	R.G. Hatton (Armstrong College, Newcastle on Tyne)
	Helen Sinclair	P	b.1892	--------	"	Principal Art mistress of Coast High School Durban
Jan. 1910	Hilda Marion Hechle	P	1886	--------	Feb. 1915	C.M.Q. Orchardson
	Mary Wilhelmine Dunham Hickson	P	1889	--------	"	J. Watson Nicol
	Florence Margaret Walden	P	1890	--------	"	(?)

First admissions under new school laws of 1910

DATE	NAME	LOWER SCHOOL OF P.	AGE	UPPER SCHOOL	RECOMMENDED BY
July 1910	Cicely Mary Primrose Andrews	"	b.1892	July 1911	J. Watson Nicol
	Agnes Weir Huntley	"	b.1890	Mar. 1911	Headmaster of Croydon School of Art
	Alice Adrienne Nash	"	b.1889	"	C.M.Q. Orchardson
Nov.	Gladys Marguerite Baker	"	b.1889	"	C.M.Q. Orchardson
	Una Hook	"	b.1889	"	J. Watson Nicol
July 1911	Sylvia Ellen Gauntlett	"	b.1890	July 1912	F.D. Walenn
	Norah Gowan	"	b.1885	"	F.D. Walenn
	Naomi Lang	"	b.1891	Jan. 1913 (left Feb.1915)	J. Watson Nicol
	Hinemoa Pakora Waterlow	"	b.1891	"	F.D. Walenn
	Rosalie Emslie	"	b.1891	July 1912	F.D. Walenn
Nov.	Mabel Redington Peacock	"	b.1888	"	C.M.Q. Orchardson
	Minnie Josephine Winser	"	b.1893	Jan. 1913	C.R. Burnett
Feb. 1912	Nancy Wordsworth Arnold	"	b.1890	July 1912	J. Watson Nicol
	Nora Elizabeth Baxter	"	b.1891	Jan. 1913	J. Watson Nicol
	Gaynor Elizabeth Bury	"	b.1890	"	J. Watson Nicol
	Helen Dorothy Kiddall	"	b.1888	July 1912	J. Watson Nicol
July	Violet Mary Barnewall	"	b.1890	Jan. 1915 (left Feb.1915)	F.D. Walenn
	Margaret (?) Beard	"	b.1890	Jan. 1913	Miss Dorothy Deane
	Thelma Somerville Cudlipp	"	b.1891	--------	F.D. Walenn
	Harriet Levy	"	b.1895	Jan. 1913	F.D. Walenn

DATE	NAME	LOWER SCHOOL OF P.	AGE	UPPER SCHOOL	RECOMMENDED BY
July 1912 Cont.	Marjorie Florence Mostyn	"	b.1893	Jan. 1913	F.D. Walenn
	Dorothy Pridham	"	b.1888	July 1913	F.D. Walenn
	Alice Dorothy Cohen	Upper School	b.1887		Miss Rose E. Welby
Nov.	Constance Winifred Honey	-------	-------	-------	Nat. Gall. Victoria (Aust)
Feb. 1913	Winifred Mary Brough	"	b.1886	Jan. 1914	F.H. Swinstead (?)
	Effie Mary Craig	"	b.1886	"	Byam Shaw
	Frances Howes Galbraith	"	b.1895	July 1913	Byam Shaw
	Winifred Beatrice Hardman	"	b.1890	July 1914 (left 1921)	F.D. Walenn
	Beatrice Ethel Lithiby	"	b.1889	July 1913 (left 1921)	F.D. Walenn
	Nora Marjorie Welchman	"	b.1890	July 1913 (left 1922)	Monat Loudan (?)
July	Winifred Broughton Edge	"	b.1896	Jan. 1914	Garden Studio, Pelham St.
	Stefani Melton Fisher	"	b.1894	Jan. 1914 (left 1922)	Byam Shaw
	Elsie Mary Haworth	"	b.1887	July 1914	City School of Art Liverpool
	Phyllis Dorrell Lambert	"	b.1893	July 1915	St. John's Wood Art School
	Florence Mary Asher	-------	b.1888	Upper School	St. John's Wood Art School
	Mary Joyce Burges	-------	b.1889	Upper School	St. John's Wood Art School
	Dorothy Fraser Litchfield	-------	b.1891	Upper School	St. John's Wood Art School
Feb. 1914	Sylvia Catherine Cooper	"	b.1891	July 1914	Byam Shaw
	Edith Winifred Hocking	"	b.1890	July 1915 (left 1920)	J.H. Swinstead

DATE	NAME	LOWER SCHOOL OF P.	AGE	UPPER SCHOOL	RECOMMENDED BY
Feb. 1914 Cont.					
July	Dorothea Lake Lyster	"	b.1891	July 1914	Byam Shaw
	Madeline Idonea Ingoldby	"	b.1894	Jan. 1915	Director of Art, Ladies' College Cheltenham
	Leonie Monica Lemon	"	b.1896	-------- (resigned 1915)	Vyvyan James
	Veronica E. Martindale	"	b.1893	Jan. 1915	F.D. Walenn
	Florence Violet Stirling Swinhoe	"	B.1896	"	Vyvyan James
	Winifred Mary Raymond Barker	------	b.1891	Upper school	F.D. Walenn
	Marie Stocquart	"			

APPENDIX VI

Exhibitions in England of the work of two or more women artists excluding those given in the text

DATE	ARTISTS	GALLERY	TITLE OF EXHIBITION	REF.*
1896 July	Miss R.J. Leigh and Miss Mabel Young	175 New Bond Street	Paintings	44 numbers
1899 Mar.	Miss C.L. Sheppard and Miss E. Norah Jones	Clifford Gallery, 21 Haymarket, S.W.	Water-colour drawings of Egypt/Miniatures	39 numbers
1899 Oct.	Miss Ida and Miss Ethel Kirkpatrick	Henry Graves Gallery 6 Pall Mall	Water-colour drawings	1900 p.121
1900 Oct.	The Misses Kirkpatrick	Henry Graves Gallery	Water-colour drawings	1901 p.115
1901 Jan.-Feb.	Miss Constance Pitcairn and Miss Aimee Wilson	The Modern Gallery, 175 Bond Street	Oil paintings and water-colour drawings	1902 p.119
1902 Feb.	Mary Barton and Ina Clogstoun	Fine Art Society, 148 New Bond Street	Water-colour drawings of "Irish Life and Scenery"/"Flowers and Gardens"	122 numbers
1902	Evelyn March Phillipps and Miss Frances Hodgkins	Doré Gallery, 35 New Bond Street	Water-colour drawings - "In Italy and elsewhere"	50 numbers
1903 June	Miss C.M. Nichols R.E. and Charlotte M.Alston	MacQueen's Gallery, 181 Tottenham Court Rd.	Oil paintings, water-colours, miniatures and etchings	250 numbers
1903 June	F. Anna Lee and Annie Taylor Blacke	Continental Gallery, 157 New Bond Street	"Egypt and the Soudan"/"Rivermists and Flowers"	70 numbers
1904 Feb.	Margaret Kemp-Welch and Blanche Baker	MacQueen's Gallery	Pictures	84 numbers
1904 Feb.-Mar.	Miss Biddy Macdonald and Miss Blanche Baker	Woodbury Gallery, 37 New Bond Street	Pictures	63 numbers
1904	Miss Mary and Miss Lydia Pringle	Modern Gallery	Pictures and Sketches of Cornwall, Norfolk and Sussex etc.	52 numbers
1904 Dec.	Lady Baker, Mrs Hemsworth Miss Duke and Miss Baker	Modern Gallery	"Here, there and everywhere" - water-colour drawings and sketches	109 numbers

* The numbers indicate the number of works listed in the catalogue, when one exists. Otherwise the reference is to where (usually a periodical) the information has been obtained. Unless otherwise indicated, the reference is to "The Year's Art".

DATE	ARTISTS	GALLERY	TITLE OF EXHIBITION	REF.
1905 Mar.	Mrs Alastair Murray and Miss M. Dawkins	Doré Gallery	Water-colour drawings	1906 p.127
1905 Nov.-Dec.	The Misses Maud and Alice M. Schloesser	92 New Bond Street	Landscape paintings and studies/ Brass nail work	29 numbers
1905	Miss Katherine McCracken and Miss Nellie Hadden RMS, FZS	Modern Gallery, 61 New Bond Street	Water-colours of Perugia/ Studies at the Zoo etc. and miniatures	95 numbers
1905	The Misses Warren	Modern Gallery	English Cathedrals and landscapes	1906 p.130
ca. 1905	Students of the Life Classes for Women painters	16 Yeoman's Row	Pictures	127 numbers
1906 Mar.	Miss Gertrude Martineau and Miss Edith Martineau	Modern Gallery	"Aviemore and the Highlands" and other water-colour drawings	186 numbers
1906 Mar.	13 Women Artists: Miss Sybil Dowie, Minnie Chambers, C. Lillian Sheppard, Janet Fisher, Florence E. Haig, R.Aspinall Syers, H. Halhed, Florence White RMS, F.M. James, Jessie E. Muntz, I.M.Sheldon-Williams, Rachel H. Forbes, L. Gwendolen Williams	Doré Gallery	Sculptures, paintings and miniatures	216 numbers
1906 Dec.	Jessie Bayes and Annie French	Baillie Gallery, 54 Baker Street		1907 p.134
1906	Mrs Charles Muller and Miss Ridsdale	Modern Gallery	Jewels and enamels/Church embroideries	1907 p.140
1906	Emily Stephens and Mrs Adrian C. Hope	Walker Gallery, 118 New Bond Street	Water-colour sketches and impressions/ Pastel portraits and fancy drawings	109 numbers
1907 Apr.	Rose Aspinall Syers and C. Lillian Sheppard	Doré Gallery	Small landscapes (mostly British)/ Pictures of Brittany and the Isle of Skye	87 numbers

DATE	ARTISTS	GALLERY	TITLE OF EXHIBITION	REF.
1907 May	13 Women Artists: C.Lillian Sheppard, Janet Fisher, R. Aspinall Syers, Florence White, R.M.S., Jessie E. Muntz, P.E. Bishopp, Evelyn Harke, Margaret Thams, Evelyn Heathcote, Ada Dennis, Ethel L. Rawlins, A. Dorothy Burbury, Agnes Gilmore	Doré Gallery	Sculptures, paintings and miniatures	203 numbers
1907 June	Mrs Sydney Bristowe and Miss Tyra Kleen	Modern Gallery	Water-colours/Drawings and litho-graphs	61 numbers
1907	Madeleine Lemaire and H.R.H. the Princess Louise	Tooth and Sons, 29 Bruton Street	Water-colour drawings/Replica of a bronze relief by...	32 numbers
1908 May	Fanny Farrer and Lilian Luard	Doré Gallery	Flower pictures/Water-colours of English and Italian Gardens	92 numbers
1908 June	Mrs Sydney Bristowe, Mrs Ronald Macleod and Miss Tyra Kleen	Doré Gallery	Water-colours/Oils/Lithographs	22 numbers
1908 Nov.- Dec.	Millicent Sowerby and Jessie Bayes	Baillie Gallery, 13 Bruton Street	Drawings/Illuminations	38 numbers
1909 June	Mrs Sydney Bristowe, Mrs Ronald Macleod and Miss Tyra Kleen	Doré Gallery	Water-colours/Paintings on china/ lithographs	22 numbers
1909 May	The Misses Dorrien-Smith	New Dudley Gallery, 169 Piccadilly	Water-colours	1910 p.140
1909	Miss Aiswen Montgomerie, The Misses Dorrien-Smith, Lady Mabel Sowerby	Dudley Gallery	Water-colours of Hampshire/Water-colours of the Scilly Isles/Water-colours of Malta and Sicily	162 numbers
1910 May- June	Evelyn Fothergill Robinson Ruth Hollingsworth, Evelyn Perceval-Clark	Baillie Gallery	Pictures	67 numbers

DATE	ARTISTS	GALLERY	TITLE OF EXHIBITION	REF.
1910 May	Miss Lilian Luard, Lady Ford and Miss A.L. Mawe	Doré Gallery	Sketches on the Riviera/Water-colours/Water-colours	1911 p.137
1910 June	Miss E. Vickers and Mrs Franks	Doré Gallery	Pictures	1911 p.137
1910	Miss Joan M. West and Miss Rachel Wheatcroft	Modern Gallery	Water-colour drawings of Holland, Italy, Norway, etc.	69 numbers
1910	Edith Martineau A.R.W.S., Gertrude Martineau and Mrs Basil Martineau	Fine Art Society	Water-colour drawings/Water-colour drawings/Oil paintings	273 numbers
1911 May	Dorothy K. Sawyer, Rachel Barclay, Mary D. Stacey	Walker's Gallery	Animals/Gardens/Landscapes	99 numbers
1911 June	The Misses Dorrien-Smith and Miss Phyllis Keys	Walker's Gallery	Water-colour sketches of the Isles of Scilly/Fans and Portraits	126 numbers
1911 Aug.-Sept.	The Misses Wright and Leeson	Walker's Gallery	Pictures in oil and water-colour	1912 p.145
1911 Oct.-Nov.	Frances MacNair and Margaret Mackintosh	Baillie Gallery		1912 p.137
1911 Dec.	Miss D. Boughton-Leigh and Miss Maud D. Hurst	Baillie Gallery	Water-colour sketches/Coloured etchings	51 numbers
1911 Dec.	The Misses Langdale	Walker's Gallery	Water-colour drawings	57 numbers
1912 Apr.-May	Sybil Dowie and Beatrice Dowie	Baillie Gallery	Portraits of Children/Water-colour drawings	48 numbers
1912 June	Ruth Hollingsworth and Evelyn F. Robinson	Baillie Gallery	Paintings	21 numbers
1912 June	Mrs Kate Haith and Mary E. Butler	Walker's Gallery	Water-colour drawings of South Africa	71 numbers

DATE	ARTISTS	GALLERY	TITLE OF EXHIBITION	REF.
1912	Miss D. Burroughs and Miss M. Heanly	Modern Gallery	Pen and ink drawings/pastel paintings	1913 p.153
1913 June-July	Mrs Pierce Loftus (Dorothy Reynolds) and Margaret Reynolds	Doré Gallery	Portraits and studies in pastel/Miniatures	80 numbers
1913 June	Mrs Walter Donne and the Hon. Mrs Astley	Dudley Gallery	Painted fans and water-colour drawings	47 numbers
1913 Oct.-Nov.	Isabella Barnes, Daisy Hansford, Freda Smith, Mabel M.C. Robinson A.R.E.	Walker's Gallery	Sketches and etchings	72 numbers
1913 Nov.	Mrs Russell Walker and Miss Dorothy Prickett	Modern Gallery	Drawings of gardens etc. in Sicily and Italy/"Australia and other subjects"	1914 p.150
1913 June	Rose Whitelaw and Ida Lovering	Lyceum Club, 52 New Bond St. 128 Piccadilly	Water-colours/Pastel portraits	75 numbers
1914 Jan.	Ethel Martin (Mrs E.D.Fridlander), Beatrix Martin, E.D. Fridlander, Anne Maitland, Harriet Halhed	Baillie Gallery	Paintings and drawings	99 numbers
1914 Mar.	Helen Sinclair and Evelyn Young	Walker's Gallery	Paintings, drawings, miniatures and designs	86 numbers
1914 May-June	Mrs W.J.C. Merry and Constance Wagstaff	Walker's Gallery	Water-colour drawin-s - "City, Town and Country"	64 numbers

APPENDIX VII

Exhibitions in France of the work of two or more women artists excluding those given in the text

DATE	ARTISTS	GALLERY	TITLE OF EXHIBITION	REF.*
1906 Dec.	Mme Madeleine Lemaire and Mlle Suzanne Lemaire	Galerie Georges Petit		Dec.1,1906 no.37 p.332
1910 June	Mme Madeleine Lemaire and Mlle Suzanne Lemaire	Galerie Georges Petit	Decorative paintings, water-colours, drawings and objets d'art	June 4,1910 no.23 pp.182,184
1912 May	Mme Madeleine Lemaire and Mlle Suzanne Lemaire	Galerie Georges Petit	Paintings, water-colours and objets d'art	May 18,1912 no.20 p.160; May25,1912 no.21 p.163
1912 Feb.	Mme Y. Postel-Vinay and Mlle Andrée Tirard	Galerie Boutet de Monvel, 18 rue Tronchet	Water-colours	Feb.3,1912 no.5 p.40
1913 Feb.-Mar.	Mlle Jaeggi, Mlle Recolin, Mme de Saint-Germain, Mlle Ferrand, Mlle de Blotinski	Galerie Boutet de Monvel, 18 rue Tronchet	Paintings and objets d'art décoratif	Feb.15,1913 p.56
1914 Mar.	Mlles Janine Aghison, Madeleine Bunoust, Juliette Roche	Galerie Bernheim Jeune 15 rue Richepanse	Paintings, water-colours, drawings and objets d'art	Mar.7,1914 no.10 p.80

* The references are to the "Chronique des Arts"

APPENDIX VIII

ONE-WOMAN EXHIBITIONS IN ENGLAND

DATE	ARTIST	GALLERY	TITLE OF EXHIBITION	REF.*
1798	Miss Linwood	Hanover Square Concert Rooms	Pictures in needlework	39 numbers
1843	Miss Eden	Messrs Dickinson's, 144 New Bond Street	Sketches of Eastern Men and Manners	"Athenaeum" Apr. 1 1843 no. 805 p.313
1848 June	Mrs Soyer (Emma Jones)	Prince of Wales Bazaar		Soyer's Philanthropic Gallery 140 numbers
1858	Rosa Bonheur	German Gallery, 168 New Bond Street	Three pictures	"Art Journal" 1858 p.191
1859 Sept.	Mme Bodichon	20 Pall Mall	A Variety of Sketches of Scenery in Africa & America	34 numbers ("Art Journal" 1859 Sept.1 p.291)
1859 Sept.	Mlle Henriette Browne	French Gallery, Pall Mall	Pictures formerly exhibited in the Champs-Elysées	"Art Journal" 1859 p.291
1860	Rosa Bonheur	German Gallery	Scenes in Scotland, Spain and France	"Art Journal" 1860 p.184
1861 May	Mme Bodichon	French Gallery	Collection of Views sketched round Algiers. 43 subjects	"Art Journal" 1861 p.159
1865 Nov.	Julia Margaret Cameron	120 Pall Mall	Photographs	158 numbers
1868 Mar.	Mrs Cameron	German Gallery		"Art Journal" 1868 p.58
1871	Mme Jerichau	142 New Bond Street	Pictures	"Art Journal" 1871 p.165
1871 May	Miss Georgina Houghton	New British Gallery, Old Bond Street	Spirit Drawings in water-colours	155 numbers. Introduction by Miss G. Houghton
1873	Mme Jerichau	Gallery of Messrs Pilgeram and L.H. Lefevre, 1a King St., St. James SW1	Pictures	"Art Journal" 1873 p.254
1877 Apr.	Miss Elizabeth Thompson	Fine Art Society, 148 New Bond St.	"Roll Call", "Quatre Bras" and "Balaclava"	Note by Cuthbert Bede

* See the bottom of page 146

DATE	ARTIST	GALLERY	TITLE OF EXHIBITION	REF.
1877	Miss Elizabeth Thompson	Fine Art Society	New Picture - "Inkerman" and her other battle pieces, "Roll Call", "Quatre-Bras" and "Balaclava"	Catalogue
1879 June-July	Mlle Sarah Bernhardt	Piccadilly Gallery	Paintings (16 subjects) and sculptures	1880 p.53
1880 Mar.	Miss Eliza Turck	Mr Rogers' Gallery, 29 Maddox St.	Collection of 35 drawings	1881 p.52
1881 sum.	Mme Arendrup	Dowdeswell Gallery, 133 New Bond Street	3 pictures	1882 p.49
1881 spr.	Miss Elizabeth Thompson	Egyptian Hall, Piccadilly	"Scotland for Ever"	1882 p.49
1881	Rosa Bonheur	L.H. Lefêvre, 1a King St. St. James's	Recent works	1882 p.50
1882 June	Mrs Oliver Wendell Holmes	Deschamps Gallery, 1 Old Bond Street	Collection of Embroideries	1883 p.51
1882 June	Miss North	Kew Gardens	Collection of 627 paintings of Flowers and Plants	1883 p.52
1882	Rosa Bonheur	L.H. Lefêvre	"The Lion at Home"	Catalogue
1882 Aug.-Sept.	Rosa Bonheur	Gladwell Bros. Gracechurch St. City	"The Lion at Home"	1883 p.52
1883 sum.	Rosa Bonheur	L.H. Lefêvre	Collection of pictures	1884 p.57
1883	Mrs H.A. Seymour	53 Great Marlborough St.	Pastels	1884 p.58
1885 May-June	Miss Seymour	103 New Bond Street	Pastel drawings	1886 p.64
1886 Mar.	Mrs Allingham R.W.S.	Fine Art Society	Drawings illustrating "Surrey Cottages"	66 numbers
1886 June	Miss E.M. Osborn	Goupil Gallery, 116-7 New Bond Street	"The Norfolk Broads"	1887 p.77

DATE	ARTIST	GALLERY	TITLE OF EXHIBITION	REF.
1887 Apr.- May	Mrs Allingham R.W.S.	Fine Art Society	"In the Country" - drawings	82 numbers
1888 Jan.	Miss Clara Montalba	Maclean's Gallery, 7 Haymarket	Water-colour drawings & sketches	95 numbers
1889 Apr.- May	Mrs Allingham R.W.S	Fine Art Society	Water-colour drawings - "On the Surrey Border"	79 numbers
1890 June	Mme Madeleine Lemaire	Goupil Gallery	A series of drawings illustrating "Flirt" by Louise Hervieu	39 numbers
1890 Oct.	Mme Marguerite Roosenboom	Fine Art Society	Water-colour drawings of flowers	46 numbers
1890 Dec.	Mme Henriette Ronner	Fine Art Society	"Animal Life"	115 numbers. Note by M.H. Spielman
1891 Apr.- May	Mrs Allingham R.W.S.	Fine Art Society	Collection of drawings illustrating "Surrey Cottages"	86 numbers. Preface by Mr Phipps Jackson
1892	Mme Henriette Ronner	Goupil Gallery	"Cats and Kittens"	31 numbers. Preface by M.H. Spielman
1894 Jan.	Kate Greenaway R.I.	Fine Art Society	Water-colour drawings	120 numbers
1894 Mar.- Apr.	Mrs Allingham R.W.S.	Fine Art Society.	Water-colour drawings	74 numbers
1894 Apr.- May	Miss Helen Thornycroft	2a Melbury Road	Water-colour drawings of the coast of Europe and flower pieces (including some works by her pupils)	220 numbers
1894	Miss L. Campbell Clark	Continental Gallery, 157 New Bond Street	Miniatures from Old Masters and Original Portraits	8 numbers
1895 May- June	Miss Mary Hill Burton	Clifford Gallery, 21 Haymarket, S.W.	Water-colour drawings of Japan, the land of flowers	55 numbers
1896 Jan.- Feb.	Mrs Ernest Hart	Dowdeswell Gallery	Pastel studies of "The Glories of the Sky and Sea in the Far East"	40 numbers.Foreword by Mr Gleeson White

DATE	ARTIST	GALLERY	TITLE OF EXHIBITION	REF.
1896 May	Miss Mary Hill Burton	Clifford Gallery	Water-colour drawings of Japan	76 numbers
1896 May	C. Dana Gibson	Fine Art Society	Drawings illustrating Society	31 numbers. Prefatory note by Mrs Arthur H. Pollen
1896 Apr.-June	Mrs F.C. Rowan	Dowdeswell Gallery, 160 New Bond Street	Series of 100 original water-colour drawings of "Australian Wild Flowers"	1897 p.122
1896 June	Miss Linnie Watt	Henry Graves and Co. 6 Pall Mall	Sketches entitled "At Home and Abroad"	1897 p.123
1896	Rosa Bonheur	L.H. Lefèvre	Complete collection of engraved works	1897 p.123
1897 Mar.	Miss Anna Nordgren	Clifford Galleries	Oil paintings and pastels - "Country and Cottage Life"	1898 p.114
1897 Mar.-May.	Miss Helen Thornycroft	2a Melbury Road	Water-colour drawings of Switzerland, Scotland, Wales, the Coast of Europe and flower pieces (and works by her pupils)	108 numbers
1897 Apr.	Miss M.R. Hill Burton	Clifford Galleries	Oil paintings and water-colours - "Scotland"	1898 p.114
1897	Mrs S. Roope Dockery	Dunthorne's Gallery (Rembrandt Gallery), 5 Vigo Street, W.	Water-colour drawings of North Portugal	76 numbers
1897	Rose Wallis	Dunthorne's Gallery	Water-colour drawings - "Gleanings from Italy"	56 numbers
1897	Miss Maude Earle	Henry Graves and Co.	Collection of Oil Paintings - "Canine Celebrities"	1898 p.116
1897	Mme Brlès	Henry Graves and Co.	French Figure Subjects	1898 p.116
1898 Feb.	Miss Kate Greenaway RI.	Fine Art Society	Collection of water-colour drawings	127 numbers
1898 Feb.	Miss Ella Du Cane	Henry Graves and Co.	Water-colours of English and continental scenery	1899 p.148
1898 Mar.	Mrs Allingham	Fine Art Society	Collection of Water-colour drawings	76 numbers

DATE	ARTIST	GALLERY	TITLE OF EXHIBITION	REF.
1898 June	Miss Rose Barton ARWS	Clifford Gallery	Water-colour drawings of London	57 numbers
1898 July	Miss Frances C. Fairman	Henry Graves and Co.	Latest Pictures of celebrated dogs	28 numbers
1898 Nov.	Miss Aimee Wilson	Walker's Gallery, 118 New Bond St.	Scenes at Home and Abroad	1899 p.150
1898 Dec.	Baroness Helga von Cramm	Clifford Gallery	Water-colour drawings	1899 p.146
1898	Miss Gemmell	St. James' Gallery (I.P. Mendoza)	Portraits	38 numbers
1899 Feb.-Mar.	Miss Helen Thornycroft	2a Melbury Road	Water-colour sketches and flower pieces	75 numbers
1899 May	Lady Wenlock	Fine Art Society	Water-colours of India	50 numbers
1899	Adele Fairholme	Continental Gallery	Peasant Life in the Tyrol - paintings and drawings	49 numbers
1900 Jan.	Miss Eva Withrow	Henry Graves and Co.	Pastel portraits and figure subjects	29 numbers
1900 Feb.	Miss Constance Daintrey	Continental Gallery	"From Norway to Italy" and "Through France and England" - 75 water-colour drawings	74 numbers. Preface by Beatrix L. Tollemache
1900 Mar.	Mrs Millar	Henry Graves and Co.	Water-colour drawings	1901 p.114
1900 Apr.	Mrs Stanhope Forbes A.R.W.S.	Fine Art Society	Pictures and water-colour drawings of "Children and Child-Lore"	49 numbers
1900 Apr.	Miss Carlisle	Henry Graves and Co.	Pastel drawings of South Africa	1901 p.114
1900 Apr.-May	Rosa Bonheur	Hanover Gallery, 47 New Bond Street	Works from her studio	1828 numbers
1900 May	Miss Ella Du Cane	Henry Graves and Co.	Water-colour drawings of Madeira, Italy and English Gardens	75 numbers
1900 Oct.	Maud Earl	Henry Graves and Co.	Oil paintings of dogs	1901 p.114
1900 Nov.-Dec.	Nancy Knaggs	MacQueen and Sons Gallery, 181 Tottenham Court Rd.	Water-colour drawings	160 numbers

DATE	ARTIST	GALLERY	TITLE OF EXHIBITION	REF.
1901 May	Mrs Allingham RWS	Fine Art Society	Water-colour drawings of the Seasons (Spring, Summer and Autumn)	67 numbers
1901 June-July	Eleanor Fortescue-Brickdale	Dowdeswell Gallery	Water-colour drawings - "Such stuff as Dreams are made of"	45 numbers
1901	Helen Thornycroft	2a Melbury Road	Pictures of Gardens and Flowers	"Art Journal" 1901 p.224
1902 Jan.	Madame Gutti	Modern Gallery, 175 Bond Street	Drawings in pastel (including a sketch from life of Her Majesty Queen Marguerite of Italy)	Manuscript sheet in the Art Library of Victoria & Albert Museum
1902 Apr.	Emily Ford	Continental Gallery	"Devotional Art"	61 numbers. Prefatory note by the artist
1902 July	Maud Beddington	Woodbury Gallery 37 New Bond Street	Pictures	61 numbers
1902 Nov.	Miss Sophia Woods	Modern Gallery	"Glimpses of Many Lands" - water-colour sketches	Catalogue
1902	Eleanor Fortescue-Brickdale	Leigh House, Kensington		"Magazine of Art" 1902 pp.256-60
1902	Sophia Beale	Doré Gallery, 35 New Bond Street	"The Shores of Provence" - water-colour drawings	44 numbers
1902	Miss Maud Coleridge	Henry Graves and Co.	Pastel portraits of Society ladies and children	21 numbers
1902	Miss Maud Earl	Henry Graves and Co.	"British Hounds and Gun Dogs"	30 numbers
1903 Feb.	Evelyn J. Whyley	Fine Art Society	Water-colours of Switzerland the Italian lakes and Spain	32 numbers
1903 Mar.	Nora Butson	Woodbury Gallery	Water-colour drawings of Venice and elsewhere	54 numbers
1903 May-June	Constance Halford	Baillie Gallery, 1 Princes Terrace, Hereford Road, W.	Drawings and Sketches	41 numbers
1903 May	Amy B. Atkinson	Continental Gallery	"People and Places in the Pas de Calais"	82 numbers
1903 May	Ida Lees	Dowdeswell Gallery	"Moonlight and other Night Effects" - oil paintings and drawings	62 numbers

DATE	ARTIST	GALLERY	TITLE OF EXHIBITION	REF.
1903 May	Miss Sybil Dowie	Continental Gallery	"Fair Women and Children" in oil and pastel	44 numbers
1903 Oct.-Nov.	Mrs Jane Inglis	MacQueen and Sons Gallery	Water-colour drawings of the three S's - Sark, Sweden and Switzerland	82 numbers
1903	Mrs Champion de Crespigny	Continental Gallery	"The Sea and its Shipping" - water-colour drawings	45 numbers
1903	Maud Earl	W.B. Paterson Gallery, 5 Old Bond Street	"Terriers and Toys" - 25 pictures	Introduction by William Arkwright
1904 Feb.	Miss Ina Clogstoun	Fine Art Society	Water-colours of English and Italian Gardens	52 numbers
1904 May	Mrs Allingham R.W.S.	Fine Art Society	Water-colours of English Country Life and Venice	100 numbers
1904 May	Isabel C. Pyke-Nott (Mrs P.G. Konody)	Goupil Gallery, 5 Regent Street	Landscape Miniatures on ivory of the Italian Lakes	17 numbers
1904 May	Eleanor Fortescue-Brickdale	Leighton House, Holland Park Road, Kensington	Loan collection of works by	35 numbers Preface by the artist
1904 Nov.	Miss Parsons	Dowdeswell Gallery	Water-colour drawings of Old English Gardens	53 numbers
1904 Nov.	Mrs Stanhope Forbes A.R.W.S.	Leicester Gallery (Ernest Brown and Phillips) Leicester Square	Water-colours, entitled "Model Children and other People"	84 numbers Preface by the artist
1904 Nov.	Miss Bertha Garnett	Modern Gallery	"From Rye to the Riviera" water-colour drawings and sketches,	66 numbers
1904 Dec.	Mary F. Raphael	Maclean's Gallery, 7 Haymarket	Sketches "At Home and Abroad"	47 numbers
1904 Dec.	Ann Macbeth	Baillie Gallery		1905 p.128
1904	Rosa Bonheur	L.H. Lefèvre Gallery	"The Duel" (The Godolphin Arabian versus Hobgoblin 1734) the latest portrait of Rosa Bonheur by Consuelo Fould and Rosa Bonheur, the complete works of the artist.	Catalogue

DATE	ARTIST	GALLERY	TITLE OF EXHIBITION	REF.
1904	Frances C. Fairman	Doré Gallery	"Dogs of all nations"	66 numbers
1905 Jan.	Miss Constance Daintrey	Doré Gallery	Water-colour drawings of boats and gardens in England, France and Italy	60 numbers
1905 Jan.	Mrs Caldwell Crofton (Helen Milman)	Fine Art Society	Water-colours of English lawns and gardens	55 numbers
1905 Jan.	Ruth Dollman	Fine Art Society	Water-colours – "On and Under a Sussex Down"	21 numbers
1905 Mar.	Miss Jessie King	Bruton Gallery, 13 Bruton Street	Black and white drawings	72 numbers
1905 Mar.	Lady Victoria Manners	Fine Art Society	Water-colours of Garden Scenes and other subjects	48 numbers
1905 Mar.-Apr.	E. Julia Robinson	Fine Art Society	Water-colours painted in many lands	115 numbers. Preface by Sir George Birchwood M.D., K.C.I.D.
1905 May-June	Lucy Kemp-Welch	Fine Art Society	Sketches and Studies in pencil and water-colour	57 numbers
1905 June-July	Eleanor Fortescue-Brickdale	Dowdeswell Gallery	Pictures in water-colour: "Such stuff as Dreams are made of", second series	27 numbers
1905 June	Mme R. Mantovani Gutti	Henry Graves and Co.	Pastels and Paintings	16 numbers
1905 June	Mary Barton	Fine Art Society	Irish water-colours	81 numbers
1905 June	Miss K.E. Halkett	Doré Gallery	Sketches in "Augusta Perusia" and elsewhere	1906 p.128
1905 June	Mrs Philip Champion de Crespigny	Doré Gallery	Water-colour drawings of "River and Seascape"	1906 p.128
1905 June	Mlle Ruth Mercier	W.B. Paterson's Gallery	Pictures	1906 p.131
1905 Oct.	Miss Duke	Doré Gallery	Water-colours	1906 p.128
1905 Oct.	Miss E. Hawke	Doré Gallery	Water-colours	1906 p.128

DATE	ARTIST	GALLERY	TITLE OF EXHIBITION	REF.
1905 Dec.	Winifred Russell Roberts	Dowdeswell Gallery	Water-colours - "At Home and Abroad"	83 numbers
1905 Dec.	Mrs Edmund Davis	Leicester Gallery	Landscape notes and sketches	50 numbers
1905	Miss Violet Burnaby-Atkins	Modern Gallery, 61 New Bond Street	Water-colour sketches - "Meadow, Wood and Garden"	54 numbers
1905	Miss Bessie Wigan	Modern Gallery	Water-colour drawings - "By Mountain, Lake and Forest"	1906 p.130
1905 Mar.	Frances C. Fairman	Doré Gallery	Dog Pictures."England and the Far East"	1906 p.127
1905 Feb.	Emily M. Paterson RSW	Maclean's Gallery	Works	1906 p.130
1906 Feb.	Mrs F.A. Hopkins	Doré Gallery	Water-colours - "Untrodden Ways in French Fields and Forests"	124 numbers
1906 Feb.	Evelyn J. Whyley	Fine Art Society	Water-colours - "From the Alps to the Appenines"	76 numbers
1906 Feb.-Mar.	Miss Hodgkins	W.B. Paterson Gallery	Water-colour drawings	1907 p.141
1906 Mar.	Miss Edith Houseman	Doré Gallery	Water-colour landscapes	48 numbers
1906 Mar.	Linnie Watt	Doré Gallery	Pictuers - "Peasant Life in Brittany"	43 numbers
1906 Mar.	Ina Clogstoun	Fine Art Society	Water-colours of Italian Spring and English Summer	55 numbers
1906 Mar.	Miss Flora Lion	Bruton Galleries	Portraits and Pictures	1907 p.135
1906 Apr.	Fannie Moody	Ryder Gallery, 47 Albemarle Street	Oil paintings and studies in chalk of "Cat and Dog Life"	43 numbers
1906 May-June	Mrs Leslie Cotton	Knoedler and Co.'s Gallery 15 Old Bond Street	Portraits	23 numbers
1906 May	Miss Fanny Farrer	Doré Gallery	Paintings of Flowers	74 numbers
1906 May-June	Miss Gerda E.M. Crump	Modern Gallery	Water-colour sketches	16 numbers
1906 May	Miss Evelyn Perceval-Clark	Modern Gallery	"Natal" oil sketches of Ladysmith, Colenso, Spion Kop, etc.	52 numbers

DATE	ARTIST	GALLERY	TITLE OF EXHIBITION	REF.
1906 May	Mrs A. Broome	Doré Gallery	Water-colour drawings of English, Swiss and Kashmir scenery	1907 p.136
1906 May	Alice Van Heddeghem	Doré Gallery	Flower Paintings	1907 p. 136
1906 May	Blanche Jenkins	Doré Gallery	Portraits and Pictures	1907 p.136
1906 June	Miss M. Dawkins	Doré Gallery	Water-colour drawings of architectural and other subjects at home and abroad	43 numbers
1906 June	Beatrice Parsons	Dowdeswell Gallery	Water-colours - "Old Gardens in England and Algiers"	39 numbers
1906 June	Miss Iris I.C. Reeve	Bruton Galleries	Pastel sketches	1907 p.135
1906 June	Evelyn de Morgan	Bruton Galleries	Anglo-Florentine Portraits	1907 p.135
1906 July	Kate M. Wyatt	Fine Art Society	Water-colours of Gay Gardens	51 numbers
1906 July	Miss Marjorie Murray	Doré Gallery	Pen and ink drawings	1907 p.136
1906 June-July	Celia Blackwood	Ryder Gallery		78 numbers
1906 June-July	Rhoda Tinling	Ryder Gallery	Water-colour and charcoal drawings	51 numbers
1906 Nov.	Mlle Layrut	Doré Gallery	Portraits, paintings etc.	31 numbers
1906 Nov.	Miss Constance Daintrey	Doré Gallery	Water-colour drawings - "Venice, Como and the New Forest"	72 numbers
1906 Nov.	Countess Camilla Hoyes	Doré Gallery	Drawings	1907 p.136
1906 Nov.	Mrs Earnshaw	Doré Gallery	Water-colours and pastels	1907 p.137
1906 Nov.	Miss Birkenruth	New Dudley Gallery, 169 Piccadilly	Tinsel Pictures	1907 p. 141
1906 Dec.	Miss H. Donald-Smith	Modern Gallery	Water-colours; "River, Lake and Garden" and some portraits in oil.	110 numbers
1906 Dec.	Countess Feodora Gleichen	New Dudley Gallery	Sculpture	1907 p.141

DATE	ARTIST	GALLERY	TITLE OF EXHIBITION	REF.
1906 Dec.	Miss Elinor Hallé	New Dudley Gallery	Decorative Work	1907 p.141
1906 Dec.	Countess Helena Gleichen	New Dudley Gallery	Pictures	1907 p.141
1906	Marguerite Verboeckhoven	Henry Graves and Co.	"A Poem of Silence" - Nocturnes painted in oil	67 numbers
1906	Louise Jopling R.B.A.	Lyceum Club, 52 New Bond Street, 128 Piccadilly	Pictures	65 numbers
1906	Lilian Stannard	Mendoza Gallery, 157a New Bond Street	Water-colour drawings - "Summer gardens of England"	52 numbers
1906	Queen Victoria	Brook Street Art Gallery, No. 14	Original Etchings	1907 p.135
1906	Miss Mary Wilson	James Connell and Sons, 47 Old Bond St.	"Scottish Gardens and Venetian Court-yards" - Pastels	1907 p.136
1906	Miss Bessie Wigan	The Modern Gallery	"A Summer's Sketches"	1907 p.140
1907 Jan.	Ruth Dollman	Leicester Gallery	Water-colours of the South Downs	52 numbers
1907 Jan.	Mima Nixon	Fine Art Society	Water-colours of Algeria and the Low Countries	74 numbers
1907 Feb.	Miss Amy B. Atkinson	Goupil Gallery	"Touraine" Preface by Anne Macdonell	60 numbers
1907 Feb.	Mrs Caldwell Crofton	Modern Gallery	Water-colours - "Gardens of Delight"	68 numbers
1907 Feb.	Sophia Beale	Ryder Gallery	Water-colours - "May on Venetian Lagoons"	45 numbers
1907 Apr.	Mrs F.A. Hopkins	Doré Gallery	Water-colours - "In Pleasant Places"	1908 p.131
1907 Apr.	Miss C. Lilian Sheppard	Doré Gallery	Animals and Landscapes	1908 p.131
1907 May	Mrs Philip Champion de Crespigny	Doré Gallery	Water-colours; "Ebb and Flow"	60 numbers
1907 May	Miss Fanny Farrer	Doré Gallery	Paintings of Flowers etc.	1908 p.131
1907 May	Maude Parker	New Dudley Gallery	Thames Studies	1908 p.135
1907 May	Miss Birkenruth	New Dudley Gallery	Tinsel Pictures	1908 p.135

DATE	ARTIST	GALLERY	TITLE OF EXHIBITION	REF.
1907 June	Miss Eve Baker	Doré Gallery	Pictures	30 numbers
1907 June	Miss Sybil Dowie	Doré Gallery	Sketches of Egypt in oil and pastel	29 numbers
1907 June	Mme "Lotus" Péralté	Doré Gallery	Pictures of India, Tibet and the East	54 numbers
1907 June	Miss Bess Norris ARMS	Stafford Gallery 13 St. James's Place	Miniatures and water-colour drawings	46 numbers
1907 June-July	Marie d'Epinay	Fine Art Society	Portraits and Studies	24 numbers
1907 June	Lady Victoria Manners	Graves' Gallery	Water-colours of Gardens etc., in England, Italy and Sicily	58 numbers
1907 June-July	Mrs Gertrude Massey	Ryder Gallery	Miniatures	29 numbers
1907 June	Alice Van Heddeghem	Doré Gallery	Pictures and Rose Boudoir	1908 p. 131
1907 June	Miss Muriel Hunt	Doré Gallery	Sketches of cats and dogs	1908 p.131
1907 Oct.-Nov.	Anna Airy	Carfax and Co. 24 Bury St. St. James's	Paintings, drawings and etchings	38 numbers
1907 Nov.	Winifred Russell-Roberts	Dowdeswell Gallery	Water-colours - "Biskra and Sicily"	46 numbers
1907 Nov.	Mrs James Jardine	Modern Gallery	Sketches; "The Rhine and Switzerland"	73 numbers
1907 Dec.	Mrs Muller	Doré Gallery	Enamels	1908 p.132
1907 May-June	Gyula Tornai	Goupil Gallery	"Japan and India" - Paintings	77 numbers
1907	Lilian Stannard	Mendoza Gallery	Water-colour drawings - "Flower Gardens of England"	30 numbers
1907	Ione Macdonald	Walker's Gallery	Water-colour sketches - "Scotland, England and the South of France"	70 numbers
1907	Miss Nora Butson (Mrs Guy Jackson)	Modern Gallery	"Venice and Ireland" - Water-colours	1908 p.134

DATE	ARTIST	GALLERY	TITLE OF EXHIBITION	REF.
1907	Miss Burnaby-Atkins	Modern Gallery	"Meadow, Wood and Garden" - sketches in water-colour	1908 p.134
1907	Augustine FitzGerald	Modern Gallery	"Scenes in the Orient and Old French Gardens" - oil paintings	1908 p.134
1908 Jan.	Lady Chance	Fine Art Society	Decorative sculptures for Garden and House	10 numbers
1908 Jan.	C. Lillian Sheppard	Doré Gallery	"Pictures of Brittany and the Isle of Skye"	87 numbers
1908 Feb.	Miss Sophia J. Ogilvie	Doré Gallery	Landscapes in oil - "Rural Scenes in Saxony"	19 numbers
1908 Feb.	Beatrice Parsons	Dowdeswell Gallery	Water-colours - "Gay Gardens under sunny skies"	44 numbers
1908 Feb.	Jessie Hall	Baillie Gallery, 54 Baker Street	Water-colours	1909 p.138
1908 Feb.	Linnie Watt	Doré Gallery	Pictures	1909 p.140
1908 Mar.	Miss Stirling	New Dudley Gallery	The Surrey Art Circle and water-colours by ..	1909 p.143
1908 Mar.	Miss F. Duke	Doré Gallery	Pictures	1909 p.140
1908 Apr.	Mrs Allingham R.W.S.	Fine Art Society	Water-colours	60 numbers
1908 May	Miss Ella Du Cane	Fine Art Society	Water-colours of Japan	93 numbers
1908 May	Edith A. Stock	Doré Gallery	Flower Pictures and Gardens	1909 p.140
1908 May	Fanny Farrer	Doré Gallery	Flower Pictures	1909 p.140
1908 May	Lillian Luard	Doré Gallery	Water-colours of English and Italian Gardens	1909 p.140
1908 June- July	Mrs Alex Rawlins	Doré Gallery	Sketches of Eton	27 numbers
1908 June July	Baroness von Preuschen	Newman Art Gallery, 29 Newman St. Oxford St.	Symbolic pictures and studies in India Burma, Ceylon, etc.	153 numbers

DATE	ARTIST	GALLERY	TITLE OF EXHIBITION	REF.
1908 June	Mrs L.T. Bowles	Brook Street Art Gall.	Water-colour drawings - "India and Jersey"	1909 p.139
1908 July	Miss McIntyre Croxford	Doré Gallery	Dog Pictuers	1909 p.140
1908 Oct.	Charlotte G. McLaren	Paterson's Gallery	Miniatures and Drawings	53 numbers
1908 Oct.	Miss D.M. Moore	Brook St. Art Gallery	"India" - Water-colour drawings	1909 p.139
1908 Nov. Dec.	Mrs Henry Campbell	Modern Gallery	Portraits in pastel and water-colours of Italy, Holland, Belgium and England	74 numbers
1908 Nov.	Amelia M. Bauerle A.R.E.	Dowdeswell Gallery	Water-colour drawings and etchings - "When the World was young"	65 numbers
1908 Nov.	Miss Fairman	Doré Gallery	Dog Pictures	1909 p.140
1908	Mrs William Lowther	26 Park Lane	1. Pictures and Prints of Old London exhibited .. in memory of the late Hon... Memorial sketch by George W.E. Russell, Appreciation by Alfred Austin, In Memoriam by Arnold White, a Tribute by Martin Hume 2. Memorial exhibition of the work of the late Mrs William Lowther. Prints and Pictures of Old London Exhibition	132 numbers
1908	Dorothy Cox	Mendoza Gallery	Water-colour drawings - "Under Autumn Skies"	66 numbers
1908	Laura Coombs Hills	Rembrandt Gallery (Robert Dunthorne) Vigo St.	Miniatures	50 numbers
1908	Miss Mary Wilson	Connell and Sons (James)	"Old Scottish Gardens" - Pastels	1909 p.139
1908	Mrs Barney of Washington	Modern Gallery	Portraits and sketches in pastel	1909 p.143
1908	Mrs H.(Ida) Foster Morley	Modern Gallery	"Landways and water-ways" - Water-colour sketches	1909 p.143
1908	Miss Katherine Johnson	Newman Art Gallery	Pictures	1909 p.144

DATE	ARTIST	GALLERY	TITLE OF EXHIBITION	REF.
Dec. 1907-Nov. 1908	Mrs Sandford	Van Brakel Gallery, 36 Albemarle Street		1909 p.145
"	Miss Helen Bulkeley	"		1909 p.145
"	Mrs Engelback	"		1909 p.145
"	Miss Lack	"		1909 p.145
"	Miss Mary L. Breakell	"		1909 p.145
"	Miss Mary L. Breakell	"		1909 p.145
1909 Feb.-Mar.	Mary McCrossan	Baillie Gallery, 13 Bruton Street	Paintings and water-colours	44 numbers
1909 Feb	Grace J. Joel	Doré Gallery	Pictures of English, Dutch, French and Figure subjects	55 numbers
1909 Mar.-Apr.	Miss H. Donald-Smith	Baillie Gallery	Paintings and drawings of Venice and the Lagoons	63 numbers
1909 Mar.	Evelyn J. Whyley	Fine Art Society	Water-colours of mountains, lakes and lowlands	81 numbers
1909 Mar.	Emily M. Paterson R.S.W.	Maclean's Gallery	Water-colours - "From the North Sea to the Adriatic"	68 numbers
1909 Mar.	Alice Charlesworth	Ryder Gallery	Water-colour drawings of Japan, China and other countries	42 numbers
1909 Mar.	Miss Edith G. Houseman	Brook Street Art Gall.	Water-colour drawings of Italy, Surrey etc.	1910 p.135
1909 Mar.	Linnie Watt	Doré Gallery	Pictures - "At Home and Abroad"	1910 p.136
1909 Mar.	Miss Rachel Wheatcroft	New Dudley Gallery	Water-colour drawings (169)	1910 p.140
1909 Mar.	Miss Charlotte Noel	New Dudley Gallery	Water-colour drawings	1910 p.140
1909 Mar.	Miss Hammond	New Dudley Gallery	Oil Paintings	1910 p.140
1909 Mar.	The Countess Amherst	New Dudley Gallery	Pastels	1910 p.140

DATE	ARTIST	GALLERY	TITLE OF EXHIBITION	REF.
1909 Apr.-May	Ruth Dollman	Leicester Gallery	Water-colours of the Sussex Downs	60 numbers
1909 Apr.	Edith A. Stock	Doré Gallery	Roses and Gardens in pastel and water-colour	1910 p.136
1909 May	The late Ina Clogstoun	Fine Art Society	Water-colours of Italian Spring and English summer	54 numbers
1909 May	Mrs Beanlands	Doré Gallery	Sketches of Victoria British Columbia	1910 p.136
1909 May	Mrs Alastair Murray	Doré Gallery	Scenes in Jamaica	1910 p.136
1909 May	Mrs Wheatcroft	Doré Gallery	Sketches of "Venice and the Italian Lakes"	1910 p.136
1909 June-July	Mima Nixon	Baillie Gallery	Water-colour drawings - "Dutch bulbs and gardens"	50 numbers
1909 June	Mary Barton	Fine Art Society	Water-colours of Mexico	55 numbers
1909 June-July	Eleanor Fortescue-Brickdale A.R.W.S.	Dowdeswell Gallery	Water-colours - "The Poems of Robert Browning"	40 numbers
1909 June	Miss Dorothy Cox	New Dudley Gallery	Water-colour pictures and sketches in "River, Marsh and Upland"	89 numbers
1909 June	Alice van Hedeeghem	Doré Gallery	Flower Pictures	1910 p.136
1909 June	Mrs Philip Champion de Crespigny	Doré Gallery	Water-colours - "Grey Mist and Autumn Fog"	1910 p.136
1909 June	Signorina Elisa Stoppolini	Doré Gallery	Water-colours of Westminster Abbey	1910 p.136
1909 July	Mrs Whipple	Doré Gallery	Enamels	1910 p.136
1909 July	Mrs Evershed	Doré Gallery	Embroideries	1910 p.136
1909 July	Miss Rose E. Wilkins	Doré Gallery	Embossed leather work'	1910 p.136
1909 July	Mrs Parsons	Doré Gallery	Old Lace	1910 p.136
1909 July	Mrs Leyland Stevenson	Doré Gallery	Frames and lustre laquer work	1910 p.136
1909 Oct.	Mrs Earnshaw	Doré Gallery	Pastel drawings - "Capri" and "On Lake Como"	96 numbers

DATE	ARTIST	GALLERY	TITLE OF EXHIBITION	REF.
1909 Nov.	Florence Paul	Baillie Gallery	Paintings - "On Deeside"	39 numbers
1909 Nov.	Myra K. Hughes	New Dudley Gallery	Etchings of Old London	41 numbers
1909 Nov.	Winifred Koe	Walker's Gallery	Sketches of Lourdes, Croagh Patrick, Holywell and some portraits	47 numbers
1909 Nov.	Miss F. Blandy	Brook St. Art Gallery	Water-colours	1910 p.135
1909 Dec.	Dorothy Cox	New Dudley Gallery	Water-colour drawings	49 numbers
1909	Mrs Burrell Hayley	Modern Gallery	"At Home and Abroad" - water-colour sketches	1910 p.140
1909	Mrs Caldwell Crofton	Modern Gallery	Water-colour drawings	1910 p.140
1910 Jan.	Mrs Walter Donne	Walker's Gallery	Illustrations and Fancies	68 numbers
1910 Feb.	Miss Elsie H. Rose	Brook St. Art Gallery	Oil Paintings and Pastels - "Brittany, Bruges etc" and Portraits	1911 p.136
1910 Mar.	Miss Margaret Bernard	Doré Gallery	Water-colour sketches and studies	54 numbers
1910 Mar.	Beatrice Parsons	Dowdeswell Gallery	Water-colours; "Romantic Gardens"	48 numbers
1910 Mar.	Emma Ciardi	Leicester Gallery	Paintings. Preface by Ugo Cjetti	79 numbers
1910 Apr.	Phyllis Vere Campbell	Doré Gallery	Drawings	35 numbers
1910 Apr.	Miss Annie M. Paterson	Baillie Gallery	Pictures	40 numbers
1910 Apr.-May	Carlotta Popert	Baillie Gallery	Water-colour drawings and etchings	82 numbers
1910 Apr.	Louisa Marchioness of Waterford	8 Carlton House Terrace	Loan exhibition of water-colour paintings by .. Memoir	343 numbers
1910 Apr.	Edith H. Adie	Fine Art Society	Water-colours - "Sunshine in Italy and England"	63 numbers
1910 Apr.	Miss Ida Betts	Brook St. Art Gallery	Water-colour drawings - "Christchurch"	1911 p.136
1910 Apr.	Mrs Alex Rawlins	Doré Gallery	Sketches of Cambridge during a vacation	1911 p.137

DATE	ARTIST	GALLERY	TITLE OF EXHIBITION	REF.
1910 Apr.	Miss Gertrude Whelpton	Doré Gallery	Animal pictures	1911 p.137
1910 Apr.	Alice van Heddeghem	Doré Gallery	Flower Pictures	1911 p.137
1910 May	Miss Mary L. Breakell	Little Gallery Van. Brakel	"Capri, Angelsey and the Isle of Man" - sea and landscape pictures	59 numbers
1910 May-June	Maria Bodtker	Baillie Gallery	Paintings of flowers, fruit and landscapes	42 numbers
1910 May	Alma B. Cull	Dowdeswell Gallery	"By Sea and Shore" and "Sketches of His Majesty's Navy" - water-colours	66 numbers
1910 May	Lady Alma-Tadema	Fine Art Society	Pictures and sketches	130 numbers Eulogy by Robert Ross
1910 May	Miss Ella Du Cane	Fine Art Society	Water-colours of Madeira	64 numbers
1910 May	Lady Gray Hill	Doré Gallery	Sketches of Syria and Egypt	1911 p.137
1910 May	Miss Fanny Farrer	Doré Gallery	Flower Pictures	1911 p.137
1910 June	Mrs Gertrude Nutt	Baillie Gallery	Paintings - "Singapore and the Federated Malay States"	28 numbers
1910 July	Mlle Mathilde Sée	Maclean's Gallery	Water-colours of Flowers	70 numbers
1910 July	Miss M. Cameron	Maclean's Gallery	Spanish and other pictures	36 numbers
1910 July	Mrs Margaret Moscheles	Brook St. Art Gallery	Oil Paintings	1911 p.137
1910 Oct.	Alicia Blakesley	Baillie Gallery	Pictures - "Algiers, Mentone etc".	47 numbers
1910 Oct.	Mme Erna Hoppe	Baillie Gallery	Paintings and Portraits	57 numbers
1910 Oct.	Olive Snell	Fine Art Society	Portraits and drawings	50 numbers
1910 Oct.	Kathleen Goodman R.I.M.S.	Doré Gallery	"England's Fair Children" - miniatures, water-colours and oils	1911 p.138
1910 Nov.	Lady Louisa Charteris	Fine Art Society	Water-colours of the Riviera, Italy and Scotland.	41 numbers

DATE	ARTIST	GALLERY	TITLE OF EXHIBITION	REF.
1910 Dec.	Vera Waddington	Carfax and Co.	Chinese Studies	42 numbers
1910 Dec.	Ueleina Parkes	Newman Art Gallery	Fountains, landscapes and Figure Paintings	67 numbers
1910 Dec.	Miss Johanna Birkenruth	Brook St. Art Gallery	Tinsel Pictures and Costume figures	1911 p.137
1910	Mathilde de Cordoba	Dowdeswell Galleries	Portrait etchings	31 numbers
1910	Edith Harwood	Dowdeswell Galleries	Tempera paintings and drawings. Preface by the artist	39 numbers
1910	Dorothy Cox	Dudley Gallery	Water-colour drawings	45 numbers
1910	Mary Dollman	Tooth and Sons, 29 Bruton St.	Drawings of Buds and Blossoms	40 numbers
1910	Miss Gerda Crump	Modern Gallery	Water-colours of London, Scotland and St. Ives	1911 p.140
1910	Miss Cara Buxton	Modern Gallery	African water-colour sketches	1911 p.140
1910	Miss Amelia Walker	Modern Gallery	Water-colours of Cornwall, Kent, Norfolk and Sussex and Portrait sketches	1911 p.140
1910	Miss Marian L. Barnes	Newman Art Gallery	Flower pictures	1911 p.141
1910	Charlotte M. Alston	Newman Art Gallery	Landscapes - "India, Japan"	1911 p.141
1910	Ethel C. Hargrove	Newman Art Gallery	Book illustrations	1911 p.141
1910	Sybil Baghot de la Bere	Newman Art Gallery	Portraits and landscapes	1911 p.141
1911 Jan.	Sarah Ball Dodson	Goupil Gallery	Oil paintings Preface	83 numbers
1911 Jan.	Rosa Wallis	Fine Art Society	Water-colours - "Flower-time in Highlands and Lowlands"	77 numbers
1911 Feb.	Ellen Maurice Heath	Walker's Gallery	Paintings and sketches	55 numbers
1911 Mar.-Apr.	Miss Wakana Utagawa	Baillie Gallery	Paintings on silk, Introduction	40 numbers
1911 Mar.-Apr.	Mabel Slocock	Walker's Gallery	Miniature and water-colour drawings of India and Cyprus.	36 numbers

DATE	ARTIST	GALLERY	TITLE OF EXHIBITION	REF.
1911 Mar.	Mrs Angela Broome	Doré Gallery	Water-colours of the Himalayas, Cashmere, Scotland and Switzerland	1912 p.138
1911 Mar.	Mary Luttrell	Doré Gallery	Water-colours of Italy, Scotland and the West of England	1912 p. 138
1911 Mar.	Miss Car Richardson	Dudley Gallery	Water-colours of Lincoln	1912 p.139
1911 Apr.-May	Miss Anne Estelle Rice	Baillie Gallery	Paintings	36 numbers
1911 Apr.-May	Helen Donald-Smith	Dowdeswell Gallery	Water-colours of "Venice and London"	88 numbers
1911 Apr.	Linnie Watt	Doré Gallery	Pictures of France and Italy	1912 p.138
1911 Apr.	Miss A.M. Goodall	Dudley Gallery	Water-colours of Gibraltar, Malta, Algeria and Portugal	1912 p.139
1911 May-June	Miss Pamela Colman Smith	Baillie Gallery	Music Pictures	40 numbers
1911 May	Miss Agnes Turner	Walker's Gallery	Water-colour drawings of "London"	63 numbers
1911 May-June	Miss E.R. Stones	Walker's Gallery	English and Italian landscapes	48 numbers
1911 May	Miss Pauline Netterwille	Doré Gallery	Miniatures	1912 p.138
1911 May	Edith Stock	Doré Gallery	Flower pictures	1912 p.138
1911 May	Isabel Roget	Doré Gallery	Streets and interiors	1912 p. 138
1911 May	Mrs Alex Rawlins	Doré Gallery	Sketches of Interior Views of Westminster Abbey and of the Field of Waterloo	1912 p.138
1911 June	Mrs Caldwell Crofton	Modern Gallery	Water-colour drawings of Gardens and Heather	36 numbers
1911 June	Beatrice Bright	Doré Gallery	Portraits and Seascapes	1912 p.138
1911 June	Mrs Philip Champion de Crespigny	Doré Gallery	Water-colours of the "New Forest and Old Thames"	1912 p.138

DATE	ARTIST	GALLERY	TITLE OF EXHIBITION	REF.
1911 June	Bettia Schebsman	Doré Gallery	Michael Mordkin's Portraits in the "Dance Bacchanale"	1912 p.139
1911 June	Romaine Brooks	Goupil Gallery	Oil paintings	1912 p.141
1911 July-Aug.	Miss Edith Gaddum	Baillie Gallery	Water-colour drawings	46 numbers
1911 July-Aug.	Miss Vere Campbell	Baillie Gallery	Water-colour drawings - "Mystery and Magic"	20 numbers
1911 July-Aug.	Mrs Edmund Davis	Leicester Gallery	A Salon of Fans	71 numbers
1911 July	Nellie Hadden F.S.Z.	Walker's Gallery	Chalk and water-colour drawings - "Egypt through an animal painter's spectacles"	59 numbers
1911 Oct.	Katherine S. Dreier	Doré Gallery	Paintings and decorative panels	40 numbers
1911 Oct.	Maud Earl	Fine Art Society	Pictures entitled "The Power of the Dog"	20 numbers
1911 Oct.	Eleanor Fortescue-Brickdale A.R.W.S.	Leicester Gallery	Water-colours illustrating Tennyson's "Idylls of the King"	37 numbers
1911 Nov.	Anna Airy	Paterson's Gallery	Oil paintings, water-colour drawings and etchings	41 numbers
1911 Nov.	Nellie Holcombe (née Hayes)	Modern Gallery	Flower paintings in oil	30 numbers
1911 Nov.	Mrs Pennell Williamson	Dudley Gallery	Water-colours and oil paintings of Kashmir and the Nile	1912 p.139
1911 Dec.	Etheldreda Gray	Leicester Gallery	Water-colours illustrating a book of children's verse	24 numbers
1911	Miss Mary G.W. Wilson	James Connell and Sons	Pastels - "Flowers and Fields"	42 numbers
1911	Lilian Cheviot	Mendoza Gallery	Oil paintings - "Animal Life"	42 numbers
1911	Miss Phil Morris	Modern Gallery	Portraits and impressions	40 numbers
1911	Lady Louisa Charteris	Fine Art Society	Water-colours of Scotland and Italy	1912 p.140

DATE	ARTIST	GALLERY	TITLE OF EXHIBITION	REF.
1911	Mrs Gascoigne	Fine Art Society	Fans	1912 p.140
1911	Lady Constance Emmett	Modern Gallery	Oil and water-colour drawings of West Highland subjects	1912 p.143
1911	Mrs Russell Walker	Modern Gallery	Water-colour drawings of gardens	1912 p.143
1911	Miss Heriot Ronaldson	Modern Gallery	"Gardens and landscapes" - water-colours	1912 p.143
1911	Miss Alice Edgelow	Modern Gallery	Water-colour drawings of the South England Coast and other landscapes	1912 p.143
1911	Miss Maud B. Worsfold	Walker's Galleries	Portraits (after Downman)	1912 p.144
Dec.1911-Jan.1912	Estella Canziani	Dowdeswell Gallery	Tempera paintings and drawings of Savoy etc.48 numbers	
1912 Feb.	Elsie H. Rose	Brook St. Art Gallery	Oils and pastels of "Italy, Normandy, and England"	1913 p.146
1912 Feb.	Ann Maitland	Baillie Gallery		1913 p.146
1912 Mar.	Susan Isabel Dacre	Walker's Gallery	Little Pictures of Italy	58 numbers
1912 Mar.	Beatrice Parsons	Dowdeswell Gallery	"Gardens" and other water-colours	55 numbers
1912 Mar.	Annette Elias	Baillie Gallery		1913 p.146
1912 Mar.	Mrs Forester-Wood	Doré Gallery	Needlework Pictures	1913 p.148
1912 Apr.	Maude Parker	Dudley Gallery	Water-colours of Tangier, London and Deeside	1913 p.149
1912 Apr.	Duchess of Buckingham and Chandos	Doré Gallery	"Christ Blessing the Children"	1913 p.148
1912 May	Dorothy Cox	Walker's Gallery	Water-colours - "Summer in the South of England"	65 numbers
1912 May	Miss Ella Du Cane	Fine Art Society	Water-colours of Spain and the Canary Islands	63 numbers
1912 May-June	Lady Butler	Leicester Gallery	"The Roll Call" and water-colour drawings	33 numbers

DATE	ARTIST	GALLERY	TITLE OF EXHIBITION	REF.
1912 May	Miss F.E. Stoddard	Doré Gallery	Miniatures and water-colours	1913 p.148
1912 May	Miss Edith Stoddard	Doré Gallery	Pencil drawings	1913 p.148
1912 June	Mary McCrossan	Baillie Gallery	Pictures of Morocco and Spain	43 numbers
1912 June	Jane Adye Ram	Doré Gallery	"Home Scenes"	1913 p.148
1912 June	Mrs Basil Johnson	Doré Gallery	Water-colours of Rome and Algeria and the West of England	1913 p.148
1912 June	Alice van Heddeghem	Doré Gallery	Flower pictures	1913 p.148
1912 July	Lucy Kemp-Welch	Dudley Gallery	Pictures and studies	87 numbers
1912 July	Mary Raphael	Baillie Gallery		1913 p.146
1912 July	Mrs Hume-Williams	Baillie Gallery		1913 p.146
1912 July	Kay Nielsen	Dowdeswell Gallery	Drawings in black and white	1913 p.149
1912 Oct.	Miss A.H. Combes	Walker's Gallery	Water-colour sketches in many lands	113 numbers
1912 Oct.	Daphne Allen	Dudley Gallery	Drawings - "A Child's Visions and Fancies" Preface by Selwyn Image	147 numbers
1912 Nov.	Ida Kirkpatrick	Goupil and co.	Water-colours	54 numbers
1912 Nov.	Amelia M. Bowerley A.R.E.	Dowdeswell Gallery	"When the World was Young' - Water-colours	1914 p.146
1912 Nov.	Adeline S. Illingworth ARE	Goupil and Co.	Etchings	47 numbers
1912 Nov.	Miss Jex-Blake	Doré Gallery	Water-colours	1913 p.148
1912 Nov.	Anna Maclean	Dudley Gallery	Drawings	1913 p.149
1912 Dec.	Miss M.V. Wheelhouse	Baillie Gallery	Water-colours and drawings	50 numbers
1912	Dorothy Smart	Ryder Gallery	Miniatures, portraits and landscapes on ivory	67 numbers
1912	Ella Wake-Walker	Ryder Gallery	Water-colour drawings of Norway and London	57 numbers
1912	Aline S. Bridge	Ryder Gallery	Impressions of France and Spain in oil and water-colours	48 numbers

DATE	ARTIST	GALLERY	TITLE OF EXHIBITION	REF.
1912	Rose Forster	Ryder Gallery	Water-colour drawings in England, Ireland, France and South America	51 numbers
1912	Mrs Walter Clutterbuck	Dudley Gallery	Water-colours of Dalmatia, Italy, etc.	60 numbers
1912	Jean Ray	Goupil Gallery	"Nos chers bébés" - water-colours	32 numbers
1912	Miss M. Helen Carlisle	Modern Gallery	"Wildflower landscapes and sunny gardens in California. Also street scenes in Mexico"	25 numbers
1912	Mrs F.A. Hopkins	Modern Gallery	"Canada, Normandy, and South Africa" - water-colours	1913 p.153
1912	Miss E. Roskruge	Modern Gallery	Water-colours	1913 p. 153
1912	Miss M.L. Harding	Modern Gallery	Water-colours of "England and France"	1913 p.153
1912	Mme Longworth	Sphinx Gallery, 7 Royal Opera Arcade, Pall Mall	Permanent exhibition of her "Impressions in sculpture"	1913 p.154
Dec.1912-Jan.1913	Gwendoline Hopton	Walker's Gallery	Sketches	71 numbers
1913 Jan.-Feb.	Charlotte Noel	Walker's Gallery	Water-colour sketches of small English gardens	32 numbers
1913 Jan.	Lilian Lancaster	Doré Gallery	Pictures	1914 p.145
1913 Jan.	Miss Frances Fairman	Doré Gallery	Pictures of dogs	1914 p.145
1913 Feb.	Miss L.E. Pierce	Walker's Gallery	Illustrations to the poetical works of John Keats, and the Rubaiyat of Omar; and water-colours of Italy and England	54 numbers
1913 Feb.	Emma Ciardi	Leicester Gallery	Paintings	80 numbers
1913 Feb.	Miss Constance Daintrey	Doré Gallery	Water-colour drawings, of England and Italy	1914 p.145
1913 Feb.	Mrs Alastair Murray	Doré Gallery	Water-colours	1914 p.145
1913 Feb.	Miss Evangeline Jex-Blake	Doré Gallery	Sketches in Brittany and other places	1914 p.145

DATE	ARTIST	GALLERY	TITLE OF EXHIBITION	REF.
1913 Feb.	Frances Drummond	Dowdeswell Gallery	"English flowers in Woodland, Field and Garden" - water-colours	1914 p.146
1913 Feb.	Bridget Keir	Dudley Gallery	"The Lagoons of Venice"	1914 p.147
1913 Mar.-Apr.	Anne Estell Rice	Baillie Gallery		35 numbers
1913 Mar.	Miss E. Thornhill	Walker's Gallery	Drawings of Rome, Brittany and England	70 numbers
1913 Mar.-Apr.	Isabel S. Legg	Walker's Gallery	Water-colour drawings of English and Swiss scenery	66 numbers
1913 Apr.	Mrs Allingham	Fine Art Society	Water-colours	56 numbers
1913 Apr.	Mildred Freeborn	Fine Art Society	"Ski tracks and snow-scenes in the Engadine"	54 numbers
1913 Apr.	Katherine Johnson	Brook St. Art Gallery	Water-colours	1914 p.144
1913 Apr.	Mrs Merewether	Doré Gallery	Water-colour sketches in England and Venice	1914 p.145
1913 Apr.	Mrs Caldwell Crofton (Helen Milman)	Modern Gallery	Drawings of landscapes and gardens	1914 p.150
1913 May	Miss Gertrude Hadenfeldt	Modern Gallery	"India - From the Cities of its Plains to the Snows of Kashmir " - water-colour drawings	84 numbers
1913 May-June	Miss F. Anna Lee	Modern Gallery	"Egypt, Dalmatia and Montreux" - water-colour drawings	60 numbers
1913 May	Evelyn Moore	Walker's Gallery	Water-colour sketches	33 numbers
1913 May	Ruth Mercier	Walker's Gallery	Water-colours and oil sketches	52 numbers
1913 May	Miss Molly Campbell	Doré Gallery	Figure sketches and humorous tinted drawings	1914 p.146
1913 May	Dorothea Landau	Dudley Gallery	Portraits in oils, water-colours and chalks	1914 p.147
1913 May	Edith Gaddum	Dudley Gallery	Water-colours of Italy, the Andaman Isles and Sicily	1914 p.147

DATE	ARTIST	GALLERY	TITLE OF EXHIBITION	REF.
1913 June-July	Jessie Bayes	Baillie Gallery	Paintings and decoration	40 numbers
1913 June-July	Mary Rowe Wallace	Baillie Gallery	Pictures of Taormina	31 numbers
1913 June	Gertrude Charlton	Twenty-one Gallery York Buildings, W.C.	Water-colour drawings	1914 p.151
1913 June	Emily Strutt	Modern Gallery	Water-colour sketches - South Africa, Scotland and elsewhere	74 numbers
1913 June	Mrs Mabel Murphy (née Jörgensen)	Modern Gallery	Irish and other sketches	1914 p.150
1913 June	Mara Corradini	Doré Gallery	Pictures of Holland	1914 p.146
1913 June	Gloria Sorrow	Doré Gallery	Studies in sculpture	1914 p.146
1913 July	Katherine Ollivant	Dudley Gallery	"Moonlight and Moor" - water-colours	1914 p.147
1913 Oct.	Margaret C. Cook	Baillie Gallery	Illustrations to Walt Whitman's "Leaves of Grass"	36 numbers
1913 Oct.	The Hon. Norah Hewitt	Dudley Gallery	Bookbindings	34 numbers
1913 Oct.	Evelyn J. Whyley	Dudley Gallery	Water-colours - "Highways, Byways and Waterways"	70 numbers
1913 Oct.	Daphne Allen	Dudley Gallery	"Visions and Fancies" - Water-colours and drawings made between the ages of 13 & 14. Preface by Reginald Buckley	149 numbers
1913 Oct.-Nov.	Miss St. John Cadell	Doré Gallery	Pictures	1914 p.146
1913 Nov.-Dec.	Ella Du Cane	Modern Gallery	Water-colours of the Banks of the Nile	49 numbers
1913 Nov.	Estelle Canziani	Baillie Gallery	Tempera and water-colour drawings	54 numbers
1913 Nov.	Gertrude Fuller-Maitland	Dudley Gallery	Water-colours	54 numbers

DATE	ARTIST	GALLERY	TITLE OF EXHIBITION	REF.
1913 Nov.-Dec.	Kay Nielsen	Leicester Gallery	Water-colour drawings - "In Powder and Crinoline"	50 numbers
1913 Nov.	Rachel Wheatcroft	Walker's Gallery	Drawings in water-colour and tempera in Normandy, Brittany and Prussian Poland	41 numbers
1913 Nov.	Louise Wood Wright	Twenty-one Gallery	Water-colours	1914 p.151
1913 Dec.	Vera Willoughby	Dowdeswell Gallery	Humorous and other drawings	61 numbers
1913 Dec.	Mrs James Jardine	Walker's Gallery	Sketches in water-colour and pastel of England and abroad	40 numbers
1913 Dec.	Miss Rita M.C. MacLachlan	Modern Gallery	"Sketches in Argyllshire" - water-colours and etchings	1914 p.150
1913 Dec.	Lady Cohen	Modern Gallery	Sketches of "London and Elsewhere"	1914 p.151
1913 Dec.	Miss E.H. Maude Schwabe	Modern Gallery	Silver-work	1914 p.151
1913	Katie Blackmore	Carfax and Co.	Drawings of Japanese Life	35 numbers
1913	Sylvia Gosse	Carfax and Co.	Drawings and etchings	37 numbers
1913	Mary Hogarth	Carfax and Co.	Etchings	23 numbers
1913	Helen M. Bulkley	Ryder Gallery	Water-colour drawings of Venice, Scotland and St. Bartholomew the Great	50 numbers
1913	Edith Gaddum	Dudley Gallery	Water-colours - "East and West"	74 numbers
1913-14	Dorothea St. John George	Sphinx Gallery	Etchings	32 numbers
1914 Jan.	Ethel L. Tanmer	Modern Gallery	Oil paintings of horses and dogs and sketches of London etc.	35 numbers
1914 Feb.	Helen Donald-Smith	Dowdeswell Gallery	Water-colours - "London and Venice by Day and Night"	104 numbers
1914 Feb.-Mar.	Mrs R.S. McClintock	Dudley Gallery	Pictures	50 numbers
1914 Feb.	Miss White-Jervis	Brook St. Art Gallery	Water-colours of "Venice, Taormina etc."	1915 p.161

DATE	ARTIST	GALLERY	TITLE OF EXHIBITION	REF.
1914 Mar.- Apr.	Winifred Austen	Leicester Gallery	Water-colours of Birds and Beasts	57 numbers
1914 Mar.	Mrs Henry Perrin	Dudley Gallery	Water-colours of British flowering plants	116 numbers
1914 March	Elsie Burrell	Dudley Gallery	Portraits in water-colour	39 numbers
1914 Mar.	Louise Jacobs	Walker's Gallery	Drawings in line and colour	42 numbers
1914 Mar.	Mrs F.A. Hopkins	Walker's Gallery	"Canada - in the days of the bark canoe" and "Peasant landscapes in France" water-colours	89 numbers
1914 Mar.	Mima Nixon	Fine Art Society	Water-colours of Royal Palaces and Gardens	61 numbers
1914 Mar.	Florence Newman A.R.M.S.	Brook St. Art Gallery	Coloured wax miniatures and bronze medallions	1915 p.161
1914 Mar.	Beatrice Parsons	Dowdeswell Gallery	"Garden, Wood and Field" - water-colours	1915 p.162
1914 Apr.- May	Mary G. Simpson	Baillie Gallery	Water-colour drawings	21 numbers
1914 May	Helena Gleichen	Goupil Gallery	Paintings	82 numbers
1914 May	Miss Koster	Walker's Gallery	Foreword, previews and autobiography	36 numbers
1914 May	Rennee Vranyczany	Goupil Gallery	Bronzes	1915 p.163
1914 June- July	Jo Davidson	Leicester Gallery	Sculpture	42 numbers
1914 June	Dorothy Cox	Brook St. Art Gallery	Water-colours of "Dartmoor and Sussex"	1915 p.161
1914	Katherine Cameron R.S.W.	James Connell and Sons	Water-colour drawings and etchings	56 numbers

APPENDIX IX

ONE-WOMAN EXHIBITIONS IN FRANCE

DATE	ARTIST	GALLERY	TITLE OF EXHIBITION	REF*
1885 Jan.	Eva Gonzalès	Salons de la Vie "Moderne", Place St. Georges	Retrospective of paintings and pastels	88 numbers Preface by Philippe Burty
1885 Feb.	Marie Bashkirtseff	Hôtel de Chimay	Oeuvres	229 numbers Preface by François Coppée
1888 Mar.	Mlle Louise Abbéma	Galerie Georges Petit, 12 rue Godot-de-Mauroi		March 24 1888 no. 12, p.91
1889 Mar.	Mlle Louise Abbéma	Galerie Georges Petit	"..des portraits, tableaux et études, à l'huile, au pastel, des éventails à l' aquarelle et quatre médaillons en plâtre"	March 24, 1889 no.12, p.91
1889	Eva Gonzalès	Théâtre d'Application		Claude Roger-Marx op.cit. p.26
1890 Apr.	Louise Abbéma	Georges Petit	Portraits, decorative panels and pastels	April 12, 1890 no. 15, p.114
1891 May	Mme Estelle Bergerat	Galerie Bernheim Jeune, 8 rue Laffitte	Paintings and pastels	30 numbers
1891 Apr.	Mary Cassatt	Galerie Durand-Ruel, 16 Rue Laffitte	Paintings, pastels and engravings	Catalogue
1892	Mme Peyrol-Bonheur	Organized by the Union des Femmes Peintres et Sculpteurs in a room of the Palais de l'Industrie	Retrospective of paintings and drawings	350 numbers
1892 June	Berthe Morisot	Boussod Valadon et Cie, 19 boul. Montmartre	Paintings and watercolours	40 numbers
1892 May	Mme Henriette Ronner	Boussod Valadon et Cie	Paintings of dogs and cats	May 28 1892 no.22, p.170

* The numbers refer to the number of works in the catalogue, when one exists. Otherwise the reference is to where (usually a periodical) the information has been found. Unless otherwise indicated the reference is to the "Chronique des Arts"

DATE	ARTIST	GALLERY	TITLE OF EXHIBITION	REF.
1893 Jan.	Mme Giraud-Bariol	Georges Petit	Portraits painted on velvet	Jan. 28, 1893, no.4, p.27
1893 Nov.-Dec.	Mary Cassatt	Durand-Ruel	Paintings, pastels and engravings	Preface by André Mellerio
1894 Apr-May	Mlle Louise Abbéma	Georges Petit	"..comprenant des panneaux décoratifs, des portraits, des paysages et des aquarelles"	April 28 1894, no.17,p.130
1894 Dec.	Mlle Ruth Mercier	MM Allard et Noël, 17 rue Caumartin	Water-colours	Dec.22, 1894 no.40 p.318
1894 Apr.	Mlle Louise Abbéma	Georges Petit		80 numbers
1896 Jan.	Mlle Marguerite Verboeckhoven	La Bodinière, 18 rue Saint-Lazare	Marine paintings	Jan 25, 1896 no.4, p.26
1896 Mar.	Berthe Morisot	Durand-Ruel	Paintings, drawings, pastels and water-colours	381 numbers Preface by Mallarmé
1896 Apr.	Mlle Louise Abbéma	Georges Petit		Apr.11, 1896 no.15 p.140
1895 June	Mme Egoroff	"L'Art Indépendant", 11 rue de la Chausée d'Antin	Drawings, water-colours, ceramics and objets d'art	June 13, 1896 no. 23 p.215
1897 Mar.-Apr.	Mlle Louise Abbéma	Georges Petit		Mar.27, 1897 no.13, p.124
1897 June	Rosa Bonheur	Georges Petit, 8 rue de Sèze	Pastels	June 12, 1897 no.23 p.218 (4 numbers)
1897 July	Mlle Desliens	Salon du "Figaro", 26 rue Drouot	Paintings	July 10, 1897 no. 25 p.244
1897 Nov.	Mlle Rosa Wennemann	Salon du "Figaro", 21 rue Drouot	Paintings	Nov. 13, 1897 no.35 p.340
1898 Apr.	Mlle Popelin	Georges Petit, 12 rue Godot-de-Mauroi	Water-colours	April 16, 1898 no.16 p.140
1898 May-June	Miss Marie I. Naylor	Galerie Dosbourg, 27 rue Le Peletier	Paintings	May 28, 1898 no.22 p.196

DATE	ARTIST	GALLERY	TITLE OF EXHIBITION	REF.
1899 Jan.	Mary Cassatt	Durand-Ruel	Paintings, pastels and water-colours	Jan.7, 1899 no.1 p.8 and Jan.14 no.2 p.10
1899 Feb.	Mme Elisabeth Ibels	Galerie Laffitte 20 rue Laffitte	Paintings	Feb. 25, 1899 no. 8 p.76
1899 Apr.	Mme Barbara-Mackay	La Bodinière		April 29, 1899 no.17 p.156
1899 Apr.-May	Mme Paul d'Udine	Galerie Arnould, 35 rue Fontaine	Paintings	April 22, 1899 no.16 p.148
1899 Apr.	Mlle Louise Abbéma	Georges Petit		April 22, 1899 no.16 p.148
1899 Apr.	Mlle Alice Mumford	Galeries de "L'art Nouveau" 22 rue de Provence		April 29, 1899 no.17 p.156
1899 Dec.	Mlle Blanche Hément	57 rue de Clichy	"exposition d'oeuvres d'art décoratif et d'un procédé nouveau de décoration"	Dec.16, 1899 no.39 p.364
1900 Jan.	Mlle C-H Dufau	Galerie Ollendorff	Paintings	Jan. 20, 1900 no.3 p.28
1900 Jan.-Feb.	Mme Briès	La Bodinière	Water-colours	Feb. 3, 1900 no.5 p.48
1900 Mar.-Apr.	Mme Adrienne d'Heureux (Enneïrda)	16 Rue Brémontier	Decorative paintings, pottery, glass and lace	March 17, 1900 no. 11 p.103
1900 Mar.	Mlle Marie Sommer	Georges Petit	Landscapes, marines and views of Holland and Italy	Mar. 3, 1900 no.9 p.83; Mar.10, no.10, p.87
1900 Mar.	Mlle Magdaleine Popelin	Georges Petit		Mar.24, 1900 no.12 p.115
1900 Apr.	Mme Elizabeth Ibels	Offices of "La Fronde", 14 rue Saint-Georges	Water-colours	April 7, 1900 no.14 p.136
1900 Apr.-May	Rosa Bonheur	Georges Petit, 8 rue de Sèze	Atelier Rosa Bonheur	1,835 numbers
1900 June	Mme Jehanne Mezeline	La Bodinière	Water-colours, paintings and pastels	June 16, 1900 no.23 p.231
1900 Nov.	Mme Hermione von Preuschen	Galerie des Artistes Modernes, 19 rue Caumartin	Paintings	Nov. 10, 1900 no.34 p.344

DATE	ARTIST	GALLERY	TITLE OF EXHIBITION	REF.
1901 Feb.	Mme Henriette Ronner	Boussod Valadon et Cie, 24 boul. des Capucines	Paintings	Feb.16,1901 no.7 p.55 Mar. 2,1901 no.9 p.68
1901 Mar.	Mlle Louise Abbéma	Georges Petit, 12 rue Godot-de-Mauroi	New works	Mar.16,1901 no.11 p.88
1901 Mar.	Mme Mathilde Augé	71 rue de Grenelle	"exposition d'émaux sur cuivre"	Mar.23, 1901 no.12 p.95
1901 Mar.	Mlle Blanche Hément	57 rue de Clichy	Decorative art	Feb.23,1901 no.8 p.64 Mar.23 no.12 p.91
1901 May	Mme Madeleine Lemaire	Galerie Tooth, 41 boul. des Capucines	Water-colours	May 11,1901 no.19 p.152
1901 May	Mlle Marie d'Epinay	Georges Petit	Portraits and studies	May 25,1901 no.21 p.168
1902 Mar.	Mlle Marie Bermond	Galerie de "L'Art Nouveau" Bing	Pastels and Paintings	Mar.15,1902 no.11 p.88
1902 Apr.	Mlle Louise Abbéma	Georges Petit	Paintings, drawings and fans	Apr.12, 1902 no.15 p.120
1902 May	Berthe Morisot	Durand-Ruel	Paintings	Apr.26,1902 no.17 p.136
1902 July	Mlle Meta Warrick	Galerie de "L'Art Nouveau" Bing	Sculptures	July 5,1902 no.25 p.204
1903 Jan.	Mme Lisbeth Delvolvé-Carrière	Durand-Ruel	Paintings	Jan.17,1903 no.3 pp.19,24
1903 Mar.	Mme Renée de Miremont	Durand-Ruel	Miniatures	Mar.14,1903 no.11 p.92
1903 May	Mme M. Hennequin	Salon de "La Plume"		"La Plume" May 1,1903 no.337 p.540
1903 Nov.-Dec.	Mme Ana de Carié	Galerie des Artistes Modernes	Paintings and pastels	Nov.28, 1903 no.37 p.316
1904 Mar.	Mlle M. Verboeckhoven	Galerie Bernheim Jeune	Paintings	Mar. 5,1904 no.10 p.84
1904 Mar.-Apr.	Mlle Blanche Hément	Galerie Arthur Bloche 51 rue Saint-Georges	Paintings, sculptures and decorative paintings	Mar.19,1904 no.12 p.100

DATE	ARTIST	GALLERY	TITLE OF EXHIBITION	REF.
1904 Apr.	Mlle Louise Abbéma	Georges Petit	Paintings	Apr.23,1904 no.17 p.140
1904 Apr.	Mlle Louise-Catherine Breslau	Georges Petit, 8 rue de Sèze	Paintings and pastels	Apr.16,1904 no.16 p.132
1904 June	Mlle Borghild Arnesen	16 boul. Edgar Quinet	Paintings, red chalk drawings and objets d'art	May 21,1904 no.21 pp.170-1, 176
1904 Dec.	Mlle Louise Abbéma	Galerie des Artistes Modernes	Decorative panels	Dec.10,1904 no.39 p.324
1905 Feb.	Mlle Yvonne Serruys	Galerie Barbazanges, 48 boul. Haussmann	Paintings and sculptures	Feb.11,1905 no.6 pp.43,48
1905 Feb.	Mme Blanche Ory-Robin	Galerie des Artistes Modernes	"ouvrages en toile-chanvre-relief"	Feb. 4,1905 no.5 pp.36,40
1905 Feb.	Berthe Morisot	Galerie Druet, 114 faub.St. Honoré	Paintings and drawings from her later period	Feb. 4, 1905 no.5 pp.36,40
1905 Feb.- Mar.	Mme Madeleine Lemaire	Georges Petit	Paintings and water-colours	Feb.11,1905 no.6 p.48 and Feb.25 no.8 p.59
1905 Mar.	Mme Gonyn de Lurieux	Galerie des Artistes Modernes	Paintings and sculptures	Mar.11,1905 no.10 p.80
1905 Apr.	Mme Anna Boberg	Galerie des Artistes Modernes	Paintings	Apr.1 1905 no.13 p.104; Apr.8 no.14 p.107
1905 May	Mlle Sophie Egoroff	Musée Guimet	Paintings	May 13,1905 no.19 p.152
1905 May	Mme Rosina Mantovani Gutti	Galerie Henry Graves, 18 rue de Caumartin	Paintings and pastels	May 6,1905 no.18 p.144; May 13, no.19 p.147
1905 Nov.	Mlle Marie-Antoinette Marcotte	Georges Petit	Paintings	Nov. 4,1905 no.33 p.284
1905 Dec.	Mme H. Ymart	Galerie Barthélemy, 52 rue Laffitte	Paintings	Dec.2,1905 no.37 p.316; Dec.9, no.38 p.319
1906 Feb.	Mme Marie Duhem	Georges Petit	Paintings	Feb.3,1906 no.5 p.40; Feb.10 no.6 p.43
1906 Feb.	Miss Louise E. Perman	Galerie Henry Graves	Paintings	Jan.27,1906 no.4 pp.27,32

DATE	ARTIST	GALLERY	TITLE OF EXHIBITION	REF.
1906 Apr.	Mme Coutesco	Galerie Hessèle, 13 rue Laffitte	Paintings	Apr.14,1906 no.15 p.120; Apr.28, no.17 p.130
1906 Nov.	Mme Anna Boberg	Galerie des Artistes Modernes	Paintings	Nov.3,1906 no.33 p.296; Nov.10 no.34 p.299
1907 Jan.	Mme Lucie Cousturier	Galerie Druet	Paintings and drawings	Catalogue
1907 May	Mlle Julia Beck	Galerie of "La Française", 43 rue Laffitte	Paintings	May 25,1907 no.21 p.196; June 1, no.22 p.201
1907 May	Mme Jacques-Marie	Galerie Bernheim Jeune, 15 rue Richepanse	Paintings	May 11 1907 no.19 p.172; May 18 no. 20 p.176 Preface to catal.by Alfred Capus
1907 June	Mlle Marie Bermond	Galerie Devambez, 43 boul. Malesherbes	Paintings	June 1,1907 no.22 p.208 June 15, no.23 p.214
1907 Dec.	Mlle Germaine Dawis	70 boul. Malesherbes	Paintings	Nov.23,1907 no.36 p.344; Dec. 7 no.38 p.354
1907	Eva Gonzalès	Salon d'Automne	ca. 20 works	Oct. 5,1907 no.31 p.297
1907	Berthe Morisot	Salon d'Automne	ca. 200 works	Oct. 5,1907 no.31 p.297
1908 Jan.	Gyula Tornai	Georges Petit	"Extrême-Orient"	Catalogue
1908 Feb.	Mme Mary Kazack	Georges Petit	Paintings	Feb.1,1908 no.5 p.44 Feb.15 no.7 p.56
1908 Mar.	Mme Elisabeth Krouglicoff	Galerie d'art décoratif, 7 rue Laffitte	Engravings and aquatints	Mar.14,1908 no.11 p.104
1908 Apr.	Mary Cassatt	Galerie Vollard 6 rue Laffitte	Paintings, pastels and engravings	Mar.28,1908 no.13 p.124 Apr.18 no.16 p.146
1908 Oct.- Nov.	Mme Clifford Barney	Galerie Bernheim Jeune	Studies and pastel portraits	Oct.24,1908 no.33 p.344 Nov. 7, no.34 p.348 Catalogue
1908 Nov.	Mme G. Agutte	Galerie Georges Petit	Water-colours	Nov. 7,1908 no.34 p.356; Nov.14 no.35 p.361

DATE	ARTIST	GALLERY	TITLE OF EXHIBITION	REF.
1908 Nov.	Mary Cassatt	Durand-Ruel	Paintings and pastels	Nov. 7 1908 no.34 p.356 and Nov.21 no.36 p.370
1908 Dec.	Mme Anna Boch	Galerie Druet, 20 rue Royale	Paintings	Dec.12,1908 no.39 p.400 and Dec.19 no.40 p.403
1908 Dec.	Mme Madeleine Lemaire	Galerie Georges Bernheim, 9 rue Laffitte	Water-colours	Dec.12,1908 no.39 pp.395,400
1909 Mar.	Mlle Mathilde Sée	Georges Petit	Water-colours	Mar. 6,1909 no.10 p.80
1909 Apr.	Mme Albert Mayer	Georges Petit	Jewellery	Apr. 17 1909 no.16 p.128
1909 Apr.	Mme Faux-Froidure	Georges Petit	Water-colours	Apr.24,1909 no.17 pp.135,140
1909 Apr.	Miss Maud Earl	Georges Petit	Pictures of dogs	Apr.10,1909 no.15 p.124
1909 May	Mlle Louise Abbéma	Georges Petit	Paintings and water-colours	May 1,1909 no.18 p.148; May 8 no.19 p.151
1909 June	Mme Marie Baudet	Galerie de l'Art Contemporain, 3 rue Tronchet	Paintings and sketches	June 5,1909 no.23 p.188
1909 Dec.	Mme Ida Bidoli Salvagnini	Galerie d'art décoratif, 7 rue Laffitte	Paintings, gouaches and drawings	Dec.18 1909 no.38 p.312 Dec.25 no.39 p.314
1910 Jan.	Mlle Blanche Odin	Georges Petit	Water-colours	Jan.22,1910 no.4 p.32
1910 Jan.	Mlle Louise Abbéma	Georges Petit	Paintings	Jan.22,1910 no.4 pp.27,32
1910 Jan.- Feb.	Mme Georgette Agutte	Galerie Druet	Paintings	Jan.22,1910 no.4 p.32; Jan.29,1910 no.5 p.36
1910 Feb.- Mar.	Mme Madeleine Lemaire	Galerie Tooth	Paintings and water-colours	Feb.19,1910 no.8 p.64
1910 Mar.	Mlle Louise-Catherine Breslau	Durand Ruel	Paintings and pastels	Mar. 5,1910 no.10 p.80 Mar.12, no.11 p.84
1910 Mar.	Mme Ch. Depincé	19 rue Saint-Georges	Paintings	Mar. 5,1910 no.10 p.80 Mar.19,1910 no.12 p.93

DATE	ARTIST	GALLERY	TITLE OF EXHIBITION	REF.
1910 Mar.	Mlle Marguerite de Glori	Georges Petit	Water-colours	Mar. 5,1910 no.10 p.80; Mar.12,no.11 p.84
1910 Mar.	Mlle Louise Hervieu	Galerie E. Blot, 11 rue Richepanse	Paintings,water-colours and drawings	Mar.12,1910 no.11 p.88; Mar.19, no.12 p.92
1910 Mar.-Apr.	Mme Anna Boberg	Durand-Ruel	Paintings	Mar.19,1910 no.12 p.96; Mar.26,1910 no.13 p.99
1910 Apr.	Mme Corras	Galerie Malesherbes, 68 boul. Malesherbes	Paintings	Apr. 9,1910 no.15 pp.115,120
1910 Apr.	Mme Laure Richard-Troney	Galerie Charles Hessèle, 54 rue Laffitte	Pastels and drawings in charcoal and pencil	Apr.16,1910 no.16 p.128
1910 May	Mlle Hilde Weigelt Middledorpf	Georges Petit	Paintings	Apr.30,1910 no.18 p.144; May 7,1910 no.19 p.147
1910 May	Mlle Marcelle Cros	Galerie Hébrard, 8 rue Royale	Tapisseries	May 14,1910 no.20 p.160
1910 May	Mme Romaine Brooks	Durand-Ruel	Paintings	13 numbers. Preface by Claude Roger-Marx
1910 Nov.-Dec.	Mme Marie-Anne Lafaurie	Galerie Devambez	Drawings	Nov.19,1910 no.35 p.280
1910 Nov.-Dec	Mlle Alice Bally	11 rue Boissonade	Paintings and colour wood-cuts	Nov.19,1910 no.35 p.280
1910 Nov.	Mme Pangon	Syndicat d'initiative de Provence, 52 rue Paradis	Decorative art	Nov. 5,1910 no.34 p.272
1910 Nov.	Mme Andrée Karpalès	Galerie des Artistes Modernes	Paintings	Nov 5,1910 no.34 p.272
1910 Dec.	Mlle Léonie Dusseuil	Galerie J. Moleux, 68 boul. Malesherbes	Paintings	Dec.17,1910 no.38 p.304 ; Dec.31 1910 no.40 p.315
1911 Jan.	Mlle Ethel Sands	Petit Musée Beaudoin 253 rue Saint-Honoré		Jan. 7,1911 no.1 p.8
1911 Jan.	Mme Bessie Potter	Georges Petit	Sculpture	Jan. 7,1911 no.1 p.8
1911 Feb.	Mlle Mathilde Sée	Georges Petit	Water-colours	Jan.28,1911 no.4 p.32; Feb.11, no.6 p.44
1911 Apr.-May	Miss Mary Cameron	Galerie des Artistes Modernes	Paintings	Apr.29,1911 no.17 p.136

DATE	ARTIST	GALLERY	TITLE OF EXHIBITION	REF.
1911 May	Mme Clifford Barney	Galerie Devambez	Pastels	May 20,1911 no.20 pp.154,160
1911 June	Mlle Louise Abbéma	Georges Petit	Paintings	June 3,1911 no.22 p.176
1911 Nov.	Mlle Pauline Adour	Georges Petit	Water-colours and decorations	Nov.18,1911 no.34 p.272 Dec. 2,1911 no.35 p.277
1911 Dec.	Mlle Hélène Dufau	Galerie Brunner, 11 rue Royale	Portraits and panels	Dec. 2,1911 no.35 p.280; Dec.16 no.37 p.291
1911 Dec.	Madeleine Pecquery	Galerie P. Chevalier	Flowers	Dec.2, 1911 no.35 p.277
1911 Dec.	Mlle Paillard	Athénée-Saint-Germain 21 rue du Vieux Colombier	Paintings, water-colours and objets d'art	Dec.30,1911 no.39 p.314
1912 Jan.	Mlle Janine Aghion	Galerie Bernheim Jeune	"aquarelles, lavis et encres"	Jan. 6,1912 no.1 p.8
1912 Feb.- Mar.	Mme Marval	Galerie E. Druet	Paintings	Feb.17,1912 no.7 p.56; Feb.24 no.8 p.59
1912 Feb.	Mlle Blanche Odin	Georges Petit	Paintings	Feb.17,1912 no.7 p.56; Feb.24 no.8 p.60
1912 Mar.	Mlle Marie-Paule Carpentier	Georges Petit	Landscapes	Mar.16,1912 no.11 p.88; Mar.23 no.12 p.92
1012 Mar.- Apr.	Mme Lisbeth Delvolvé- Carrière	Galerie Bernheim Jeune	Landscapes, still-lives and flowers	103 numbers. Preface by Gabriel Mourey
1912 Mar.	Mlle Marthe Gallard	Galerie Hessèle	Paintings and drawings	31 numbers
1912 Apr.	Mlle Irène Luczinska	Galerie Boutet de Monvel, 18 rue Tronchet	Paintings	Apr. 6,1912 no.14 p.112
1912 Apr.- May	Mme R. Mantovani Gutti	Galerie Marcel Bernheim, 2 bis rue de Caumartin	Paintings	Apr.27,1912 no.17 p.136
1912 Apr.- May	Mme Marie-Madeleine Franc-Nohain	Galerie Bernheim Jeune	Pastels	59 numbers
1912 Apr.	Mme Hanin	Galerie Devambez	Paintings	Apr.20,1912 no.16 p.128
1912 June	Mlle Marguerite Klee	Galerie E. Blot	Paintings	June 15,1912 no.23 pp.181,188

DATE	ARTIST	GALLERY	TITLE OF EXHIBITION	REF.
1912 Oct.	Mme Helga von Cramm	Galerie Marcel Bernheim	Water-colours	Oct.19,1912 no.32 p.260
1912 Nov.	Miss E. Hilda Rix	Galerie Chaine et Simonson, 19 rue de Caumartin	Drawings	Nov.30,1912 no.35 p.284
1912 Dec.	Mme Marie Alix	Galerie J. Moleux, 68 boul. Malesherbes	"objets d'art composés et decorés"	Dec.21,1912 no.38 p.308
1912 Dec.	Mme Magdeleine Popelin	Galerie J. Moleux	Water-colours	Nov.30,1912 no.35 p.284
1912 Dec.	Mme Marie Baudet	Maison d'art septentrional, 9 rue Dupuytren	Paintings	Nov.30,1912 no.35 p.284
1912 Dec.- Jan.	Mme Madeleine Lemaire	Galerie Devambez	Drawings, paintings and water-colours	Dec.14,1912 no.37 p.300
1912	Isabel Beaubois de Montoriol	Galerie Hessèle	Paintings	Catalogue
1913 Feb.	Miss Mary Cameron	Georges Petit	Paintings	Feb. 1,1913 no.5 p.40; Feb. 8,1913 no.6 p.42
1913 Mar.	Mlle Mathilde Sée	Georges Petit	Water-colours	Mar. 1,1913 no.9 p.72
1913 Mar.- Apr.	Mlle Susanne Frémont	Galerie Grandhomme, 40 rue des Saints-Pères	Water-colours	Mar.29,1913 no.13 p.104; Apr. 5,1913 no.14 p.107
1913 Apr.	Mme Sonia Lewitzka	Galerie B. Weill, 25 rue Victor-Massé	Paintings, water-colours and drawings	Apr.12,1913 no.15 p.120; Apr.19 no.16 p.125
1913 May	Mlle Elisabeth de Groux	Galerie Grandhomme	Pastels and engravings	May 3,1913 no.18 p.144
1913 June- July	Mme Valentine Gross	Galerie Montaigne, 13 avenue Montaigne	Paintings	June 7,1913 no.23 pp.184,188
1913 July	Mlle Dujardin-Beaumetz	Galerie Henri Manuel, 27 rue du faubourg Montmartre	Paintings	July 5,1913 no.25 p.200
1913 Nov.	Mlle Margarethe Patter-son	Galerie Lévesque, 109 faubourg Saint-Honoré	Paintings	Nov. 8,1913 no.34 p.272
1913 Nov.	Mme Laure Heyman	Georges Petit	Sculpture	Nov. 8, 1913 no.34 p.277

DATE	ARTIST	GALLERY	TITLE OF EXHIBITION	REF
1913 Nov.- Dec	Mlle Colette Myrtille	6 rue d'Albouy	Decorative works of art	Nov.22,1913 no.35 p.280
1913 Dec.	Mlle Léo Jasmy	13 rue Washington	Paintings	Dec.20,1913 no.38 p.304
1913 Dec.- Jan.	Mlle Magdeleine Popelin	Salons de l'Etoile, 17 rue de Chateaubriand	Water-colours	Dec.20,1913 no.38 p.304
1913 Dec.	Miss Blondel Malone	Lyceum Club, 8 rue de Penth- iêvre	Paintings	Dec. 6,1913 no.36 p.288
1913 Dec.	Mme Fournier des Corats	Villa Brune	Paintings	Dec.13,1913 no.37 p.296
1913 Dec.	Mlle M. Tongue	Galerie Ashnur, 24 boul. Raspail	"Projets décoratifs"	Dec.13,1913 no.37 p.296
1913 Dec.	Mme Bertha Holley	Chez Desti, 4 rue de la Paix	Decorative works of art	Dec. 6, 1913 no.36 p.288
1913 Dec.	Mme René Berthelot	Galerie Boutet de Monvel	Water-colour landscapes	Dec. 6,1913 no.36 p.288
1914 Jan.	Miss Blondelle Malone	American Art Students' Club, 4 rue de Chevreuse	Paintings	Jan.10,1914 no.2 p.16
1914 Jan.	Mme Hanna Kochinsky	Galerie Bernheim Jeune	Sculpture	Preface Gustave Kahn
1914 Feb.- Mar.	Mme Yvonne Détraux	Maison d'art septentrional	Water-colours and paintings	Feb.28,1914 no.9 p.72
1914 Feb.	Mme Rey-Rochat de Théollier	Galerie Boutet de Monvel	Paintings, water-colours, drawings and prints	Jan.31,1914 no.5 p.40
1914 Feb.- Mar.	Mlle Andrée Tirard	Galerie Boutet de Monvel	Water-colours and pastels	Feb.14,1914 no.7 p.56
1914 Mar.- Apr.	Eva Gonzalès	Galerie Bernheim Jeune	Paintings, water-colours and drawings	34 numbers Notes by Phillippe Burty, Emile Zola, Octave Mirbeaux, Claude Roger-Marx
1914 Mar.	Mlle Marie-Paule Carpentier	Georges Petit	Water-colours	Feb.28,1914 no.9 p.72 Mar.14 no.11 p.84

DATE	ARTIST	GALLERY	TITLE OF EXHIBITION	REF.
1914 Mar.	Mlle Blanche Odin	25 rue La Boëtie	Paintings	Mar. 7,1914 no.10 p.80
1914 Mar.	Mme Georgette Agutte	Galerie Bernheim Jeune	Paintings, decorative paintings and water-colours	72 numbers. Preface by Gustave Kahn
1914 Apr.	Berthe Morisot	Galerie Manzi-Joyant, 15 rue de la Ville-l'Evêque	Retrospective exhibition	Apr.11,1914 no.15 pp.20,115
1914 Apr.	Mme Lucie Delarue-Mardrus	Galerie Bernheim Jeune	Paintings, drawings and engravings	Apr.25,1914 no.17 p.136 Catalogue
1914 May	Mme Lucie Habay	Galerie des Artistes modernes	Paintings	May 23,1914 no.21 p.168
1914 June	Miss Mary Cassatt	Durand-Ruel	Recent works: paintings, pastels, drawings and dry-point etchings	June 6,1914 no.23 p.184; June 27, no.25 p.197
1914 June	Mme Pangon	Galerie'Mam', 3 avenue de l'Opéra	"Tissus battikés"	June 13,1914 no.24 pp.192,197
1914 June	Mlle Emma Ciardi	Georges Petit	Paintings	June 6,1914 no.23 pp.184,188. Preface by M.L. Bénédite
1914 June–July	Mme Bérengère Bricard-Lassudrie	29 rue d'Astorg	Paintings and sculptures	June 27,1914 no.25 p.200; July 25,1914 no.27 p.213
1914 June	Mme Madeleine Lemaire	Université des Arts, 39 rue La Boëtie	Paintings	June 27,1914 no.25 p.200

APPENDIX X

WORKS BY WOMEN AT VERSAILLES, (TAKEN FROM SOULIE CATALOGUE)

(Listed alphabetically, by artist)

Mme Alaux:	"Lanneau de Marey (Pierre-Antoine-Victor de), fondateur du collège de Sainte-Barbe"	no. 4783
Mme Auzou:	"Adieux de Marie-Louise à sa famille - 13 mais 1810" (Salon 1812)	no. 1751
Mme Auzou:	"Arrivée de M-L à Compiègne - 18 mars 1810" (Salon 1810)	no. 1752
Mlle Belloc:	"Condé (Eléonore de Roye, princesse de)"	no. 3188
Louise de Bouteiller:	"Frotté (Louis de) général vendéen" (Salon 1822)	no. 5045
Mlle Bouteiller, après Rigaud:	"Bossuet (Jacques-Benigné)"	no. 3576
Mlle Bresson:	"Cheverny (Philippe Hurant, comte de), chancelier de France"	no. 3317
Mlle Bresson:	"Chevreuse (Claude de Lorraine, duc de)"	no. 3385
Mlle Bresson:	"Chevreuse (Marie de Rohan - Montbazon, duchesse de Luynes, puis de)"	no. 3386
Mlle Bresson:	"Bouillon (Emmanuel-Théodose de La Tour d'Auvergne, cardinal de)"	no. 3638
Mlle Bresson:	"Orléans (Louis, duc d')"	no. 3723
Mlle Bresson:	"La Vauguyon (Antoine-Paul-Jacques de Quelen-de-Stuer-de Caussade, duc de)"	no. 3927
Mlle Bresson:	"Longueville (Léonor d'Orleans, duc de)"	no. 4090
Mme Brune:	"Phelyppeaux (Paul), seigneur de Pontchartrain, secrétaire d'Etat"	no. 3328
Mme Brune, d' après Nattier:	"Clermont (Marie-Anne de Bourgon-Condé, Mlle de)"	no. 3761
Mme Brune:	"Morand (Charles-Antoine-Louis-Alexis, comte), lieutenant général"	no. 4766
Mme Bruyère:	"Gramont (Antoine IV, duc de)"	no. 1106
Mme Bruyère:	"Noailles (Louis, duc de) et d'Ayen"	no. 1126
Mme Bruyère:	"Beauyau-Craon (Charles-Just, prince de)"	no. 1147
M. Carpentier, d'après Mlle Harvey:	"Bernardin de Saint-Pierre (Jacques Henri)" (original Salon 1804)	no. 3005

Mlle Charpentier:	"Morlant (Jean-Pierre) buste-en plâtre"	no. 2766
Mlle Julie Charpentier (1814):	"Lescot (Pierre), architecte, buste en marbre"	no. 2803
Mme Chaudet:	"Marie-Laetitia-Josèphe Murat, comtesse Pepoli" (Salon 1806)	no. 4713
Mme Chéradame:	"Desvaux de Saint-Maurice (Jean-Jacques, baron), général de division" (Salon 1819)	no. 4751
Elisabeth-Sophie Chéron:	Chéron (E-S), Madame Le Hay, peintre, graveur, poète et musicienne"	no. 3678
Mlle Cogniet:	"Louis de Marillac"	no. 1050
Mme Cordellier-Delanoue:	"Tallard (Camille d'Hostun, comte de), duc d'Hostan"	no. 1091
Mme Cordellier-Delanoue d'après Rigaud:	"Pierre Mignard, peintre"	no. 2912
Mme Cordellier-Delanoue:	"La Rochefoucauld (François 1er, comte de)"	no. 3109
Mlle Cordellier-Delanoue:	"Elisabeth d'Autriche"	no. 3241
Mlle Cordellier-Delanoue:	"Catherine de Bourbon, duchesse de Bar"	no. 3290
Mlle Cordellier-Delanoue:	"Geoffrin (Marie-Thérèse Rodet, Mme)"	no. 3777
Mme Cordellier-Delanoue:	"Jules Romain (Giulio Rippi, dit), peintre et architecte"	no. 4048
Anne Seymour-Damer:	"Charles-Jacques Fox, orateur; buste en marbre"	no. 618
Mme Dansse:	"Condé (Charlotte-Godefride-Elisabeth de Rohan, princesse de)"	no. 3916
Mme Dansse:	"Condé (Louis-Henri-Joseph de Bourbon, prince de)"	no. 3917
Mme Davin-Mirvault:	"Lefebvre (François-Joseph), duc de Dantzick"	no. 1139
Mme Davin:	"Asker-Khan, ambassadeur de Perse"	no. 4792
Mme Dehérain:	"Charles IV, dit le Bel"	no. 699
Mme Dehérain:	"Orléans (Marie de Bourbon-Montpensier), duchesse d'"	no. 2065
Mme Dehérain:	"Narbonne-Lara (Louis-Marie-Jacques-Amalric,) comte de), général de division"	no. 4768

Mme Deliège:	"De Billy (Jean-Louis), général de brigade"	no. 4747
Mme Desnos:	"Bellièvre (Pompone de), chancelier de France"	no. 3321
Mme Desnos:	"Bichat (Marie-François-Xavier), médecin"	no. 4624
Mme Desnos:	"Berckheim (Frédéric-Sigismond, baron de), lieutenant général"	no. 4739
Mme Desnos:	"Castex (Bertrand-Pierre, vicomte), lieutenant général"	no. 4744
Mme Desnos:	"Dumas (Mathieu, comte), lieutenant général"	no. 4752
Mme Desnos:	"Franceschi (Jean-Baptiste, baron Delonne), général de brigade"	no. 4756
Mme Desnos:	"Lemarois (Jean-Léonard-François, comte), lieutenant général"	no. 4762
Mme Desnos:	"Mouton-Duvernet (Regis-Barthélemi, baron), lieutenant général"	no. 4767
Mme Desnos:	"Romeuf (Jean-Louis, baron de), général de brigade"	no. 4774
Mme Desnos:	"Sorbier (Jean Barthelemot, comte), lieutenant général"	no. 4776
Mme Desnos:	"Delorme (Pierre-François), capitaine de vaisseau"	no. 4781
Mme Desnos:	"Périer (Casimir), président du conseil des ministres"	no. 4808
Mme Desnos:	"Guilleminot (Armand-Charles, comte), lieutenant général"	no. 4818
Mlle Ducluseau:	"Révol (Louis de), secrétaire d'Etat"	no. 3320
Mme Du Lonez, d'après Ph. de Champagne:	"Arnaud d'Andilly (Rober-), théologien"	no. 2900
Mme Du Lonez, d'après Coello:	"Ferdinand, infant d'Espagne"	no. 4113
Mlle Duvidal:	"Campan (Jeanne-Louise-Henriette Genest, madame)"	no. 4831
Mme Feytaud:	"La place (Pierre-Simon, marquis de), géomètre"	no. 3008
Mme Filleul:	"Les enfants du comte d'Artois" (1781)	no. 3908
Mme Filleul:	"Angoulême (Louis-Antoine d'Artois, duc d')"	no. 3976
Mlle Clotilde Gérard:	"Aubeterre (François d'Esparbès de Lussan, vicomte d')"	no. 1034
Mlle Clotilde Gérard:	"Henriette-Marie de France, reine d'Angleterre"	no. 2080

| Mlle Clotilde Gérard: | "Piesque (Anne Le Veneur, comtesse de)" | no. 3507 |

| Mlle Clotilde Gérard: | "Conty (Louis-François de Bourbon, prince de)" | no. 3820 |

| Mlle Clotilde Gérard d'après Velasquez: | "Marguerite-Thérèse d'Autriche, infante d'Espagne" | no. 4282 |

| Mlle Girard: | "Gazan de la Peyrière (Honoré-Théophile-Maxime, comte), lieutenant général" | no. 4757 |

| Mlle Godefroid d'après Gérard: | "Lauriston (Jacques-Alexandre-Bernard Law, marquis de)" | no. 1166 |

| Mlle Godefroy: | "David (Jacques-Louis), peintre" | no. 3009 |

| Mlle Godefroid d'après Gérard: | "Talleyrand-Périgord (Charles-Maurice, duc de), prince de Bénévent" | no. 4718 |

| Mlle Godefroid d'après Gérard: | "Staël-Holstein (Anne-Louise Germaine Necker, baronne de)" | no. 4784 |

| Mlle Godefroid: | "Campan (Jeanne-Louise-Henriette Genest, madame)" | no. 4785 |

| Mlle Grasset, d'après Gérard: | "Canova (Antoine), sculpteur" | no. 4839 |

| Mme Guiard: | "Louise-Elisabeth de France, duchesse de Parme" (Salon 1789 | no. 3876 |

| Mme Guiard: | "Victoire (Madame)" (Salon 1789) | no. 3960 |

| Mme Haudebourt-Lescot: | "Prise de Thionville - 23 juin 1558" | no. 63 |

| Mme Haudebourt-Lescot: | "Le pape Eugène III reçoit les ambassadeurs du roi de Jérusalem - 1145" (1839) | no. 435 |

| Mme Haudebourt: | "Choiseul (Claude, comte de)" | no. 1088 |

| Mme Haudebourt: | "Broglie (François-Marie, duc de)" | no. 1108 |

| Mme Haudebourt: | "Mirepoix (Gaston-Charles-Pierre de Lévis, duc de..)" | no. 1120 |

| Mme Haudebourt: | "Lorges (Guy-Michel de Durfort, duc de)" | no. 1122 |

| Mme Haudebourt: | "Fitz-James (Charles, duc de)" | no. 1143 |

| Mme Haudebourt: | "Lévis (François-Gaston, duc de)" | no. 1151 |

| Mme Haudebourt: | "Conty (Marie-Fortunée d'Esté, princesse de)" | no. 4537 |

| Mme Hersent: | "Louis XV visite Pierre-le-Grand à l'hôtel de Lesdiguières - 10 mai 1717" | no. 174 |

| Mme Juillerat: | "Duras (Jacques-Henri de Durfort, duc de)" | no. 1077 |

Mlle le Baron d'après Van Dyck:	"Monçade (François de) Marquis d'Ayetonne"	no. 3416
Mme Lebrun:	"Marie-Antoinette, reine de France"	no. 2097
Mme Lebrun:	"La Bruyère (Jean de), moraliste"	no. 2940
Mme Lebrun:	"André-Hercule de Fleury, cardinal"	no. 2962
Mme Lebrun:	"Marie-Antoinette, reine de France"	no. 3893
Mme Lebrun:	"Le Dauphin et sa soeur" (Salon 1785)	no. 3907
Mme Lebrun:	"Orléans (Louise-Marie-Adélaide de Bourbon, duchesse de)"	no. 3912
Mme Lebrun:	"Marie-Antoinette et ses enfants" (Salon 1787)	no. 4520
Mme Lebrun:	"Orléans (Louise-Marie-Adélaide de Bourbon, duchesse d')"	no. 4524
Mme Lebrun:	"Grétry (André-Ernest-Modeste)"	no. 4556
Mme Lebrun:	"Marie-Annunciade-Caroline Bonaparte, reine de Naples" (1807)	no. 4712
Mad.Lefèvre-Deumier:	"Sibuet (Benoist), général de brigade; buste en marbre"	no. 4946
Mme Le Fèvre-Deumier:	"Paixhans (Henri-Joseph), lieutenant général; buste en marbre" (1859)	no. 1655 bis
Mme de Léomenil:	"Henri IV"	no. 714
Mme de Léomenil:	"L'Hôpital (Michel de)"	no. 3217
Mme de Léomenil:	"Humières (Charles, sire d') marquis d'Encre"	no. 3319
Mme de Léomenil:	"Isabeau de Bavière, reine de France"	no. 4004
Mme de Léomenil:	"Sévigné (Marie de Rabutin-Chantal, marquise de)"	no. 4262
Mlle Henriette Lorimier:	"Pouqueville (François-Charles-Hugues-Laurent), historien" (1830)	no. 4829
La princesse Marie d'Orléans:	"Jeanne d'Arc, surnommée 'La Pucelle d'Orléans' statue en marbre" (1837)	no. 1854
Mlle Irma Martin d'après Lebrun: Mme	"Claude-Joseph Vernet, peintre"	no. 2999
Mlle Irma Martin d'après Coello:	"Rodolphe II, empereur d'Allemagne"	no. 4152
Mlle Irma Martin d'après Coello:	"Ernest, archiduc d'Autriche, gouverneur des Pays-Bas"	no. 4153

Mlle Montfort:	"Houchard (Jean-Nicolas), général de brigade en 1792"	no. 2357
Mlle Moré:	"Turenne (Henri de La Tour d'Auvergne, vicomte de), maréchal de France"	no. 2057
Mlle Marie Palluy:	"Lebrun (Anne-Charles), duc de Plaisance, grand Chancelier de l'ordre impérial de la Légion d'honneur"	no. 4820
Mlle Philippain:	"Custine (Adam-Philippe, comte de), général en chef des armées du Rhin et du Nord"	no. 1206
Mlle Prin d'après Winterhalter:	"Eugénie (Marie-Eugénie de Gusman, comtesse de Téba et de Montijo) impératrice des Français"	no. 5019
Mme Rang:	"Mort de Bisson - 5 novembre 1827" (1837)	no. 1797
Mlle Revest:	"Gustave 1er (Gustave Wasa), roi de Suède"	no. 4056
Mlle Revest d' après M.Rouget:	"Biron (Armand Louis de Gontaut, duc de), général en chef de l'armée du Rhin"	no. 1205
Mlle Robert:	"Buckingham (George Villiers, duc de)"	no. 3426
Mme Rochard:	"Gramont (Antoine III, duc de)"	no. 1053
Mme Rochard:	"Montesquiou (Pierre de), comte d'Artagnan"	no. 1093
Mme Rochard:	"Marguerite de Provence, reine de France"	no. 3993
Mlle Rossignon:	"Forget (Pierre), seigneur de Fresnes, secrétaire d'Etat"	no. 3325
Mme Rumilly:	"Borgia (César), duc de Valentinois"	no. 3089
Mme Rumilly d' après Tocque:	"Graffigny (Françoise d'Issembourg - d'Apponcourt, Mme de)"	no. 3778
Mlle Salogne:	"Charles V, duc de Lorraine"	no. 4290
Mlle Servoisier:	"Marcognet (Pierre-Louis Binet, baron de), lieutenant général"	no. 4764
Mme Therbusch:	"Frédéric II, roi de Prusse" (1772)	no. 4501
Mme Tripier-Lefranc d'après Mme Lebrun:	"Lebrun (Marie-Louise-Elisabeth Vigée, madame), peintre"	no. 4555
Mlle Vallier:	"Constant de Rebecque (Benjamin), président du Conseil d'Etat"	no. 4809
Mme Varcollier:	"Chilpéric 1er"	no. 660
Mme Varcollier:	"Klein (Louis-Antoine-Dominique, comte), lieutenant général"	no. 1233

TABLES

Notes to Tables

1. Tables 1 to 10, 19 & 20.
 An attempt has been made to include extra numbers given in
 exhibition catalogues in the total estimate of works. In
 other words, 1*, 1 bis and 1a as well as 1 where such additions
 exist.

2. Table 1.
 In 1800, 1801 and 1810 the water-colour section comprises
 miniatures only. In the same years the architectural section
 (ARCH.DRAWING) includes sculpture.
 When there is no water-colour section, all paintings (i.e. oils,
 water-colours, miniatures, pastels) were listed together indis-
 criminately in the catalogue.
 The water-colour section usually includes miniatures and
 drawings.

3. Table 6.
 The Dudley Gallery held separate exhibitions for works in oil,
 water-colour and black and white.

4. Table 7.
 When a number in brackets is given under the year, this indicates
 the number of supplements which are given at the back of the
 catalogue, in other words the edition which has been used.
 Monuments publics, when they are given in the catalogues, have been
 divided into paintings and sculptures and included in the Painting
 and Sculpture sections.

5. Tables 11 to 18.
A	=	Associate
M	=	Member
E	=	Exhibitor
HM	=	Honorary Member
LS	=	Ladies Section
LM	=	Lady Member

TABLE 1

ROYAL ACADEMY

	PAINTING			WATER-COLOUR ETC.			ARCH. DRAWING			SCULPTURE			PRINTS			TOTAL		
	TOT.	WOM.	%	TOT.	WOM.	%	TOT.	WOM.	%	TOT.	WOM.	%	TOT.	WOM.	%	TOT.	WOM.	%
1800	797	71	8.9	138	30	21.7	165	3	1.8							1100	104	9.4
1801	704	44	6.2	136	23	16.9	197	7	3.5							1037	74	7.1
1810	557	29	5.2	130	16	12.3	218	5	2.2							905	50	5.5
1820	880	68	7.7				123	0		69	0					1072	68	6.3
1830	1168	127	10.8							110	0					1278	127	9.9
1840	509	20	3.9	400	111	27.7	184	0		134	3	2.2				1264	133	10.5
1850	642	18	2.8	460	88	19.1	189	4	2.1	164	6	3.6				1456	116	7.9
1855	996	53	5.3	413	80	19.3				149	1	.6				1558	134	8.6
1860	834	48	5.7	64	20	31.2				151	3	1.9	47	0		1096	71	6.4
1865	769	75	9.7				68	1	1.4	186	9	4.8	54	1	1.8	1077	86	7.9
1870	664	32	4.8	250	48	19.2	79	0		194	11	5.6	42	3	7.1	1229	94	7.6
1880	923	65	7.0	315	81	25.7	139	0		146	14	9.5	135	8	5.9	1658	168	10.1
1885	1160	149	12.8	500	146	29.2	227	3	1.3	168	22	13.0	79	4	5.0	2134	324	15.1
1890	1172	170	14.5	400	138	34.5	234	3	1.2	176	33	18.7	137	12	8.7	2119	356	16.8
1895	888	136	15.3	385	166	43.1	201	1	.4	102	22	21.5	137	29	21.1	1713	354	20.6
1900	1090	164	15.0	436	189	43.3	233	3	1.2	145	32	22.0	153	27	17.6	2057	415	20.1

TABLE 2

BRITISH INSTITUTION

	TOTAL	WOMEN	%
1806	257	11	4.2
1807	310	32	10.3
1808	486	42	8.6
1809	344	36	10.4
1810	318	25	7.8
1811	312	30	9.6
1812	218	25	11.4
1813	206	22	10.6
1814	230	16	6.9
1815	242	11	4.5
1820	325	19	5.8
1825	416	21	5.0
1830	512	25	4.8
1831	552	27	4.8
1835	546	17	3.1
1840	461	22	4.7
1845	521	25	4.7
1850	500	19	3.8
1855	559	27	4.8
1860	649	34	5.2
1867	636	40	6.2

TABLE 3

SOCIETY OF BRITISH ARTISTS

	PAINTING			WATER-COLOUR			SCULPTURE			PRINTS			TOTAL		
	TOT.	WOM.	%	TOT.	WOM.	%	TOT.	WOM.	%	TOT.	WOM.	%	TOT.	WOM.	%
1824	327	16	4.8	298	75	25.1	42	0		221	30	13.5	590	46	7.7
1830	480	26	5.4	257	33	12.8	46	0		52	0		876	101	11.5
1835	506	16	3.1	146	30	20.5	41	0					804	49	6.0
1840	588	21	3.5	170	32	18.8	15	0					749	51	6.8
1845	646	18	2.7	192	46	23.9	21	0					837	50	5.9
1850	537	22	4.0	210	75	35.7	6	0					735	68	9.2
1855	604	39	6.4	228	47	20.6	10	2	20.0				814	114	14.0
1860	635	58	9.1	292	63	21.5	19	0					873	107	12.2
1865	753	54	7.1	415	75	18.0	15	0					1064	117	10.9
1870	580	34	5.8	346	67	19.3	5	0					1010	109	10.7
1875	585	52	8.8	272	51	18.7	12	2	16.6				936	119	12.7
1880	537	54	10.0				2	1					821	107	13.0
1890	586	114	19.4				2	0					588	115	19.5
1895	512	113	22.0										514	113	21.9
1900	499	97	19.4										499	97	19.4

TABLE 4

PORTLAND GALLERY

	PAINTING			WATER-COLOUR			SCULPTURE			TOTAL		
	TOT.	WOM.	%	TOT.	WOM.	%	TOT.	WOM.	%	TOT.	WOM.	%
1850	304	6	1.9	74	18	24.3				378	24	6.3
1851	365	14	3.8	101	15	14.8				466	29	6.2
1852	302	12	3.9	79	24	30.3				381	36	9.4
1853	341	17	4.8	75	27	36.0				416	44	10.5
1854	397	16	4.0	48	20	41.6				445	36	8.0
1855	526	34	6.4				4	0		530	34	6.4
1856	504	11	2.1	79	23	29.1	5	0		588	34	5.7
1857	464	15	3.2	69	18	26.0				533	33	6.1
1858	578	33	5.7				1	0		579	33	5.6
1860	435	24	5.5	56	15	26.7	1	0		492	39	7.9
1861										602	43	7.1

TABLE 5

GROSVENOR GALLERY

	PAINTING			WATER-COLOUR			SCULPTURE			TOTAL		
	TOT.	WOM.	%	TOT.	WOM.	%	TOT.	WOM.	%	TOT.	WOM.	%
1877	87	7	8.	50	12	24	14	0		151	19	12.5
1878	150	9	6.0	78	14	17.9	14	1	7.1	242	24	9.9
1879	219	23	10.5	50	9	18	40	5	12.5	309	37	11.9
1880	207	28	13.5	86	30	34.8	31	8	25.8	324	66	20.3
1881	315	67	21.2				10	1	10.0	325	68	20.9
1882	362	66	18.2				24	3	12.5	386	69	17.8
1883	291	50	17.1	74	28	37.8	28	4	14.2	393	82	20.8
1884	381	74	19.4				51	12	23.5	432	86	19.9
1885	392	80	20.4				30	6	20.0	422	86	20.3
1886	334	61	18.2	3	3		42	12	28.5	379	76	20.0
1887	370	62	16.7				47	11	23.4	413	73	17.6
1888	361	50	13.8				19	4	21.00	380	54	14.2
1889	372	44	11.8				47	12	25.5	419	56	13.3
1890	392	70	17.8				36	9	25.0	428	79	18.4

TABLE 6

DUDLEY GALLERY

	WATER-COLOUR			OIL			BLACK AND WHITE		
	TOT.	WOM.	%	TOT.	WOM.	%	TOT.	WOM.	%
1865	523	61	11.6						
1866	682	84	12.3						
1867	693	99	14.2	294	16	5.4			
1868	701	91	12.9	348	27	7.7			
1869	729	131	17.9	215	20	9.3			
1870	684	127	18.5	282	25	8.8			
1871	667	140	20.9	333	44	13.2			
1872	692	168	24.2	397	56	14.1	522	32	6.1
1873	595	128	21.5	401	58	14.4			
1874	672	129	19.1	412	47	11.4			
1875	611	108	17.6	453	48	10.5	532	56	10.5
1876	595	117	19.6	489	54	11.0	615	71	11.5
1877	648	149	22.9	468	62	13.2	603	70	11.6
1878	672	172	25.5	466	56	12.0	646	77	11.9
1879	643	169	26.2	478	65	13.598	587	69	11.7
1880	683	180	26.3	466	53	11.3	642	82	12.7
1881	685	157	22.9				639	70	10.9
1882	646	175	27.0						
1883	538	140	26.0	424	79	18.6			
1884	628	184	29.2	406	93	22.9			
1C35	578	165	28.5	290	58	20.0			
1886	486	147	30.2						
1887	222	36	16.2						
1888				171	36	21.0			
1889	299	76	25.4						
1889	387	149	38.5						
1890	389	156	40.1						
1891	562	188	33.4						
1893	390	137	35.1						
1893	289	79	27.3						
1895	334	102	30.5						
1896	259	72	27.7						
1900	329	127	38.6						

TABLE 7
PARIS SALON

Year	PAINTING			WATER-COLOUR ETC.			ARCH. DRAWINGS			SCULPTURE			PRINTS			TOTAL		
	TOT.	WOM.	%	TOT.	WOM.	%	TOT.	WOM.	%	TOT.	WOM.	%	TOT.	WOM.	%	TOT.	WOM.	%
1800 (1)	413	59	14.2				19	0		54	4	7.4	54	3	5.5	540	66	12.2
1801 (1)	385	58	15.0				15	0		60	3	5.0	30	1	3.3	490	62	12.6
1808	631	96	15.2				17	0		89	2	2.2	65	0		802	98	12.2
1810 (1)	871	144	16.5				26	0		134	2	1.4	92	4	4.3	1123	150	13.3
1817 (2)	836	118	14.1				11	0		138	2	1.4	112	1	.8	1097	121	11.0
1822 (2)	1436	216	15.0				14	0		176	1	.5	179	1	.5	1805	218	12.0
1831 (7)	2697	378	14.0				24	0		208	0		282	7	2.4	3211	385	11.9
1840	1666	210	12.6				16	0		85	0		82	0		1849	210	11.3
1850 (1)	3179	333	10.4				107	0		466	2	.4	201	3	1.5	3953	338	8.5
1855 (1)	1867	126	6.7				183	3	1.6	376	3	.7	286	1	.3	2712	133	4.9
1861	3178	302	9.5				115	0		566	12	2.1	321	5	1.5	4180	319	7.6
1865	2263	157	6.9	601	143	23.7	46	0		359	16	4.4	332	7	2.1	3601	323	8.9
1870	3011	270	8.9	1238	345	27.8	136	0		728	47	6.4	359	19	5.2	5472	681	12.4
1875	2042	131	6.4	808	296	36.6	105	0		679	36	5.3	264	16	6.0	3898	479	12.2
1880	4001	503	12.5	2085	863	41.3	111	0		741	55	7.4	351	28	7.9	7289	1449	19.8
1884	2488	284	11.4	749	257	34.0	165	0		782	83	10.0	474	41	8.6	4658	665	14.2
1889	2771	400	14.4	1194	521	43.6	173	0		1145	148	12.9	527	74	14.0	5810	1143	19.6
1895	1962	220	11.2	966	199	51.6	244	0		825	74	8.9	568	89	15.6	4565	882	19.3
1900	1379	225	16.3	579	285	49.2	99	0		439	49	11.1	376	50	13.2	2872	609	21.2

TABLE 8

SOCIETE NATIONALE

	PAINTING			WATER-COLOUR ETC.			PRINTS			SCULPTURE			OBJETS D'ART			ARCHITECTURE			TOTAL		
	TOT.	WOM.	%	TOT.	WOM.	%	TOT.	WOM.	%	TOT.	WOM.	%	TOT.	WOM.	%	TOT.	WOM.	%	TOT.	WOM.	%
1864	274	3	1.0							39	0								312	3	.9
1890	911	67	7.3	310	80	25.8				84	6	7.1							1305	153	11.7
1895	1293	76	5.8	483	114	23.6	180	9	5.0	127	10	7.8	266	22	8.2	46	0		2395	231	9.6
1899	1492	100	6.7	622	88	14.1	167	6	3.5	147	14	9.5	213	32	15.0	66	1	1.5	2707	241	8.9
1912	1292	128	9.9	466	91	19.5	254	11	4.3	395	27	6.8	224	51	22.7	58	0		2689	308	11.4

TABLE 9

SOCIETE DES ARTISTES INDEPENDANTS

	TOTAL	WOMEN	%
1886	404	38	9.4
1889	208	47	22.5
1891	1254	91	7.2
1892	1232	80	6.4
1895	1564	152	9.7
1899	203	44	21.6
1911	6752	1314	19.4

TABLE 10

SALON D'AUTOMNE

	PAINTING			DRAWING ETC.			SCULPTURE			ARCH.*PHO.			PRINTS			DEC. ART.			TOTAL		
	TOT.	WOM.	%	TOT.	WOM.	%	TOT.	WOM.	%	TOT.	TOT.	%	TOT.	WOM.	%	TOT.	WOM.	%	TOT.	WOM.	%
1904	1317	133	10.0	383	51	13.3	143	15	10.4	22	30	0	115	2	1.7	67	16	23.8	2078	217	10.4
1910																			1235	237	19.1

* PHO. = Photographs. Women were not represented in the architectural or the photographic section in 1904

<center>TABLE 11 (i) (Honorary Members of the R.A.)</center>

NAME	YEARS OF MEMBERSHIP
Mrs. A	1808
Mrs. Acton	1806
Miss Adams	1831
Miss L. Adams	1819, 1820, 1829, 1831, 1836-1840, 1842, 1843
Miss Charlotte Adams	1829, 1835, 1836, 1838-1840, 1842, 1843
Mrs. Addison	1837, 1839, 1843
Miss Ainslie	1823, 1824, 1826-1829, 1831, 1832, 1835
Miss Alexander	1820
Miss M. Allen	1807
Miss Andree	1825, 1827, 1828, 1830-1832
Miss C. D'Arce	1814
Miss Baker	1810, 1812, 1818
Miss A E Barker	1855, 1858
Miss Barnett	1814
Sophia Barney	1819
Mrs. Battersby	1833
Miss Batty	1809, 1810, 1812-1816
Mrs. Bell (Lady)	1816, 1819, 1820
Lady Beechey	1805
Miss Belson	1800
Miss Bennell	1807
Miss Bernard	1800
Miss M. Betham	1808
Miss Elizabeth Blackwell	1819
Miss Booth	1809
Miss M. Boulogne	1815, 1817
Miss R. Boughton	1806
Mrs. Brawn	1822
Mrs. Brydges	1807
Mrs. Burchell	1800
Miss Anna Burchell	1819
Miss Byam	1817
Miss Byrne	1838-1840, 1842-1843, 1846-1848
Miss E. Byrne	1838-1840, 1842-1843, 1846, 1847
Miss M. Caton	1808
Emma Cayley	1838, 1839
Miss Chapman	1815-1818, 1821, 1822, 1825
Miss B. Clutton	1803, 1806
Miss H. Cole	1866
Duchess of Colonna Castiglione	1866
Miss Cooke	1804
Mrs. Creswick	1867
Mrs. Dalton	1808, 1809
Hon. Mrs. Anne Seymour Damer	1800, 1803-1807, 1810, 1813, 1814, 1816, 1818
Miss A. Darby	1813, 1817
Miss Davis	1817, 1818
Mrs. Delap	1820
Mrs. T. Dickins	1812-1814
Mrs. J. Dimock	1817
Mrs. Dighton	1820-1824
Miss M. Dowding	1822
Miss Dredge	1815, 1816, 1818
Miss Dubuisson	1805-1808, 1814-1816
Miss E. Dubuisson	1840
Miss Earle	1821, 1822

TABLE 11 (ii)

NAME	YEARS OF MEMBERSHIP
Hon. Mary J. Eden	1815
Elizabeth Elford	1815-1817, 1821
Miss Evans	1822, 1823
Miss E. Farhill	1804
Mrs. E.W. Field	1824, 1830, 1831, 1833, 1836
Miss Field	1828, 1830
Miss Fitzwalter	1803
Miss Fletcher	1838
Mrs. Forster	1814
Mrs. Foster	1800
Miss Fox	1804, 1827
Miss E. Francillon	1800. 1807
Mrs. C. Few	1806
Miss Adelaide A. Godfrey	1848
Mrs. C.Godwin	1832
Miss Godwin	1847
Miss H. Gouldsmith	1807, 1808, 1816
Mrs. Green	1804-1806
Miss Green	1837, 1844
Mrs. Groves	1819
Miss Hales	1815
Mary Hamilton	1825
Miss Haworth	1844
Miss C. Heath	1804, 1806
Mrs. Heatley	1800, 1804, 1805
Miss Henderson	1809, 1810
Mrs. Ireland	1817
Miss Jackman	1821
Miss H.A.E. Jackson (Mrs. John Browning)	1803-1810, 1812-1816, 1825, 1828, 1831
Miss Jenkins	1831
Miss Johnson	1809
Mrs. Johnstone	1835, 1836, 1839
Miss M.A. Jones	1806, 1809
Miss L. Kemp	1803, 1804
Miss Kentish	1815
Miss Kirkman	1815-1817, 1819-1821, 1823, 1825
Mrs. Knowles	1803
A Lady	1800, 1803, 1805, 1807-1810, 1812, 1815, 1822, 1826, 1848, 1852
A Lady	1800, 1803, 1807, 1809, 1822,
A Young Lady	1800, 1803, 1815
A Young Lady	1800
Miss E.J.Land	1832
Miss Lewis	1803
Mrs. T. Lilburne	1825
Mrs. Charles Long	1807, 1808, 1810, 1812, 1814-1817, 1819, 1822
Miss Macleay	1824
Miss Mainwaring	1822
Miss E.FManners	1806-1808
Miss Martin	1824
Mrs. H. Matthew	1803
Miss Mayer	1805
Miss Maynard	1813, 1814
Miss Maxwell	1839
Miss Monat Keith	1818
Mrs. Morris	1822
Mary Mulready Lecky (Stone)	1842-1846
Miss S. Nayler	1812

TABLE 11 (iii)

NAME	YEARS OF MEMBERSHIP
Miss Nailor	1819
Miss Naylor	1819
Mrs. D. Nelson	1855
Miss A. Nihill	1825, 1829
Miss L. North	1810
Miss P. Page	1816-1819
Miss M. Palmer	1821
Miss Paris	1850
Miss Parkinson	1815, 1816, 1818-1822, 1824, 1826, 1828
Miss Pawsey	1800
Miss Paytherus	1803
Miss Pearson	1824
Mrs. H. Peile	1836
Miss Phillips	1808
Miss Price	1845
Miss A. Raper	1838
Miss Ravenscroft	1824
Mrs. Read	1805
Miss Reeve	1855
Miss E. Reeves	1822-1824
Miss K. Reinagle	1804
Miss Rennell	1805
Miss Richter	1842, 1844
Miss Elizabeth Rickerby	1844
Miss G. Roberts	1813, 1814
Countess of Rochefort	1851
Miss Russell	181805, 1806, 1809, 1812, 1813
Mrs. R. Sass	1800, 1812
Miss Serres	1800
Miss S. Serres	1800
Miss A.C. Serres	1800
Mrs. J.T. Serres	1800
Mrs. Sheffield	1807, 1809, 1813
Miss Mary Sheffield	1812
Miss Sheppard	1818
Mrs. Slous	1812
Miss M.A. Smith	1808
Mrs. A. Smith	1837
Miss E.D. Smith	1838
Miss C.S. Smith	1839
Miss Soilleux	1810, 1813, 1816
Miss M. Spicer	1800
Miss Stacey	1817
Miss Stratham	1837, 1838
Mlle A.A. de Suchemont	1816
Miss Helen Tasker	1840
Miss Thomas	1841, 1842
Miss M. Tullock	1806
Mrs. W . Tringham	1839
Miss Twining	1831, 1835
Miss Vincent	1816
Mrs. S. Wall	1823
Mrs. Warwick	1823
Miss Waters	1816
Miss M. Whitworth	1814
Eliza Whitmarsh	1840

TABLE 11 (iv)

NAME	YEARS OF MEMBERSHIP
Miss Wickens	1813
Miss Willis	1800, 1803
Mrs. J.L. Yeats	1824, 1825
Miss H.G.	1805, 1806
Miss M.C.	1800
Miss S.M.	1800
Miss E.F.D.	1806
Miss H.	1809
Miss S.	1813
Miss M'L	1816, 1819
Miss M.	1820, 1821
Miss F.N.	1820
Miss W.C.	1822, 1825
Miss M.P.	1826
The Misses -	1830, 1831
Miss S.S.T.	1830
Miss F.H.	1849

Numbers of male and female Honorary Members (selected dates)

YEAR	MEN	WOMEN
1800	51	21
1805	27	12
1810	36	9
1815	30	15
1820	24	9
1825	26	9
1830	27	5
1835	26	4
1840	13	7
1845	10	2
1850	5	1
1855	9	1
1867	4	1

TABLE 12

MANCHESTER ACADEMY OF FINE ARTS

	HONORARY MEMBERS		MEMBERS OF COUNCIL		MEMBERS		ASSOCIATES		LADY EXHIBITORS
	MEN	WOMEN	MEN	WOMEN	MEN	WOMEN	MEN	WOMEN	
1879	10	0	9	0	35	0	20	0	9
1882	13	0	9	0	36	0	27	0	14
1883	13	0	9	0	48	0	26	0	15
1884	14	0	13	0	49	0	28	0	15
1885	14	0	9	0	48	6	37	11	
1886	14	0	9	0	49	7	35	9	
1887	12	0	13	0	46	7	36	9	
1888	11	0	9	0	45	7	36	13	
1889	12	0	9	0	47	7	33	12	
1890	11	0	9	0	44	8	34	10	
1891	13	0	8	0	38	7	30	10	
1892	11	0	12	0	39	7	24	9	
1893	12	0	11	1	37	7	22	9	
1894	11	0	11	1	36	7	27	8	
1895	11	0	12	2	35	7	30	11	
1896	11	0	13	2	34	7	28	11	
1897	11	0	13	2	33	8	28	12	
1898	9	0	12	2	30	8	29	12	
1899	9	0	12	2	35	9	26	12	
1900	9	0	12	3	36	10	27	9	

TABLE 13
SOCIETY OF BRITISH ARTISTS

	1824	1825	1826	1827	1828	1831	1832	1833	1834	1835	1837	1839	1840	1845	1846	1860	1902	1905	1910	1914
Miss Beaumont	HM																			
Lady Bell					HM	HM	HM													
Miss W. Brunton						HM	HM	HM	HM	HM	HM	HM	HM							M
Miss F. Corbaux						HM	HM	HM	HM	HM	HM	HM	HM							
Miss L. Corbaux						HM	HM	HM	HM	HM	HM	HM	HM							
Miss Dagley						HM	HM	HM	HM	HM	HM									
Miss M. Dovaston																				M
Mrs Field						HM												M		
Countess Gleichen																				
Miss Gouldsmith	HM	HM	HM	HM	HM	HM	HM	HM	HM	HM	HM	HM	HM	HM						
Miss C. Halliday				HM	HM	HM	HM	HM	HM	HM										
Mrs M. Hankey	HM																M			
Miss Heaphy		HM																		
Mrs L. Jopling																	M	M		M
Mrs L. Kemp-Welch																		M		M
Mrs G. Maddox	HM	HM	HM	HM	HM	HM	HM	HM	HM	HM	HM	HM	HM				M			M
Miss H. McNicoll																		M		
Mrs A.L. Merritt																	M			
Mrs Pearson	HM	HM	HM	HM	HM	HM	HM	HM	HM	HM	HM	HM	HM							
Mrs Pierce						HM	HM	HM	HM	HM	HM	HM	HM							
Miss D. Roberts																				M
Miss Vivian Rolt																				M
Miss M.A. Sharpe						HM	HM	HM	HM	HM	HM	HM	HM					M		M
Miss D. Sharp																				
Miss Sharples					HM	HM	HM	HM	HM	HM	HM	HM	HM							
Miss F. Steers																				
Miss A. Underwood																				M
Miss Helen Wilson																				M
Mrs Withers														HM	HM					
MEMBERS (MEN)	26	28	29	30	29	29	29	27	25	25	23	28	28	39			186		180	171
MEMBERS (WOMEN)		1	2	2	2	2	2	2	2	3	2	2	2	2			4		4	9
HON. MEMBERS (MEN)	1	2	2	2	2	2	2	2	2	2	3	2	2	2			9		12	13
HON. MEMBERS (WOMEN)	5	4	3	4	6	11	10	10	10	10	10	9	9	6						

NO MORE HONORARY MEMBERS

HONORARY MEMBERS REINTRODUCED WITHOUT WOMEN

WOMEN ADMITTED AS FULL MEMBERS

TABLE 14 (1)

OLD WATER-COLOUR SOCIETY

MEMBERS ONLY (1805–1812) · SOCIETY OF PAINTERS IN OIL AND WATER-COLOURS OPEN TO ALL (1813–1820)

	1805	1806	1807	1808	1809	1810	1811	1812	1813	1814	1815	1816	1817	1818	1819	1820
Miss Badger																E
Miss Baker												E				
Miss E. Barber										E	E					E
Miss Betham																E
Miss Byrne		A	A	A	M	M	M	M							E	E
Mrs Carpenter															E	E
Miss Collins																E
Miss Cotton																E
Mrs T.H. Fielding									M	M	M	M	M	M	M	M
Miss Gouldsmith													E	E	E	E
Mrs J. Groves													E			E
Miss Hayter																E
Miss E. Jones											E	E	E	E	E	E
Miss E.E. Kendrick															E	E
Miss Knight											E	E	E	E		E
Miss Landseer									E	E	E	E	E			E
Mrs Mulready																E
Miss Nicholson													E			
Miss Roe									E							
Miss M. Stewart											E	E	E	E	E	E
Miss Walton															E	
Mrs C. White																E
MALE MEMBERS	16	16	18	19	19	21	23	24	17	15	16	14	12	13	13	14
MALE ASSOCIATES		7	7	6	7	8	8	6								

TABLE 14 (11)

OLD WATER-COLOUR SOCIETY

SOCIETY OF PAINTERS IN WATER-COLOURS: MEMBERS ONLY

WOMEN ADMITTED AS HONORARY MEMBERS (1850)
WOMEN ADMITTED AS LADY EXHIBITORS (1851)

	1821	1823	1829	1834	1835	1836	1837	1839	1843	1847	1849	1850	1851	1852	1856	1860
Miss Barrett	M	M	M	M	M	M										
Miss Byrne		M	M													
Mrs H. Criddle											M	HM	LS	LS	LS	LS
Mrs Fielding	M	M	M	M	M											
Margaret Gillies											M	HM	LS	LS	LS	LS
Maria Harrison										M		HM	LS	LS	LS	LS
Nancy Rayner														LS		
Miss Scott		M	M	M	M	M	M									
Miss Eliza Sharpe			M		M	M	M	M	M	M	M	HM	LS	LS	LS	LS
Miss Louisa Sharpe			M		M	M	M	M								
MALE MEMBERS	15	16	23	22	23	24	24	24	24	25	25	26	27	25	27	28
MALE ASSOCIATES	4	12	15	17	17	16	17	17	17	13	17	17	15	17	17	18

TABLE 14 (111)

OLD WATER-COLOUR SOCIETY

WOMEN ADMITTED AS ASSOCIATE EXHIBITORS

	1861	1871	1874	1875	1878	1879	1881	1883	1884	1885	1886	1887	1888	1889
Helen Allingham				A	A	A	A	A	A	A	A	A	A	A
Helen Angell						A	A	A						
Mrs H. Criddle	AE	A	A	A	A	A	A	A						
Miss Mary Forster									A	A				
Margaret Gillies	AE	A	A	A	A	A	A	A	A	A	A	A		
Maria Harrison	AE	A	A	A	A	A	A	A	A	A	A	A	A	A
Princess Louise					HM	HM	HM	HM	HM	HM	HM	HM	HM	HM
Miss Edith Martineau													A	A
Clara Montalba			A	A	A	A	A	A	A	A	A	A	A	A
Maud Naftel									A	A	A	A	A	A
Miss Constance Phillot											A	A		A
Eliza Sharpe	AE													
Princess of Wales							HM	HM	HM	HM	HM	HM	HM	HM
MALE MEMBERS	27	30	30	30	30	30	30	36	38	40	40	40	40	41
MALE HONORARY MEMBERS								5	5	5	5	5	5	7
MALE ASSOCIATES	18	29	32	33	33	33	37	39	35	35	35	35	38	37

TABLE 14 (1v)

OLD WATER-COLOUR SOCIETY

WOMEN ADMITTED AS FULL MEMBERS

	1890	1891	1892	1894	1895	1896	1899	1900	1901	1902	1903	1905	1906
Queen Alexandra	A												HM
Mrs H. Allingham		M	M	M	M	M	M	M	M	M	M	M	M
Miss Rose Barton				A	A	A	A	A	A	A	A	A	A
Miss Mildred Butler						A	A	A	A	A	A	A	A
Miss E. Fortescue-Brickdale										A	A	A	A
Miss Maria Harrison	A	A	A	A	A	A	A	A	A	A	A	A	
Princess Louise	HM	HM	HM	HM	HM	HM	HM	HM	HM	HM	HM	HM	HM
Miss Edith Martineau	A	A	A	A	A	A	A	A	A	A	A	A	A
Miss Clara Montalba	A	A	M	M	M	M	M	M	M	M	M	M	M
Miss Constance Phillot	A	A	A	A	A	A	A	A	A	A	A	A	A
Miss Minnie Smythe													A
Miss E. Stanhope-Forbes							A	A	A	A	A	A	A
Miss Alice M. Swan													A
Princess of Wales	HM	HM	HM	HM	HM	HM	HM	HM	HM	HM	HM	HM	HM
MALE MEMBERS	38	38	38	35	36	36	35	37	37	37	37	36	38
HONORARY MALE MEMBERS	6	6	5	8	8	8	7	5	5	5	5	6	6
MALE ASSOCIATES	38	40	38	38	37	38	30	28	29	28	28	31	31

TABLE 14 (v)

OLD WATER-COLOUR SOCIETY

	1907	1909	1911	1912	1914
Queen Alexandra	HM	HM	HM	HM	HM
Mrs H. Allingham	M	M	M	M	M
Miss Rose Barton	A	A	M	M	M
Miss Mildred Butler	A	A	A	A	A
Miss E. Fortescue-Brickdale	A	A	A	A	A
Miss H. Hopwood	A				
Miss Laura Knight		A	A	A	A
Princess Louise	HM	HM	HM	HM	HM
Miss Edith Martineau	A				
Miss Clara Montalba	M	M	M	M	M
Miss Constance Phillot	A	A	A	A	A
Miss Minnie Smythe	A	A	A	A	A
Miss E. Stanhope Forbes	A	A	A	A	A
Miss Alic Swan	A	A	A	A	A
Miss Katherine turner					
MALE MEMBERS	41	41	39	39	40
MALE HONORARY MEMBERS	6	6	5	5	5
MALE ASSOCIATES	28	28	28	28	22

TABLE 15

ASSOCIATED ARTISTS IN WATER-COLOUR

	1808	1809	1810	1811	1812
Miss Betham				E	E
Miss Bourlier					E
Miss Gartside	E				
Mrs Green	M	M	M		E
Mrs S. Jones			M		
Mrs Meen	M				
Miss Emma Smith					
Miss J. Steele				E	M
Mrs Tulloch		E	E		
MALE MEMBERS	16	17	15	22	22
MALE EXHIBITORS	17	18	17	11	32

TABLE 16 (1)

NEW SOCIETY OF PAINTERS IN WATER-COLOURS

The columns 1860–1879 are headed: **WOMEN LISTED IN SEPARATE LADY MEMBERS SECTION**

	1835	1837	1838	1842	1845	1850	1854	1855	1860	1865	1870	1875	1879
Miss Rosa Bonheur											HM	HM	HM
Mme Henriette Browne											HM	HM	HM
Mrs Angell												LM	
Mrs J. Chase		M	M										
Miss Marian Chase												LM	LM
Miss F. Corbaux		M	M	M	M				LM	LM	LM	LM	LM
Miss L. Corbaux		M	M	M	M				LM	LM	LM	LM	LM
Mrs William Duffield							M	M	LM				
Miss Jane S. Egerton						M			LM				
Miss Emily Farmer							M	M	LM	LM	LM	LM	LM
Miss Mary L. Gow									LM	LM		LM	LM
Mrs Fanny Harris							M	M	LM			LM	
Mrs Harrison	M	M	M	M	M	M	M	M					
Miss Laporte	M	M	M		M								
Lady Lindsay of Balcarres									LM	LM	LM	LM	LM
Mrs Mary Margetts				M			M	M	LM	LM	LM	LM	LM
Mrs Elizabeth Murray							M	M	LM	LM	LM	LM	LM
Mrs W. Oliver						M	M	M	LM				
Miss M.A. Rix	M												
Miss Sarah Setchell					M	M	M	M	LM	LM	LM	LM	LM
Mrs Clarendon Smith						M			LM				
Miss Fanny Steers						M	M	M	LM				
Miss Elizabeth Thompson												LM	
MALE MEMBERS	29	30	29	42	42	48	48	48	32	37	39	45	51
MALE HONORARY MEMBERS											6	6	5
MALE ASSOCIATES									18	17	22	22	16

TABLE 16 (11)

NEW SOCIETY OF PAINTERS IN WATER-COLOUR

	1885	1890	1900	1905	1910
H.I.H. Crown Princess of Germany	HM				
Princess Royal of G.B. and Ire.	HM	HM	HM		
Empress Fred. of Germany		HM	HM		
H.R.H. Princess Henry of Battenburg		HM	HM	HM	HM
H.R.H. Princess Beatrice	HM				
H.S.H. Princess Louis of Battenburg			HM		
Mlle Rosa Bonheur	HM	HM			
Mme Henriette Browne	HM	HM	HM		
Miss Marian Chase	LM	LM	LM		
Miss Jane M. Dealy		LM	LM	LM	LM
Miss Gertrude Demain Hammond			LM	LM	LM
Mrs William Duffield	LM	LM	LM	LM	
Miss Emily Farmer	LM	LM	LM	LM	
Miss Mary L. Gow	LM	LM	LM		
Miss Kate Greenaway		LM	LM		
Mme Theresa Hegg de Landerset		LM	LM	LM	LM
Miss Alice M. Hobson		LM	LM	LM	LM
Lady Lindsay of Balcarres	LM	LM	LM	LM	LM
Mrs Mary Margetts	LM				
Mme Henriette Ronner			LM	LM	
Miss Sarah Setchel	LM	LM			
Mrs Clarendon Smith	LM	LM			
Miss Alice Squire		LM	LM	LM	LM
Miss K.M. Whitley		LM	LM	LM	LM
Miss A.M. Youngman		LM	LM	LM	LM
Mrs W. Oliver	LM				
MALE MEMBERS	77	69	82	83	86
MALE HONORARY MEMBERS	6	12	11	7	6

(The Council was composed of men only throughout this period)

TABLE 17 (1)

DUDLEY WATER-COLOUR SOCIETY

	1883	1884	1885	1886
Mrs. Edwin Arnold	M	M		
Miss M. Beresford	M	M	M	M
Mrs. S. Berkley				M
Lady Louisa Charteris	M	M		
Miss Fanny Currey		M	M	M
Miss Jane Dealy			M	
Miss Victoria Dubourg	M			
Miss Mary Eley	M	M	M	M
Miss Frances C. Fairman			M	M
Miss Mary Forster	M	M		
Miss Maude Gardell-Ericson		M		
Miss Alice Grant	M			
Mrs. A. Lukis de Guerin	M	M		
Miss Kate Macaulay	M	M	M	M
Mrs. Marrable	M	M		
Miss Edith Martineau	M	M	M	M
Miss Gertrude Martineau	M	M	M	M
Miss Maude Naftel	M			
Miss Caroline Paterson	M			
Miss Annette Riviere	M	M	M	
Miss Helen Thornycroft	M	M	M	M
Miss Linnie Watt	M			
MALE MEMBERS	75	71	72	60
FEMALE MEMBERS	17	14	10	9

TABLE 17 (ii)

DUDLEY WATER-COLOUR SOCIETY

	1887	1889	1890	1891	1893	1895	1900
Miss M.B. Bailward	M						
Miss Rose Barton	M	M	M	M	M	M	
Miss C.M. Beresford	M	M					
Miss M. Bernard		M	M	M	M	M	M
Mrs E. Brace							M
Miss M.H. Butler		M	M	M	M	M	M
Miss A. Charlesworth							M
Miss J. Christy					M	M	M
Miss M.J. Cleminshaw		M	M	M	M	M	
Miss Violet Common							M
Miss Mabel Edith Cooper							M
Miss C.P. Culverwell			M		M	M	
Miss Fanny Currey	M			M	M	M	
Miss Norah Davison				M	M	M	M
Miss L. Dean				M			
Miss E. Dell				M			
Miss K. Devine				M	M		
Mrs Dockery					M		
Miss R. Douglas						M	M
Miss L.H. Sylvia Drew							M
Miss F.C. Fairman	M	M	M	M	M		
Miss R.C. Foster							M
Miss J.A. Gilchrist							M
Mrs M. Gregory						M	M
Miss M.H. Green							M
Miss A.L. de Guerin		M	M	M			
Mrs G. Hake							M

TABLE 17 (111)

DUDLEY WATER-COLOUR SOCIETY

	1887	1889	1890	1891	1893	1895	1900
Miss M.S. Hagarty		M	M	M	M	M	M
Mrs G. Heathcote		M	M	H	M	M	M
Mrs Hussey Freake			M				
Miss A. Hussey		M	M				
Miss Alice Helen Loch	M	M	M	M	M		M
Miss Kate Macaulay	M	M	M	M	M	M	M
Miss E.E. Manly			M	M	M	M	M
Miss A.E. Manly			M	M			
Miss Edith Martineau	M	M	M	M	M	M	M
Miss Gertrude Martineau			M	M	M	M	M
Miss R. Mead		M	M	M	M	M	M
Miss A. Morgan			M	M	M	M	M
Mrs Moberley							M
Miss E. Frances Nesbitt							M
Miss Helen O'Hara	M	M	M	M	M	M	M
Miss E.M. Osborn		M	M		M	M	M
Miss J. Maur Peel			M	M	M	M	M
Mrs Protheroe					M	M	M
Mrs Roxby					M	M	M
Miss A. Rudd		M	M	M	M	M	M
Miss H. Skidmore					M	M	M
Miss M.A. Sloane					M	M	M
Miss Smallfield			M	M	M	M	
Miss St. John Mildmay		M		M	M	M	M
Miss Stevens		M		M	M		M
Mrs Mary Stormont	M						
Miss Helen Thornycroft							M
Miss Maud Turner		M	M				M
Lady Waterford	M	M					
Lilian Young		M					
MALE MEMBERS	57	67	76	74	70	68	59
FEMALE MEMBERS	11	22	22	24	24	23	34

TABLE 18

NEW ENGLISH ART CLUB

	1889	1890	1891	1892	1893	1894	1895	1896	1897	1898	1899
Miss Elizabeth Armstrong	M										
Mrs Annie Ayrton	M										
Millie T. Dow	M	M	M								
Miss A. Draper					M	M	M	M	M		
Mrs S. Jervis Edwards (Honorary Member in 1887)											M
Miss A Fanner		M									
Mrs Stanhope Forbes											
Miss Inglis (Honorary Member in 1888)											
Mrs Laidley (Honorary Member in 1887)											
Miss Laidley (Honorary Member in 1887)											
Mrs Walter Langley (Honorary Member in 1887)											
Miss Bertha Newcombe	M	M	M								
Mrs Ed Penton (Honorary Member in 1887 and 1888)											M
Miss E. Walker											
MALE MEMBERS	74	66	57			37	39				32

TABLE 19

SOCIETY OF FEMALE ARTISTS

(from 1872 the Society of Lady Artists
from 1899 the Society of Women Artists)

1857 - 358	1886 - 534		
1858 - 582	1887 - 561		
1859 - 311	1888 - 568		
1860 - 319	1889 - 559		
1861 - 333	1890 - 577		
1862 - 283	1891 - 553		
1863 - 269	1892 - 465		
1864 - 255	1893 - 453		
1865 - 281	1894 - 394		
1866 - 403	1895 - 383		
1867 - 399	1896 - 603		
1868 - 413	1897 - 763		
1869 - 484	1898 - 711		
1870 - 473	1899 - 726		
1871 - 456	1900 - 753		
1872 - 427	1901 - 782		
1873 - 469	1902 - 764		
1874 - 592	1903 - 862		
1875 - 605	1904 - 845		
1876 - 666	1905 - 821		
1877 - 715	1906 - 826		
1878 - 797	1907 - 701		
1879 - 835	1908 - 613		
1880 - 714	1909 - 587		
1881 - 767	1910 - 640		
1882 - 750	1911 - 507		
1883	1912 - 455		
1884 - 764	1913 - 472		
1885 - 763	1914 - 413		

WOMEN'S INTERNATIONAL ART CLUB

1900 - 235	
1901 - 274	
1902 - 325	
1903 - 416	
Jan. 1904 - 520	
1904 - 507	
1905 - 447	
1906 - 307	
1907	
1908 - 250	
1909 - 348	
1910 - 394	
1911 - 356	
1912 - 314	
1913 - 255	
1914 - 244	

TABLE 20

L'UNION DES FEMMES PEINTRES ET SCULPTEURS

	PAINTING	SCULPTURE	TOTAL	
1882			94	("Chronique des Arts" Jan 28 1882 no.4 p.27)
1884	262	24	286	
1885	272	20	292	
1886	324	23	347	
1887	315	17	332	
1888			ca. 500	("Chronique des Arts" Mar 3 1888 no.9 p.65)
1889	651	37	688	
1890	740	18	758	
1891	797	33	830	
1897			942	("Chronique des Arts" Feb 6 1897 no.6 p.51)
1901			ca. 967	("Chronique des Arts" Mar 9 1901 no.10 p.75)
1902			ca.1100	("Chronique des Arts" Feb 15 1902 no.7 p.51)
1903			ca.1200	("Chronique des Arts" Feb 14 1903 no.7 p.50)
1905			ca.1300	("Chronique des Arts" Feb 18 1905 no.7 p.51)
1906			ca.1500	("Chronique des Arts" Feb 17 1906 no.7 p.52)
1907			1357	("Chronique des Arts" Feb 16 1907 no.7 p.50)
1911			ca.1400	("Chronique des Arts" Feb 18 1911 no.7 p.51)

SOCIETE DES FEMMES ARTISTES

1895 - 207
1896 - 197
1898 - 213
1901 - 233
1902 - 142
1903 - 195
1904 - 230
1906 - 265
1907 - 242

BIBLIOGRAPHY

1. General reference books

Jean Baptiste Emile Bellier de la Chavignerie and Louis Auvray :
"Dictionnaire général des artistes de l'école française depuis l'origine
des arts du dessin jusqu'à nos jours" 2 vols. Paris 1882-5

Emmanuel Bénézit : "Dictionnaire critique et documentaire des peintres,
sculpteurs, dessinateurs, et graveurs" 10 volumes, Paris 1976

Marie Brédif : "Répertoire des Artistes ayant exposé au Salon des
Indépendants 1884-1914" Paris 1969

M. Bryan : "Dictionary of Painters and Engravers" 5 vols. London 1903-5

Clara Erskine Clement and Lawrence Hutton : "Artists of the Nineteenth
Century and their Works" 2 vols. Cambridge 1899

Dictionary of National Biography 22 volumes 1908-9

Algernon Graves : "A Dictionary of Artists 1760-1893" London 1901

Algernon Graves : "A Century of Loan Exhibitions 1813-1912" 5 vols.
London 1913-1915

Algernon Graves : "The British Institution 1806-1867" London 1908

Algernon Graves : "Royal Academy Exhibitors 1769-1904" 8 vols.
London 1905-1906

Edouard Joseph : "Dictionnaire biographique des Artistes contempor-
ains 1910-1930" 3 vols. Paris 1930-4, supplement 1936

Stanislas Lami : "Dictionnaire des sculpteurs de l'école française
au XIXe siècle" 4 volumes, Paris 1914-1921

Louis Gabriel Michaud : "Biographie Universelle : Ancienne et Moderne"
new odition 45 vols. Paris and Leipzig 1842-1865

H. Mireur : "Dictionnaire des Ventes d'Art faites en France et à
l'Etranger pendant les XVIII et XIX siècles" 7 vols. Marseille
1901-1912

GKNagler : "Neues Allgemeines Künstlerlexikon" 25 vols. Munich
1835 - Linz 1914

V.G. Plarr : "Men and Women of the Time" 15th edition London 1899

Samuel and Richard Redgrave : "A Century of Painters of the English School" 2 volumes London 1866

Samuel Redgrave : "A Dictionary of artists of the English School" London 1878

W.G. Strickland : "A Dictionary of Irish Artists" 1913

"The Society of British Artists 1824-1893" Antique Collectors Club 1975

U. Thieme and F. Becker : "Allgemeines Lexikon der Bildenden Künstler von der Antike bis zur Gegenwart" 36 vols. Leipzig 1907-1950

Gustave Vapereau : " Dictionnaire Universelle des Contemporains" Paris 1893

Hans Vollmer : "Allgemeines Lexikon der bildenden Künstler des XX Jahrhunderts" 6 vols. Leipzig 1953-62

Christopher Wood : "A Dictionary of Victorian Painters" Antique Collectors Club 2nd edition 1978

2. Periodicals
England
"Ackermann's Repository of Arts, Literature, Commerce, Manufactures and Politics" 1809-1828

"Alexandra Magazine" 1864-1866

"Art Journal" 1849-1912

"Art Student" 1864-1865

"Art Union" 1839-1848

"The Artist" 1880-1902

"Athenaeum" 1828-1912

"La Belle Assemblée" 1806-1832

"The Court Magazine and Belle Assemblée" 1832-1848

"Academy Notes with illustrations of the principal pictures at Burlington House" ed. Henry Blackburn.27 volumes London 1875-1882, 1885-1903

"Connoisseur" 1901-1914

"Country Life" 1897-1914

"The Director" 1807

"English Woman's Journal" 1858-1864

"Englishwoman's Review" 1866-1910

"Fraser's Magazine for Town and Country" 1830-1869

"Illustrated London News" 1842-1914

"Keepsake" 1828-1857

"Ladies Companion at Home and Abroad" 1850-1870

"Ladies Pocket Magazine" 1824-1840

"London Society" 1862-1898

"Magazine of Art" 1878-1904

"Monthly Repository" 1830-1840

"People's Journal" 1846-7

"Portfolio" 1870-1893

"Somerset House Gazette" 1823-4

"Spectator" 1828-1850

"Studio" 1893-1914

"Year's Art" 1879-1914

France

"Archives de l'Art Français" 1851-1866

"L'Art : revue hebdomadaire" 1875-1894, 1901-1907

"L'Art dans les deux mondes" 1890-1

"L'Art en Province" 1835-1859

"L'Art et les Artistes" 1905-1914
"L'Art Moderne" 1875-6

"L'Art pour tous" 1861-1906

"L'Artistes : journal de la littérature des beaux-arts" 1831-1837, 1839-1867, 1867-1904

"Le Bas Bleu . Moniteur Mensuel des Productions Artistiques et Litt-éraires des Femmes" 1873-1874

"Les Beaux- Arts : Musée des chefs d'oeuvre contemporains" 1875-1880

"Bulletin de l'Art ancien et moderne" 1899-1914

"Chronique des Arts et de la Curiosité" 1859-1868 ; then "Chronique politique des Arts" 1869-1870 ; then "Chronique des Arts" 1871-1914

"Courrier Artistique" 1861-5

"Fémina" 1901-1914

"La Fronde" 1897-1914

"Les Gauloises" 1874-1877 (continuation of "Le Bas Bleu")

"Gazette des Beaux-Arts" 1859-1914

"Gazette des Femmes : Revue du Progrès des Femmes dans les Beaux-
Arts et la littérature, l'enseignement et la charité, la musique
et le théâtre" 1873-1884

"Journal des Arts : Chronique de l'Hôtel Drouot" 1879-1914

"Journal des Femmes Artistes" 1890-1901

"Journal des Jeunes Personnes" 1833

C.P.Landon:"Précis historique des productions des Arts, peinture,
sculpture, architecture et gravure" (vols. 2-4 as "Nouvelles des
Arts, peinture et sculpture") 4 vols. Paris 1801-4

C.P.Landon:"Annales du Musée et de l'école moderne des Beaux-Arts"
Paris 1800-1822

"Magasin des Demoiselles" 1845

"Musée Universelle" 1873-9

"La Plume" 1889-1905

"Revue de l'Art Ancien et Moderne" 1897-1914

"Revue des Arts décoratifs" 1880-1902

"Revue Internationale de l'Art et de la Curiosité" 1869-1870

"Revue Universelle des Arts" 1855-1866

Note : Newspapers have not been included in the bibliography because
they have only been consulted on specific dates and not consistently

3. Exhibition catalogues
England

Royal Academy summer exhibitions 1800-1900
Old Water-colour Society 1805-1900
Old Water-colour Society (Winter exhibitions of sketches and
studies) 1862-1900
British Institution 1806-1867
Associated Artists in Water-colour 1808-1812
Society of British Artists 1824-1900 (except for the years 1887
and 1896)
New Society of Painters in Water-colour 1832-1900 (except for the
years 1842 and 1884)
New Society of Painters in Water-colour (Winter exhibitions of
sketches and studies) 1866-1872
National Institution (Portland Gallery) 1850-1861 (except for the
year 1859)
Society of Female Artists (Society of Lady Artists from 1872 and
Society of Women Artists from 1899) 1857-1914
Dudley Gallery (exhibitions of water-colours) 1865-1900 (except
for the years 1888, 1892, 1894, 1897, 1898 and 1899)
Dudley Gallery (exhibitions of oil paintings) 1867-1888 (except
for the years 1881, 1882, 1886 and 1887)
Dudley Gallery (exhibitions of work in black and white) 1872-1881
(except for the years 1873 and 1874)
Grosvenor Gallery 1877-1890

Grosvenor Gallery (Winter exhibitions) 1878-1883
Institute of Painters in Oils 1883-1897
New English Art Club 1886-1899
New Gallery 1888-1900 (except for the year 1892)
Society of Portrait Painters 1891-1900
Society of Miniaturists 1899-1900
Women's International Art Club 1900-1914 (except for the year 1907)

France
Paris Salon 1800-1900 (except for years when Salons were not,
apparently held, in 1803, 1805, 1807, 1809, 1811, 1813, 1815,
1816, 1818, 1820, 1821, 1823, 1825, 1826, 1828, 1829, 1830 (there
was an Exposition au profit des blessés in 1830), 1832, 1851,
1854, 1856, 1858, 1860, 1862, 1871)
Paris Salon (Catalogues illustrés) 1879-1900 (except for the
years 1886, 1889, 1891. 1894, 1897)
Société Nationale des Beaux-Arts 1864, 1890-1899
Salon des Indépendants 1884-1899 (except for the years 1885,
1887, 1890, 1893, 1894 and 1900)
Union des Femmes Peintres et Sculpteurs 1884-1898 (except for
the years 1888, 1892-1897)
Société des Femmes Artistes 1895, 1896 and 1898

4 (a) Books and articles on women artists and women in general

Books

Jean Alesson: "Les Femmes Artistes au Salon de 1878" Paris 1878

C.S. Bremmer : "The Education of Girls and Women in Great Britain"
London 1897

Madeleine Bunoust : "Quelques Femmes Peintres" Paris 1936

Edmée Charrier : "L'Evolution intellectuelle féminine" Paris 1931

Ellen C. Clayton : "English Female Artists" 2 vols. London
1876

Clara Erskine Clement : "Women in the Fine Arts from the Seventh Century
B.C. to the Twentieth Century A.D." Boston 1904

Julie Daubié : "La femme pauvre au XIXe siècle" Paris 1866

Emily Davies: "The Higher Education of Women" London 1866

R J. Durdent : "Galerie des Peintres Français au Salon de 1812, ou coup
d'oeil critique sur les principaux tableaux et sur les différens
ouvrages de Sculpture, Architecture et Gravure" Paris 1813 pp.19-30

Mrs. Elizabeth Fries Lummis Ellet : "Women Artists in All Ages and
Countries" New York 1859

Mrs. Ellis : "The Daughters of England, their position in Society,
character and responsibilities" London and Paris 1845

M.H. Elliott : "Art and Handicraft in the Woman's Building of the
World Columbian Exposition, Chicago, 1893 "Paris 1893

Octave Fidière : "Les femmes artistes à l'Académie Royale de Peinture
et de Sculpture" Paris 1885

"History of the Glasgow Society of Lady Artists' Club" Glasgow 1950

Ernst Guhl : "Die Frauen in der Kunstgeschichte" Berlin 1858

Hans Hildebrandt : "Die Frau als Künstlerin" Berlin 1928

Anton Hirsch : "Die Frauen in der bildenden Kunst" Stuttgart 1905

Maria Lambers de Vits : "Les Femmes sculpteurs, graveurs et leurs oeuvres" Paris 1905

Laura Marholm : "Modern Women" (an English rendering by Hermione Ramsden) Boston 1896

François Mathey : "Six Femmes Peintres" Paris 1951

Charles Oulmont : "Les femmes peintres du dix-huitième siècle" Paris 1928

Bessie Rayner Parkes : "Essays on Woman's Work" London 1866

Alicia C. Percival : "The English Miss. Today and Yesterday" London 1939

Laura Ragg : "Women Artists of Bologna" London 1907

Mme Necker de Saussure : "L'Education Progressive ou Etude au Cours de la Vie" 3 vols, Paris 1838. "Etude de la Vie des Femmes" vol. 3

Walter Shaw Sparrow : "Women Painters of the World" London 1905

Marius Vachon : "La femme dans l'art, les protectrices des arts, les femmes artistes" Paris 1893

Anthony Valabregue : "Les Princesses Artistes" Paris 1888

"Women in Professions, being the Professional Section of the International Congress of Women, London 1899" London 1900

I.E. Wessely : "Kunstübende Frauen" Leipzig 1884

"Discours prononcés le premier messidor an XI (June 30 1803) dans une des salles du onzième arrondissement de la municipalité de Paris, lors de l'ouverture de L'ECOLE GRATUITE DE DESSIN en faveur des jeunes personnes" Paris 1803

Articles
"Les Dames Artistes" in "L'Artiste" 1836 vol.10 pp.15-16

De Peyronnet : "Les Arts" in "Journal des Jeunes Personnes" March 1 1833 no. 1 pp.415-418

E.M. Evors : "Some Women Illustrators of Children's Books" in "Girl's Realm" April 1903 vol. 5 pp.455-463

Jules Fleury : "Une Visite au Louvre" in "L'Artiste" 1844 vol. 2 pp. 210-212

Clive Holland : "The Lady Art Student's Life in Paris" in "Studio" 1904 vol.30 pp.225-33

C.J. Holmes : "Women as Painters" in "The Dome" April-July 1899
NS vol.3 pp.3-9

Jules Janin : "La femme artiste" in "L'Artiste" 1839 vol.2 pp.226-291

Henri Jouin : "L'exposition des artistes femmes" in "Journal des beaux-arts et de la littérature" Brussels 1882 vol.24 p.66

Junius : Conversations on the Arts by Junius between Miss K. and Miss Eve in "Ackermann's Repository" March 1812 vol.7 pp.136-7

Léon Lagrange : "Du rang des femmes dans les arts" in "Gazette des Beaux-Arts" Oct. 1 1860 vol.8 pp.30-43

Gustave de Léris : "Les femmes à l'Académie de Peinture" in "L'Art" 1888 vol.2 pp.122-133

Anna Lea Merritt : "A Letter to Artists : Especially Women Artists" in "Lippincott's Magazine" 1900 vol.65 pp.463-9

Frederick Miller : "Women Workers in the Art Crafts" in "Art Journal" 1896 pp. 117-118

Francis Turner Palgrave : "Women in the Fine Arts" in "Macmillan's Magazine" 1865 vol.12 pp.118-127, 209-221

Thomas Purnell : "Woman and Art" in "Art Journal" 1861 p.107-8

Roger : "Les Femmes Peintres" in "Magasin des Demoiselles" 1845 vol. 1 pp.236-9

Women's Pictures at the Royal Academy in "Victoria Magazine" July 1866 pp.246-8

"La Femme Moderne par elle-même" in "Revue Encyclopédique" Paris 1896 pp 841 ff

"Les Femmes exclues de l'enseignement des beaux-arts par la République Française" in "Revue Universelle des Arts" April-Sept. 1863 vol. 17 pp.55-61

"Women Artists" in "The Westminster Review" July 1858 vol.70 pp.91-104

"The Sisters in Art", a story in the "Illustrated Exhibitor and Magazine of Art" July 1852 vol. 2 pp.214-364

"Art-work for Women" I in "Art Journal" 1872 p.66
"Art-work for Women" II in "Art Journal" 1872 p.102
"Art-work for Women" III in "Art Journal" 1872 p.130

"The Female School of Design in the Capital of the World" in "Household Words" March 1851 p.579

"Les Femmes Peintres Françaises au XVIIe et XVIIIe Siècles" in "Le Magasin Pittoresque" 1851 pp.287-8

"Les Ecoles de Femmes-Peintres" in "Fémina" Feb.15 1903 no. 50 pp.437-440

4 (b) Books on specific women artists

Pierre Angrand : "Marie-Elizabeth Cavé ; disciple de Delacroix"
Lausanne and Paris 1966

Betty Askwith : "Lady Dilke. A Biography" London 1969

Marie-Juliette Ballot : "Une élève de David. La comtesse Benoist, l'
Emilie de Demoustier 1768-1826" Paris 1914

Cecilia Beaux : "Background with Figures" Boston and New York 1930

"Barbara Leigh Smith Bodichon. An American Diary 1857-8" ed. Joseph
W. Reed Jn. London 1972

Hester Burton : "Barbara Leigh Smith Bodichon 1827-1891" London 1949

Le comte Arnauld Doria : "Gabrielle Capet" Paris 1934

Beatrice Caroline Erskine : "Lady Diana Beauclerk" London 1903

Arthur Fish : "Henrietta Rae (Mrs. Ernest Normand)" London, Paris,
New York and Melbourne 1905

Jan Fontane and Jean Burton : "Elisabet Ney" New York 1943

Frances A. Gerard : "Angelica Kauffman" London 1893

W.H. Helm : "Vigée-Lebrun. Her Life, Works and Friendships" London 1916

Mrs. Howitt-Watts : "An Art Student in Munich" 2 vols. London 1853

Marcus B. Huish : "Happy England as painted by Helen Allingham
R.W.S." London 1903

Mme Elisabeth Jerichau : "Memories of Youth" London 1874

Louise Jopling-Rowe : "Twenty Years of My Life 1867-1887" London 1925

Henri Jouin : "Mlle M.G. Bouliar" Paris 1891

"In the Open Country . The Work of Lucy Kemp-Welch" London 1905

Lady Kennet : "Self Portrait of an Artist" London 1951

Laura Knight : "Oil Paint and Grease Paint" London 1936

Katherine McCook Knox : "The Sharples : their portraits of George
Washington and his Contemporaries . A diary and account of the
work of James Sharples and his family in England and America" New
York 1972 (first published in 1930)

Edouard Lepage : "Une Page de l'Histoire de l'Art au dix-neuvième
siècle. Une Conquête Féministe. Madame Léon Bertaux" Paris 1912

A. Magué : "La Duchesse d'Uzès" Paris 1890

Gertrude Massey : "Kings Commoners and Me" London 1934

Elizabeth Murray : "Sixteen Years of an Artist's Life in Morocco,
Spain and the Canary Islands" 2 vols. London 1859

Percy Noble : "Ann Seymour Damer, A Woman of Art and Fashion 1748-1828"
London 1908

Pierre de Nolhac : "Mme Vigée-Lebrun, peintre de la reine Marie-
Antoinette 1755-1842" Paris 1908

Pierre de Nolhac : "Mme Vigée-Lebrun" Paris 1912

Baroness Orczy : "Links in the Chain of Life" London 1947

Charles Pillet : "Mme Vigée-Lebrun" Paris 1890

Edmond Pilon : "Constance Mayer 1775-1821" Paris 1927

" The Journal of Beatrix Potter from 1881 to 1897" London (1974
edition)

Sainte Vallière : "Marie-Eléonore Godefroid ; artiste peintre" Paris
1847

M.H. Spielmann and G.S. Layard : "Kate Greenaway" London 1905

"Souvenirs de la Duchesse d'Uzès" Paris 1939

"Souvenirs de Mme Vigée-Lebrun" 2 vols. Paris 1835-7

4 (c) Articles on specific women artists

Léon Arbaud : "Mlle Godefroid" in "Gazette des Beaux-Arts" Jan.1
1869 vol.1 pp.38-49

Louis Batissier : "Mme Dehérain", obituary in "L'Artiste" 1839-1840
vol.3 pp.72-3

Emile Bellier de la Chavignerie : "Mlle Sophie Fremiet (Mme François
Rude)" obituary in "Chronique des Arts" Dec.15 1867 p.301

Henri Bouchot : "Une artiste française pendant l'émigration, Mme
Vigée-Lebrun" in "Revue de l'Art Ancien et Moderne" 1898 vol.1
pp. 51-62, 219-230

Philippe Burty : "L'Atelier de Mme O'Connell" in "Gazette des Beaux-
Arts" March 15 1860 pp. 349-355

James L. Caw : "The Art Work of Mrs. Traquair" in "Art Journal" 1900
pp.143-8

Paul Claudel : "Camille Claudel" in "L'Occident" August 1905 pp.81-5

Gladys B. Crozier : "Elizabeth Stanhope-Forbes" in "Art Journal"
1904 pp.382-4

Alfred Darcel : "Mme Parmentier (Mlle Eugénie Morin)" in "Chronique
des Arts" Dec. 19 1874 pp 383-4

Jeanne Doin : "Marguerite Gérard (1761-1837)" in "Gazette des Beaux-
Arts" 1912 vol.109 pp.429-452

M. Hepworth Dixon : "Eleanor Fortescue-Brickdale" in "Magazine of
Art" 1902 pp.256-60

M. Hepworth Dixon : "Henrietta Montalba : - A Reminiscence" in "Art Journal" 1894 pp.215-217

B. Dufernex : "Mme Angèle Delasalle" in "Magazine of Art" 1902 pp. 349-354

Laura Dyer : "Mrs. Allingham" in "Art Journal" 1888 pp.198-9

Raymond Escholier : "Angèle Delasalle" in "Gazette des Beaux-Arts" 1912 vol.2 pp.319-332

Charles Gueulette : "Mlle Constance Mayer and Prudhon" in "Gazette des Beaux-Arts" 1879 vol. 19 : May 1 pp.476-488, Oct. 1 pp.337-357, Dec. 1 pp.525-538

René Jean : "Mme de Mirbel" in "Gazette des Beaux-Arts" 1906 vol. 35 pp.131-146

Camille Mauclair : "Hélène Dufau" in "Art et Décoration" 1905 vol. 1 pp. 105-116

Alice Meynell : "Laura Alma-Tadema" in "Art Journal" 1883 pp.345-7

Alice Meynell : "Mlle Sarah Bernhardt" in "Art Journal" 1888 pp.134-9

Alice Meynell : "Mrs. Adrian Stokes" in "Magazine of Art" 1901 vol. 25 pp. 241-7

"Miss Clara Montalba" No. 17 of a series of "Silhouettes d'artistes contemporains" in "L'Art" 1882 vol.3 pp.207-213

F. d'O : "Mme Haudebourt-Lescot" obituary in "L'Illustration" Jan. 18 1845 p.520

André Pérate : "Les esquisses de Gérard" in "L'Art et les Artistes" 1909 pp.4-7

Baron Roger Portalès : "Adélaide Labille-Guiard" in "Gazette des Beaux-Arts" Nov. 1 1901 pp. 353-67, Dec. 1 1901 pp.477-94 ; Jan-June 1902 pp. 100-118, April 1.1902 pp. 325-347

Fr. Rinder : "Henrietta Rae" in "Art Journal" 1901 pp.303-7

W.M. Rossetti : "Dante Gabriel Rossetti and Elizabeth Siddall" in "Burlington Magazine" March-May 1903 pp.273-295

Paul de Saint-Victor : "L'atelier de Mme Lefèvre-Deumier" in "L'Artiste" May 15 1852 pp.187-8

Mme Anna Seaston-Schmidt : "Les Peintures d'Elizabeth Nourse" in "Studio" Dec. 1905 p

Walter Shaw Sparrow : "Evelyn de Morgan" in " Studio" 1900 vol. 19 pp.220-232

A. Valabrègue : "Mme Haudebourt-Lescot" in "Les Lettres et les Arts" 1887 vol. 1 pp. 102-9

Emile Dupont Zipcy : "Marcello" in "Musée Universel" 1876 pp.50-1

5. General books

M. Allard : "L'Art Department et l'enseignement du dessin dans les écoles anglaises" Rouen 1867

Percy Bate : "The English Pre-Raphaelite Painters : their Associates and successors" London 1899

Quentin Bell : "The Schools of Design" London 1963

Albert Boime : "The Academy and French Painting in the Nineteenth Century" London 1971

Frank P. Brown : " South Kensington and its Art Training" London 1912

H.M. Cundall : "History of British Watercolour Painting" London 1908

R.J. Durdent : "Galerie des Peintres français au Salon de 1812, ou coup d'oeil critique sur leurs principaux tableaux et sur les différens ouvrages de Sculpture, Architecture et Gravure" Paris 1913

Théodore Duret : "Les Peintres Impressionistes" Paris 1922 (originally published in 1878)

Maurice Du Seigneur : "L'Art et les Artistes au Salon de 1880" Paris 1880

L. Dussieux : "Les Artistes Français à l'Etranger" Paris 1876

Louis Enault : "Paris Salon , 1881" Paris 1881

J.J. Foster : "British Miniature Painters and their Works" London 1898

Shirley Fox : "An Art Student's Reminiscences of Paris in the 1880s" London 1909

William Fredeman : "Pre-Raphaelitism, A Bibliocritical Study" London 1965

Théophile Gautier : "Abécédaire du Salon de 1861" Paris 1861

Jean Gigoux : "Causeries sur les artistes de mon temps" Paris 1885

Martin Hardie : "Water-colour painting in Britain" 3 vols. London 1967-9

Walter E. Houghton : "The Victorian Frame of Mind 1830-1870" Yale University Press, 1957

Hesketh Hubbard RBA : "An Outline History of the Royal Society of British Artists" London 1937

Sidney Hutchinson : "The History of the Royal Academy 1768-1968" London 1968

J.-K. Huysmans : "L'Art Moderne" Paris 1883

A. Jal : "Esquisses, croquis, pochades ou tout ce qu'on voudra sur le Salon de 1827" Paris 1828

C. Lemonnier : "L'Ecole Belge de Peinture" Brussels 1906

George Dunlop Leslie R.A. : "The Inner Life of the Royal Academy"
London 1914

J. Maas : "Victorian Painters" London 1969

Stuart Macdonald : "The History and Philosophy of Art Education"
London 1970

Jules Martin : "Nos Peintres et Sculpteurs" Paris 1897

Eugène Montrosier : "Artistes Modernes" 4 vols. Paris 1881-4

George Moore : "Modern Painting" London 1893

A.J. Munby : 'Man of Two worlds'" Derek Hudson ed. London 1972

"Le Pausanias Français. Salon de 1806. Etat des Arts du Dessin en
France à l'ouverture du XIXe Siècle" publié par un observateur
impartial. Paris 1806

Nicolas Pevsner : "Academies of Art, Past and Present" Cambridge
1940

Forrest Reid : "Illustrators of the Sixties" London 1928

John Rewald : "The History of Impressionism" 4th revised edition
New York 1973

Comte Louis Clément de Ris : "Notice du musée impérial de Versailles"
Paris 1859 (supplement 1881)

John-Lewis Roget : "A History of the Old Water-Colour Society"
2 vols. London 1891

William Michael Rossetti : "English Painters of the Present Day"
London 1871

William Michael Rossetti : "Pre-Raphaelite Diaries and Letters"
3 vols. London 1900

William Michael Rossetti : "Some Reminiscences" London 1906

"The Works of John Ruskin" ed. E.T. Cook and A.D.O. Wedderburn
London 1903-1912

William Sandby : "A History of the Royal Academy of Arts" London 1862

E. Soulié : "Notice du Musée National de Versailles" 3 vols. Paris
1878-81

C.H. Stranahan : "A History of French Painting from Its Earliest to
Its Latest Practise Including an Account of the French Academy of
Painting, Its Salons, Schools of Instruction and Regulations"
New York 1888

Sarah Tytler : "Modern Painters and their Paintings" London 1882

Th. Véron : "De l'Art et des Artistes de mon temps" Paris 1875

Claude Vignon : "Le Salon de 1850-1" Paris 1851

Claude Vignon : "Le Salon de 1852" Paris 1852

Claude Vignon : "Le Salon de 1853" Paris 1853

Claude Vignon : "Exposition Universelle des Beaux-Arts" Paris 1855

Horace Walpole : "Anecdotes of Painting in England" 5 vols. London and New Haven 1937

Joseph W. Gleeson White : "English Illustration of the Sixties 1855-1870" Westminster 1897

Sir Henry Trueman Wood : "A History of the Royal Society of Arts" London 1913

Parliamentary Papers include the Reports of the Council on the Schools of Design in the 1840s, the Report of the Select Committee on the School of Design in 1849, the Report of the Department of Practical Art in 1853, and the Reports of the Department of Science and Art from 1853.
A volume of "Reports of the Female School of Art 1863-1906" in the Library of the Central School of Art and Design was an extremely useful source.

6. BIBLIOGRAPHY FOR CHAPTER FIVE (BIOGRAPHIES)

Thieme-Becker's "Allgemeines Lexikon der Bildenden Künstler" and
Benezit's "Dictionnaire des Peintres, Sculptres etc." have been
consulted in every case and will therefore not be cited in the
individual bibliographies. Main sources only are given here.
Occasional references are given in the notes.

1. Margaret Sarah Geddes (Mrs. William Carpenter)

Principal exhibitions :-

RA	1814-1825, 1828-1863, 1865, 1866	=	156
BI	1814-1817, 1819-1824, 1826-1833,		
	1835, 1837-1840, 1842-1853	=	61
SBA	1831-1836	=	19
EU	1855	=	1
SFA	1858, 1863	=	4
OWS	(according to A. Graves)	=	1

"Art Journal" 1873 p.6 (obituary)
M. Bryan op.cit. vol.1 pp. 254-5
E.C.Clayton : op.cit. vol. 1 pp. 386-389
Lionel Cust : "Eton College Portraits" London 1910
DNB vol. 3 p.1068
Algernon Graves : "A Century of Loan Exhibitions" vol. 1 pp.
 151-2, vol.4 pp. 1824-5 (41 works)
Samuel Redgrave op.cit. p. 71
William Roberts : "Art Monographs" vol. 1 1916
Donald C. Whitton : "The Grays of Salisbury" San Francisco 1976

2. The Misses Sharpe :-

Principal exhibitions :-

Charlotte Sharpe (Mrs. Best Morris)

RA	1817-1820, 1822, 1823, 1830, 1832,		
	1835, 1837, 1839-1841	=	19

Eliza Sharpe (sometimes exhibited as Miss Sharpe
after the marriage of Charlotte in 1821)

RA	1817-1824, 1826-1829, 1838, 1841,		
	1847, 1850, 1851, 1853, 1855,		
	1858, 1865, 1867	=	48
OWS	1829-1833, 1835-1839, 1841-1857,		
	1859-1870	=	88
SFA	1860, 1861, 1868-1870,		
	1873, 1874	=	12

Louisa Sharpe (Mrs. Woldemar Seyffarth)

RA	1817-1824, 1826-1829	=	29
OWS	1829-1833, 1835-1842	=	39

Mary Ann Sharpe

RA	1819-1824, 1826, 1827, 1838-1840,		
	1847, 1852-1854, 1858, 1859, 1862,		
	1863	=	19
SBA	1826, 1827, 1830, 1831, 1835, 1837,		
	1844-1848, 1852, 1854-1856, 1862,		
	1864	=	25
SFA	1860, 1861, 1865	=	6

"Art Journal" 1874 p. 232 (obituary, Eliza)
"Art Union" 1843 p. 59 (obituary, Louisa)
M. Bryan op.cit. vol. 5 p.72
E.C. Clayton op.cit. vol. 1 pp. 379-382
DNB vol. 17 pp. 1362-3

Otto Nagler op.cit. vol. 16 p.331
Samuel Redgrave op.cit. p. 389
J.-L. Roget op.cit. vol. 1 pp. 547-8, vol. 2 pp. 42. 206-7

3. Margaret Gillies

Principal exhibitions :-

RA	1832-1861		=	101
SBA	1834, 1837-1839, 1842		=	8
BI	1846, 1853		=	2
PG	1851, 1852, 1854		=	7
OWS	1852-1884, 1887		=	258
EU	1855		=	2
SFA	1858-1861, 1863-1865		=	13
GG	1877-1881		=	9

"Academy" July 30 1887 no. 795 pp. 75-6 (obituary)
"Art Journal" 1887 p. 318 (obituary)
Frances Blanshard : "Portrait of Wordsworth" London 1959
M. Bryan op.cit. vol. 2 p. 241
E.C. Clayton op.cit. vol. 2 pp. 87-94
DNB vol. 21 (1890 edition) pp. 368-9
Algernon Graves : "A Century of Loan Exhibitions" vol. 1
 p. 419 (2 works)
J.-L. Roget op.cit. vol. 2 pp. 372-377
"Times" July 26 1887 p. 7 (obituary)

4. Sarah Setchel

Principal exhibitions :-

RA	1831-1833, 1835-1837, 1839, 1840	=	9
SBA	1832-1837, 1839, 1840	=	15
NSPW	1834, 1842, 1845, 1847-1850, 1852, 1854, 1856, 1866/7-1867/8	=	31

M. Bryan op.cit. vol. 5 p.70
E.C. Clayton op.cit. vol. 2 pp. 124-129
J.-L. Roget op.cit. vol. 2 p. 338
"Year's Art" 1895 p. 282 (obituary)

5. Mary Anne Alabaster (Mrs. H. Criddle)

Principal exhibitions :-

BI	1830-1847	=	25
SBA	1831, 1838-1841, 1843, 1844	=	17
RA	1837-1839, 1841, 1843-1846, 1848	=	11
OWS	1849-1880	=	149
Great Exhibition 1862		=	1

Agnes and Maria E. Catlow : "The Children's Garden and what
 they made of it" London 1865, illustrated by
 Mrs. Criddle
E.C. Clayton op.cit. vol. 2 pp. 70-74
J.-L. Roget op.cit. vol. 2 pp. 337-339

6. Louisa and Fanny Corbaux

Principal exhibitions :-

Louisa Corbaux

SBA	1828-1837, 1840, 1850	=	16
NSPW	1832-1834, 1837-1859, 1861-1872, 1876-1878, 1880, 1881	=	86
RA	1833, 1834, 1836	=	3
SFA	1857, 1865	=	6

Fanny Corbaux

SBA	1828-1840	=	48
RA	1829-1848, 1850-1854	=	86
BI	1830-1833, 1836-1841	=	15

```
                  NSPW   1832-1834, 1837-1852, 1854        =    38
                  EÜ     1855                              =     2
"Athenaeum" Feb. 10 1883 p. 192 (obituary, Fanny)
E.C. Clayton op.cit. vol. 2 pp 68-70
DNB               vol. 4 pp. 1120
"Year's Art" 1884 p. 217 (obituary, Fanny)
```

7. Louisa Stuart Marchioness of Waterford)

Principal exhibitions :-

```
                  DG     1877, 1889                         =     3 (?)
                  GG     1878-1882                          =    20
                  SFA    1886, 1887, 1890                    =     3
E.C. Clayton op.cit. vol. 2 pp. 338-340
"Fine Arts Quarterly Review" 1864 vol. 2 p. 198
Algernon Graves : "A Century of Loan Exhibitions" vol. 4 p. 1608
                  (26 works)
Augustus Hare : "The Story of Two Noble Lives" London 1893
                  3 volumes
H.M. Neville : "Under a Border Tower" 1897
General Charles Stuart : "Short Sketch of the Life of Louisa
                  Marchioness of Waterford" London 1892
"Studio" 1910 vol. 49 pp. 283-286
Virginia Surtees : "Sublime and Instructive : Letters from John
                  Ruskin to Louisa Marchioness of Waterford, Anna
                  Blunden and Ellen Heaton" London 1972 pp. 1-77
```

8. Eliza Florence Fox (Mrs. Frederick Lee Bridell)

Principal exhibitions :-

```
                  SBA    1846-1850, 1854, 1856, 1857        =    14
                  RA     1848, 1850, 1853, 1854, 1857-1861,
                         1863-1865, 1867, 1868, 1870, 1871,
                         1883                                =    20
                  SFA    1857, 1858, 1860, 1861, 1866, 1867,
                         1869-1874, 1877-1879, 1885-1887     =    51
                  BI     1862, 1863                          =     2
                  DG(oil) 1867, 1870, 1873                   =     4
                  DG     1877, 1878, 1881                    =     3
                  Paris salon   1866                         =     1
E.C. Clayton op.cit. vol. 2 pp. 80-7
Algernon Graves : "A Century of Loan Exhibitions" vol. 1
                  p. 105, vol. 4 p. 1806 (5 works)
```

9. Susan D. Durant

Principal exhibitions :-

```
                  RA     1847-1853, 1856-1860, 1863, 1864,
                         1866-1869, 1872, 1873               =    38
                  SFA    1858, 1863                          =     6
                  BI     1860                                =     1
"Art Journal" 1873 p.80 (obituary)
Clement and Hutton op. cit. vol. 1 p.228
"Englishwoman's Review" April 1873 no. 14 p.157 (obituary)
Samuel Redgrave op.cit. p.133
```

10. Anna Blunden (Mrs. Francis Martino)

Principal exhibitions :-

```
                  RA     1854, 1856-1859, 1862-1864, 1866,
                         1867, 1872                          =    11
                  SBA    1854-1866, 1868, 1876/7             =    34
                  SFA    1857-1859                           =     8
                  BI     1860                                =     1
                  DG     1865-1875, 1877                     =    24
```

 DG(oil) 1868 = 1
"A Catalogue of Birmingham and West Midlands painters of the
 nineteenth Century" (Sidney and Kathleen
 Morris" 1974
E.C Clayton op.cit. vol. 2 pp 196-226
Virginia Surtees : " Sublime and Instructive. Letters from
 John Ruskin to Louisa Marchioness of Waterford,
 Anna Blunden and Ellen Heaton" London 1972 pp.
 79-140

11. Joanna Mary Boyce

Principal exhibitions :-
 SBA 1853 = 1
 RA 1855-1857, 1859-1862 = 9
Catalogue for "An Exhibition of Paintings by Joanna Mary Boyce"
 at the Tate Gallery, June-July 1935
"Art Journal" 1861 p. 273 (obituary)
M. Bryan op.cit. vol. 5 p. 354
Clement and Hutton op.cit. vol. 2 p.344
"Critic" July 27 1861 p. 109 (obituary)
"English Woman's Journal" 1861 vol. 8 no. 43 pp. 143-4
 (obituary)
Samuel Redgrave op.cit. p. 463
Sarah Tytler op.cit. p. 299

12. Henrietta Mary Ada Ward (Mrs. Edward Matthew Ward)

Principal exhibitions :-
 RA 1846-1847, 1849-1860, 1362-1864,
 1866-1879. 1882, 1889, 1890, 1893
 (+) = 43
 SFA 1857-1860, 1865, 1868, 1869, 1871-
 1875, 1877, 1883 = 25
 DG(oil) 1872 = 2
"Art Journal" 1864 pp. 357-359. No. 77 of a series on "British
 Artists : their style and character" by James Dafforne
E.C. Clayton op.cit. vol. 1 pp. 161-166
Clement and Hutton op.cit. vol. 2 pp. 333-4
Algernon Graves : "A Century of Loan Exhibitions" vol. 4 p.
 1604 (11 works)
Sarah Tytler op.cit. p.300
Mrs. E.M. Ward : "Memories of Ninety Years" London 1939

13. Emily Mary Osborn

Principal exhibitions :-
 RA 1851-1867, 1870-1873, 1875, 1877,
 1880, 1884 = 43
 BI 1852-1854, 1856 = 4
 SBA 1857, 1858, 1862, 1863, 1865,
 1873/4, 1875, 1877, 1888 = 11
 DG(oil) 1872, 1877 = 3
 SFA 1875, 1889-1891, 1893-1900 (+) = 40
 Paris Salon 1879, 1881 = 2
 GG 1882-1884, 1887, 1888, 1890 = 7
 NG 1888-1894, 1896-1900 (+) = 14
 DG 1889 = 6
 SPP 1896 1
"Art Journal" 1864 vol. 26 pp. 261-3 No. 75 of a series
 on "British Artists : their style and
 character" by James Dafforne
"Art Journal" 1868 vol. 30 pp. 148-9
"Art Journal" 1872 pp. 10-11

Clement and Hutton op.cit. vol. 2 p.156
Algernon Graves : "A Century of Loan Exhibitions" vol. 2 p.886,
 vol. 4 p. 2105 (7 works)

14. Lucy Madox Brown (Mrs. William Michael Rossetti)

Principal exhibitions :-

DG	1869-1872	=	5
RA	1870	=	1
DG(oil)	1871	=	1

"Art Journal" 1894 p.192 (obituary)
"The Artist" Feb. 1897 vol. 19 pp. 49-56
Percy Bate op.cit. pp. 22-3
"Chronique des Arts" April 21 1894 no. 16 p.127 (obituary)
E.C. Clayton op.cit. vol. 2 pp. 116-124
DNB vol. 17 pp. 289-90
Ford Madox Hueffer : "Ford M. Brown. A Record of his Life and
 Work" London 1896
"Magazine of Art" 1890 vol. 13 pp. 289-296 and 1895vol. 18
 pp. 341-6
Lucy Madox Rossetti : "Mrs. Shelley" London 1890
William Michael Rossetti : "Some Reminiscences" London 1906
"Year's Art" 1895 p.282 (obituary)

15. Marie Spartali (Mrs. W Stillman)

Principal exhibitions :-

DG	1867-1873, 1875-1878	=	23
SFA	1869	=	1
RA	1870, 1873, 1875-1877	=	7
DG(b&w)	1872	=	1
SBA	1874/5	=	1
GG	1877, 1879-1885, 1887	=	21
NSPW	1886, 1887	=	2
NG	1888-1899	=	33

Percy Bate op.cit. p.112
EC Clayton op. cit vol. 2 pp.135-7
Clement and Hutton op.cit. vol. 2 pp.265-6
"Portfolio" August 1870 vol. 1 pp.113,118
William Michael Rossetti : "Some Reminiscences" London 1906
 pp. 342, 492
William Michael Rossetti : "English Painters of the Present
 Day" 1871
"Studio" 1904 vol. 30 pp.254 ff

16. Elizabeth Thompson (Lady Butler)

Principal exhibitions :-

DG	1867, 1871-1874	=	7
SFA	1867-1869, 1871-1875, 1877	=	23
DG(oil)	1868, 1872, 1873	=	3
DG(b&w)	1872, 1874	=	5
RA	1873-1875, 1879, 1881, 1882, 1885,		
	1887, 1889, 1890, 1892, 1893,		
	1895, 1897-1899, 1902, 1903, 1905	=	20
NSPW	1874-1877	=	9
EU	1877	=	1
NG	1896	=	1

Lady Butler : "An Autobiography" London 1922
Lady Butler : "Letters from the Holy Land" London 1903
Lady Butler : " From Sketch-book and diary" London 1909
"Chronique des Arts" Dec.10 1898 no. 39 pp.355-6
E.C. Clayton op.cit. vol. 2 pp.139-143

Clement and Hutton op.cit. vol. 2 pp.292-3
Algernon Graves : " A Century of Loan Exhibitions" vol. 1
 p.131, vol. 4 p.1817 (20 works)
"Magazine of Art" 1879 pp.257-262
Viola Meynell : "Alice Meynell. A Memoir" London 1929
Wildrid Meynell : "The Life and Work of Lady Butler" in
 the "Art Annual" 1898 vol. 18
V Plarr op.cit
"Times" Oct. 3 1933 p.7

17. Félicie de Fauveau

Principal exhibitions :-
 S 1827, 1830, 1842, 1852 = 5
 EU 1855 = 3
"L'Artiste" 1841 vol. 7 pp.350-1
"L'Artiste" 1842 vol. 1 pp.6-9, 39-43, 84-87
"L'Artiste" 1884 vol. 1 pp.85-100
"English Woman's Journal" 1859 vol. 2 pp.83-94
"Gazette des Beaux-Arts" 1887 vol. 35 pp.512-521
Jean Gigoux : "Causeries sur les artistes de mon temps" Paris
 1885 pp.211-215
Stanlislas Lami op.cit. pp.346-7
"Revue Brittanique" March 1857 pp.356-8

18. Rosa Bonheur

Principal exhibitions :-
 S 1841-1850, 1853, 1899 = 43
 EU 1855, 1867, 1889 = 13
 Brussels 1851, 1858, 1881 = 8
 RA 1869 = 2
 NSPW 1867, 1868, 1875 = 3
 SFA 1861, 1862, 1865, 1867, 1870,
 1873 (England) = 16
"Atelier Rosa Bonheur" L. Roger-Miles. Paris 1900
"L'Art" 1903 vol. 3 pp.419, 464, 541
F. Lepelle de Bois-Gallais : "Biographie de Mlle Rosa Bonheur"
 Paris 1856
Pierre Bonnefont : "Nos Grandes Françaises. Rosa Bonheur" Paris
 1893
"Century" October 1884 vol. 28 pp.833-840
"Gazette des Beaux-Arts" May 1900 vol. 23 pp.435-439
Algernon Graves : "A Century of Loan Exhibitions" vol. 1 pp.75-6,
 vol. 4 pp.1794-5 (41 works)
Anna Klumpke : "Rosa Bonheur. Sa vie, son oeuvre" Paris 1908
"Magazine of Art" 1902 vol. 26 pp.531-536
Eugène de Mirecourt : "Les Contemporains(21ème série). Rosa Bonheur"
 Paris 1856
E. Montrosier : "Grands peintres français et étrangers" vol. 2
 Paris 1880 "Rosa Bonheur"
E. Perraud de Toury : "Notice biographique sur Mlle Rosa Bonheur"
 Paris 1855
René Peyrol : " Rosa Bonheur, her life and work" ("Art Annual"
 1889)
"Revue des Revues" Jan.15 1897 p.131, June 14 1899 p.605
L. Roger-Miles : "Rosa Bonheur, sa vie, son oeuvre" Paris 1900
Theodore Stanton ed. : "Reminiscences of Rosa Bonheur" London 1910

19. Henriette Browne

Principal exhibitions :-
 S 1853, 1857, 1859, 1861,

```
                    1863-1870, 1872-1878          =    45
        EU      1855, 1867                         =     7
        NSPW    1867                               =     1
        SFA     1867                               =     1
        RA      1871, 1872, 1875, 1879            =     5
```
"L'Art" 1877 vol. 2 pp.97-103
"Chronique des Arts" March 30 1901 no. 13 p.103 (obituary)
"English Woman's Journal" April 1 1860 vol. 5 no. 26 pp.85-92
"Fine Arts Quarterly Review" Oct. 1863 vol. 1 pp.299-306
Algernon Graves : "A Century of Loan Exhibitions" vol. 1 pp.
 116-7, vol. 4 p.1812 (11 works)
"Musée Universel" 1878 vol. 12 p.66
"Year's Art" 1902 p.319 (obituary)

20. Berthe Morisot

Principal exhibitions :-
```
        S       1864- 1868, 1870, 1872, 1873      =    12
                Impressionist Exhibitions  1874, 1876,
                1877, 1880, 1881, 1882, 1886       =    89
```
Monique Angoulvent : "Berthe Morisot" Paris 1933
"Art Journal" 1895 p.190 (obituary)
M.L. Bataille and G. Wildenstein : "Berthe Morisot - Catalogue
 des peintures, pastels et aquarelles" Paris 1961
"Chronique des Arts" March 9 1895 no. 10 p.92 (obituary)
Théodore Duret : "Les Peintres Impressionistes" 1922 edition
 pp.115-125
"Gazette des Beaux-Arts" 1907 vol. 2 pp.390-392, 491-508
Elizabeth Mongan : "Berthe Morisot - Drawings, Pastels, Water-
 colours" New York 1960
"Correspondance de Berthe Morisot " Denis Rouart ed. Paris 1950

21. Mary Cassatt

Principal exhibitions :-
```
        S       1872-1876                          =     6
                Impressionist Exhibitions  1879, 1880,
                1881, 1886                         =     ?
```
"L'Art décoratif" 1902 vol.8 no.47 pp.177-185
"L'Art et les Artistes" 1910-1911 vol. 12 pp.69-75
"Les Arts" 1926 vol. 10 pp.107-111
Adelyn Breeskin : "The Graphic Work of Mary Cassatt" New York 1948
Adelyn Breeskin : "Mary Cassatt : A Catalogue raisonne of the
 Oils, Pastels, Watercolours and Drawings"
 Washington D.C. 1970
J.-K. Huysmans : "L'Art Moderne" Paris 1883 pp.231-234
Achille Segard : "Mary Cassatt, un peintre des enfants et des
 mères" Paris 1913
Frederick Sweet : "Miss Mary Cassatt, Impressionist from
 Pennsylvania" Oklahoma 1966

22. Eva Gonzalès

Principal exhibitions :-
```
        S       1870, 1872, 1874, 1876, 1878-1880,
                1882, 1883                         =    17
        SR      1873                               =     1
```
"L'Artiste" Feb. 1885 p.131
"Chronique des Arts" May 12 1883 no.19 p.153
"Chronique des Arts" Jan. 24 1885 no.4 pp.25-6
"Courrier de l'Art" 1885 p.52
Catalogue for an exhibition of her paintings and pastels at the
 Salons de la Vie Moderne in 1885. Preface by
 Philippe Burty, essay by Théodore de Banville

"Renaissance" June 1932 no. 6 pp.110-115
Claude Roger-Marx : "Eva Gonzalès" Paris 1950

23. Louise Breslau

Principal exhibitions :-

S	1879-1888, 1894 (+)		=	18
UFPS	1884		=	2
EU	1889		=	3
SN	1890-1893, 1895 - 1897, 1899 (+)		=	99
RA	1882		=	1

Arsène Alexandre : "Louise Breslau" Paris 1928
"L'Art et les Artistes" 1910 pp. 208-213
"Les Arts" 1910 no.99 pp.12-17
"Gazette des Beaux-Arts" 1905 vol. 2 pp.195-206
Edouard Joseph op.cit. vol. 1 p 202
"Revue de l'Art Ancien et Moderne" 1921 vol.39 pp.253-262
Madeleine Zillhardt : "Louise-Catherine Breslau et ses amis"
Paris 1933

24. Virginie Demont-Breton

Principal exhibitions :-

S	1880-1885, 1887-1900 (+)	=	37
UFPS	1887, 1890, 1891	=	5
NG	1898	=	2

Virginie Demont-Breton : "Les Maisons que j'ai connues"
3 volumes, Paris 1926
Edouard Joseph op.cit. vol. 1 pp.383-4
Emile Langlade : "Artistes de mon temps" vol. 2 "Virginie
Demont-Breton" Paris 1933
G. Maroniez : "Virginie Demont-Breton" Paris 1895
Eugene Montrosier : "Artistes Modernes" vol. 4 1884 pp.113-116
"Revue de l'Art Ancien et Moderne" 1935 vol. 67 p.110
"Revue Encyclopedique" 1896 vol. 6 p.855
"Zeitschrift fur bildende Kunst" 1881 vol. 16 pp.358-9

25. Marie Bashkirtseff

Principal exhibitions :-

S	1880, 1881, 1883-1885	=	8
UFPS	1884	=	4

"Le Journal de Marie Bashkirtseff" ed. A. Theuriet, 2 volumes
Paris 1887
"Les Lettres de Marie-Bashkirtseff" Preface by François Coppée
Paris 1891
"Nouveau Journal inédit de Marie Bashkirtseff" Paris 1901
Catalogue for an exhibition of her works held by the Union des
Femmes Peintres et Sculpteurs. Paris 1885
Mathilde Blind : "A Study of Marie Bashkirtseff" in A. Theuriet's
"Jules Bastien-Lepage" Paris 1892 pp.149-190
M.L. Breakell : "Marie Bashkirtseff. The Reminiscence of a
Fellow-Student" in "The Nineteenth Century and
after" 1907 vol. 62 pp 110-125
A. Cahuet : "Moussia ou la vie et la mort de Marie Bashkirtseff"
Paris 1926

ACKNOWLEDGEMENTS

I would like to thank the staff of the following libraries for help in my research: the British Library, the Courtauld Institute Library, the Victoria and Albert Museum Library, the London Library, the Royal Academy Library, the Fawcett Library, the Lambeth Public Library, the libraries of the Central School of Art and Design and the Institute of Education, the Bibliothèque Nationale, the Bibliothèque Marguerite Durand, the library of the Ecole des Beaux-Arts and in addition the staff of the Archives Nationales and the Royal Commission on Historical Manuscripts.

In particular I would express thanks to the staff of the Bibliothèque d'Art et d'Archéologie and of the Witt Library and to Dr. Laver in the Wordsworth Library for constant help in my research on Margaret Gillies.

In addition thanks are due to Stephen Winkworth at the Heatherley School of Fine Art, Major M. Lee for help and advice in my work on Lady Butler, Carolyn Harden at the Victoria and Albert Museum and to Mrs. Imogen Dennis, Mrs. Rhona Butler and Mr. Rupert Butler for allowing me to see their private collections. Mrs. Dennis and Mrs. Butler were extremely hospitable and helpful and gave me much first-hand information for which I am very grateful.

I received assistance from the staff of numerous provincial museums and art galleries and owe special thanks to David Phillips at the Castle Museum Nottingham, Leo Buckingham at the Southampton Art Gallery, Miranda Strickland-Constable at Temple Newsam House and Mme Marguerite Guillaume at the Musée de Dijon.

I am most grateful to my typist, Rebecca Reed, who was efficient and understanding.

Finally, I would like to thank my husband who took many of the photographs, mounted them all on paper and has given constant help, advice and encouragement.

The most valuable contemporary work on the subject of women artists is the catalogue of the exhibition "Women Artists: 1550-1950" (Los Angeles County Museum of Art, Dec. 1976) compiled by Ann Sutherland Harris and Linda Nochlin. This I found extremely helpful and encouraging in my work.

This thesis was supervised by Professor Alan Bowness.